Wadsworth Atheneum Paintings II
Italy and Spain

Fourteenth through Nineteenth
Centuries

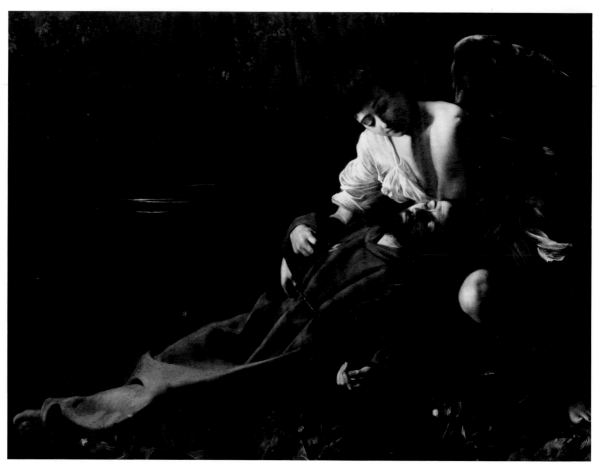

Michelangelo Merisi da Caravaggio, *St. Francis*

Wadsworth Atheneum Paintings II

Italy and Spain

Fourteenth through Nineteenth Centuries

Jean K. Cadogan, Editor

Italian Paintings by Jean K. Cadogan and Michael R. T. Mahoney

Spanish Paintings edited by George Kubler and Craig Felton

Hartford

Cover: Bernardo Strozzi, *St. Catherine of Alexandria*

Copy editor: Thomas Repensek
Designer: Nathan Garland
Typesetter: Southern New England Typographic Service, Inc.
Printer: The Stinehour Press

Copyright © 1991 Wadsworth Atheneum
Library of Congress Catalogue Card Number: 77-82219
ISBN 0-918333-09-1

Contents

Preface

The permanent collection of works of art determines the character of any museum. No matter how splendid its exhibitions or inventive and responsible its educational programs, or enlightened the attitudes of trustees and staff, the way the collection is installed and interpreted, conserved and catalogued, remains the true test of the quality and seriousness of the institution. Central to that mission is the need to catalogue and thus make widely available and accessible to scholars, students, and the ordinary reader the most complete and the most recent knowledge regarding the collection.

The Wadsworth Atheneum takes great pride in the publication of this catalogue of its Italian and Spanish schools for several reasons. It brings into focus one of the most important strands in the pictorial collection of the museum. It represents a decade of laborious and intensive research at the highest levels of scholarship, and the most demanding connoisseurship on the part of Dr. Jean Cadogan, the Charles C. and Eleanor Lamont Cunningham Curator of European Paintings, Sculpture, Prints, and Drawings, and that of her colleagues, Professor Michael Mahoney of Trinity College, Hartford, Professor George Kubler of Yale University, and Professor Craig Felton of Smith College. It brings together both the accumulated wisdom of the past and the new light of recent findings.

The Wadsworth Atheneum's distinguished collection of Italian and Spanish paintings owes itself almost entirely to the vision and acumen of two directors, A. Everett Austin, Jr. (1927–45), and his successor, Charles Cunningham (1946–66), as Dr. Cadogan has so arrestingly shown in her introduction. Austin's prescient acquisitions of baroque paintings have become an honored part of the history of the Wadsworth Atheneum and, indeed, of the emergence of the taste for baroque art in American museums in the 1930s and 1940s. Austin had a brilliant, intuitive (but not unschooled) eye and sensibility. It took a confident successor in Charles Cunningham to build on those foundations, to amplify the collection and to begin to collect systematic information and knowledge about the works. Charles Cunningham's scholarly interests in the works acquired by his predecessor and himself form the starting point for Dr. Cadogan's research.

Dr. Cadogan has made many important new discoveries about the collection that should bring to the awareness of a wider audience its significance and quality. It should be a matter of greater surprise than it is to reflect that this collection has been accumulated in the last sixty years. It would be impossible to re-create it now, even with unlimited resources. Perhaps for too long the great collections of America's older art museums have been taken for granted. We have come to expect that cities of even relatively modest size like Hartford will have a great art museum as a natural part of the urban fabric. Dr. Cadogan's catalogue is an important reminder to us of the great rarity as well as the great beauty of these collections and the impossibility that they can ever be created again. It certainly remains a challenge to the museums in the present day as to how these collections can be renewed, added to, and given continuing life to future generations. It is a challenge which the Wadsworth Atheneum is happy to meet.

Lastly, American museums have in the past century lived through a great age of accumulation of treasure. Today the emphasis falls less on accumulation than on interpretation. Every museum worth its salt greatly concerns itself about educating its diverse public in and through its permanent collection as well as its special exhibitions. The museum, rightly, for the most part, addresses a broad lay public. Catalogues such as this are an important reminder that the art museum shares with institutions of higher learning a responsibility to contribute to new knowledge. The responsibility of the museum must extend beyond the secure and appropriate housing of its great collections to providing the most recent knowledge at the highest levels of scholarship about individual works which it owns.

A monumental enterprise of this kind depends on both the quality and the stamina of the curator involved, and the Wadsworth Atheneum owes a great debt to Dr. Cadogan for her sustained labors on this work. The museum also owes a debt to those who have generously funded the project over the years, and in particular to the National Endowment for the Arts, to a generous anonymous donor, and to Emilie de Brigard, whose contribution to the catalogue is in memory of her father, A. Lincoln Rahman. To all of these institutions and individuals, the Wadsworth Atheneum expresses its heartfelt gratitude, knowing that it has earned the gratitude of scholars and colleague museums the world over that knowledge of these works is now easily available.

Patrick McCaughey
Director

Acknowledgments

Over the years this catalogue has been in preparation many debts of gratitude have been incurred by the authors. We are grateful to the scholars who have looked at pictures in painting storage and poured over photographs, offering opinions, ideas, and directions for further inquiry; these include Everett Fahy, Mina Gregori, Sir John Pope-Hennessy, Pierre Rosenberg, Nicola Spinosa, Federico Zeri, and the late Raffaello Causa. Countless scholars have answered specific queries and given advice; their contributions are acknowledged in the notes of relevant entries. We are also grateful to the staffs of the libraries we have visited, including the Biblioteca Hertziana; the Kunsthistorisches Institut; the Service de Documentation, Département de Peintures, Musée du Louvre; the Witt Library, Courtauld Institute of Art; the Fine Arts Library of Harvard University; the Art and Architecture Library and Sterling Memorial Library, Yale University; the library of the National Gallery of Art, Washington; and the Frick Art Reference Library.

Colleagues at the Wadsworth Atheneum were a long-standing source of support and practical assistance; these include Director Patrick McCaughey and former director Tracy Atkinson; former chief curators Phillip Johnston and Gregory Hedberg; former curator of costume and textiles Marianne Carlano; and my current fellow curators Elizabeth Kornhauser and Andrea Miller-Keller. Linda Horvitz Roth, associate curator of European decorative arts, began her Atheneum career as my assistant in this project and is owed a special debt of gratitude for her work on the eighteenth-century Italian pictures. Eugene Gaddis, archivist, and John Teahan, librarian, also lent their invaluable assistance. Our esteemed conservation staff, Stephen Kornhauser, chief conservator, Patricia Sherwin Garland, conservator, and Zenon Gansziniec, conservation assistant, spent many hours examining every picture and answering endless questions about condition and treatment. Gertrud Pfister Bourgoyne worked tirelessly on the manuscript, and Raymond Petke helped assemble and make new photographs. Finally, a succession of hard-working interns helped in countless ways; we wish to thank particularly William Griswold, James Ganz, and Emma Guest.

The research for this catalogue was started in the early 1970s by graduate students from Yale under the direction of the late Charles Seymour for early Italian pictures, and George Kubler for Spanish pictures. While the Italian entries advanced no further than very preliminary form, the Spanish entries were much further advanced and are here edited and enlarged in varying degrees by Craig Felton. We therefore wish to acknowledge the contribution of Mary Carrasco for her work on the Bayeu, the Ribalta, and the Murillo; Jeff Kowalski for his work on the García Hidalgo, the El Greco, and the Juan de Juanes; Otto Naumann for his contribution to the Valdés Leal, the Fortuny, the Zurbaráns, and the Eugenio Lucas the Elders; and the late Oswaldo Rodríguez-Roque for his work on the Goya, the Mazo, and the Meléndez. Craig Felton wrote the biographies for each entry as well as the commentaries to the Eugenio Lucas the Elders, the Meléndez, and the Riberas. He also added references to recent literature for all the entries. Edmund Pillsbury very kindly wrote the entry for the Jacopo Zucchi, *Bath of Bathsheba*.

The publication of this catalogue has been supported by several sources. The Ford Foundation provided the initial funding, and was joined by the Gladys Krieble Delmas Foundation, which funded research by Linda Horvitz Roth in Venice; the Connecticut Italian-American Cultural Organization; the National Endowment for the Arts, a federal agency; the J. Paul Getty Trust; Emilie de Brigard, in memory of her father, A. Lincoln Rahman; and a much appreciated anonymous donor.

Finally, we wish to thank our copy editor, Thomas Repensek, for his careful review of the manuscript and proofs, and his compilation of the indices. We are also grateful to William Glick and his colleagues at The Stinehour Press for their fine printing, as well as our designer, Nathan Garland, for his sympathetic and elegant design.

Jean K. Cadogan

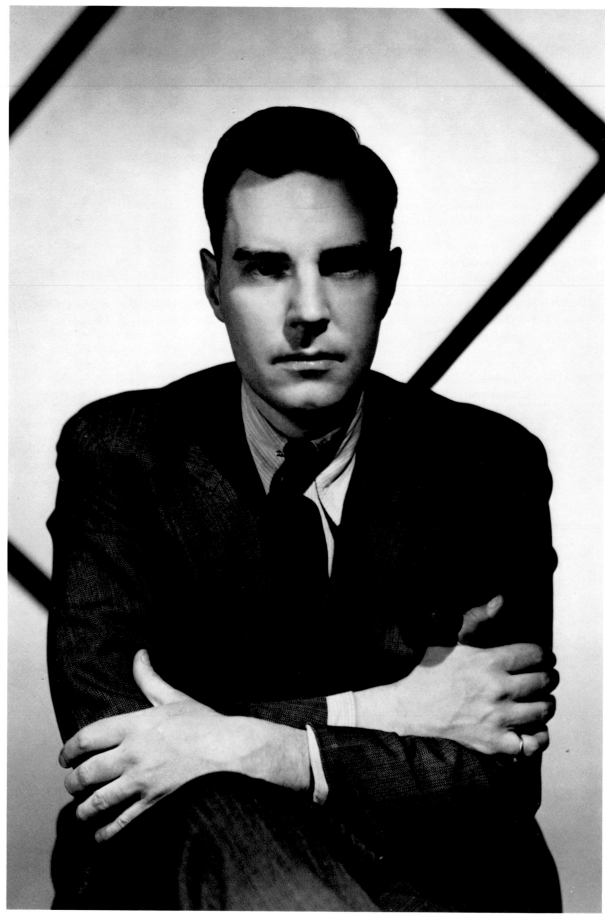

Figure 1. A. E. Austin, Jr., 1936
Courtesy Estate of George Platt Lynes

Introduction: the formation of "a small but distinguished collection"

by Jean K. Cadogan

A visitor to the Wadsworth Atheneum in the early 1920s could have roamed through galleries filled with interesting things—superb American paintings by Thomas Cole and Frederic Church, exquisite French and German porcelain given to the museum from J. P. Morgan's estate in 1917, furniture from the Pilgrim century collected by Wallace Nutting; but he would have found few European pictures, none of great quality.[1] While the Flemish, Dutch, and German schools benefited somewhat from the interest of local collectors, such as Samuel Beresford and James G. Batterson, the southern European schools appear to have found little favor with Hartford collectors.[2] The sole Italian picture in the bequest of Daniel Wadsworth, *Ruth and Boaz* by an unknown seventeenth-century painter, is undistinguished and infrequently exhibited; the 1905 bequest of Elizabeth Hart Jarvis Colt brought only pedestrian examples of late nineteenth-century taste, such as copies of Raphael's *Madonna della Sedia* and genre pictures by late nineteenth-century Italian painters Hermann-David Corrodi and Antonio Paoletti. Well into the twentieth century, Italian pictures were largely acquired by gift and are minor. The small *ricordo* by Gregorio Lazzarini, given in 1914, and the *Adoration of the Magi* by a follower of the late eighteenth-century Florentine artist Giovanni Camillo Sagrestani, given in 1911, are perhaps the most distinguished examples. The rare purchases from this period were also modest; the small altarpiece of the *Crucifixion and Other Scenes*, now attributed to a follower of the Lombard artist Bernardino Butinone, was bought in 1911 with the immodest attribution to Masaccio! Of the Spanish pictures, García Hidalgo's *Death of St. Joseph* was given to the Atheneum in 1888, the *Virgin of the Litanies* was a gift of Clara Louise Kellogg Strakosh in 1914, and the *Sketch of a Head* by Mariano Fortuny came to the museum as part of the bequest of George H. Story in 1923.

The pace and character of acquisitions changed dramatically in 1927 with the coincidence of two fortuitous and fortunate events: the Sumner bequest and the appointment of A. Everett Austin, Jr., as director (Fig. 1). It is to Austin, and his successor as director Charles Cunningham, that we owe the shaping of the European painting collection, especially the Italian and Spanish schools.

The Sumner bequest, created through the generosity of Frank Chester Sumner (1850–1924), came to the Atheneum following the death of his wife, Mary Catlin Sumner, on 11 August 1927.[3] Frank Sumner, a prominent local figure and president of the Hartford, Connecticut Trust Company from 1919, was not a collector and indeed had little interest in art. He had inherited the estate of his brother George Sumner (1841–1906), who was, however, interested in the museum, and who had stipulated in

his will that if Frank predeceased him, the estate should go to the museum to form a collection of paintings in memory of his wife, Ella Gallup Sumner. Frank outlived George Sumner by eighteen years, but when he died in 1924, he followed George's example and bequeathed his estate to the Wadsworth Atheneum, providing his wife, Mary, with use of it during her lifetime. Upon her death, the funds, then just over one million dollars, came to the museum to be used as an endowment for the purchase of paintings to be known as the Ella Gallup Sumner and Mary Catlin Sumner Collection.

In the months preceding the Sumner bequest, the trustees had been searching for a new director. Frank Butler Gay, who had been curator and then director, resigned to devote his time to the Atheneum's Watkinson Library of rare books. Charles A. Goodwin, president of the board of trustees, wrote to Edward Waldo Forbes, then director of the Fogg Museum at Harvard, for recommendations. Forbes's reply of 19 January 1927 described in detail several possible candidates, among them A. Everett Austin, Jr.: "He is an attractive man with brains and good taste, and I think he has the makings of a very good museum man."[4] Austin had graduated from Harvard in 1922 and had spent the following year in Egypt and the Sudan working with George Reisner, a renowned archaeologist.[5] In 1923 he returned to Harvard for graduate study in architecture, where he took Forbes's course on painting techniques of the Italian Renaissance. Forbes had pioneered interest in techniques and conservation, establishing the first conservation department in an American museum. The next year, Austin was Forbes's teaching assistant, and in the summer of 1924, he worked with Federigo Ioni, a skilled copyist, in Siena, learning more about the technical procedures of the great Renaissance masters. In 1926, after a trip to Chichén Itzá, in the Yucatán peninsula of Mexico, where Forbes sent him in his place to advise on the care of newly discovered wall murals, Austin was in Europe. He wrote to Forbes on 17 August 1926, telling him of the demise of his partnership with Harold Woodbury Parsons, a consultant on acquisitions to several American museums:

> By this time you have I suppose learned that the partnership of Parsons and Co. was dissolved about July 1. I am afraid that Parsons's interest in art is chiefly social-conversational and financial. . . . Are there any "jobs" in sight? . . . If you hear anything of a way to make me useful—would you mind awfully writing to me about it?[6]

Goodwin acted on Forbes's recommendation and appointed Austin acting director. Forbes was persuaded to accept the position of honorary director for a year, "with such duties as you may assign to yourself and at a salary of our everlasting good will and appreciation." Goodwin went on about Austin: "Personally I have become very greatly taken with him and feel he has the temperament and knowledge to carry him far. . . . This is about all you and I can do for him and after that it must be his own good sword and about the outcome I have not the shadow of a doubt."[7]

Just two months later, the news of the Sumner bequest broke, inevitably making acquisitions a major focus of the new director's activities. Austin and Forbes lost no time in turning their attention to the art market. An article in the Hartford *Times* discussed Austin's and Forbes's plans "to acquire for Hartford, over a period of years, a series of acknowledged and unquestionable art masterpieces."[8] A sheet of notes in Forbes's hand, dating from around this time, gives a more complete idea of the program for Austin's administration.[9] The main tasks, in order of importance, were the following: buying works of art; arranging them; planning a new wing; special exhibitions; educational work. He ended with the notes "loan exhibitions of great distinction" and "make Hartford a place of pilgrimage."

Whether Austin himself had in the beginning a predetermined program for his tenure, or even for his acquisitions with the Sumner fund, we do not know. It is true, however, that his personal acquisitiveness, coupled with his knowledge of the history of Western art, nurtured by his Harvard training and extensive travels, and the sudden availability of funds joined to transform the decidedly provincial Atheneum into a prominent cultural institution. Austin was in the enviable position, almost unimaginable today, of forming a painting collection virtually from scratch. The Sumner fund provided him with about sixty thousand dollars a year to spend on acquisitions in those first years, a considerable sum, though not without limits.

Austin's early acquisitions were made in conjunction with Forbes and show a pronounced "Fogg taste" for old master European pictures, particularly of the Italian Renaissance.[10] Already on 20 September 1927, Forbes reported to Charles Goodwin that Austin was "hunting for pictures among the dealers."[11] While in a letter of 5 December 1927 to Austin, Forbes offered to go around to the New York dealers with him, he added, "But if you want to do it all by yourself, go ahead. I just want you to know that I will be there in case I can be of any service to you."[12] In spite of Forbes's hands-off approach, Austin nonetheless felt bound to follow his guidance. On the track of a picture by the Venetian Renaissance artist Tintoretto as the first purchase with the new Sumner bequest, Austin wrote to William Milliken of Cleveland on 16 December 1927: "Mr. Forbes did not like the picture from the photo, so I felt I could not consider it any longer."[13] He went on to report that the museum had, however, purchased Tintoretto's *Hercules and Antaeus* from the New York firm of Durlacher Brothers. The next summer, Forbes wrote to Austin from Innsbruck:

I saw the Tintoretto (at Brass) which you liked so much last year. Usually, I think, you and I agree fairly well, and I have a high opinion of your taste and judgement. In this matter I have to confess that I do not agree with you. I felt just the same way about the picture as I did about the photograph, and I did not even like the color much. Perhaps it is a prejudice. I remember at Naushon I was amused to see that when I pointed out to Dr. Ross some view that I particularly liked he would not warm up;— but a minute later he would make a discovery of something I did not like so much, and would express great enthusiasm. Perhaps it is the same phenomenon. We all like to be discoverers.[14]

The Tintoretto was unveiled at the exhibition *Distinguished Works of Art*. The exhibition, Austin's first, opened on 18 January 1928 and included loans drawn from museums, dealers, and private collectors. As the Hartford *Times* noted, "The purchase [of the Tintoretto] by the Atheneum marks the initial move in the policy of the management to buy one great picture each year, rather than to acquire a series of pictures of less value. In time, this policy will secure for the Atheneum a collection of truly world famous paintings."[15] Speaking of the Tintoretto in an article in the magazine *Hartford*, Austin said:

It is the building up of a small collection of pictures of this quality which will inevitably attract the foreign student and scholar to Hartford, and will be instrumental in carrying Hartford's fame to every foreign cultural center, no matter how distant. . . . It will be the policy of the Atheneum to build a small but distinguished collection, buying one important picture per year, without reference to filling out of any given school.[16]

The exhibition was conceived to focus attention on the first Sumner purchase, but it also had a larger purpose. First, it was to show the history of art from its earliest beginnings, in a general survey. As noted again by the *Times*, this kind of exhibition would not be offered again; rather, in the future certain epochs or schools would be highlighted. Thus, *Distinguished Works of Art* was, in Austin's words, a "primer" of exhibitions to come.[17] Additionally, however, the exhibition, which stressed the superb quality of works of art ranging from the thirteenth to the twentieth century, and included sculpture, prints, and decorative arts as well as paintings, was intended by Austin as a demonstration of the goals of his acquisition policy.

The relationship between *Distinguished Works of Art* and Tintoretto's *Hercules and Antaeus* established a pattern between temporary exhibitions and acquisitions that would endure through Austin's tenure at the Atheneum. The shows he organized at the Athe-

neum illuminated his acquisitions; at the same time, especially as time went on, acquisitions were made with future exhibitions in mind.

Following the Tintoretto, acquisitions were made at a rapid pace. Again the counsel of Forbes was crucial. Correspondence between Austin and Forbes in the summer of 1928 reveals a wide range of works under consideration, including pictures by Daumier, Fra Angelico, Velázquez, El Greco, and others. Forbes also urged Austin to visit the collection of Count Contini-Buonaccorsi, who was selling from his rich collection of Italian paintings. Austin, in Venice, cabled Forbes in London, 31 July 1928: "Will you see Goya and Greuze at Savile Gallery and secure if satisfactory. Which two of Greco Daumier Angelico trio vo[sic] you advise. . . ."

Thus, Daumier's beautiful watercolor of the *Mountebanks Changing Place* and Fra Angelico's *Head of an Angel* were purchased with Sumner funds. Drawings attributed to Goya (now, however, given to Eugenio Lucas) and Greuze were also bought with the Keney fund, another fund for acquisitions. Additionally that first year, several American watercolors were acquired through the Sumner fund, including two by Hopper and one by Demuth.

While strict interpreters of Frank Sumner's will might raise eyebrows at the expenditure of Sumner funds on watercolors, Austin deliberately pursued them as part of his strategy of acquiring high-quality works, particularly by modern masters, and still staying within his budget. A letter Austin sent to the editor of the Hartford *Times* early in 1929 reveals this policy:

> Mr. Richard Burkheim in the Times of February 8th, wrote a letter criticizing the buying policy of the Wadsworth Atheneum, and saying that the Trustees should buy modern art in preference to the old masters. . . . During the past year, the Atheneum has acquired no less

than six examples by prominent modern American artists,—two by Hopper and one each by Sargent, Dodge MacKnight, Demuth and Dickenson. In the investment of funds in pictures, it is the wisest course always for the Museum to place its income in works of certain and recognized value rather than to run the risk of buying expensive paintings by modern artists, the value of which may be considerably lowered by the criticism of the next generation. However, the policy of buying water-colors is a sound one, as in this way much smaller amounts are involved.[18]

By the first half of 1929, Austin had settled into his role of director, so much so that on 7 May 1929 Forbes wrote to Charles Goodwin offering to resign as honorary director. In the end, Forbes retained the position, though his involvement in acquisitions became more limited.[19]

In the fall of 1929, Austin began planning his first show of the new year, *Italian Art of the Sei- and Settecento* (Fig. 2). Writing, prophetically, to John Ringling on 19 November 1929 to ask for loans, he said, "I am a great admirer of seventeenth and eighteenth century painting and want to do all I can to change the underestimation in which it has been held for so many years." Austin was well aware of the reevaluation of baroque painting that was taking place among knowledgeable scholars and collectors. As a twenty-one-year-old, in 1922, he had seen the exhibition at the Palazzo Pitti in Florence of Italian art of the period, an exhibition whose size and quality refuted the notions of decadence with which the period had previously been associated.[20] He was certainly aware, too, of the work at Harvard by Arthur McComb in researching the period. McComb, author of the first book in English on baroque painting, published by Harvard in 1934, had given a lecture course on the subject at the Fogg in 1928.[21] In conjunction with the

Figure 2. *Italian Art of the Sei- and Settecento*, 1930

lectures, an exhibition of Italian seventeenth- and eighteenth-century paintings and drawings was shown at the Fogg early in 1929.[22] Although it relied exclusively on loans from museums and private collections in the Boston area, the Fogg exhibition, like the Pitti exhibition before it, emphasized certain painters, in particular Alessandro Magnasco and artists active in Venice in the seventeenth and eighteenth centuries, such as Strozzi, Fetti, and Piazzetta. Such artists had gradually come to be seen as antecedents to modern painting, Magnasco himself credited with the invention of the *dipingere di tocco*, or impressionist brushwork. In addition, the tenor of many baroque works, a certain intensity of emotion associated particularly with Italian and Spanish baroque painting, was thought to anticipate the anguished images of early twentieth-century expressionism. The elevation of these "other" seventeenth-century painters, in contrast to the works of Annibale Carracci and his Bolognese followers, which had been highly praised in the eighteenth and nineteenth centuries, but which had been dismissed as academic and eclectic in the twentieth, became almost a vogue in the late 1920s.[23]

The Atheneum exhibition of baroque painting reflected these recent advances in scholarship and taste more fully and accurately than had the Fogg show. Examples of Bolognese painting, such as works by Annibale and Lodovico Carracci, Guercino, and Reni, were exhibited alongside works by Caravaggio and his followers, among them two Caravaggio attributions from the Fogg, the *Cardplayers* and a *St. Sebastian*, now given to Caracciolo. Rosa, Preti, Ribera, Solimena, Stanzione, and Giordano represented the Neapolitan school, while Venetian painters included familiar names, such as Tiepolo and Guardi, along with less familiar names, such as Longhi, Marieschi, Piazzetta, and Pittoni. Even the Florentine baroque was represented with Carlo Dolci and Francesco Furini. Newly fashionable artists, such as Fetti with two works and Magnasco with ten—the single largest group in the exhibition—were also shown. The exhibition included works by non-Italian artists active in Italy, such as Poussin and van Dyck. A section of drawings, including large groups by Guercino and Tiepolo father and son, was also included.[24]

The press coverage of the exhibition was favorable, billing the show as the first complete showing of baroque paintings and drawings in the United States,[25] and acknowledging the Atheneum's position in the forefront of appreciation for the period.[26] Forbes wrote to congratulate Austin on the exhibition,[27] as did acquaintances outside Hartford, such as the dealer Julius Weitzner.[28] Lectures in conjunction with the exhibition were given by Arthur McComb and by Austin himself. The notes from Austin's lecture do not survive, but those from a lecture on the same subject in 1937 demonstrate the remarkable depth of his acquaintance with regional schools and individual artists.[29]

As with *Distinguished Works of Art*, the baroque exhibition included several new acquisitions, including Salvator Rosa's *Night Scene with Figures* and Luca Giordano's *Rape of Helen* and *Rape of Europa*. A *Head of a Boy* loaned by the dealer Wildenstein, then

thought to be by Caravaggio, and the *Holy Family* drawing by Giovanni Battista Tiepolo, on loan from Harold Parsons, were both acquired shortly after the exhibition closed.[30] This group of objects suggests that Austin's interests in the baroque were not driven purely by fashion, but were informed by the balanced, scholarly view of baroque art formulated by McComb. A note on the Giordanos, coauthored by Austin and Henry-Russell Hitchcock, a Harvard colleague then teaching at Wesleyan University in Middletown, offers this appraisal of the artist:

> Giordano has as a painter little to say, but he says it with a wealth of eloquence, a vivacity and a versatility which is disarming. To consider him as one does a Guercino or a Caravaggio would be absurd. But it is not absurd to consider him as a very successful rival of Le Brun, and a worthy forerunner of Solimena or Tiepolo. . . . For Giordano no subject was too grandiose, but he must have a subject that would justify that redundant heaping of riches, those splendid groups of figures, nude or in brilliant costumes, with which he covered walls and ceilings. Subjects meant no more to him than to the composer of tableaux in a revue. Only they must have breadth. Indeed if his immediate predecessors were painters of grand opera, he is a painter of revue, to whom a gesture is valid not for its expressiveness so much as for its suitability to fill a corner or tie a group together.[31]

The analogies with theater evoked in the last sentences are perhaps key to understanding Austin's view of the baroque and the fascination it held for him. In a later article on the baroque, Austin said, "Today the adverse critics of the Baroque find it over-theatrical and pretentious. They merely fail to comprehend its true greatness. Theatrical it may be. . . . The world itself had become a vast and exciting stage."[32] Just this theatrical aspect of baroque art appealed to Austin on an emotional as well as intellectual level. While Austin's interest in the theater can be demonstrated through his activities in many areas— an exhibition of reproductions illustrating the history of baroque theater had been shown at the Atheneum in late 1929[33]—those who knew him stress the essentially theatrical nature of his personality. T. H. Parker perhaps put it best:

> The peculiar attribute of Mr. Austin's genius was a flair for the dramatic. . . . There never was a dull moment in Mr. Austin's world. . . . His spirit, at least, was primarily of the theater. The other worlds were part of his stage. . . . But viewed from the grander point, and certainly that was the vantage from which Mr. Austin looked upon things, life and theater were interchangeable experiences to him.[34]

If the Giordanos represented the grand decorative tradition of the baroque, the Rosa acquisition was seen to illustrate the protoromantic sensibility in the seventeenth century. Henry-Russell Hitchcock, again writing in the Atheneum *Bulletin*, offered a surprisingly insightful evaluation of Rosa and of his position in seventeenth-century art:

> Salvator Rosa was in the midst of the Baroque a Romantic, born more than a century before his day. . . . If we look at the Baroque . . . as a prelude to Romanticism, breaking down the Classicism of the Renaissance, but providing no full set of creative emotional conventions in its place, Salvator Rosa appears perhaps more important than if the Baroque is considered, as it must be by most, as a movement, not a transition, except incidentally, but a fuller and more complete classicism than that of the Renaissance. However that may be, the regular Baroque canons do not explain Salvator Rosa. . . . His contemporaries found in him a charming incidental master, outside the real current of their time. We may find him the same; but we must not forget that this quality of being outside his own time, is the necessary character of the forerunner who is not powerful enough to carry his time with him.[35]

The Caravaggio *Head of a Boy* and the brilliant drawing of the *Holy Family* by Tiepolo, representing the beginnings and end of the baroque, nicely rounded out this first group of acquisitions of seventeenth-century art.

Following the baroque exhibition, Austin concocted a dizzyingly varied exhibition program that reflected his wide interests. Exhibitions on modern Mexican art, modern German art, contemporary photography, and the paintings of the surrealist painter de Chirico were mounted in 1930; of landscape painting, of the contemporary artists Tchelitchew, Berman, Leonid, and Berard (the so-called neoromantics), and the first exhibition of surrealism in America, called *Newer Super-Realism*, in 1931.[36] While Austin made acquisitions linked to these exhibitions, he continued to devote significant time and resources to the acquisition of baroque pictures. Indeed, just as the baroque exhibition closed, in February of 1930, Austin entered into negotiations through Harold Parsons with the Venetian dealer Italico Brass for the acquisition of the *St. Catherine of Alexandria* by Bernardo Strozzi that he had seen years before at the 1922 Pitti exhibition.[37] While the purchase was not made until the next year owing to confusion over which version of the picture was offered, the acquisition is nonetheless remarkable for demonstrating the range of Austin's taste. The *St. Catherine*, as Henry-Russell Hitchcock noted, is from Strozzi's earlier, Genoese period, with is reminiscences of late sixteenth-century mannerism, particularly in color and drawing.[38] Its addition to the previous seventeenth-century acquisitions thereby enriched the chronological and historical character of the group as well as its quality. Pietro Longhi's *Temptation* and

Giovanni Battista Tiepolo's *Last Supper* (now, however, given to Giovanni Domenico) were also bought in 1931.

The 1932 acquisition of Piero di Cosimo's *Finding of Vulcan*, which had been the highlight of the winter show, *Art of the Italian Renaissance*, marks in one sense a return to Austin's original goal of acquiring one great work of art per year, as well as a revision of that policy. The picture, well known for its distinguished provenance, had been exhibited most recently in the 1930 exhibition of Italian art in London. The Atheneum bought the picture from Duveen Brothers' New York gallery for $100,000, a sum that exceeded by more than twice the amount of Austin's most expensive purchase to date, the Goya *Gossiping Women* for $38,250 in 1929.

Austin's article on the Piero di Cosimo in the 1932 *Bulletin* reveals his fascination with the picture.[39] Thought to represent Hylas's capture by nymphs, the secular theme was seen by Austin to capture the "discovery of the world and of man," the essence of the new Renaissance spirit as characterized by the historian Jacob Burckhardt.[40] In so doing, Austin noted, it complemented well the earlier purchase of Fra Angelico's *Head of an Angel*. Austin also noted the strange blend of observed natural detail and fantasy in the picture, which appealed to his own interests in the realism of the baroque, as well as the disconcerting blend of the real and the fantastic characteristic of surrealism, his other great passion. That Piero di Cosimo was claimed by the surrealist theoretician André Breton as the spiritual ancestor of the modern surrealists may or may not have been known to Austin, but the affinity of the two certainly appealed to him.[41]

The local newspapers celebrated the Piero as a great painting, reporting Austin's judgment of it as the most significant to date of the Sumner collection. Austin was also quoted on the role of art in the life of the human spirit, particularly in times of adversity. The mood of the Depression is chillingly evoked:

> While the purchase of such a picture as the Piero di Cosimo . . . may seem to some of questionable taste in such difficult times, it must be remembered that under terms of the Sumner will, the income from the fund can be applied only to the purchase of paintings, and at the present moment it is possible to invest such money most favorably. On the other hand, this beautiful painting, I am certain, will give joy to many persons at a time when appreciation of works of art serves somewhat to allay for some moments the worry and anxiety in which we all share.[42]

While celebrated in the press and among colleagues, the Piero di Cosimo acquisition put a halt to Austin's acquisitions for the time being. It was the single Sumner purchase in all of 1932 and 1933, with the excep-

tion of the acquisition in the latter year of the collection of ballet set and costume designs from Serge Lifar for ten thousand dollars. Although the lament that funds were lacking is a constant in Austin's correspondence with dealers over the years, in this case it was all too true. A note in the minutes of the executive committee for 23 February 1932 stated laconically, "No part of the Sumner Fund for 1932 is available, as part of two years' income has been expended for the Piero di Cosimo picture."[43] Non-Sumner purchases were made, of course, the sculpture of *Venus with Nymph and Satyr* by the Flemish-born sculptor Pietro Francavilla being the most distinguished example.

After Sumner money became available for purchase again in 1934, there is a gradual but perceptible shift in the character of acquisitions away from the canonical Italian Renaissance, the taste of his mentor Forbes, to Austin's particular interests, especially baroque painting and modern painting. While in part a reaction to the prolonged period of inactivity, this gradual change in policy also reflects Austin's reassessment of the art market as well as his growing confidence in his own eye and taste.

From the beginning of Austin's directorship, he maintained active contact with New York and foreign dealers through frequent visits and copious correspondence. While much of this correspondence concerns the mundane details of shipping and payment, revealing little of Austin's intentions, certain New York dealers nonetheless emerge as major sources of Austin's acquisitions. Kirk Askew at Durlacher, a friend from Harvard and the center of a circle of New York friends the Austins socialized with frequently, shared Austin's enthusiasm for baroque and contemporary painting. From the first Askew supplied Austin with major purchases, among them the Tintoretto, the Goya, the Giordanos, the Tiepolo *Last Supper*, and the Le Nain, to name only the earliest. Paul Byk at Arnold Seligmann, Rey & Co., while not a personal friend, had a "knack," as Henry-Russell Hitchcock put it, of turning up pictures of personal interest for Austin.[44] Austin relied on Byk increasingly through the thirties for major acquisitions, including the Poussin in 1935, the Batoni in 1936, the Murillo and the Solimena in 1937, and so on, culminating in his purchase of the Caravaggio in 1943. The established firm of Wildenstein was a major source of eighteenth- and nineteenth-century French works, including the Corot, the Greuze, the David, the Robert, and the Géricault. Julien Levy, another Harvard friend, and Pierre Matisse were major suppliers of contemporary works.

At the same time, Austin had always made the rounds of galleries during his yearly trips to Europe. As the decade of the thirties progressed and the political situation, particularly in Germany, became more menacing, Austin sought to adapt his acquisition strategies. In the late twenties, when Americans were buying up European pictures at a great rate, Austin encountered a scarcity of fine pictures and rising prices;[45] by the middle thirties, however, he reported that there were many good pictures available, with the exception of German pictures, although they were being sold quickly.[46] Increasingly,

then, Austin sought to buy in Europe, purchasing, for example, no fewer than six paintings from the Galerie Sanct Lucas in Vienna in 1937 and six paintings, four of them still lifes, from the Amsterdam dealer de Boer in the same year. Agnes Rindge, another friend from Austin's years at Harvard, met up with Austin in Vienna in 1937 and has left a hilarious account of their travels. She confirms that it was Austin's intention, instead of buying baroque pictures in New York, to get them "at the source."[47]

At the same time that Austin was adapting his acquisition strategies to suit the changing art market, he was increasingly honing in on objects that interested him personally. His taste, while always, in Agnes Rindge's words, "unfettered by dogma," moved away from the encyclopedic toward something more personal, stimulated by the contemporary scene. Then too, Austin's Harvard training in the history of art, in techniques, and in connoisseurship buoyed his confidence as he embarked in a direction contrary to established practice. Indeed, Austin's confidence in his own eye is amusingly demonstrated in a letter to Forbes. When Forbes wrote to ask Austin how he knew a particular Sienese primitive was a forgery, Austin replied, "I have no proof that the Sano is a forgery except for my eye and the fact that it cost in Florence $5.00."[48]

As before, the exhibitions that Austin mounted during these years at the Atheneum are key to defining this emerging taste. It almost seems, indeed, that the exhibitions were conceived to work out for Austin himself, and for the public, how contemporary movements fit in with the art of the past. Austin believed that "contemporary art has always a double importance. Besides its own intrinsic interest, it is perpetually leading us into some new part of the past which has been forgotten."[49] That conviction is surely the inspiration behind the highly creative thematic shows he organized in the thirties, doubly creative when seen in the context of the banal conceptions that were the standard fare of museum exhibitions.

The exhibition *Literature and Poetry in Painting since 1850* was on view between 24 January and 14 February 1933.[50] By juxtaposing nineteenth- and early twentieth-century painting, Austin sought to demonstrate the literary content of certain contemporary paintings. In 1933 this was a strikingly novel idea. Modernist criticism sought to explicate the purely formal aspects of much contemporary painting and their source in the avant-garde painting of the previous century, such as impressionism. Indeed, Austin had at one time subscribed to this view of contemporary art, declaring in a lecture at the Atheneum in 1930: "All great paintings can be enjoyed in fragments, if the quality is good enough. The appeal is through design, color, surface texture and not through literary ideas, which have no place in painting. . . . In all great paintings, the subject is of secondary importance. . . . A painting must not tell a story."[51] Henry-Russell Hitchcock, writing in the introduction to the exhibition catalogue, soundly rejects this idea:

The antithesis between form and content, between technical matters and poetry, rather generally accepted by the modern mind, is based on a misinterpretation. Perhaps only the Impressionists at their purest, and the Cubists, really established a way of painting in which the subject matter was not only of little interest to the lay mind, but relatively unimportant in the aesthetic whole. So, in a sense, almost any painter of the last eighty years could properly find a place in the present exhibition.[52]

Hence Picasso was hung next to Puvis and Bouguereau, Redon to Kandinsky, Corot to Douanier Rousseau, Monet to di Chirico, and Gérôme to Dali. As Hitchcock noted, "To apprehend, to study, to appreciate the newest paintings, is ever to find a renewed wealth of interest in the art of the past."

Certainly in Austin's case, interest in surrealism had stimulated this new awareness of content, a reaction against abstraction and formalism that was shared by contemporary artists and some critics. But the idea had been germinating for some time; in the introduction to the landscape exhibition, in 1931, Henry-Russell Hitchcock stressed the weight of ideas in the greatest landscapes. And the exhibition of the neoromantics, also in 1931, implicitly celebrated the new emphasis on literary content. Austin did not, however, after 1933, abandon his interest in the formalists in contemporary art. The first American retrospective of Picasso's paintings in 1933, which included the romantic early works as well as the near abstractions of the teens and neoclassical works of the twenties and thirties, the exhibition of Pevsner, Gabo, Mondrian, and Domela in 1935, and the exhibition *Abstract Paintings from the Collection of the Société Anonyme* in 1940 assured a balanced presentation of contemporary art.

Austin's interest in the new objectivity of modern art is the thread that links the diverse exhibitions of older art he staged throughout the 1930s. The exhibition of the French seventeenth-century realist painters Le Nain and Georges de la Tour, organized by Knoedler and including the Atheneum's Le Nain, *Peasants in a Landscape*, while linked to his earlier interest in baroque painting, marks a further refinement of that interest, concentrating on Caravaggesque realism, not only in its subject matter, but also in its detailed description of surfaces.[53] Austin's interest was surely spurred by the return to finish that was characteristic of Dali's paintings. The exhibition *Forty-three Portraits*, while encouraging "the consideration of portraits chiefly as works of art, not as decoration nor yet as 'speaking likeness,'" closed with a Salvador Dali, *Geodesical (Portrait of Gala)*. Austin noted in his introduction: "Only within the last five years, with the various forms of reaction against abstract art, has the portrait, as something other than commercialized flattery, entered upon a revival."[54]

In *The Painters of Still Life* of 1938, Austin takes on the notion of still life as a mere pretext for formalist manipulation. Again seemingly inspired by surrealist respect for the integrity of objects, Austin illustrated, with still lifes from four centuries, the object as a theme in painting. The introduction to the catalogue,

again coauthored by Austin and Hitchcock, emphasized, in an analogy with surrealist ideas, the identity of the objects depicted as well as their formal role:

> The still life has often appeared to be only a sort of painting for painters, a vehicle of virtuosity exterior to the fullest possibilities of the art. But to see still-life painting thus is to neglect its broader implications. First Cubism and then Surrealism, while neglecting perhaps the object as such, served to recall in the many characteristic works, which are certainly still-lifes, the possible significance of the object in painting. . . .
>
> The subject matter of most still-lifes is minor and irrelevant, compared to the often elaborately literary "subjects" of figure paintings. . . . But the object itself becomes a special type of "subject," or perhaps one should say more precisely that the "subject" is really nothing but the recognizability of the object.[55]

The exhibition began with seventeenth-century Italian and Dutch examples—"these insects, these shells, these hams, [which] seem to live with something of the mysterious double-life to which the Surrealists have called our attention"—and moved to still lifes of Chardin and Oudry in the eighteenth century, van Gogh and Cézanne, Harnett and Raphaelle Peale in the nineteenth, to Dali, Matisse, Braque, and Miró in the twentieth. Exhibited *hors catalogue* was the Arp relief *Objects on Three Planes Like Writing*, representing "almost the precise moment of balance between the purging of the 'semi-object' of the Cubists and the return of the object as 'dream-object,'" and a Cornell box, a "composition of real objects."

Night Scenes, shown in February and March of 1940, explored a genre that had, like still lifes, come of age during the baroque but that, in Austin's view, had particular resonance for the twentieth century. While the tenebrism of Caravaggio and his followers naturally found pride of place, its antecedents, such as Leandro Bassano and Orsi, and descendants, such as Rembrandt, Delacroix, and George Bellows, were also included. The twentieth-century section featured works by Klee, Miró, and Rouault as well as the neoromantics Berman and Tchelitchew.

Austin's acquisitions in the 1930s and early forties mirror the interests explored in the exhibitions of those years. At the same time, Austin moved away from his earlier strategy of acquiring one great picture a year and thereby forming a comprehensive collection illustrating the history of art. Instead, Austin devised a strategy of buying against the market, spurred by the conviction that the most expensive pictures on the market are not the only good pictures, or even the best, available. In reporting recently acquired paintings by Vrel and Weenix, the press noted that Austin was "increasingly conscious of the way public taste in paintings, music and other forms of art is influenced by advertising. . . . He feels, how-

ever, he says, that just as much aesthetic pleasure can often be derived from paintings by lesser masters, whose reputations have not been so built up that their work is valued at prices which put it too often beyond the reach of any but the extremely wealthy."[56]

In an article in *Art News*, Austin articulated his new point of view and its implications for the Atheneum:

> For some years it has been the growing belief of the Atheneum's director that the "star-system" as applied to the art museum policy of purchasing masterpieces exclusively by great masters is for Hartford (situated between New York and Boston where such works are numerous) unnecessary and ill-advised, even were there funds available. Furthermore it seems to me that there can be observed a dangerously growing tendency on the part of the American public to interest itself solely in the greatest names of the pictorial just as in the musical and theatrical worlds, thus arbitrarily excluding many artists who have produced extremely interesting and above all, enjoyable works of art, even though their names may not be on the tip of everyone's tongue. The argument, of course, is that if the product isn't nationally advertised it can't be any good. If the local museum can't produce a Rembrandt (since the Laughton film), there is no point in going in. If Toscanini isn't conducting, you might as well save your ears.
>
> Now it appears to me that an art museum, especially a provincial one, should seek to teach its public the enjoyment of art in its widest implications, not merely impress it by means of "expensive" names. It is for this reason that the Wadsworth Atheneum has sought to purchase during the last year paintings which would be distinguished, yet which might often be by masters not necessarily shown in the larger museums of the adjacent cities, and sometimes even by masters quite unheard of, provided always of course, that the quality in each instance made the picture significant.[57]

Armed with clearly defined interests and bolstered by confidence in his own ability to discern quality, Austin bought in the middle and late thirties paintings that, while at first glance diverse and even bizarre, on reflection are entirely consistent with his stated goals. The baroque pictures show a concentration on the realists, such as Crespi, Vrel, Miel, Tinelli, Honthorst, Sweerts, Terbrugghen. Still lifes were acquired in such numbers that they quickly formed a subcollection within the collection, including works from all periods by artists as diverse as Valdés Leal, Chardin, Harnett (the great *Faithful Colt*), and Balthus. Landscapes, too, emerge as a slightly smaller mini-collection, including works by Brughel, Rosa, Claude, Guardi, Carlevarijs, Ricci, and Vernet. Surrealist pictures were purchased with increasing frequency, starting with Roy's *Electrification of the Country* in 1931, and including Miró's *Composition* in 1934, Dali's *Paranoic-Astral Image* and pencil drawing of figures in

1935, de Chirico's *Maladie du Général* in 1937, Dali's *Apparition of Face and Fruit-Dish on a Beach* in 1939, and so on.

Many acquisitions appealed to Austin on more than one level; two Arcimboldesque allegories of Spring and Summer represented a genre of seventeenth-century still life, yet also illustrated, *avant la lettre*, the surrealist double image.[58] The Weenix *Roman Campagna with Figures* evoked for him the landscape styles of Claude, Le Nain, and Berman.[59] A gallery devoted to "fantastic" art housed many new acquisitions: a Bosch follower's *Temptation of St. Anthony*, the Arcimboldesque paintings, and a pair of animal caricatures, attributed to Ghezzi, seen by Austin as the true ancestors of Mickey Mouse.[60] In the Dali *Apparition*, the traditions of fantasy and of realism came together, much as they had in the Piero di Cosimo purchased years earlier. The Dali, he wrote, "unites those interests of the past touched upon above, now combined to make a fantasy a concrete reality, a frozen dream."[61] Austin's interest in theater is another unifying thread in these acquisitions, whether they treat theatrical subjects, such as the commedia dell'arte, or employ theatrical devices, such as the dramatic lighting of Georges de la Tour's *St. Francis*, or the tragic figures of Vernet's *Seascape*.

It is not surprising to find many of Austin's acquisitions exhibited in his special exhibitions; indeed, as we have seen, Austin's exhibitions and acquisitions are merely two manifestations of the vision that inspired him. Klee's *Marionettes in a Storm* and Ernst's *Butterflies*, exhibited in *Literature and Poetry in Painting*, were acquired in 1933 and 1943 respectively. Robert's *Camille Desmoulins* and Degas's *Cousins of the Painter* were included in *Forty-three Portraits*. Numerous paintings owned by the Atheneum or acquired shortly thereafter were included in the still-life show, such as the Baschenis, the Meléndez, the Chardin, and the Harnett. *Night Scenes* numbered no fewer than fifteen Atheneum works, including the Leandro Bassano *Flagellation of Christ*, the Orley *Crucifixion*, the Poussin *Crucifixion*, and the eventually acquired Caravaggio *St. Francis*.

While the benefits of Austin's acquisition policy are evident in the rich collection acquired in this way, disadvantages, though less apparent, do exist. Perhaps most glaring are the lacunae, again the products of Austin's taste, most notably the absence of Bolognese seventeenth-century pictures, or of cubist pictures of the 1910s. Austin's all-consuming passion for Caravaggesque realism and surrealism led, almost inevitably, to their exclusion. Moreover, by buying in little-known areas, Austin usually had scant art historical information to bolster his eye. Not a scholar himself, he relied on the opinions of others. Scholarship, particularly in seventeenth-century studies, has altered our view of certain pictures, which have simply not stood the test of time. Austin's first Caravaggio acquisition, the *Head of a Boy*, was soon recognized as not by the master, and is now generally given to a

French follower of Caravaggio;[62] the Honthorst *Supper at Emmaus* is probably by a follower of Honthorst, the Georges de la Tour *Ecstasy of St. Francis* is most likely a copy, and the Guercino *St. Sebastian*, by a pupil. Yet these inevitable adjustments in attribution do nothing to cloud the very lengthy list of pictures whose reputations have survived intact the scrutiny of modern scholarship, such as the Strozzi, the Piero di Cosimo, the Valdés Leal, or the Caravaggio *St. Francis*.

While today we celebrate the particular imprint of Austin's taste on the collection of pictures, by the early forties Austin was encountering growing resistance to his ideas from the Atheneum trustees. It had long been a battle to win some trustees over to certain purchases, particularly of modern art, but when war closed the European art market and curtailed museum activities, Austin became more critical of his board for its conservatism. He turned to amateur theatricals and magic shows to raise funds for the Atheneum—and to find an outlet for his creative energies. His frustration is clearly expressed in a letter inviting May Sarton to one of his magic shows in the spring of 1942:

> I am doing my last show in two weeks. . . . It is my last I am certain because I am sure to be out of a job after it is over but I am still determined to do it. The trustees have become increasingly maddened by my antics yet they give me no money for exhibitions or other museum activities so I am forced to keep going in some way or other.[63]

The trustees' uneasiness over Austin's theatrical activity and its competition with the Bushnell, the local concert hall, is alluded to in a letter from Charles Goodwin to Edward Forbes:

> The net result of his [Austin's] work here in building the museum, in selecting the exhibits, and in fixing the essential policy has been beyond praise. His administration has not been at a par with his other abilities and yet we have gotten along very well. He seems incapable of selling his work and himself except to a very few people who are able to understand and appreciate his real contribution and make allowances for the manner of presentation. Certain of his activities have not been well received here and he has undertaken them under great difficulties. . . .
>
> He had given throughout his service unsparingly of himself and the exhibits still show the result of his taste and judgment in matters of selection, but he has really lost interest in his work and it has not helped that he has blamed others for the failure to reach the goals he expected to reach.
>
> . . . A provincial museum, as you know, has not the resources of the great metropolitan museums. Nevertheless, the field is worthy [of] any man's effort and we could have here in quality, if not in quantity, a little museum to compare with the best.[64]

Forbes wrote back to Goodwin:

> I think he [Austin] has done a magnificent job at Hartford and that he has shown himself to be the most brilliant and ablest of the younger group of museum directors. I quite realize his eccentricities and the fact that he is not a good methodical business man, but I think he has done wonders.[65]

In July of 1943 Austin began a six-month sabbatical, but before he left he secured a much-wanted acquisition, one that he saw as a linchpin of the rich baroque collection he had built up over the years. Caravaggio's *St. Francis* had been first offered to Austin by Paul Byk of Arnold Seligmann, Rey & Co. in the spring of 1939.[66] Austin had borrowed it for *Night Scenes*, but after long consideration and thinking the price too high, had the picture sent back to New York in May of 1942.[67] On 10 June 1943, Austin wrote to Robert Huntington, chairman of the trustee acquisitions committee, urging him to approve its purchase:

> You will surely remember the picture which we had first in Hartford in the exhibition of Night Scenes some years ago. . . . At that time the picture was being held for a very high price,— over fifty thousand dollars as I remember it. It is the only authentic Caravaggio in America and yet at that time I did not feel, important as the picture was, that we should spend that much money on it, as the whole question of Caravaggio is a pretty mysterious one, and it is difficult to get a consensus of opinion among the various scholars on the matter. During the years that ensued, however, the price of the painting was gradually lowered, and, as I told you before, this last Christmas Arnold Selifmann [sic] Rey and Co., finally offered us the picture for seventeen thousand dollars. . . .
>
> Now, as you know, the greatest strength of the Atheneum collections lies in the field of seventeenth century art which have now become, I am sure, the greatest in this country. Both in Italy and in the other countries of Western Europe, Caravaggio was the greatest single influence on that century, and for that reason it has always been most essential that we have a work by this great master as a pivot to the many wonderful pictures we have bought. . . .
>
> I hope that I have made all of this clear to you. That Caravaggio is one of the greatest masters in the history of art no one would deny. That we need an authentic and beautiful picture by him is obvious. That this is the time to get it is very clear as no others, as far as is now known, can come on the market.[68]

Austin's efforts were successful, and the picture was purchased on 22 July 1943. An exhibition *Caravaggio and the Seventeenth Century* was shown, with the new acquisition as its centerpiece, in Avery Court between 26 June 1943 and 16 January 1944, and united the

Figure 3. Charles C. Cunningham, ca. 1966

baroque pictures he had assembled over the years with the addition of seven loans, mostly from New York dealers. Fittingly, this exhibition would be Austin's last at the Atheneum, for his leave was extended to 1 January 1945, when he resigned as director.

The Atheneum inherited by Charles Cunningham when he took up the directorship in January of 1946 was entirely different from the museum Austin found in 1927 (Fig. 3). Cunningham, like Austin Harvard trained, had been an assistant curator at the Museum of Fine Arts in Boston before coming to Hartford. While Austin had been confronted by a tabula rasa in the collection of European and modern paintings, Cunningham was mindful of Austin's achievement and sought to build on it. He consciously sought to round out the collection and to enrich it with "stars." Writing in *Art News* in 1951, Cunningham said:

> During the years from 1928 to 1945, when A. Everett Austin served as director, the collection of Italian painting of the Baroque and Rococo schools grew to the extent that the Wadsworth Atheneum became known the world over for outstanding examples of these styles. Mr. Austin's policy was "that a provincial museum should acquire paintings which are distinguished, but which are not necessarily by masters who are well represented in the neighboring cities." However, Hartford's is no longer a provincial museum. . . . For this reason, there has been, in recent years, a conscious effort to develop those areas in the collections where representation is not as strong, especially the nineteenth century, the Renaissance and the Baroque schools of the North and of Spain. A good cast needs a star to lead it to great theatrical heights, and an orchestra needs a brilliant conductor to bring out the work of fine musicians: no museum exists that has only stars, but stars of greater or lesser degree are, nevertheless, necessary, whether Shakespeare or Sheridan, Beethoven or Gershwin, Michelangelo or Monet.[69]

Cunningham went on to discuss his most recent purchases, including the Tintoretto *Contest of Apollo and Marsyas*, the Zurbarán *St. Serapion*, the Tiepolo *Building the Trojan Horse*, and several notable pieces of sculpture. These pictures and the others he acquired during his twenty-year directorship brought a needed balance and sobriety to the eccentric, if brilliant acquisitions of Austin. Unencumbered by the driving convictions of Austin, Cunningham brought the scholar's analytical and detached eye to museum collecting. He was uncompromising about quality and had a deep respect for art historical research. A glance at the masterpieces acquired during his tenure—Monet's *Beach at Trouville*, Panini's *Gallery of Cardinal Valenti Gonzaga*, Rosa's *Lucretia*, Sebastiano's *Portrait of a Man in Armor*, Ribera's *Sense of Taste*, Hunt's *Lady of Shallot*, to name only a few—suffice to measure his contribution. Moreover, once the pictures arrived in Hartford, Cunningham tirelessly wrote to scholars the world over for information and opinions. It is to Cunningham we owe the correspondence with Roberto Longhi, Bernard Berenson, Erwin Panofsky, and other eminent art historians that fills the curatorial files and enriches our understanding of these works.

The number of acquisitions diminishes drastically after Cunningham's directorship, reflecting the changed art market and the narrowing purchasing power of the Sumner fund encountered by James Elliott (1966–76) and Tracy Atkinson (1977–87). Then too, other priorities—the upkeep of the buildings, the exhibition program, and research on the collection—mark the coming of age of the museum. The Atheneum today faces the seemingly insurmountable problems of high prices and indifferent supply confronted by all but the richest museums. The superb collection is at once a comfort and a challenge: what can we buy that will hold its own next to Caravaggio or Zurbarán? An understanding of the goals and convictions of our predecessors will perhaps provide the answer.

1. A complete account of the early history of the Wadsworth Atheneum is yet to be written. Discussion of the earliest acquisitions can be found in R. Saunders and H. Raye, *Daniel Wadsworth, Patron of the Arts*, Hartford, 1981, 34–37, and of the Morgan bequest in Hartford, Wadsworth Atheneum (also New York, Pierpont Morgan Library, and elsewhere), *J. Pierpont Morgan, Collector*, 18 Jan.–15 Mar. 1987, exh. by L. Roth.

2. *Wadsworth Atheneum Paintings I: The Netherlands and the German-speaking Countries*, Hartford, 1978, 11–12.

3. A. Galonska, "The Sumner Collection: The First Fifty Years," 1977, typescript in curatorial file.

4. E. W. Forbes to C. A. Goodwin, 19 Jan. 1927, Austin papers, box 35, Wadsworth Atheneum Archives.

5. E. W. Forbes, "A. Everett Austin, Jr.," in Sarasota, 1958, 17.

6. A. E. Austin to E. W. Forbes, 17 Aug. 1926, Austin papers, box 35, Wadsworth Atheneum Archives.

7. C. A. Goodwin to E. W. Forbes, 9 June 1927, Austin papers, box 35, Wadsworth Atheneum Archives.

8. "Two New Directors of Atheneum Here," Hartford *Times*, 25 Oct. 1927.

9. Austin papers, box 35, Wadsworth Atheneum Archives.

10. For an assessment of Forbes's tenure as director of the Fogg, see Cambridge, Mass., Fogg Art Museum, *Edward Waldo Forbes, Yankee Visionary*, 16 Jan.–22 Feb. 1971, exh. cat. by Agnes Mongan et al.

11. E. W. Forbes to C. A. Goodwin, 20 Sept. 1927, Austin papers, box 35, Wadsworth Atheneum Archives.

12. E. W. Forbes to A. E. Austin, 5 Dec. 1927, Austin papers, box 35, Wadsworth Atheneum Archives.

13. A. E. Austin to W. Milliken, 16 Dec. 1927, Austin papers, box 29, Wadsworth Atheneum Archives.

14. E. W. Forbes to A. E. Austin, 26 May 1928, Austin papers, box 29, Wadsworth Atheneum Archives.

15. "Atheneum Buys a Noted Tintoretto," Hartford *Times*, 12 Jan. 1928.

16. A. E. Austin, Jr., "Hartford's Art Museum," *Hartford*, XII, Apr. 1928, 4.

17. "Atheneum Invites Large Attendance," Hartford *Times*, 25 Jan. 1928.

18. A. E. Austin, 19 Feb. 1929, curatorial file.

19. E. W. Forbes to C. A. Goodwin, 7 May 1929, and C. A. Goodwin to E. W. Forbes, 8 May 1929, Austin papers, box 35, Wadsworth Atheneum Archives.

20. U. Ojetti, L. Dami, N. Tarchiani, 1924.

21. McComb, 1934.

22. "Exhibition of Italian XVII and XVIII Century Paintings and Drawings at the Fogg Art Museum," 14 Jan.–9 Feb. 1929, typescript in Fogg Museum Archives. The author is grateful to Fogg Archivist Phoebe Peebles and Assistant Abigail Smith for information on this exhibition.

23. These points are made repeatedly in the literature; see, for example, H. B. Wehle, "Some Italian Baroque Paintings," *Bulletin of the Metropolitan Museum of Art*, XXIV, no. 7, July 1929, 187–90; [A. E. Austin, Jr.], "A Painting by Alessandro Magnasco," *Wadsworth Atheneum Bulletin*, VII, no. 3, July 1929, 22–23; A. McComb, "Exhibition of Italian Paintings and Drawings of the Sei- and Settecento," *Parnassus*, II, no. 2, Feb. 1930, 8–9, 38.

24. Hartford, 1930.

25. "Baroque Art to Be Shown at Memorial," Hartford *Times*, 14 Jan. 1930.

26. "Baroque Exhibit Attracts Crowd," Hartford *Times*, 23 Jan. 1930.

27. E. W. Forbes to A. E. Austin, 23 Jan. 1930, Austin papers, box 16, Wadsworth Atheneum Archives.

28. J. Weitzner to A. E. Austin, 7 Feb. 1930, Austin papers, box 16, Wadsworth Atheneum Archives.

29. Also surviving are Austin's copies of Julien Levy's notes from a course given by Erwin Panofsky at the Institute of Fine Arts in 1936, and a typescript of Panofsky's seminal essay "What Is Baroque?"; Austin correspondence, box 1, Wadsworth Atheneum Archives.

30. Two Neapolitan works, Ribera's *Mocking of Christ* and Giordano's *St. Sebastian*, on loan from Frank Gair Macomber, a Boston private collector, were acquired by gift in 1936.

31. JRS, 1930.

32. A. Everett Austin, Jr., "The Baroque," *Art News Annual*, II, Nov. 1949, 12.

33. H.-R. Hitchcock, "The Baroque Theatre," *Wadsworth Atheneum Bulletin*, VIII, no. 1, Jan. 1930, 12–14.

34. T. H. Parker, "A. Everett Austin, Jr. and the Theatre," in Sarasota, 1958, 53.

35. H.-R. Hitchcock, *Wadsworth Atheneum Bulletin*, 1930, 22–23.

36. D. Zlotsky, "'Pleasant Madness' in Hartford: The First Surrealist Exhibition in America," *Arts Magazine*, LX, no. 6, 1986, 55–61.

37. H. Parsons to A. E. Austin [12 Feb. 1930], and I. Brass to A. E. Austin, 14 Feb. 1930, curatorial file.

38. Hitchcock, 1931, 14–15.

39. A. E. Austin, "'Hylas and the Nymphs' by Piero di Cosimo," *Wadsworth Atheneum Bulletin*, X, no. 1, Jan. 1932, 3–6.

40. J. Burckhardt, *Civilization of the Renaissance in Italy*, trans. S. Middlemore, London, 1929.

41. L. Vertova, review of Bacci, 1966, in *Apollo*, LXXXVII, 1968, 223.

42. "Atheneum Buys Great Painting," Hartford *Times*, 16 Jan. 1932.

43. Executive Committee Minutes, Wadsworth Atheneum Archives.

44. Interview with Hitchcock, 12 Sept. 1974, audiotape in Wadsworth Atheneum Archives.

45. "Atheneum Plans Interesting Year," Hartford *Times*, 24 Aug. 1928.

46. "Wadsworth Atheneum Director Home from Study of European Art Centers," Hartford *Times*, 7 Sept. 1937.

47. Interview with Agnes Rindge Claflin, 22 Oct. 1974, audiotape in Wadsworth Atheneum Archives.

48. A. E. Austin to E. W. Forbes, 29 Apr. 1940, Austin papers, box 29, Wadsworth Atheneum Archives.

49. Hartford, 1938.

50. Hartford, 1933.

51. "Austin Speaks on Abstract Art," Hartford *Times*, 21 Nov. 1930.

52. Hartford, 1933, 5.

53. New York, Knoedler and Co. (also Hartford, Wadsworth Atheneum), *Loan Exhibition of Paintings by Georges de la Tour, Antoine Le Nain, Louis Le Nain, Mathieu Le Nain*, 23 Nov.–12 Dec. 1936.

54. Hartford, Wadsworth Atheneum, *Forty-three Portraits*, 26 Jan.–10 Feb. 1937, n. p.

55. Hartford, 1938, n. p.

56. "Atheneum Purchases Another Seventeenth Century Work," Hartford *Times*, 24 Dec. 1937.

57. Austin, 1939, 8.

58. As Austin was quoted in the Hartford *Times*, 5 Apr. 1939.

59. Austin, 1939, 9.

60. Austin, 1940, 8.

61. Austin, 1939, 9.

62. Nicolson, 1979, 36.

63. A. E. Austin to M. Sarton [May 1942], Austin papers, box 21, Wadsworth Atheneum Archives.

64. C. A. Goodwin to E. W. Forbes, 3 Aug. 1943, Austin papers, box 35, Wadsworth Atheneum Archives.

65. E. W. Forbes to C. A. Goodwin, 6 Aug. 1943, Austin papers, box 35, Wadsworth Atheneum Archives.

66. P. Byk to A. E. Austin, 20 Mar. 1939, curatorial file.

67. A. E. Austin to P. Byk, 26 May 1942, Austin papers, box 5, Wadsworth Atheneum Archives.

68. A. E. Austin to R. Huntington, 10 June 1943, curatorial file.

69. C. C. Cunningham, "How to Buy?—and What," *Art News*, L, no. 7, 1951, 30–33, 60–61.

Note to the Reader

The catalogue is divided into sections treating the Italian paintings and the Spanish paintings. Within each section the entries are arranged alphabetically by artist; in the event more than one painting by an artist occurs, they are arranged in the order in which they were acquired.

The biographies preceding each entry are intended to place in focus for the reader the facts of the artist's life and career, and to indicate the artist's historical importance. These vary in length; those for which no recent monograph or exhibition catalogue is available are more detailed in an attempt to bring together information which may be widely scattered or inaccessible.

Preliminary information is structured in the following way:

1. medium and support, dimensions in centimeters and inches, height preceding width
2. information related to the above: format other than rectangular, cradling, trimming, lining, grain, decorative molding
3. surface condition: varnish, abrasion, cracks, losses, tears, pentimenti, overpainting, inpainting, later additions
4. signatures and inscriptions on the painting
5. inscriptions and labels on the verso
6. provenance: chronological list of owners, to the best of our knowledge
7. exhibitions in which the work has been shown, in chronological order
8. credit line

The commentary discusses the attribution, dating, original context or association with other paintings, such as pendants or versions, and imagery of the painting; condition, including results of recent conservation, and provenance are also discussed where pertinent. Right and left are referred to from the standpoint of the spectator.

The notes acknowledge the sources of information, published or unpublished, and contain more detailed information that may be of interest to the specialist. Published sources cited more than once are abbreviated to author and date or, in the case of exhibition catalogues, to place and date. Full citations of abbreviated works are listed in the bibliography.

References to photograph collections are abbreviated as follows:

Alinari photo = Fratelli Alinari, Florence
Arch. Foto. Sop. Modena = Archivio Fotografico, Soprintendenza per i Beni Artistici e Storici di Modena
Courtauld photo = Photographic Survey, Courtauld Institute of Art, London
FARL = Frick Art Reference Library, New York
Foto. Gall. Mus. Vat. = Archivio Fotografico, Gallerie e Musei Vaticani
Foto. Sop. Florence = Gabinetto Fotografico, Soprintendenza ai Beni Artistici e Storici di Firenze
Foto. Sop. Gall. Napoli = Archivio Fotografico, Soprintendenza alle Gallerie, Napoli
G.F.N., Rome = Gabinetto Fotografico Nazionale, Rome, more recently called the Istituto Centrale per il Catalogo e la Documentazione
MAS = Ampliaciones y Reproducciones MAS, Barcelona

A subject index and an index of previous owners appear after the entries.

Color Reproductions

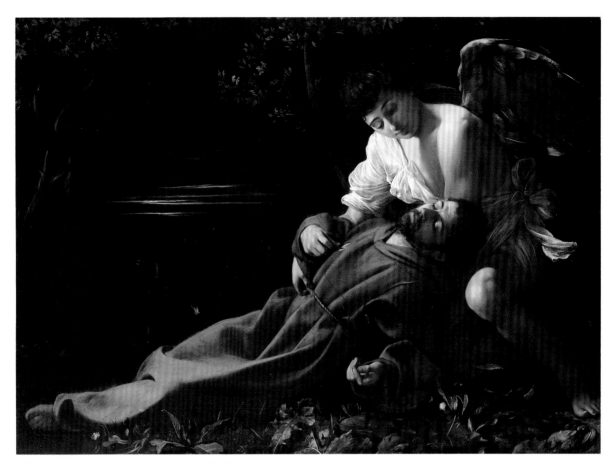

Michelangelo Merisi da Caravaggio, *St. Francis*

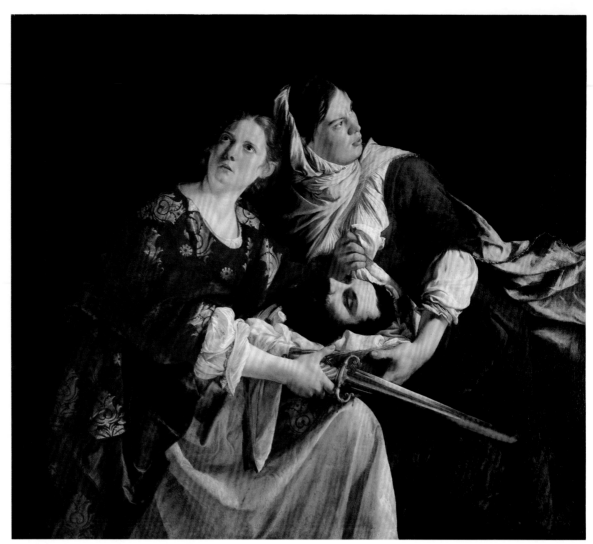

Orazio Gentileschi, *Judith and Her Maidservant with the Head of Holofernes*

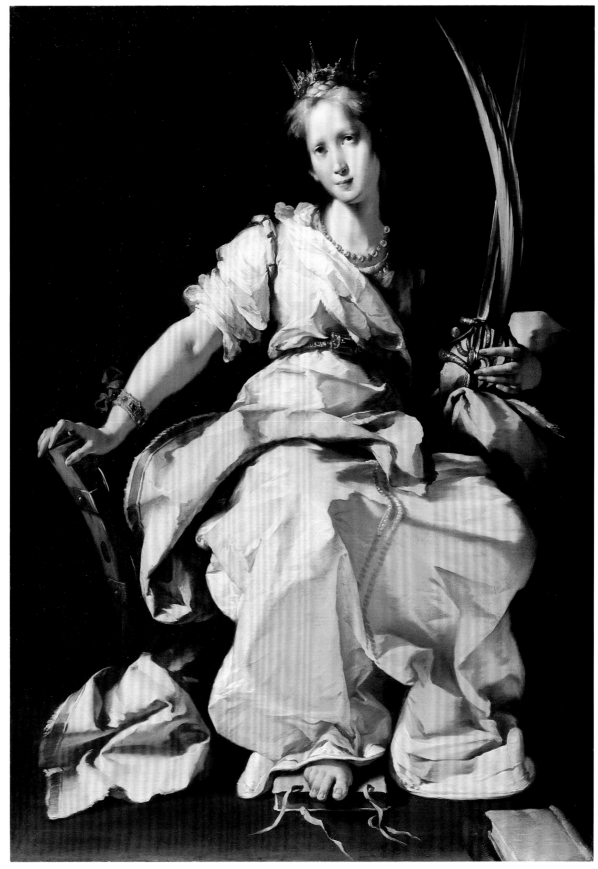

Bernardo Strozzi, *St. Catherine of Alexandria*

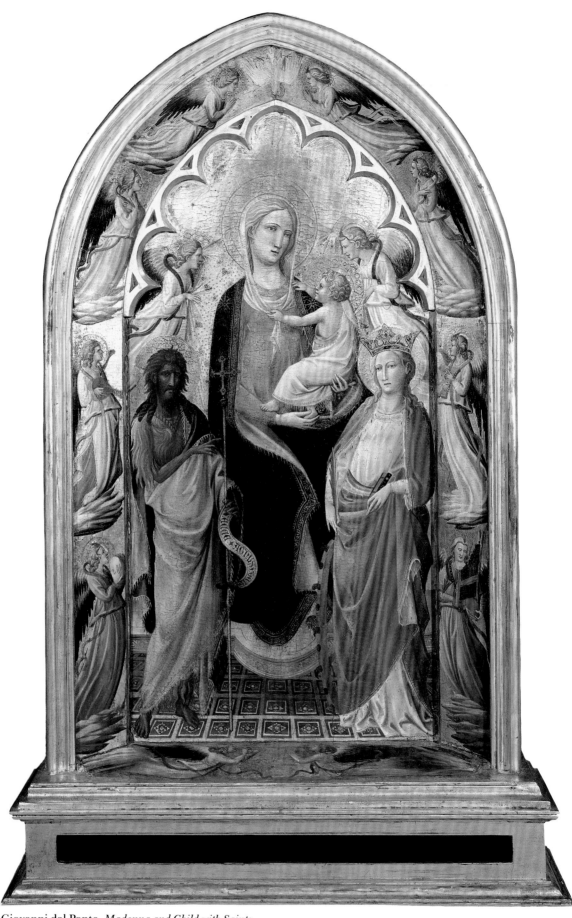

Giovanni dal Ponte, *Madonna and Child with Saints
John the Baptist and Catherine*

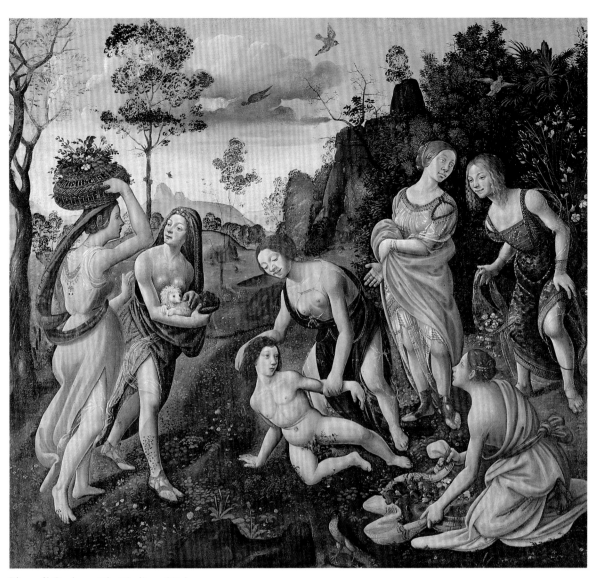

Piero di Cosimo, *The Finding of Vulcan*

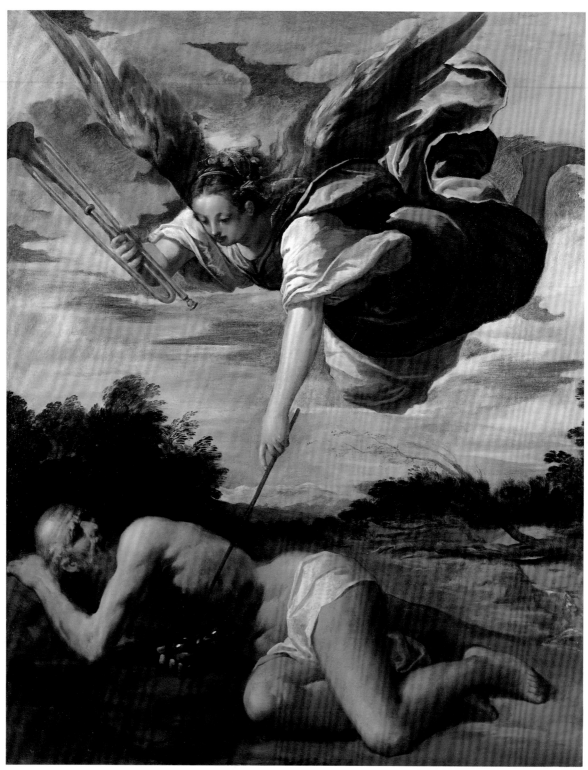

Scarsellino, *Fame Conquering Time*

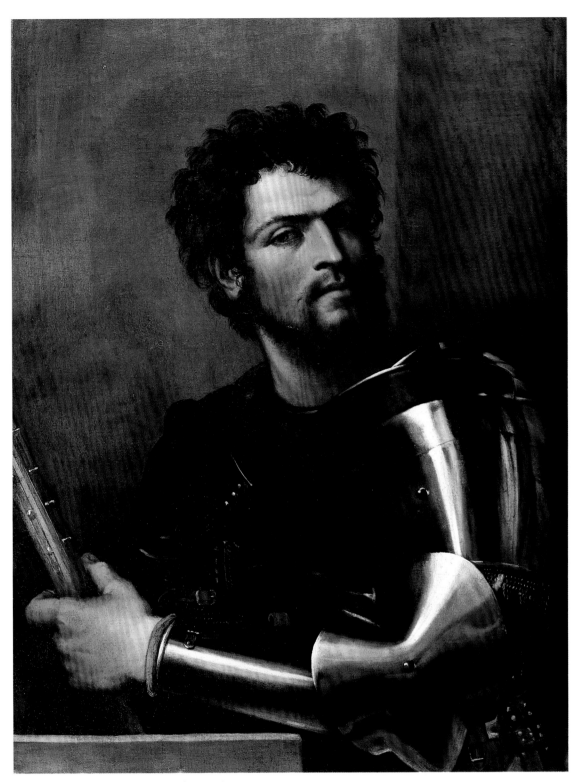

Sebastiano del Piombo, *Portrait of a Man in Armor*

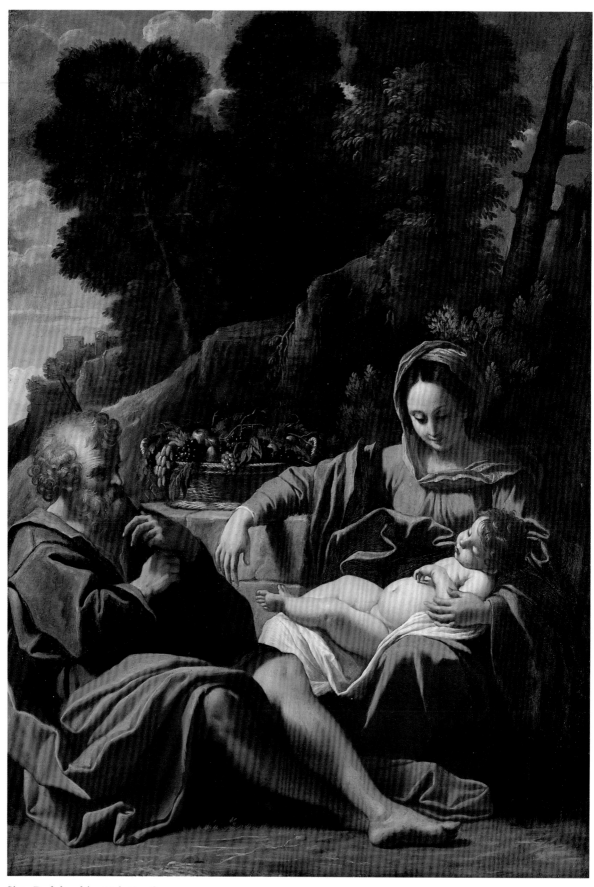

Sisto Badalocchio, *Holy Family*

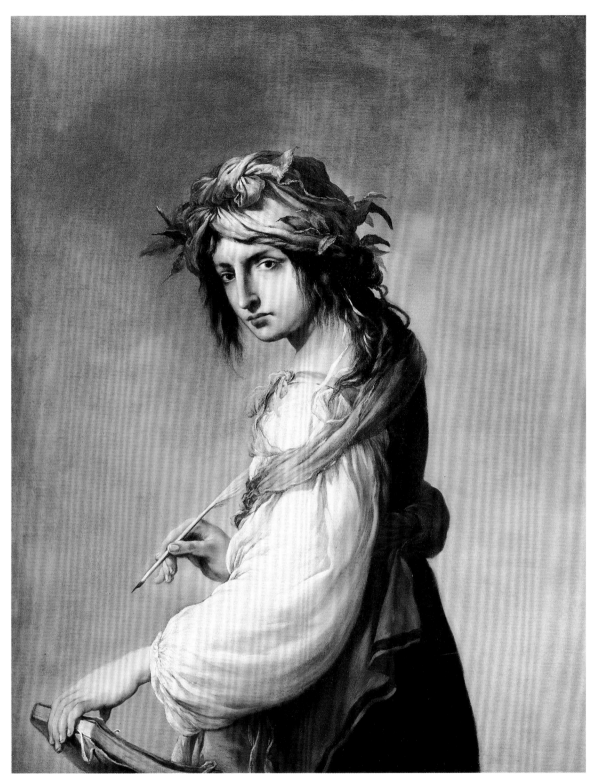

Salvator Rosa, *Lucrezia? as the Personification of Poetry*

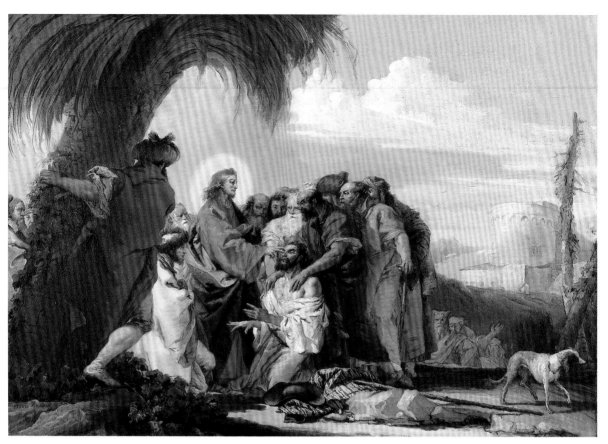

Giovanni Domenico Tiepolo, *Christ Healing the Blind*

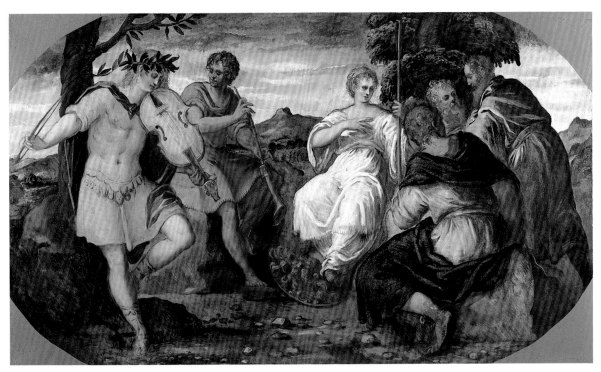

Jacopo Tintoretto, *The Contest between Apollo and Marsyas*

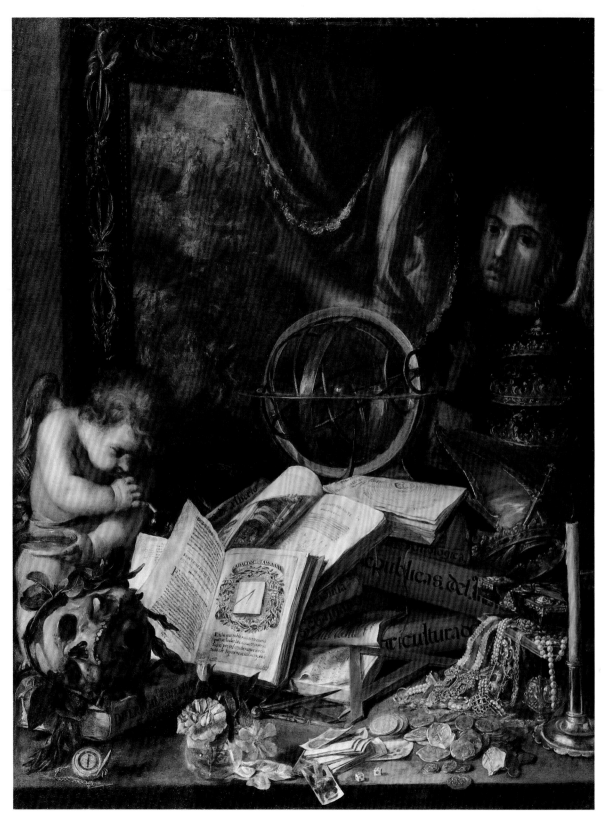

Juan de Valdés Leal, *Vanitas*

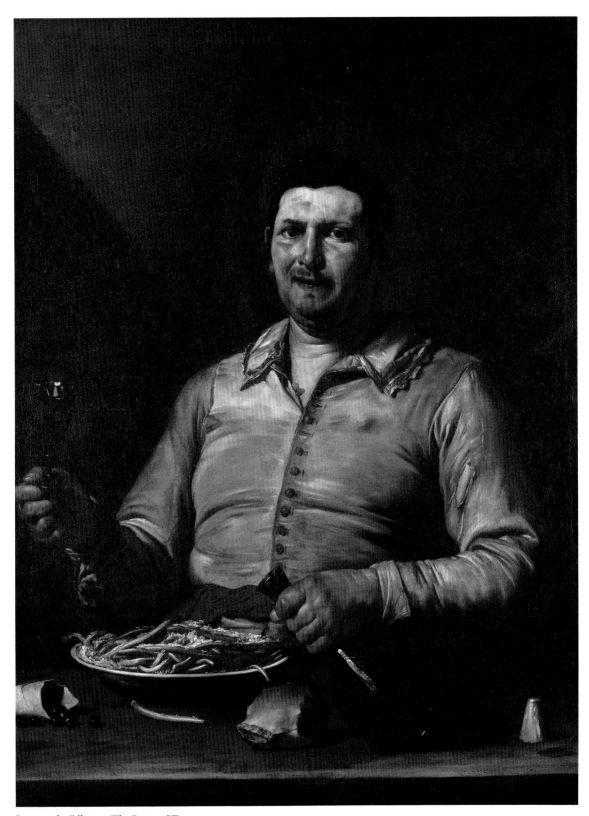

Jusepe de Ribera, *The Sense of Taste*

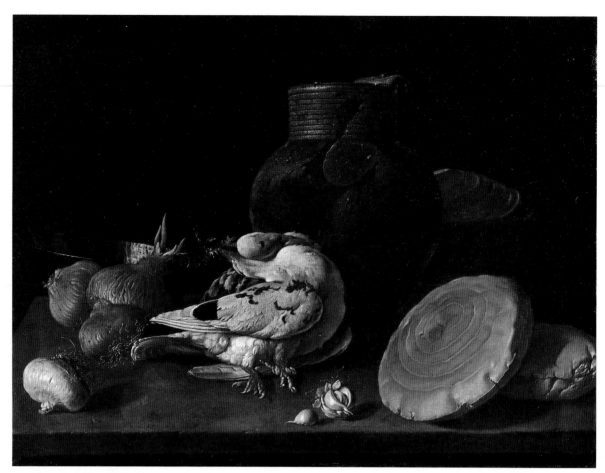

Luis Egidio Meléndez, *Still Life: Pigeons, Onions,*
Bread, and Kitchen Utensils

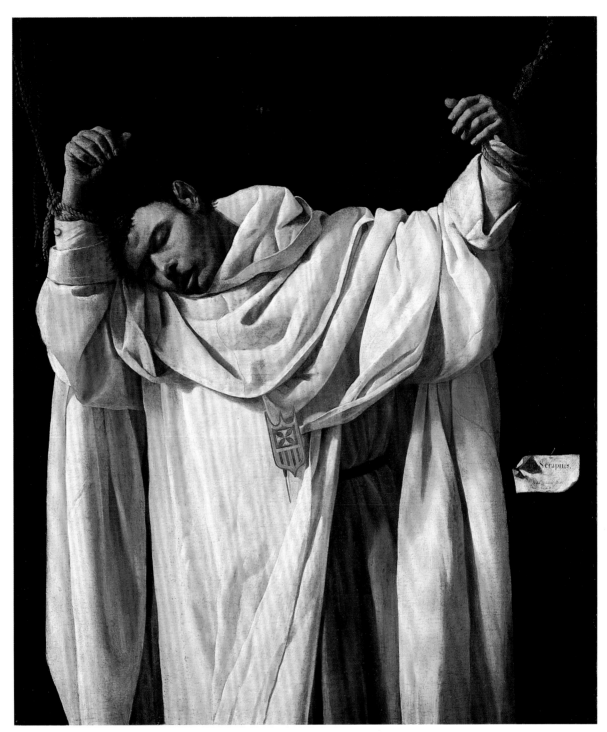

Francisco de Zurbarán, *St. Serapion*

Giovanni Paolo Panini, *The Picture Gallery of Cardinal Silvio Valenti Gonzaga*

Italian Paintings

Fra Angelico
(active 1418–1455)

Guido di Pietro, also called Fra Giovanni da Fiesole and Beato Angelico, was long thought to have been born in 1387 or 1388, as related by Vasari.[1] More recently, evidence has been brought to light that places his birth date about 1395–1400.[2] His activity as a painter dates from 1418, when, still a layman, he was paid for an altarpiece in the Florentine church of S. Stefano al Ponte, which has not survived.[3] His novitiate in the Dominican convent of S. Domenico di Fiesole, near Florence, presumably dates to about 1420–22[4] and was certainly before 1423.[5]

Though presumably active as a painter throughout the 1420s, Angelico's first datable altarpiece is the triptych of the *Virgin and Child with Saints Dominic, John the Baptist, Peter Martyr, and Thomas Aquinas* painted in 1428.[6] Discussion of Angelico's oeuvre in the decade before the St. Peter Martyr triptych has been lively,[7] but most critics accept the altarpiece of the *Madonna and Child with Saints Thomas Aquinas, Barnabas, Dominic, and Peter Martyr* in S. Domenico in Fiesole as preceding the St. Peter Martyr triptych by about five years.[8]

From the 1430s Angelico's documented works are numerous, including, most importantly, the triptych for the guild hall of the Arte dei Linaiuoli, or linen workers' guild, commissioned in July 1433,[9] and the polyptych for the church of S. Domenico, Perugia, now in the Galleria Nazionale dell'Umbria, documented to 1437.[10] Between about 1440 and 1445 Angelico was occupied with painting frescoes and an altarpiece for the convent and church of S. Marco, Florence.[11]

Sometime in 1445, Angelico was called to Rome by Pope Eugenius IV and returned to Florence only in late 1449 or 1450. In Rome he was principally occupied with decorating several chapels with frescoes.[12] Of these, only the scenes from the lives of Saints Stephen and Lawrence in the chapel of Nicholas V (who succeeded Eugenius in 1447) survive.

Angelico returned to Florence by early 1450 and was named prior of S. Domenico di Fiesole sometime before June of that year.[13] Documented works from this period are few, although most critics assign the altarpiece for the high altar of the church of S. Buonaventura at Bosco ai Frati, now in the Museo di S. Marco, the Louvre *Coronation of the Virgin*, and several panels of the cupboard for the church of SS. Annunziata to these years.[14]

By February of 1455 he is known to have died in Rome.

Angelico's master is not known, though suggestions have ranged from such late Gothic masters as Lorenzo Monaco, Gherardo Starnina, and Ambrogio di Baldese, to more progressive painters such as Masolino and the Marchigian artist Gentile da Fabriano.[15] His early works show a remarkable understanding of the innovations in Florentine painting of the young Masaccio and Gentile. He built on the precedents of those artists a style that conformed to the demands of the age for restrained naturalism and heart-felt piety. His influence was widespread and his imitators many. His best-known pupils include Benozzo Gozzoli and the miniaturist and painter Zanobi Strozzi.

1. Vasari, 1906, II, 505.
2. Cohn, 1955, 207–16; 1956, 218–20. Orlandi, 1954, 167–68; 1964, 1–2.
3. Cohn, 1956, 218–20.
4. Orlandi, 1964, 18.
5. Orlandi, 1964, 173, doc. VII.
6. Orlandi, 1954, 180, doc. I.
7. See, most recently, Pope-Hennessy, 1974, 5, 9–14; M. Boskovits, *Un'Adorazione dei Magi e gli inizi dell'Angelico*, Bern, 1976; Ahl, 1980, 360–81.
8. Pope-Hennessy, 1974, 10, 189–90.
9. Pope-Hennessy, 1974, 15–17, 194–95.
10. Pope-Hennessy, 1974, 17, 198–99.
11. Pope-Hennessy, 1974, 19–27, 199–210.
12. Pope-Hennessy, 1974, 29–33, 212–14; C. Gilbert, "Fra Angelico's Fresco Cycles in Rome: Their Number and Dates," *Zeitschrift für Kunstgeschichte*, XXXVIII, 1975, 245–65.
13. Orlandi, 1964, 117; Pope-Hennessy, 1974, 7.
14. Pope-Hennessy, 1974, 33–38, 215–18.
15. Ahl, 1980, 367–68, n. 32.

Workshop of Fra Angelico
Head of an Angel

Tempera and oil on panel, 17.5 x 13.9 cm (6⁷/₈ x 5¹/₂ in.)
The panel has been cradled.
Condition: good. The upper left and right corners have been regessoed. There is some regilding in the halo.
Provenance: an unspecified Russian collection; René Gimpel, Paris, 1925–28.[1] Purchased by the Wadsworth Atheneum in 1928 from René Gimpel, New York, for $24,000 from the Sumner Fund.
Exhibitions: Westport, 1955, no. 2.
The Ella Gallup Sumner and Mary Catlin Sumner Collection, 1928.321

The *Head of an Angel* is a fragment from the panel of the *Madonna with Lily* now in the Rijksmuseum, Amsterdam (Fig. 4). The Amsterdam panel may have already been cut down when it entered the Grand Ducal Museum in Oldenburg in 1869; it entered the Rijksmuseum in 1923.[2]

The panel shows the Madonna and Child seated on a cushion in front of a richly embroidered curtain. The Child is clothed only by a translucent drape, and the Virgin holds a lily. The motif of the Virgin seated on the ground is known as the Madonna of Humility and has been shown by Meiss to have originated in Siena, probably in paintings by Simone Martini of the mid fourteenth century, and to have had great popularity throughout the fourteenth and fifteenth centuries.[3] The curtain behind the Virgin, the Cloth of Honor, alludes to her role as Queen of Heaven and was likewise a popular motif in the fourteenth century.[4] The stars in the Virgin's halo refer to the Woman of the Apocalypse, whose attributes were often conflated with those of the Virgin of Humility.[5] The lily, usually a symbol of the Annunciation, may also refer to St. Dominic, whose order was devoted to the Virgin of Humility.[6]

The panel was originally taller. Gómez-Moreno has pointed out the similarities in the dies used to punch the halo decoration and the incised decoration on the underside of the brocaded cloth in the Hartford and Amsterdam pictures. She has postulated that the Atheneum panel formed the top left part of the Amsterdam picture and that the Amsterdam picture was originally rectangular in form. Another angel holding the Cloth of Honor, and perhaps the dove of the Holy Spirit, originally formed part of the composition and have been lost since the panel was cut to its present arched form.[7] A painting in the Galleria dell'Accademia in Florence attributed to Andrea di Giusto shows the probable original format of the Amsterdam picture and is perhaps dependent on it or on a common model.[8]

The wood grain of the Atheneum panel runs at approximately a 45-degree angle to the lower edge of the panel and suggests that the reconstruction proposed by Gómez-Moreno is not entirely correct.[9] The angel must have leaned more closely toward the Virgin and Child. The lower right corner has not been repainted. It is possible, then, that the original was arched in form.

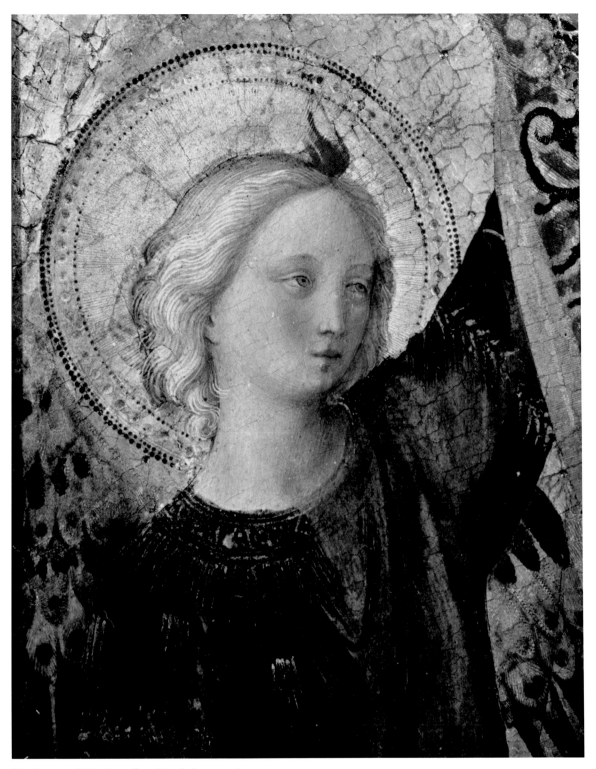

Workshop of Fra Angelico, *Head of an Angel*

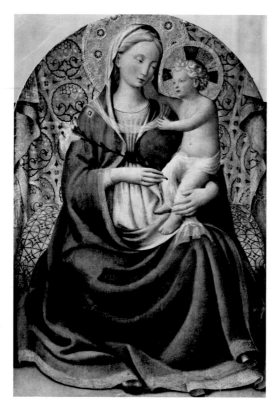

Figure 4. Fra Angelico, *Madonna with Lily*, Amsterdam, Rijksmuseum

1. R. Gimpel, *Journal d'un collectionneur-marchand de tableaux*, Paris, 1963, 287, n. 1.
2. Inv. A3011; panel, 74 x 52 cm, arched top. Van Os and Prakken, 1974, 29–31, no. 2; van Thiel, 1976, 83.
3. Meiss, 1936, 435–65.
4. R. Goffen, "Icon and Vision: Giovanni Bellini's Half-Length Madonnas," *Art Bulletin*, LVII, 1975, 497.
5. Meiss, 1936, 462.
6. Gómez-Moreno, 1957, 186.
7. Gómez-Moreno, 1957, 183–93.
8. Gómez-Moreno, 1957, 186; Pope-Hennessy, 1974, 220.
9. Gómez-Moreno, 1957, 185, fig. 1.
10. For the Amsterdam painting, see van Os and Prakken, 1974, 30; van Thiel, 1976, 83. The Atheneum panel is attributed to Angelico in the following: A. E. Austin, Jr., "A Small Tempera Panel by Fra Angelico," *Wadsworth Atheneum Bulletin*, Jan. 1929, 2–3; Hartford, 1934, 24; *Wadsworth Atheneum Handbook*, 1958, 30; Berenson, 1963, I, 14 (as repainted); Baldini, 1970, 103, no. 62A; Fredericksen and Zeri, 1972, 584. The following studies attribute the panel to the workshop of Angelico: Gómez-Moreno, 1957, 193; "Fantasy and Flair," *Apollo*, LXXXVIII, 1968, 406, 409, pl. 1; Pope-Hennessy, 1974, 220; Silk and Greene, 1982, 18–19.
11. Pope-Hennessy, 1974, 220.
12. Pope-Hennessy, 1974, 221.
13. Pope-Hennessy, 1974, 221.
14. Pope-Hennessy, 1974, 229, now Countess Margit Batthyany, Montevideo, Uruguay.
15. Pope-Hennessy, 1974, 231.
16. Shapley, 1979, I, 13–14, no. 5, II, pl. 8.
17. Venturi, 1927, 12, dated the Amsterdam panel to about 1438; van Marle, 1928, X, 138, to late in Angelico's career; Austin, 1929, 3, dated the Atheneum panel between 1425 and 1440; G. Bazin, *Fra Angelico*, trans. M. Logé, New York, 1949, 181, dates the Amsterdam panel to about 1440; Pope-Hennessy, 1952, 197, to after 1440–45; L. Collobi Ragghianti, "Una mostra di Angelico," *Critica d'arte*, X, 1955, 392, dates it late in Angelico's career; Gómez-Moreno, 1957, 193, to between 1438 and 1440; Orlandi, 1964, 59, dates the Amsterdam panel to after 1445; Baldini, 1970, 68, to about 1440.

The Amsterdam-Hartford panel is generally thought to have been painted in the workshop of Angelico, while some scholars ascribe the panel to Angelico himself.[10] Pope-Hennessy has suggested that the studio assistant who executed the Virgin Annunciate roundel of the Perugia polyptych also executed the Amsterdam-Hartford panel.[11]

Several similar pictures of the Virgin and Child are related to the Amsterdam-Hartford panel, including a *Madonna and Child with St. Catherine and an Angel*, private collection, Basel;[12] the *Madonna and Child with Saints Dominic and Peter*, Staatliche Museen, Berlin;[13] the *Madonna and Child with Five Angels*, formerly Thyssen Collection, Lugano;[14] the *Madonna and Child with Four Saints*, Galleria Nazionale, Parma;[15] and the *Madonna and Child with Two Angels*, National Gallery of Art, Washington.[16] These panels are generally attributed to an assistant of Angelico rather than to the master himself.

Dating of the Amsterdam-Hartford panel has been varied, from between 1438 and 1440 to the late 1440s.[17] A date in the late 1440s seems preferable.

J.C.

Vito d'Anna
(c. 1720–1769)

This Palermo painter, best known as a frescoist, founded a school in his native city. He studied for at least eight years in Acireale with Pietro Paolo Vasta (1697–1760), when in 1744, having refused the hand of Vasta's daughter, he returned to Palermo to marry the daughter of a prominent painter there, Olivio Sozzi (1696–1765), a disciple of Sebastiano Conca and Corrado Giaquinto. The latter warmly received d'Anna in Rome, where he was admitted to the Accademia di S. Luca in 1763, and made a papal count and knight of the Golden Spur. After his brief Roman sojourn he returned to Palermo and died in a few years. He is said to have been a placid man, of few words, and in temperament "era più proprio di una buona, timida feminuccia."[1]

1. Parrino, 1932, 10–17. The Accademia di S. Luca, Rome, preserves his *Self-Portrait*; see Susinno, 1974, 237, figs. 32, 256.

Hagar and Ishmael Rescued by an Angel

Oil on canvas, 36.9 x 26 cm (14½ x 10½ in.)
 A cusp at the top is cut off.
 Condition: good. There are minor retouchings on the left and right.
 Provenance: The previous history of the painting is unknown. Given to the Wadsworth Atheneum in 1921 by the estate of Mrs. Charles Dudley Warner.
 Exhibitions: Kent, 1966, as Corrado Giaquinto.
 Gift of the Estate of Mrs. Charles Dudley Warner, 1921.423

Ishmael was the son of Abraham by his tainted union with Hagar, the Egyptian maidservant of his wife Sarah, who, despite her great age, thereafter gave birth to a legitimate son, Isaac. Ishmael mocked his half-brother, the child of God's covenant with Abraham, for which transgression Hagar and Ishmael were banished into the wilderness, where they were rescued by an angel. The theme is a frequent one in Italian art of the Counter Reformation. Paul had used the story as an allegorical justification of the new Jerusalem, that is, the Church. In the seventeenth century this became, by extension, an allegorical justification for the sole legitimacy of the Roman church.[1]

This sketch entered the Atheneum at an early date, as the *Glorification of St. Paul*, with an attribution to the Venetian Sebastiano Ricci (1659–1734). Cunningham felt it might possibly be by the Bolognese Gaetano Gandolfi (1734–1802),[2] which Zeri thought more likely than an attribution to Sebastiano[3] and so listed the sketch in the *Census*.[4] However, Gaetano Gandolfi's touch, especially in his sketches, is much more liquid and his treatment of form more animated than seen here.[5] Byam Shaw observed the picture's stylistic proximity to Corrado Giaquinto (1703–1765),[6] who trained with Solimena in Naples, was then active in his maturity prominently in Rome as the epitome of the Roman rococo, and thereafter in Madrid, where he was to affect the young Goya. Generically, this is a more plausible direction of inquiry in the search to identify the author of the Atheneum sketch, but once again the quality here simply does not match the brio so characteristic of Giaquinto's dashing *bozzetti*, especially one of the same subject and almost the same size in the Pinacoteca Civica, Montefortino.[7] The latter would seem to date to the artist's final maturity, his Spanish years, 1753 to 1762. The Atheneum sketch is similarly quite unlike *bozzetti* of Giaquinto's Roman period, beginning in 1723, when he collaborated with Sebastiano Conca (1680–1764) and absorbed the expansive virtuosity of the seventeenth-century Roman baroque. It does not even resemble works of this period that have the pronouncedly brownish palette seen here.[8] Might the Atheneum sketch then be an early work by Giaquinto of his Neapolitan period (1719–23)? Such would be pure speculation, there being scant comparative material to document the artist's development before he emerges as an independent figure in the 1730s with his frescoes in S. Nicola dei Lorensi, Rome.[9]

Longhi proposed that the sketch is probably the

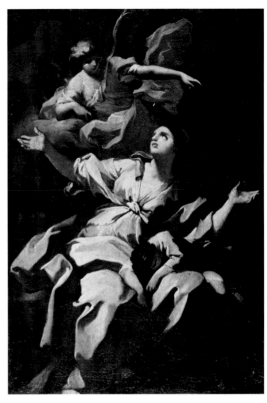

Vito d'Anna, *Hagar and Ishmael Rescued by an Angel*

work of Vito d'Anna.[10] The Accademia di S. Luca, Rome, has its reception piece by d'Anna, *Samson Destroying the Temple*, signed and dated 1763.[11] As Samson wrenches down a column, two women fall backward in terror. Their frozen poses, their drapery, and their deep-set eyes very much resemble Hagar's here. Also the treatment of hands, extended palms outward in a declamatory gesture, is very similar in both, and the sketchy convention for the heads in the background of the *Samson* is very like the angel's here. Faldi comments on the precocious neoclassicism of the *Samson*, which could be adduced to account for the bulky frontality of the Atheneum sketch.[12] Longhi's proposal is a stimulating one that awaits further examination. M.M.

1. Genesis 21:1–21; Galatians 4:21–31. See Mckenzie, 1965, 330–31.
2. C. Cunningham to F. Zeri, 9 Oct. 1959, curatorial file.
3. F. Zeri to C. Cunningham, 5 Nov. 1959, curatorial file.
4. Fredericksen and Zeri, 1972, 77, 255, 584.
5. Compare the Atheneum picture with such Gaetano Gandolfi sketches as *Justice*, 44 x 33.5 cm, Ceschi Collection, Bologna (repr. Bianchi, 1936, pl. 33, and Roli, 1977, pl. 77d); *Rape of Ganymede*, 50.5 x 39 cm, Ceschi Collection, Bologna, and later with Hazlitt, London (repr. Bianchi, 1936, pl. 34, and Roli, 1977, pl. 77c); *Death of St. Andrea Avellino*, Pinacoteca Vaticana 409 (repr. Roli, 1977, 272a, or Fot. Gall. Mus. Vat. VII–36–6); *Founding of the Foundlings' Hospital*, 1788, Museo Civico, Pisa (repr. Roli, 1977, 279, or Alinari no. 37067); or *Allegorical Figure*

of *Abundance*, after 1774, Museo Stibbert, Florence (repr. Chiarini, *Paragone*, 1978, pl. 57).

6. 29 Apr. 1963, memorandum in curatorial file.

7. *Hagar in the Wilderness*, before the birth of Ishmael, an earlier episode in the Genesis narrative (16:4–14), canvas, 46 x 36 cm, given in 1863 to the Pinacoteca Civica by the painter Fortunato Duranti as part of a remarkable group of Giaquinto's (L. Mortari in Rome, 1959, 116, nos. 262 and 263), repr. d'Orsi, 1958, fig. 103, or Rome, G.F.N. E3477. In the same collection are two further *bozzetti*, both of the birth of the Virgin, to be compared with the Atheneum sketch: one with the same framing motif at the top (repr. d'Orsi, 1958, fig. 96, or Rome, G.F.N. E7376); the other horizontal in format (repr. d'Orsi, 1958, fig. 92, or Rome, G.F.N. E7369). Neither bears any stylistic resemblance to the Hartford picture

8. Compare the Atheneum picture with such a typical work as the *Apollo and Daphne bozzetto* for the 1733 panel in the Villa della Regina, Turin, or with such works of a brown cast as the *Vision of St. Eustache bozzetto*, each respectively in Milanese and London private collections (repr. L. Dania in *Atti Giaquinto*, 1971, figs. 4 and 5; see also 11–12).

9. D'Orsi, 1958, 21–26. The Atheneum picture is not listed in this author's monograph on Giaquinto. While having no alternative to suggest, Rosenberg also rejected the attribution to Giaquinto (P. Rosenberg verbally to P. Marlow, 10 Mar. 1971, memorandum in curatorial file).

10. R. Longhi to C. Cunningham, 31 Jan. 1960, curatorial file.

11. Oil on canvas, 81 x 66 cm, Rome, G.F.N. E72918.

12. Faldi, 1974, 149–50.

Francesco Bacchiacca (1494–1557)

The birth date of Francesco d'Ubertino Verdi, called Bacchiacca, is recorded as 1 March 1493 (1494 modern reckoning) in the baptismal records of S. Maria del Fiore in Florence.[1] His father, Ubertino di Bartolommeo, was a goldsmith from S. Lorenzo, in the Mugello Valley east of Florence, and his brother Bartolommeo, or Baccio, born in 1484, was also a painter.[2] Few other details of his life have come to light. Vasari devoted no separate biography to him, although he is mentioned in the lives of other artists. He may have gone to Rome in 1524–25, as he is mentioned as living there in Benvenuto Cellini's autobiography.[3] He died in Florence in 1557.

Vasari tells us that Bacchiacca was trained by Perugino,[4] and it is Perugino's style, with a distinctly Florentine accent, that is visible in Bacchiacca's earliest paintings.[5] As an independent master he took part in the commission to decorate the bedroom of Pier Francesco Borgherini in his palazzo on Borgo S. Apostolo with scenes from the life of Joseph. This commission, according to Vasari,[6] was given to Andrea del Sarto, Pontormo, Granacci, and Bacchiacca by Salvi Borgherini on the marriage of his son, which took place in 1515.[7] Bacchiacca's panels from this scheme are now in the National Gallery, London, and the Galleria Borghese, Rome, and probably date from the time of the commission, about 1515–16.[8]

Bacchiacca's mature style begins to emerge in the miniature of *Saints Cosmas and Damian in a Landscape*, from a *Genealogia Medicea* now in the Biblioteca Laurenziana and datable to 1518–19,[9] and it is fully visible in the predella with stories of St. Acasio for Sogliani's *Pala dei Martiri*, documented to 1521.[10] Vasari attributes to Bacchiacca two *cassone* or *spalliere* of the *Baptism of Christ* and the *Legend of the Dead King* painted for an antechamber in the house of Giovanni Maria Benintendi in Florence.[11] These panels, in the Bode Museum, Berlin, and the Gemäldegalerie, Dresden, are generally dated to about 1523.[12]

Vasari tells of other works Bacchiacca painted for the Medici, including the *Journey of Lorenzo the Magnificent to Naples* and the *Return from Exile of Cosimo il Vecchio* in honor of the marriage of Duke Cosimo in 1539, and frescoes in the courtyard of the Palazzo Medici on the occasion of Eleonora of Toledo's entry

into Florence.[13] These no longer survive, but they may have been the reason Bacchiacca entered the duke's service. By 1550–51 he was a salaried employee of the court.[14] Among other work for the duke, Bacchiacca made cartoons for tapestries of *grotesques*, woven between 1546 and 1551, and the *Months of the Year*, woven in 1552 and 1553.[15] A notebook of drawings in the Uffizi dated 1527 is generally attributed to him.[16]

Bacchiacca's art, a compendium of influences from his contemporaries, especially Andrea del Sarto, Fra Bartolommeo, and Michelangelo, nonetheless strikes an individual note. In style and in format, especially in the smaller decorative panels, he remains an artisan who reflects the profound changes in Florentine art of the first decades of the sixteenth century.

1. Abbate, 1965, 46, n. 24.
2. Vasari, 1906, III, 592; R. Salvini, "Baccio Ubertini," in Thieme and Becker, 1939, XXXIII, 522.
3. *The Autobiography of Benvenuto Cellini*, trans. J. A. Symonds, New York, 1927, I, 30–31, 52. See also Abbate, 1965, 42–43.
4. Vasari, 1906, III, 592. His apprenticeship presumably took place in Florence during the first years of the sixteenth century; see Abbate, 1965, 31–32.
5. The *Deposition* in the Museo Civico, Bassano, and the *Resurrection* in the Musée des Beaux-Arts, Dijon, are based on compositions by Perugino and probably date to about 1510–15; see Nikolenko, 1966, 35–36, figs. 1 and 4; and Abbate, 1965, 31–33.
6. Vasari, 1906, VI, 454.
7. Gould, 1975, 200, 201, n. 6; A. Braham, "The Bed of Pierfrancesco Borgherini," *Burlington Magazine*, CXXI, 1979, 754–65.
8. Della Pergola, 1955–59, II, 14–15, nos. 8–12; see also Abbate, 1965, 37–38, for a summary of dating problems.
9. Shearman, 1977, I, 399–402, II, pl. 136.
10. The predella is now in the Uffizi, and the altarpiece in S. Lorenzo. See Vasari, 1906, VI, 454; A. Scharf, "Bacchiacca: A New Contribution," *Burlington Magazine*, LXX, 1937, 60–65; *Gli Uffizi*, 1979, 39, no. P105.
11. Vasari, 1906, VI, 454.
12. Abbate, 1965, 41, 48–49, n. 54.
13. Vasari, 1906, VI, 87, 443.
14. Nikolenko, 1966, 4.
15. Abbate, 1965, 43, n. 1; illustrated in M. Tinti, *Il Bachiacca*, Florence, 1925, figs. 30–45; the documents are transcribed on 8–9. See also M. Tinti, "Francesco Bachiacca e i suoi arazzi," *Dedalo*, I, 1921, 803–15; *Gli Uffizi*, 1979, 1058–60, nos. Ar15–18; Adelson in Florence, 1980, 47–52, nos. 70–79; Adelson, 1980, 141–200.
16. L. Marcucci, "Contributo al Bacchiacca," *Bollettino d'arte*, XLIII, 1958, 31–35; this attribution has been contested by Shearman, 1977, I, 400, n. 5.

Tobias and the Angel

Oil on panel, 40 x 33 cm (15³⁄₄ x 13 in.)

Condition: fair. There are losses in the right hand of Tobias, in the angel's left wing, above and to the right of the dog, and in the sky.

Provenance: collection Eugen Rieffel-Müller, Frankfurt, by 1925; bought by the Wadsworth Atheneum in 1930 from Durlacher Bros., New York, for $3,000 from the Sumner Fund.

Exhibitions: possibly Berlin, Kaiser Friedrich Museum, 1914, no. 3; Frankfurt, Staedelsches Kunstinstitut, *Ausstellung von Meisterwerken alter Malerei aus Privatbesitz*, 1925 (cat. published 1926), 2, no. 5, fig. 37; Hartford, 1931, 10, no. 5; possibly Vassar College, 1937; Westport, 1955, no. 3; Baltimore, Baltimore Museum of Art, *Bacchiacca and His Friends*, 10 Jan.–19 Feb. 1961, 37, no. 7, repr.

The Ella Gallup Sumner and Mary Catlin Sumner Collection, 1930.79

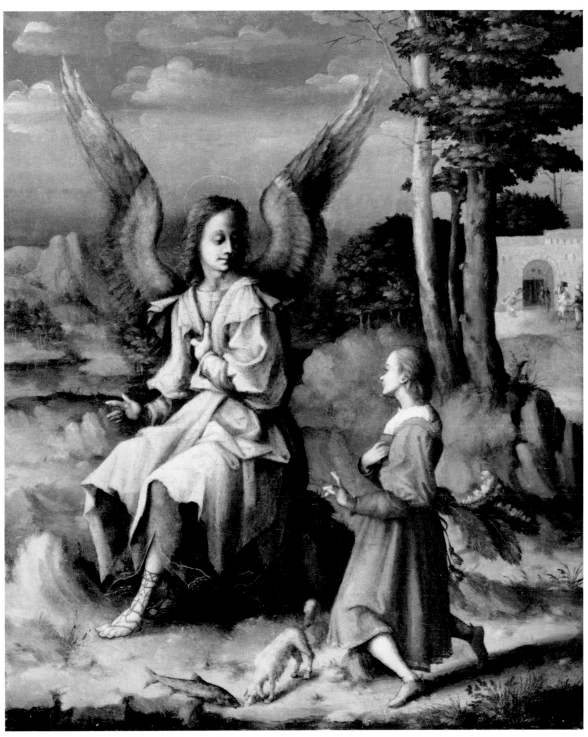

Francesco Bacchiacca, *Tobias and the Angel*

Tobias and the Angel has been attributed to Bacchiacca since its appearance in the literature.[1]

The subject of Tobias and the angel is from the apocryphal book of Tobit (6:1–6). Tobias and the archangel Raphael set out on a journey to collect a debt. Raphael instructs Tobias to catch a fish that has lept from the water as he was washing himself in a river, and to save its gall, heart, and liver. The gall will be used later to cure the blindness of Tobias's father, Tobit, and the heart and liver to exorcise the devil that will possess his future wife, Sarah.

The subject enjoyed great popularity in Florentine art of the late fifteenth and early sixteenth centuries. Members of the Compagnia di Raffaello, a religious confraternity, may have favored the theme, as may have merchant families who sent their sons on business trips abroad.[2] While most depictions of the Tobias legend show Raphael and Tobias striding through a landscape, hand in hand, Bacchiacca shows Tobias kneeling in adoration.[3] And yet the small dog and the fish, Tobias's attributes, leave no doubt that the subject has been correctly identified.

Bacchiacca painted another version of the theme, now in the Uffizi, Florence, in which Raphael leads the young Tobias on their journey, accompanied by a small white dog.[4] Tobias is dressed in elegant contemporary costume, as he is in the Atheneum picture. The style of the painting, particularly the landscape and Raphael's voluminous drapery, which show the influence of Fra Bartolommeo and Albertinelli, points to a somewhat earlier date than the Atheneum picture.[5] Another painting, formerly in the collection of Eduard Simon, Berlin,[6] is a variant of the Atheneum picture. The figures are posed identically, but the angel wears a laurel wreath, and details of dress, foreground, and background are different.

It was not uncommon for Bacchiacca to reuse motifs in his compositions, and indeed the figure of Tobias in the Atheneum picture is identical to the figure of the legitimate son in the *Legend of the Dead King* in Dresden (Fig. 5), while the figure of the angel is an adaptation of the figure seated at the right.[7] Bacchiacca borrowed details such as the dog, the double-peaked mountain, and the entrance block of the building in the background from Lucas van Leyden's print of the *Prodigal Son*.[8] The building in Lucas's print appears in more complete form in the Dresden painting, the *Leda* in the Metropolitan Museum, New York,[9] and the *Beheading of St. John* in Berlin,[10] while the landscape and building motifs from the Atheneum painting recur in other paintings by Bacchiacca, in particular the *Eve with Cain and Abel*, Metropolitan Museum, New York.[11]

Bacchiacca's constant reuse of these motifs makes the relationship of the Atheneum picture to other pictures with these features difficult to establish; however, it is likely that the Atheneum picture was painted after the Dresden painting and must date to after 1523, the date generally assigned to the Dresden and Berlin pictures.[12] The style of the Atheneum picture, with its delicate figures and pastel colors, also points to a date in the mid 1520s. J.C.

1. A. McComb, "Francesco Ubertini (Bacchiacca)," *Art Bulletin*, VIII, 1926, 167, n. 31; Hartford, 1934, 25; Lugt, 1944, 326, n. 8; *Wadsworth Atheneum Handbook*, 1958, 33; Nikolenko, 1966, 15, 46, fig. 33.
2. Achenbach, 1943–45, 71–86; E. H. Gombrich, "Tobias and the Angel," *Symbolic Images*, London, 1972, 26–30.
3. Achenbach, 1943–45, figs. 1–19; see also Lugt, 1944, 325–26.
4. *Gli Uffizi*, 1979, 39, no. P103.
5. Abbate, 1965, 34, dates it to about 1510–15.
6. On panel, 40 x 35.3 cm; sale Berlin, Cassirer and Helbing, 10–11 Oct. 1929, no. 9; W. Suida notes the Berlin variant in a letter to C. Cunningham, 21 Dec. 1946, excerpt in curatorial file; illustrated in Berenson, 1963, II, pl. 1246; see also M. Salmi, "Un codice e un dipinto," *Miscellanea di studi in memoria di Anna Saitta Revignas*, Florence, 1978, 330, n. 4.
7. Nikolenko, 1966, 17, fig. 28.
8. As noted by J. Byam Shaw, oral communication, 29 Apr. 1963; see Bartsch, 1866, VII, 383–84, no. 78; J. Marrow et al., eds., *The Illustrated Bartsch*, New York, 1981, XII, 211, no. 78.
9. Nikolenko, 1966, fig. 45; New York, Metropolitan Museum of Art, *The Jack and Belle Linsky Collection*, New York, 1984, 43–44, no. 11.
10. Nikolenko, 1966, fig. 69.
11. Zeri, 1971, 193.
12. A preparatory drawing by Bacchiacca for the Dresden painting suggests the primacy of the latter; see Turner, 1986, 100, no. 66. For a possible date of 1518 for the Dresden painting, see Chappell, 1986, 28.

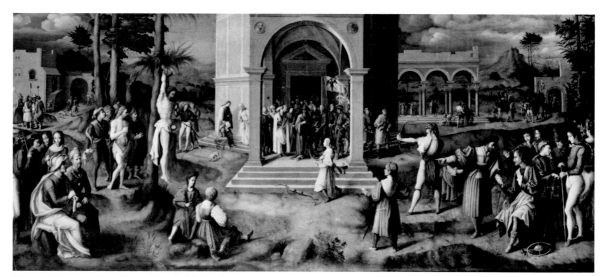

Figure 5. Francesco Bacchiacca, *Legend of the Dead King*, Dresden, Gemäldegalerie

Sisto Badalocchio
(1585–after 1620)

Sisto Badalocchio was born 28 June 1585 in Parma to Giovanni and Margarita Badalocchio.[1] His godfather was Andrea della Rosa, from whom he perhaps received the sobriquet Sisto Rosa, as he was occasionally called by contemporary and later sources.[2] The date of his death has not been established but is presumed to have occurred during the 1620s.

Agucchi's letter of 1609 furnishes the earliest evidence of Badalocchio's training. Agucchi says that Badalocchio lived in the house of Annibale Carracci in Rome, where he was noted for his facility, particularly in drawing.[3] Mancini, writing in about 1621,[4] gives further details: Badalocchio and Giovanni Lanfranco were sent by Ranuccio Farnese, duke of Parma, to Annibale's workshop in Rome.[5] Mahon supposes that the two artists had contact with Agostino Carracci, who visited Parma in 1600–1602 before his death in Bologna 23 February 1602, and that Lanfranco left for Rome immediately after Agostino's death. Badalocchio may have accompanied him or followed later.[6]

In Rome Badalocchio left few documented works. His print after the Laocoon is signed and dated 1606; in 1607 he and Lanfranco dedicated a series of etchings after the frescoes by Raphael in the Vatican Loggie to Annibale.[7] According to Bellori, Badalocchio was called in to help on the decoration of the Herrera Chapel in S. Giacomo degli Spagnoli, executed largely by Albani on Annibale's design between about 1605 and 1606.[8] Bellori also describes an *Ecce Homo*, frescoed by Badalocchio in the oratory of St. Andrew in S. Gregorio Magno at the time Domenichino and Guido Reni were working there (1609).[9] Passeri also attributes grisaille frescoes of the prophets David and Isaiah in the oratory of St. Silvia to Badalocchio, an attribution accepted by Pepper.[10] Scholars have also detected Badalocchio's participation in such Carracci school projects as the walls of the Farnese Gallery, the Aldobrandini lunettes in the Doria Gallery, and the Palazzo Mattei frescoes.[11]

Badalocchio's association with Annibale lasted until the latter's death in 1609.[12] At the master's death his workshop dispersed; Badalocchio and Antonio Carracci, Agostino's son, returned to Bologna, where, according to Bellori, the two artists planned to continue the Carracci school after Lodovico's death.[13] They soon returned to Rome, however, where Badalocchio participated in various fresco projects; Bellori cites a lost fresco of *Saints Peter and Paul* in S. Sebastiano fuori le Mura.[14] The frescoes in the Palazzo Verospi, cited by Bellori,[15] probably date from just after 1611, when the building was finished.[16]

By 1613 Badalocchio had returned to North Italy; a letter written 1 October by an agent of Marchese Enzo Bentivoglio suggests that Badalocchio had been painting frescoes in the Palazzo Bentivoglio in Gualtieri.[17] Badalocchio's frescoes in the dome and pendentives of the church of S. Giovanni Evangelista, Reggio Emilia, can also be dated to 1613 through documented payments between May and August.[18]

After another short journey to Rome, where he painted a ceiling fresco for the Marchese Mattei in early 1615[19] and a painting of *Alexander and Taxiles* for Cardinal Montalto, of which only a copy survives,[20] he evidently established himself in Parma, where he married in 1617;[21] but he probably traveled frequently, as mentioned in Mancini,[22] Scanelli,[23] and Bellori.[24]

Two paintings for the Oratorio della Morte in Reggio Emilia were commissioned in 1618.[25] One, an *Entombment of Christ*, survives only in three fragments in the Galleria Estense in Modena; the other, a *Capture of Christ*, can be traced only through copies or variants.[26] Badalocchio also worked at this time for the duke of Parma, Ranuccio Farnese, on the decoration of the Teatro Farnese, for which payment is recorded 13 September 1618.[27] He may have made a last journey to Rome in about 1620–21.[28]

Numerous other works have been attributed to Badalocchio on the basis of style alone, although his chronology is yet to be worked out in detail.[29] The *Tancred and Clorinda* in the Galleria Estense in Modena[30] is generally accepted as a work of his first Roman years;[31] the picture of the same subject at Alnwick Castle shows his later style, which moves away from the classicism of Annibale's early Roman style toward a more fluent, colorful idiom of his native Emilia.[32] Badalocchio's activity as a draughtsman has also begun to emerge through the researches of Schleier, van Tuyll, and others.[33]

1. Scarabelli-Zunti, "Documenti e memorie di belle arti parmigiane" (unpublished ms. in the Biblioteca Comunale di Parma), V, n.d., as cited in Salerno, 1958, 46, n. 8; confirmed by D. Mahon, "Afterthoughts on the Carracci Exhibition–II," *Gazette des Beaux-Arts*, 6th ser. XLIX, 1957, 284, n. 65; 1958, 2. Mahon found on fol. 155v of the *Liber baptizatorum* in the baptistery at Parma the entry, "Sixtus Filius d Joanis de badalochijs et d marg.te ux."
2. Letter dated 12 Sept. 1609, from G. B. Agucchi at Rome to the Canonico Bartolomeo Dulcini at Bologna, published by Malvasia, 1967, I, 369–70.
3. Agucchi in Malvasia, 1967, I, 369.
4. Mahon, 1947, app. 2, 292–95.
5. Mancini, 1956–57, I, 247; also cited in Mahon, 1951, 82–83.
6. Mahon, 1951, 83, n. 37.
7. Published by Giovanni Orlandi in Rome, reprinted in Amsterdam in 1614 and 1638. See V. Birke, ed., *The Illustrated Bartsch*, New York, 1982, XL, 337–59, 369. The dedication was reprinted by Malvasia, 1967, I, 370–71.
8. Bellori, 1672, 94; Posner, 1971, I, 142–45. Badalocchio worked on a lunette fresco of the *Preaching of St. Diego*; however, as Bellori relates, Badalocchio's inexperience with fresco caused Annibale to have it removed and to redo it himself with Albani's help. The fresco, in poor condition, has been detached and is in the Museo de Arte in Barcelona; see Posner, 1971, II, pl. 165.
9. Bellori, 1672, 124. Passeri, 1934, 148, attributes this fresco to Lanfranco. Although Hess in Passeri, 1934, 148, n. 4, considered the work lost, Pepper, 1971, 372, n. 7, reports its survival in situ. The condition of the fresco precludes definite attribution.
10. Passeri, 1934, 84–85; Pepper, 1971, 372.
11. Posner, 1971, I, 124; Spear, 1982, I, 135, nos. 12v, 12vi, attributes the execution of lunettes of *Fortitude* and *Temperance* to Badalocchio, as does van Tuyll, *Burlington*, 1983, 470, n. 13.
12. Mahon in Bologna, 1956, 167–68, no. 248; see also the documents published by F.-C. Uginet, *Le Palais Farnèse*, III, pt. 1: *Le Palais Farnèse à travers les documents financiers (1535–1612)*, Rome, 1980, 105–6, docs. 1003, 1005, that document Sisto's association with Annibale in 1608.
13. Bellori, 1672, 124; Agucchi in Malvasia, 1967, 369.
14. Bellori, 1672, 124–25.
15. Bellori, 1672, 125.
16. Gilbert, 1963, 65.
17. G. Campori, *Lettere artistiche inedite*, Modena, 1866, 83–84.
18. Artioli and Monducci, 1978, 86.
19. The contract between Badalocchio and the Marchese Asdrubale Mattei for the ceiling decoration in a room in the Palazzo Mattei di Giove is dated 30 Dec. 1614; payments were made until 30 May 1615; see G. Panofsky-Soergel, "Zur Geschichte des Palazzo Mattei di Giove," *Romisches Jahrbuch für Kunstgeschichte*, XI, 1967–68, 179–80, doc. XXX; Mancini, 1956–57, I, 279, II, 191, n. 1443, also states that Badalocchio worked in the Palazzo Mattei in 1615.
20. E. Schleier, "Ancora su Antonio Carracci e il ciclo di Alessandro Magno per il Cardinal Montalto," *Paragone*, no. 381, 1981, 10–25; van Tuyll, *Paragone*, 1983, 62–67.
21. Scarabelli-Zunti, as cited in Salerno, 1958, 47.
22. Mancini, 1956–57, I, 242.
23. Scanelli, 1657, 368.
24. Bellori, 1672, 125.
25. Van Tuyll, 1980, 181.
26. Van Tuyll, 1980, 180–81; see also C. Gilbert, "Italian Paintings at St. Meinrad Archabbey," *Gazette des Beaux-Arts*, LII, 1958, 359–61; and Artioli and Monducci, 1978, 58.

27. G. Lombardi, "Il Teatro farnesiano in Parma," *Archivio storico per le provincie parmensi*, n.s. IX, 1909, 33.

28. E. Schleier, "Due opere 'toscane' del Lanfranco," *Paragone*, no. 359, 1980, 26–27.

29. Mahon, 1951, 81–84; Salerno, 1958, 46–51; Schleier, 1962, 247–51.

30. Pallucchini, 1945, 112, no. 235.

31. It is mentioned as Sisto's in an inventory of 1624; see Campori, 1870, 67. Other attributions to Badalocchio's early career have recently been advanced by van Tuyll, *Burlington*, 1983, 469–76.

32. Mahon, 1951, 83–84. Mahon noted, letter in curatorial file, 18 May 1958, that the *Guardian Angel* in the Duomo in Parma, attributed to Badalocchio in an early eighteenth-century inventory and in subsequent guide books, is a useful benchmark of his late style, as it may have been painted about 1621, the date of the opening of the Oratorio di Sta. Maria delle Grazie in Parma. Van Tuyll in Washington, 1986–87, 373, mentions unpublished payments for the picture in September 1619, thus confirming Mahon's suggestion.

33. K. Oberhuber, review of A. E. Popham, *British Museum, Drawings by Artists Working in Parma in the Sixteenth Century*, in *Master Drawings*, VIII, 1970, 280; Schleier, 1962, 251; van Tuyll, *Paragone*, 1983, 62–65.

Sisto Badalocchio, *Holy Family*, detail of reverse

Holy Family

Oil on panel, 80.9 x 57 cm (31 7/8 x 22 1/2 in.)

Condition: excellent. There is some thinness in the sky and the Virgin's face. A pentimento in the profile of the wall is visible.

A wax stamp with a fleur-de-lis is on the upper center of the back of the painting. Incised in the wax is also the number *299*. Inscribed center verso, with a brush, in white: *454*. At the lower left verso is an illegible sticker with an embossed seal.

Provenance: Farnese Collection, Rome, by 1653 (see below); Farnese Collection, Parma, by about 1680; Carlos of Bourbon, Naples; John Udney, sale London, Christie's, 25 Apr. 1800, no. 52; Colonel Murray; earl of Ashburnham; by descent to Lady Catherine Ashburnham, sale London, Sotheby's, 24 June 1953, no. 39, pl. 9; D. Koetser; Sir John Heathcoat Amory. Purchased by the Wadsworth Atheneum in 1956 from Thos. Agnew & Sons, London, for $5,320 from the Sumner Fund.

Exhibitions: London, 1950–51, 2nd ed., 127, no. 313; Hartford, 1982; Washington, 1986–87, no. 120.

The Ella Gallup Sumner and Mary Catlin Sumner Collection, 1956.160

As Mahon has shown, the *Holy Family* once formed part of the Farnese Collection in the Palazzo del Giardino in Parma.[1] An entry in an inventory of the pictures in the palace, made about 1680, lists "un quadro alto braccio uno, oncie cinque e meza, largo braccio uno, oncie una in tavola. Una Madonna a sedere col Bambino in grembo sopra panno bianco, con il braccio destro sopra un sasso, e sopra di quello un canestro di fiori, anzi frutti, S. Giuseppe a sedere nella destra con le mani al bastone, di Sisto Badalochio n. 299."[2] An earlier inventory, to be published by Bertini, is dated to 1653 and reveals that the painting was originally in the Palazzo Farnese in Rome, where it was attributed to Giovanni Lanfranco.[3] The picture was transferred to Parma and remained in the Farnese collections until the end of the eighteenth century.[4] Upon the death of the last

Farnese duke, Antonio, in 1731, the collections passed to Carlos of Bourbon, son of Philip V of Spain and Elisabetta Farnese, who became king of Naples in 1734. The collection was installed in the royal palace at Capodimonte and was looted by the French in 1798. The *Holy Family* was later part of the collection of John Udney (1727–1800), British consul at Livorno and was acquired by him in Italy. His collection was sold by his brother Robert Udney in London in 1800.[5] It was bought for 1,100 guineas by Colonel Murray, from whose collection it eventually entered the collection of the earl of Ashburnham at an unknown date.[6]

Its attribution to Badalocchio, as cited in the 1680 inventory, was lost sight of while the picture was still in the Farnese collections; the inventories of 1653 and 1708 list it as by Lanfranco and the Udney sale catalogue as by Lodovico Carracci. It was still attributed to Lodovico in the Ashburnham catalogue,[7] and then to Annibale in the 1850 Ashburnham sale; but at the Royal Academy exhibition of 1950–51[8] and later at the Ashburnham sale in 1953, the attribution was changed back to Lodovico.[9]

Mahon was the first in modern times to propose the attribution of the Atheneum picture to Badalocchio.[10] Mahon's discovery of the 1680 inventory corroborated the attribution, which has been accepted by all subsequent scholars.[11]

In the Atheneum picture Badalocchio closely approximates his master Annibale's style, and for this reason it has often been dated to Badalocchio's first Roman stay, between 1602 and 1609–10,[12] a dating further supported by the Roman provenance of the picture. The striking solidity of the figures and the balanced compositional design point to an at least superficial approximation of Annibale's late works, for example, Annibale's *Pietà* in Vienna of about 1603–4, as suggested by Mahon,[13] while the lighting, drapery design, and landscape background recall Sisto's Emilian heritage, as van Tuyll has remarked.[14] A similar blend of Roman and Emilian influences is found in the *Susanna and the Elders* in the Ringling Museum, Sarasota, attributed by van Tuyll to Badalocchio and dated to about 1609–10.[15] A date just before Sisto's trip to Bologna in about 1609–10 seems reasonable for the *Holy Family;* but, as van Tuyll has most recently remarked, it may also have been painted just after his return to Emilia.[16] J.C.

Sisto Badalocchio, *Holy Family*

1. Mahon, 1958, 1.

2. "A painting one braccio five and one half oncie high, one braccio one oncia wide, on panel. A Madonna with the Child on her lap seated on a white cloth, with her right arm on a stone, and on top of this a basket of flowers, or rather fruits, St. Joseph seated on the right holding a staff, by Sisto Badalocchio." The inventory is entitled "Inventario dei quadri di Palazzo del Giardino," Archivio di Stato di Parma, Casa e corte farnesiane, s.vii, busta 54, fasc. 4, and is dated to about 1680 by Campori, 1870, 205. The entry for the Atheneum picture is found in Campori, 226, and Bertini, 1987, 245, among the paintings in the "Quinta camera, detta di Santa Clara." The dimensions cited in the inventory, approximately 79 x 58.7 cm, roughly correspond with those of the painting, if one figures a Parmesan braccio as 542.15 mm, an oncia as 45.175 mm; see Doursther, 1840, 72, 369. Recognition is due to Diane DeGrazia, who checked the inventories in Parma, and to Giuseppe Bertini, who generously lent his transcriptions of the relevant entries before publication.

3. Archivio di Stato di Parma, Raccolta manoscritti, no. 86, "Quadri di Palazzo Farnese di Roma nel 1653": "332. Un quadro in tavola, con la Madonna Bambino in grembo, e S. Gioseppe sedente con un cestino de frutti e prospettiva di boscaglia cornice nera profilata d'oro verso la pittura mano di Gio. Lanfranchi" (Bertini, 1987, 215). In a letter to C. Cunningham, 6 Apr. 1957, curatorial file, Mahon had suspected that the inventory of 1653 would list the Atheneum picture as well. The inventory is also mentioned by van Tuyll in Washington, 1986–87, 377, no. 120.

4. An inventory in the Archivio di Stato in Parma entitled "Quadri di antica ragione della Casa Farnese alias esistenti nel Palazzo del Giardino," Archivio di Stato di Parma, Archivio segreto, Farnese, Galleria dei quadri e i medagliere, is dated to the beginning of the eighteenth century by Filangieri di Candida, 1902, 220. Filangieri di Candida publishes the entry on page 283: "299. Sisto Badalocchio. Sacra Famiglia 1,5 ½ x 1,1 in tavola." As Mahon, 1958, 2, has pointed out, the number 299 appears also on the back of the Atheneum painting. A further inventory of 1708, also in the Archivio di Stato in Parma, entitled "Inventario di quanto si trova nella galeria di S.A.S.ma si de quadri, come delle medaglie, & altro," Archivio di Stato di Parma, Casa e corte farnesiane, s.viii, busta 53, fasc. 5, lists a picture that has also been identified as the Atheneum picture: "320. Quadro in tavola con cornice dorata, alto br.a uno, onc.e cinque e mezzo, largo br.a uno onc.e una. La Madonna a sedere col Bambino s.a ginocchia in lino bianco, appoggia il braccio destro ad un sasso su del quale un canestro di fiori, S. Giuseppe a sedere alla destra con le mani al bastone. Del Lanfranchi n. 299" ("Painting on panel with a gilded frame, one braccio five and one half oncie high, one braccio one oncia wide, the Madonna seated with the Child on her knee on a white cloth, resting her right arm on a stone on which rests a basket of flowers, St. Joseph seated at the right with his hands on a staff, by Lanfranco"); published by Campori, 1870, 473, and Bertini, 1987, 196, and kindly checked by Diane DeGrazia. Filangieri di Candida, 1902, 219–20, 276, n. 11, no. 15; and Mahon, 1958, 2, n. 8, have noted the identity of the pictures described in these two entries.

5. The catalogue of the sale reads: "Ludovico Caracci.— Repose.—This most elegant and graceful composition is carried to the greatest degree of perfection the art of painting is capable of, and is the most exquisite specimen of the genius and sublime expression of this master. On a thick pannel [sic]; was painted for the Parma family, and has their seal on it." The sale catalogue was reprinted by Buchanan, 1824, II, 18–19.

6. A manuscript catalogue of the Ashburnham Collection, dated 1793, lists the picture on page 9, no. 101, as from the Parma Collection, purchased for 840 pounds; a typescript is in the Provenance Index, Getty Center for the History of Art and the Humanities. The entry is possibly a later addition to the inventory. The picture was also included in the sale in London, Christie's, 20 July 1850, no. 70, as Annibale Carracci, bought in. It remained in the Ashburnham Collection until it was sold after the death of Lady Ashburnham in 1953, when it was bought by D. Koetser for 1,300 pounds.

7. Manuscript catalogue, 1793, 9, no. 101.

8. London, 1950–51, 127, no. 313.

9. London, Sotheby's, 24 June 1953, no. 39.

10. He had mentioned the picture as by Ludovico in his review of the exhibition at Burlington House, 1951, 81; but in a letter to C. Cunningham, 6 Apr. 1957, curatorial file, he relates how he had changed his mind in favor of Badalocchio soon after. R. Longhi, in a letter to F. Gregory, 30 Oct. 1956, curatorial file, also affirmed the attribution to Badalocchio.

11. Mahon, 1958, 1–4; Bologna, 1959, 234–35, no. 120; Gilbert, 1963, 65; J. Spike in Princeton, 1980, 18; van Tuyll, Burlington, 1983, 469; van Tuyll in Washington, 1986–87, 377, no. 120.

12. Mahon, 1958, 4; Bologna, 1959, 235; Princeton, 1980, 18; van Tuyll, Burlington, 1983, 472; Bertini, 1987, 196, no. 320.

13. Mahon, 1958, 4; Posner, Carracci, 1971, II, 62, no. 139.

14. Van Tuyll, Burlington, 1983, 472.

15. Van Tuyll, Burlington, 1983, 472, dated the Ringling picture to about 1610, but in Washington, 1986–87, 374, no. 119, dated it slightly earlier, to about 1609.

16. Van Tuyll in Washington, 1986–87, 377, no. 120.

Didier Barra
(active c. 1608–after 1652)

Until recently, two northern artists, both active in Naples in the first half of the seventeenth century and both from Metz in Lorraine, were conflated under the name Monsù Desiderio; "Monsù," a corruption of *Monsieur*, being a contemporary usage in Italy to indicate a foreigner. De Dominici attributed to this notional figure, supposedly a much praised painter of panoramas, the view of Naples at the bottom of an altarpiece by Onofrio Palumbo in Santissima Trinità dei Pellegrini, Naples, the *S. Gennaro Interceding for Naples*, circa 1652. The artist was actually Didier Barra, a topographical painter with a careful, finicky touch who specialized in panoramic bird's-eye views, as in Palumbo's painting and as seen in the Atheneum's picture. The other artist lumped together with Barra is François de Nomé, who painted richly impastoed and frenetically imaginative architectural fantasies, an example of which is also owned by the Atheneum.[1] The key picture in identifying Barra's style and thus assigning to him the panorama in Palumbo's altarpiece is a *View of Naples* in the Museo Nazionale di S. Martino, Naples, signed and dated on the reverse: Desiderius Barra/ EX Civitate Metensi/ in Lotharingia F. 1647.[2]

1. For a summary of how Sluys, Causa, and Tribout de Morembert disentangled these artists, see F. Petrelli in London, *Painting in Naples*, 1982, 108. The same author discusses Palumbo's painting in the same catalogue, 203–4, no. 93, repr.

2. Inv. no. 3566, 69 x 129 cm. Exhibited in London, *Painting in Naples*, 1982, 109, no. 3, repr. The original signature came to light during recent conservation; previously, the text was known only from a transcription on a relining. Great confusion has been caused by that transcription's having been said erroneously to be on the back of a completely different Neapolitan view also in S. Martino, and also attributed to Barra, a view of Castel dell'Ovo and Posillipo (inv. no. 12041, 76 x 152.5 cm, A.F.S.G. 40884). For example, see Sluys, 1961, 14–15, 58, no. 1. Petrelli questions if the latter, no. 12041, is in fact an autograph work by Barra (F. Petrelli to M. Mahoney, 7 Apr. and 3 June 1983, curatorial file).

Didier Barra, *View of Naples*

View of Naples

Oil on canvas, 116.8 x 177.2 cm (46 x 69¾ in.)

Condition: good, although heavily damaged in the sky. There is a 20-centimeter cut with minor losses rising diagonally from above the three ships at anchor (in a line to the left of the lighthouse) to the horizon line.

Provenance: purchased in London by Screpel in the late 1950s;[1] J. O. Leegenhoek, Paris, sale Vienna, Dorotheum, 19 Mar. 1963, no. 12, repr. figs. 6 and 7, pls. II and III, bought by J. Weitzner, London, for the Wadsworth Atheneum for 250,000 schillings ($11,700) from the Sumner Fund.

Exhibitions: Paris, Hôtel de Croy, *Le Cabinet de l'amateur*, no cat., n.d.;[2] Newport, 1964, no. 3; Hartford, 1979, 3, no. 8.

The Ella Gallup Sumner and Mary Catlin Sumner Collection, 1963.39

The Atheneum picture,[3] which Longhi is said to have regretted was not bought for Capodimonte,[4] is congruent in every way with the signed S. Martino painting and Barra's share in Palumbo's altarpiece. Further like pictures, also with prominent maritime activity in the foreground, are a painting formerly belonging to A. Everett Austin[5] and a painting sold from the Mondolfo Collection in 1978.[6]

As Petrelli points out,[7] Barra has adapted to his own needs two topographical prints of Naples by Alessandro Baratta, his *Fidelissimae urbis neapolitanae* and his *Cavalcade for the Entry of Marie of Austria, Queen of Hungary*, first published in 1629 and 1630 respectively.[8]

In the Atheneum picture the artist's view is taken from approximately atop the Castel dell'Ovo. In the lower left are portions of the sheds of the Arsenal and the Castel Nuovo. The Torre di S. Vincenzo in the foreground and the lighthouse farther back enclose the military harbor, beyond which lies the commercial port. The overall ensemble has not only greatly changed since the mid seventeenth century, but the artist distorts the prominence of the foreground, surely because the event depicted in the harbor is a specific and important one.

In the center of the foreground a papal galley, seen from astern, bears what first appears to be the papal arms, but is actually a large cagelike object, presumably a metal lantern, through which pass the papal keys surmounted by the tiara. Next to it floats a red banner on which, beneath the tiara and keys, are fragmentary arms, apparently those of Innocent X Pamphili (pope 1644–55).[9] In the right foreground, surrounded by small craft, a similar vessel flying a large red banner with the Medici grand ducal arms is being boarded by a party from a large galley seen sideways, which flies three red pennants with Medici arms. Behind the two ships another ship under sail flies a white banner with a red oval device with traces of yellow from its stern. It also flies three white banners with a red cross plus a banner with horizontal red, white, and blue stripes. A galley to the left of this ship flies a white banner with a red cross. Within the military harbor, above and to the left of the papal ship, two vessels fly red banners with white crosses. On the stern of the nearer, a galley, is affixed a white Maltese-type cross. Thus the scene would seem to commemorate the meeting between 1644 and 1655 of a papal and a Medici ship in the presence not of vessels of the Order of Malta but perhaps of the analogous Order of St. Stephen, founded in Pisa by the Medici to combat Barbary pirates and so closely modeled on the Order of Malta as to imitate its arms.[10]

M.M.

1. J. Leegenhoek to C. Cunningham, 4 and 14 Mar. 1964, curatorial file.
2. J. Leegenhoek to C. Cunningham, 4 and 14 Mar. 1964, curatorial file.
3. Reproduced by Herbst, 1963, detail on cover and 9 in anticipation of the picture's sale in Vienna at the Dorotheum. *Apollo*, LXXVII, June 1963, 531, repr. 531. Constable, 1963, 2–4. *Wadsworth Atheneum Bulletin*, Spring 1964, 23. Fredericksen and Zeri, 1972, 16, 585.
4. H. Herbst to C. Cunningham, 6 May 1963, curatorial file. A. Brejon de Lavergnée thought it a good example of this rare artist (P. Marlow, 16 Mar. 1977, memorandum in curatorial file).
5. Sarasota, 1950, 26, no. 57, pls. 33–33b. Scharf, 1950, 22, fig. 20, presently in the collection of David Austin.
6. Rome, Christie's, 26 Jan. 1978, "La Collezione dei dipinti di Monsù Desiderio di proprietà del Dott. Mondolfo," no. 4, repr., 49.5 x 91.5 cm, formerly in the Allomello Collection. Causa, 1956, 35, fig. 28, associates the scene with the 1631 eruption of Vesuvius.
7. London, *Painting in Naples*, 1982, 109, no. 3.
8. De Seta, 1981, 149ff., figs. 100 and 112; 1980, 48–49, figs. 2a and 2b also reproduce the *Urbis*.
9. What can be seen is a triply serrated band at the top and a portion of a dove's head beneath.
10. See the Atheneum's possibly Tuscan school, circa 1770, *View of Pisa*, for references to the order.

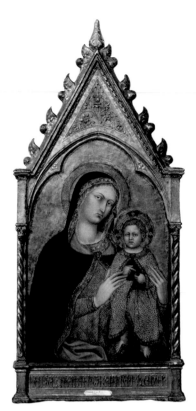

Taddeo di Bartolo, *Madonna and Child*, with frame

Taddeo di Bartolo (1362/3–1422)

Taddeo di Bartolo was born in 1362 or 1363, the son of Bartolo di Maestro Mino, not the painter Bartolo di Fredi as claimed by Vasari.[1] In 1393 he had begun his extensive travels, having executed two paintings, now lost, for the church of S. Luca in Genoa. In the years following he worked in S. Gimignano (1393?), Pisa (1395), Perugia (between 1400 and 1404 and in 1413), and Volterra (1411). Taddeo was resident in Siena from 1412 onward, when he became a member of the Consiglio, the first of several civic posts he held. In 1421 he formed a partnership with his student Gregorio di Cecco, whom he adopted shortly thereafter and made his heir.[2] He died in August 1422.

There exist many signed, dated, and documented works by Taddeo in panel and fresco. The earliest, a polyptych executed for the chapel of St. Paul in the church of SS. Vito e Modesto, Collegalli, is dated 1389 and shows Taddeo's training in the late fourteenth-century Sienese tradition of Bartolo di Fredi.[3] His other works show the influence of Sienese artists of the early fourteenth century, most notably of Simone Martini and the Lorenzetti, as well as of practitioners of the international style that he would have seen in his travels. His latest dated work, the signed panel of the *Madonna and Child* in the Fogg Art Museum, Cambridge, Mass., of 1418, reveals, in the context of contemporary Florentine developments, a retardataire style that is unmistakably Sienese.

Taddeo's assimilation of stylistic currents from outside Siena, as well as his adherence to the traditions of the earlier fourteenth century, were particularly important for the fluorescence of Sienese painting in the early fifteenth century.[4]

1. Vasari, 1906, II, 33; a chronology of Taddeo's life with references to published documents is given in Symeonides, 1965, 17–21, 27–29.
2. G. Corti, "La Compagnia di Taddeo di Bartolo e Gregorio di Cecco, con altri documenti inediti," *Mitteilungen des kunsthistorischen Instituts in Florenz*, XXV, 1981, 273–77.
3. Berenson, 1968, II, pl. 469.
4. M. Mallory, *The Sienese Painter Paolo di Giovanni Fei*, New York, 1976, 201–3; van Os, 1990, 65–73.

Madonna and Child

Tempera and oil on panel, 72.4 x 46.8 cm (28 1/2 x 18 7/16 in.)
The painting has been transferred and cradled.
Condition: fair. There are pockets of separation between the transfer panel and the paint layer. The gold background and the Virgin's robe appear to be new; the blue robe may be over regessoed ground. The halo of the Virgin is made of modern punchwork; there are other small areas of modern punchwork in the panel. The frame appears to be a composite of modern and antique elements.[1]
Inscribed on base of frame: AVE MARIA GRATIA PLENA
Provenance: Wallraf-Richartz Museum, Cologne, by 1869;[2] private collection, Munich, 1924; P. Bottenwieser, Berlin, 1928; Arthur Bliss Collection, sale London, Sotheby's, 8 Mar. 1944, no. 88, as Taddeo di Bartolo; Robert Lehman Collection, New York. Given to the Wadsworth Atheneum in 1962 by the Robert Lehman Art Foundation.
Exhibitions: Cincinnati, 1959, 15, no. 23.
Gift of the Robert Lehman Art Foundation, 1962.444

The Virgin holds the standing Christ Child, who is dressed in a robe identifying Him as a priest. He holds a goldfinch, symbol of the soul and Christ's Resurrection, and inserts His finger into the bird's mouth.[3] The Virgin originally sat on a throne which was lost when the picture was transferred.[4]

There are many versions of this composition from Taddeo's hand. The signed polyptych at Grenoble, dated 1395, shows the Child standing and the same motif of the Child inserting His finger in the finch's mouth,[5] as do the polyptych of 1403 from Perugia and the fragment in the museum at Nancy.[6] The Atheneum panel was probably part of a larger altar-

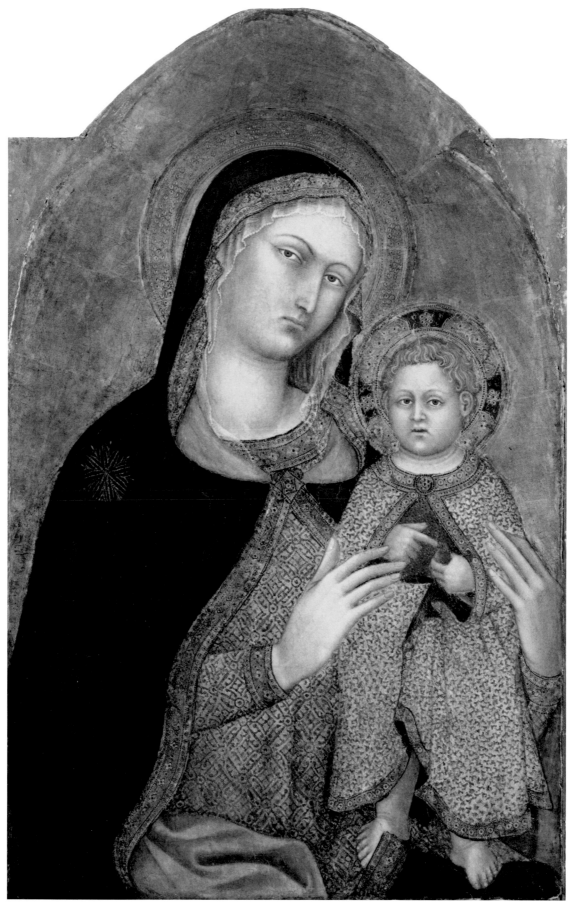

Taddeo di Bartolo, *Madonna and Child*

piece, with accompanying, bust-length saints, similar to the polyptych in the Museo Civico in S. Gimignano with the Virgin and Child and Saints Nicholas, Christopher, John the Evangelist, and a bishop saint.[7]

The Atheneum painting was attributed to school of Simone Martini while in the museum at Cologne,[8] and to an anonymous follower of Simone by Thode.[9] Van Marle attributed it to Pietro Lorenzetti but noted its poor quality,[10] while Perkins[11] and Gronau[12] cited it as a characteristic work by Taddeo di Bartolo, an attribution that has been retained.[13]

The date of the Atheneum painting has been placed around 1400, based on similarities with the altarpiece of the Compagnia di Sta. Caterina della Notte, Siena, of 1400, and the Perugia polyptych of 1403.[14] J.C.

1. The present frame was put on between 1924, when the picture in a modern frame was illustrated by Perkins, 1924, illus. facing page 8, and 1928, when it is seen with its present frame in a photograph in the Kunsthistorisches Institut, as with the dealer P. Bottenwieser, Berlin.
2. Cologne, 1869, 136, no. 740.
3. Friedmann, 1946, 7–9.
4. The entry in the Cologne catalogue, 1869, 136, no. 740, describes the Virgin seated on a Gothic throne. The dimensions cited in the catalogue, 30 x 23 in., are slightly larger than the present dimensions.
5. Symeonides, 1965, pl. XA.
6. Symeonides, 1965, pls. XXXVIII, L.
7. Berenson, 1968, I, 421; van Os, 1990, 217 n. 75.
8. Cologne, 1869, 136, no. 740; see also Cologne, *Verzeichnis der Gemälde des Wallraf-Richartz Museums der Stadt Köln*, 1910, 162, no. 510.
9. H. Thode, "Pitture di maestri italiani nelle gallerie minori di Germania," *Archivio storico dell'arte*, II, 1889, 50.
10. Van Marle, 1924, II, 370, n. 2.
11. Perkins, 1924, 9.
12. In a letter of 1921; transcription on verso of a photograph in the Kunsthistorisches Institut, Florence.
13. Cincinnati, 1959, 15, no. 23; Fredericksen and Zeri, 1972, 585.
14. Symeonides, 1965, 210, dates it between 1400 and 1403.

Evaristo Baschenis (1617–1677)

Francesco Maria Tassi, Baschenis's principal biographer, tells us that the artist was born in 1617 and died in 1677 at the age of seventy;[1] the ambiguity of Tassi's statement has been clarified by recent archival discoveries of Baschenis's baptismal record in the church of S. Alessandro in Colonna in Bergamo of 7 December 1617,[2] and his death notice in the records of the same church of 16 March 1677.[3]

Baschenis seems to have passed his entire career in Bergamo. A possible trip to Venice is suggested by a painting formerly in the Albanese Collection and now in a private collection in Milan that is signed *Evaristo Baschenis Venezia 1647*.[4] Also, until their removal after 1805, there were eight paintings of musical instruments by Baschenis in the library of S. Giorgio Maggiore in Venice, given to the monastery by Abbot Francesco Soperchi (abbot 1667–71).[5]

Baschenis is generally credited with the invention of a genre of still-life painting composed primarily of musical instruments.[6] That he also did more traditional still lifes of fruit and fowl is

attested to by surviving pictures; several autograph portraits are also known.[7] His oeuvre, painted mainly for patrician families in Bergamo, is still largely in local private collections.[8]

In spite of the existence of thirteen signed paintings by Baschenis, the problem of assembling a corpus of autograph works is complicated by a large number of variants, primarily of musical-instrument still lifes, produced by his workshop.[9] Rosci has divided this production into five series of related works produced in the shop after prototypes by the master and single or independent works by the master himself.[10] While Rosci has advanced a plausible hypothesis of how the workshop functioned, the identity of Baschenis's collaborators and followers is less firmly established. The existence of a still life of musical instruments in the Collegio Vescovile di S. Alessandro in Bergamo inscribed *BB.P* and a date that can be read as either 1640 or 1650 suggests that already by the 1640s Baschenis's workshop had begun the mass production of such works. Moreover, the identity of the painter "B.B.," whose initials appear on no fewer than ten works[11] and who is frequently thought to be the painter Bartolomeo Bettera, is likely to be an independent personality, as Bettera, born in 1639, would at the age of eleven be an unlikely candidate for a collaborator of such magnitude in the workshop.[12] The production of musical-instrument still lifes was carried on after Baschenis's death by Bettera and his son Bonaventura Bettera and countless imitators until well into the eighteenth century.

A chronology of Baschenis's works can be no more than hypothetical, given the paucity of dated pictures and the subtle differences among individual works.[13]

1. Tassi, 1793, I, 233–37.
2. P. Capuani, "Dipinti di artisti famosi abbellivano molte locande della Bergamo antica," *Lunedì dell'Eco di Bergamo*, 15 July 1968, 3; as cited in Rosci, 1971, 28, n. 20.
3. Rosci, 1971, 28, n. 19.
4. Rosci, 1971, 20, considers this a workshop version of a lost prototype by Baschenis.
5. E. A. Cigogna, *Delle iscrizioni veneziani raccolte et illustrate*, Venice, 1834, IV, 273, 376, n. 298, 389, n. 340, 598; for further discussion, see also Angelini, 1946, 61–76; L. Angelini, "Evaristo Baschenis," *Dizionario biografico degli Italiani*, Rome, 1965, VII, 61–62.
6. Tassi, 1793, I, 234, says, "Quello in che veramente riuscì fu una bizzarrissima maniera, ch'egli s'inventò; e questa sua propria, nè più usata da altri, nè più veduta; e fu il dipingere ogni sorta di strumenti da suono con incredibile naturalezza e verità; e n'è riuscito con tanta perfeizone, che io non so ch'altri l'abbia uguagliato giammai." (He invented a most bizarre style, that was all his own, nor is it used by others or seen anymore; and that was to paint every sort of musical instrument with amazing naturalness and precision; and I do not know that others were ever able to equal it.)
7. Rosci, 1971, figs. 86, 111, 112.
8. Tassi, 1793, I, 235; Rosci, 1971, 42–43.
9. De Logu, 1962, 164, lists the paintings signed by Baschenis.
10. Rosci, 1971, 36, 39–44.
11. See Angelini's list, 1946, 89–91; De Logu, 1962, 169; and Rosci, 1971, 56, n. 28.
12. Rosci, 1971, 20; for the history of the attributions to B.B., see 55–56, n. 27.
13. Rosci, 1971, 45–49, attempts a general chronology based on style; see also Mueller, 1977, 17–18, for another view.

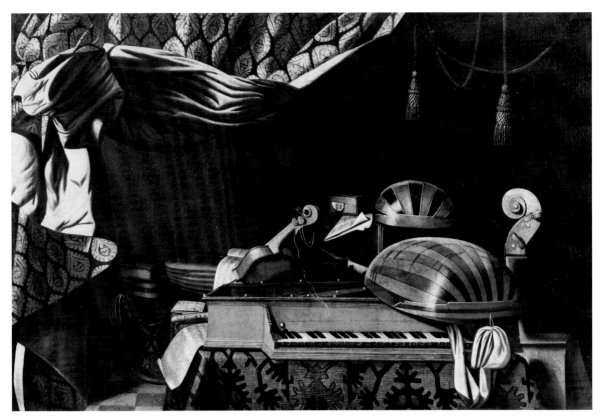

Workshop of Evaristo Baschenis,
Still Life with Musical Instruments

Workshop of Evaristo Baschenis
Still Life with Musical Instruments

Oil on canvas, 97.5 x 149.5 cm (38³/₈ x 58⁷/₈ in.)

Condition: fair. The painting is very abraded overall, with large losses in the top right corner.

Inscribed on a piece of paper placed in the book: B.+B.

Provenance: Gans Collection, Paris; Julien Levy Gallery, New York. Purchased by the Wadsworth Atheneum in 1937 from Julien Levy Gallery for $700 from the Sumner Fund and by exchange.

Exhibitions: Hartford, 1938, no. 2, repr., as Battista Battera [sic]; Boston, Institute of Modern Art (also New York, Wildenstein & Co.), *The Sources of Modern Painting*, 2 Mar.–9 Apr. 1939, 31, no. 18, repr., as Battista Bettera; Chicago, Arts Club of Chicago, *Origins of Modern Art*, 2–30 Apr. 1940, no. 19, as Bettera; Providence, R.I., Rhode Island School of Design, *Keyboard and Strings: Early Instruments and Performers*, 7 Mar.–29 Apr. 1951, no cat.

The Ella Gallup Sumner and Mary Catlin Sumner Collection, 1937.248

A heavy curtain is pulled back to reveal a table covered with musical instruments: a clavichord, two lutes, a violin, a guitar, a mandolincello, a double bass, and a flute.[1] Several sheets of music are scattered about; a folded letter awaits. The theme of the passage of time and the transience of earthly cares is suggested by the finger marks in the dust on the lutes, the broken strings of violin and cello, and the curling pages of music. The dust is itself a symbol of the fleetingness of life, evoking the passage from Ecclesiastes (3:19–20): "Men have no advantage over beasts; for everything is emptiness. All go to the same place: all came from the dust, and to the dust all return."[2]

The Atheneum picture belongs to a large group of musical-instrument still lifes inscribed with the monogram *B.B.* or *B + B*. Rosci has demonstrated that the ten works inscribed *B.B.* comprise an independent series produced in Baschenis's workshop, the prototype of which is a variant of a composition by the master.[3] Pendants to seven of the works are related to groups of works dependent on prototypes by Baschenis, further confirming the relation of the *B.B.* group to works produced in the Baschenis workshop.[4]

In addition to the works inscribed *B.B.*, the Atheneum painting is also related to unsigned works. The same arrangement of instruments occurs in a painting in Kassel, Staatliche Kunstsammlung.[5] The pulled-back curtain, with its distinctive brocade leaf design, occurs in many pictures by Baschenis and studio,[6] as does the carpet covering the table.[7]

Although formerly attributed to both Baschenis and Bettera,[8] the Atheneum painting is most likely by an anonymous assistant of Baschenis.

The existence of a single work by the painter *B.B.* with a date that can be read as 1640 or 1650 suggests an approximate date for the Atheneum picture of the mid seventeenth century. J.C.

1. See Diagram Group, 1976, for illustrations of seventeenth-century instruments.
2. See also Bergström, 1975, 288.
3. Rosci, 1971, 42–44.
4. Rosci, 1971, 42.
5. Mueller, 1977, fig. 1.
6. See the illustrations in Rosci, 1971, figs. 35, 36, 39, 40, 48, 49, 51, 53, 55, 56, 57, 101.
7. Rosci, 1971, figs. 21, 24, 35–41, 45–49, 51, 53, 56, 59, 63, 66–74, 95, 97, 101.
8. "Four Recently Acquired Paintings," *Art News*, XXXV, 30 Jan. 1937, 18, as Baschenis; A. M. Frankfurter, "The Sources of Modern Painting," *Art News*, XXXVII, no. 24, 11 Mar. 1939, 13, as Bettera; Fredericksen and Zeri, 1972, 585, as Bettera; Mueller, 1977, fig. 15, as Bettera.

Imitator of Evaristo Baschenis
Still Life with Musical Instruments

Oil on canvas, 86.6 x 136 cm (38⁷/₈ x 53¹/₂ in.)

Condition: fair. There is much inpainting which has discolored, and the varnish layer is uneven.

Provenance: The previous history of the painting is unknown. Purchased by the Wadsworth Atheneum in 1937 from N. V. Kunsthandel Pieter de Boer, Amsterdam, for $400 from the Sumner Fund.

Exhibitions: Hartford, 1938, no. 1, repr.; New London, 1954; Milwaukee, Milwaukee Art Institute, and Cincinnati, Cincinnati Art Museum, *Still-Life Painting since 1470*, Sept.–Nov. 1956, no. 1; Kent, 1966.

The Ella Gallup Sumner and Mary Catlin Sumner Collection, 1937.490

On a table draped with heavy damask lie a clavichord, three lutes, a violin, and a guitar, as well as a wooden box, a small coffer, several books of music, and an apple. The studied confusion of the arrangement suggests haste or neglect by the instrument players. The passage of time is also implied by the apple, which shows blemishes indicating overripeness or decay. The vanitas theme of the picture is underscored by the instruments themselves; in the seventeenth century the lute in particular evoked the futility of earthly cares.[1]

The Atheneum painting belongs to the large group of pictures by anonymous followers of Evaristo Baschenis.[2] Although no surviving autograph paint-

Imitator of Evaristo Baschenis, *Still Life with Musical Instruments*

ing by the master served as the prototype, the arrangement of instruments in the Atheneum painting is close to that in the paintings of Rosci's second group.[3] Distinguishing the Atheneum picture from those of the master or his close followers are the confused spatial composition, the poorly executed foreshortening, and the weak handling. The picture was perhaps painted by an imitator of Baschenis late in the seventeenth century. J.C.

1. Bergstrom, 1975, 288.
2. It was acquired as by Baschenis; Fredericksen and Zeri, 1972, 585, also list it as by Baschenis. F. Heinemann, oral communication, 17 Sept. 1974, thought it was a copy after Baschenis.
3. Rosci, 1971, 48.

Jacopo Bassano
(c. 1510/15–1592)

The birth date of Jacopo da Ponte (or dal Ponte),[1] called Jacopo Bassano, has not been determined precisely. A census of 1561 declares his age as forty-five; another of 1589 says he was seventy.[2] Ridolfi says he was born in 1510,[3] while Borghini, writing in 1584, reports his age as sixty-six.[4] His earliest works date to the early 1530s; Verci records a painting in Bassano of the *Madonna and Child with St. Joseph and Mary Magdalene*, no longer identifiable, signed and dated 1531; he also reports a date of 1534 for the *Flight into Egypt*, now in the Museo Civico in Bassano, a date no longer evident today.[5] A date between 1510 and 1515 is generally accepted.[6]

Jacopo presumably had his first training in Bassano from his father Francesco,[7] but by 1535 he is noted in Venice, where he received a patent for some kind of water invention.[8] Ridolfi says that in Venice Jacopo was trained by Bonifacio de' Pitati (1487–1553),[9] and indeed Bonifacio's influence is visible in his early pictures, including the *Podestà Matteo Soranzo Presented to the Virgin and Child*, signed and once dated 1536,[10] and the three pictures for the Sala dell'Udienza in the Palazzo Pretorio in Bassano, executed sometime between late 1534 and early 1536.[11] Other pictures from the 1530s indicate that Jacopo worked in various places in the Veneto[12] before settling down in Bassano after the death of his father in about 1539.[13]

In Bassano, Ridolfi tells us, Jacopo carried on the family workshop.[14] Dated and documented works from this period include the *Madonna and Child with Saints Zeno and John the Baptist* in Borso del Grappa, dated 1538,[15] and the *St. Anne and the Virgin with Saints Jerome and Francis* in Bassano, signed and dated 1541,[16] and show Jacopo's style moving from a provincial Venetian idiom toward a style influenced by the art of Pordenone and Parmigianino, as well as that of Central Italian artists, possibly transmitted through prints.[17] For the next two decades few reference points for Jacopo's development exist; the *St. John the Baptist* in Bassano, documented to 1558, and the *Crucifixion* from the Convento di S. Paolo in Treviso, documented to 1561–63, show his highly personal mannerist idiom fully matured.[18]

The *Adoration of the Shepherds* in Bassano, documented to 1568, reveals Jacopo's return in the 1560s and 1570s to a colorful, naturalistic style in which religious subjects are frequently given pastoral settings.[19] At the same time, the production of genre subjects, amplified by the participation of his sons Francesco and Leandro, increased to fill a seemingly inexhaustible demand.[20] Pictures from the 1570s, such as the *Martyrdom of St. Lawrence* in Belluno, signed and dated 1571, the *Rectors of Vicenza Adoring the Virgin* in Vicenza of 1573, the *Entombment of Christ* of 1574, and the *Preaching of St. Paul*, dated 1574 and signed by Jacopo and Francesco, show renewed interest in sweeping space and brilliant colors heightened by nocturnal settings, as well as Francesco's regular intervention.

Although it had been thought for many years that Jacopo

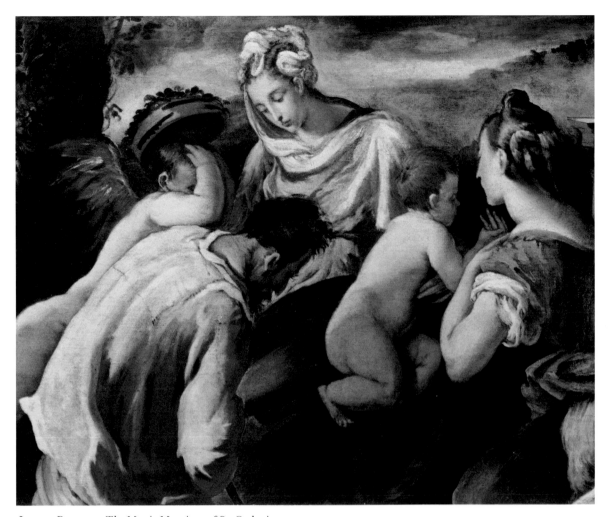

Jacopo Bassano, *The Mystic Marriage of St. Catherine*

stopped painting in about 1580, dates in the mid 1580s have recently been revealed on several autograph paintings, notably the *Susannah and the Elders* from Nîmes of 1585.[21] In these late paintings Jacopo's haunting, loosely brushed forms are similar to those in Titian's late works.

Jacopo died on 27 April 1592. An inventory of his studio drawn up shortly after his death lists almost two hundred paintings, in various stages of completion, of every genre.[22] Jacopo's will, recently discovered, lists as his primary beneficiaries his sons Girolamo (b. 1566) and Giambattista (b. 1553). His sons Francesco (b. 1549), who moved to Venice in 1579, and Leandro (b. 1557) were seen as able to provide for themselves.[23] While Francesco died in the same year as his father, Leandro continued the family tradition in Bassano until his death in 1622.

Though working outside a major artistic center, Jacopo produced works that are of a range and quality to rank with those of the greatest Venetian painters of the sixteenth century. His highly individual synthesis of contemporary influences from Venice and the terra firma had wide influence.

1. F. Rigon, "Taccuino Bassanesco," *Arte veneta*, XXXII, 1978, 174.
2. These documents are published in *Bollettino del Museo Civico di Bassano*, II, 1905, 67, 104, note.
3. Ridolfi, 1914–24, I, 385.
4. Borghini, 1584, 563.
5. Verci, 1775, 79, 86; see also Magagnato and Passamani, 1978, 18–19, no. 6.
6. Pallucchini, 1982, 11.
7. Ridolfi, 1914–24, I, 386.
8. Arslan, *I Bassano*, 1960 ed., I, 38–39.
9. Ridolfi, 1914–24, I, 386.
10. Magagnato and Passamani, 1978, 19, no. 7.
11. Magagnato and Passamani, 1978, 20–21, nos. 8–9. Shearman, 1983, 20, has proposed that Jacopo may have trained with the painter Francesco Torbido of Verona.
12. Arslan, *I Bassano*, 1960 ed., I, 42–49.
13. Arslan, *I Bassano*, 1960 ed., I, 53.
14. Ridolfi, 1914–24, I, 386.
15. Arslan, *I Bassano*, 1960 ed., I, 48–49.
16. This date has been questioned; see Arslan, *I Bassano*, 1960 ed., I, 55; Magagnato and Passamani, 1978, 21, no. 437.
17. Arslan, *I Bassano*, 1960 ed., I, 53–67; Ballarin, 1967, 86.
18. Arslan, *I Bassano*, 1960 ed., I, 73; Magagnato and Passamani, 1978, 24–25, no. 19.
19. Arslan, *I Bassano*, 1960 ed., I, 144–48; Magagnato and Passamani, 1978, 27, no. 17.
20. See in particular Rearick, 1968, 241–49.
21. A. Ballarin, "Chirurgia bassanesca I," *Arte veneta*, XX, 1966, 112–36; W. R. Rearick, "Jacopo Bassano's Last Painting: The Baptism of Christ," *Arte veneta*, XXI, 1967, 102–7; London, 1983–84, 150–51, no. 11.
22. Verci, 1775, 91–100.
23. Pallucchini, 1982, 14.

The Mystic Marriage of St. Catherine

Oil on canvas, 89.5 x 111.8 cm (35 1/4 x 44 in.)
The painting has been cut along the bottom edge and at the right side.[1]

Condition: good. The canvas has a pronounced herringbone weave. There has been abrasion over the entire surface, especially noticeable in the loss of glazes in the saint's and Virgin's drapery.

Provenance: William Grosvenor, third duke of Westminster (d. 1963), sale London, Sotheby's, 24 June 1959, no. 2, as *The Virgin and Child with Saints*.[2] Purchased by the Wadsworth Atheneum in 1959 from J. Weitzner, New York, for $8,000 from the Sumner Fund.

Exhibitions: Hartford, 1982.

The Ella Gallup Sumner and Mary Catlin Sumner Collection, 1959.254

According to the *Golden Legend*, Catherine, the daughter of King Costus of Alexandria, was martyred by Emperor Maxentius because she refused to marry him.[3] Frequently depicted in painting is the incident of her mystic marriage, in which the infant Christ appears to her and places a ring on her finger.[4] The Atheneum picture shows the Child seated on the Virgin's lap accompanied by St. Joseph and a putto bearing a basket of fruit. Christ turns to put a ring on the saint's finger.

The *Mystic Marriage of St. Catherine* has been attributed to Jacopo Bassano since its appearance in the literature.[5] Arslan and Pallucchini have pointed to the similarities with accepted works of Bassano, in particular the *Way to Calvary* in the Musée des Beaux-Arts, Budapest, and pictures of the *Adoration of the Shepherds* in the Nationalmuseum in Stockholm and the Galleria Borghese in Rome. The Atheneum picture shares with these works the compacted compositions, elongated figure style, and play of line, particularly of *profil perdu*, that marks the apogee of Parmigianino's influence on Jacopo's style. The daring colors of the Atheneum painting—the combination of reds, oranges, and greens—and the application of paint in broad sweeps of a loaded brush are also similar in these pictures.

The *Mystic Marriage of St. Catherine* has been dated to 1545 by Longhi,[6] between 1550 and 1560 by Arslan and Ballarin,[7] and to about 1550–55 by Pallucchini.[8] Its closeness to the *St. John the Baptist* in Bassano, documented to 1558, confirms a dating in the middle 1550s. J.C.

1. Both Arslan, *Wadsworth Atheneum Bulletin*, 1960, 1, and Pallucchini, 1982, fig. 20, have called the Atheneum painting a fragment. While the figures seem cropped arbitrarily at the right and left, pictures painted at about the same time show similar decorative, fragmentary compositions. The glimpse of a fragment of a balustrade at the right, or of part of St. Catherine's robe in the lower right corner, confirms that the picture has been cropped at the right edge.
2. As noted by E. Waterhouse, letter to C. Cunningham, 7 Mar. 1960, curatorial file, many of the pictures in the Westminster Collection were acquired from the Welbore Ellis Agar Collection in 1806 (sale London, Christie's, 2–3 May 1806; the sale was never held because the collection was purchased *en bloc* by Robert, second Earl Grosvenor (d. 1845), in April 1806, for 30,000 guineas). The Agar sale catalogue, of which only a French edition is known, lists a painting of the *Mystic Marriage of St. Catherine* by Tintoretto (no. 20), measuring "2 p. 5 pieds sur 3 pieds de large," equivalent to 74 x 36 in. If the Hartford picture

has been cut along the bottom and at the right side, as is very likely, and if the height and width dimensions of the Agar picture were reversed, then the Atheneum picture may be identical to the picture in the Agar Collection, as suggested by Waterhouse; but such identification seems unlikely. The Agar Collection passed to Robert Grosvenor's grandson, Hugh Richard Arthur Grosvenor, second duke of Westminster (d. 1953), and by descent to the third duke. (The Atheneum picture is not, however, listed in J. Young, *Catalogue of the Pictures at Grosvenor House*, 1821, or the *Catalogue of the Collection of Pictures at Grosvenor House Belonging to His Grace the Duke of Westminster*, London, 1913.)
3. Jacobus de Voragine, 1969, 713–14.
4. *Bibliotheca sanctorum*, III, col. 963–68.
5. Arslan, *Wadsworth Atheneum Bulletin*, 1960, 1–3; Ballarin, 1967, 98; Fredericksen and Zeri, 1972, 585; Pallucchini, 1982, 30–32, fig. 20; Silk and Greene, 1982, 34–35, repr. It was also attributed to Jacopo by H. S. Francis, oral communication, Dec. 1959; R. Longhi, letter to C. Cunningham, 22 Mar. 1960, curatorial file; W. R. Rearick, letter to C. Cunningham, 3 Aug. 1960, curatorial file; F. Heinemann, oral communication, 17 Sept. 1974.
6. Letter to C. Cunningham, 22 Mar. 1960, curatorial file.
7. Arslan, *Wadsworth Atheneum Bulletin*, 1960, 2; Ballarin, 1967, 98.
8. Pallucchini, 1982, 32.

Leandro Bassano
(1557–1622)

Leandro da Ponte, the third son of Jacopo da Ponte, was baptized in Bassano on 26 June 1557.[1] Trained in the family workshop, his contribution becomes distinguishable from that of his father and brother Francesco only about 1575.[2] Ridolfi tells us that Leandro went with his father to Venice, probably in 1577–78.[3] Datable to about 1582 is the *Circumcision* in Rosà, signed by Leandro, for which payments exist to Jacopo.[4]

Leandro probably moved to Venice in 1582;[5] he is noted in the painters' guild in Venice from 1588 until his death, while he is absent from the tax roles in Bassano from 1589.[6] From 1589 on exist numerous signed and dated works that permit a view of his mature style, including the *Madonna and Child with Saints* in Motta di Livenza, documented to 1589,[7] and the *Podestà Lorenzo Cappello Kneeling before the Virgin* in Bassano, dated 1590.[8] After Francesco's death, he completed the *Meeting of Pope Alexander III and Doge Sebastiano Ziani* for the Sala del Consiglio dei Dieci in the Palazzo Ducale in Venice.[9]

In 1595 or 1596, Ridolfi tells us, Leandro was knighted by Doge Marin Grimano for his excellence in portraiture.[10] After this time, he frequently added EQUES to his signature.[11]

Leandro's later style, of which numerous documented works exist, shows an increasing rigidity of form and repetition of outmoded composition types. He died 15 April 1622 and was buried in S. Salvatore in Venice.[12]

1. G. Gerola, "Il Testamenti di Francesco il Giovane e di Gerolamo da Ponte," *Bollettino del Museo Civico di Bassano*, II, 1905, 106, n. 2; Ridolfi, 1914–24, II, 167–71; Arslan, *I Bassano*, 1960 ed., I, 233.
2. See Arslan, *I Bassano*, 1960 ed., I, 234–36, on Leandro's early work.
3. Ridolfi, 1914–24, II, 165.
4. Arslan, *I Bassano*, 1960 ed., I, 237.
5. Ridolfi, 1914–24, II, 166, says that Leandro moved to Venice only on the death of Francesco in 1592; but see von Hadeln, 166, n. 2, who argues for an earlier date.
6. Arslan, *I Bassano*, 1960 ed., I, 239.
7. Arslan, *I Bassano*, 1960 ed., I, 239–40.
8. Magagnato and Passamani, 1978, 34, no. 27.
9. Arslan, *I Bassano*, 1960 ed., I, 241.
10. Ridolfi, 1914–24, II, 166.
11. Arslan, *I Bassano*, 1960 ed., I, 243.
12. Arslan, *I Bassano*, 1960 ed., I, 250.

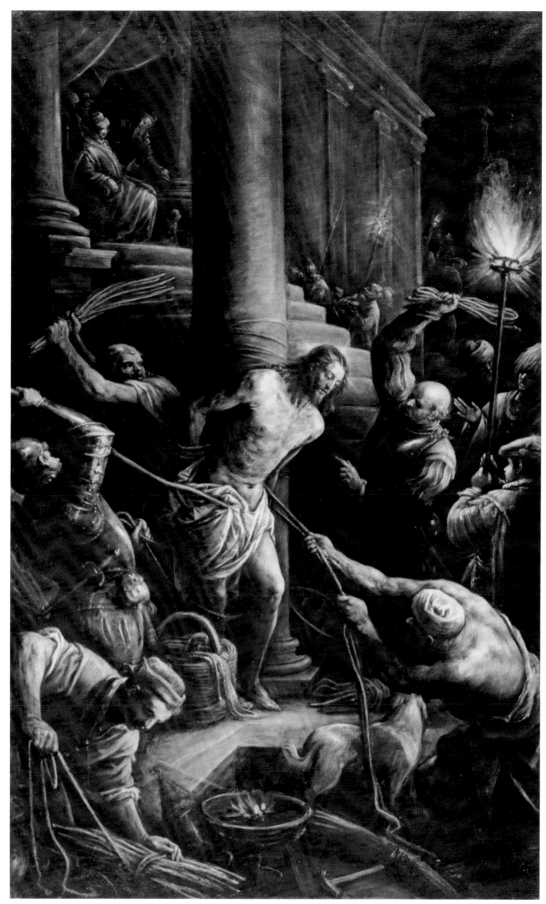

Leandro Bassano, *The Flagellation*

The Flagellation

Oil on canvas, 168.2 x 102.5 cm (66¼ x 40⅜ in.)

Condition: good. A tear in the upper left corner has been patched; in the upper right is an imprint of a seal on the back of the canvas. There are small patches on the upper and lower right of the canvas. The canvas has been restretched but not lined. There are many pentimenti visible, in the tail of the dog, in the lower front leg of Christ, and in the arm and torso of the right flagellant. Although there is some thinness visible in the darks, a recent cleaning has revealed the vibrancy of colors and the richness of impasto.

Signed on base of column: LEANDER BASS O / F. A wax seal on the upper left verso of the canvas reads PROV IN VERONA I.R.

Provenance: an unidentified collection in Verona; possibly Delacotte Collection; Demotte, Paris; R. Frank, London, 1938; Arnold Seligmann, Rey & Co., New York; purchased by the Wadsworth Atheneum in 1940 from Arnold Seligmann, Rey & Co. for $1,800 from the Sumner Fund.

Exhibitions: Hartford, 1940, no. 3, repr.; New York, *European and American Paintings*, 1940, 5, no. 3; Hartford, 1964, 48, no. 204.

The Ella Gallup Sumner and Mary Catlin Sumner Collection, 1940.25

At least eight compositions of the *Flagellation* attributed to various members of the Bassano family relate to the Atheneum picture. The likely prime version is the canvas now in the Museo d'Arte Antica, Castello Sforzesco, in Milan, painted by Francesco Bassano as part of a series of nine paintings of the Passion of Christ for the church of S. Antonio Abate at Brescia (Fig. 6).[1] The general design of the space and the pose of Christ and of the flagellant at the far right are similar in the Milan and the Atheneum paintings. A version of the Milan painting, perhaps a preparatory sketch, is in the Willumsen Collection, Copenhagen.[2] Another version of the Milan painting is in the Museo Civico in Vicenza, in which the poses of Christ and the flagellants are identical to those in the Milan painting, but the space differs slightly and the dimensions have been altered to form a horizontal rectangle.[3] A version of the Vicenza painting, with slight alteration of the background details and the elimination of the figure on the far right, is in the North Carolina Museum of Art, Raleigh.[4] A variant that combines the three lower figures in the Milan painting with two of the flagellants in the Atheneum picture is in the collection of the earl of Plymouth, Oakley Park, Shropshire (Fig. 7).[5] A hastily executed version of the Shropshire painting was in the possession of Arnold Seligmann, Rey & Co. in 1936.[6] A composition virtually identical to the Atheneum version of the *Flagellation*, with some deletions, and more freely executed, is in Prague, in the National Gallery (Fig. 8).[7] A signed study on copper for the Atheneum painting was in 1963 in the collection of Franz Hardy, Beudorf-Rhein.[8] Finally, a *Flagellation* by a follower of Leandro is in the Würzburg Mainfränkisches Museum.[9]

The Atheneum picture follows a practice well established in the Bassano workshop of repeating compositions devised by Jacopo and, later, by Francesco.[10] While the Milan *Flagellation* is perhaps an original composition by Francesco, the Atheneum painting, besides being signed by Leandro, shows his calligraphic touch, particularly in the draperies. Comparison with other compositions by Leandro, for example, the signed *Trinity with Saints* in SS. Giovanni e Paolo in Venice,[11] confirms the attribution to Leandro.[12]

The Atheneum painting probably dates to the middle 1580s, as suggested by its dependence on Francesco's composition from about 1583[13] and its closeness to Leandro's documented pictures of the decade, such as the *Circumcision* in Rosà of 1582, and to the first pictures executed by Leandro in Venice, such as the SS. Giovanni e Paolo *Trinity* and the *Presentation in the Temple* in the church of Sta. Maria delle Zitelle.[14] The form of the signature would also point to an early dating, before he was knighted in 1595 or 1596.[15]

J.C.

1. The cycle was seen in situ by Ridolfi, 1914–24, I, 390. They were removed in the early nineteenth century and dispersed. See Arslan, *I Bassano*, 1960 ed., I, 195–96, 207, n.38. Magagnato and Passamani, 1978, 8, no. 22, suggest that the Hartford painting belonged to the Brescia series; this seems unlikely as the other paintings in the series are much larger than the Atheneum painting, averaging about 260 x 130 cm.
2. Illustrated in Venturi, 1929, IX, pt. iv, fig. 835, attributed to Jacopo.
3. It was formerly in the Chiesa della Maddalene, Vicenza; Arslan, *I Bassano*, 1960 ed., II, fig. 268, as possibly by Giambattista da Ponte.
4. Arslan, 1931, 282, attributed it to Leandro; Shapely, 1966, III, 48–49, fig. 88, to Giambattista Bassano.
5. Photograph Courtauld Institute, no. B65/579.
6. It was attributed to Francesco Bassano the Younger in New York, Arnold Seligmann, Rey & Co., *Titian, Tintoretto, and Veronese*, Jan. 1936, no. 2.
7. Inv. O. 2619; oil on canvas, 122.5 x 95 cm; reproduced in *Emporium*, LXVIII, no. 4, Apr. 1962, 151. This painting seems to be a copy of the Atheneum painting, as it agrees in almost every detail, yet is more freely brushed and omits the background detail of the architecture and the figure of Pilate.
8. Letter to C. Cunningham, 12 Sept. 1963, curatorial file.
9. No. 11459; Arslan, *I Bassano*, 1960 ed., I, 386.
10. See, for example, the listing in the inventory dated 27 Apr. 1592 of Jacopo's studio after his death of "La Flagellazion di N. Signore alla colonna di notte," in Verci, 1775, 95, no. 93, measuring "lungo br. 3 alto br. 2 in circa."
11. Arslan, *I Bassano*, 1960 ed., II, fig. 279.
12. The Atheneum painting has been published as Leandro in C. Rothschild, "Recent Museum Acquisitions," *Parnassus*, XII, no. 5, 1940, 47; Arslan, *I Bassano*, 1960 ed., I, 236–37, II, fig. 280; Berenson, 1957, I, 22; Fredericksen and Zeri, 1972, 585.
13. Arslan, *I Bassano*, 1960 ed., I, 195.
14. Arslan, *I Bassano*, 1960 ed., II, figs. 279, 283, 285.
15. Arslan, *I Bassano*, 1960 ed., I, 236–37, dates the picture to Leandro's early period, before 1590; F. Richardson, in a letter to C. Cunningham, 20 Apr. 1959, curatorial file, dates the picture to about 1584–85.

Leandro Bassano, *The Flagellation*, detail

Figure 6. Francesco Bassano, *Flagellation*, Milan,
Museo d'Arte Antica

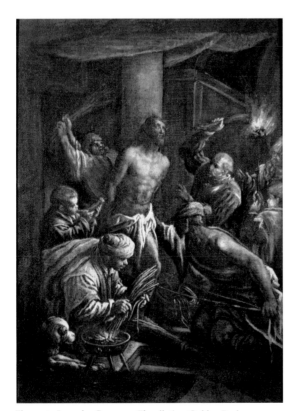
Figure 7. Leandro Bassano, *Flagellation*, Oakley Park,
collection Earl of Plymouth

Figure 8. Leandro Bassano, *Flagellation*, Prague,
National Gallery

Pompeo Batoni
(1708–1787)

Born in Lucca and trained as a goldsmith, which might account in part for the polish and finish of his later works, Batoni moved permanently to Rome in 1728, where he was supported by a stipend from a Lucchese nobleman. By his own account, life-drawing, the collections of antique sculpture in Rome, and the works of Raphael were his mentors. Presumably while studying Raphael in the Farnesina he met his first wife, the daughter of the custodian of the villa. The match seemingly was ill-considered or ill-timed, for his Lucchese patron withdrew his support, leading to a difficult time when Batoni lived marginally by painting fans, selling his drawings after antique sculpture, and painting figures in the landscape works of other artists. However, from the mid to late 1730s onward his work received ample recognition and compensation. By mid century he was recognized as one of the principal Italian artists, if not the artist, in Rome. His friend Anton Raphael Mengs thought so. Yet despite Batoni's fascination with the antique and his assured familiarity with the theories of Johann Joachim Winckelmann, he was not a strict neoclassicist. A biographer described him as a painter "dalla natura," rather than, like Mengs, a painter "dalla filosofia." His early style was particularly assimilative of the grand academic traditions of Italy and France. For his history and religious pictures he drew from the work of his predecessors: Raphael, Correggio, the Bolognese—especially Domenichino and Guido Reni—, the Romans Pietro da Cortona and Carlo Maratti, and from Nicolas Poussin. It was only in his later subject pieces that his style substantially moved toward the neoclassic. He was most famous as a portraitist, particularly of the English gentry on the Grand Tour, the first of whom was painted in 1744. The Atheneum's picture is such a work, conceivably a life sketch anticipating two larger versions, where the sitter is typically presented in a setting indicative of the cultured pursuits of the northern travelers. At the end of Batoni's life, Onofrio Boni wrote that just as Alexander the Great wished to be painted only by Apelles, many princes passing through Rome wished to have their portraits done by Batoni.[1]

1. Belli Barsali, 1965.

Portrait of Sir Humphry Morice

Oil on canvas, 77.1 x 63.5 cm (30³/₈ x 25¹/₆ in.)
 Condition: good, except for minor retouching throughout. There is a heavy pentimento along the bridge of the nose.
 Provenance: possibly the duke of Sutherland, Stafford House, London. Purchased by the Wadsworth Atheneum in 1936 from Arnold Seligmann, Rey & Co., New York, for $5,000 from the Sumner Fund.[1]
 Exhibitions: Minneapolis, 1952, no. 21; Storrs, 1973, no. 81.
 The Ella Gallup Sumner and Mary Catlin Sumner Collection, 1936.43

This oval half-length[2] was dated by Anthony Clark to about 1761 or 1762, when Batoni painted two magnificent full-lengths of Morice, seated with three hunting dogs in an Italian landscape. One of those full-lengths, initialed and dated 1762,[3] belongs to Sir James Graham, Norton Conyers, near Ripon, Yorkshire; the other is in the collection of Sir Brinsley Ford, London.[4] Bowron and Clark wonder if the Atheneum's intimate, bust-length format did not precede the two grander pictures, serving as Batoni's life sketch, which as a group "are invariably fresher and more sensitively drawn and illustrated Batoni's handling at its most spontaneous and personal."[5]

Close examination lends the conjecture some support. Around the splendidly constructed and executed face and hand there is a dark penumbra in the underpainting, in the manner of a sketch from life in which the master left the inessential passages for an assistant to fill out. The drapery, in fact, is notably deficient structurally on the shoulder and in volume on the sleeve. However, in the latter area, the plasticity of the form might be weakened by the effects of the dark underpainting having become more prominent with the passage of time. The sitter is presented in a modified van Dyck costume, something Batoni did several times.[6] His jacket is a cool green gold and the mantle blue gray.

Clark considered a similarly sized (76.2 x 63.5 cm [30 x 25 in.]) version, formerly belonging to Sir John Heygate, Ballarena, Londonderry, a studio copy.[7] A further, now unlocated version was with Vicars Brothers, London, before World War II, misidentified as "Captain Gordon."[8]

Humphry Morice (1723?–1785) was the son of Humphry Morice (1671?–1731), a City merchant, member of Parliament, and governor of the Bank of England, who was rumored to have taken poison to forestall the discovery he had defrauded the bank.[9] In 1750 the younger Humphry inherited from a cousin, Sir William Morice, a baronetcy, a fortune, and an estate, Werrington, in Devon, with the parliamentary patronage of four seats from the neighboring boroughs of Lauceston and Newport, one of which he ineffectually filled himself from 1750 to 1780. The remaining three he brokered for favor and preferment, accommodating successive governments. From 1757 to 1761 he was clerk comptroller of the Green Cloth, a board that licences London gambling; a clerk comptroller of George II's household from 1757 to 1760, and of George III's in 1763; a privy councillor in January 1763;[10] from 1763 to 1783 lord warden of the stannaries, the crown's tin mines in Cornwall; high steward of the duchy of Cornwall; and rider and master of the forest of Dartmoor. In 1775 Morice sold Werrington and its electoral patronage for a reported 100,000 pounds to the first duke of Northumberland, began to withdraw from public affairs, and spent his last years in declining health. He left England in 1782 and died in Naples in 1785.[11] His sizable collection of pictures was purchased by Lord Ashburnham for 4,000 pounds.[12]

It was his health that first took him to Italy. In April 1760 Horace Walpole, his neighbor in Chiswick, recommended Morice, a man of "vast wealth" on his way to Naples for reasons of health, to Horace Mann in Florence. Morice was in Rome in the spring of 1761, when he commissioned a *Diana and Cupid* from Batoni dated 1761, which is the same size as his above-mentioned two full-lengths.[13]

Walpole described Morice as puny and precious. Such was his love for animals he provided 600 pounds a year in his will to maintain his dogs and horses. A contemporary remarked, "The honours shown by Mr. Morice to his beasts of burthen were only inferior to those which Caligula lavished on his charger." His will also directed he should be buried in Naples in a lead coffin, but "before it is soldered I request the surgeon . . . to take out my heart or to perform some other operations, to ascertain my being really dead."[14]

M.M.

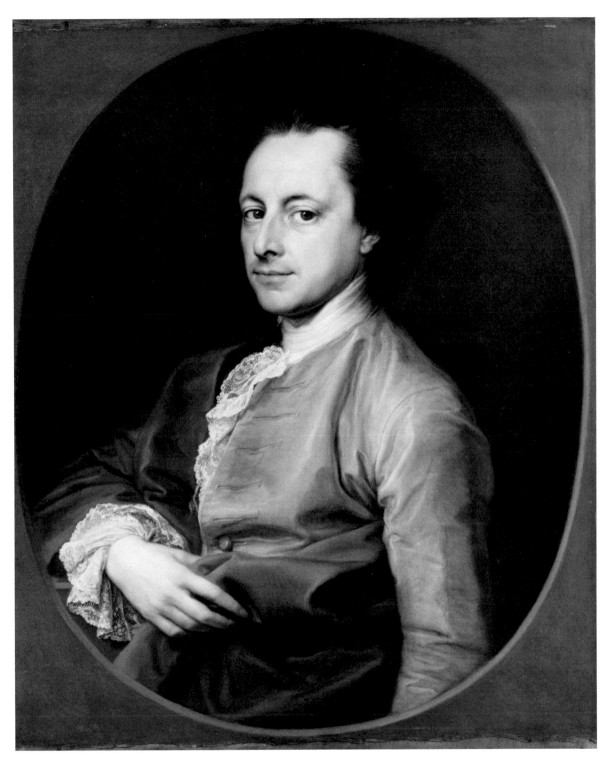

Pompeo Batoni, *Portrait of Sir Humphry Morice*

1. The Arnold Seligmann, Rey & Co. invoice for $5,000 of 26 Apr. 1935 suggests the picture was in Hartford by that date, but was given an accession number only when the bill was paid in April 1936. Although not cited in that invoice, the dealer had earlier written of a provenance, followed in Clark's notes and posthumous monograph (see below), from the collection of the duke of Sutherland, Stafford House. P. Byk of Arnold Seligmann, Rey & Co. to A. E. Austin, Jr., 24 Jan. 1935, curatorial file: "I am sending you for your further consideration the marvellous Batoni from the Duke of Sutherland's collection." This assertion has neither been substantiated nor discounted, except that a picture fitting this description does not appear in such sources as Jameson, 1844; Waagen, 1854 and 1857; P. and D. Colnaghi, Scott, and Co., *Catalogue of the Pictures in the Gallery at Stafford House*, London, 1862; or Graves, 1913–15.

2. *Wadsworth Atheneum Bulletin*, Oct. 1963, 1. Davis, 1952, 150–51. Cited by Briganti and Carpegna in Rome, 1959, no. 41. Fredericksen and Zeri, 1972, 20, 529, 584.

3. E. Bowron to M. Mahoney, 6 July 1984, curatorial file. At that writing, Bowron, who generously forwarded manuscript entries for all these three, had not verified the Sutherland provenance for the Atheneum work. Clark's published catalogue entry, prepared by Bowron (Clark, 1985, 283, no. 241), retains the Sutherland provenance. The full-length painting in Norton Conyers is Clark, 1985, 283, no. 242, 117.5 x 172.8 cm (46¼ x 68 in.), pl. 224. This Graham picture (Courtauld photo B72/1323) was exhibited in the Art Gallery, York, as the picture of the month in May 1970. The picture passed to the present owner at the death of his father, Sir Richard, in 1982 (R. Green to M. Mahoney, 29 June 1984, curatorial file).

4. The Ford version (Rome G.F.N. E43604) was exhibited in London, *Batoni*, 1982, no. 16, illus. Clark describes it as an "autograph replica" (1985, 284, no. 243, 117.5 x 172.8 cm [46¼ x 68 in.]).

5. London, *Batoni*, 1982, 45–46, no. 17, where the Atheneum picture was discussed but not actually exhibited. See also Clark, 1985, 283, no. 241.

6. F. den Broeder in Storrs, 1973, nos. 81, 86.

7. From Clark's manuscript notes. Richard Heygate, Chester, who inherited the picture, speculated it was purchased by the family in the first quarter of the nineteenth century (R. Heygate to M. Mahoney, 28 July 1983, curatorial file). The painting was offered for sale in London, Christie's, 16 Mar. 1984, no. 88, repr., bought in, and again on 23 Nov. 1984, no. 87, repr., bought in. In the March sale the painting was catalogued as "a replica of the portrait in the Wadsworth Atheneum, Hartford. Like other second versions there is probably some workshop participation." Copies a and c listed in Clark's catalogue (1985, 282, no. 241) are, in fact, this single picture.

8. C. Humphrey, Vicars Bros., to C. Cunningham, 14 June 1947, curatorial file. Cunningham mistakenly describes this version as having been reproduced in *Apollo*, XXVII, Sept. 1938, 165 (C. Cunningham to B. Ford, 3 Apr. 1957, curatorial file). He is followed in Clark's notes, where Clark refers to this version as a "probable copy"; in the 1985 catalogue, 282, no. 241 Clark refers to it as a copy.

9. Sedgwick, 1970, II, 277.

10. Namier and Brooke, 1964, III, 166–68.

11. Robbins, 1894, 941–43 in the 1963–64 reprinting.

12. Clark, 1985, 24, n. 85.

13. London, *Batoni*, 1982, 20, 24, n. 85, 45, as *Venus and Cupid*. The *Diana* was sold in London, Christie's, 9 July 1982, no. 70, signed and dated "Roma 1761," repr., $242,269. Exhibited New York, Colnaghi, 1982, 9, 46–47, no. 19, repr., where the Atheneum picture is mentioned, and subsequently acquired by the Metropolitan Museum of Art. Clark, 1985, 280–81, no. 235, pls. XIII and 219.

14. Robbins, 1894, 943 in the 1963–64 reprinting.

Bernardo Bellotto
(1721–1780)

Bernardo Bellotto was born in 1721 in Venice.[1] His mother, Fiorenza, was the sister of Antonio Canal, the painter, and Bernardo became his uncle's only identifiable pupil, entering Canaletto's workshop about 1735. In 1738 Bellotto was inscribed in the Venetian *Fraglia dei pittori* at the early age of eighteen, perhaps with the aid of his uncle's intervention. In 1742 he went to Rome, by way of Florence and Lucca; he had returned to Venice by 1743, when he exhibited two pictures on the occasion of the doge's yearly visit to the Scuola di S. Rocco. In 1743 or 1744 he married and his only son, Lorenzo, who became his assistant, was born. His name is absent from the *Fraglia* in this year, however, and it is presumed that he had departed Venice again, this time for Lombardy, Piedmont, and Verona. It was during these few years, between 1744 and 1746, that Bellotto's independent style emerges from that of his uncle. It was also during this period that Bellotto worked for the first of his many royal patrons, Charles Emmanuel III, king of Sardinia and duke of Savoy. Bellotto probably returned to Venice for short periods before his final departure for Dresden in 1747. By then his working relationship with his uncle had all but ended, although the younger artist began to affix his uncle's diminutive, Canaletto, to his own name.

Bellotto was invited to Dresden by Augustus III, elector of Saxony and king of Poland (reigned 1733–63), and he remained in the city until 1758. Named court painter in 1748, he produced a large number of dated or documented works, primarily views of Dresden and the surrounding countryside, for the king, members of the court, particularly Count Heinrich Brühl, the prime minister, and private collectors. This intense period of work was interrupted in 1756 by the events of the Seven Years' War; on 14 October Augustus's forces were defeated by the Prussian forces of Frederick the Great, and shortly thereafter the king and his sons and important members of the court fled to Warsaw. Bellotto remained in Dresden during the Prussian occupation, but in 1758, with renewed fighting in Saxony and evidently no improvement of the situation in Dresden, he prepared to leave the city. He had arrived in Vienna by January 1759.

In Vienna Bellotto worked for the Empress Maria Theresa, Prince Joseph Wenzel von Liechtenstein, and Prince Wenzel Anton Kaunitz-Rietberg, the imperial chancellor. The views of Vienna constitute the only documentation for his stay in the city, which lasted less than two years. By early 1761 he had left Vienna and, after a stay of several months in Munich, he returned to Dresden.

Bellotto's second stay in Dresden, from 1761 to 1766, was under conditions utterly different from the first. The Seven Years' War continued; Augustus and Count Brühl, his principal patrons, were still in Warsaw, and the patronage of the court had all but disappeared. Bellotto spent his time making replicas of his earlier views for private patrons and pursuing minor employments, but with the death of Augustus and the count in 1763, just after their return to Saxony, and the changed political and social status of Saxony, Bellotto looked to other courts for employment. He found it at the court of King Stanislaus Poniatowski in Warsaw, where he spent the rest of his life.

Bellotto's first years in Warsaw, to 1770, were occupied by the decoration of the palace of Ujazdow, but he also painted a series of views of Rome. Starting in 1770 he executed twenty-six views of Warsaw and other decorative works for the royal castle in that city. The Warsaw views took on particular significance in the twentieth century, when they were used to rebuild the old city of Warsaw after the bombings in World War II.

Bellotto died in Warsaw in 1780 at the age of fifty-nine. He was one of the last of the Italian artists to work internationally; and his large oeuvre, including drawings and prints as well as paintings, is testament to the close and complex ties that bound northern and southern Europe in the eighteenth century.

1. For the following information, see the comprehensive monograph by Kozakiewicz, 1972. Camesasca, 1974, 83–85, includes a useful chronology of the artist's life; see also Venice, 1986, and Verona, 1990.

Bernardo Bellotto, *Sonnenstein Castle and Pirna from a Hill on the Königstein Road*

Sonnenstein Castle and Pirna from a Hill on the Königstein Road

Oil on canvas, 48.9 x 80.1 cm (19¹/₂ x 31¹/₂ in.)

Condition: good. Scoring marks are visible in the buildings and in the horizon at the left. There are slight damages to the paint film at the edges.

Inscribed, with the brush, on the verso of the canvas: *Bern. Bellotto d. Canal/dipinse 1763*.

Provenance: Wolf Collection, Kassel; Julius Böhler, Munich, 1931; bought by the Wadsworth Atheneum in 1931 from Julius Böhler for $4,200 from the Sumner Fund.

Exhibitions: Munich, Julius Böhler, *Ausstellung altvenezianischer Malerei*, 1931; New York, Kleinberger Galleries, *Italian Baroque Painting and Drawing of the Sixteenth, Seventeenth, and Eighteenth Centuries*, 10–22 Oct. 1932; Northampton, 1932; Springfield, 1933, no. 71; New York, 1938, no. 30; New Haven, 1940, no. 1; Brooklyn, Brooklyn Museum, *European and American Landscape Painting*, 8 Nov. 1945–1 Jan. 1946, no. 22; Detroit, 1952, no. 5; Hartford, 1956, 15, no. 3; Dresden, *Bernardo Bellotto gennant Canaletto in Dresden und Warsaw*, 8 Dec. 1963–31 Aug. 1964, 84, nos. 18C and E (erroneously listed as two separate paintings); Vienna, *Bernardo Bellotto gennant Canaletto*, 29 Apr.–25 July 1965, 106, no. 25d.

The Ella Gallup Sumner and Mary Catlin Sumner Collection, 1931.280.

On the right is a vew of Sonnenstein Castle, showing from the left the Kommandantenhaus, or commander's house, two towers, the further of which is the Luntenturm, and the low buildings comprising the Rundflugel, the round wing that enclosed the inner courtyard. At the left, below the castle, is the town of Pirna, dominated by the Marienkirche; in the background is seen the river Elbe and, on the horizon, the city of Dresden.

The Atheneum picture is a smaller version of a painting now in the Gemäldegalerie in Dresden (Fig. 9).[1] On 26 April 1753 Bellotto was issued a warrant, addressed to the bailiff of the town of Pirna, to the southeast of Dresden, requesting assistance for the artist in his drawings of the town. Three years later, in 1756, another request for assistance in Bellotto's work around the castle of Königstein was

Figure 9. Bernardo Bellotto, *Sonnenstein Castle and Pirna from a Hill on the Königstein Road*, Dresden, Gemäldegalerie

issued. It must have been in this period that Bellotto produced the eleven views of Pirna, including *Sonnenstein Castle and Pirna from a Hill on the Königstein Road*, and four large views of Königstein that were intended for the royal collection; the Pirna views, along with fourteen views of Dresden that were painted between 1747 and 1753, have remained in Dresden since they were first inventoried in the Saxon royal collection; the Königstein views were probably never delivered to the king and found their way to private collections in England.[2]

During these same years Bellotto produced a second series of views, including a version of *Sonnenstein Castle and Pirna from a Hill on the Königstein Road*, for Count Heinrich Brühl, Augustus's prime minister, which is now in the Hermitage in Leningrad.[3] This version, which is virtually identical in size to the royal version, shows very slight differences in the figures.

Yet another version, of almost the same dimensions as the Atheneum picture, is in a private collection in New York.[4] Both the New York and Atheneum versions show changes in the arrangement of cows, the elimination of the two figures at the right, and the addition of a figure seen from the rear mounted on a horse. In addition, an etching which incorporates again slight changes in staffage was produced.[5]

The Atheneum version is inscribed on the verso and dated 1763. Although it is unlikely that the inscription is in Bellotto's hand, the information is probably accurate. The painting is undoubtedly one of the versions produced during Bellotto's second Dresden period, when his original patrons were absent and court life was curtailed by the Seven Years' War. Kozakiewicz[6] notes that the Atheneum picture shows the Luntenturm as it was before 1755. In that year its roof was lowered to the level of the cornice of the Rundflugel. This is further evidence of the connection of the Atheneum picture with the earlier versions. Although many of the versions Bellotto painted in the years when the Atheneum picture was produced betray the hand of assistants, there is no evidence of studio work in the Hartford picture, which shows Bellotto's characteristic lush colors and animated touch.[7] J.C.

1. Inv. no. 620, 132 x 235 cm; Kozakiewicz, 1972, II, 174–79, no. 220; Venice, 1986, 94–95, no. 23.
2. Kozakiewicz, 1972, I, 83–84, argues for the inclusion of the Königstein views in the royal series.
3. On this series, see Kozakiewicz, 1972, I, 85; the Leningrad picture is discussed in vol. II, 179, no. 221.
4. Kozakiewicz, 1972, II, 179, no. 222, 48.2 x 80 cm.
5. Kozakiewicz, 1972, II, 179, no. 224.
6. Kozakiewicz, 1972, II, 179.
7. The painting was considered autograph by McComb, 1934, 123; *Wadsworth Atheneum Handbook*, 1958, 86; Constable, 1963, 10–12; Fredericksen and Zeri, 1972, 584; Camesasca, 1974, 103, no. 128.

Niccolò di Buonaccorso
(d. 1388)

Niccolò di Buonaccorso was probably the son of the Sienese painter Buonaccorso di Pace, who made his will in 1348. He was inscribed in the Sienese painter's guild at an undefined date, and he held various civic posts in Siena in 1372, 1377, and 1381. He is mentioned in documents of 1376 and 1385, but the works there referred to do not survive. He was buried in May of 1388 in S. Domenico in Siena.[1]

Niccolò's only signed work is a panel of the *Marriage of the Virgin* in the National Gallery in London. Pictures of the *Presentation of the Virgin*, now in the Uffizi,[2] and of the *Coronation of the Virgin*, in the Lehman Collection, Metropolitan Museum, New York, are generally thought to belong to the same series as the London picture.[3] Another signed panel, dated 1387, a *Madonna and Child*, and a panel of *S. Lorenzo*, both part of a dismembered altarpiece, were seen by Milanesi in 1854 in the church of Sta. Margherita in Costa al Pino, near Siena.[4] The figure of S. Lorenzo survives and has been recently restored.[5]

Niccolò is generally seen, with Bartolo di Fredi and Paolo di Giovanni Fei, as one of the minor masters of the late Trecento, who coupled recollections of earlier Trecento painting with rich decorative effects. A recent reconstruction of his oeuvre has emphasized his unique spatial compositions in the context of contemporary Sienese painting and his possible importance for Sassetta's early work.[6]

1. The documents are published by Milanesi, 1854, I, 31–32.
2. *Gli Uffizi*, 1979, 395, no. P1115.
3. Davies, 1961 ed., 384, no. 1109; Pope-Hennessy, 1987, 33–35, no. 14.
4. Milanesi, 1854, I, 32, note.
5. Boskovits, 1980, 4–5.
6. Boskovits, 1980, 3–4; see also Maginnis, 1982, 18–20.

Workshop of
Niccolò di Buonaccorso
The Annunciation

Tempera and oil on panel, 39 x 25.3 cm (15 1/4 x 10 1/4 in.) painted surface
The panel has been cradled. Wood strips .5 cm in width have been added to all edges; the panel was originally engaged.
Condition: fair. The faces are worn, and there is scattered inpainting throughout, especially in a prominent center vertical crack. The haloes and background have been partially regilded and retooled. The pastiglia of the arch has been shaved down.
Inscribed on scroll: [AV]E GRATIA PLENA
Provenance: possibly Oliver B. James, Phoenix; J. Weitzner, New York; bought by the Wadsworth Atheneum in 1951 from J. Weitzner for $1,000 from the Sumner Fund and by exchange.
Exhibitions: Stamford, Conn., Stamford Museum and Nature Center, 15 Dec. 1956–6 Jan. 1957; Hartford, 1967.
The Ella Gallup Sumner and Mary Catlin Sumner Collection, 1951.94

The *Annunciation* was probably part of a polyptych which included the *Lamentation over the Dead Christ* in the Lehman Collection, Metropolitan Museum, New York (Fig. 10).[1] The pictures are similar in size, in format, in the gesso decoration in the spandrels, and in the tooling of the cusped arch and haloes.

The painting was first published by Berenson, who attributed it to a follower of Niccolò,[2] an opinion shared by Maginnis.[3] Ames attributes the figures only

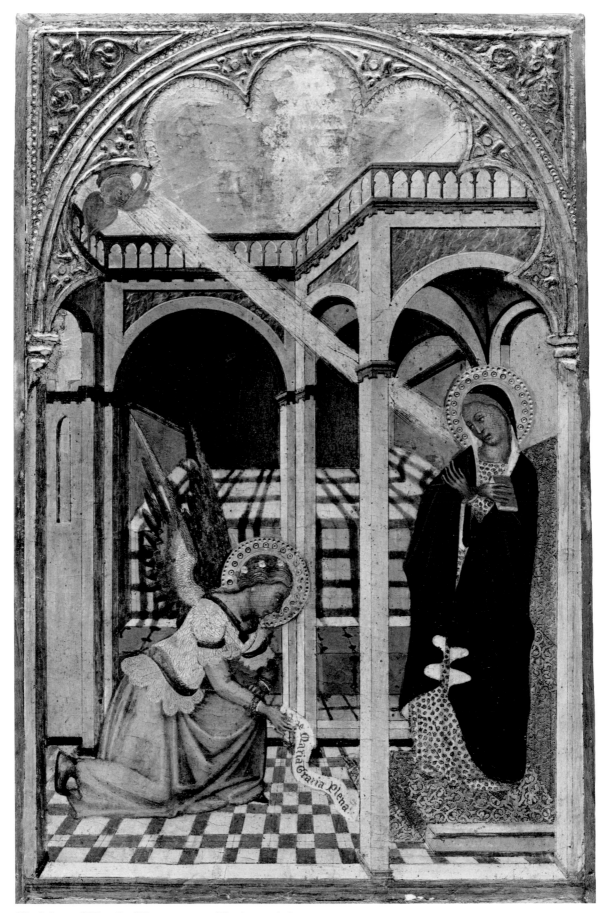

Workshop of Niccolò di Buonaccorso, *The Annunciation*

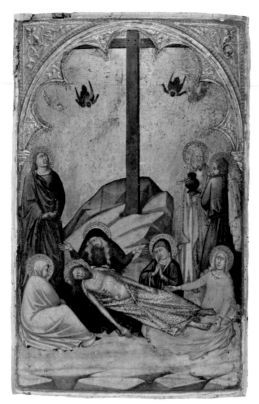

Figure 10. Workshop of Niccolò di Buonaccorso, *Lamentation over the Dead Christ*, New York, Metropolitan Museum of Art, Lehman Collection

to Niccolò,[4] while Boskovits assigns the picture to Niccolò himself,[5] and Pope-Hennessy to the workshop of Niccolò.[6] The composition of the picture is surely due to Niccolò, while the handling of drapery perhaps signals a workshop hand.

The Atheneum picture has been dated to the last decade of the artist's career, about 1378–88, by Boskovits.[7]　　　　　　　　　　　　　　　　J.C.

1. The dimensions of the Lehman picture are 39.4 x 25.5 cm (painted surface). The link of the Hartford and New York pictures was made by Maginnis, 1977, 299. The Lehman picture was formerly in the Bruscoli Collection in Florence and was attributed to Niccolò by F. Zeri, review of Torriti, 1978, in *Antologia di belle arti*, II, 1978, 151, and to workshop of Niccolò by Pope-Hennessy, 1987, 36–37, no. 15.
2. B. Berenson, "Quadri senza casa: Il Trecento senese II," *Dedalo*, XI, 1930–31, 342–43.
3. Maginnis, 1977, 299, and 1982, 18.
4. K. Ames, "An 'Annunciation' by Niccolò di Buonaccorso," *Wadsworth Atheneum Bulletin*, II, no. 2, 1966, 28.
5. Boskovits, 1980, 3.
6. Pope-Hennessy, 1987, 36.
7. Boskovits, 1980, 6.

Bernardino Butinone
(active 1484–after 1507)

Son of Jacopo di Treviglio, Bernardino Butinone was born around 1450. By 1484 he was resident in Milan and the head of a workshop.[1] His first documented work is from the same year, a signed and dated polyptych of the *Madonna and Child with St. Vincent and St. Bernardino*, possibly painted for the chapel of S. Leonardo in the church of the Carmine in Milan and now in the Pinacoteca di Brera.[2] All of his other dated works were executed in collaboration with Bernardo Zenale, including the large polyptych in S. Martino, Treviglio (commissioned 26 May 1485), and the frescoes in the Grifi Chapel in S. Pietro in Gessate, Milan (commissioned sometime after 1489 and probably finished before 1493; formerly inscribed with the artists' names).[3] In 1507 the painters applied to the vicar of the archbishopric of Milan for the remaining payment for the Treviglio polyptych.[4] After this date, notice of Butinone ceases and he is presumed dead.

Butinone's style is generally thought to have been formed under the influence of Ferrarese and Paduan models, particularly Mantegna, either through direct or indirect contact with those centers.[5] Starting in the 1480s, in the Brera painting, his gradual recovery of a Lombard style, particularly under the influence of Vincenzo Foppa, is evident. His later style is difficult to document precisely because of his collaboration with Zenale and the ruined condition of the Grifi frescoes.[6]

1. E. Motta, "L'Università dei pittori milanesi nel 1481," *Archivio storico lombardo*, 3rd ser. III, 1895, 422; L. Beltrami, "Altre notizie d'archivio relative a pittori milanesi durante il primo soggiorno di Leonardo da Vinci in Milano," *Rassegna d'arte*, XVI, 1916, 164; Baroni and Samek Ludovici, 1952, 259.
2. Inv. no. 249. M. Salmi, "Il Trittico del Butinone nella Pinacoteca di Brera," *Archivio storico lombardo*, LII, 1925, fascs. I–II, 154–58; 1928–29, 336.
3. Malaguzzi Valeri, 1902, 8–11; Baroni and Samek Ludovici, 1952, 259–60; Carlevaro, 1982, 19–46.
4. Malaguzzi Valeri, 1902, 10–11.
5. Malaguzzi Valeri, 1902, 28–32; Salmi, 1928–29, 336–60, 395–426; R. Longhi, *Officina ferrarese*, Rome, 1934, 80; Baroni and Samek Ludovici, 1952, 225–29; Milan, 1958, 147.
6. Mazzini, 1965, 476, pls. 248–51, has proposed as late works the frescoes in the church of Sta. Maria Maddalena in Camuzzago di Ornago, near Milan, an attribution accepted most recently by Vergani, 1985, 31–44.

Circle of Butinone
The Crucifixion and Other Scenes

Lunette: Christ with the Virgin and St. Dominic and angels holding the instruments of the Passion. Upper level: Pietà with St. Mary Magdalene and an unidentified female saint; Crucifixion with St. Catherine of Siena?, St. Thomas Aquinas, and St. Mary Magdalene; the Descent into Hell. Lower level: Apparition to an unidentified saint (St. Clare?); the Resurrection; the Stigmatization of St. Francis.

Oil and tempera on panel, 79.8 x 55.7 cm (31 3/8 x 22 in.) overall; lunette 14.2 x 41 cm (5 1/2 x 16 1/4 in.); upper level 23.5 x 43.7 cm (9 1/4 x 17 1/4 in.); lower level 22.8 x 43.6 cm (9 x 17 1/8 in.)

The panel has been disengaged from its original frame; the present frame is partly new, including the top arch, the bottom, and the lower part of the sides. In the lower level, the finials between scenes have been shortened; possibly small columettes dividing the scenes have been removed.

Condition: good. The paint film shows small areas of damage overall; the blues may be new.

Provenance: private collection, Italy; George H. Story, 1906; bought by the Wadsworth Atheneum in 1911 from George H. Story for $700 from the Henry and Walter Keney Fund.

Gift of Henry and Walter Keney, 1911.21

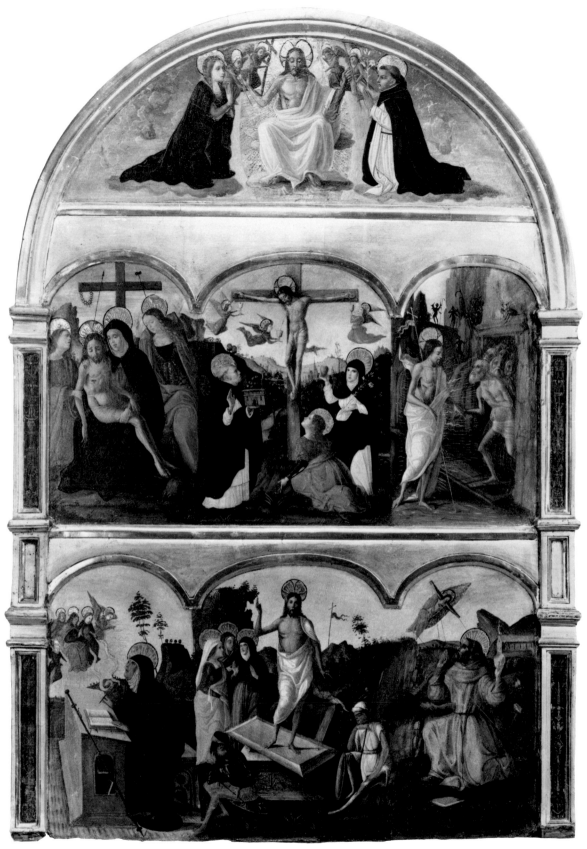

Circle of Bernardino Butinone,
The Crucifixion and Other Scenes

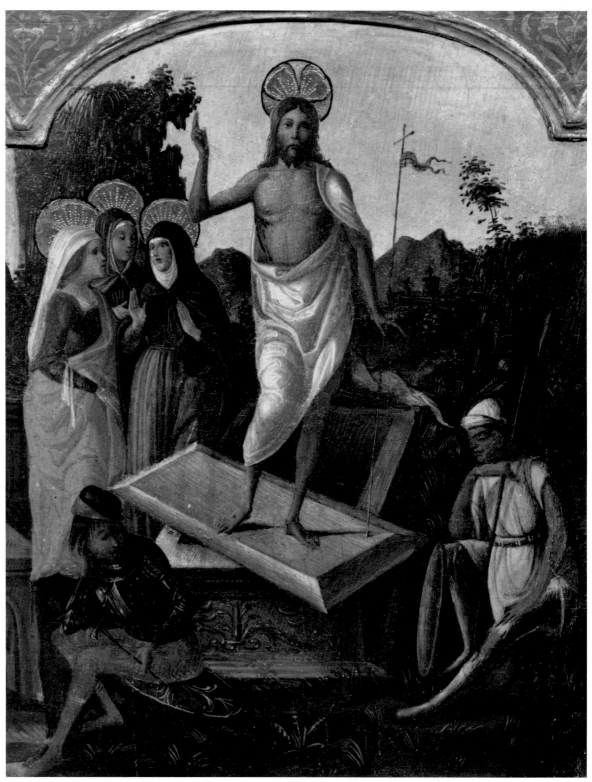

Circle of Bernardino Butinone,
The Crucifixion and Other Scenes, detail

The presence of Dominican and Franciscan saints in a single panel is unusual and suggests that the painting was made for a private home.

Thought to be by Masaccio when it was acquired by the Atheneum,[1] the panel was attributed by Berenson to the Umbrian school around 1500.[2] Byam Shaw first attributed it to the Lombard school, close to Butinone;[3] this view was shared by Gilbert,[4] Mazzini,[5] and Vertova.[6] Fredericksen and Zeri proposed an attribution to a follower of Butinone, or to the Sicilian school of the fifteenth century;[7] while Fahy proposed an attribution to Butinone himself.[8]

The Atheneum panel is related to other small-scale works of Butinone, particularly the predella of the Treviglio polyptych.[9] It is also close in style to a series of fourteen panels of the Life of Christ, once part of a polyptych but now dispersed, that is generally attributed to Butinone.[10]

The Atheneum panel shows affinities of figure style and color with these works, yet there are differences. The figures in the Atheneum panel, especially the Resurrected Christ, show more elegant poses and softer, classicizing draperies than the Treviglio predella and the Life of Christ panels. The use of prominent architectural backgrounds in several of the Life of Christ panels is absent in the Atheneum panel.

It has been observed that the Life of Christ panels do not show unanimity of style and must have been painted by different members of the Butinone shop. As yet, however, independent works by students of Butinone have not emerged either from documents or from analysis of style. Hence, the name of the artist responsible for the Atheneum panel, if he was indeed active in Butinone's shop, as seems likely, cannot now be proposed.[11]

A small tabernacle in the Museo d'Arte Antica, Castello Sforzesco, Milan, is a version on a smaller scale of the Life of Christ series and is probably also a product of the Butinone shop, yet it too differs from the Atheneum panel in figure style and composition.[12]

The Life of Christ series is generally dated to around 1480, and the Castello tabernacle to slightly later.[13]

The Atheneum panel is primarily indebted to Butinone for its style, yet there is evidence of other influences. The citation of Vincenzo Foppa's panel of the *Stigmatization of St. Francis* from the Brera polyptych,[14] or of the fresco of the same subject from Sta. Maria del Giardino and now in the Museo d'Arte Antica, Castello Sforzesco, Milan, is evident in the same scene in the Atheneum panel.[15] The *Pietà* in the Atheneum panel is also derived from Foppa's influential painting of the same subject, formerly in S. Pietro in Gessate.[16] The female at the left in the *Pietà* is, on the other hand, extremely close in facial and figure type to works of the young Bramantino, especially the *Nativity with Saints* in the Ambrosiana of about 1495.[17] The soft, curving draperies which distinguish the Atheneum panel from Butinone's surely attributed works are also close to Bramantino's distinctive drapery style.

The Atheneum panel is thus probably by a student or close follower of Butinone, who was also influenced by artistic events in Milan in the 1490s and the first decade of the sixteenth century. J.C.

1. F. B. Gay, "A Florentine Panel Painting," *Wadsworth Atheneum Bulletin*, II, no. 4, 1924, 2.
2. L. Ehrich to G. Story, 20 Feb. 1909, curatorial file.
3. Oral communication, 29 Apr. 1963.
4. Letter to C. Cunningham, 3 Aug. 1965, curatorial file.
5. Letter to C. Cunningham, 16 Feb. 1966, curatorial file.
6. Letter to S. Wagstaff, 2 May 1967, curatorial file.
7. Fredericksen and Zeri, 1972, 584.
8. Oral communication, 8 May 1984.
9. The following studies attribute all or part of the Treviglio predella to Butinone: Malaguzzi Valeri, 1902, 26–28 (*Nativity, Crucifixion,* and *Ecce Homo* only); Salmi, 1928–29, 414 (*Crucifixion* and *Resurrection* only); Baroni and Samek Ludovici, 1952, 256; Milan, 1958, 153–54, pl. CXCVI.
10. Salmi, 1928–29, 351–56; Baroni and Samek Ludovici, 1952, 235–39; Zeri, 1955, 77; Milan, 1958, 148–49; Davies, 1961 ed., 132–33, no. 3336; Brigstocke, 1978, 25–27, no. 1746. The suggestion has been made in Milan, 1958, 149, that the panels belong to more than one series.
11. Baroni and Samek Ludovici, 1952, 235–36; Milan, 1958, 149.
12. Reproduced in Zeri, 1955, fig. 15; see also Milan, 1958, 149, no. 472.
13. Salmi, 1928–29, 352, 426, n. 21; Baroni and Samek Ludovici, 1952, 240.
14. Wittgens, 1950, 97, pl. LXIV.
15. Wittgens, 1950, 101, pl. LXXX.
16. The painting was formerly in the Kaiser Friedrich Museum in Berlin. It was destroyed in 1945; see Wittgens, 1950, 105–6, pl. XCIX. See M. Ferrari, "Lo Pseudo Civerchio e Bernardo Zenale," *Paragone*, XI, no. 127, 1960, 38, 41–43, pls. 21, 28, 29, for other reflections of this composition in Lombard painting around 1500.
17. G. Dell'Acqua and F. Mulazzani, *L'Opera completa del Bramantino e Bramante pittore*, Milan, 1978, 88, no. 5, pls. XVII-XXI.

Michele Pace, called Michelangelo di Campidoglio (c. 1610–1670)

Little is known of this seventeenth-century Roman painter, mentioned merely in passing by Pascoli in the 1730s as Michele di Campidoglio, so called because he is said to have held office in the Capitol—the Campidoglio.[1] Lanzi in 1815 called him Michelangelo da Campidoglio and spoke of him as the preeminent painter of fruit still lifes in seventeenth-century Rome, an artist who had been almost forgotten despite the fact that his works were found not infrequently in collections there and elsewhere.[2] His name appears in inventories of prominent Roman collections, in those of the Chigi, for example, for whom he intriguingly painted, in addition to still lifes, pictures of greyhounds and other hunting dogs.[3] De Logu proposed a core group of attributions based upon their resemblance to one of a pair of pictures now in the Hermitage that came from Robert Walpole's collection at Houghton and was reproduced by Boydell in 1776,[4] with Horace Walpole's traditional attribution to Campidoglio.[5] In the 1964–65 Naples exhibition Causa expanded this core group,[6] but thereafter rejected all his own attributions and came to accept only the two Hermitage paintings and Faldi's attribution of a picture in the Art Gallery and Museum, Leicester.[7]

1. Pascoli, II, 57. The problems of the artist's dates and the variations of his name were, as far as can be ascertained, first addressed in 1904 (G. Williamson, ed., *Bryan's Dictionary of Painters and Engravers*, London, 1904, IV, 54), when he is referred to as Michelangelo Pace, called di Campidoglio. This was followed in Thieme and Becker, where he is listed as Michelangelo di Campidoglio, properly di Pace (1911, V, 472). Neither source cites an authority. In the course of describing the Chigi holdings, Golzio referred to him as Michele Paci or Pace, better known as Michelangelo del Campidoglio (Golzio, 1939, 152, 239, 271).

2. Lanzi, 1815, II, 206: "nella maestria di figure ogni maniera di frutti tenne il campo un romano detto Michelangiolo da Campidoglio; ito quasi in dimenticanza per la lunghezza degli anni, ma non raro nelle gallerie anche fuor di Roma: la nobil famiglia Fossombroni in Arezzo ne ha uno dei più bei quadri ch' io ne vedessi." (In the mastery of representing all manner of fruit a Roman, called Michelangelo da Campidoglio, led the field; although almost forgotten over the years, his work is not rare in galleries, even outside Rome. The noble Fossombrone family of Arezzo has one of the most beautiful pictures by him I have seen.) Lanzi's index cites Pascoli's: "fioriva c. 1600."

3. Golzio, 1939, 152, 239, 271–72. Faldi, 1966, 34–36, 144–50. Salerno, 1977–80, II, 584–85, no. 90.1, illustrates such a work.

4. De Logu, 1962, 189, pl. 66, and Salerno, 1984, 181, fig. 43.3. The Hermitage painting, inv. no. 2486, is reproduced in Kuznetzov, 1966, 200–201, pl. 76, oil on canvas, 98 x 134 cm, a pendant to inv. no. 2485. The print, drawn by Joseph Farington, cut by Richard Earlom, and printed by John Boydell, is included in Boydell, 1788, I, pl. XLI.

5. Walpole, 1752, 73: "Two Fruit-pieces over the Door [to the Marble Parlor] by Michael Angelo Campidoglio, from Mr. Scawen's Collection."

6. Naples, 1964, 67–69, nos. 132–37.

7. Causa, 1972, 1051, n. 102. See also Salerno, 1984, 178–81, nos. 43.1–4, who points out that the paintings in Causa's 1964–65 group are actually by David de Coninck. The Leicester picture is reproduced by Salerno, no. 43.2.

Still Life with Fruit and Flowers

Oil on canvas, 64.7 x 54.7 cm (25 1/2 x 21 9/16 in.)

Condition: good, although the transitions in the background are no longer intact.

Provenance: Mrs. Gurdon Wadsworth Russell by 1864; bequeathed to the Wadsworth Atheneum in 1921 by Mrs. Gurdon Wadsworth Russell.

Exhibitions: Palm Beach, 1952, no. 15; Westport, 1955.[1]

Bequest of Mrs. Gurdon Wadsworth Russell, 1921.340

The painting came to the museum at a very early date with the attribution to Michelangelo di Campidoglio, one that Longhi thought likely.[2] It should be compared to the key Hermitage work[3] and with other traditional attributions in Russia, such as the Pushkin *Still Life with a Peacock and a Turkey*.[4] The slightly elevated point of view is consistent with those works, but the perspective is somewhat less assured. The composition here seems merely complex, not expansive; the space stifled; and the brushwork at times dry and even coarse, as in the topmost blooms. Fredericksen and Zeri thought the attribution an uncertain one,[5] and Causa suggested the picture could be of French origin.[6] M.M.

Michelangelo di Campidoglio,
Still Life with Fruit and Flowers

1. The curatorial file records these exhibitions, for which no other documentation has been found: Palm Beach, Fla., Society of the Four Arts, *Two Centuries of Flower Paintings*, 1952, no. 15; Wesport, Conn., Leonid Kipnis Gallery, *Flowers in Art*, sponsored by the Cancer Committee of Wesport and Weston, Apr. 1955.

2. R. Longhi to C. Cunningham, 22 Mar. 1980, curatorial file: "[1921.340] which is likely by Pace and certainly earlier than the pendants [Spadino, 1951.161 and 162]."

3. Reproduced by Kuznetzov, 1966, color pl. 76.

4. De Logu, 1962, 189, pl. 67, inv. no. 3003. De Logu interprets the architectural background to be a quotation of one of the buildings on the Campidoglio, an allusion that would support the attribution.

5. Fredericksen and Zeri, 1972, 41, 506, 584, as "attributed to" Michelangelo di Campidoglio.

6. Verbally to M. Mahoney, June 1983.

Giovanni Antonio Canal, called Canaletto (1697–1768)

Giovanni Antonio Canal was born in Venice on 17 or 18 October 1697, to a family of substantial but not aristocratic background.[1] The essentials of his biography are well known. The artist's father, Bernardo, was a painter of theatrical decorations, and it is likely that he was Antonio's teacher.[2] Father and son were in Rome in 1719–20, also working for the theater,[3] although Zanetti and other principal sources for Canaletto's biography say that the young painter renounced this line of work in 1719.[4] By 1720 Canaletto was probably back in Venice, as his name and that year appear in the Venetian *Fraglia*.[5]

From the early 1720s on Canaletto's activities as a painter are

well documented through payments and letters exchanged with his patrons, mostly Englishmen.[6] Except for a possible trip to Rome in the early 1740s,[7] Canaletto remained in Venice until his departure for England in 1746.[8] His English sojourn was probably in search of new patrons, the War of the Austrian Succession having interrupted the flow of travelers to Venice. In England Canaletto found important clients, though his stay there was not without difficulties and he returned to Venice once for unknown reasons, probably in 1750 or 1751.[9] His final return to Venice is not known, but was probably in 1756.

Of Canaletto's last years little is known. He was elected to the Venetian Academy in 1763, and presented his *Capriccio: A Colonnade Opening onto the Courtyard of a Palace*, dated 1765, now in the Accademia, Venice.[10] His death was recorded on 19 April 1768.[11]

Thanks to a large number of documented and datable works, there is general critical agreement on the outline of Canaletto's oeuvre and the development of his style.[12] Most recently, discussion has centered on Canaletto's early works and possible influences on him. Morassi's articles of 1956 and 1966,[13] and his discovery of the large painting of classical ruins, signed and dated 1723,[14] have clarified Canaletto's beginnings and his debt to painters of imaginary views, such as Marco Ricci.[15] While Canaletto claimed to have renounced theatrical painting by 1719, these early paintings show that he depended heavily on his experience with theatrical painting for compositional principles and the integration of identifiable monuments with purely imaginative scenes. The two paintings Canaletto participated in for the series of the *Tombeaux des princes*, commissioned by Owen McSwiney and finished by 1726, also confirm Canaletto's early experience with theatrical imagery.[16] Only by about 1722 or 1723, the date of the four Venetian views formerly in the Liechtenstein Collection, did Canaletto begin to evolve the style of view painting for which he became known.[17] While from this time Canaletto was principally active as a *veduta* painter, he returned to the imaginary views at certain points in his career.[18]

Canaletto was also active as a graphic artist of considerable stature.[19] Recent exhibitions of Canaletto's work in London,[20] Venice,[21] and New York have yielded new insights into Canaletto's technique and the relationship of his paintings to his graphic work.[22]

Canaletto's only known pupil was his nephew Bernardo Bellotto, although he seems to have directed a small studio later in his career.[23] His work was also copied by many other artists, including Michele Marieschi and Francesco Guardi.

1. For a full account of Canaletto's family, and citation of documents, see Constable and Links, 1976, I, 1–7; see also Links in New York, 1989–90.
2. E. Pavoledo, "Canal," in *Enciclopedia dello spettacolo*, Rome, 1954, II, 1625, establishes the collaboration of father and son on theatrical decorations in Venice in 1716–18.
3. Constable and Links, 1976, I, 9; 1989, I, xxi.
4. Zanetti, 1771, 463.
5. Constable and Links, 1976, I, 11.
6. Constable and Links, 1976, I, 11–32; see also J. G. Links, *Canaletto and His Patrons*, London, 1977.
7. Constable and Links, 1976, I, 29–32, argue against the trip, which was suggested by Voss, 1926, 21–22.
8. G. Vertue establishes the date of Canaletto's arrival in London as May 1746. The most complete account of this trip is that of H. Finberg, "Canaletto in England," *Volume of the Walpole Society*, IX, 1920–21, 21–76, which was based on Vertue's notebooks in the British Museum; see also Constable and Links, 1976, I, 32–34.
9. Constable and Links, 1976, I, 34–42.
10. Constable and Links, 1976, II, 465–66, no. 509.
11. Constable and Links, 1976, I, 44.
12. See Constable and Links, 1976, I, 85–98, for a useful chronological table.

13. Morassi, 1956, 357–60; 1966, 207–17.
14. Morassi, 1963, 145–50. This discovery has met with some skepticism, however; see D. Mahon, "When Did Francesco Guardi Become a 'Vedutista'?," *Burlington Magazine*, CX, 1968, 72–73, and Constable and Links, 1976, II, 449, no. 479**, who accept the attribution but are reluctant to accept the date of 1723.
15. See also W. G. Constable, "An Early Painting of Rome by Canaletto," *Burlington Magazine*, CVI, 1964, 509–10; Pallucchini, 1973, 155–88. For a discussion of the terms *capricci*, *vedute ideate*, and *vedute di fantasia*, all of which have been applied to Canaletto's paintings of imaginary architecture, and their historical background, see Barcham, 1977, 3–9.
16. Constable and Links, 1976, I, 99–100, II, 469–70, nos. 516–17. The date they report, 1722, has now been shown to be incorrect. See J. G. Links, "A Homecoming for Canaletto," *Apollo*, CXVI, 1982, 190.
17. For the ex-Liechtenstein paintings, see Constable and Links, 1976, I, 100, II, 185, no. 1, 260, no. 182, 272, no. 210, 312, no. 290; Pedrocco in Venice, 1986, 27–32; New York, 1989–90.
18. Canaletto's activity as a painter of imaginary scenes has been discussed by Barcham, 1977.
19. D. von Hadeln, *Die Zeichnungen von Antonio Canal genannt Canaletto*, Vienna, 1930; Parker, 1948; Pignatti, 1958; R. Bromberg, *Canaletto's Etchings*, London, 1974.
20. London, 1980–81.
21. Venice, 1982.
22. New York, 1989–90.
23. Constable and Links, 1976, I, 163–65.

Landscape with Ruins

Oil on canvas, 72.7 x 55.4 cm (28⅝ x 21¾ in.)
 The right edge has been trimmed by about an inch.
 Condition: fair. The middle tones have become translucent, resulting in lack of definition in the shadows, and there are scattered retouchings overall. Discolored varnish also obscures the surface.
 Provenance: collection Count Donà delle Rose, Venice, by 1934; bought by the Wadsworth Atheneum in 1939 from Adolf Loewi, New York, for $1,600 from the Sumner Fund.
 Exhibitions: Toronto, 1964, 152–53, no. 127, as Marco Ricci; Venice, 1967, 90–91, no. 41; Hartford, 1982.
 The Ella Gallup Sumner and Mary Catlin Sumner Collection, 1939.290

The ruins of a temple and other classical monuments are scattered before two columns and the remains of an entablature. At the right a vase surmounts a crumbling plinth. In the middle ground a low cottage, covered with foliage, nestles amid the ruins, while in the center background a building closely resembling a corner of the upper story of Sansovino's Libreria Marciana is seen. Small figures—one, at the left, with a flag, another gesturing toward the back, and a female figure partly obscured at the right—animate the scene.

The Atheneum picture is one of a pair of architectural fantasies. The pendant, now in the Sorlini Collection, Venice, shows a ruined temple at the left, and in the center background a crumbling arena.[1]

The Atheneum picture is one of several imaginary view paintings that have in the last few years been attributed to young Canaletto.[2] This attribution has now been generally accepted, although Constable continued to uphold an attribution to Marco Ricci.[3] Indeed, the Atheneum picture and its pendant show striking similarities to paintings known to have been

painted by Canaletto before 1723, including the ex-Liechtenstein views. Points of contact include the abruptly foreshortened buildings, the dramatic chiaroscuro, and the freely painted figures.[4] In its combination of classical ruins with recognizable monuments, ancient or modern, the Atheneum picture is closest to two imaginary views which, though not universally accepted as Canaletto's, are most likely to be by the young painter, the *Arch of Constantine*, formerly Bracaglia Collection, New York,[5] and the *Capriccio with Ruins* in a private collection in Milan, signed and dated 1723.[6] Constable has pointed out the common use of a dark reddish ground, the strong contrasts of light and shade, and the handling of paint, resulting in a striking impasto, between the Atheneum painting and the ex-Bracaglia painting.[7] The fragile structures of the ruins, the handling of paint, particularly in the figures, and the dramatic orthogonals along which the picture is constructed also link the Atheneum picture with the 1723 painting. The combination of ruins with Venetian Renaissance architectural monuments—Sansovino's library in the Atheneum picture, and Palladio's basilica at Vicenza in the Milan painting—are also shared. The sunny atmosphere and hint at a palpable mist, so striking in the Milan picture, are also present in the Atheneum picture and its pendant.

It must be conceded that the Atheneum picture differs from generally accepted early paintings by Canaletto in a number of ways. The expansive space—the deep penetrations into space, accomplished particularly by the paved roads in the ex-Bracaglia and Milan paintings—is notably absent from the Atheneum painting, which has a narrow, stagelike foreground with only abbreviated indications of middle- or background. The way the urn and fragments of columns pile up at the left in the Atheneum painting is also not common to the paintings generally proposed as young Canaletto's. Just these features tie the Atheneum painting more closely to Marco Ricci's ruin paintings from the early and mid 1720s, for example, the pair of *Ruins with Statuary* in Kassel, Staatliche Kunstsammlungen,[8] the pair of *Classical Ruins with Figures* in the Gaggia Collection, Lausanne,[9] and the large picture of *Ruins with Figures* in the Museo Civico in Vicenza.[10] The anomalous position of the Atheneum picture can perhaps be clarified if we consider a picture exhibited in Milan in 1967 as by Marco Ricci.[11] The Milan picture shows essentially the same composition as the Atheneum picture, but in the Atheneum picture the architectural ruins have been made lighter and more fanciful; the foreshortenings, for example, of the Sansovinesque structure in the mid ground, have been made sharper and more daring; the lighting has been made more dramatic and the atmosphere more palpable; and overall detail has been obscured by a virtuoso manipulation of paint. These are all features that characterize generally accepted youthful works by Canaletto. In the Milan painting, by contrast, the

pedantic touch and literal treatment of detail is close to Marco Ricci's paintings of ruins cited above. It seems reasonable to accept the attribution of the Milan painting to Ricci and Precerutti-Garberi's proposal that the Atheneum painting was a free copy by Canaletto of Ricci's work.[12] If this is so, it would not only provide the first concrete link between Canaletto's early paintings and Ricci's contemporary ruin paintings, but it would also perhaps explain the pronounced Riccesque features of the Atheneum painting.[13]

The date of the Atheneum painting has been generally thought to be between 1720, the year of Canaletto's return from Rome, and 1723, the *terminus ante quem* of the ex-Liechtenstein paintings.[14] A date close to Canaletto's return to Venice from Rome, about 1721–22, seems preferable. J.C.

1. The pendant reportedly measures 72 x 54 cm. The pictures were together until at least 1934, when they were in the Donà delle Rose Collection; see Lorenzetti and Planiscig, 1934, 31, nos. 154–55. The Sorlini picture was mistakenly thought by Pallucchini, 1973, 159, to have been in the Atheneum; Martini, 1982 ed., 533, pointed out this error and mentioned that the pendant had been also with Loewi, and subsequently in the Freidemberg and Sorlini collections. Morassi, 1966, 210, suggested that a picture of ruins formerly in the Agosti Collection, Belluno, illustrated by him as fig. 251, might be a pendant to the Atheneum picture. The dimensions of the Belluno picture, reported by Morassi to be 82 x 63.5 cm, seem too large for a pendant.
2. The attribution to young Canaletto was made by Martini, 1964, 176, n. 90, and Morassi, 1966, 210, 217, n. 6, fig. 252. It was accepted by Zampetti in Venice, 1967, 90, no. 41; Pilo, 1967, 273; Bindman and Puppi, 1970, 89, no. 6; Fredericksen and Zeri, 1972, 585; Pallucchini, 1973, 159, 160, 166–67; Constable and Links, 1976, II, 449, no. 479****; Barcham, 1977, 91 (who, however, confuses his discussion of the Hartford painting with a picture of ruins formerly in Belluno); Martini, 1982 ed., 79; and Corboz, 1985, I, 390, fig. 454, II, 562, no. P11. The attribution to Canaletto was also accepted by J. Byam Shaw, letter to C. Cunningham, 6 June 1963, curatorial file, and by W. Barcham, letter to L. Horvitz, 14 Aug. 1984, curatorial file.
3. Constable, 1963, 4–6; W. G. Constable, "Some Venetian *vedute* Paintings in the Wadsworth Atheneum," *Antiques*, Nov. 1965, 669–71; and in Toronto, 1964, 152, no. 127. Constable, in a letter to C. Cunningham, 27 June 1963, curatorial file, said, "The photograph of the Marco Ricci gives some evidence in favor of Canaletto the painter, but I should not like to dogmatize until I had seen the painting." Previous attributions to Ricci include Lorenzetti and Planiscig, 1934, 31, nos. 154–55; J. W. Lane, "Notes from New York," *Apollo*, XXVII, 1938, 263; and M. Milkovich in Memphis, Books Memorial Art Gallery, *Sebastiano and Marco Ricci in America*, 19 Dec. 1965–23 Jan. 1966, 53.
4. For discussion of these paintings, see Constable and Links, 1976, I, 100–101; for good illustrations, see Venice, 1967, 38–39, nos. 3–4.
5. Constable and Links, 1976, II, 390, no. 382*.
6. Constable and Links, 1976, II, 449, no. 479**.
7. Toronto, 1964, 152, no. 127. Constable, however, retains the attribution of the Atheneum picture to Ricci, saying that it was just these aspects of his early style that Canaletto learned from Ricci. Further observations on Canaletto's technique are made by V. Pemberton-Pigott in New York, 1989–90, 53–63.
8. Bassano, 1963, 74–75, nos. 50–51.
9. Bassano, 1963, 86–87, nos. 60–61.
10. Bassano, 1963, 88–89, no. 62. Pilo, 1967, 271–73, in his review of the 1967 exhibition at the Palazzo Ducale, says that of all the proposed early pictures by Canaletto, the Atheneum picture is the most difficult to accept because of its proximity to Marco Ricci.

Canaletto, *Landscape with Ruins*

11. Precerutti-Garberi, 1967, 10–11, no. 2.

12. Precerutti-Garberi notes that the Milan picture is smaller than the Atheneum picture, 42 x 36 cm. The close correspondence of the compositions suggests that the Atheneum picture has not been cut down substantially, as suggested by Morassi, 1966, 217, n. 6. Precerutti-Garberi also proposes that the pendant to the Atheneum picture, now Sorlini Collection, was also copied after Marco; in the absence of Ricci's model, however, this cannot be confirmed.

13. Indeed, it is the composition of the Atheneum painting that has caused greatest hesitation in attributing it to Canaletto. The coloration, lighting, and touch have been cited as most characteristic of Canaletto; see, for example, Pilo, 1967, 273. Canaletto's relations with Ricci have been the subject of some discussion; see, for example, Morassi, 1966, 210–11; Constable and Links, 1976, I, 58–59. Certainly, Canaletto knew Ricci's works and profited from them, particularly from the fantasies with ruins that Ricci painted after his return to Venice in 1716. That the two artists met in Rome in 1719–20, as tentatively proposed by Precerutti-Garberi, 1967, 10, is pure speculation.

14. Morassi, 1966, 210, suggests a date of 1722–23, "if not before"; Zampetti in Venice, 1967, 90, no. 41, dates it to 1720–22; Bindman and Puppi, 1970, 89, no. 6, to 1722; Pallucchini, 1973, 166–67, to 1720–21; Constable and Links, 1976, II, 449, no. 479****, accept Zampetti's date of 1720–22.

View of Venice: Piazza and Piazzetta S. Marco

Oil on canvas, 66.1 x 103.4 cm (26 x 40³/₄ in.)

Condition: good. Numerous incisions made in the wet gesso are visible, for example, along the portico of the church of S. Marco, along the top of the Palazzo Ducale, in the pavement of the Piazza in front of the Procuratie Vecchie. These incisions are episodic, however, and were used as aids in the execution of the picture. They do not constitute a coherent compositional scheme.

Inscribed, lower left, in red: 3[?] 4[?] 5

Provenance: collection Martin Colnaghi, London; Louis Costa Torro; sale New York, Anderson Galleries, 20–21 Jan. 1927, no. 36, bought by Knoedler & Co. for $750; Gaston Neumans, Paris, 1928; Rosenbaum, Berlin; Hugo Moser, sale New York, Parke-Bernet Galleries, 20 Apr. 1946, no. 32, bought by Schoeneman Galleries, New York, for $5,500; purchased by the Wadsworth Atheneum in 1947 from J. Schoeneman for $6,500 from the Sumner Fund and by exchange.

Exhibitions: Hartford, *Fifty Painters of Architecture*, 1947, 9, no. 9, pl. V, fig. 12; New Haven, Conn., Yale University Art Gallery, '*Ars in Urbe': An Exhibition of Civic Art from Renaissance to Present Times in Europe and the United States*, 10 Apr.–17 May 1953, cat. in *Bulletin of the Associates in Fine Arts at Yale University*, XX, no. 3, 1953, no. 23, pl. 8; Hartford, 1955, 8, no. 29; Toronto, 1964, no. 25; Ithaca, N.Y., Andrew Dickson White Museum of Art, Cornell University, *Views of Venice*, 7 Sept.–17 Oct. 1971, no cat.

The Ella Gallup Sumner and Mary Catlin Sumner Collection, 1947.2

The Piazza and the Piazzetta S. Marco are seen from somewhere just in front of the Torre dell'Orologio. The campanile, with a low shed at the base, is seen obscuring the facade of the Libreria Marciana; to the right extend the Procuratie Nuove. At the far right the Procuratie Vecchie are seen in steep perspective;

at the left, part of the facade of the basilica of S. Marco and, beyond, a glimpse of the facade of the Palazzo Ducale are seen. Three flag poles and five vendors' booths fill the piazza. In the distance the Bacino di S. Marco is crowded with shipping, obscuring somewhat the view of S. Giorgio Maggiore.

The Atheneum picture is one of a number of paintings by Canaletto showing the same scene from approximately the same viewpoint.[1] The others include a painting in the Soane Museum, London (Fig. 11), in which the viewpoint is shifted slightly to the east and the whole facade of the basilica is shown, and another variant of the Soane picture that was in the London art market in 1956.[2] A picture in the Cleveland Museum of Art shows a similar view of the Piazza, but the viewpoint is shifted to the west and the complete facade of the church is seen (Fig. 12).[3] A view from a standpoint slightly to the east of that in the Atheneum painting, showing the entire facade of the basilica but only the first few bays of the Procuratie Nuove and part of the campanile, is in the Royal Collection at Windsor Castle.[4]

Though Canaletto described views such as the Atheneum picture as "prese da i luoghi,"[5] it has been recognized that these pictures are subtly crafted manipulations of appearances.[6] In the Atheneum picture the artist employs at least two vanishing points—one, for the Piazzetta, just to the left of the column of St. Theodore, and another, just to the right of the facade of S. Geminiano; but the perspective schemes are not rigidly adhered to.[7] Moreover, it has long been recognized that many of Canaletto's pictures, including the Atheneum painting, show views that are impossible to replicate in real life.[8] That Canaletto, therefore, made use of a *camera ottica* or other photomechanical device in making the Atheneum picture has frequently been suggested.[9] The question of Canaletto's use of the *camera ottica* is complex. Contemporary sources testify to his use of such a device, and a portable *camera ottica* found recently in the Correr Museum in Venice inscribed with the artist's name corroborates their accounts.[10] How Canaletto actually employed it, and how he incorporated its data into his pictures, however, is an open question.[11] Parker is undoubtedly correct when he says that even if Canaletto used a *camera ottica* for a given picture, it is probably impossible to detect its use.[12] In any case, there is no physical or visual evidence in the Atheneum picture that would betray Canaletto's use of a *camera ottica*.

The few drawings by Canaletto that can be associated with the Atheneum picture do not shed any light on its genesis or its relation to the other versions. A drawing in pen and ink inscribed *Anno 1731* shows a view of the Piazza and Piazzetta close to the Atheneum view, but, like the Soane picture, seen from slightly to the east.[13] This drawing, however, is probably an independent work, conceived in the studio, rather than a preparatory drawing for a specific picture. That Canaletto may have made use of it in composing the Atheneum picture cannot be excluded, nor can it be demonstrated.[14] Another drawing at Windsor shows a view similar to the Atheneum picture, but with the Procuratie Nuove seen from almost straight on, as in the Cleveland

Canaletto, *View of Venice: Piazza and Piazzetta S. Marco*

picture.[15] Again, the drawing is highly finished and shows signs of being an independent composition worked up in the studio, rather than preparatory to a specific picture.

Constable and Links also suggest that an etching by Luca Carlevarijs, published in 1703 and showing the Piazza and Piazzetta from a viewpoint similar to that of the Atheneum picture and its related versions, may have served as a model for Canaletto.[16] A similar view of the Piazza was published in D. Louvisa, *Il grand teatro* in 1720, and an etching by Marieschi in *Magnificentiores selectioresque* in 1740. In the absence of complete documentation of Canaletto's working methods, it is impossible to determine whether any of these prints were used by Canaletto in painting the Atheneum picture.

The date of the Atheneum picture may be gauged only on the basis of style. The precision of detail and the somewhat staid character of the figures suggest a date of around 1740.[17] J.C.

1. Bindman and Puppi, 1970, 107, no. 190A; Constable and Links, 1976, II, 209–10, no. 54, I, pl. 20. Further bibliography, in addition to that cited below, includes C. C. Cunningham, "Florence and Venice as Seen by Vanvitelli and Canaletto," *Wadsworth Atheneum Bulletin*, Feb. 1947, 1; J. McAndrew, "Built in Paint," *Art News*, XLVI, Nov. 1947, 52; H. S. Francis, "Canaletto Piazza S. Marco, Venice," *Bulletin of the Cleveland Museum of Art*, XLIX, 1962, 190; Pallucchini, *Arte veneta*, 1966, 319; Fredericksen and Zeri, 1972, 585; Cleveland, Cleveland Museum of Art, *European Paintings of the Sixteenth, Seventeenth, and Eighteenth Centuries*, 1982, 318; Corboz, 1985, II, 650, no. P305.

2. Constable and Links, 1976, II, 210, no. 54a–b. The latter is tentatively ascribed to the young Bellotto. Constable and Links state incorrectly that the southern-most flag pole is seen to the right of the campanile in the Soane picture; it is just to the left.

3. Constable and Links, 1976, II, 208–9, no. 53, I, pl. 20, with related versions.

4. Levey, 1964, 63, no. 404.

5. Canaletto himself differentiated between views "ideate" and those "prese da i luoghi" in the title of his etchings dedicated to Joseph Smith and published in Venice sometime after 1744; see R. Bromberg, *Canaletto's Etchings*, New York, 1974, 37–41, no. 1. See also Parker, 1948, 25; and Barcham, 1977, 3–9 on the difference between Canaletto's topographical and imaginary views.

6. Although contemporary sources report that Canaletto worked out of doors, most of his works must have been conceived and executed in the studio from memory or with the aid of drawings and engravings; see Constable and Links, 1976, I, 158, 1989, I, xxv–xxviii. See also Corboz, 1974, 205–16; 1985, I, 80–81, figs. 69, 72; and Links in New York, 1989–90, 14.

7. N. Knobler, *The Visual Dialogue*, New York, 131, says that "the [Atheneum] painting is composed of two separate views, though these have been combined to conform to perspective rules." This does not, however, seem to be the case.

8. Pignatti, 1979, no. 26. Corboz, 1974, 206, notes that in the Atheneum picture the distance between the basilica and the Torre dell'Orologio is impossibly large; see also London, 1980–81, 17–19, and various catalogue entries on the paintings in this exhibition that note the variations of Canaletto's views from sightings made on the spot.

9. Constable, 1963, 10.

10. Constable and Links, 1976, I, 161–62.

11. Pignatti, 1958, makes a reasonable suggestion of how Canaletto may have employed a *camera ottica*, to make general panoramic views that he would use as guides to integrate detailed sketches made on the spot. See, however, D. Gioseffi, *Canaletto. Il Quaderno delle gallerie veneziane e l'impiego della camera ottica*, Trieste, 1959, for another view; Constable and Links,

Figure 11. Canaletto, *Piazza and Piazzetta S. Marco*, London,
Sir John Soane's Museum

Figure 12. Canaletto, *View of the Piazza S. Marco, Venice, and
the Piazzetta Looking towards S. Giorgio Maggiore*, Cleveland,
Cleveland Museum of Art

1976, I, 114; and J. Byam Shaw, review of London, 1980–81, in *Burlington Magazine*, CXXIII, 1981, 182. Corboz, 1974, 212, makes the interesting point that Canaletto probably used the distortions of appearances produced by the *camera ottica* as a means of manipulating reality and not of recording it. Indeed, Zanetti's remark (1771, 462), that Canaletto "unì ne' suoi quadri alla natura le pittoresche licenze con tanta economia che le opere sue vere compariscono," suggests that Canaletto's artifice was always recognized.

12. Parker, 1948, 26; Parker, 41, nonetheless remarks in relation to a group of drawings in Windsor, including one (no. 62) that shows a view of the Piazza and Piazzetta similar to the Atheneum view, that "the salient feature of the drawings is their capricious distortion of spatial distances, while their architectural features are essentially accurate in rendering. The effect produced is rather like that of viewing the scenes through inverted binoculars. It remains a moot point whether they were fancifully conceived or actually seen by the artist through a combination of lenses." Links, in his annotation to Constable, 1976, II, 486, says, "However, it is hard to imagine any combination of lenses which could produce these views from any viewpoint. . . . The alternative of their being 'fancifully conceived' is the only acceptable explanation."

13. Constable and Links, 1976, I, pl. 214, no. 537*. This may be the same drawing mentioned as lost by Constable and Links, 1976, I, 114, n. 1.

14. See Parker, 1948, 30, nos. 7–10; and Constable and Links, 1976, I, 107, on Canaletto's independent drawings.

15. Parker, 1948, 41, no. 62; Constable and Links, 1976, II, 485–86, no. 537, I, pl. 97.

16. Constable and Links, 1976, II, 486, no. 537; Rizzi, 1967, 102, fig. 92.

17. Constable, in Toronto, 1964, 52, suggested a date between 1730 and 1741; Bindman and Puppi, 1970, 107, no. 190A, a date of between 1740 and 1745; Corboz, 1974, 206, also between 1740 and 1745; H. Potterton, *Pageant and Panorama: The Elegant World of Canaletto*, Oxford, 1978, 36, a date in the early 1730s; W. Barcham, oral communication, 1984, to the late 1730s.

Giovanni Battista Caracciolo (1578–1634)

No fully accepted works of Caracciolo's Neapolitan youth survive, but it is agreed that he put aside the late mannerist style in which he was nurtured when Caravaggio first appeared in Naples in 1606. From 1607 until 1614, that is, until he first visited Rome, he wholeheartedly adopted Caravaggio's tenebrism and can properly be described as his most sensitive Neapolitan convert.[1] But the conversion took place when Caracciolo, called Battistello, was in his late twenties, and it is not surprising, therefore, that his mannerist formation intrudes even into his tenebrist phase and is recalled throughout his career, especially in his angular sense of form and his linearity in design. Indeed, therein lies much of the artist's appeal. After 1614 he departed from his tenebrist mode radically, embracing such varied influences as that of the Gentileschi and of Bolognese classicism, an evolution reflecting not only the accumulated effects of his travels to Rome, Florence, and Genoa in the 1610s, but also the availability in Naples of important works by Vouet in the 1620s, as well as the presence there of Guido Reni (as early as 1612 and in 1622), Artemisia Gentileschi (by at least 1630), and Domenichino (1631–41).[2]

1. For example, *The Immaculate Conception with Saints Dominic and Francis of Paul*, Sta. Maria della Stella, Naples, which de Castris has shown to be a work of 1607 (London, *Painting in Naples*, 1982, 111–12, no. 5).

2. Stoughton, 1973, 56–62.

The Annunciation

Oil on canvas, 62.7 x 49 cm (24⅝ x 19¼ in.)
 Condition: fair. There are discolored repairs throughout the background. At the back of the vaulted space, before a recessed niche, the bottom portion of which forms a bed or bench, there hangs a curtain whose deep green has darkened. The figures are intact. The heavy shadowing over the back of the angel's right hand is original. The flowers similarly are intact, despite their flat appearance under discolored varnish.
 Monogrammed in the upper left: CA[intertwined]B
 Provenance: Romano Collection, Florence. Purchased by the Wadsworth Atheneum in 1932 from Durlacher Bros., New York, for $3,000 from the James J. Goodwin Fund.
 Exhibitions: New York, Durlacher Bros., 1932, no. 2; Poughkeepsie, Vassar College, 1936?;[1] Hartford, 1940, no. 4; San Francisco, 1941, no. 11; New York, 1946, no. 3; Hartford, 1948, no. 1; Ann Arbor, 1951–52, no. 1; Poughkeepsie, 1956, no cat.; Sarasota, 1958, no. 14; Kent, 1966; Caracas, 1967, no. 7.
 James J. Goodwin Fund, 1932.292

The picture first appeared in the early 1930s and was described then as a characteristic Caracciolo bearing the artist's initials.[2] The well-drawn, gilt monogram has been read in various ways, but is sensibly interpreted as an interlocked capital CA followed by an attached, smaller capital B, that is, *Battistello CA*racciolo.[3] The attribution has been well received in the literature.[4]

Moir placed this painting among a group of works about 1615–20, which he sees as Caracciolo's most intensely Caravaggesque phase, climaxing in the *Christ Washing the Feet of the Apostles* of 1622 for the monastery of S. Martino, Naples.[5] His words regarding the latter could well be used to describe the Atheneum picture:

> It shows traces of that primary awareness of the two-dimensional by which Caracciolo was haunted; the figures exist on a stage, cut off from the dimness of the background. They are arranged in a . . . composition which works as much from left to right as from near to far. The sharply defined outlines and the mannered poses . . . are characteristic. In the same manner the figures are bulky without being massively solid; their movements are agitated but appear to be frozen rather than momentarily suspended. All of this suggests a striving for a more dynamic style through means that are linear rather than purely plastic, and hints at a recrudescence of Mannerism.[6]

This two-dimensional, mannered quality of projecting form in the full round can be well illustrated by comparing the angel here with a drawing in Berlin of the same subject.[7] In each, the body is less a coherent plastic mass than a series of hinged units.

Stoughton, who cites a provenance from the Romano Collection, Florence, probably acquired in Naples, dates it about 1628–29, that is, immediately prior to the last and completely different stylistic phase of the artist's work. He suggests it is undoubtedly a sketch, comparable stylistically, as well as in the

Giovanni Battista Caracciolo,
The Annunciation, detail

proportions of the figures to the architectural setting, to the *bozzetto* in the Museo Correale, Sorrento, for *St. Ignatius Loyola and the Pious Works of the Jesuits*, a lost altarpiece completed in 1629.[8]

Prohaska adopts the same dating and links the Atheneum painting to the *Madonna of the Purification of the Soul with Saints Francis and Clare*, Sta. Chiara, Nola, and to the monogrammed *Madonna and Child*, Los Angeles County Museum, which he dates respectively about 1625 and about 1626–29.[9] Certainly there are parallels to be drawn with the Madonna's head here and in each of those pictures, particularly that in Los Angeles. He also comments on the similarity between the profile of the angel here and those of the rightmost attendant figures, also in profile, firstly in the *Birth of the Virgin*, a fresco in the Oratorio dei Nobili, Gesù Nuova, Naples, and secondly in a *Salome Receiving the Head of John the Baptist* in the Museo de Bellas Artes, Seville, both of which he dates to about 1629. This convention is interpreted as a Tuscan influence, as is the architectural setting in the Hartford painting, whose source he suggests could be Jacopo Ligozzi's *Circumcision* in St. Anastasia, Lucca, where a friezelike arrangement of figures is disposed on steps before a groin-vaulted room.[10] Finally, Prohaska sees parallels in the angel's drapery here with passages in the above-mentioned *Birth of the Virgin* and the *bozzetto* for the *St. Ignatius*, adding a comparison with the angel in the sketch for *St. Januarius Emerging Unharmed from the Fiery Furnace*, part of a fresco series for the saint's chapel in S. Martino, Naples, which he dates 1632.[11]

A date in the second half of the 1620s would be congruent with de Castris's observation that between 1625 and 1631 Caracciolo's work assumed a hybrid character, that there was a reassertion then of his mannerist sensibilities, wherein Caravaggesque tene-

brism is combined with the linearity and distorted forms of Lanfranco.[12] Certainly, such elements can be said to characterize the Atheneum picture.

The architectural setting could not be described as felicitous. Even if it is meant to be read as a backdrop for the friezelike disposition of the foreground figures, that is, that it does not attempt to enclose the figures, the realization of the groin vaulting is spatially inept. The vanishing point suggested by the top of the door behind the angel and by the top of the patch of light above the Virgin is, with iconographic aptness, on her womb, but as individual design elements they are weak. The figures, however, are superb. Under magnification the heads of the Madonna and Gabriel, plus the Paraclete are seen to be liquidly described with a delicate touch. That the painting is monogrammed might indicate it was considered a finished work, conceivably a small devotional picture for private use.　　　　　M.M.

1. While the curatorial file indicates such a loan, no other substantiating documentation has been found.
2. Borenius, 1931, 221, repr. 229. Offered to the Atheneum in November 1932 by Durlacher's together with a transcription of a letter (curatorial file) from H. Voss, "a very fine example of the master." *Wadsworth Atheneum Bulletin*, Apr. 1933, 7. Wadsworth Atheneum, *Avery Memorial*, 1934, 26, illus.
3. Stoughton, 1973, 4–5. Stoughton notes that although there is no reason to doubt the monogram's authenticity, the A is unusual in that it is the only example with curved legs. Examination of the monogram under high magnification gives no indication that it is other than contemporary to the picture surface.
4. McComb, 1934, 123; Longhi, "Ultimi studi," 1943, 44, n. 30; *Art News*, XXXXV, Mar. 1946, 38, repr.; Bloch, 1948, 63; Volpe, 1972, 56–57, fig. 10, "una delle opere più pertinenti della antologia Caravaggesca"; Fredericksen and Zeri, 1972, 44, 305, 584; Nicolson, 1979, 30; Spinosa, 1984, pl. 98. Also see below Moir, 1967; Stoughton, 1973; Prohaska, 1978.
5. Moir, 1967, I, 162, n. 27; the *Christ Washing the Feet of the Apostles* is reproduced in III, fig. 185.
6. Moir, 1967, I, 163.
7. Kupferstichkabinett 24363, black chalk on blue paper, 210 x 123/132 mm (irregular), Pacetti Collection (Lugt 2057), inscribed in the lower right: D. Batis[ta]/Napol[i]. Prohaska, 1978, 234, fig. 189, dates the drawing circa 1623–25, and places it in the context of Caracciolo's frescoes for the Severino Chapel, Sta. Maria la Nuova, Naples. Excellently reproduced by Dreyer, 1979, no. 63. For further Caracciolo drawings, see those in Stockholm published by Moir, 1970, one of which, *An Officer with Heads of Two Other Figures* (fig. 12, inv. no. 1748.1863), is very like the above Berlin drawing.
8. Stoughton, 1973, 141–42, no. 55, figs. 44 and 45. For the *bozzetto*, see Stoughton, 1973, 139–41, no. 54, 46 x 35.5 cm; reproduced in Prohaska, 1978, 240, fig. 216, or Fot. Sop. Gall. Nap. 6421.
9. Prohaska, 1978, 252–53; the Nola and Los Angeles paintings are reproduced in figs. 194 and 218. Stoughton, 1973, 95–98, nos. 24 and 25, dates them both circa 1615–16.
10. Prohaska, 1978, 252–53, figs. 217–19. Stoughton, 1973, 166–67, no. 75, and 108–9, no. 34, dates them respectively circa 1634–35 and circa 1620. The Ligozzi is reproduced by G. Bacci in *Proporzioni*, IV, 1963, pl. 50.
11. Prohaska, 1978, 252–53. His fig. 227 reproduces the *bozzetto* for the *Januarius and Companions Pulling Timothy's Chariot*. The *bozzetto* for the *Fiery Furnace* is reproduced by Moir, 1967, II, pl. 197. Stoughton, 1973, 129–34, nos. 49 and 50, dates the *bozzetti*, which are in the Museo di S. Martino, Naples, circa 1625 and the frescoes circa 1625–26.
12. P. de Castris in London, *Painting in Naples*, 1982, 111.

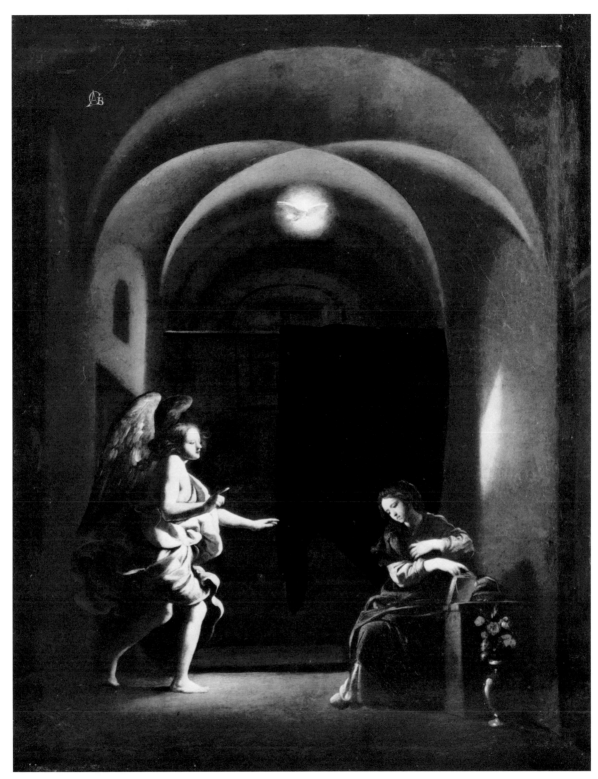

Giovanni Battista Caracciolo, *The Annunciation*

Michelangelo Merisi da Caravaggio (1571–1610)

Because his father, according to Mancini, was in the service of Francesco Sforza Colonna, Marchese di Caravaggio, the artist spent his youth between the Lombard town of Caravaggio, after which he is popularly called, and Milan, where he was apprenticed in 1584 for four years to Simone Peterzano. When he established himself in Rome after July 1592, he lived precariously at the start and in great difficulty, according to his biographers, Giulio Mancini (1619/20), Giovanni Baglione (1642), and Giovanni Bellori (1672), who, however, do not speak with one voice regarding the nature of his earliest work and patrons. According to Bellori, Caravaggio entered Cavaliere d'Arpino's workshop, where he painted still lifes. Some authorities would connect one of the Atheneum's pictures with this phase. His other early works are allegorical subjects, genre scenes, and easel-sized religious pictures that use real-life models and situations to convey their moralizing or religious messages. A developed work of this phase is the Atheneum's *St. Francis*, which, if not the first, is among the first to incorporate Caravaggio's celebrated use of tenebrist settings illuminated by a light that is at once naturalistic and symbolic. Painted about 1595, when the painter was about to be, or had already been taken up by the cultivated Cardinal Francesco Maria del Monte, the picture marks a transition that culminated in his public success as a history painter: the St. Matthew triad in the Contarelli Chapel in S. Luigi dei Francesi (1599–1602), and the two canvases, *The Crucifixion of St. Peter* and *The Conversion of St. Paul*, in the Cerasi Chapel in Sta. Maria del Popolo (1600–1601). The following half decade brought more, much discussed Roman commissions, but was paralleled by the increasing violence of his character, aggressiveness which led him to flee to Genoa in 1605, and then to leave Rome definitively the following year after killing someone in a dispute over a ball game in May 1606. He first sheltered with the Colonna in Zargarolo outside Rome. Thereafter, Caravaggio was in Naples in the autumn of 1606, and had moved to Malta by July 1607, where he painted the portrait of the grand master of the Order of St. John and was made a knight of the order. But by October, after being imprisoned, he fled the island to Sicily. He worked then in Syracuse, Palermo, and Messina. By October 1609, he was back in Naples, again involved in a brawl. Thereafter, he started back to Rome in anticipation of a pardon, but died en route of a fever in Porto Ercole.

This short-lived and contentious figure was the first to weld the grand, monumental tradition of Italian Renaissance art to a vocabulary that, while equally symbolic, was rooted in the real world. Even in his own century, the implications of his point of view were more important throughout the whole of Europe than his specific style. Twentieth-century art history in particular sees Caravaggio as one of the greatest generative forces in the Western pictorial tradition.[1]

1. M. Gregori in London, *Painting in Naples*, 1982, 123, and in New York, 1985, 28–47.

St. Francis

Oil on canvas, 93.9 x 129.5 cm (37 x 51 in.)

Condition: good. The picture was treated with outstanding success in 1983 by Gisela Helmkampf under the direction of John Brealey at the Metropolitan Museum of Art. The effects of darkened pigments in the middle of the sky above the landscape, in part owing to the surface having been scorched in an old relining, have been minimized. The scorched area, which begins 6 centimeters from the top and about 45 centimeters in from the left edge, is an elliptical shape about 23 centimeters high and 8 centimeters at its widest. Unnecessary inpainting over a loss on the angel's left cheek and hair was reduced by a half, to a patch about 15 by 10 centimeters. A composite X ray (Fig. 13) shows the extent of the loss. There are pentimenti on both figures, for example, on the saint's upper left arm, left foot and ankle, the crook of his arm, and, importantly, on the back of his right hand. That area, sometimes read to be a covered-over stigma, is a pentimento. Originally, Caravaggio had brought the cuff of the sleeve midway down the back of the hand. Something of that intention has reappeared with the passage of time. There are adjustments, too, in the angel's leg. Finally, the restoration has brought into high relief the crisply defined plants and flowers in the foreground.

Provenance: presumably Ottavio Costa, Rome, by 1606 (see below); Ruggero Tritonio, Rome, by 1607; by bequest in 1612 to his nephew, Ruggero Tritonio; Dr. Guido Grioni, Trieste, by 1929. Purchased by the Wadsworth Atheneum in 1943 from Arnold Seligmann, Rey & Co., New York, for $17,000 from the Sumner Fund.

Exhibitions: Naples, 1938, no. 4; Hartford, 1940, no. 5; Hartford, *Caravaggio*, 1943, no cat.; New York, 1946, no. 1; Hartford, *In Retrospect*, 1949, no. 3; Milan, 1951, no. 17; Seattle, 1954, no cat.; New York, 1958, 60 bis; Sarasota, 1958, no. 15; Poughkeepsie, 1959, no cat.; Richmond, 1961, repr. 59; Baltimore, Baltimore Museum of Art, May 1964, lent in honor of the museum's fiftieth anniversary year; Detroit, 1965, no. 2; Cleveland, 1971–72, no. 14; New York, 1985, no. 68.

The Ella Gallup Sumner and Mary Catlin Sumner Collection, 1943.222

In 1894 Joppi published the "1597" will of Ruggero Tritonio, a Roman cleric, born in Udine, who had as a benefice the abbey of Pinerolo in the Piedmont. In the will a *St. Francis* by "the celebrated painter" Caravaggio, a gift to the testor from Ottavio Costa, was bequeathed to a nephew with the injunction that it should be kept in the family forever. Joppi identified this with a picture then in S. Giacomo, Fagagna, a gift to the Friulian church in 1852 from Count Francesco Fistulario,[1] presumably a descendant of Tritonio's Friulian heirs. In 1925 the whereabouts of the picture was unknown to Borenius when he republished Joppi's information.[2] In 1928 A. Venturi tentatively identified the Costa/Tritonio work with a painting in the Museo Civico, Udine (Fig. 14).[3] But in 1929 Marangoni published the Atheneum's similarly sized version of the same composition, then in the collection of Dr. Guido Grioni in Trieste, a painting said to have come from Malta. Citing the "finest possible condition" of the Trieste/Atheneum picture, which "boasts such freshness in painting as to exclude a priori the characteristics of a copy," and comparing it to the "disastrous state" of the Udine painting, Marangoni argued that at best both could be "originals from the hand of the master, recognizing, however, that one of the two is in the worst possible condition and entirely repainted."[4] Longhi conceded

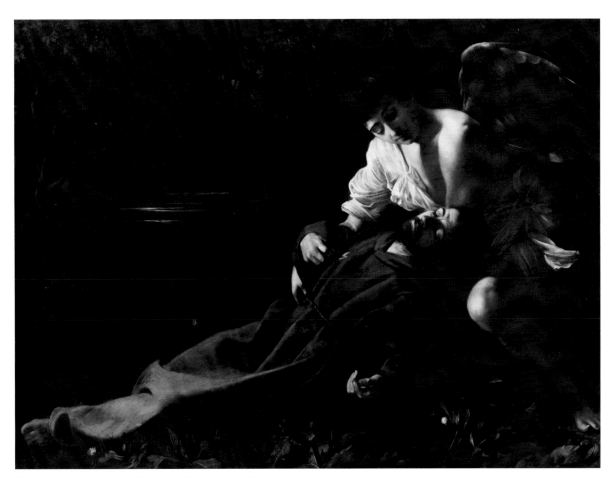

Michelangelo Merisi da Caravaggio, *St. Francis*

the superiority of the Trieste/Atheneum picture and initially thought both derived from a lost original of about 1594.[5] Later he came to consider the Udine picture a copy of the Trieste/Atheneum picture, the original work.[6] The Trieste picture was exhibited in Naples in 1938,[7] was brought to America in 1939,[8] shown at the museum in 1940, and then acquired in 1943. Thereafter it was exhibited at the 1951 Milan, the 1971 Cleveland, and the 1985 New York and Naples Caravaggio exhibitions. On the first two occasions the painting was given to Caravaggio as a youthful work of the 1590s,[9] an attribution and dating that have been widely accepted,[10] but not unanimously nor with unanimous enthusiasm.[11] Despite the fact that the Hartford picture is generally thought to be the superior, its history vis-à-vis the Udine version remains a nettlesome problem.[12] How could the picture entailed on Tritonio's heirs turn out to be a copy? Is it possible that Costa, knowingly or unknowingly, had simply passed on a copy to Tritonio?[13] But then

one would have to ask if Tritonio, given his situation in Rome, would have been unaware of such a fact, for Tritonio was secretary there to Sixtus V's nephew, Cardinal Montalto, a post he had occupied since at least 1599.[14]

Ottavio Costa, of the Genoese noble family, was a banker in Rome for the Vatican.[15] He made a will on 6 August 1606, offering his friend Ruggero Tritonio a choice between two unattributed pictures, either a *St. Francis* or a *Saints Martha and Mary Magdalene*, plus naming Tritonio as coexecutor.[16] Costa did not die until 1639, but he presumably gave Tritonio the *St. Francis*, for it was in the following year, on 25 October 1607—*not in 1597* as Joppi initially reported in 1894— that Tritonio made his will leaving his nephew Ruggero a painting received as a gift from Costa, a *St. Francis* by Caravaggio, who, it now being 1607, is aptly described as being "most famous." It is assumed the unattributed *St. Francis* in Costa's 1606 will is that by Caravaggio in Tritonio's 1607 testament. In the latter the heir is urged to emulate his uncle and seek a career in the Roman Curia.[17] How this was achieved,

Figure 13. Caravaggio, *St. Francis*, X ray

Figure 14. Caravaggio, *St. Francis*, Udine, Museo Civico

after the young Ruggero inherited in 1612, might be explained by the appearance in the 1627 estate inventory of Cardinal del Monte, Caravaggio's principal early patron, of "u S. Francesco in Estasi di Michel Agnolo da Caravaggio con Cornice negre di Palmi quatro," that is, 89.2 centimeters vs. the 93.9-centimeter height of the Atheneum picture.[18] It is suggested Ruggero the Younger cultivated his preferment in Rome by letting del Monte have the early Caravaggio, despite the testamentary prohibition, and that a copy was substituted, retained in the family, and ultimately reached the Udine museum.[19] When Cardinal del Monte died in August 1627, his heirs, first his nephew Uguccione and then the latter's brother Alessandro, were, ironically, similarly enjoined not to sell the Caravaggio in the 1627 inventory but were forced to do so to pay debts. It was auctioned in Rome on 25 May 1628 for 70 scudi.[20]

Marini proposed the del Monte picture passed back to the Costa family, for in 1631 Ottavio's son Antoniotto sent a *St. Francis*, among other unspecified pictures of Caravaggesque subjects, to Malta,[21]

where the Costa family had property and great influence, exercised, one can speculate, on Caravaggio's behalf during his sojourn there.[22] The wished-for implication of the presumption behind the last hypothesis is that the picture thereafter found its way from Malta to the Grioni Collection in Trieste.

As attractive as portions of these hypotheses might be, they are unsubstantiated. The least complicated hypothesis for many was proposed by Frommel, who unearthed what could seem to be the Atheneum picture in the del Monte 1627 estate inventory: that it was painted for Cardinal del Monte, young Caravaggio's patron, and that the Costa/Tritonio work was a contemporary copy that passed ultimately to Udine.[23] Marini, who is not dismissive of the quality of the Udine version, suggests, equally succinctly, that Costa might have commissioned an autograph replica of del Monte's picture, a commission that Caravaggio, unbeknown to Costa, entrusted to an assistant, perhaps Mario Minniti, but conceivably touched up himself, although such interventions, if any, are indecipherable in the present state of the Udine picture.[24] But there recently emerged a further, upright *St. Francis in Ecstasy*, 103 centimeters high by 65.5 centimeters, now in the Johnson Collection, Princeton, N.J., that Bologna identifies with the picture cited in the 1627 del Monte inventory, the *St. Francis in Ecstasy* by Caravaggio "con Cornice negre di Palmi quatro," that is, 89.2 centimeters—presumably high—vs. the 93.9-centimeter height of the Atheneum painting, computed on the basis of the standard Roman palm equaling 22.3 centimeters. However, the measurements in the 1627 inventory were not made according to this standard scale but according to an idiosyncratic one. Using the measurements of the Thyssen *St. Catherine* in Lugano, incontrovertably also in the 1627 inventory, Bologna argues the Johnson picture, not the Atheneum's, conforms proportionately to the 4 palms on the idiosyncratic scale used by the compiler of the 1627 del Monte inventory.[25]

The certain fact that 1607, not 1597, was the *terminus ante quem* for Costa's gift to Tritonio has not greatly altered the opinions of writers since the 1971 Cleveland show concerning the picture's attribution or date, which hovers about 1595, depending on one's view of Caravaggio's early Roman development after his arrival in the city not earlier than the second half of 1592.[26]

Cinotti points out this youthful period itself can only be approximately defined as encompassing the years circa 1593 to the first half of 1599, and suggests it is vain to attempt to assign any single painting of the period to a specific year. Instead she divides this phase into four sequential groups of youthful works and places the Atheneum picture second in the second such category, together with the Metropolitan *Concert* first, the Fort Worth *Card Sharps* third, and the Capitoline *Fortune Teller* and Hermitage *Lute Player* following.[27]

Stylistically, the painting has echoes, generally, of such Lombard antecedents as Moretto and Savoldo, as well as reminders, specifically, of Caravaggio's North Italian origins. The angel's pose recalls a drawing in the Castello Sforcesco, Milan, by his master Peterzano.[28] The picture echoes, too, the artist's own early Roman works, most obviously in the physiognomy of the angel. His inclined head and his approximate features appear in the various versions of the *Boy Peeling Fruit* and in the Eros figure in the Metropolitan Museum's *Concert*.[29] This face, be it a preferred convention or, as is often suggested, drawn from a model,[30] is, as many have observed, generic to young Caravaggio's canon, for example, in the Uffizi *Bacchus*, the Leningrad *Lute Player*, or the Louvre *Fortune Teller*. The angel's right arm was completely realized undraped, after which the artist, as in other early works, superimposed the drapery.[31] Pearce reads the latter as a shirt worn backwards, over the shoulder, with the loose sleeve impromptuly tied to the shirttail at the waist and elaborated by the artist into a bow.[32] When suggesting the picture was done for del Monte, who might have commissioned the subject because he was named after St. Francis, Frommel also proposed the saint here could be a likeness of the prelate.[33]

In his earliest works Caravaggio, to borrow a phrase from Christiansen, approached allegory as "dressed up genre."[34] This picture marks an important advance thereon. It not only is one of his first essays at full-length figure painting, but is one of the first, if not the first, religious subject conceived as a nocturnal scene in which light is both literally illuminating and figuratively so as well, a metaphor for divine presence or recognition thereof. Here begins Caravaggio's mature manner, wherein he peoples tenebrist settings with figural types drawn from real life in order to address abstract, religious themes. The content here is a visual exposition of a devotional attitude fostered by the post-Tridentine renewal in the Church: Franciscus alter Christus, the identification of St. Francis with Christ, as in the stigmatization.

Although Brother Leo is present in the left background, the omission of the seraph, the unstigmatized hands, the nocturnal setting, and the angel's presence here all depart from traditional representations of the saint's stigmatization on Mount Alverna, as Askew discusses in her extended iconographical analysis of the picture. Traditional representational elements of Francis's stigmatization and his ecstatic, mystical self-identification with the body of Christ are enriched here in this "angelic consolation," with references to representational conventions associated with Christ's birth (the shepherds in the background astonished at the light in the sky) and Passion (Christ consoled in Gethsemane, the dead Christ supported by an angel). Citing Franciscan traditions as old as St. Bonaventure's life of the saint and as contemporary as current theological attitudes that were to be crystalized in St. François de Sales's 1616 *Traité de l'amour de Dieu*, Askew proposes Caravaggio mixed them with a host of Christological allusions and their sixteenth-century representations.[35] Thus Caravaggio created a

generalized, inspirational image of St. Francis consoled, sustained, and ultimately immortalized in death by Christ's divine love.[36]

Orr would argue for an entire further level of allusion in the painting, a neo-Platonic iconography that parallels the Franciscan/Christological one. She compares St. Francis supported by an angel to antique representations, available to Caravaggio or his mentors, of Endymion, beloved of the moon goddess Selene (or interchangeably, Diana), who endowed Endymion with immortality by casting him into an eternal, chaste sleep. Therein Endymion is supported either by the winged personification of sleep (Somnus) or of the destiny of the soul (Hypnos). Orr notes late sixteenth-century literary sources wherein the Endymion myth was interpreted as the apotheosis of the soul through divine love, bestowed on the shepherd, commonly by Selene's kiss, just as the Christian soul achieves eternal life through Christ's love. One has only to think of Annibale Carracci's almost contemporary frescoes of the late 1590s in the Farnese Gallery celebrating the loves of the pagan gods to be reminded of the long-standing neo-Platonic tradition that ancient myths and philosophy adumbrated the doctrines of Christianity, in this instance that love is the means to achieve knowledge of and communion with God.[37]

The rich, yet general nature of Askew's analysis led to further interpretations in which Caravaggio's reworking of the St. Francis theme was seen to be an autobiographical expression of his interest in the themes of conversion and submission to divine will, but tinged with his own (or del Monte's) fascination with androgynous adolescence.[38] For example, the angel's solicitous tenderness for the passive figure here would coincide with what some see to be a homosexual orientation in Caravaggio's early paintings, especially those conceived during del Monte's patronage.[39] Others see larger psychological implications in such works,[40] while yet others see this aspect of Caravaggio's oeuvre to be Christological in its intended symbolism.[41]

Spear invokes iconographical restraint, warning that attempts to explicate Caravaggio's iconography too often adduce textual parallels and symbolic conventions without differentiating between "legitimate causation on one hand and unintentional analogy on the other."[42]

The picture's modest size suggests it was made for private devotional purposes,[43] yet this obviously moving and intensely realized work defied specific analysis[44] until Treffers suggested it was designed throughout in accordance with the devotional needs of a member of or adherent to the Confraternity of the Girdle of St. Francis. This was a Franciscan reform movement, founded in 1585 and greatly favored by the Franciscan pope Sixtus V, who offered its members plenary indulgences. It was a neo-Bonaventuran movement that led to the completion in 1596 of an edition of that saint's complete works. Images, particularly prints, associated with the confraternity were widespread in Italy. The most well known of these was Agostino Carracci's 1586 engraving *A Franciscan Allegory*, wherein Francis bestows his girdle on an allegorical figure of the Church and on its members, among them Sixtus V, who unlocks a treasure of indulgences.[45] The key to Treffers's linking the Atheneum picture to the confraternity lies in the hitherto unremarked detail of the angel's grasping the cord at the saint's waist. Although the stigmatization provides the overall context of the painting, it is not per se the subject in Treffers's reading. Francis bears only one wound, albeit the last and most important stigma, that in his side. This is the wound to the heart, toward which the saint gestures, wherein lies the love and thus the potential to identify oneself (Conformitas) with Christ through love (Caritas), as Francis has achieved. The angel is similar in size to Francis, not because of Caravaggio's youthful gaucherie,[46] but to suggest Francis has become a second angel and is lovingly recognized as such. The angel supports the saint and gently turns him by the venerated cord to expose his wounds and his ecstatic swoon of death and rebirth. The picture thus is a meditational image, inspired by the Confraternity of the Girdle, of Francis as the fulfillment of the Imitation of Christ.[47]

M.M.

1. Joppi, 1894, 41. The relevant passage of Tritonio's will is reprinted in Friedlaender, 1955, 294, and in Dell'Acqua and Cinotti, 1971, 149, F15. It is reproduced by Spezzaferro, 1974, 579–80, figs. C–E. Marini, 1987, 371, says the picture was a donation from Count Giacomo Fistulario and was subsequently purchased by the Udine Museum in 1894.

2. Borenius, 1925, addendum on 26.

3. Venturi, 1928, 58–59. Inv. no. 45, 93 x 129 cm, repr. by Someda de Marco, 1956, 170, as an autograph replica of the Hartford picture. Repr. by Rizzi, 1969, no. 6, who speculated that much needed restoration would show the picture to be an autograph variant. Repr. by Cinotti and Dell'Acqua, 1983, 638, as an anonymous copy, purchased by the museum in 1894 from the Fagagna church to which it had been given in 1852 by Conte Francesco Fistulario, last of the Tritonio line (440).

4. Marangoni, 1929, 34.

5. Longhi, 1928, 30, n. 2, where Longhi acknowledges, *pace* Volpe, 1972, 59, that Marangoni had discovered the Trieste/Atheneum picture.

6. Longhi, "Ultimi studi," 1943, 9, 39; immediately thereafter, Longhi, "Ultimissime sul Caravaggio," 1943, 106, challenged Schudt's failure to include the Atheneum picture in his 1942 monograph.

7. Naples, 1938, room II, no. 4.

8. Cinotti and Dell'Acqua, 1983, 440, no. 19, col. 2, acquired by Arnold Seligmann, Rey & Co., New York.

9. Milan, 1951, 21–22, no. 17, datable between 1593 and 1595. Cleveland, 1971–72, 5–6, 68–69, no. 14, datable between 1592/3 and 1597.

10. Oertel (1938, 228–30), conceivably Caravaggio's earliest work, painted in northern Italy under the strong influence of Savoldo.

Art News, XXXXV, Apr. 1946, 55.

Ainaud, 1947, 388, mistakenly thinks the Udine picture is the same as the Trieste/Hartford one.

Bloch (1948, 61–62), echoes of Savoldo.

Berenson (1951, 36, fig. 55; 1953 English ed., 37), in date and quality akin to the Doria *Rest on the Flight*, and like that work reminiscent of Tintoretto's idyllic landscapes in the Scuola di S. Rocco; the angel is the twin of the Berlin *Eros*, but probably earlier.

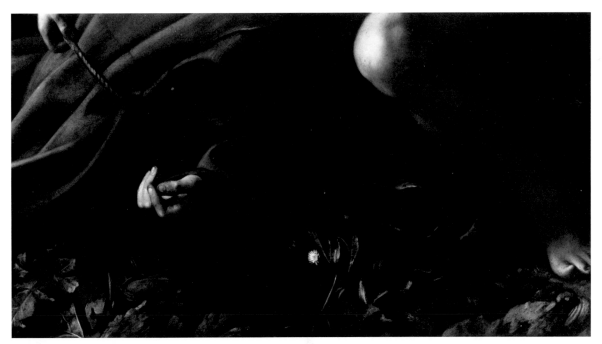

Michelangelo Merisi da Caravaggio, *St. Francis*, detail

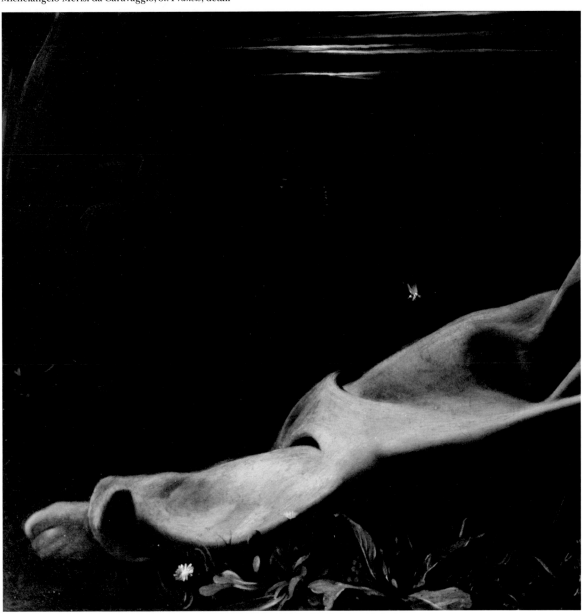

Michelangelo Merisi da Caravaggio, *St. Francis*, detail

Mahon ("Egregius," 1951, 227, no. 49, 233, no. 105), the Udine picture is a copy of the Atheneum's, "a remarkable work of Caravaggio's youth," 1594–95.

Longhi (1952 ed., 24, 34; 1968 ed., 20), several years before 1597.

Mahon (*Burlington*, 1952, 4, 7–10, 18–19, nn. 24, 27, 28, 38, 44, 91), a tentative, experimental work circa 1592–93, long before the *Calling of Matthew*; a pentimento around the right hand of the saint; the angel's left cheek and ear recently retouched.

Mahon (*Paragone*, 1952, 24), appreciably earlier than the Metropolitan's *Musica*, which is circa 1594–95.

Grassi, 1953, 63, 64.

Hinks (1953, 21, 44, 95, no. 5), 1593–94.

Mahon, 1953, 213, no. 5, 219, no. 35.

Calvesi, 1954, 133.

Friedlaender, 1954, 149.

Baumgart, 1955, 94, no. 3.

Bialostocki, 1955, repr. pl. 9.

Arcangeli in Bologna, 1956, 109–110, no. 5.

Arcangeli, 1956, 35.

Someda de Marco (1956, 170), critical opinion confirms the Udine picture is an autograph replica of that in Hartford.

Hess, 1958, 142, no. 13.

Wadsworth Atheneum Handbook (1958, 61), between 1592–98.

Wittkower (1958, 28, 336, n. 24; 3rd ed. rev., paperback, 1973, 55, 511, n. 27), circa 1595; the Atheneum's seems the better of the two versions.

Berne Joffroy, 1959, 248, 333, 337–38.

Mariani (in *Encyclopedia of World Art*, 1959, III, 63), among the early works.

Pearce, 1959, fig. 2.

Czobor, 1960, 84, fig. 21.

Jullian (1961, 51, 53, 60, 72–75, 225, repr.), about 1593.

Landcastle (1961, 55), shortly before 1597.

Baroni (1962, fig. 14), circa 1594.

Baltimore Museum of Art News, XXVII, 1964, nos. 2–4, n.p.

Venturi (1963, 16, 21, 54, no. 12), circa 1593–97.

De Logu (1964, 46, 148, no. 14), circa 1594–95.

Causa (1966, no. 154, figs. 8 and 9), the integrity of modeling excludes the possibility it is an old copy; before 1597.

Moir (1967, I, 1, n. 1, 15, n. 18, 197, n. 7, 256, n. 9, II, 37), a very early work; the Atheneum version is almost certainly the original.

Ottino della Chiesa (1967, 86, no. 4), 1591–92.

Paoletti, 1968, 423–25.

Askew (1969, 284–94), about 1592.

Kitson (1969, 85–86, no. 7), 1591–92, accepted by most authorities; mistakenly says Longhi rejected the attribution in *Proporzioni*, 1943, whereas both articles in that journal that year accept it.

Moir, 1969, 355, n. 13, 370.

Rizzi (1969, no. 6), a much needed restoration might reveal the Udine picture to be an autograph replica; unspecified references to Zahn and Fiocco, who are said to accept and reject the Udine version respectively, references that might mention the Atheneum picture.

Bergerhof, 1970, 14.

Dell'Acqua and Cinotti (1971, 18, 57, n. 22, 65, 92, 98–100, 149, doc. 15, 174, n. 38, 184, nos. 191–201), an early work, close to his mannerist beginnings under Peterzano; circa 1594–95, shortly before the Metropolitan's *Concert*.

Gregori, 1971, 9.

Posner (*Art Quarterly*, 1971, 323, n. 61), stylistically contemporary with the Doria *Flight* and the Metropolitan's *Concert*.

11. Arslan (1951, 446), a poor thing, but apparently in good condition.

Voss (1951, 168), not fully certain of the attribution of the Atheneum picture to Caravaggio.

Friedlaender (1955, 145, 148–49, no. 6, 159), without having seen both versions it is impossible to say which is the original or if both derive from a lost original; if the work is by Caravaggio, then stylistically it is much earlier than the Doria *Flight*.

Wagner (1958, 226–27), replica by a follower, perhaps from the circle of Saraceni.

Arslan (*Arte antica e moderna*, 1959, 198, 213, nn. 29 and 30), an old copy, characterized by youthful gaucheries.

Hibbard and Levine (1965, 371), an early, crude, and naively painted work, if indeed by the master at all.

Borea (1972, 154), a "fragile" attribution.

Held (1972, 42), a less than satisfactory painting.

12. A *Death of St. Francis* in the Maréschal Soult sale, Paris, 19–22 May 1852, no. 115, for 505 francs?, could not be, as Ainaud suggests (1947, 388, no. 22), another version. That painting was an upright (190 x 42 cm), depicting two angels plus a still life of a cross, skull, and books at the saint's feet. One angel supports St. Francis by his arms; the other leans against a tree trunk. A "copy" of the Atheneum composition with a city in the left background is mentioned by Friedlaender (1955, 149, with a New York dealer, 93.98 x 130.18 cm). Spear in Cleveland, 1971–72, 68–69, no. 14, n. 9, describes it as a copy belonging to Donald McGlone, New York. Moir, 1976, 84, speaks of it as a seventeenth-century copy belonging to Donald McGlone and George Sabatella, New York, 94 x 131 cm, fig. 14. Moir cites (83) another "seventeenth-century copy" in Munich (Staatsgemäldesammlungen no. 11158, 132.8 x 96.8 cm [sic]), recorded in the Residenz, Passau, in 1804. Marini, 1974, 346, repr. 98, fig. E4, speaks of a further version of modest quality in Rome.

13. Volpe, 1972, 58; Bergamo, 1973, 63, copy, 65, copy?; Scano, 1977, 23; Hibbard, 1983, 286, no. 30; Marini, 1983, 132; Gregori in New York, 1985, 46, 221; Treffers, 1988, 165.

14. Spezzaferro, 1974, 580, n. 5. However, one might question how discriminating the Montalto circle was, considering that the cardinal paid a handsome price for a Raphael forged by one of his own protégés, an artist called Terenzio (see Alsop, 1982, 158, for the references in Mancini and Baglione). Treffers, 1988, 165.

15. Matthiesen and Pepper, 1970, 452. His brother, Pier Francesco, was *cameriere* to Sixtus V and thereafter bishop of Savona (Treffers, 1988, 165).

16. The second executor was Costa's banking partner Giovanni Enriquez de Herrera, who was to receive the picture Tritonio passed over. This is now identified as the *Conversion of the Magdalen* in Detroit (Spezzaferro, 1974, 579).

17. Spezzaferro, 1974, 579–81; 1975, 113–14. Gregori in New York, 1985, 221, gives the nephew's name as Francesco.

18. Frommel, *Storia dell'arte*, 1971, 8–9, 34, also 11, 14–16, 24, 27–28, 50–51, the assumption being that the 89.2 centimeters is the upright measure of the picture without frame, in Roman *palmi*.

19. Spezzaferro, 1974, 579–81; 1975, 113–14. Marini, 1978, 76, n. 9. Gash, 1980, 40. Cinotti and Dell'Acqua, 1983, 440.

20. Kirwin, 1971, 55.

21. Marini, 1974, 344–45, sec. A, 346, sec. H. A *St. Francis* given to Caravaggio in the 1639 Costa estate inventory would thus be a different picture of a different iconographic type, as Spezzaferro suggests, 1974, 584–86; 1975, 114–17. The suggestion is followed by Hibbard, 1983, 287, 338, 340, fig. 191, who proposes that if the picture in the 1639 Costa inventory is not the Atheneum's, then it could be a *St. Francis in Meditation*, the best version of which he considers that now in Palazzo Venezia, Rome.

22. Ippolito Malaspina, prior of the Order of St. John in Naples, was the uncle of Laura Spinola, one of Ottavio Costa's wives. Costa may have recommended Caravaggio to Malaspina, whose *stemma* appears on the Valletta *St. Jerome Writing* and through whose good offices Caravaggio perhaps came to paint the Louvre portrait of the order's grand master, Alof de Wignacourt. Hess, 1958, 142, where the Atheneum picture is mentioned in n. 13; Matthiesen and Pepper, 1970, 452; Spezzaferro, 1974, 585, no. 49, and 1975, 106–7.

23. Frommel, *Storia dell'arte*, 1971, 8, also suggests the Costa/Tritonio version is by Mario Minniti, Caravaggio's early Roman companion (15, n. 61). This thesis is admitted as a possibility by Spezzaferro, 1971, 84–85, who observes that while the Atheneum picture might be among the first for the cardinal, it is not to be excluded that it was a copy, for the cardinal had a copy of a *St. Matthew* by Caravaggio; by Volpe, 1972, 58; by Moir, 1976, 121, n. 180, and 1982, 76; by Hibbard, 1983, 55; and by Scano, 1977, 823. It is accepted by Spear, 1972, 157, and in the 1975 revised edition of Cleveland, 1971–72, 227, n. 14; by Röttgen, 1974, 254, n. 168; and by Gregori in New York, 1985, 221–27.

24. Marini, *Caravaggio "pictor praestantissimus,"* 1987, 371.

25. Bologna, 1987, 159, 164–68. Patrick Matthiesen, through whose London firm the Johnson picture passed, kindly made available a draft of this article, which is later to be a chapter in Bologna's forthcoming *Nuovi studi sul Caravaggio,* Turin. In reporting the sale by Matthiesen, Marini suggests the Johnson picture is by Orazio Gentileschi and sees similarities between the features of the Johnson *St. Francis* and Orazio's St. Francis in the latter's 1615 *Stigmatization* in S. Silvestro in Capite, Rome, as well as in his 1616 *St. Francis in Meditation* fresco, S. Venanzo, Fabriano (*Tempo*, 1987, 1). Russo de Caro, 1987, 1, suggests the fine, well-tailored stuff of the saint's habit in the Johnson picture is the product of the looms of the Capuchin monastery at Fabriano.

26. Fredericksen and Zeri (1972, 44, 582), as the *Ecstasy of St. Francis*.

Nicolson (1972, 113), closely allied to contemporary works by Cavaliere d'Arpino.

Pepper, 1972, 170.

Werner, 1972, 70.

Sharp Young, 1972. 61.

Rossi (in Bergamo, 1973, 64–65, no. 8), at least 1596 or even earlier; also 181, 202.

Enggass, 1973, 401.

Mariani (1973, 41), 1594–95.

Röttgen (in Rome, *Arpino*, 1973, 40, 84), circa 1595, to be compared to Cavaliere d'Arpino's more or less contemporary *St. Francis Comforted by an Angel Playing a Violin*, Douai.

Cummings, 1974, 3, 7, 11–12, 15.

Marini (1974, 19, 65, n. 123, 98–99, no. 9, 333, 344–46, no. 9, 348, 373, 461, 468), 1594.

Röttgen (1974, 43, 198–99, 254, n. 168), perceptible influence of Arpino, therefore earlier than Caravaggio's move to del Monte's palace.

Bovi, 1975, 144–47.

Gregori in *Novità*, 1975, 28.

Spezzaferro in *Novità*, 1975, 103–18.

Rizzatti (1975, 86), circa 1595–96.

Gregori, 1976, 868 (according to Cinotti and Dell'Acqua, 1983, 442).

Moir, 1976, 83, no. 3.

Marini, 1978/1979, 16, 74, n. 1, 76, nn. 5 and 9.

Nicolson, 1979, 32.

Gash, 1980, 12, 14, 40, no. 6.

Marini, 1980, 12, no. 7 (according to Cinotti and Dell'Acqua, 1983, 442).

Bissell, 1981, 16, 85, n. 37.

Marini, *Storia dell'arte*, 1981, 381.

Longhi, 1982, 182, no. 20.

Moir (1982, 76), probably painted for Cardinal del Monte and probably late 1596; also 17–19, 48, 56.

Silk and Greene, 1982, 36–37.

Cinotti and Dell'Acqua (1983, 440–42, no. 19), as more able than the Metropolitan's *Concert* and of the same year, 1595?; also 217, 408, 582.

Gilbert (1983, 35), circa 1595.

Hibbard (1983, 286–87), just before or after Caravaggio joined del Monte, for whom it could have been specifically painted (55).

Bonsanti (1984, 11–14, fig. 9), circa 1595.

Spike (1985, 416), a secure attribution.

Marini, 1987, *Caravaggio*, 369–72, no. 10.

27. Cinotti and Dell'Acqua, 1983, 408. Group I is the Borghese *Sick Bacchus* and *Boy with a Basket of Fruit*, the London *Boy Eating a Fruit*, and the London *Boy Bitten by a Lizard*. Group III comprises the Uffizi *Bacchus*, the Louvre *Fortune Teller*, the Ambrosiana *Basket of Fruit*, and the Doria *Flight into Egypt*. Group IV is the destroyed Berlin *Courtesan*, the Thyssen *St. Catherine*, the Detroit *Magdalen*, the Uffizi *Medusa*, the Galleria Nazionale, Rome, *Narcissus* and *Judith and Holofernes*, and the Florence *Portrait of Maffeo Barberini*.

28. Calvesi, 1954, 133, fig. 32; also repr. by Moir, 1969, 358, fig. 4.

29. Friedlaender, 1955, 145.

30. Frommel, *Castrum peregrini*, 1971, 30–31, fig. IIa, suggests the model may have been the Sicilian painter and Caravaggio's younger companion Mario Minniti.

31. Gregori in New York, 1985, 221. Marini, *Caravaggio*, 1987, 371, reports the white pigment is congruent chemically with samples from other early works. Moir, 1969, 355, n. 13, remarked how Caravaggio, "drawing" with a loaded brush, differentiated the angel's left arm from his chest by reinforcing the contour of the upper arm.

32. Pearce, 1959, 129. Posner, *Art Quarterly*, 1971, 323, n. 61, argues that similar costumes in the Atheneum picture and the Doria *Flight* confirm that the two are contemporary to the Metropolitan's *Concert*.

33. Frommel, *Storia dell'arte*, 1971, 15, 24, also notes a resemblance between the saint as depicted here and the central figure in the Fort Worth *Card Sharps*.

34. Christiansen, 1986, 423.

35. Askew, 1969, where the various sources are discussed at length. For the Atheneum picture, see especially 284ff. Landcastle, 1961, 58–59, had noted Caravaggio's appropriation here of the Pietà and Deposition motifs. Arcangeli, 1956, 35, 47, n. 35, suggested Caravaggio might have stopped in Bologna en route to Rome, saw and then drew upon the iconography of Lodovico Carracci's *Vision of St. Anthony*, now in the Rijksmuseum, Amsterdam, although Dempsey in New York, 1985, 120–22, no. 28, illus., notes another version by Lodovico, the *Virgin and Infant, St. Francis, and an Angel Truly from Paradise*, was in Rome.

36. C. Strinati, "Riforma della pittura e riforma religiosa," in Rome, 1982–83, 35–56, especially 48–56. The Atheneum picture is mentioned on 52–53.

37. Orr, 1982, 78–89.

38. Hibbard, 1983, 60–61.

39. Posner, *Art Quarterly*, 1971, 301–19.

40. Röttgen, 1974, 173–75.

41. Calvesi, 1971, 15, 17, 51.

42. Spear in New York, 1985, 25–27.

43. Marini, *Caravaggio*, 1987, 371, reports it suffered burns in two places, but S. Kornhauser, the Atheneum conservator, sees only a single scorch, as described in the above comments on the painting's condition, and believes its blistered texture suggests an accident in relining.

44. Strinati in Rome, 1982–83, 92, no. 82. See Chorpenning, 1987, 149–58, where the Atheneum picture is reproduced as fig. 4, for a further discussion of Caravaggio's response to Counter-Reformation meditative practices.

45. S. Properi Valenti Rodinò, "La Diffusione dell'iconografia francescana attraverso l'incisione," in Rome, 1982–83, 163–64, 172–77, no. 99, repr. See also DeGrazia, 1984, 148–49, no. 141, fig. 168, and Treffers, 1988, 161–64, figs. 10 and 11.

46. Hibbard, 1983, 56.

47. Treffers, 1988, 145–66. Professor Treffers was kind enough to discuss his ideas prior to their publication.

Follower of Caravaggio?
Still Life with Flowers and Fruits

Oil on canvas, 76.2 x 100.4 cm (28⅝ x 39½ in.)

Condition: X rays (Fig. 15) show that in the upper right background a swagged curtain, a ghost of which can be seen behind the rightmost leaf, has been painted out, presumably owing to damages in the area, including a large, irregularly shaped, diagonal loss in the upper right, 18 to 20 centimeters long by 7 to 10 centimeters high. X rays (Fig. 16) suggest the woven basket was originally conceived as an elliptical, bowl-shaped container. In the middle left of the central floral arrangement is a diagonal, jagged, branched repair, about 16 centimeters long.

Provenance: The previous history of the picture is unknown. Purchased by the Wadsworth Atheneum in 1942 from the Koetser Gallery, New York and London, for $2,500 from the Sumner Fund.

Exhibitions: New York, 1944, as Fede Galizia; San Francisco, 1949, 35, as Fede Galizia; Paris, 1952, no. 66, as unknown Italian at the beginning of the 17th century (see below); Sarasota, 1958, no. 31, as attributed to Fede Galizia; Montclair, 1961, no. 14, as attributed to Fede Galizia; Houston, 1962, no. 6, as Fede Galizia; Philadelphia, 1963, 120, as Caravaggio follower; Hartford, 1963, no. 9, as Caravaggio follower; Hanover, 1964, no. 12, as Caravaggio follower; Claremont, 1966, no. 30, as Caravaggio follower; American Federation of Arts, 1968–69, trav. exh. (see Ostrow, 1968), no. 6, as Italian follower of Caravaggio, circa 1630; North Salem, 1971, as Caravaggio; Amherst, 1974, no. 86, as Caravaggio follower; New York, 1983, no. 10, as Caravaggio follower (see below); New York, 1985, no. 65 (see below).

The Ella Gallup Sumner and Mary Catlin Sumner Collection, 1942.353

The painting was acquired as the work of the Milanese portraitist and still-life painter Fede Galizia (1578?–c. 1630).[1] Suida favored that attribution,[2] one also propounded, if waveringly, by Bottari, who associated the picture with another in the Museo Civico, Teramo, which in turn he thought compared well with a signed and dated Galizia of 1602, once in the Anholt Collection, Amsterdam.[3] In the 1952 still-life exhibition in Paris, Sterling tested the attribution by exhibiting the Hartford picture together with an unsigned Galizia still life, then in the Vitale Block Collection, The Hague, that enjoys a reputation equal to that of the Anholt painting.[4] In the catalogue prepared before the exhibition opened, Sterling already remarked upon a thoroughly Caravaggesque quality in the Atheneum picture, mixed with Flemish influence. The Caravaggesque elements singled out were such motifs as the clear glass vase and the basket of fruit perched at the very edge of the table; the compositional effect of deep space, achieved by a receding triangle formed by the two vases and the basket; the roundness of forms and the transparency of the cast shadows; and, finally, the dark background, a portion of which is lit by a diffuse, luminous light. While spotted fruit and flies appear in Caravaggio's work, such passages here are treated with a meticulousness that is, to Sterling, Flemish, as is the somewhat dry description of flowers and leaves. This led Sterling to exhibit the painting as Italian, stylistically an archaic work painted no later than about 1615–20 by an unknown artist greatly influenced by Caravaggio but also familiar with contemporary Flemish flower painting, as seen, for example, in the work of Jan "Velvet" Brughel the Elder, who was in Milan in the 1590s.[5] In a monograph following the exhibition, Sterling firmly rejected the attribution to Galizia and suggested that, although it was not worthy of the master's hand, the picture conceivably could be a copy after a lost early Caravaggio.[6] Not dissimilarly, Longhi thought it Flemish, a free copy of a lost early Caravaggio.[7] In this vein Moir, while listing the picture for convenience under the Atheneum's original attribution,[8] actually described it as "primitive, dry, and overdetailed, without convincing effects of light and atmosphere, and seems more like the work of a northern European master."[9]

Thereafter, speculation about who this artist could be and what would have been the milieu of such an early seventeenth-century still-life painter turned toward those artists traditionally cited as founders

Figure 15. Caravaggio, *Still Life with Flowers and Fruits*, X ray

Figure 16. Caravaggio, *Still Life with Flowers and Fruits*, X ray

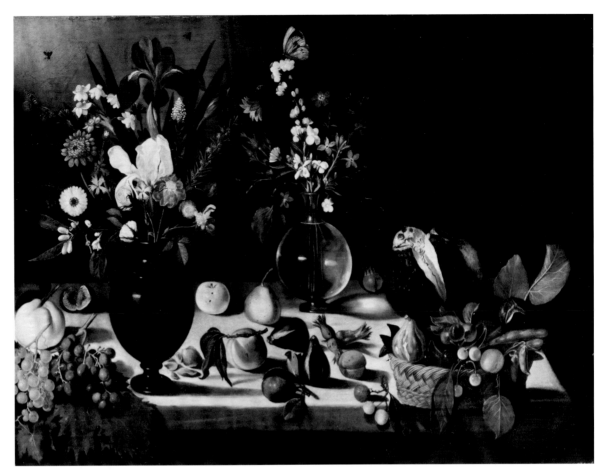

Follower of Caravaggio?,
Still Life with Flowers and Fruits

of the Roman still-life school under Caravaggio's potent influence: Tommaso Salini, Giovanni Battista Crescenzi, and Pier Paolo Bonzi. A number of pictures were grouped with the Hartford work. In 1965 Hüttinger drew a comparison between the latter and an even more wooden still life formerly with the Galleria Lorenzelli, Bergamo,[10] which Bologna in 1968 gave to a master active in Rome about 1610–20, but familiar with the fruit and the flower paintings Caravaggio produced while in Cavaliere d'Arpino's workshop.[11] At the same time Bologna put forward an oblong still life he proposed to be just such an original Caravaggio.[12] This idea in a certain sense anticipated Zeri's 1976 proposal, discussed below, in the course of which that author published a pendant to the above oblong, both as in "the Manner of

Caravaggio."[13] In 1972 Volpe saw a parallel between the Atheneum picture and two still lifes, formerly in the Parisi Collection, Frascati, that passed through Finarte, Milan.[14] The same author linked the Atheneum's picture to the artist responsible for the still-life passage of an unidentified allegory, also formerly in the Milan trade, the major portion of which depicts two female nudes that he and Ottani Cavina had earlier assigned to Carlo Saraceni, whose Roman style in the first two decades of the century was greatly influenced by Caravaggio. Volpe proposed the still-life portion of this collaborative work to be by a Roman painter similarly responsive to Caravaggio's innovations but restrained by northern convention. In addition, he speculated that future research in connection with the Atheneum picture might profitably be directed toward Crescenzi,[15] but subsequently proposed that Crescenzi's name be associated with a much more sumptuous and developed still-life style than that demonstrated here.[16] In 1975 Gregori

hypothesized that Crescenzi's work was very different in character from Volpe's proposal; that, in fact, the Atheneum picture and its associated works might conceivably illustrate the formative stage, before 1610, of Crescenzi's career, which matured in the following decade presumably in close association with such Caravaggisti as Saraceni, the Pensionante del Saraceni, and Cecco del Caravaggio. Gregori associated three further works with the Hartford picture—one unlocated, the second in the Galleria Estense in Modena, and the third in a Tuscan private collection—and suggested they illustrate Crescenzi's activity in the second decade of the century before he left Rome definitively in 1620 for Spain.[17] As neither hypothesis concerning the nature of Crescenzi's style has been verified by signed or documented works, each theory must be taken as a suggestion until this pivotal figure becomes more securely defined.[18]

In 1972 Fredericksen and Zeri first listed the picture as the work of a Caravaggio follower.[19] Zeri in 1976 escalated the attribution by including it in a group—primarily those works already associated with the Atheneum picture—he interpreted to be representative of the first Roman works of Caravaggio himself, when, as is reported in Bellori, the young artist, newly arrived in the city, served in the studio of Giuseppe Cesari, the Cavaliere d'Arpino, as a flower and fruit painter.[20] Zeri importantly added to the group two still lifes in the Borghese Gallery, Rome, a *Still Life with Birds* and a *Still Life with Flowers and Fruit*.[21] These he identifies with entry nos. 38 and 39 in the inventory of items confiscated in 1607 from Cavaliere d'Arpino in a legal action that was resolved by Cesari's pictures passing to the collection of the pope's nephew Cardinal Scipione Borghese. Zeri searched the same inventory for further entries that might be construed to describe pictures in the kinship group of the Hartford canvas. Therein is mentioned under no. 96, "Un quadro con una Caraffa di fiori et altri fiori non compito," an unfinished flower piece, which Zeri elegantly posits to be the unidentified allegory mentioned earlier, before it was completed at a time after 1607 with two female nudes by Saraceni. Of more immediate interest is no. 47, "Un quadro pieno di frutti, et fiori con due Caraffe," a picture full of fruit and flowers with two carafes, which Zeri equates with the Hartford picture itself.[22]

Zeri proposes that the inventory date, 1607, eliminates Crescenzi as the possible author of these works. In seeking to assign an identity to this artist, who, as is shown in this group, rejected mannerist antecedents and groped, if tentatively, toward a greater naturalism, Zeri understandably looks to the circle of Cesari, from whose collection four have a proposed provenance. He enticingly infers that all are works executed over a very short span of time, perhaps the second half of 1593—hence their homogeneity of conception and repeated motifs—by the young Caravaggio working as a kind of commercial artist in Cesari's studio—hence the unevenness in quality. Zeri argues that if these are copies after Caravaggio, it is firstly odd that all the originals have been lost,

and secondly highly unlikely that the then unknown Caravaggio would have attracted either a copyist or a follower at such an obscure stage in his career.[23]

Adding a further picture to the group, one formerly with Mont in New York,[24] Zeri asserts that the wicker baskets in the latter, in the Borghese *Still Life with Flowers and Fruit*, and in the Atheneum work are virtually interchangeable with the similar basket in the Borghese *Boy with a Basket of Fruit*, also acquired by Cardinal Scipione from d'Arpino, and a picture universally accepted as among Caravaggio's earliest works. Zeri offers a chronology for the group: it begins with the Lorenzelli picture with its echoes of Moroni and of Cremonese mannerists; progresses to the picture formerly with Mont; the Parisi pair that passed through Finarte; the Borghese companion pieces; and culminates in the Hartford picture and that completed by Saraceni.[25]

It goes without saying that any new contribution to the Caravaggio canon is an event of the first order. Zeri's reconstruction is in every way intriguing but not one that convinces all. First, it is very difficult to reach a consensus from photographic reproductions of varying quality as to what works can or cannot be admitted to this group.[26] Then one confronts the recurrent irony of the art-historical method whereby, without documentation, judgments based on stylistic analysis can be accused of being subjective, yet we balk when documentation points to conclusions that are stylistically unpalatable. Such is the case here. Despite Zeri's arresting argument, it is difficult to see the Hartford picture and its related works as the antecedents of Caravaggio's still lifes as seen in such accepted works as the Borghese *Boy with a Basket of Fruit*, the Uffizi *Bacchus*, or the Ambrosiana *Still Life*. Yet it is certainly not unreasonable to see some kinship between the Hartford work and such an equally fundamental Caravaggio attribution as the Hermitage *Lute Player*'s still life.

Strinati agreed with Zeri.[27] Sterling thought the hypothesis one to be seriously considered,[28] and Rosci, after some reservation, accepted it.[29] Causa,[30] Marini,[31] Volpe,[32] Harris,[33] Spear,[34] and Calvesi,[35] however, are among those who do not accept that the Atheneum *Still Life* is by Caravaggio.

In 1983 Spike brought together in his exhibition[36] three of the pictures associated by Zeri with entries in the 1607 inventory of items confiscated from Cavaliere d'Arpino: the Hartford picture[37] plus the two Borghese works in question, the *Still Life with Flowers and Fruit* and the *Still Life with Birds*.[38] Spike felt the Borghese pictures to be by the same hand and the Atheneum picture a "slightly advanced work by this same artist of controversial identity."[39] Exhibiting them as by a Caravaggio follower, Spike, following Posner, emphasized that d'Arpino was a picture dealer as well as the head of a prolific studio. The fact that two generally uncontested Caravaggios came to

the Borghese from the 1607 settlement, the *Bacchino Malato* and the *Boy with a Basket of Fruit*, does not preclude the possibility of d'Arpino's owning by way of stock-in-trade a mixed bag of still lifes by various anonymous artists in Rome who had been impressed by Caravaggio's prototypes by 1607, Zeri's proposed *terminus ante quem* for the pictures.[40] Independently, Cinotti shared the same reservations. In 1983 she rejected attributions to Salini or Crescenzi and further saw a different and anonymous hand in Hartford's picture from that in any portion of the Borghese *Still Life with Flowers and Fruit*,[41] as does Salerno.[42] Marini, agreeing partially with Zeri, divided the authorship of the latter among *three* participants: the central portion by Caravaggio, the left portion by an unknown close to Bonzi, and the right section by the Atheneum's master.[43] Herein again lies the core of the problem: want of any agreement regarding what paintings are to be included in the group and to what extent even these are sufficiently homogeneous to be said to be by one hand, albeit at different moments, or collaborative works. Spike's grouping of the two Borghese pictures together with the Hartford work notwithstanding, there would appear to be only approximate kinship between the Atheneum picture and the Borghese *Still Life with Flowers and Fruit* and scant likeness between the Atheneum work and the *Still Life with Birds*, although Spike's proposal that they generically illustrate anonymous artists' early reaction in Rome to Caravaggio's powerful stimulus is certainly reasonable.[44] Cinotti, for example, would group the Atheneum picture only with the Parisi pair that passed through Finarte plus possibly the still-life picture Saraceni seems to have completed with a figural passage. With a sense for the cyclical, one notes, she proposes, finally, that the artist could be Italian or a Fleming working in Rome.[45]

But who? The still-life elements in undoubted early Caravaggios display a technical competence plus an assertive naturalism that must have greatly impressed less gifted and archaizing contemporaries. It is among these, still very unknown entities, that critics unaccepting of Zeri's hypothesis search for an attribution for the Atheneum picture and its kin. Following an exchange of ideas with Zeri and Strinati, Marini in 1984 proposed just such a figure: Francesco Zucchi (c. 1562–1622). Tuscan born, the brother of another painter, Jacopo, Francesco Zucchi was a collaborator of Cavaliere d'Arpino. He was a figure painter, assisted d'Arpino with cartoons for the latter's St. Peter's mosaics, painted allegorical *Seasons* derived from Giuseppe Arcimboldo, and, according to Baglione, was an excellent flower and fruit painter, as seen in his frescoed garlands of fruit and flowers in the crossing of the Lateran. Marini suggests Zucchi, to whom he assigns a number of further works, was influenced in d'Arpino's workshop by the Dutchman Floris van Dijck and Caravaggio, whose hand he sees contributing the basket of fruit and purple figs on the tabletop in the Atheneum picture,[46] a view repeated in his 1987 monograph, where the Atheneum picture

is simply listed as "opera di collaborazione."[47] That same publication, in the entry for the Borghese *Still Life with Flowers and Fruit*, introduces to the discussion a new figure, Pietro d'Asaro, a Sicilian painter, present in Rome about 1600, known also as Il Monocolo di Racalmuto.[48] Certainly, the still-life details from altarpieces by the artist signed and dated 1626 and 1633 published by Demma[49] suggest d'Asaro has a place in the equation—if ever finally fully worked out—that would explain the Atheneum picture and its kin.

In 1984 Salerno linked three further works with the group,[50] none of which he considers to be by Caravaggio.[51] He argues the Atheneum picture is by Francesco Zucchi,[52] to whom he assigns the still-life element in Jacopo Zucchi's Borghese *Cupid and Psyche*, signed and dated 1589.[53]

The problem was a focus of the New York and Naples 1985 Caravaggio exhibitions, where Gregori brought the Atheneum picture and the two Borghese pictures together again and where they could be compared directly with the still-life elements in the Borghese *Boy with a Basket of Fruit*, the London *Boy Bitten by a Lizard*, and the Uffizi *Bacchus*.[54] Gregori does not accept associating Francesco Zucchi with the group.[55] She argues that seventeenth-century biographical allusions to and inventory citations of still lifes by Caravaggio, be they accurate or simply suggestive, were contemporary indications of "the widely diffused notion that Caravaggio painted still lifes."[56] She agreed with Zeri that there were "incontrovertible" morphological similarities within the group of proposed early Caravaggio attributions and with readily accepted works, specifically that the wicker baskets in the Atheneum, ex-Mont, and the Borghese floral/fruit still lifes were "almost interchangeable." Finally, she suggested the reluctance to accept these attributions—limited as the works are in conception and quality—may stem from current views of the artist's career that might not sufficiently allow for minor juvenilia in his first Roman years.[57] M.M.

1. *Art News*, XLIII, no. 7, 15–31 May 1944, 12, as Fede Galizia.
2. D. Koetser to A. E. Austin, Jr., 27 Nov. 1941, curatorial file, "Dr. Suida . . . was of the definite opinion [the] painting is also by Fede Galizia." W. Suida to C. Cunningham, 21 Dec. 1946, transcription in curatorial file, "a most important document of Fede Galizia's activity as a painter."
3. S. Bottari to E. Bryant, 29 Apr. 1961, curatorial file. The Anholt painting, *Still Life with a Bowl of Fruit and a Rose*, of 1602, is reproduced by C. Benedict in *L'Amour de l'art*, 1938, 309, pl. 1, and in Bottari, 1965, pl. 6, where the signature is said to be on the reverse (13). See also Bottari (1963, 311, pl. 120b), where the Anholt picture is captioned "Londra, già Sotheby's, già Parigi, Collezione Bloch." The Teramo painting is reproduced by Bottari, 1963, pl. 122A. In this same study in which a group of Galizia attributions is assembled around a number of core works, Bottari reconsidered his 1961 opinion of the Hartford picture (318, n. 29): "Con l'occasione faccio ammenda di alcune mie precedenti attribuzioni alla Galizia. In primo luogo della tela

del Wadsworth Atheneum di Hartford, che in ragione della qualità, il Bloch ritiene copia tarda (comunicazione orale)." Yet, subsequently, he cited the painting as typical of the synthesis Galizia effected in her late style between northern still-life painters such as Jan Velvet Brughel and Caravaggio's luminism (Bottari, 1967, XIII, col. 417).

4. Paris, 1952, 89, no. 67. The Bloch picture is reproduced in color by Sterling in his 1952 publication and in the 1959 first revised edition as the frontispiece. It is plate 22 bis in his 1981 second revised edition. In 1965 Hüttinger exhibited the Bloch picture as lent by E. Zurstrassen, Heusy, Belgium (Zurich, 1964–65, 33, no. 17).

5. Paris, 1952, 87–89, nos. 66 and 67.

6. Sterling, 1952, 53, "La tentation est grande d'y voir une copie d'un original perdu." The painting is reproduced in this 1952 edition as "copie d'après Caravaggio?" (pl. 55), but all discussion of the work is dropped from the 1959 first revised edition, where the reproduction, while retained (pl. 55), is labeled "peintre de l'entourage de Caravaggio." As mentioned below, in the second revised edition Sterling thought Zeri's later attribution to the young Caravaggio one to be "considered very seriously" (1981, 17).

7. R. Longhi to C. Cunningham, 22 Mar. 1960, curatorial file, "Not by [Galizia]. I studied it in Paris . . . and I think it is a Flemish free copy from a lost early Caravaggio."

8. Moir, 1967, II, 37, Register of Places.

9. Moir, 1967, I, 27, n. 19.

10. Zurich, 1964–65, 36, no. 33, as by an anonymous Caravaggesque master. Cinotti and Dell'Acqua, 1983, 632, fig. 1.

11. Bologna in Bergamo, 1968, fig. 10. Repr. by Cinotti and Dell'Acqua, 1983, 632, fig. 1.

12. Bologna in Bergamo, 1968, fig. 9. Repr. by Cinotti and Dell'Acqua, 1983, 633, fig. 5.

13. Zeri, *Diari*, 1976, 102, fig. 100. Repr. by Cinotti and Dell'Acqua, 1983, 633, fig. 4.

14. Volpe in Milan, 1972, no. 9. Zeri, *Diari*, 1976, 98, pls. 97 and 98, describes them as having previously been in the Parisi Collection, Frascati. The two are also reproduced and discussed in connection with the Atheneum *Still Life* by Gregori, in *Novità*, 1975, 43, pls. 22A and 22B. Reproduced by Cinotti and Dell'Acqua, 1983, 632, figs. 4 and 5. Sold in Castello Scotti di Vigoleno (Piacenza), Conte Giovanni Olivares sale, 14–17 May 1987, 4.7 billion lire.

15. Volpe, 1972, 73–74. The painting is reproduced with Volpe's attribution of the figures to Saraceni by Ottani Cavina, 1968, 105, pl. 48. Reproduced by Cinotti and Dell'Acqua, 1983, 632, fig. 3.

16. Volpe, 1973, 25–36.

17. Gregori, 1973, 41–48, figs. 25, 26, 27. Gregori also raised the possibility (47) that the still life on the table in the *Young Man with a Recorder*, attributed to Cecco del Caravaggio in the Ashmolean (*Summary Catalogue of Paintings in the Ashmolean Museum*, 1980, 23, inv. no. A451B, pl. XIII), might be connected with the Atheneum picture. Marini, 1986, 12, assigns Gregori's fig. 27 to Francesco Zucchi.

18. Marini, *Getty Journal*, 1981, assigns Crescenzi further still lifes and figure pieces, the latter attributions assembled around a work with contemporary documentation. Salerno, for his part, *Apollo*, 1984, 438, believes that of the traditionally cited founders of the Roman Caravaggesque still-life school, the Salini-Crescenzi-Bonzi triad, only Salini could be correctly so described.

19. Fredericksen and Zeri, 1972, 44, 506, 585. Mitchell, 1973, 76–77, pl. 89, also describes the picture as the work of a follower.

20. Zeri, *Diari*, 1976, 92–103. Zeri (99, n. 1) does not see a connection between the Hartford picture and those three still lifes Gregori, 1973, 41–48, dates to the 1610s, suggesting instead the latter are the work of a Roman painter of some note, active about 1620, who might one day prove to be Crescenzi. Zeri, 102, pl. 101, credits Bologna with the intuition that the Hartford picture and its ilk were much earlier than hitherto proposed, but he questions Bologna's attribution to the young Caravaggio of the picture that precipitated the notion (see also Bergamo, 1968, pl. 9).

21. Zeri, *Diari*, 1976, 94, figs. 92 and 91. Repr. by Cinotti and Dell'Acqua, 1983, 633, figs. 7 and 6.

22. Zeri, *Diari*, 1976, 92–96.

23. Zeri, *Diari*, 1976, 99–102.

24. Zeri, *Diari*, 1976, 98, fig. 96. Repr. by Cinotti, and Dell'Acqua, 1983, 632, fig. 2.

25. Zeri, *Diari*, 1976, 97–99.

26. For Zeri's own exclusions, see note 20 above. Gregori in New York, 1985, 209, would exclude the two oblong paintings formerly with the Galleria Lorenzelli.

27. Rome, 1979, 62–65, 92–93, pl. 10.

28. Sterling, 2nd rev. ed., 1981, 17.

29. Rosci, 1977, 95, 98, 166, nn. 62 and 67, 200, as Master of the Hartford Still Life. Repr. by Rosci, 1982, 92, fig. 126, as Caravaggio.

30. R. Causa to P. Marlow, 17 June 1977, curatorial file, "an anonymous Roman work." Causa had rejected the attribution in his 1972, 1033, and in Bordeaux, 1978, 41.

31. Marini, *Storia dell'arte italiana*, 1981, 354, pl. 309, as Master of the Hartford Still Life.

32. London, *Painting in Naples*, 1982, 57, as an anonymous Roman work painted immediately after Caravaggio's death in 1610.

33. Harris, 1983, 514.

34. Spear, 1984, 165.

35. Calvesi, 1985, 280, by an unknown artist who looked for sources in Caravaggio and in Jan Velvet Brughel.

36. New York, 1983, 41–47, nos. 8–10.

37. New York, 1983, 46–47, no. 10, pl. 10. See also 15.

38. New York, 1983, Respectively no. 8, oil on canvas, 105 x 184 cm, pl. 8; no. 9, oil on canvas, 103.5 x 173 cm, pl. 9.

39. New York, 1983, 41, but qualified (44) as "the author (or authors) of the Galleria Borghese and Hartford still lifes."

40. New York, 1983, 44.

41. Cinotti and Dell'Acqua, 1983, 567–68.

42. Salerno, *Natura morta*, 1984, 427, "Zucchi," n. 6.

43. Marini, 1978/79, 43–44, n. 128; *Artibus et historiae*, 1981, 50; *Storia dell'arte italiana*, 1981, 359.

44. Such is Salerno's opinion as well, that is, that although it may be conceded some of these pictures can possibly be identified with those listed in the Arpino confiscation in 1607, this might only indicate that imitators had appeared before that year (*Apollo*, 1984, 438). In agreeing with Spike's reservations regarding the Caravaggio attribution of the two Borghese still lifes, Harris, 1983, 514, similarly points out the latter attest to Caravaggio's early influence in Rome.

45. Cinotti and Dell'Acqua, 1983, 568.

46. Marini in Rome, 1984, 13, 17, n. 32. Marini (22–23, no. 2) also gives to Francesco Zucchi the picture exhibited as Anonymous Roman School in Zurich, 1964–65, and in Bergamo, 1968, no. 25. He thereafter published as "Master of the Hartford Still Life—Francesco Zucchi?" four further still lifes (Marini, 1986, 11–13, figs. 12–14 and 24–29, figs. in passim), one of which, fig. 13, is Gregori's *Paragone*, 1975, fig. 27, then attributed by her to G. B. Crescenzi. He also assigns to Francesco Zucchi (10, fig. 10) the still-life passage in the portrait of Monsignor Matteo Barberini in the Corsini Gallery, Florence, a picture he captions as by Nicodemo Ferrucci.

47. Marini, *Caravaggio*, "*pictor praestantissimus*," 1987, 358, no. 2. The author kindly made available proofs of this publication.

48. Marini, *Caravaggio*, "*pictor praestantissimus*," 1987, 357–58, no. 1.

49. Racalmuto, 1984–85, 52–53, no. 9, fig. 15, pl. VIII, for the 1626 *Holy Family*, Chiesa Madre, Cammarata, and 54, no. 10, fig. 16, pl. IX, for the 1633 *Holy Family*, Chiesa Madre, Canicattà.

50. Firstly and secondly, two unpublished still lifes likened to the Bologna/Zeri oblongs (Salerno in Munich, 1984–85, nos. 10 and 11, repr.; also see Salerno, *Natura morta*, 1984, 46, 48–49, figs. 13.2 and 13.3). Thirdly, a still life in the Molinari Pradelli Collection, Bologna (Salerno, *Natura morta*, 1984, 46–47, fig. 13.1, as private collection), which the authors of the catalogue of that collection, when shown in Bologna, thought belonged, along with the Bologna/Zeri oblongs, to a different stylistic phase than the Atheneum picture, if they are not by another artist altogether (Bologna, 1984, 50, no. 9, repr.).

51. Salerno, *Natura morta*, 1984, 46–55, which summarizes the various proposals to that date.

52. Salerno, *Natura morta*, 1984, 51–52, fig. 13.6, as Francesco Zucchi?. He thinks the two Borghese still lifes are by a different, unknown painter from Arpino's studio (427, "Zucchi," n. 6).

53. Salerno, 1984, *Natura morta*, 52–53, fig. 14.2. Salerno (51, fig. 13.5, 54–55) believes the vases of flowers in the Atheneum picture and in the ex-Lorenzelli picture [i.e., the picture mentioned above first attributed by Hüttinger] are by the same artist, who had become Caravaggesque without renouncing decorative conventions that would be unthinkable in Caravaggio's own work.

54. New York, 1985, respectively nos. 63, 64, 65, 66, 70, and 71. No. 75, the Ambrosiana *Still Life*, did not, in the event, reach the exhibition.

55. New York, 1985, 206, 211.

56. New York, 1985, 208, nos. 63–64.

57. New York, 1985, 209–11, no. 65. In that entry Gregori refers to the reservations M. Calvesi had regarding the Caravaggio attribution of the Hartford picture ("Nature morte resuscitate," *L'Espresso*, 11 Feb. 1979, 75–76). In reviewing the exhibition in New York, Schwartz, 1985, 76–77, spoke of the triad as early works of questioned authenticity. In his review Previtali, 1985, 76, found the attribution of the Atheneum and two Borghese pictures to Caravaggio hard to accept when compared to other still lifes in the exhibition: the Borghese *Boy with a Basket of Fruit*, the Uffizi *Bacchus*, and the London *Supper at Emmaus*. Spike, 1985, 416–17, felt the 1983 National Academy exhibition convinced most observers that neither the Borghese nor Atheneum still lifes are painted by anyone trained in Lombardy and that comparisons with the fruit in the Uffizi *Bacchus* and in the Borghese *Boy with a Basket of Fruit* more than suffice to disqualify once again Caravaggio's authorship of these still lifes.

Luca Carlevarijs (1663–1730)

Luca Carlevarijs was born in Udine on 20 January 1663.[1] His father, Leonardo, was an artist of local renown, though few works by him have survived; those that do reveal a modest talent. Orphaned by the age of six, Luca was raised by his sister, with whom he moved to Venice in 1679. We have little precise knowledge of his early years; literary sources assert that he had no one master,[2] and that he traveled to Rome as a youth.[3] He may also have resided in Florence and Bologna.[4]

Carlevarijs had returned to Venice at least by 1699, when he married. The rest of his life was presumably passed in the Veneto. His name is inscribed in the *Fraglia* in 1708, and appears there until 1713; it reappears only in 1726–28. While Luca may have traveled during these years, no evidence of a prolonged absence from Venice has come to light.

Carlevarijs's will was made on 26 May 1727, and he died 12 February 1730.

A number of signed and dated or documented works by Carlevarijs form the basis of his oeuvre as we understand it today. His etched views of Venice, *Le Fabriche e vedute di Venetia disegnate, poste in prospettive, et intagliate da Luca Carlevariis*, was published in Venice in 1703;[5] its popular success may have determined the further course of his painting career, for in the next year the Lucchese collector (and later patron of the young Canaletto) Stefano Conti commissioned from Carlevarijs three *vedute*, which were delivered in 1706.[6] The *Port with a Walled City* in the Piperno Collection in Rome is signed and dated 1704, while the large painting of the *Entrance of the Earl of Manchester, British Ambassador, into the Palazzo Ducale*, now in the Birmingham City Art Gallery, was probably executed just after the event on 22 September 1707.

In the next few years Carlevarijs continued to document the pagentry of his adopted city. The large *Regatta in the Grand Canal in Honor of King Frederick of Denmark*, now in the Castle of Frederiksborg, was most likely executed in 1709, when the event took place; the view of the *Bacino of S. Marco with the Bucintoro*, formerly in the Lazzaroni Collection in Rome, is signed and dated 1710; the *Regatta in Honor of the Prince Elector of Saxony*, now in the Hermitage in Leningrad, was executed in 1716; and the *Entrance of the Imperial Ambassador, the Count Colloredo, into the Palazzo Ducale* in Dresden was executed in 1726. At the same time he produced landscapes and *vedute di fantasia*, presumably for private collectors. Among the latter are the *Landscape with Architecture* in the Museo Civico in Vicenza, signed and dated 1712; the *View of a Port* and *Roman Ruins* in a private Roman collection, signed and dated 1713 and 1714, respectively; and two port scenes in the Galleria Sacerdoti, Milan, also signed and dated 1713 and 1714.

Carlevarijs has been called the father of the Venetian view painters, and it is certain that he inspired Canaletto, who became his rival and eventually surpassed him.[7] Carlevarijs's relationship with Marco Ricci is more obscure; it is not clear if Ricci inspired Carlevarijs to produce romantic and picturesque landscapes or if the influence went the other way around. Documented works in this genre by either artist do not occur until the first decade of the eighteenth century; that each artist was inspired by the work of northern European artists active in Rome at the end of the seventeenth century is clear.[8] While Carlevarijs's work in topography, both in painting and in the etchings of *Le Fabriche e vedute*, was especially influential, his bringing together of the traditions of the imaginary view, festival and ceremonial painting, and topography was perhaps his most notable achievement. He was, moreover, the first Venetian artist to produce topographical paintings in large numbers for foreign visitors, and he likely created the market for which the major part of Canaletto's oeuvre was produced.

1. For this and much of the following information, see Rizzi, 1967, 13–16. A register of dates is on 69–70.
2. Orlandi, 1753, 349.
3. Moschini, 1806, III, 49.
4. Orlandi, 1753, 349.
5. Rizzi, 1967, 102, figs. 1–190.
6. F. Haskell, "Stefano Conti, Patron of Canaletto and Others," *Burlington Magazine*, XCVIII, 1956, 297.
7. Moschini, 1806, III, 87, says Canaletto was Carlevarijs's pupil, that the younger artist surpassed the elder, and that Carlevarijs died an embittered man. The Dresden painting suggests, however, that Carlevarijs had important commissions until the end of his life. See also Constable and Links, 1976, I, 67–74.
8. Constable and Links, 1976, I, 58–59; Barcham, 1977, 51–53; 60–65. Rizzi, 1967, 27–31, argues for Carlevarijs's decisive influence on Marco Ricci; see also Reale, 1982, 119-20.

Luca Carlevarijs, *Feast of Sta. Maria della Salute*

Feast of Sta. Maria della Salute

Oil on canvas, 120.6 x 151.4 cm (47 1/2 x 59 5/8 in.)

Condition: good. There is mild abrasion in the sky.

Stamp on verso: Douane Centrale Exportation Paris; sticker on stretcher: 2139

Provenance: unidentified private collection, Scotland; sale London, Christie's, 11 Apr. 1924, no. 10, as J. Marieschi; Sackville Gallery, London, 1925; Rothschild, Paris, 1925; Gonse, Paris, 1939?; D'Atri, Paris; Wildenstein & Co., New York, 1939; bought by the Wadsworth Atheneum in 1939 from Wildenstein & Co. for $3,000 from the Sumner Fund.

Exhibitions: New Haven, 1940, no. 13, repr.; Cambridge, Mass., Fogg Art Museum, *Venice in the Eighteenth Century*, 7 May–10 June 1948, no. 8; Dayton, 1951, 17, no. 5; Detroit, 1952, 24–25, no. 20, repr.; Boston, Mass., Museum of Fine Arts, *Scenic Painters and Draughtsmen of Eighteenth-Century Venice*, 22 Jan.–2 Mar. 1958, no cat.; Venice, 1967, 43, no. 20, repr.; Cambridge, Mass., Fogg Art Museum, *Venice Benefit Exhibition*, 5–27 Mar. 1971, no cat.; Amsterdam, 1990–91, 122–23, no. 15.

The Ella Gallup Sumner and Mary Catlin Sumner Collection, 1939.268

The Feast of Sta. Maria della Salute is celebrated in Venice on 21 November. On that day a bridge supported by barges is erected across the Grand Canal from the Calle Scuola dei Fabbri (now Calle del .Traghetto) to the customhouse to fulfill a vow made by Venetians in 1630 for delivery from a plague. Carlevarijs shows at the left the Pisani-Gritti Palace and other buildings in steep perspective; at the right is the Dogana and in the distance the church of S. Giorgio Maggiore. The church of the Salute itself is outside the field of view to the right. Carlevarijs shows the lively traffic on the bridge, including some nuns leading young charges from the church. In the foreground are shown several gondolas filled with passengers.

Since its appearance in the literature in 1926,[1] the *Feast of Sta. Maria della Salute* has been considered a masterpiece by Luca Carlevarijs.[2]

Generally considered a work of his maturity,[3] questions of attribution have centered around the possible intervention of the Swedish artist Johan Richter in the foreground figures.[4] That Richter was studying Carlevarijs's work closely in these years, as remarked by Rizzi, probably explains the similarity, rather than that the painting, which presents a seamless appearance, is a work of collaboration. J.C.

1. Voss, 1926, 6–8, fig. 1.
2. De Logu, 1930, 81; F. Mauroner, *Luca Carlevarijs*, Venice, 1931, 32; Austin, 1939, 8; F. Mauroner, *Luca Carlevarijs*, Padua, 1945, 56, pls. 22–23; A. Morassi, "Settecento inedito II," *Arte veneta*, IV, 1950, 44; A. Morassi, "Una Mostra del settecento veneziano a Detroit," *Arte veneta*, VII, 1953, 58; V. Moschini, *Canaletto*, Milan, 1954, 12; Donzelli, 1957, 54; Pallucchini, 1960, 34; Constable, 1963, 7–8; F. Valcanover, *I Vedutisti veneziani*, Milan, 1966, 10; Rizzi, 1967, 60–63, 88–89, pls. 115–16; P. Zampetti in Venice, 1967, 42, no. 20.
3. Rizzi, 1967, 61 and 88, dates it to about 1720, based on comparison with the Leningrad *Regatta in Honor of the Prince Elector of Saxony* of 1716.
4. Detroit, 1952, 25; R. Longhi, in a letter to C. Cunningham, 22 Mar. 1960, curatorial file, thought the picture was by Richter; Constable, 1963, 7–8, considered the possibility of Richter's intervention but decided in favor of Carlevarijs; R. Pallucchini, in a letter to L. Horvitz, 25 June 1984, curatorial file, remarked on the similarity of the figures in the foreground boats to Richter, but noted the figures on the bridge are typical of Carlevarijs; Reale, 1982, 123, attributed the picture to Richter; M. Gregori, oral communication, 27 Nov. 1983, thought the whole by Carlevarijs except perhaps the very front figures by Richter; Amsterdam, 1990–91, 122–23, no. 15, gave the picture to Carlevarijs. On Richter, see Pallucchini, 1960, 35.

Giovanni Benedetto Castiglione (1609–1663)

Castiglione was among the most eclectic artists of the seventeenth century, extracting stylistic and thematic inspiration from such seemingly mutually exclusive sources as van Dyck, whose work he would have known during his youth in Genoa; from Poussin and Bernini during his Roman sojourns (1632–34, 1647–51); or from Rembrandt, whose prints greatly impressed him. In a century marked by virtuosi, he was among the greatest of his age, equally distinguished as a painter, draughtsman, and printmaker. His lightly brushed oil studies on paper were something entirely new, as was his invention of the monotype. But most outstanding is Castiglione's special, imaginative turn of mind. The exotic permeates his work in the extravagance of his virtuosity, in his picturesque and splendid biblical and pastoral pageants with their implied yearning after an abundant and idyllic lost age, and in the ambiguous and restless allegories that embody the proto-Romanticism Castiglione shared with his contemporaries Pietro Testa and Salvator Rosa. A work of the latter category is the Atheneum's *Allegory*.

Castiglione traveled widely in Italy. He was in Naples in 1635, home in Genoa in 1639, probably in 1640–41, and in 1646. After his second Roman period, he was in Genoa from 1652–55 and late in the decade moved to Mantua, where he was an advisor to the Gonzagas. His brother, Salvatore (1620–1676), and Giovanni Benedetto's son, Giovanni Francesco (1641–1710), were his collaborators, but to what degree is still under inquiry.[1]

1. See Blunt (17–20) and Percy (21–46) in Philadelphia, 1971, as well as Algeri, 1979, where the Atheneum picture is cited on 85. Manning, 1984, 691, would have the artist reestablished in Rome in 1645. The artist's birth and death dates here, as well as those for his son, Giovanni Francesco, and for his brother, Salvatore, are taken from Standring, 1982, I, 5, 8, 31, and on 19 are Castiglione's movements circa 1650; *Print Quarterly*, 1987, 67; *La Pittura a Genova*, 1987, 174–75, 179. The sojourn in Genoa in the 1650s is from Standring, verbally to M. Mahoney, July 1989.

An Allegory

Oil on canvas, 70.8 x 79.7 cm (27⅞ x 31⅜ in.)

Condition: generally good, although heavily damaged and repaired in the upper left sky as well as between the two columns, above the head of the principal figure; damaged on the infant's right thigh.

Inscribed in white, in the lower left corner: W. W. W.

Provenance: Thomas Worsley, Hovingham Hall, Yorkshire, by 1777; by descent to Sir William Worsley. Purchased by the Wadsworth Atheneum in 1970 from Thos. Agnew & Sons, London, for 7,000 pounds ($16,800) from the Sumner Fund.

Exhibitions: London, 1950, no. 401; Barnard Castle, 1964, no. 21; London, 1969, no. 21; Denver, 1971.

The Ella Gallup Sumner and Mary Catlin Sumner Collection, 1970.2

Traditionally the picture has been called the sorceress *Medea* or *The Goddess of Tragedy*.[1] There being only one child, not two, would seem to preclude Medea's homicidal revenge on her own two infant sons by Jason,[2] yet Dempsey believes it is the Medea theme.[3] If it was Castiglione's intention to depict Medea wavering between the love of her children and the desire for revenge on her husband, then the artist made no effort to depict the scene with any textual accuracy.[4] It has been suggested alternatively that Medea is magically rejuvenating Jason's father, Aeson, but the action here is much too passive for that scene, one of the most pyrotechnical of all classical narratives and one in which Aeson must necessarily figure as an old man with a slashed throat if Ovid is the source.[5]

Percy calls the picture simply a *Sorceress*,[6] and notes its stylistic descent from Dosso Dossi's enchantress *Melissa* in the Borghese Gallery, Rome, a painting described in a 1650 inventory as a *Sorceress Casting a Spell*[7] and a work in keeping with the tradition, from Dosso Dossi down to Castiglione, whereby witches are depicted as beautiful women.[8] She discusses at length how Castiglione used the seated figure as well as elements of the still life in the Atheneum picture in other different, yet interrelated themes of vanitas, melancholia, and magical enchantment (Circe, *The Golden Ass* of Apuleius), concluding that the combination here of elements from these three themes indicates, not want of invention, but the artist's intent to connect them.[9]

Firstly, Percy shows how Castiglione used Hartford's seated figure, with variations, as Circe, whose wand changed Ulysses' followers into beasts, in drawings in the Uffizi (1640s)[10] and in the Lugt Collection,[11] as well as in a painting in the Bacarelli Collection, Florence,[12] and another in the Pitti of circa 1653.[13] In addition, she points out that further Circe figures, virtually identical to the Atheneum's figure, appear in Castiglione's etching of Circe wherein the enchantress points to armor and a feathered cap analogous to that of the Hartford painting,[14] in the etching's preparatory drawing in Darmstadt,[15] and in a painting, formerly in the Robiati Collection, Milan, now deposited in the Poldi Pezzoli Museum, Milan.[16] De Logu illustrated a now lost *Circe*, signed and dated 1653, from the Sanguinetti Collection, Genoa, whose seated figure and some of the armor in its still life have parallels with the Atheneum picture.[17] Manning adds another *Circe* in a New York private collection.[18] Percy illustrates a further Windsor drawing[19] plus a Circe/Melancholia drawing belonging to the late van

Figure 17. Attributed to Giovanni Benedetto Castiglione, *Melancholia*, Edinburgh, National Galleries of Scotland

Regteren Altena[20] that might be included in these comparisons.[21]

Secondly, Percy identifies the same type of figure used in three drawings spanning the artist's entire career to illustrate another tale of transformation, *The Golden Ass* of Apuleius:[22] one in the Morgan Library,[23] another in the Louvre,[24] and a third in Hamburg.[25]

Finally, Percy cites the appreciable compositional affinities in the pose of the Atheneum figure to Castiglione's representations of melancholia: one in an etching much dependent on Domenico Fetti's *Melancholia* painting;[26] another in a Windsor drawing of the 1640s, where skeletal apparitions torment the melancholiac and where there is a child, sprawled across a stone block, gazing fixedly, like the main Atheneum figure, upon a skull;[27] and again in a late drawing in Philadelphia.[28]

Thus a repertory of interchangeable design motifs is bound up here with a repertory of interrelated themes: magic, melancholy, and vanity. Dempsey, who commented on this interchangeability as well, proposes that Castiglione's "invention" was fueled by this interplay of recurring stylistic and thematic elements. In relating Castiglione's treatments of Circe to melancholia (which was commonly said to be induced by witches' phantasms), he noted that the infant Practice in Dürer's print *Melencolia I*, one of Castiglione's points of reference, scrawls meaninglessly while Melancholy broods, immobile among her tools, despite her theoretical knowledge.[29] Consider the principal figure in the Atheneum picture, the pensive and comely woman who sits leaning her head upon one hand. Languid and self-absorbed, she gazes away to the left seemingly unaware of, certainly not responsive to, the fact that she holds in her other hand a bloodied sword, while at her feet there lies an infant whose skull has been slashed. Might this be Melancholy, who has slain the infant Practice, that is, creativity and action, and drifts off in a revery of *accidie*, that is, sloth, the seventh deadly sin, subsumed since St. Gregory's writings under *tristitia*?[30] On the ledge on which she sits, before a classical portico, is a smoking urn decorated with a garland and tipped pitcher, both in raised relief, evocative of

ancient funerary observances and sacrifices—a memento mori. The large open book and the huge rootlike vegetable (splendidly tinted in silvery green) may allude to the futility of learning and of abundance. Beneath the ledge is a massed still life of armor and other objects found elsewhere in Castiglione's pictures,[31] and here closely quoted, as Percy noted, from two very similar, earlier treatments of the *Meeting of Melchizedek and Abraham*.[32] This still life might, therefore, be a vanitas illustrating the futility of action (the armor), of inspiration (the feathered wings), of fame (the trumpet), and of imagination or fantasy (the plumed cap).[33]

Percy observes the linking of the melancholia theme to that of vanitas and in turn to witchcraft and magic is not as improbable as it seems, there having been a long tradition, since the Middle Ages, of associating astrology, magic, and melancholy. Castiglione may have had a particular interest in magic and astrology, for an early biographer in 1714 wrote enigmatically of the artist's succeeding in Rome more with his "astrological" than with his "pictorial" drawings.[34] Standring demonstrates Castiglione could have had access to the cabalistic and alchemic texts of the hermetic tradition in the remarkable library of his Genoese teacher Giovanni Battista Paggi in 1627.[35] In her discussion of the transformation of the triumphant sorceress theme into the melancholia/vanitas leitmotif in Castiglione's work, Manning, who suggests the Atheneum picture might be an allegory of the vanity of war,[36] writes, "when we take the trouble to look closer, particularly at the series of his so-called 'Circe' representations, we are struck by the depth of thought that dominates, leading him to develop this theme even further, possessed by liana-like ramifications of thought, until it ultimately by far transcends any of the literary sources known and becomes interwoven with an amalgamation of iconographic ideas that range from mutability to creativity on all levels of the arts and sciences, to instability and finality which in Castiglione's invention becomes attached to the idea of Vanitas Vanitatis and Melancholia."[37]

Because he saw in it the iconographical influence of Domenico Fetti, court painter to the Gonzagas circa 1614–21, Blunt dated the Atheneum picture to the second half of the 1640s, when, he thought, Castiglione began his association with the Mantuan court.[38] Percy feels it is somewhat later than 1655,[39] specifically, later than a group consisting of the Pitti *Circe* of circa 1653,[40] the Bodemuseum *Deucalion and Pyrrha* dated 1655,[41] and a pair of oblong octagonals, an *Allegory* now in a Genoese private collection and the *Temporalis aeternitatis* now in the Getty Museum.[42] For her, the Hermitage *Sacrifice to Pan*[43] may form a transition from this latter group to the Atheneum work, which Percy comments has a distinctly cooler tonality, lacks Castiglione's usual warm red-brown ground, and has a broader brushstroke and more massive figures and objects than the above group of four, thus suggesting a date between 1655 and 1659. She likens the Atheneum work to an *Angel Appearing to Hagar and Ishmael* and a *Cain and Abel*, respectively

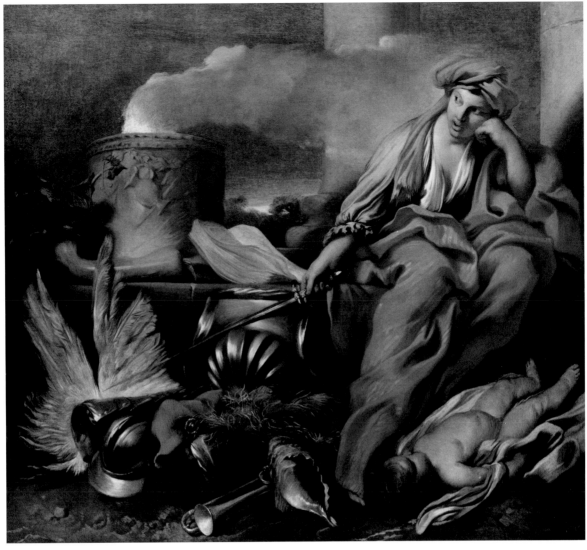

Giovanni Benedetto Castiglione, *An Allegory*

in the Palazzo Rosso and Palazzo Bianco, Genoa,[44] noting, however, that Castiglione does not seem to have pursued this coloristic phase beyond a few works, returning in his very late pictures to his rich, red-brown grounds and high color.[45] Manning thinks it a very late work.[46]

Standring rejects the attributions of both the Atheneum picture plus the above-cited Palazzo Rosso *Hagar and Ishmael* and Palazzo Bianco *Cain and Abel* to Giovanni Benedetto. He places them in a group together with the *Sacrifice of Noah* in the El Paso Museum, ascribed by Percy to the son, Giovanni Francesco,[47] with an unlocated *Tobit Burying the Dead*,[48] and with the *Moses Striking the Rock* in Norfolk, Virginia, rejected by both Standring and Percy as Giovanni Benedetto and given by Percy to Giovanni Francesco.[49] Standring, for his part, would tentatively assign all the above pictures to Giovanni Benedetto's brother, Salvatore. An attribution to Giovanni Francesco would seem to be excludable, to judge from photographs, if the touchstones for the son's work are the signed and dated *Voyage of Rebecca* of 1661, published by Spike, and the *Pastoral Journey* in the Ambrosiana of 1687 or 1689.[50] Standring thinks

Salvatore based both the *Tobit* and the Atheneum picture on Giovanni Benedetto's prints, in the case of the Atheneum's picture, on Giovanni Benedetto's *Circe*. He would assign the group to the 1640s.[51]

Percy published a drawing, auctioned as Testa[52] and now in Edinburgh,[53] that is close thematically to the Atheneum picture (Fig. 17). Therein a dejected female figure sits against classical ruins, flanked on her left by familiar objects of the Melancholia repertory—books, scrolls, statuary fragments, an astrolabe, a burning brazier on a tripod—while at her feet, on her right, lie an overturned hourglass and an inert, perhaps dead infant. Percy very tentatively suggests this might be a Giovanni Benedetto Castiglione drawing, "although the rather harsh and angular draughtsmanship is not typical of his usually loose and more lyrical pen-drawing style."[54] The drawing may figure, too, in the attribution of the Atheneum picture, which, though odd, Percy has never felt inclined to detach from Giovanni Benedetto Castiglione.[55] M.M.

1. London, 1950–51, 151, no. 401, as *Medea* or *The Goddess of Tragedy*, lent by Sir William Worsley, catalogue entry by A. Blunt; repr. in an exhibition *Souvenir*, 58. Blunt, 1954, 15, n. 2, as *Medea* or *The Goddess of Tragedy*. Barnard Castle, 1964, no. 21, as *Medea* or *The Goddess of Tragedy*. These titles were retained when the picture was listed in the privately printed *Pictures at Hovingham Hall: Room to Room Catalogue*, 1964, 15 (Percy, 1970, 10, n. 5) and thereafter in London, 1969, no. 21, repr., as probably painted in Rome in the 1640s. Both the Barnard Castle and Agnew catalogues cite the picture as having belonged to Thomas Worsley, the builder of Hovingham, Yorkshire, by 1777, and thus by descent to Sir William Worsley. See also Percy, 1970, 2, 10, nn. 1–3. Repr. in *Apollo*, LXXXIX, Apr. 1969, pl. LXXIII in advertisements, as *Medea*. Repr. in *Gazette des Beaux-Arts*, La Chronique des Arts, LXXVII, 1225, Feb. 1971, 73, no. 347. *Wadsworth Atheneum Bulletin*, Spring/Fall 1971, 10, 23. Denver, 1971, as *Medea* or *The Goddess of Tragedy*. Listed in *La Pittura a Genova e in Liguria*, 1971, entry by P. Costa Calcagno, 189, as *Medea o la Dea della Tragedia*, 1645–55. Repr. in McCorquodale, 1979, fig. 62, as *Medea Casting a Spell*.

2. Euripides, *Medea*, 1271ff.

3. Percy, 1970, 12, n. 27.

4. Percy, 1970, 5.

5. *Metamorphoses*, VIII, 160–293. Percy, 1970, 5, cites the further Medea sources, wherein there are no thematic parallels with the Atheneum picture.

6. Philadelphia, 1971, 42. Percy, 1970, 2–27. Note: as Percy's 1970 *Wadsworth Atheneum Bulletin* article on the painting was issued only in 1972, it is cited here after her 1971 Philadelphia exhibition catalogue, where the argument of her *Bulletin* article was adumbrated.

7. Philadelphia, 1971, 58, n. 139. Percy, 1970, 6. See also Manning, 1984, 691–92.

8. Salerno, 1978, 228.

9. Percy, 1970, 4–8.

10. Santarelli 7054, oil on paper, 278 x 406 mm. Exhibited Florence, Gabinetto dei Disegni e delle Stampe degli Uffizi, *Disegni italiani della collezione Santarelli*, 1967, 74, no. 66, fig. 89. Percy, 1970, 8, fig. 11. Manning, 1984, fig. 679.

11. Fondation Custodia, Institut Néerlandais, Paris, inv. no. 1031a, pen and brown ink on paper, 230 x 202 mm. Exhibited Paris, Rotterdam, Haarlem, *Le Dessin italien dans les collections hollandaises*, 1962, I, 104, no. 171, as *La Mélancolie*, II, pl. CXXI. Cited in Philadelphia, 1971, 58, n. 136. Percy, 1970, 8, fig. 12.

12. Oil on canvas, 99.4 x 134.3 cm (39 1/8 x 52 7/8 in.). With David Koetser, New York, in 1967–68 and with Gilberto Algranti, Milan, in 1969. Percy, 1970, 8, fig. 13, as unlocated. Sale Milan, Finarte, 9 Nov. 1971, no. 54, as 100 x 135 cm, pl. XLII. Albrici, 1973, 42, fig. 3. Standring, verbally to M. Mahoney, July 1989, rejects this painting as Giovanni Benedetto's work.

13. Inv. no. 6464, oil on canvas, 184 x 216 cm. Philadelphia, 1971, 40, n. 127, fig. 20. *Gli Uffizi*, I, 1979, 211, illus.

14. Bartsch 21.22, as *Melancholia*. Philadelphia, 1971, 145, no. E23, as *Circe*, probably early 1650s. Percy, 1970, 8, fig. 4. Bellini, 1982, 159–61, no. 60, as *Circe*, datable 1650–51, in any case before the artist left Rome. The Atheneum picture is mentioned (161) and the literature on the print summarized. Manning, 1984, fig. 689.

15. Inv. no. AE 1857, pen on paper, 198 x 280 mm, in the 1775 Mariette sale as *Melancholia*. See Philadelphia, 1971, 98, no. 70. Percy, 1970, 8, fig. 15. Manning, 1984, fig. 688.

16. Arslan, 1965, 177, repr. 173, when it was in the Robiati Collection, Milan. Oil on canvas, 99 x 141 cm, deposited in 1976 by the Ministero per i Beni Culturali e Ambientali, inv. no. D.T. 717. Percy, 1970, 8, fig. 16. *Museo Poldi Pezzoli*, 1982, I: *Dipinti*, 102–3, no. 72, pl. 194, where the Atheneum picture is mentioned. Manning, 1984, fig. 609.

17. De Logu, *Castiglione*, 1928, 25–26, a large picture that he describes as the prototype for a numerous series of replicas of all sizes by Castiglione and his studio: the Uffizi, Florence; Ospedale S. Martino, Genoa; and especially a large picture signed and dated 1653 beneath the bust of a garlanded satyr. The ex-Sanguinetti picture is repr. by Standring in *La Pittura a Genoa*, 1987, II, 169, fig. 148.

18. Manning, 1984, 692, fig. 681. Repr. Standring in *La Pittura a Genova*, 1987, II, 169, fig. 146.

19. Inv. no. 4067, drawn in brown oil paint on paper, 392 x 544 mm. Blunt, 1954, 36, no. 133, pl. 25. Philadelphia, 1971, 98–99, no. 71, illus. Manning, 1984, fig. 682.

20. Pen and brown ink on paper, 163 x 259 mm (irregular). Philadelphia, 1971, 131, no. 129, illus. Manning, 1984, 697. Percy has come to consider this drawing to be by Francesco Castiglione (A. Percy to M. Mahoney, 28 July 1986, curatorial file).

21. The figure also appears as the laurel-crowned personification of Music in a *Poetry, Music, and a Satyr* in a Genoa private collection (Arslan, 1965, 177, fig. 4).

22. Percy, 1970, 7.

23. Inv. no. IV.193, brush, 282 x 411 mm. Philadelphia, 1971, 62, no. 1, illus. Percy, 1970, 7, fig. 8.

24. Inv. no. 9456, brush, 378 x 567 mm. Philadelphia, 1971, 98, no. 69, illus. Percy, 1970, 7, fig. 9.

25. Kunsthalle, inv. no. 21155B, brush, 401 x 577 mm. Percy, 1970, 7, fig. 10.

26. Bartsch XXI, 1870, no. 22. Philadelphia, 1971, 142, no. E14, probably done in Genoa before 1647. Percy, 1970, 6, fig. 4. Manning, 1984, 697, fig. 687. For a discussion of how Castiglione derived his interpretations of the melancholia theme both from Dürer and Domenico Fetti, see Philadelphia, 1971, 142, no. E14.

27. Inv. no. 3924, pen, brown ink on paper, and wash with red chalk, 220 x 345 mm. Blunt, 1954, 13, 32, no. 35, pl. 30, as *St. Mary of Egypt*. Philadelphia, 1971, 97, no. 66, illus. Percy, 1970, 6, fig. 5.

28. Philadelphia Museum of Art, Academy Collection, inv. no. 39, brush drawing in brown paint on paper, 282 x 408 mm. Philadelphia, 1971, 126, no. 117, illus., after 1660. Percy, 1970, 7, fig. 7. Manning, 1984, fig. 691.

29. Dempsey, 1972, 119.

30. Cross, 1957, s.v. "Seven Deadly Sins," 1245. St. Thomas Aquinas, *Summa Theologica*, pt. 11–11, quest. 35, art. 4.

31. Philadelphia, 1971, 33, fig. 22, *Allegory in Honor of the Duke of Mantua*, private collection, Italy; *Diogenes*, Prado; or *Melchizedek and Abraham*, Louvre, inv. no. 238.

32. Percy, 1970, 4–5. One is Louvre, inv. no. 238, repr. as fig. 2 by Percy. The other, then on loan to the Staatsgalerie, Bayreuth, is now in the Bayerische Staatsgemäldesammlungen, Munich, inv. no. 2311.

33. The trumpet and the plumed cap appear as attributes of the figure of Fame in the artist's print *The Genius of Castiglione*. The plumed hat is specifically linked with Fantasy by Rash Fabbri, 1970, 330, n. 21.

34. Percy, 1970, 6–7.

35. Standring, 1982, I, 220–41.

36. Manning, 1984, 708, n. 30

37. Manning, 1984, 689. The Atheneum picture is discussed particularly on 697, 700, illus. fig. 692.

38. Blunt, 1954, 14, 15, n. 2.

39. Philadelphia, 1971, 42. Percy, 1970, 3.

40. Inv. no. 6464, oil on canvas, 184 x 216 cm. Philadelphia, 1971, 40, no. 127, fig. 20. *Gli Uffizi*, I, 1979, 211, illus.

41. Inv. no. 2078, oil on canvas, 83.3 x 107 cm. Philadelphia, 1971, 40, n. 128, fig. 21.

42. Sale London, Christie's, 27 Nov. 1970, lots 101–2, oil on canvas, 109.2 x 109.2 cm, octagonals. Philadelphia, 1971, 41, no. 130–31, figs. 22–23. The *Temporalis aeternitatis* is J. Paul Getty Museum, *Arcadian Shepherds*, inv. no. 72. PA. 19.

43. Inv. no. 186, oil on copper, 52 x 67.5 cm. Philadelphia, 1971, 41, n. 132, fig. 24.

44. Philadelphia, 1971, 42, where *Hagar* is fig. 28, inv. no. 355, oil on canvas, 100 x 123 cm. Percy, 1970, 4, where the *Cain* is cited as being reproduced in Genoa, Palazzo Bianco, *Mostra dei pittori genovesi a Genova nel '600 e nel '700*, 1969, 187, no. 77.

45. Percy, 1970, 3–4. Further "atypical" works of 1655–59 are cited in Philadelphia, 1971, 42.

46. Manning, 1984, 697.

47. Inv. no. K1705, Samuel H. Kress Collection, oil on canvas, 99 x 123.3 cm. Philadelphia, 1971, 45–46, n. 164, fig. 41.

48. Sales: London, Christie's, 28 May 1982, no. 52, as 65 x 81 cm (25 1/2 x 34 1/4 in.); Monte Carlo, Sotheby's, 20 June 1987, no. 320.

49. Philadelphia, 1971, 45, n. 161. See Norfolk, Museum of Arts and Sciences, *Italian Renaissance and Baroque Paintings from the Collection of Walter P. Chrysler, Jr.*, 1968, 36, no. 30, repr., signed: IO. BENEDITUS/CASTILIONUS IANVE.

50. Spike, 1980, figs. 85 and 84 respectively. Repr. by Standring in *La Pittura a Genova*, 1987, II, 176, fig. 157 and 174, fig. 155.

51. Verbally to M. Mahoney, June 1983. The print is Bellini, 1982, no. 69. For further speculation regarding Salvatore's and Giovanni Francesco's suggested borrowings from Giovanni Benedetto's prints, see Standring in *La Pittura a Genova*, 1987, II, 176–78, and *Print Quarterly*, 1987, 67–68.

52. London, Christie's, 26 Nov. 1968, lot 78, pen and brown ink on paper, 160 x 190 mm (6 5/16 x 7 1/2 in.).

53. National Gallery of Scotland, inv. no. D5004, as Pietro Testa.

54. Percy, 1970, 7, and n. 41.

55. A. Percy to M. Mahoney, 28 July 1986, curatorial file.

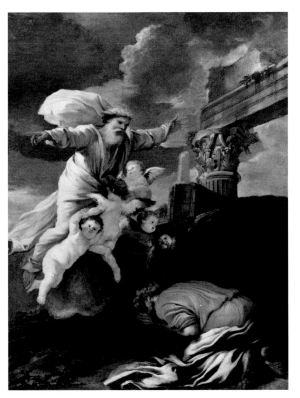

Giovanni Benedetto Castiglione,
God Appearing to Abraham

God Appearing to Abraham

Oil on canvas, 98.6 x 73.9 cm (38 7/8 x 29 1/16 in.)

Condition: poor. Except for the lower right figure, the state of the original paint is obscured by at least two programs of extensive retouchings.

Provenance: sale London, Christie's, 4 May 1979, no. 34, bought by Colnaghi's; Colnaghi's, London. Given to the Wadsworth Atheneum in 1986 by Mr. and Mrs. Leonard Greenberg.

Gift of Mr. and Mrs. Leonard Greenberg, 1986.12

The painting was aptly compared in the sales room[1] to a Windsor drawing of God, supported by angels, bestowing the tablets of the law of Moses.[2] The Atheneum's kneeling figure is a frequent motif in Castiglione's work, found in such further drawings of biblical subjects as the *Sacrifice of Noah* in the Louvre[3] and in the *Angel Appearing to a Patriarch?* in the Art Institute of Chicago.[4] But the two latter drawings are many figured; much closer to the Atheneum composition is a drawing in the Metropolitan Museum of Art wherein, in a landscape setting with classical ruins and architectural fragments, God, supported by angels, appears to a prostrate, kneeling figure behind whom are two women, each with a child. Stampfle and Bean interpret the subject to be God appearing to Abraham, after Raphael's treatment of the theme in the Vatican Loggia.[5] Percy interprets the women to be Rachel and Leah with some of their children and thus reads the scene as God appearing to Jacob at Bethel.[6]

It is not unreasonable to suggest that the Atheneum's subject is one of the special revelations granted to Abraham in dreams, visions, and theophanies,[7] specifically the occasion of God's covenant with the patriarch, wherein "Abram fell on his face: and God talked with him, saying . . . behold my covenant is with thee, and thou shalt be a father to many nations."[8]

In so far as one can judge from its present state, the treatment of the angels, the picture's tonality, and the kneeling figure can be compared stylistically with such an early Poussin as the London National Gallery's *Adoration of the Shepherds*[9] of circa 1637, a decade when that artist's influence on Castiglione was a potent one. Standring would date the picture to the late 1630s.[10] M.M.

1. London, Christie's, 4 May 1979, no. 34, illus., bought by Colnaghi's for 11,000 pounds.

2. Blunt, 1954, 36, no. 128, pl. 22.

3. Inv. no. 9445. Exhibited Paris, Musée du Louvre, *Le Dessin à Gênes du XVI–XVII siècles*, 1985, 85–86, no. 72, illus.

4. Inv. no. 1966.34, Clarence Buckingham Collection. See A. Percy in Philadelphia, 1971, 94, no. 57, illus., for this and its related drawings.

5. Inv. no. 1965.176, purchase, Robert Lehman Gift. F. Stampfle and J. Bean in New York, 1967, 58, no. 76, illus.

6. A. Percy in Philadelphia, 1971, 69, no. 19, illus.

7. J. D. Davis, s.v. "Abraham," in *A Dictionary of the Bible*, London, 4th ed. rev., 1958, 7–10.

8. Genesis 17:1–22.

9. Inv. no. 6277. Blunt, 1966, 32–33, no. 40.

10. Verbally to M. Mahoney, July 1989.

Bernardo Cavallino
(1616–c. 1656)

It is difficult to reconstruct the life and stylistic development of this short-lived Neapolitan artist. Of his eighty odd surviving paintings only one is signed and dated, the *St. Cecilia in Ecstasy* of 1645, and the only biography, De Dominici's of 1742–43, is often undependable. Cavallino's style is founded firstly on Caravaggio's naturalistic legacy in Naples during the 1630s: the work of the Spaniard Jusepe de Ribera and the equally influential effect of his still anonymous but also seemingly Spanish-born contemporary the Master of the Annunciation to the Shepherds. Both these artists were then revising their harsh realism in favor of a more painterly style and a warmer, more evocative sentiment. Just at this time Massimo Stanzione had returned to Naples after a Roman sojourn, during which he had been particularly responsive to Bolognese classicism. He, too, moderated the stark naturalism of the Neapolitan tradition in favor of a more elegant narrative style. Cavallino fused the evolving naturalistic sources with a very idiosyncratic delicacy of style and interpretation, akin to the sensibilities of Massimo Stanzione with whom he might even have studied, if De Dominici is to be believed. His maturing work is notable for easel-sized pictures that combine his naturalistic sources and themes with this characteristic grace. Such a work is the Atheneum's woefully preserved, but nonetheless eloquent picture. The fully mature works after 1645 are as tender, but generally even more delicate and lighter in hue and illumination. His early death, about the time of the plague in Naples in 1656, limited Cavallino's influence in seventeenth-century art, but his work and its temperament prefigure the eighteenth-century rococo.[1]

1. Based on N. Spinosa's biography and entries in London, *Painting in Naples*, 1982, 135–47, nos. 21–37. See also the same author's "Painting in Naples during Bernardo Cavallino's Lifetime," in Cleveland, 1984, 35–42.

The Flight into Egypt

Oil on canvas, 102.2 x 126.8 cm (40^1/2 x 49^7/8 in.)

Condition: poor. Much of the pigment has become so transparent that the figures and their relationship to the dark landscape setting are difficult to read; for example, there are three angels in the entourage. The balance between landscape and sky is lost. The picture is much abraded and was drastically cleaned at one time. The hands of the left angel are reconstructions.

Provenance: sale London, Christie's, 8 May 1931, no. 102, as Bassano, bought by Parkes, 2 pounds; Kenneth Clark. Purchased by the Wadsworth Atheneum in 1942 from Durlacher Bros., New York, for $2,800 from the Sumner Fund.

Exhibitions: London, 1932–33, no. 22;[1] London, Royal Academy, 1938, no. 312, lent by Kenneth Clark, Esq.; Northampton, 1947, no. 6; Sarasota, 1958, no. 16; Bridgeport, 1962; Detroit, 1965, 145, no. 161; Cleveland, 1984, no. 8 (no. A7 in the Italian edition of the catalogue).

The Ella Gallup Sumner and Mary Catlin Sumner Collection, 1942.348

The distant source for this picture is in Venetian art. Moir, by way of illustration, cites Tintoretto for similarly treating a biblical narrative as a pastoral, nocturnal scene.[2] He could have invoked Bassano just as well, the generic name under which this work actually once passed through the sales room. Thereafter it belonged to Kenneth Clark and was exhibited as Cavallino, the now accepted attribution.[3] More immediately, the painting is a compendium of sources that shaped Cavallino. The tenebrism and naturalistic setting come from Caravaggio, whose Neapolitan works were not only at hand but whose heritage had been kept alive in Naples by Caracciolo, who stood as godfather for Cavallino's younger brother, born in 1623;[4] from Ribera; and from the Master of the Annunciation to the Shepherds. Such precedents were given an infusion of elegant Bolognese classicism by Massimo Stanzione, with whom Cavallino is said to have studied, according to De Dominici.[5] While De Dominici's statement is unsubstantiated, some close relationship between the two artists is apparent from this picture, where the angel, sauntering gracefully at the head of the cavalcade, is, as Moir observed, as Stanzionesque as any in Cavallino's career,[6] yet already has, as Percy remarks, the mannered grace combined with the intense naturalism that distinguishes Cavallino from his contemporaries.[7] Percy likens the figure of St. Joseph to Zachariah's in *The Baptist Taking Leave of His Parents* by Stanzione in the Prado, part of a series Pérez Sánchez dates to the mid 1630s,[8] and the Virgin's head to Stanzione's Virgin in his *Annunciation* in Sta. Maria Regina Coeli, Naples, documented to early in 1640.[9] Such powerful naturalism was also probably impressed on Cavallino by the Master of the Annunciation to the Shepherds, with whom, Spinosa has pointed out, Cavallino was closely linked between circa 1635–40.[10] That still undocumented painter transformed biblical scenes into pastoral and genre subjects, combining Caravaggio's tenebrism, Ribera's naturalism, and the realism of Velázquez's Seville period.[11] In writing of the Atheneum picture when it was included in the 1984–85 Cavallino exhibition, Percy joined Causa, Ferrari, and Spinosa in seeing Cavallino's beginnings in the following three works:[12] the Budapest *Meeting of Anne and Joachim*, once given to Stanzione with assistance from Cavallino;[13] the Brunswick *Adoration of the Shepherds*, identified by Percy and published by De Vito;[14] and the Capodimonte *St. Bartholomew*.[15] Percy places the Atheneum picture close stylistically and chronologically—that is, in the mid 1630s—to these three large-scale works very much connected stylistically with the Master of the Annunciation to the Shepherds.[16] The scale here is that of an easel picture, something that became Cavallino's specialty. There is already articulated that delicacy of touch combined with both a lyric presentation and a lyric sentiment that prefigures his mature style as illustrated in the signed and dated *St. Cecilia in Ecstasy* of 1645, now on deposit in the Palazzo Vecchio, Florence.[17]

Percy remarks that the distant landscape on the right is reminiscent of the delicate palette and touch of Domenico Gargiulo and compares it to a similar passage in the Budapest *Meeting of Anne and Joachim*, given by Causa to Scipione Compagno.[18] The same landscape convention appears in the Capodimonte *Finding of Moses*, another early work, of the late 1630s for Percy.[19] Whatever is the resolution of this proposal, the landscape in the Atheneum picture does not seem to have any iconographic intention; the

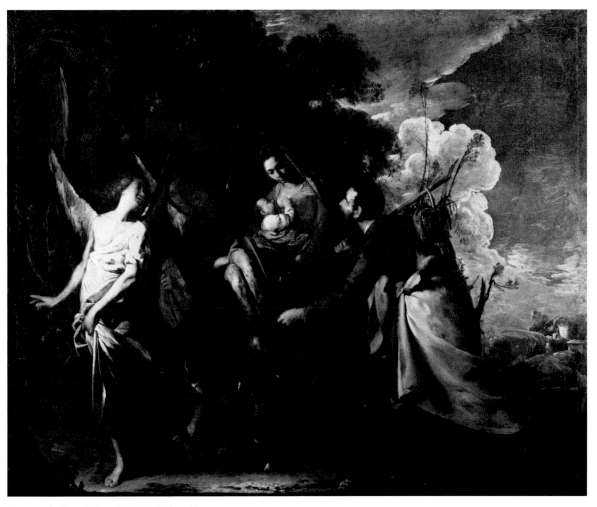

Bernardo Cavallino, *The Flight into Egypt*

blasted tree would not seem to signify escape from a threatening world—from Herod's Israel into the protection of Egypt.[20] Indeed, there is no urgency at all or sense of flight. The balletic grace of the principal angel, the serenity of the Madonna, and Joseph's solicitude for her generate the all-pervading mood of a bucolic idyll. Note that Joseph is gently proffering the donkey a handful of grass; he is not leading him. • This is an untraced but, according to Blunt, common iconographic usage by which the unguided donkey finding his way with the help of an angel symbolizes divine intervention.[21] M.M.

1. According to the Durlacher Bros. invoice.
2. Detroit, 1965, 145, no. 161. Spinosa in Cleveland, 1984, 35, points to the needed elucidation of the relationship between Rome's neo-Venetianizing painters circa 1630 and Neapolitan painters in the 1630s.
3. Fredericksen and Zeri, 1972, 50, 275, 585.
4. Refice, 1951, 262.
5. De Dominici, 1844, III, 159–62.
6. Detroit, 1965, 146.
7. Cleveland, 1984, 64, no. 8.
8. Pérez Sánchez, 1965, 459, pl. 164, Prado inv. no. 291. Repr. in Cleveland, 1984, 9, fig. 8.
9. Cleveland, 1984, 64, no. 8.
10. London, *Painting in Naples*, 1982, 135.
11. See De Vito's summary of the current thinking regarding this artist. London, *Painting in Naples*, 1982, 190–91, and the related entries, nos. 80–85, 191–95, especially no. 80. Further attributions are in De Vito, 1983.
12. Cleveland, 1984, 9–10, 30, n. 47.
13. Budapest, Museum der bildenden Künste, no. 766, 229 x 178.5 cm; Pigler, 1968, I, 663–64, II, fig. 127.
14. Herzog Anton Ulrick Museum, no. 128, 191 x 141 cm. De Vito, 1982, 37–39. London, *Painting in Naples*, 1982, 137–38, no. 24, repr.
15. Inv. no. IC544, 204 x 158 cm; photo no. I.12.1970, after restoration.
16. Cleveland, 1984, 9–10. In addition to her catalogue entry (64, no. 8), Percy mentions the Atheneum picture on 8, 53.
17. London, *Paintings in Naples*, 1982, 141, no. 28, repr.
18. Cleveland, 1984, 51–53, no. 1, 64, no. 8.
19. Cleveland, 1984, 74, no. 13.
20. Matthew 2:13–15, 19–22.
21. Blunt, 1982, 210.

Giacomo Ceruti
(1698–1767)

Because of the large number of his works extant in or near Brescia, Ceruti was presumed to have been born there. While the family is recorded in the city in 1711—his mother might have been Brescian—Ceruti was actually born in Milan, where he married Angiola Carozza, a woman appreciably his senior, in 1717. By 1721 he was back in Brescia, where the long tradition of Lombard realism exerted a strong influence on the portraiture and genre works for which he is noted. In the mid 1730s he moved to the Veneto, possibly with a younger woman, Matilde de Angelis. There he was impressed by contemporary Venetian painting, as seen in the Atheneum's *Girl with a Dove*. In 1736 he was working for the Venetian collector Marshall von der Schulenberg, and in the following year Ceruti offered to execute an altarpiece for the basilica of St. Anthony (the Santo) in Padua, where he seems to have resided for several years.[1] In the following decades he is mentioned again in Brescia (1743), Piacenza (1743, 1744–47), and in Milan (1766), where he died, reunited in the meanwhile with his wife.[2]

1. Caprara, 1980, 61.
2. Gregori, 1982, 105–16; Milan, 1991, 133–43.

Girl with a Dove

Oil on canvas, 61.2 x 46 cm (24 1/8 x 18 1/8 in.)
 Condition: generally good, but for damages at the edges. Pentimenti are visible along the back of the figures's neck, on the left sleeve, and on the forefinger of the right hand. Puncture damages on the pupils are repaired. The painting was cleaned with excellent results in 1985 by Stephen Kornhauser.
 Provenance: Spiridon Collection, Paris; F. Kleinberger & Co., New York; consigned to Arnold Seligmann, Rey & Co., New York;[1] purchased by the Wadsworth Atheneum in 1942 from Arnold Seligmann, Rey & Co. for $3,000 from the Sumner Fund.
 The Ella Gallup Sumner and Mary Catlin Sumner Collection, 1942.352

The painting entered the collection attributed to Giacomo Francesco Cipper, Il Todeschini. Suida proposed a Solimena attribution.[2] Fredericksen and Zeri suggested that this picture and the Atheneum's *Boy with a Pug Dog*, below, may well be by Paolo Borroni.[3] In her Ceruti monograph, Gregori rejects that idea out of hand and places this picture among those done in the Veneto, arguing the attribution and dating on the basis of the subtle color range in the draperies, the "Venetian" handling of the impasto in the flesh, and the elegant positioning of the hands.[4] The sitter's right hand is compared to that of the principal figure in Ceruti's 1737 commission for Padua, *St. Prosdocimo Baptizing St. Giustina*,[5] or with the hand in an unlocated *Portrait of an Ecclesiastic*, one of a series of four oval portraits assignable to the early 1740s.[6]

The compelling, yet reticent presence in the Atheneum picture, the finesse of the palette, and the superbly structured anatomy leap to the eye when comparison is made to what Gregori considers to be an autograph replica in a private collection in

Bergamo.[7] This latter Gregori judges to be more individualized than the Atheneum picture and suggests the model might be the same as that in a portrait now in the Zornmuseet, Mora, Sweden, a likeness Heden had speculated might be based on Ceruti's companion in those years, Matilde de Angelis,[8] by whom the artist had three children.[9] M.M.

1. P. M. Byk to A. E. Austin, Jr., 14 Oct. 1940, with annotations by C. Cunningham, curatorial file.
2. W. Suida to C. Cunningham, 21 Dec. 1946, transcript in curatorial file.
3. Fredericksen and Zeri, 1972, v, 51, 532, 585.
4. Gregori, 1982, 74, 76, 452, no. 128, repr. 287, fig. 128.
5. Gregori, 1982, 451–52, no. 123, repr. 280, fig. 123.
6. Gregori, 1982, 460, no. 176, repr. 330, fig. 176.
7. Gregori, 1982, 452, no. 127, 62.5 x 49 cm, repr. 286, fig. 127.
8. Gregori, 1982, 455, no. 139, repr. 297, fig. 139.
9. Gregori, 1982, 102.

Boy with a Pug Dog

Oil on canvas, 64.3 x 49 cm (25 1/16 x 19 5/16 in.)
 Condition: good, with the exception of three punctures in the background. The stretcher could be original.
 Provenance: The previous history of the picture is unknown. Purchased by the Wadsworth Atheneum in 1942 from the Schaeffer Galleries, New York, for $400 from the Sumner Fund.
 Exhibitions: New York, 1942, no. 21, as Maggiotto.
 The Ella Gallup Sumner and Mary Catlin Sumner Collection, 1942.404

The painting was acquired as Domenico Maggiotto,[1] a Piazzetta follower, presumably on the strength of the subject matter alone, for stylistically it bears no relationship to that artist.[2] Equally unconvincing but geographically more apt was Suida's suggestion[3] that the painting was by Giacomo Francesco Cipper, called Il Todeschini, whose work is coarser.[4] Longhi recognized the Atheneum picture was by Todeschini's contemporary, Giacomo Ceruti, whose works have been frequently confused with Todeschini's.[5] Gregori published it as certainly by Ceruti, datable to a little after 1745.[6] Ceruti's agreeably tender mood is present, but the brushwork, overall, may be altogether too unsophisticated for Ceruti's. Although there is merit in the placing and rendering of the hands, the face is awkwardly constructed and painted, when compared, for example, with the Atheneum's *Girl with a Dove*. The model's right cheek here is not structured nor is it turned in a way that is congruent with the other side of the face. The features are not built up on an underlying paint layer as in the *Girl with a Dove*. Nor does the pug dog seem to be comparable in quality to others by the artist.[7] Could this be a copy, perhaps a workshop repetition, after what must be a stunning original? Fredericksen and Zeri suggest this picture might well be a copy,[8] perhaps by Paolo Borroni (1749–1819), who obviously was greatly impressed by Ceruti's work.[9] The simplification of Ceruti's prototype here is not unlike Borroni's personification of Summer reported to be in a private collection.[10] However, Gregori reaffirmed her attribution and dating on reexamining the painting in November 1983. M.M.

Giacomo Ceruti, *Girl with a Dove*

Giacomo Ceruti, *Boy with a Pug Dog*

1. Reproduced by A. M. Frankfurter, "Baroque Reading on the Barometer of Today's Taste," *Art News*, XL, no. 20, 1–14 Feb. 1942, 23, as Maggiotto. Purchased together with Recco's *Still Life with Fish* for $1,000; this painting was valued at $400 (Mrs. H. Schaeffer to C. Cunningham, 13 Mar. 1963, curatorial file).
2. For Maggiotto, see Pallucchini, 1932.
3. W. Suida to C. Cunningham, 21 Dec. 1946, curatorial file.
4. For Todeschini, see Tognoli, 1976.
5. R. Longhi to C. Cunningham, 22 Mar. 1960, curatorial file.
6. Gregori, 1982, 466, no. 198.
7. Gregori, 1982, nos. 156 and 255.
8. Fredericksen and Zeri, 1972, 51, 528, 585, as a copy after Ceruti.
9. Fredericksen and Zeri, 1972, v. For further work on Borroni, see Malagutti, 1968, and Tellini Perina, 1971. Gregori's attribution (1982, 452, no. 128) of the Atheneum's *Girl with a Dove* to Ceruti seems quite right, although Fredericksen and Zeri, 1972, v, think it also is perhaps Borroni.
10. Malagutti, 1968, 38, fig. 7.

Viviano Codazzi (1603/4–1670) and Michelangelo Cerquozzi (1602–1660)

Codazzi's small reputation belies his importance in the history of Italian art. The *vedute* painters of eighteenth-century Rome and Venice descend directly from his early initiative. It is conjectured that Codazzi left his native Bergamo about 1620 to settle in Rome, where, in concert with the *bamboccianti* genre painters, he instilled a new realism, inspired by Caravaggio's naturalism, into his depictions of urban scenes and monumental ruins. Others, however, assert Codazzi went directly to Naples circa 1620, for at his marriage there in 1636, he declared he had been a resident for fifteen years.[1] Certainly, he was in Naples from 1634 until financial pressure forced him to move to Rome about 1648. Although he may have been away thereafter about 1653, and perhaps from 1659 to 1666, he lived in Rome, on the edge of poverty, until his death.[2]

Codazzi called upon other artists to provide the figures in his paintings. His frequent Roman partner was Michelangelo Cerquozzi, as in the following picture. Domenico Gargiulo was his close partner in Naples, as in the Atheneum's *Men's Bath*.[3]

The training of Michelangelo Cerquozzi, an affluently born, native Roman, is in dispute. If Passeri is correct in maintaining he first studied with the fashionable Cavaliere d'Arpino, the latter had little effect upon him. The same author's assertion he thereafter studied with the battle painter Jacob de Hase (1575–1634), called Giacomo Fiammingo, is more reasonable, for that would be a likely source for instruction in a genre that became one of Cerquozzi's specialties, battle pieces. He was popularly called Michelangelo delle Battaglie. While he painted still lifes as well, his other specialty was in genre scenes inspired by the street life and everyday activities of Rome. Along with Pieter van Laer, Il Bamboccio, he introduced this type of painting in Rome, giving it a Caravaggesque realism that distinguishes the Italian manifestation from its northern predecessors. Longhi called this "Caravaggismo a passo ridotto," attenuated, or in this case, domesticated Caravaggism, if you will. Although these genre painters were dismissed by the academically trained painters of idealized history and religious subjects, they nonetheless were immensely popular, Cerquozzi in particular.

He frequently provided the figures for Viviano Codazzi's architectural settings, as in this Atheneum picture.[4]

1. Zeri, *Walters Art Gallery*, 1976, II, 463. Salerno, c. 1977–80, III, 504.
2. Marshall, who describes Codazzi's *quadratura* work at S. Martino from 1644 to 1646, speaks of paintings with figures by Gargiulo dated 1652 and 1654 or 1655, thus suggesting further excursions from Rome in the 1650s (1986, 49, n. 7). Marshall also believes the generally accepted birth date, 1603/4, is perhaps too early and prefers the vaguer dates 1604–11. He also believes Codazzi's career really began in Naples in the early 1630s without a prior Roman interlude (D. Marshall to M. Mahoney, 27 May 1987, curatorial file).
3. Scavizzi, 1982.
4. Scavizzi, 1979.

The Courtyard of an Inn

Oil on canvas, 42.5 x 66.6 cm (16³/₄ x 26¹/₂ in.)

The canvas has its original tacking edges, and the strainer-type stretcher is probably original as well.

Condition: generally good, except for extensive damages in the sky and minor damages in some figures. The haystacks on the right no longer read coherently. Straightedge guidelines are visible on the eaves of the inn and on the overhang of the leftmost building.

Stamped illegibly on the relining canvas.

Provenance: Leger & Sons, London, 1936; H. Sperling, Kleinberger Galleries, New York.[1] Purchased by the Wadsworth Atheneum in 1944 from A. F. Mondschein, New York, for $850 from the Sumner Fund.

Exhibitions: Hartford, *Architecture*, 1947, as Scorza; Kent, 1966, as Codazzi and Cerquozzi.

The Ella Gallup Sumner and Mary Catlin Sumner Collection, 1944.33

The picture was acquired as *The Blacksmith's Yard* by the Lombard Sinabaldo Scorza, but in 1949 Voss nudged the attribution in the appropriate direction when he said the picture was by the Roman *bambocciante* and battle painter Michelangelo Cerquozzi, likening it to paintings then given to Cerquozzi in the Incisa della Rocchetta Collection, Rome. One of these, *The Women's Bath*, Longhi had published as Cerquozzi, but Briganti later recognized it as a collaborative work by Viviano Codazzi and Cerquozzi described by both Baldinucci and Pascoli.[2] This enabled Longhi to refine the Atheneum attribution, assigning the figures therein to Cerquozzi and the architectural setting to Codazzi.[3] Noting the sign hanging from the arcaded building, Longhi aptly titled the picture *Travelers Stopping at the Halfmoon Inn* and suggested that it was earlier than Codazzi's move from Naples to Rome in 1647–48, that it was datable between 1635 and 1640, which would thus require that Codazzi was in Rome or Cerquozzi in Naples sometime in those years.[4] Longhi's attribution, if not his dating, has been well received.[5] The strong side

Viviano Codazzi and Michelangelo Cerquozzi,
The Courtyard of an Inn

lighting, the substantial treatment of architectural forms, and the paint facture compare well with a pair of architectural fantasies in the Pitti that Briganti gives to Codazzi at his most independent and original moment, in collaboration with Cerquozzi immediately after 1647,[6] an evaluation and dating shared by Brunetti.[7] Marshall dates the Atheneum picture circa 1650, comparing it with the *Courtyard of an Inn* in the Walters Art Gallery, Baltimore, a picture he believes bears a date that is possibly 1650.[8] For further purposes of attributing the van Laer inspired figures in the Atheneum picture, a constructive comparison can be made with those in Codazzi's *Sacking of a Village* in S. Martino, Naples, signed 1630;[9] or with such convincingly attributed Codazzi/Cerquozzi collaborations as the *Section through the Pantheon* in the Lisano Vicario Collection, Rome, dated by Brunetti 1632, because it incorporates references to work done on the building then;[10] or with the former Incisa della Rocchetta *Carnival at the Palace*, another Codazzi/Cerquozzi collaboration confirmed by Baldinucci and Pascoli.[11]

The coat of arms and its coronet affixed to the wall of the inn would seem to be notional, conceivably simply a device to suggest that this ramshackle, yet architecturally grandiose building had seen better days. The building itself is one that Codazzi repeated, with variations: one is an unlocated upright;[12] the other variation is the above-mentioned Walters Art Gallery picture, whose figures are by Domenico Gargiulo.[13] In all three paintings, beneath the signboard of each inn there hangs a horn and horseshoe, perhaps to indicate the inn provided shoeing and post-horses.

Stylistically, the picture represents the dilution of two very separate strains in Roman seventeenth-century painting. Here obviously is late Caravaggesque realism, Longhi's Caravaggio "a passo ridotto."[14] It is joined most surprisingly to the early style of Claude Lorraine, similarly "a passo ridotto," an influence which Brunetti intriguingly suggests was transmitted to Codazzi in Rome in the 1620s by Hermann van Swanevelt. Certainly, Swanevelt's *Campo Vicino* of 1631? in the Fitzwilliam Museum is the close relative, conceptually and stylistically, of the Atheneum picture.[15] M.M.

1. A note in the curatorial file in the hand of C. Cunningham, undated but before the attribution was changed from Scorza, says the picture was acquired at a Hôtel Drouot sale in Paris circa 1935–36 by H. Sperling of Kleinberger Galleries, New York, who placed it in the Plaza Art Auction Galleries, New York. However, Sperling, in a letter to C. Cunningham, 22 Nov. 1947, curatorial file, said that he had bought the picture from Leger & Sons, London, in March 1936, and sold it in New York, American Art Association–Anderson Galleries, 17 Dec. 1938 [on which date there was no paintings sale. Nor does such a picture appear in any other paintings sale in 1938 at that house]. The latter provenance was the correct one in Cunningham's mind, for it was that given in what seems to be his typescript note for publication preserved in the curatorial files (C.C. C[unningham], "Notes on Reattributions of Italian Paintings," n.d., after 1960, 3–4, n. 2), wherein Longhi's 1960 published attribution is acknowledged.
2. H. Voss to C. Cunningham, 10 July 1949, curatorial file. Longhi, "Ultimi studi," 1943, 34, figs. 83 and 84. Briganti, 1950, 191, 198, n. 28, fig. 15.
3. R. Longhi to C. Cunningham, 22 Mar. 1960, curatorial file.
4. Longhi, 1960, 43–44, fig. 40.
5. Soria, 1961, 443, fig. 214C. Fredericksen and Zeri, 1972, 51, 55, 493, 585.
6. Pitti nos. 773 and 774, each 73 x 98 cm. Briganti, 1950, 191, 198, n. 28, figs. 20 and 21; 1983, 690, no. 20, figs. 670 and 676. The Atheneum picture is cited by Briganti, 1983, 691, no. 27, fig. 723.
7. Brunetti, 1956, 56, figs. 24 and 25.
8. D. Marshall to M. Mahoney, 27 May 1987, curatorial file.
9. Repr. *Burlington Magazine*, CV, May 1963, 211, fig. 27.
10. Brunetti, 1958, 311–12, fig. 17.
11. Rome, *Bamboccianti*, 1950, 39, n. 27, fig. 25.
12. A. F. Mondschein to A. E. Austin, 23 Mar. 1943, curatorial file, together with a photograph. In the lower right of the latter, under an unidentified emblem of an unlocated archive or museum, the photograph is numbered 38123.
13. Zeri, *Walters Art Gallery*, 1976, II, 464, n. 340, fig. 230. If Marshall reads the date correctly, 1650, then it would seem Codazzi returned to Naples in the early 1650s (D. Marshall to M. Mahoney, 27 May 1987, curatorial file).
14. Longhi, 1955, 41–42.
15. Brunetti, 1956, 50–51, fig. 11A.

Viviano Codazzi (1603/4–1670) and Domenico Gargiulo (1609/10–1675)

For Codazzi's biography, see the entry above.

Gargiulo is commonly called Micco Spadaro, a nickname traceable to his father's trade as a swordsmith. Gargiulo's hand is most readily recognized in his pictures chronicling contemporary events in his native Naples, such as the S. Martino *Masaniello's Revolt*, crowded compositions with multitudes of tiny, elongated figures derived from Jacques Callot via Aniello Falcone, with whom De Dominici says he studied, at the same time as did Salvator Rosa, with whom Micco is said to have painted landscapes from nature. Both aspects of this early training are evident in his contribution to the Atheneum's *Men's Bath*: in the figures and in the glimpsed landscapes. The same picture also demonstrates his familiarity and collaboration with the Roman *bamboccianti*, or genre specialists, in this case, with Viviano Codazzi, who was in Naples at least from 1634 to 1647–48, and for whose architectural compositions Gargiulo often provided the staffage. In the 1640s Gargiulo began a long association with the Certosa di S. Martino, where he frescoed religious and landscape subjects. The newly arrived Johann

Heinrich Schönfeld affected Gargiulo's style at this time. When Gargiulo's association with the certosa ended after the 1656 plague, he was influenced by the young Luca Giordano, but his late style is still to be defined.[1]

1. Saxl, 1939–40, 70–87, and B. Daprà in London, *Painting in Naples*, 1982, 248–54, nos. 145–51.

The Men's Bath

Oil on canvas, 139 x 193 cm (53¾ x 70 in.)

Condition: good. Approximately 25 centimeters from the upper right corner is a repaired rip, shaped like an inverted V, each arm approximately 20 centimeters long. Receding perspective lines formed by the benches and the edges of the pools are drawn with a straightedge. The tie beams seem to be ruled as well and the groin vaulting may have been roughly drawn with a mechanical instrument. The now somewhat transparent figures are painted over the completely finished architectural setting. The canvas is of a heavy square weave, creating a cobblestone effect on the surface of the paint.

Provenance: Mr. Blum, London; Arcade Gallery, London; Benedict Nicolson, by 1951–52, sale London, Sotheby's, 24 June 1959, no. 71, bought by the John Nicholson Gallery, New York, for 650 pounds. Purchased by the Wadsworth Atheneum in 1959 from the John Nicholson Gallery, New York, for $4,500 from the Sumner Fund.

Exhibitions: Amherst, 1974, no. 87.

The Ella Gallup Sumner and Mary Catlin Sumner Collection, 1959.256

Codazzi's stupendous architectural setting would seem to be his imaginative interpretation, in contemporary idiom, of colossally scaled, ancient Roman architecture. Even the subject, men bathing in a series of pools, evokes ancient Rome. The conception is truly proto-romantic, anticipating the grandiose architectural *capricci* of the next century. The only veristic seventeenth-century touches are found in Gargiulo's figures, inserted after the setting was completely finished: the men's contemporary hair styles, the valets' liveries, the still life on the left bench, and the footman spreading a picnic on the first window ledge.

This architectural motif is one Codazzi returned to again and again, albeit with variations. The prototype can be considered the upright *Architectural Interior with Three Figures*, published by Brunetti as a formative work, done when, in her view, the artist arrived in Rome about 1620 and one in which this young "Canaletto of the 17th century" was practicing his hand at complicated architectural renderings and perspective recession.[1] The setting of the Atheneum picture is a horizontal variation of the above work, which Briganti compares to paintings he dates circa 1650.[2] Three bays of essentially the same grand space appear again in the *Women's Bath*, formerly in the Incisa della Rocchetta Collection, Rome. Baldinucci and Pascoli describe that enigmatic painting as a collaborative work by Codazzi and the Roman Michelangelo Cerquozzi. Thus Briganti dates the

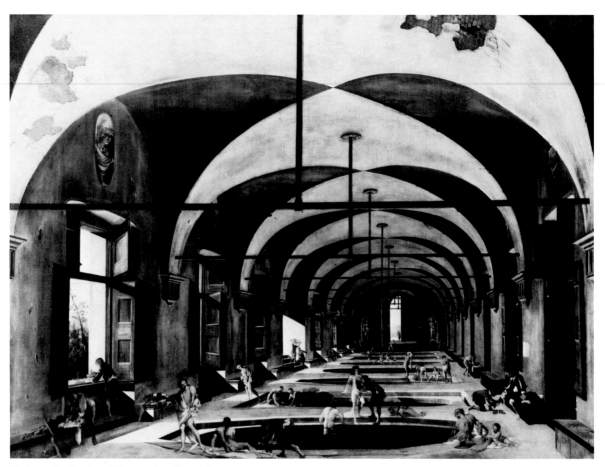

Viviano Codazzi and Domenico Gargiulo,
The Men's Bath

Incisa picture after 1647, after Codazzi moved to
Rome permanently and therefore when he was assur-
edly in contact with Cerquozzi.[3] In fact, Briganti
published Hartford's *Men's Bath* initially as a first
idea, on a reduced scale, for the Incisa picture.[4] How-
ever, the Atheneum picture is actually larger than the
Incisa *Bath* and reasonably can be considered to ante-
date 1647 or 1648, when Codazzi moved to Rome, for
the figures are by Gargiulo, with whom Codazzi col-
laborated during his long sojourn in Naples.[5] He was,
as said, established there at least by 1634 and
remained until 1647 or 1648,[6] presumably, therefore,
the time during which the Atheneum picture was
executed. Yet it conceivably is even earlier than 1634,
if Daprà, who thinks Codazzi was in Rome in the
1620s, is correct in speculating that Gargiulo first
encountered Codazzi during a trip to Rome,[7] or par-
ticularly if one accepts the artist's own assertion at his
marriage in 1636 that he had been a resident of
Naples already for fifteen years.[8]

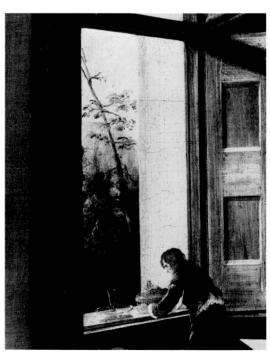

Viviano Codazzi and Domenico Gargiulo, *The Men's Bath*, detail

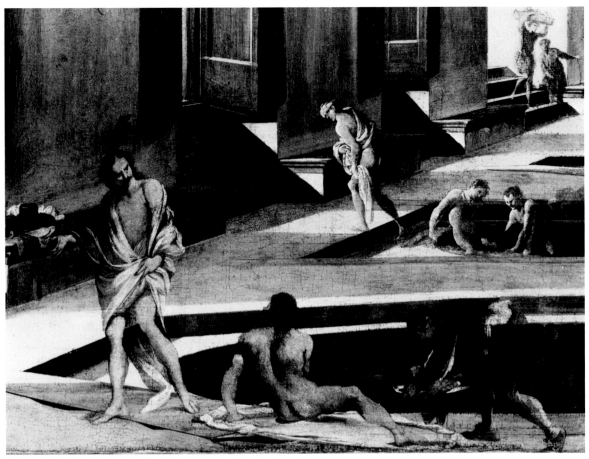

Viviano Codazzi and Domenico Gargiulo, *The Men's Bath*, detail

For Briganti, the Atheneum picture is a late Codazzi, that is, painted in Rome and thus precluding Gargiulo's participation. He initially suggested the figures might possibly be by Filippo Lauri (1623–1694),[9] but thereafter decided they were by an anonymous, not easily identified painter.[10] The attribution of the figures to Gargiulo is that of Benedict Nicolson, who owned the picture.[11] Brunetti assigned the picture to Codazzi's Neapolitan period and thought the figures reminiscent of the very early Gargiulo, before 1638.[12] The bathers in the foreground are indeed congruent anatomically with a drawing style Gargiulo developed when he and Salvator Rosa were students with Aniello Falcone, a style wherein the articulation of the body's dynamics is poorly understood, for example, in the way the torsos pivot on the hips of the two men seen from the rear seated in the foreground. The more wispy figures in the background of the painting also have parallels in Gargiulo's drawings.[13] The attribution of

the figures to Gargiulo has been accepted by others,[14] among them Marshall, who dates the painting about 1641.[15] The landscape vignettes on the left and at the end of the perspective are stylistically compatible with sketches for documented Gargiulo frescoes of 1642–46 in the prior's apartment in the Certosa di S. Martino, Naples.[16]

Biavati Frabetti identified the Atheneum work with the picture cited as being by Codazzi's son Niccolò with figures by Giuseppe del Sole, in the 1713–14 inventory of the collection of Ferdinando de' Medici.[17] Briganti finds this untenable, as the Medici picture is specifically described as having both male and female figures.[18] M.M.

1. Brunetti, 1956, 49, 51–52, fig. 12, 73 x 60 cm, as private collection, Rome.
2. Briganti, 1983, 693, no. 49, repr. figs. 677 and 717, as 74 x 62 cm, as private collection, Milan.
3. Rome, *Bamboccianti*, 1950, 39, no. 26, figs. 24, 26, 27, 123 x 172.5 cm.
4. Briganti, 1950, 198, n. 28, and Rome, *Bamboccianti*, 1950, 39, no. 27. Briganti was followed by Longhi, 1955, 42, and Brunetti, 1956, 63, n. 21.
5. Longhi, 1955, 43.

6. Brunetti, 1956, 65.

7. London, *Painting in Naples*, 1982, 248.

8. Zeri, *Walters Art Gallery*, 1976, II, 463. Salerno, c. 1977–80, III, 504.

9. G. Briganti to C. Cunningham, 24 Feb. 1960, curatorial file. Briganti speculated that a Roman building, for instance, the granaries of Urban VIII on the Strada Pia, might have inspired Codazzi's architecture here. He cites a painting close to Codazzi of an architectural interior with monumental laundry troughs as a further variation on this architectural theme. The Lauri proposal seemed convincing to Cunningham (C. Cunningham to G. Briganti, 15 Mar. 1960, curatorial file). The interior with laundry troughs is 150 x 60 cm (Briganti, 1983, 693, no. 49).

10. Briganti, 1983, 691, no. 26, repr. 739.

11. Who also provided the provenance (B. Nicolson to C. Cunningham, 22 Jan. 1960, curatorial file). *Wadsworth Atheneum Bulletin*, Spring 1960, 20, repr. opp. 26. Fredericksen and Zeri, 1972, 55, 494, 585, as Codazzi.

12. Brunetti, 1958, 312, n. 14.

13. Mahoney, 1977, I, 47, 145–48, II, figs. 3.1A–3.1G, especially 3.1C and 3.1F.

14. Soria, 1961, 446, n. 20. D. Mahon (undated note by C. Cunningham in curatorial file). R. Causa verbally to M. Mahoney, June 1983.

15. D. Marshall to M. Mahoney, 27 May 1987, curatorial file.

16. B. Daprà in London, *Painting in Naples*, 1982, 250, nos. 146 and 147, repr.

17. Biavati Frabetti, 1979, 85–86.

18. Briganti, 1983, 691, no. 26.

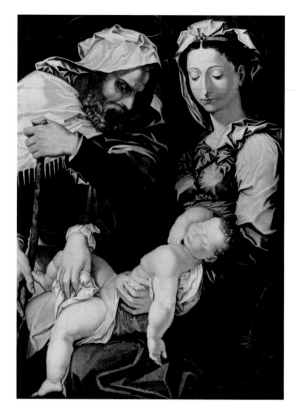

After Jacopino del Conte, *Holy Family*

Jacopino del Conte
(c. 1502–c. 1590)

Jacopino del Conte was born in Florence in about 1502. He was probably a pupil of Andrea del Sarto, as related by Vasari;[1] although the style of his early pictures also points to influence from Pontormo and Michelangelo.[2] He went to Rome in about 1535–36, where he painted a number of religious works and participated in the decoration of the oratory of S. Giovanni Decollato. His frescoes of the *Preaching of the Baptist* and the *Baptism* are dated 1538 and 1541, respectively; the *Annunciation to Zacharias* probably was the first finished, about 1536–37, and the altarpiece of the *Deposition* the last, after 1551.[3] The dramatic change in style of the oratory works from his earlier work reflects the influence of Perino del Vaga, newly returned to Rome in 1537–38.[4]

A number of works from the middle 1540s indicate Jacopino's increasingly abstract style.[5] Although he was commissioned, with Pellegrino Tibaldi and Siciolante da Sermoneta, to complete the fourth chapel on the right in the church of S. Luigi dei Francesi, left unfinished by Perino del Vaga in 1547, he is known to have traveled a good deal during these years and to have bought a house in Florence in 1547.[6] His artistic production in his later years centered around the painting of portraits, many of which are referred to in contemporary documents and letters.[7]

He was made a Roman citizen in 1558 and was elected consul of the Accademia di S. Luca in 1561. He died in Rome in about 1590.[8]

1. Vasari, 1906, V, 58.

2. Cheney, 1970, 32–33; von Holst, 1971, 48–52; V. Pace, "Osservazioni sull'attività giovanile di Jacopino del Conte," *Bollettino d'arte*, LVII, 1972, 220–22; Zeri, 1978, 114–21; S. J. Freedberg, "Jacopino del Conte: An Early Masterpiece for the National Gallery of Art," *Studies in the History of Art*, XVIII, 1985, 59.

3. J. Weisz, *Pittura e Misericordia. The Oratory of S. Giovanni Decollato in Rome*, Ann Arbor, 1984, 18–21.

4. Cheney, 1970, 34; Zeri, 1978, 118.

5. Cheney, 1970, 37; F. Zeri, "Interno a Girolamo Siciolante," *Bollettino d'arte*, XXXVI, 1951, 141–44; B. Davidson, "Some Early Works by Girolamo Siciolante da Sermoneta," *Art Bulletin*, XLVIII, 1966, 64; F. Zeri, *Pittura e controriforma: L'arte senza tempo di Scipione da Gaeta*, Turin, 1957, 35.

6. J. von Henneberg, "An Unknown Portrait of St. Ignatius by Jacopino del Conte," *Art Bulletin*, XLIX, 1967, 141, publishes many new facts about Jacopino's life in the 1550s and 1560s.

7. Cheney, 1970, 39–40; Zeri, 1978, 118–21; Cheney, 1982, 17–20.

8. Shearman, 1983, 135.

After Jacopino del Conte
The Holy Family

Oil on canvas, 99 x 70.3 cm (39 x 27^{11}/16 in.)

Condition: good. There are minor losses over the surface.

Provenance: The previous history of the picture is unknown. Purchased by the Wadsworth Atheneum in 1942 from Arnold Seligmann, Rey & Co., New York, for $5,000 from the Sumner Fund.

The Ella Gallup Sumner and Mary Catlin Sumner Collection, 1942.406

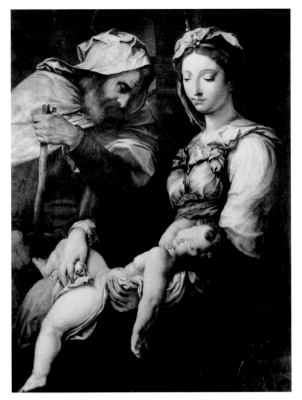

Figure 18. Jacopino del Conte, *Holy Family*, Madrid, Museo del Prado

Figure 19. Attributed to Jacopino del Conte, *Holy Family*, Leningrad, Hermitage

Several versions of the *Holy Family* exist. A *Holy Family* in the Prado, Madrid, attributed to Jacopino del Conte is identical to the Atheneum picture except in minor details (Fig. 18).[1] The position of Joseph's hands differs in the Prado picture from that of the Atheneum picture, and there is no fringe on Joseph's robe. The Christ Child's right arm rests just below the Virgin's sash in the Prado picture, while it rests on top of the sash in the Atheneum picture; the Virgin's drapery is also softer and fuller than that in the Atheneum picture. The coloring of the Prado picture, painted in warm pinks, blues, and yellows, also contrasts with the harsh colors of the Atheneum picture.

Another version of the composition entered the Hermitage, Leningrad, in 1923, when it was attributed to Daniele da Volterra (Fig. 19).[2] It was subsequently attributed to Siciolante da Sermoneta.[3] The Leningrad version is similar to the Atheneum version in the position of Joseph's hands, the fringe on his cloak, and the pose of the Child's right arm; but it differs in the treatment of the Virgin's headdress, which in the Atheneum picture is closer to the Madrid version. The color of the Leningrad painting, pastel blue primarily, differs from that of both the Madrid and Hartford paintings. Unlike the Madrid and

Hartford versions, which show an arch and column in the background, the figures in the Leningrad version are shown before a draped background.

A third version of the composition, formerly in a private collection in London, is closest in detail to the Atheneum picture.[4] A fourth version of the composition, possibly identical to the ex-London picture, was published in 1972.[5]

A drawing attributed to Perino del Vaga has been published as a preparatory study for the Madrid picture.[6] It differs in some details from the Madrid picture, namely in the position of Joseph's left hand and the child's right arm, and in the background; yet these same aspects of the drawing recur in the Leningrad, ex-London, and Atheneum versions of the composition.

The many variations of detail among the several versions of the *Holy Family* preclude a simple relationship of model and copies. The drawing may preserve the composition of the prime version, no longer extant, on which the Madrid picture and others depend. The extremely dry and schematic handling of the Atheneum picture suggests that it is no more than a distant relative of the Madrid picture.

The Atheneum *Holy Family* was attributed to the Spanish artist Luis Morales when it was acquired.[7] Suida,[8] however, cited a picture of the *Virgin with Sleeping Child and an Angel* at Windsor Castle, now attributed to Francesco Salviati,[9] and a *Madonna and Child with St. Peter and St. Paul* in 1942 at Carlo Foresti, Milan, attributed to Perino del Vaga, at present

untraced, as possibly by the same hand as that in the Atheneum picture. Comparison with the Windsor picture reveals the poor quality of the Atheneum picture, however, and precludes an attribution to Salviati. Berenson attributed the Atheneum painting to Jacopino del Conte,[10] while Voss, citing the relationship with the Prado picture, which he attributed to Jacopino, saw the Atheneum picture as a poor copy.[11] Cheney also called the Atheneum painting a copy after the Madrid picture, which she attributes to Jacopino.[12] Ragghianti attributes it to a Roman painter close to Daniele da Volterra and Jacopino,[13] while Fahy has also pointed out similarities between the Atheneum painting and the *Madonna and Child with the Magdalene* in the Ringling Museum, Sarasota, which is attributed to Jacopino.[14]

Given the poor quality of the Atheneum picture, it is unlikely a precise attribution can be found.

The Atheneum painting probably dates to the sixteenth century. Cheney dates it to about 1570.[15] Ragghianti, noting its relationship to Parmigianino's *Madonna del collo lungo*, has suggested a date of about 1550.[16]

J.C.

1. *Museo del Prado, Catálogo de las Pinturas*, Madrid, 1972, 152–53, no. 329. The Madrid picture measures 105 x 100 cm. The painting was sent to the Escorial, 15 Apr. 1574, by Phillip II as "de mano de Salviate romano, pintor del Rey de Francia." It was attributed to Salviati until Berenson advanced an attribution to Jacopino del Conte; Zeri subsequently attributed the picture to Perino del Vaga; see F. Zeri, "Salviati e Jacopino del Conte," *Proporzioni*, II, 1948, 180–83.
2. Information kindly supplied by T. Kustodieva, letter to J. Cadogan, 28 May 1987, curatorial file.
3. Gosudarstvennyi Ermitazh, 1976, 134, no. 5526.
4. W. Suida, in a letter to C. Cunningham, 21 Dec. 1946, mentions having seen another example of the Atheneum composition at a London dealer. It was attributed to Pontormo and measured 105 x 80 cm. I. Cheney, in a letter to O. Naumann, 4 Mar. 1975, describes a photograph in her possession of the same composition as the Atheneum picture, measuring 105 x 80 cm, inscribed *Pontormo*, as with Bellesi, 47 Duke St., London.
5. Ragghianti, 1972, 78, fig. 61, attributed to a Roman painter about 1550, listed as location unknown. Iris Cheney has kindly brought this publication to our attention.
6. C. von Prybram-Gladona, *Unbekannte Zeichnungen alter Meister aus europäischem Privatbesitz*, Munich, 1969, 35–36, no. 40.
7. "Recent Accession," *Wadsworth Atheneum Bulletin*, Oct. 1942, 1.
8. Letter to C. Cunningham, 21 Dec. 1946, curatorial file.
9. Shearman, 1983, 216–17, no. 229.
10. Letter to C. Cunningham, 23 Mar. 1950, curatorial file.
11. Letter to C. Cunningham, 10 July 1949, curatorial file.
12. Letter in curatorial file, 4 Mar. 1975.
13. Ragghianti, 1972, 81.
14. Oral communication, 8 May 1984; see also Tomory, 1976, 13.
15. Letter in curatorial file, 4 Mar. 1975.
16. Ragghianti, 1972, 81.

Hermann Corrodi
(1844–1905)

The Corrodi's were Waldensian dissenters who had fled Milan about the sixteenth century and settled in Zurich, where the name was sometimes spelled Korradi. Hermann's grandfather was a pastor there. His father, Salomon (1810–1892), himself a painter particularly esteemed for his water colors of the Roman campagna, repatriated the family in 1843 and settled in Rome, where he was a leading figure in the Künstlerverein of foreign artists, especially German-speaking ones, resident in Rome. Hermann and his devoted younger brother Arnold (1846–1874) were both first trained by their father and both enjoyed a fashionable success throughout Europe, where they traveled widely until Arnold's early death. Meissonier, Gérôme, and Alma-Tadema were their friends. In 1876 Hermann married an Englishwoman, cementing ties with that country, whose royal family was his patron, as were a number of German courts. While he continued to live in Rome and summer occasionally in German spas, he also traveled to the Near East, whose exotic themes were incorporated into his repertoire of academic landscapes and genre scenes.[1]

1. Magnani, 1983. For Salomon Corrodi, see also Rome, 1985.

Venetian Lovers

Oil on canvas, 59.7 x 44.7 cm (23 1/2 x 17 5/8 in.)
 Condition: excellent. The painting is unlined.
 Signed in the lower left: H. Corrodi Roma
 Provenance: Elizabeth Hart Jarvis Colt, Hartford.
Bequeathed to the Wadsworth Atheneum in 1905 by Elizabeth Hart Jarvis Colt.
 Exhibitions: Hartford, 1958, no. 51; Williamstown, 1982, no. 16.
 Bequest of Elizabeth Hart Jarvis Colt, 1905.26

Hermann Corrodi, *Venetian Lovers*

It is a vivid comment on the history of late nine-teenth-century American taste that the Colt family, founders of the Hartford arms industry, was content to acquire pictures like this, while at the same time Mary Cassatt was successfully advising the Havemeyers to buy Degas and the school of Paris. So utter was the oblivion to which such anecdotal paintings were consigned, it was only after the painting was exhibited in 1958 as by "Connodj" that the artist's name was correctly entered in the museum's files.[1]

When the picture was exhibited more recently, Panczenko observed that for Corrodi and like artists "the motivating factor was a desire to entertain on a popular level and to comply with, and perhaps mold, the pace-setting taste of important collectors. One of the most successful artists to operate from this premise was . . . Corrodi . . . a favorite of Europe's royal families in Germany, France, Russia, Spain, and especially England, where he was appointed instructor to the Princess Alexandra. Making expected trips to Egypt, Syria, and Constantinople, he earned a reputation as a distinguished orientalist but his staples were views of Rome, landscape paintings, and genre scenes. The romantic, story-book flavor of *Venetian Lovers* . . . is somewhat unusual, but the exotic nocturnal setting, the sense of fantasy, and the suave colorful technique are all attributes . . . which help to account for his phenomenal success."[2] M.M.

1. Hartford, 1958, no. 51. 6 Oct. 1958, memorandum in curatorial file.
2. Williamstown, 1982, 24, 72, no. 16.

Pietro Berrettini, called Pietro da Cortona (1596–1669)

Born to a modest family in Cortona on 1 November 1596, Pietro da Cortona received his earliest training from the Florentine painter Andrea Commodi.[1] As a young apprentice he went with his master to Rome in 1612, where he studied the monuments of Renaissance Rome and associated with Tuscan artists resident there. His first major works, the frescoes in the church of Sta. Bibiana, were executed between 1624 and 1626 for Pope Urban VIII. From then on a series of important commissions solidified his reputation and indelibly influenced the course of seventeenth-century Italian painting. His ceiling fresco on the theme of the triumph of Divine Providence for the Barberini Palace, executed between 1631 and 1638, marks the apogee of baroque ceiling decoration; his decorations for the Pitti Palace in Florence, commissioned by Grand Duke Ferdinand II and executed between 1637 and 1647, extended his influence even further.

Pietro was also an architect of great scope and talent. His prodigious output and the high quality of his work has secured his place, with Gian Lorenzo Bernini, as the preeminent artist of the baroque.

1. Briganti, 1982, and G. Briganti, "Pietro Berrettini," in *Dizionario biografico degli italiani*, 1967, IX, 398–405.

After Pietro da Cortona, *The Glorification of the Trinity with the Adoration of the Instruments of the Passion*

After Pietro da Cortona
The Glorification of the Trinity with the Adoration of the Instruments of the Passion

Oil on canvas, 97.7 x 97.2 cm (38 1/2 x 38 1/4 in.)
 Condition: good.
 Provenance: The previous history of the picture is unknown. Given to the Wadsworth Atheneum in 1961 by Colonel and Mrs. C. Michael Paul.
 Gift of Colonel and Mrs. C. Michael Paul, 1961.644

The painting, which was said to have been acquired by Colonel Paul a number of years before in Brussels, was received by the Atheneum in 1961 as a *modello* for the dome fresco in Sta. Maria in Vallicella, called the Chiesa Nuova, the Roman mother church of St. Filippo Neri's Oratorians.[1] Cortona's relations with the order were long-standing and cordial. He accepted the dome commission as early as 1646, while completing his frescoes in Palazzo Pitti, Florence, for Grand Duke Ferdinand II de' Medici. In November 1647 he was back in Rome and began cartoons ("i cartoni") for the cupola and the arch of the tribune. Scaffolding was in place in May 1648, in June he was at work drawing on the walls ("disegnare sui muri"), and the cupola was unveiled in May 1651.[2] Cortona's attention was then drawn to Innocent X's commission to fresco the gallery in Palazzo Pamphili, Piazza Navona. He returned to complete the Chiesa Nuova's pendentives and tribune only in 1655–60 and the nave in 1664–65.[3]

Only a small number of drawings for the dome are known.[4] They show the artist's developing ideas for single motifs and single passages in the ensemble. Whether they record, albeit in a fragmentary way, the graphic deliberations that lead to the cartoons, or

are in fact the cartoons from which Cortona drew on the walls is unclear. Whatever their status, they bear no relationship to this work, which is surely a copy after the completed project, as Briganti felt was undoubtedly the case.[5] It would seem to be a copy made on the spot, as it includes the pendentives, which are absent in Aquila's 1696 print of the dome plus the lantern zone.[6]　　　　　　　　　　M.M.

1. C. Cunningham, 1961, 18–21, as after Cortona's ceiling.
2. Briganti, 1982, 248–49, no. 115, fig. 246. Liversidge, 1980, 341.
3. Briganti, 1982, 250–51, 261, 267–68.
4. See Vitzthum, 1961, and Liversidge, 1980.
5. G. Briganti to C. Cunningham, 10 Dec. 1962, curatorial file. The picture appeared too late for the first, 1962 edition of Briganti's Cortona monograph and is not mentioned in the revised, 1982 edition. Fredericksen and Zeri, 1972, 165, 360, 585, as a copy.
6. An example of the latter is in the Bibliothèque Nationale, Paris.

Domenico Corvi
(1721–1803)

Born in Viterbo, Corvi settled in Rome probably in 1736, where he received a traditional academic training under Francesco Mancini for a career as one of Rome's most eclectic and influential artists of the century. Despite the fact that he is little known and little appreciated today, Mengs, who was his neighbor in 1753, ranked him on a par with Batoni. The fact that he painted the last of the Stuart pretenders, Henry Cardinal of York (see below), is some indication of his prominence as a portraitist. But his best-known works are those executed in oil and in fresco for Roman churches and palaces, one such being another Atheneum picture below.[1] Admitted to the Accademia di S. Luca in 1756, his most productive years were between 1760 and 1780, when he interwove late baroque and rococo elements into a style that became increasingly neoclassic.[2]

1. Clark in Chicago, 1970, 192, and Scavizzi, 1983.
2. See also Rudolph, 1982, 1–45; Barroero, 1984, 66–71.

Henry Stuart, Cardinal Duke of York

Oil on canvas, 130.5 x 96.8 cm (51³/₈ x 38¹/₈ in.)
 Condition: fair. The modeling of the face has suffered from cleaning. There is a large pentimento on the sitter's right forearm. Inscribed at the top of one page: *Altezza Reale Eminen . . .*; on the page above the latter: *A/ Sua Altezza Real / Il Sign[.] Card . . ./ Abb . . . Comend . . . / Maria di Ripa*; at the middle of this page: *Per*; at the bottom of this page: *Cele . . .*
 Provenance: the Hon. W. Keith Rous, Worstead House, Norfolk, sale London, Christie's, 29 June 1934, no. 50, as Pompeo Batoni; Irwin E. Friedman and Judge Samuel E. Friedman; given to the Wadsworth Atheneum in 1960 by Irwin E. Friedman and Judge Samuel E. Friedman.
 Exhibition: Kent, 1966, as Ceccarini.
 Gift of Irwin E. Friedman and Judge Samuel E. Friedman, 1960.286

The picture was accessioned as a portrait of Cardinal Cecchi by Jacopo Amigoni (1675–1752).[1] Zeri likened it to Sebastiano Ceccarini's portrait of Cardinal Fabrizio-Veralli, signed and dated 1754, in the Spada Collection, Rome.[2] Thereafter, Busiri Vici included the Atheneum picture in his survey of the portraiture of this painter (1703–1783) from Fano who was active in Rome.[3] The Hartford work stands out in the latter grouping as being less robustly conceived and executed than Ceccarini's sturdy portraits. Thereafter, Fredericksen and Zeri attributed the painting to Domenico Corvi.[4] The attribution was confirmed and the identification of the sitter settled with Kerslake's publication of Pietro Campana's print after a three-quarter-length portrait by Domenico Corvi similar in every essential respect, except in the placing of the hands, to the Atheneum picture. The print is a likeness of Cardinal Henry Benedict Maria Clement Stuart, Duke of York (1725–1807).[5]

 Henry was the last in the direct line of Stuart pretenders to the throne of England. His father, the Old Pretender, and his Polish mother, Maria Clementina, daughter of James Sobieski, lived in Rome, where the papal court recognized his claim to be James III and where his two sons, Charles and Henry, were born in the Stuart palace, Palazzo Muti in Piazza SS. Apostoli.[6] After the battle of Culloden Moor in 1746 deprived his elder brother, Bonnie Prince Charlie, of the last hope for a Stuart restoration, Henry was created a cardinal deacon in 1747 with Sta. Maria in Campitelli designated as his Roman parish. Ordination followed in the next year. He was styled Cardinal of York, from his titular English royal dukedom. Horace Mann, the British representative in Florence and an understandably hostile reporter of Jacobite activities in Italy noted, "The Cardinal of York pretends to wear ermine on his cappa as a sign of royalty."[7] Although deficient in force of character, Henry was said to have been genial and amiable. He was made archpriest of St. Peter's in 1748 with the parish of SS. Apostoli as a benefice and then made *camerlengo* of the papal court with the basilica of Sta. Maria in Trastevere as a further holding. In 1758 he was consecrated archbishop of Corinth *in partibus infidelium*. In 1761 he was appointed bishop of Frascati and in 1767 vice-chancellor of the Holy See with the Cancelleria as his residence. From these offices, plus further benefices directed to him from the kings of France and Spain, Henry lived very splendidly, especially at Frascati, where he collected a fine library—a life certainly congruent with this portrait's soft and anodyne characterization and its sumptuous setting.[8] He was highly popular and admired,[9] especially for his great charity, particularly in Frascati. His villa there was sacked in 1799 during the Napoleonic exactions, which impoverished the cardinal and forced him to flee eventually to Venice, where he began to receive what was to be a continuing annual stipend from George III. After the death in 1788 of his elder brother, the cardinal styled himself Henry IX, more as a point of form than of substance, for by then the title was not recognized even in Rome.[10] When he died in 1807, by which time he had become dean of the Sacred College of Cardinals, he

Domenico Corvi, *Henry Stuart, Cardinal Duke of York*

bequeathed to the Prince Regent any object that might be of historical interest to the reigning house. Thus two jewels said to be associated with the English and Scottish regalia were returned. His most precious legacy, the major portion of the voluminous archive of Stuart correspondence in exile, was presented by the pope to the Prince Regent and is now at Windsor. The Prince Regent contributed 50 pounds to the Canova monument in St. Peter's to the cardinal, his brother, and his father, thus leading to the tradition, erroneous according to Vaughn, that George IV was solely responsible for the monument to the last Stuarts.[11]

Stylistically, this is an early work by Corvi[12] and must have been painted when the prince became a cardinal in 1747, or shortly thereafter. A full-length variant in Buckingham Palace is inscribed, similarly on a letter, "A Sua Altezza Reale/Il Sig.re Carte Duca d' York/Per/Mon.re Ottavio Angelelli Vescovo di Gubio." The bishop of Gubbio, with whom the cardinal corresponded, thus received the picture.[13] Consequently, the "Per/Cele . . ." in the Atheneum inscription would perhaps likewise allude to the person for whom the picture was made.

There was a brisk demand for likenesses of the exiled Stuarts.[14] Kerslake discusses the various types of representations of the cardinal, of which many examples can be expected to be found.[15] For instance, closely related to the Atheneum picture, in addition to that in the Royal Collection, are a bust-length with a diamond pectoral at Stanford Hall,[16] another bust-length in the Darnaway Castle Collection,[17] a third bust in the Municipio, Frascati,[18] a fourth bust-length in the Scottish National Portrait Gallery,[19] and a studio work formerly belonging to Anthony Clark.[20] Kerslake lists a further example at Blairs College, Kincardineshire.[21] M.M.

1. The identification was based on Cunningham's interpretation of the inscription (C. Cunningham to J. Weitzner, 21 Dec. 1960, curatorial file), but no source for the attribution is indicated. Both were accepted by Weitzner when he appraised the painting for the donors (18 Dec. 1960, copy in the curatorial file). When the painting was sold from the collection of the Hon. W. Keith Rous (London, Christie's, 29 June 1934, no. 50, as Pompeo Batoni, *Portrait of Henry, Duke of York*), it was described as being signed with initials, bought by Mason for 45 guineas. The Atheneum picture is not to be confused with a smaller picture in Christie's, 30 June 1913, no. 119, 71.8 x 56.5 cm (28¼ x 22¼ in.), as Pompeo Batoni, *Cardinal York Holding a Book*, bought by Gray for 31 pounds 10 shillings. The latter might be the painting now reported to be in the Darnaway Castle Collection and formerly in the Hamilton Palace 1882 sale and earl of Moray's collection (see below).
2. For the Spada work, see Zeri, 1954, 55–56, no. 294, Rome, G.F.N. E2820. Repr. by Servolini, 1959, 39.
3. Busiri Vici, 1968, 266, fig. 6.
4. B. Fredericksen to the Atheneum, 8 Nov. 1966, and F. Zeri to C. Cunningham, 7 Dec. 1966, curatorial file. Fredericksen and Zeri, 1972, 56, 518, 585.
5. Kerslake, 1977, I, 327, II, pl. 931. The print is labeled "D. Corvi inv. et delin. . . . P. Campana scul. s. per." This refers, Clark feels, to Campana's source in a painting, not a drawing, "dilineavit" often standing for "pinxit" in Rome at the time (A. Clark to J. Elliott, 21 Sept. 1969, curatorial file).
6. Vaughn, 1906, 2–3.
7. Vaughn, 1906, 51.
8. Vaughn, 1906, 50–65.
9. Pastor, 1961, XXXV, 184.
10. Vaughn, 1906, 72–76, 197–201, 219–42.
11. Vaughn, 1906, 259–60, 266–67, 269, 272–75. See also Henderson, 1963–64; Hare, 1905, 71–72; Pastor, 1961, XXXV, 340–41. Shield, 1908, seems to be more a felt than a reliable biographical source.
12. Clark in Chicago, 1970, 192.
13. Levey, 1964, 101, no. 652, fig. 214, as 18th-century Roman school.
14. Kerslake, 1977, I, 348–49.
15. Kerslake, 1977, I, 327–28.
16. Attributed to Corvi (Courtauld photo B77/1371).
17. Kerslake, 1977, I, 327, as in the Hamilton Palace sale in London, Christie's, 1 July 1882, 92, no. 699, 28 ½ x 23 in., bought by the earl of Moray.
18. O. Michel to P. Marlow, 10 Sept. 1968, curatorial file. Repr. in *Capitolium*, Mar. 1961, 16.
19. From the Elphinstone family; 68.6 x 53.4 cm (27 x 21 in.); sold in Edinburgh, Dowell's (now Phillips), 24 Oct. 1903, sale of pictures from Logie Elphinstone Mansion, Aberdeenshire (H. Smailes to M. Mahoney, 19 July 1983, curatorial file).
20. Sold in London, Christie's, 6 July 1978, no. 24, 39.5 x 28 cm (15½ x 11 in.).
21. Kerslake, 1977, I, 327. He also mentions a miniature by Verona Telli, née Stern, in London, Christie's, 21 Nov. 1967, no. 22; plus a painting with the head reversed belonging to P. Maxwell Stuart, Traquair House.

A Miracle of St. Filippo Neri

Oil on canvas, 223 x 176 cm (69¼ x 87⅞ in.)
 Condition: good.
 Provenance: unknown private collection; bought by the Wadsworth Atheneum in 1981 from Heim Gallery, London.
 The Ella Gallup Sumner and Mary Catlin Sumner Collection, 1981.24

In a *Miracle of St. Filippo Neri*, the saint kneels in a large chapel before an altar adorned with a picture of the Virgin and Child. He appeals to the Madonna to revive the dead child in his arms, while colorfully garbed spectators look on.

St. Filippo Neri was a saint of the Catholic reform movement. He died in 1595 in Rome and was canonized in 1622, at the same time as other great saints of the baroque age, such as Theresa of Avila and Ignatius of Loyola. The Oratorians, one of the great orders of the seventeenth century, which emphasized simple lay piety and personal devotion, was founded by St. Filippo Neri.[1]

During the seventeenth and eighteenth centuries, many incidents from the saint's life were depicted in paintings, particularly the apparition of the Virgin and Child to the saint.[2] Another recorded miracle of his life was his revival of the child Paolo de' Massimi in Rome.[3] The Atheneum picture depicts neither of these recorded incidents, but is perhaps a conflation of the two. It is possible that Corvi painted it for one of the many churches in or around Viterbo and the Papal States, where he was active in the 1770s and 1780s.[4]

The *Miracle of St. Filippo Neri* probably dates to the middle 1770s or 1780s.[5] J.C.

Domenico Corvi, *A Miracle of St. Filippo Neri*

1. Réau, 1959, III, pt. 3, 1072–73; Wittkower, 1965 ed., 3.

2. Réau, 1959, 1073, lists several examples.

3. *Bibliotheca sanctorum*, V, col. 782; Florence, 1989, 38.

4. Faldi, 1970, 81–83.

5. E. Peters Bowron has dated it to the early 1770s, and compares it to a painting of *A Saint Giving Extreme Unction to a Child in the Plague of 1630* in S. Domenico, Turin, which likely dates between 1765 and 1776; see notes from Heim Gallery in curatorial files.

Piero di Cosimo
(1461/2–c. 1521)

From Florentine catasto declarations in 1469 and 1480, we know that Piero di Lorenzo di Piero d'Antonio was born in 1461 or 1462. His father was a *succhiellinaio* (a wood or leather worker) with a workshop in Por S. Piero, and the family, consisting of his parents and several brothers and sisters, lived in a house on via della Scala. The 1480 catasto also says that Piero was a *garzone* without salary in the workshop of Cosimo Rosselli.[1] In 1498 Piero made his tax declaration as head of the household.[2] The only other documentation for Piero's life is his matriculation in the Arte dei Medici e Speziali in 1504,[3] and his participation in the commission to determine the location of Michelangelo's *David*, also in 1504.[4]

Although documentary evidence for Piero's life is limited, Vasari gives an unusually detailed account of his life and work that has been the major source for assembling Piero's oeuvre.[5] Many pictures he describes, including, in the second edition of the *Lives*, one that he owned, can be identified today. Vasari also relates Piero's training with Cosimo Rosselli and attributes to Piero the landscape in the fresco of *Christ Preaching* painted by Rosselli in the Sistine Chapel in 1481–82.[6] Piero's hand in the fresco is difficult to isolate today, although some critics persist in attributing it to him.[7] In addition, Vasari's account of Piero's strange habits and bizarre personality would seem to confirm the view of a somewhat eccentric artist that can be deduced from the pictures themselves.

Apart from Vasari's account, documentation has recently emerged for several works. On 13 October 1489, payments were made for the frame of the *Visitation* altarpiece in the Capponi Chapel in S. Spirito, now in the National Gallery, Washington, thus establishing a probable *terminus post quem* for the painting and a reference point for the early works.[8] The altarpiece of the *Madonna Enthroned with Angels and Saints*, painted for the chapel of the Pugliese in the church of the Ospedale degli Innocenti in Florence, was installed in 1493.[9] Piero's work on the Carro de' Morti, described by Vasari, is documented to 1507, and a painting for Filippo Strozzi of the *Liberation of Andromeda*, also described by Vasari and now in the Uffizi, is tentatively connected to payments made in 1510–11.[10]

Piero is one of the most interesting personalities at the end of the fifteenth century. His art, formed on the late Quattrocento realism of Rosselli and Ghirlandaio, was also profoundly influenced by the styles of Filippino Lippi and Signorelli and, after 1500, of Leonardo. He was the master of Andrea del Sarto and possibly of Fra Bartolommeo, and his late style reflects the profound changes in Florentine art in the first years of the sixteenth century.

According to Vasari he died in 1521 at the age of eighty.[11] If this date is correct, as is likely, he would have been about sixty years of age.

1. Bacci, 1966, 61, summarizes the document.
2. Bacci, 1966, 62.
3. Bacci, 1966, 62.
4. S. Levine, "The Location of Michelangelo's *David*: The Meeting of January 25, 1504," *Art Bulletin*, LVI, 1974, 43.
5. Vasari, 1906, IV, 131–44.
6. Vasari, 1906, III, 189, IV, 132.
7. See Bacci, 1966, 68–69, for a summary of attributions; see also F. Abbate, review of Bacci, *Paragone*, no. 215, 1968, 75.
8. Craven, 1975, 572.
9. Bellosi, 1977, 12.
10. Craven, 1975, 575–76; see also Beck and Schultz, 1985, 9–14.
11. Vasari, 1906, IV, 143.

The Finding of Vulcan

Oil and tempera on canvas, 155 x 174.5 cm (61 x 68 3/4 in.)

The canvas is composed of two pieces joined at a horizontal seam approximately 31 centimeters (12 1/4 inches) from the top edge. It has been lined at least twice. The left edge has been damaged heavily; the original canvas is irregular and has been backed with new canvas, adding a minimum of 1.5 centimeters and a maximum of 3.5 centimeters to the overall width.

Condition: poor. The paint surface is heavily abraded overall, possibly from a restoration in the nineteenth century.[1] Both right and left edges have been extensively repainted, at the left lower edge to a width of approximately 4 centimeters.

Provenance: possibly collection Francesco di Filippo del Pugliese,[2] Florence, c. 1487–1519 (see below); William Blundell Spence, Florence, by 1861;[3] William Graham, by 1882,[4] sale London, Christie's, 8 Apr. 1886, no. 216, as *Triumph of Chastity* by Signorelli; Colnaghi, London; Robert and Evelyn Benson, by 1914–27; Joseph Duveen; bought by the Wadsworth Atheneum in 1932 from Duveen Bros., New York, for $100,000 from the Sumner Fund.

Exhibitions: London, Burlington Fine Arts Club, *Exhibition of the Work of Luca Signorelli and His School*, 1893, 22, no. 118; London, New Gallery, *Exhibition of Early Italian Art from 1300 to 1550*, 1893–94, 16, no. 84; London, Grafton Galleries, *Exhibition of Old Masters in Aid of the National Art-Collections Fund*, 1911, no. 23, pl. XVIII; Manchester, England, City of Manchester Art Gallery, *Loan Exhibition of the Benson Collection of Old Italian Masters*, 27 Apr.–30 July 1927, 23, no. 63; New York, M. Knoedler & Co., *Loan Exhibition of Primitives*, Feb. 1929, no. 15; London, Royal Academy, Burlington House, *Exhibition of Italian Art, 1200–1900*, Jan.–Mar. 1930, 147, no. 235 (mistakenly said to be on wood); Hartford, Wadsworth Atheneum, *Exhibition of Italian Renaissance Art*, Jan.–Feb. 1932, no. 2; New York, Schaeffer Galleries, *Piero di Cosimo*, Nov.–Dec. 1938, no. 3, repr.; Baltimore, Baltimore Museum of Art and Walters Art Gallery, *The Greek Tradition in Painting and the Minor Arts*, 15 May–25 June 1939, repr. frontispiece; Baltimore, Baltimore Museum of Art, *The Art of the Medici*, 6 Oct.–26 Nov. 1939, no cat.; New York, 1939, no. 17; Montreal, 1942, 70, no. 107; Hartford, 1946, no. 44; Hartford, *In Retrospect*, 1949, no. 2; New York, 1958, 28, repr.

The Ella Gallup Sumner and Mary Catlin Sumner Collection, 1932.1

The *Finding of Vulcan* has been recognized as the pendant[5] to *Vulcan and Aeolus* in the National Gallery of Canada, Ottawa, since 1927 (Fig. 20).[6] The two pictures are on an identical diamond weave canvas, unique in Piero's oeuvre and rare at the end of the Quattrocento in Florence. Moreover, the dimensions

Figure 20. Piero di Cosimo, *Vulcan and Aeolus*, Ottawa, National Gallery of Canada

of the pictures are similar, the Hartford picture being approximately 10 centimeters wider.[7]

The Hartford and Ottawa pictures have been identified with pictures described by Vasari in the house of Francesco del Pugliese in Florence: "Fece parimente in casa di Francesco del Pugliese intorno a una camera diverse storie di figure piccole, nè si può esprimere la diversità de le cose fantastiche che egli in tutte quelle si delettò dipignere, et di casamenti, et d'animale, et di abiti, et strumenti diversi, et altre fantasie che gli sovennono, per essere storie di favole, come un quadro di Marte et Venere con i suoi Amori, et Vulcano fatto con una grande arte et con una pazienza incredibile."[8] If this identification is correct, as is possible, then it would appear that the Hartford and Ottawa pictures may have belonged to a larger group, the other paintings of which are lost.[9]

The subject of the painting, called the *Triumph of Chastity* while in the Graham Collection, was generally identified as *Hylas and the Nymphs* in the early literature.[10] Panofsky, however, recognized the subject as an episode in the myth of the god Vulcan, keeper of fire who taught its uses to man.[11] According to Panofsky, the Atheneum picture shows the moment when Vulcan as a child was thrown from Mount Olympus because his parents were dissatisfied with his deformed leg.[12] He landed on the island of Lemnos, where he was raised by its inhabitants. Vulcan is shown awkwardly posed on the ground, where he has fallen after being thrown from Olympus through a prominent hole in the cloud above. He is helped to his feet by a nymph, while her companions look on.[13] In the Ottawa picture Vulcan is shown in his workshop forming a horseshoe, while Aeolus, the God of the Winds, works a pair of bellows to fan Vulcan's fire. In the background is seen the civilization men have achieved with the help of Vulcan's fire. Men build a primitive house, while at the right is a family group and in the center foreground a youth sleeps peacefully.

Panofsky identified the Hartford and Ottawa pictures as part of a series, with two pictures in the Metropolitan Museum of Art in New York of a *Hunting Scene* and a *Return from the Hunt* and a picture in the Ashmolean Museum in Oxford, *Fire in a Forest*, which depicts the rise of civilization through the discovery of fire. The link of the Vulcan story with the history of civilization was made by Boccaccio in the *Genealogia deorum* and would have been well known in the Renaissance. Boccaccio quotes a passage from book ten of the Roman architect Vitruvius's *De architectura* describing a spontaneous fire in a forest, from which primitive man discovered its use and from which human society evolved. Boccaccio thus calls Vulcan the founder of human civilization.[14]

Boccaccio's text may also be the source for the subjects of the pictures in New York and Oxford. According to Panofsky, these pictures represent human civilization before Vulcan, when fires burned out of control and there were no metal tools, no woven materials, no agriculture, and no organized family or community life. The two sets of pictures

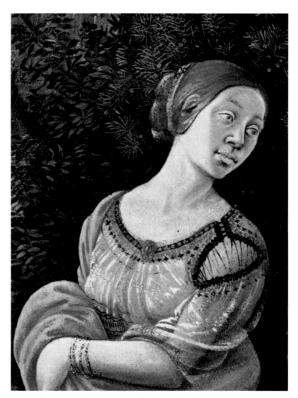

Piero di Cosimo, *The Finding of Vulcan*, detail

would thus have a common theme of the early history of man, the New York and Oxford pictures showing the age before Vulcan, and the Hartford and Ottawa pictures showing life under Vulcan's benign influence.[15] Panofsky goes on to suggest that the five pictures comprise a single decorative scheme in two rooms, perhaps that of Francesco del Pugliese.[16]

Panofsky's interpretation of the Atheneum picture as the *Finding of Vulcan* was challenged by Gamba and R. Langton Douglas.[17] Douglas's chief objection is that Panofsky failed to interpret the large bird clutching another bird in the foreground of the Hartford picture as a peregrine falcon, a bird of prey and therefore a symbol of the fate of Hylas, who, having gone to fetch water, was dragged into the pool by nymphs.[18] Panofsky's interpretation of the theme of the Atheneum picture does, however, seem more convincing than Douglas's defense of the traditional subject of *Hylas and the Nymphs*, particularly in relation to the subject of the Ottawa picture, which has not been in dispute.[19] Later authors have accepted the *Finding of Vulcan* as the subject of the Atheneum picture.[20]

More difficult to accept is Panofsky's linking of the Hartford and Ottawa pictures with the Oxford and New York pictures. The formats of the two groups are entirely different, the Oxford and New York pictures being on wood and much smaller,[21] and it is hard to imagine their forming a conventional decorative scheme.[22] Moreover, the New York and Oxford pictures would appear to date to slightly later than the Hartford-Ottawa pair.[23] Nor can Panofsky's assertion that the New York and Oxford paintings were the pictures painted for Francesco del Pugliese as described by Vasari be corroborated.[24]

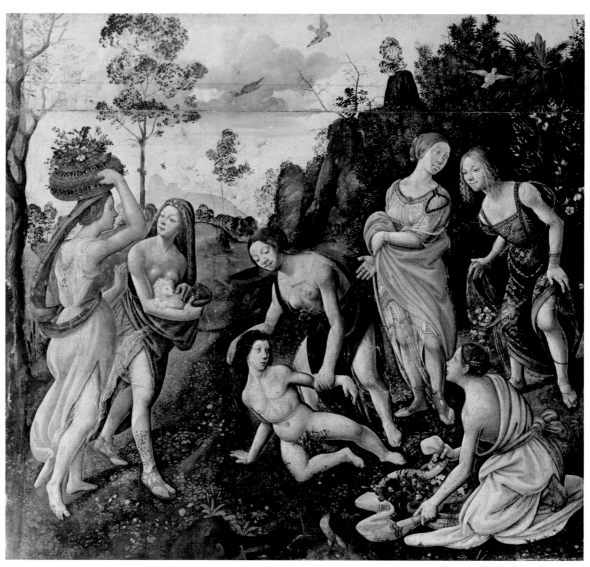

Piero di Cosimo, *The Finding of Vulcan*

The *Finding of Vulcan* was attributed to Signorelli by Spence[25] and in the William Graham sale. Although some early writers doubted the attribution to Piero,[26] all later writers have accepted it.

In the absence of firm points of reference for Piero's chronology, there have been many different opinions on the date of the Atheneum picture. External evidence may provide a clue; Landucci reports that in 1487 Lorenzo il Magnifico received a giraffe as a gift from the sultan of Egypt.[27] The presence of the exotic animal in the Ottawa picture may provide a *terminus post quem* for the Hartford and Ottawa pictures.[28] A date in the late 1480s, based on analogies with the Capponi *Visitation*, seems most reasonable. The Atheneum picture shows the same large forms pressed close to the picture plane and expansive landscape as does the *Visitation*. The superior condition of the latter perhaps gives an inkling of the original rich surface of the Atheneum picture, in spite of the difference of technique.[29] J.C.

1. Its pendant (see note 6 below) is similarly abraded and the paintings were perhaps treated sometime before they were separated in 1861. Knapp, 1899, 32–34, notes the abraded condition of the Atheneum picture.
2. For the Pugliese family, see Horne, 1915, 54–55, 73, 104.
3. Fleming, 1979, 571, n. 28.
4. *Catalogue of Pictures, Ancient and Modern, 35 Grosvenor Place*, 1882, 21, no. 371, as *Triumph of Chastity* by F. Lippi; in Graham's copy of the catalogue, the attribution to Lippi has been crossed out and changed to Piero di Cosimo by a later hand.
5. The two paintings may also belong to a larger group, the other paintings of which are lost; Vasari, 1906, IV, 139, mentions a picture of *Mars, Venus with Her Lovers, and Vulcan*, which is evidently lost. See below for discussion of paintings on related themes by Piero di Cosimo.
6. Venturi, 1927, 69–70, remarked that "si fa riscontro in qualche modo all'altro posseduto dal Benson." The two pictures were evidently together until Spence sold the Ottawa picture to Lord Lothian in 1861; see Fleming, 1979, 571, n. 28.
7. Hubbard, 1957, 1, 33, no. 4287; Laskin and Pantazzi, 1987, I, 221–26, no. 4287.
8. "He executed in the house of Francesco del Pugliese, around a chamber, divers stories of little figures: nor is one able to describe the diversity of fantastic things which he, in all those stories, so delighted to paint, both of buildings and animals and habits and divers instruments and other fantasies which occurred to him on account of their being stories of fable; as, for example, a panel of Mars and Venus, with their Loves, and Vulcan, done with great art and with incredible patience" (1550, 38; translation in Horne, 1915, 104). In the 1568 edition, Vasari

reported that these pictures had been removed after the death of Francesco and his sons (they were in fact his cousins), and he was unaware of their location (1906, IV, 139).

9. As Horne, 1915, 104, remarked, the account in the 1568 edition of Vasari makes it seem as if the paintings of Mars, Venus, and Vulcan were independent of the Pugliese decoration; whereas the earlier edition suggests that the Mars, Venus, and Vulcan theme was part of the decor. How many pictures there were is not clear. Francesco del Pugliese and his uncle Piero built a house on the via de' Serragli that was finished by 1498, and perhaps by 1486; see Horne, 1915, 73. Douglas, 1946, 14–16, supposes the Hartford-Ottawa pictures were painted for this house, but we have no other archival documentation to confirm Vasari's account. Gamba, 1936–37, 52–56, proposed that the Hartford-Ottawa canvases and other paintings on panel were painted for a room in the house of Giovanni Vespucci, also described by Vasari as by Piero di Cosimo (1906, IV, 141). The Vespucci pictures, however, are identifiable with the panels at Worcester and Cambridge, Mass., and they were most likely painted after 1499; see Davies, 1974, I, 436–37.

10. Ffoulkes, 1894, 168, who questioned the identity of the subject, but did not offer an alternative; Ulmann, 1896, 53, 120–22, repr.; Knapp, 1899, 32–35, repr.; B. Berenson, *Florentine Painters of the Renaissance*, 2nd ed. rev., 1900, 131; Haberfeld, 1900, 35–38; H. Horne, "Piero di Cosimo's Battle of Centaurs and the Lapithae," *Architectural Review*, XII, 1902, 61, repr.; S. Reinach, *Répertoire de peintures*, I, Paris, 1905, 637; L. Cust, "La Collection de M. R.-H. Benson," *Les Arts*, LXX, 1907, 26, illus. 12; Schiaparelli, 1908, 189; R. Muther, *Geschichte der Malerei*, Leipzig, 1909, I, 208–9; Venturi, 1911, VII, 1, 712, n. 1; R. Fry, "Exhibition of Old Masters at Grafton Galleries," *Burlington Magazine*, XX, 1911–12, 66; W. von Seidlitz, "Die Grafton-Austellung in London, 1911," *Repertorium für Kunstwissenschaft*, XXXV, 1912, 82; T. Borenius, *Catalogue of Italian Pictures Collected by R. and E. Benson*, 1914, 55; G. J. Hoogewerff, "De Kunst van een Zonderling (Piero di Cosimo)," *Elseviers Geïllustreerd Maandschrift*, LIX, 1920, 364; R. Fry, "Pictures at the Burlington Fine Arts Club," *Burlington Magazine*, XXXVIII, 1921, 137; Schubring, 1923, 317, no. 411; A. Alexandre, "La Collection Benson," *Renaissance de l'art français*, X, 1927, 480; Venturi, 1927, 69–70; Lord Balniel, K. Clark, E. Modigliani, *A Commemorative Catalogue of the Exhibition of Italian Art, London, Burlington House, 1930*, London, 1931, 101, no. 294, who question the identity of the subject as Hylas and the Nymphs; van Marle, 1931, XIII, 346; Venturi, 1931, no. CCXVII; A. E. Austin, "Hylas and the Nymphs," *Wadsworth Atheneum Bulletin*, Jan. 1932, 1–6; B. Degenhart, "Piero di Cosimo," in Thieme and Becker, 1933, XXVII, 15; Gamba, 1936–37, 52–56; A. Frankfurter, "Fifty-five Years of U.S. Museums," *Art News*, LVI, 1957, 46.

11. Panofsky, 1939, 33–67.

12. The sources for the story of Vulcan's fall include Apollodorus, *The Library*, I, 3:5–6; and Lucian, *On Sacrifices*, 6. For sixteenth-century sources, see V. Cartari, *Le Imagini delli dei degli antichi* (1556), Padua, 1608, 359, who describes the story of Vulcan as follows: "Le favole poi, che si leggono di Volcano, sono molte, e tutte ponno darci argomento di farne dipinture in diversi modi, cominciando dal nascimento suo; perche si legge, che ci nacque di Giunone, e che questa, vedendolo cosi brutto, lo sdegnò e gittolo via, onde il misero andò a cadere in Lenno isole nei mare Egeo, e dalla caduta restò sciancato, sicchè fu poi sempere zoppo." ("There are many stories of Vulcan that can be depicted in paintings, beginning with his birth, in which we read that his mother Juno despised him because he was ugly, and she cast him off. The poor child fell on the island of Lemnos in the Agean sea, and was crippled, and was thereafter lame.") For further information on the myth of Vulcan, see M. Delcourt, *Hephaistos ou la légende du magicien*, Paris, 1957; F. Brommer, *Hephaistos, der Schmiedegott in der antiken Kunst*, Mainz, 1978; see also P. Bober and R. Rubinstein, *Renaissance Artists and Antique Sculpture*, Oxford, 1986, 82–83.

13. The inhabitants of Lemnos were shown as nymphs because, according to Panofsky, copies of Servius's *Commentary on Virgil*, which transmitted the Vulcan story to the Renaissance, corrupted the original text to read that Vulcan was brought up by

nymphs (Panofsky, 1939, 36–37).

14. Panofsky, 1939, 38–39.

15. See, however, Christiansen, 1983, 39, who points out that in the New York pictures human progress does not seem related to man's control of fire.

16. Panofsky, 1939, 56–57.

17. C. Gamba, "Poesia di Piero di Cosimo, *Illustrazione toscana e dell'Etruria*, XVIII, 1940, 8; Douglas, 1946, 34–39; also in an exchange of letters to the editor with Panofsky in *Art Bulletin*, XXVIII, 1946, 286–89; XXIX, 1947, 143–47, 222–23. P. Morselli, "Ragioni di un pittore fiorentino: Piero di Cosimo," *Arte*, n.s. XXII, 1957, 136–39, favors Douglas's interpretation of the theme.

18. For a contemporary interpretation of the scene, see the *Scenes from the Story of the Argonauts* by Biagio di Antonio in the Metropolitan Museum of Art, New York. There the nymphs seize young Hylas, who is fully dressed in armor. See Zeri, 1971, 143–45, inv. no. 09.136.2.

19. The *Finding of Vulcan* seems not to have been depicted previously in painting; however, innovative subject matter is characteristic of Piero's oeuvre.

20. J. W. Lane, "Notes from New York," *Apollo*, XXIX, 1939, 34; E. S. Siple, "Art in America. The Mid-Winter Season," *Burlington Magazine*, LXXIV, 1939, 81; *Duveen Pictures in Public Collections of America*, New York, 1941, no. 127; Shoolman and Slatkin, 1942, 294, pl. 277; E. Waterhouse, review of Douglas, 1946, in *Burlington Magazine*, LXXXIX, 1947, 230; R. W. Kennedy, *The Renaissance Painter's Garden*, New York, 1948, pls. XVI, LVI; Salmi, 1953, 109; *Wadsworth Atheneum Handbook*, 1958, 28; Zeri, 1959, 44; Frankfurter, 1959, 60; R. F. C., "Hartford: Opere del Wadsworth Atheneum Esposte a New York," *Emporium*, CXXIX, 1959, 86–87; Grassi, 1963, 55, who cites both subjects; Bacci, 1966, 76; Paoletti, 1968, 420–22; S. N. Behrman, *Duveen*, Boston, 1972, 222; Cieri Via, 1977, 10; A. Jouffrox, *Piero di Cosimo*, Paris, 1982, 48–53; Silk and Greene, 1982, 20–21.

21. The dimensions of *Hunting Scene*, inv. no. 75.7.2, are 70.5 x 169.5 cm; of *Return from the Hunt*, inv. no. 75.7.1, 70.5 x 168.9 cm (Zeri, 1971, 176–80). The dimensions of *Fire in a Forest*, inv. no. A 420, are 71.2 x 202 cm (Lloyd, 1977, 147–51).

22. For a discussion of decorative schemes, see Schiaparelli, 1908, I, 162–68, 301, and Callman, 1986. The following authors reject the notion that the Hartford-Ottawa pair belongs to the New York–Oxford group: Zeri, 1959, 44, who proposes that the panel of the *Construction of a Building* in the Ringling Museum, Sarasota, should be grouped with the New York and Oxford pictures; Grassi, 1963, 44, 55; E. Fahy, "Some Later Works of Piero di Cosimo," *Gazette des Beaux-Arts*, LXV, 1965, 200, follows Zeri in grouping the New York, Oxford, and Sarasota pictures; Zeri, 1971, 176; Cieri Via, 1977, 9; Christiansen, 1983, 39.

23. The dating of the New York and Oxford pictures has varied. See Zeri, 1971, 176–77. A date in the early or middle 1490s seems most reasonable.

24. Cieri Via, 1977, 10–14, in an interpretation of the theme of primitivism, distinguishes a positive view of civilization, as seen in the Hartford-Ottawa pair, from an idealization of primitive life, as seen in the New York pictures; she suggests that the optimistic view prevailed during the age of Lorenzo de' Medici, while a crisis about 1490 heralded Piero's changing view of primitive life. She also proposes that the Pugliese, who were known to be supporters of Savonarola, were the patrons of the New York pictures.

25. Fleming, 1979, 571, n. 28.

26. Ffoulkes, 1894, 168, who suggested the composition depends on a print by Cristofano Robetta; Knapp, 1899, 35, as workshop; Venturi, VII, 1911, 712; Schubring, 1923, 317, no. 411.

27. L. Landucci, *Diario fiorentino dal 1450 al 1516* (1583), ed. I. del Badia, Florence, 1883, 52–53.

28. Douglas, 1946, 21.

29. The *Visitation* is on panel. Ulmann, 1896, 120, dates the Atheneum picture early in Piero's career; Knapp, 1899, 35, to 1485; Haberfeld, 1900, 35, to 1484; Gamba, 1936–37, 56, to before 1500; Panofsky, 1939, 47, n. 44, dates the Atheneum picture to about 1490; Douglas, 1946, 20, to about 1488; Salmi, 1953, 109, dates it to 1488–89; Hubbard, 1957, I, 33, to about 1485–90; Zeri, 1959, 44, to about 1510; Grassi, 1963, 55, to between 1495 and 1500; Bacci, 1966, 77–78, to between 1480 and 1490; Paoletti, 1968, to about 1490; Cieri Via, 1977, to between 1480 and 1490.

Giuseppe Maria Crespi (1665–1747)

Born in Bologna 14 March 1665 to a comfortable but modest family, Giuseppe Maria Crespi studied painting from Angelo Michele Toni, a minor local artist.[1] About 1682 he studied briefly with the painter Domenico Maria Canuti, and later, around 1684, he joined the workshop of Carlo Cignani, a painter of evocative nudes, where he remained until 1686. In that year Cignani left for Forlì, and Crespi and the painter Giovan Antonio Burrini took over Cignani's studio. Burrini introduced Crespi to his first important patron, Giovanni Ricci, who bought his early pictures and funded his travels to Venice, Parma, Modena, Urbino, and Pesaro, where he immersed himself in the works of earlier artists, among them Correggio, Barocci, and the Venetian painters, much as had Annibale Carracci a century earlier. This period of education lasted until 1690, when Crespi attended an academy of the nude in the Palazzo Ghisilieri.

In that year Crespi was forced to withdraw after offending Count Cesare Malvasia, one of the directors of the academy, by caricaturing him as a chicken. After a brief exile to Venice, Crespi returned to the academy, but he stayed only a short time before setting up on his own. During the next ten years Crespi worked for a variety of patrons and in a variety of media. From 1691 date the now lost frescoes in S. Francesco di Paolo in Pistoia, done in collaboration with the painter Chiarini, and also possibly from this date are the frescoes of the *Triumph of Hercules* and the *Banquet of the Gods* in the Palazzo Pepoli in Bologna.[2] These latter are Crespi's only surviving frescoes; the lack of comment on them by his biographers suggests that they did not find favor.[3] Datable paintings from the 1690s include the *St. Anthony Tempted by Demons*[4] in S. Nicolò degli Albari, painted for Count Malvasia in 1690, and a small *Pastoral Scene*, formerly signed and dated 1698.[5] The *Portrait of Virginia Sacchetti Caprara* dates to 1699.[6] These few early documented works suggest Crespi's mastery of the Bolognese tradition as well as considerable range and independence in his interpretation of subject matter.

The first decade of the eighteenth century was a decisive one for Crespi. From 1701 dates the *Ecstasy of St. Margaret of Cortona*, commissioned by Ferdinand de' Medici to replace an altarpiece by Lanfranco, now in the Galleria Palatina, Palazzo Pitti, Florence;[7] and from the next year possibly the *Resurrection*, now Raleigh, North Carolina Museum of Art.[8] The *Massacre of Innocents* was painted for Ferdinand de' Medici in 1706–8 and began a period of sympathetic patronage of Crespi by the prince.[9] The ambition to succeed in traditional forms—the monumental altarpiece and the dramatic narrative, which the pictures from the early 1700s show—was nurtured and broadened by the prince's taste, which extended to genre and pastoral subjects as well. During Crespi's two sojourns in Florence in 1708 and 1709, he painted a number of documented pictures, such as the *Family of the Painter* and the *Fair at Poggio a Caiano*, in which his bent toward sympathetic observation of everyday events and people was given free range. For the rest of his career, this concern with genre and observation carried over to his work in all areas.

After Crespi's return to Bologna in 1709, he seldom left his native city. He worked steadily and produced a huge corpus of work; unfortunately, only a small portion is datable so that reconstructing a chronology is difficult. Crespi's habit of making replicas of earlier pictures compounds the problem. Also, his ability to adapt his style to fit his subject matter makes chronological ordering of his oeuvre uncertain.[10] Nonetheless, a short list of dated paintings is useful, including the *Annunciation with*

Saints John the Baptist, Joseph, and Stephen from Sarzana Cathedral of 1722,[11] the *Martyrdom of St. Andrew* and the *Martyrdom of St. John the Evangelist* for the S. Paolo d'Argon in Bergamo of 1728;[12] the *Jupiter among the Corybantes* of 1729 in Stuttgart;[13] the *Founders of the Servite Order* in Guastalla of 1730;[14] the *Joshua Stopping the Sun* of 1737 in Bergamo;[15] the *Portrait of Cardinal Lambertini* in the Vatican of 1740; the *Virgin* and *Annunciate Angel* for the oratory of the Mascascarella of 1741;[16] and the *Adoration of the Shepherds* (with assistance), now Turin, Galleria Sabauda, of 1742.[17]

Crespi was also active in founding the Accademia Clementina in 1709, and served as its director in 1712 and 1714. He soon became disenchanted with it, however, and withdrew from its activities. Crespi's strong concerns for the status and professional standards of painters are well known and are an intriguing counterpart to his innovations in subject matter, especially in low-life genre.

Crespi's sons Luigi (1708–1779) and Antonio (1712–1781) were also painters and participated in his shop. They were, however, largely dependent on their father for inspiration. While Luigi Crespi concentrated on portraiture and literary pursuits, Antonio's career after his father's death in 1747 is obscure.

1. For this and the following information, see the authoritative monograph by Merriman, 1980, 23; and the introductory essay by Spike in Fort Worth, 1986, 13–38. Roli, 1977, 247–48, publishes a useful register of dates. The major contemporary sources for Crespi's life are Zanotti, 1739, II, 31–73; and Crespi, 1769, 201–32.
2. Merriman, 1980, 274–77, nos. 148–49.
3. Spike in Fort Worth, 1986, 18.
4. Merriman, 1980, 262, no. 105.
5. Robert Manning Collection. Merriman, 1980, 308, no. 255.
6. Merriman, 1980, 287, no. 185.
7. Merriman, 1980, 269, no. 130.
8. Merriman, 1980, 253–54, no. 64.
9. Merriman, 1980, no. 36.
10. Merriman, 1980, 12–13.
11. Merriman, 1980, no. 137.
12. Merriman, 1980, nos. 100–101.
13. Merriman, 1980, no. 160.
14. Merriman, 1980, no. 146.
15. Merriman, 1980, no. 13.
16. Merriman, 1980, nos. 18–19.
17. Merriman, 1980, no. 24.

Portrait of the Artist in His Studio

Oil on canvas, 57.5 x 43 cm (22⅝ x 16¹⁵⁄₁₆ in.)

Condition: good. The picture is very thinly painted; with time the paint film has become transparent in places.

Provenance: collection Carlo Foresti, Milan, 1935; Adolf Loewi; purchased by the Wadsworth Atheneum in 1936 from Arnold Seligmann, Rey & Co., New York, for $3,500 from the Sumner Fund.

Exhibitions: Bologna, 1935, no. 20, pl. VI; New York, Durlacher Bros., *Paintings by Giuseppe Maria Crespi*, 6 Jan.–6 Feb. 1937, no. 8; New York, 1938, no. 5, repr.; New York, 1939, no. 63, pl. 69; Baltimore, 1944, 28, no. 15, repr.; Northampton, 1947, no. 14; Buffalo, Albright Art Gallery, *Eighteenth-Century French and Italian Paintings*, 16 Apr.–16 May 1948, no. 14; Hartford, *In Retrospect*, 1949, 13, no. 13, pl. III; Sarasota, 1958, no. 18; Chicago, 1970, 118, no. 46; Hartford, 1982; Fort Worth, 1986, 168–70, no. 29.

The Ella Gallup Sumner and Mary Catlin Sumner Collection, 1936.499

Giuseppe Maria Crespi, *Portrait of the Artist in His Studio*

Figure 21. Giuseppe Maria Crespi, *Self-Portrait with Family*, Florence, Galleria degli Uffizi

Figure 22. Giuseppe Maria Crespi, *Portrait of the Artist in His Studio*, sale London, Sotheby's

Seated in an upholstered chair, intently bending over his easel, the artist is seen surrounded by the accoutrements of his profession. Casts of faces and body parts are on the shelves and walls; pictures, one of which is Crespi's own copy of Guercino's *Ecstasy of St. Francis*, hang over the chimney and bookcase; a lute rests on an adjacent table; the books on the shelves are jumbled from frequent consultation.[1] Light steals in the half-opened shutter and illumines the bookcase, easel, and mantel. The image of order and of intellectual activity which Crespi seemingly imputes to painting accords well with his own high opinion of his profession; on the other hand, the homey interior he depicts indicates the lack of pretension with which he pursued it.[2]

Thought to be a self-portrait of the artist in his studio since its appearance in the literature,[3] this identification has recently been challenged by Merriman.[4] The author noted that if the Atheneum work is a self-portrait, the artist's youthful appearance would signal a date early in his career, as generally conceded by scholars.[5] Indeed, the painter's face, small and somewhat generalized in the Atheneum picture, accords well with other portraits of Crespi as a man of young or early middle age (Fig. 21).[6]

Merriman objects, however, that the style and subject of the Atheneum picture would be unique in Crespi's pictures before the second decade of the eighteenth century.[7] She proposes an identification of the sitter as the artist's son Luigi and a date in the 1730s.[8] Spike, discounting the evidence of the sitter's age, concurred with Merriman's late dating.[9] The extremely thin application of paint and delicate light effects of the Atheneum picture argue in favor of a late dating. The bravura impasto of Crespi's early pictures, so well described by Merriman, is confined in the Atheneum picture to the full sleeves of the artist's shirt.

A replica of the *Portrait of the Artist in His Studio* was recently sold in London (Fig. 22).[10] The London picture shows slight variations of detail from the Atheneum picture, and it depicts generally a more legible, detailed interior. And yet, as Spike has noted, the Atheneum picture is the more evocative image.[11] Merriman also noted an "illustrative" quality to the London work, citing a reorientation of forms to parallel the picture plane, a flattening of the space, and elongation of the figure proportions.[12]

Spike has furthermore cited a reference to a picture by Crespi of "his person in the act of painting at the easel in his room" that was sent in 1742 as a gift to the marchese d'Ormea, first minister of Charles Emmanuel III, king of Sardinia.[13] The identification of the Atheneum picture with the portrait sent to d'Ormea would support a late date for the picture, or at least provide a *terminus ante quem* for it. The reference could also refer to the London replica. J.C.

1. The Guercino picture, painted in 1620 for the church of S. Pietro at Cento, entered the Louvre in 1797, inv. no. 83. Crespi's copy, in Bologna in the Boni-Maccaferri Collection, has generally been thought to date to early in his career because of its fidelity to the original; see Merriman, 1980, 265, no. 116; Bologna, 1990, 4–5, no. 2.
2. Miller in Chicago, 1970, 188, no. 46; Merriman, 1980, 25–26.
3. "Hartford: Two Masterpieces of the Settecento," *Art News*, XXXV, 2 Jan. 1937, 8, 20; A. M. Frankfurter, "The Neglected Importance of Crespi," *Art News*, XXXV, 16 Jan. 1937, 12; *Art News Guide and Picture Book, Masterpieces of Art*, New York, 1939,

Giuseppe Maria Crespi, *Way to Calvary*

pl. 69; *Maanblad von Belldende Kunsten*, XXIII, no. 3, Mar. 1948, 63, repr.; *Wadsworth Atheneum Handbook*, 1958, 87; Roli, 1977, 250, 314a.

4. Merriman, 1980, 299, no. 222.

5. Miller in Chicago, 1970, 118, no. 46, dated the picture to about 1705.

6. See, for example, the *Self-Portrait* in Leningrad of 1700–5, the *Self-Portrait* in the Uffizi of 1708, painted for Prince Ferdinand de' Medici (Merriman, 1980, 286, no. 181), and the *Self-Portrait with Family* of 1708, also in the Uffizi (Merriman, 1980, 287, no. 184).

7. Merriman, 1980, 299.

8. Merriman's further objection, that the exalted view of painting implied by the Atheneum picture does not accord with Crespi's "defiant populism," as seen in the Uffizi *Self-Portrait with Family*, would seem to be misplaced. While both pictures blur the distinctions between portraiture and genre, the Uffizi painting was done specifically to amuse the prince and to poke fun at himself; its special conditions in no way apply to the Atheneum picture (Merriman, 1980, 29, 130). Indeed, the seriousness of the other self-portrait sent by Crespi to the prince would suggest how unusual the family portrait is. Instead of seeing the Atheneum picture at variance with the sentiments expressed in the family portrait, might we not see the Atheneum picture as a counterpart to it, representing the serious, scholarly, and assiduous aspect of the painter's craft, particularly as Crespi practiced it? Indeed, both attitudes are discernible in the Atheneum picture.

9. Fort Worth, 1986, 168–70. Viroli, in Bologna, 1990, 126, dates it to 1715–20.

10. London, Sotheby's, 5 July 1989, no. 72, 53.5 x 38.5 cm (21 x 15 in.); Bologna, 1990, 126–27, no. 64.

11. Letter to J. Cadogan, 28 Mar. 1987, curatorial file.

12. Letter to J. Cadogan, 8 Oct. 1987, curatorial file.

13. The reference is to a letter written by Paolo Salani, abbot of S. Michele in Bosco, Bologna, to d'Ormea in Turin, in December 1742, first published in L. Frati, "Quadri dipinti per il Marchese d'Ormea e per Carlo Emanuele III," *Bollettino d'arte*, X, 1916, 282, as cited in Fort Worth, 1986, 170. See Spike in Fort Worth, 1986, 170, nn. 4–6, on the interrelationship of Crespi, Salani, and d'Ormea.

Way to Calvary

Oil on canvas, 55.2 x 75.8 cm (21 3/8 x 29 7/8 in.)

Condition: fair. The background and the foreground have suffered minor losses. There are scattered retouches around the feet of Christ, in the figures at the left, and along the edge of the ladder.

Provenance: Schaeffer Galleries, New York; Henry T. Kneeland, Bloomfield, Conn., 1948–86. Given to the Wadsworth Atheneum in 1986 by Beatrice Kneeland.

Gift of Beatrice Kneeland in memory of Henry T. Kneeland, 1986.273

Marcello Oretti, the eighteenth-century Bolognese historian, describes a painting by Crespi in his house "sotto il portico in una lunetta No Signore condotto al Calvario figure al naturale."[1] In 1935 a picture in the collection of Luigi Neri was identified as the lunette to which Oretti refers.[2] The current location of the Neri picture is unknown.

The Atheneum picture is an autograph, reduced version of the lunette described by Oretti that was in the Neri collection in 1935.[3] The slight divergences of the reduced version from the life-sized lunette, such as the view of the ladder between the lance-bearer and the Cross, seem to result from Crespi's adaptation of the lunette composition to a rectangular format.[4]

The Atheneum version was probably painted, like the Bologna lunette, in the late 1730s or early 1740s.[5] J. C.

Giambattista Crosato, *Europa and the Bull*

1. "In an arch under the portico Our Lord being led to Calvary, life-sized figures"; in Bologna, Biblioteca Comunale, MS B.131, 362, as cited in Merriman, 1980, 252, no. 56.
2. Bologna, 1935, 15, no. 46, 79 x 255 cm.
3. J. Spike, letter to J. Cadogan, 28 Mar. 1987, curatorial file, accepts the Atheneum version as autograph, as does M. Merriman, letter to J. Cadogan, 9 Oct. 1987, curatorial file.
4. J. Spike, letter to J. Cadogan, 28 Mar. 1987, curatorial file.
5. Merriman, 1980, 252, no. 56, dates the lunette to the 1730s; J. Spike, letter in curatorial file, 27 Mar. 1987, dates the Atheneum version to between the late 1730s and 1744.

Giambattista Crosato
(c. 1685–1758)

Born in Venice about 1685, Giambattista Crosato's earliest works in his native city have not survived. These include frescoes and an altarpiece in the sacristy of Sta. Maria dei Servi, executed in 1729.[1] By 1733 he was active in Turin, perhaps called there by Filippo Juvarra, the architect to Victor Amadeus II, to decorate the antechamber, the Sala degli Scudieri, and the chapel vestibule in the hunting lodge of Stupinigi, outside Turin, and other rooms in the Villa della Regina.[2] He also executed for the bathroom of the villa in 1733 a chimneypiece with Venus and Vulcan.[3] In these works scholars have noted awareness of the Bolognese G. M. Crespi, and have suspected that Crosato passed a certain time around Bologna before arriving in Turin.[4]

In 1736 Crosato was back in Venice, where he was inscribed in the *Fraglia dei pittori*.[5] Further work in 1738 and 1739 also in Sta. Maria dei Servi does not survive,[6] and by 1740 he had returned to Turin. His second visit produced the decorations of the Santuario della Consolata di Torino and work in local churches, including a chapel of S. Francesco de Sales in the church of the Visitation in Pinero,[7] and in the churches of SS.

Marco e Leonardo and the Immaculata Concezione.[8] During this trip he was also active designing sets for the theater.[9]

Sometime after 1742 Crosato finally returned to Venice, where he worked in local churches and in the Veneto; from 1748 date the frescoes at Ponte a Brento.[10] His name appears again in the *Fraglia* in 1752; from that year must also date the ceiling of the ballroom in the Ca' Rezzonico, universally attributed to Crosato and perhaps his best-known work.[11]

Crosato was elected to the Venetian Academy in 1756, and died 15 July 1758.[12]

Crosato's art, charming in itself, documents the spread of Venetian decorative style throughout northern Italy in the first half of the eighteenth century.

1. Fiocco, 1944, 99; see also Harrison, 1983, 7–69.
2. Fiocco, 1944, 39–42.
3. Griseri, *Paragone*, 1961, 52; Pallucchini, 1960, fig. 74.
4. Pallucchini, 1960, 27; P. Mattanolo, "La Formazione emiliana di Giambattista Crosato," *Arte veneta*, XXV, 1971, 194–204.
5. Fiocco, 1944, 99.
6. Fiocco, 1944, 45, 99–100.
7. Fiocco, 1944, 100.
8. Harrison, 1983, 45–46.
9. Fiocco, 1944, 100.
10. Fiocco, 1944, 101.
11. Fiocco, 1944 63, 101.
12. Fiocco, 1944, 102.

Europa and the Bull

Oil on panel, 24.8 x 41.8 cm (9³/₄ x 16⁵/₈ in.); paint surface 24.1 x 41.3 cm (9¹/₄ x 16¹/₄ in.)

The original panel has been thinned and glued to a board. The paint surface stops approximately ¹/₄ inch from the edges of the panel, suggesting that the original panel had some sort of frame.

Condition: excellent. There is minor retouching through a prominent horizontal crack in the center of the panel. A pentimento is visible to the left of the central figures.

Provenance: Feilchenfeldt Collection, Zurich, as Diziani; Colnaghi & Co., London; bought by the Wadsworth Atheneum in 1963 from Colnaghi & Co. for $2,380 from the Sumner Fund.

The Ella Gallup Sumner and Mary Catlin Sumner Collection, 1963.1

Ovid, in the *Metamorphoses*,[1] relates how Zeus, smitten by Europa, transformed himself into a bull in order to seduce the maiden and carry her off. The Atheneum picture shows the moment when Europa, having just straddled the patient bull, beckons her maidservant to attach the clasp of her robe.

Europa and the Bull is related to a panel of the same subject in the Palazzo Madama in Turin (Fig. 23).[2] The Turin panel is one of a series of twenty panels by Crosato representing different stories from the *Metamorphoses*.[3] Griseri assumes that the panels formed a *zoccolo*, or dado, that was originally in the Appartamento d'Inverno in the Palazzo Reale.[4]

The Atheneum painting shows nominal variations from the Turin panel and is probably a preparatory sketch for it. The more spacious composition of the Atheneum version can perhaps be explained by the decorative exigencies of the commission; the more ample setting seen in the Atheneum picture may have been sacrificed for lack of space.

A date of about 1733 for the Turin panels, and for the Atheneum sketch, has been proposed by Griseri, based on analogies of style with the documented *Venus and Vulcan* of that year.[5] J. C.

1. Ovid, *Metamorphoses*, II, 835–77.
2. Griseri, *Paragone*, 1961, 57, fig. 44, noted the connection of the Atheneum painting with the Turin panel, as did Harrison, 1983, 135.
3. All oil on panel, about 46 centimeters high, varying in width from 18 centimeters to 1.25 meters. Griseri, *Paragone*, 1961, 54–58, attributes the panels to Crosato, based on correspondences between one of the panels and a drawing published by Fiocco. The panels were exhibited in Turin, *Mostra del Barocco Piemontese*, 22 June–10 Nov. 1963, II, nos. 140–59. The Atheneum panel is noted in no. 141, as with Colnaghi.
4. The provenance for the panels is not known, nor does Griseri cite reasons for her assertion.
5. Griseri, *Paragone*, 1961, 52; Harrison, 1983, 29–32.

Figure 23. Giambattista Crosato, *Europa and the Bull*, Turin, Museo Civico

Vincenzo Damini
(c. 1690/92–after 1749)

Almost nothing is known of Damini's life. His place of birth is not known, though it is probably Venice. Literary sources, who seem not to have been intimate with him, say only that he was a student of Giovanni Antonio Pellegrini, with whom he worked in England, and later in England a student of Francesco Riari.[1] Though Vertue says "he came to England soon after his master left it the first time,"[2] that is, in 1713, scholars have assumed Damini's trip to England dated somewhat later, to 1719–20.[3] Recently, it has been suggested that Damini participated in Pellegrini's decorative cycle at Narford Hall, Norfolk, and that he had therefore arrived in England before about 1711–13.[4] After Pellegrini's departure in 1713, Damini may have been a student in Riari's studio.[5]

Between 1713 and 1720 Damini's activities are unclear; he may have been with Pellegrini in Paris in 1719–20, and he probably was in Venice at some point during this time.[6] By 1720 he was probably back in England; from this period only works executed in Lincoln, an *Ascension* in the church of St. Peter-at-Arches, destroyed in 1932, for which an oil sketch survives, and a series of bishops in Lincoln Cathedral, are known.[7]

Damini left England in 1730 in the company of his pupil Giles Hussey, whom he left at Bologna.[8] His further movements are not known until his signed and dated work, *St. John of Capistrano at the Battle of Belgrade* of 1737, in S. Giuliano in L'Aquila, in the Abruzzi.[9] Further dated works in L'Aquila suggest Damini settled there. The last notice of him is from 1749.

While it has been shown that Damini's early works imitated the style of his master Pellegrini,[10] his works from the later 1710s and 1720s suggest conversion to the dramatic chiaroscuro and rich coloring of Bencovich and Piazzetta.[11] His mature style is an idiosyncratic product of Venetian culture of the early eighteenth century, which seems to have found favor abroad and in the provinces rather than at home.

1. Early information on Damini dates only from his English period and includes Vertue, 1933–34, 41, 64, 108; Walpole, 1849 ed., II, 702; Edwards, 1808, 150–51; these are conveniently reprinted by Young, 1979, 78. See also Pallucchini, 1960, 125–26; Zampetti, 1971, IV, 37–38.
2. Vertue, 1933–34, 41.
3. Pallucchini, 1960, 125.
4. Young, 1979, 72; on Pellegrini, see Pallucchini, 1960, 19.
5. Young, 1979, 75.
6. Young, 1979, 75.
7. Young, 1979, 75.
8. Vertue, 1933–34, 41, 108; Walpole, 1849 ed., 702; Edwards, 1808, 151.
9. Pallucchini, 1960, 125.
10. Young, 1979, 74.
11. Pallucchini, 1960, 125.

Gaius Mucius Scaevola before Lars Porsena

Oil on canvas, 164.8 x 128.6 cm (64⁷/₈ x 50⁵/₈ in.)
Condition: fair. Glazes have been rubbed or cleaned away, resulting in a loss of transitional values and enhancement of the dramatic light effects.
Provenance: Paul W. Cooley, Simsbury, Conn.; purchased by the Wadsworth Atheneum in 1964 from Paul W. Cooley for $2,000 from the Sumner Fund.
The Ella Gallup Sumner and Mary Catlin Sumner Collection, 1964.157

Gaius Mucius Scaevola vowed to assassinate Lars Porsena, king of Clusium, who was besieging Rome in an attempt to reestablish the Tarquinian dynasty.[1] Mucius Scaevola murdered the secretary of the king by mistake and was captured. Brought to trial before the king, Mucius Scaevola thrust his hand into a blazing fire. Lars Porsena was so impressed with his bravery that he freed him and made peace with the Romans.

Traditionally attributed to Rubens, the ascription of the Atheneum painting to Damini was first proposed by H. Voss.[2]

The Atheneum picture had a pendant, *Volumnia and Her Children before Coriolanus*, whose present location is unknown.[3] The coupling of scenes of bravery and clemency is a common feature of contemporary cycles of history paintings.

Scenes from Roman history, particularly Republican Roman history, enjoyed a vogue in Venice in the early eighteenth century.[4] Among other renditions of the same theme is that of Piazzetta, painted perhaps in about 1710 as a companion to Antonio Balestra's *Family of Darius before Alexander*, both now in the Palazzo Barbaro-Curtis in Venice.[5] Giovanni Battista Tiepolo also painted the subject of Mucius Scaevola at least twice, first about 1725–30 as part of a series of ten canvases for the large hall in the Ca' Dolfin, Venice; five of these, including *Mucius Scaevola before Porsena* and *Volumnia and Her Children before Coriolanus*, are now in the Hermitage in Leningrad.[6] Another version of the subject, coupled with a *Family of Darius before Alexander*, was formerly in the Residenz in Würzburg; both are now in the Martin von Wagner Museum der Universität, and they date to the 1750s.[7] Finally, Gian Antonio Guardi painted four large canvases with stories from Roman history,

including a *Mucius Scaevola before Lars Porsena*, probably in the 1750s. They are now in the Bogstad Villa near Oslo.[8]

Of all the contemporary renditions of the subject, Damini's painting is closest to that of Piazzetta. The general composition, including the king on a high, stepped throne, the group of soldiers at the left, the body of the dead secretary, and the inclusion of the dog, is strongly reminiscent of Piazzetta's work. If the Piazzetta had been executed as early as 1710, Damini could have known the picture, if not in his youth, then on subsequent trips to Venice in the 1710s and 1720s, when, as Pallucchini has suggested, the style of Piazzetta and Bencovich took on special interest for him.[9] Damini could also have known Tiepolo's version of the subject; indeed, the general compositions are similar, and Tiepolo's cycle included the subject of Volumnia, which Damini painted as a pendant to the *Mucius*.[10]

The final identity of Damini's model cannot be determined because the dating of all the pictures is uncertain. The rich colors and brushwork point to a date of about 1725–30, that is, during Damini's English sojourn, for the Atheneum picture.[11] Such a date would allow for the influence of Tiepolo or of Piazzetta, if an earlier dating for the Palazzo Barbaro-Curtis painting is accepted.[12] J.C.

1. Livy, *The History of Rome*, II, 12–13.
2. Cunningham, 1964, 19. A subsequent attribution to Nicola Grassi was also proposed. A. Rizzi tentatively attributed the painting to Giuseppe Nogari, letter to Sam Wagstaff, Jr., 24 Oct. 1964, curatorial file.
3. Paoletti, 1968, 25. The picture is mentioned as on the art market in 1964.
4. Knox, 1975, 96–104.
5. The hall that the paintings decorate had been remodeled between 1694 and 1698 and included a ceiling by Antonio Zanchi and a large *Rape of the Sabines* by Sebastiano Ricci, painted about 1700; Knox, 1975, 96. Pallucchini and Mariuz, 1982, 105–6, no. 125, have disputed the early dating of the Piazzetta, proposing instead a date in the 1740s. They suggest that Piazzetta's painting replaced an earlier painting and was installed during renewed work on the palace in the 1740s.
6. Morassi, 1962, 15, figs. 298–99.
7. Pallucchini and Piovene, 1968, 118, nos. 205–6.
8. Morassi, 1973, 92, no. 95, fig. 116.
9. Pallucchini, 1960, 125.
10. Tiepolo's sketch in the Musée Magnin, Dijon, might be adduced as evidence that Tiepolo's work was influenced by Piazzetta's design, and not the other way around, as has been assumed. In the sketch Tiepolo included a large sculpture in the background, perhaps a standing Apollo, as in Piazzetta's canvas. In Tiepolo's final version, the sculpture was omitted. See Brejon de Lavergnée, 1980, 107–9, no. 101.
11. Cunningham, 1964, 19, and Paoletti, 1968, 25, propose a date after 1730, when Damini had returned to Italy; Young, 1979, 76, proposes a date around 1730.
12. The correspondences of the Atheneum picture with Piazzetta's do, however, argue for a date before 1740 for the latter.

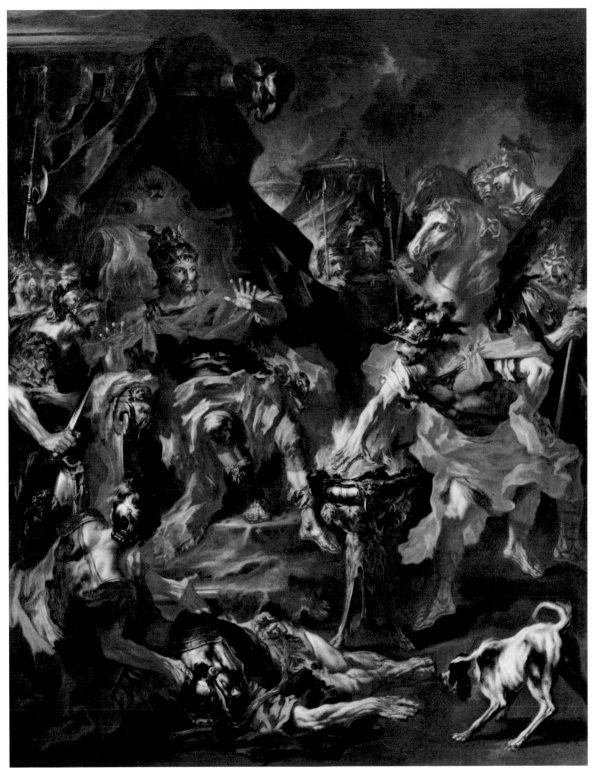

Vincenzo Damini, *Gaius Mucius Scaevola before Lars Porsena*

Carlo Dolci
(1616–1686)

Carlo Dolci was born in Florence 25 May 1616. He was trained by Jacopo Vignali and already by the age of fifteen was producing pictures independently, such as the signed portrait of Stefano della Bella and the portrait of Fra Ainolfo de' Bardi in the following year, both now in the Pitti. Works from the 1640s, such as the *Christ in the House of the Pharisee* and the *St. Andrew Adoring His Cross*, show his distinctive style already developed. Baldinucci's detailed and sympathetic account of his life, taken with the signed and dated works that remain, allow a clear view of his oeuvre.[1] He died in Florence 17 January 1686.

Appreciation of Dolci's autograph works has been hampered by the existence of many replicas and variants, especially of his religious pictures. Recently, Dolci's stature as one of the most distinguished Florentine baroque artists has been elucidated, and the way cleared for a more balanced evaluation of his intensely cogitated and highly polished images.[2]

1. Baldinucci, 1847, 335–64.
2. McCorquodale, 1973, 477–88.

Christ Child with Flowers

Oil on canvas, 95.5 x 78.1 cm (37⅝ x 31¾ in.)
 Condition: fair. The painting is heavily abraded and has been extensively inpainted, especially in the sky.
 Provenance: collection of the earl of Listowel; John Hare, Kingston House, Prince's Gate, London, sale London, Christie's, 16 Apr. 1937, no. 21, bought by Mondschein; W. Sabin, London; Galerie Sanct Lucas, Vienna; bought by the Wadsworth Atheneum in 1937 from Galerie Sanct Lucas for $170 from the Sumner Fund.
 Exhibitions: Vienna, 1937, no. 30; Kent, 1966.
 The Ella Gallup Sumner and Mary Catlin Sumner Collection, 1937.488

Baldinucci describes a picture by Dolci: "Dugento però gliene furono dati pel Gesù, in età di sei anni in circa, in atto di sedere, sopra l'ingresso dell'orto, che si ha nei Sacri Cantici, e con una ghirlanda di bellissimi fiori in mano, quasi invitando l'anima ad inghirlandarsi di cristiane virtù: e questa figura pare fu mandata a Venezia. Da questo ne ricavò un altro simile, che poi l'anno 1675 lo ebbe la maestà dell'imperatrice Claudia Felice, figliuola del serenissimo arciduca Ferdinando Carlo, e della serenissima arciduchessa Anna dei Medici: al qual quadro fu dato luogo nella propria camera dell'imperatrice; ed a Carlo furono donati trecento scudi."[1] A picture of the Christ Child at Burghley House, identical to the Atheneum picture but showing the head and shoulders only, is inscribed with the lines from the Song of Solomon, 5, "Veni . . . in ortum meum soror mea," and suggests that this is the theme described by Baldinucci.[2]

The picture described by Baldinucci is generally thought to be a canvas in the Thyssen-Bornemisza Collection, Castagnola,[3] that is identical to the Atheneum picture in detail and color (Fig. 24). A second version of the picture, painted, Baldinucci tells us, for the Empress Claudia Felice (1653–1676), is in the Kunsthistorisches Museum, Vienna.[4] It is identical to the Thyssen and Atheneum pictures with the exception of the pose of the left hand and the

Carlo Dolci, *Christ Child with Flowers*

Figure 24. Carlo Dolci, *Christ Child with Flowers*, Castagnola, Thyssen-Bornemisza Collection

omission of the orb surmounting the balustrade at the left. Numerous other versions of the Atheneum picture exist[5] and indicate the popularity of the image as a religious icon as well as a work of art.[6]

The Atheneum picture has generally been attributed to Dolci himself,[7] who frequently made versions of his pictures.[8]

In view of its close dependence on the Thyssen picture, the Atheneum painting may be one of the earlier versions of the composition and may date to the 1660s. J.C.

1. "He received two hundred for the Jesus at the age of about six years seated at the entrance to the garden in the pose that is used during the Sacred Hymns and with a garland of the most beautiful flowers in one hand, as if he were inviting the soul to crown itself with Christian virtues; and this too was sent to Venice. From this he made a similar one, which then in the year 1675 was sent to the Empress Claudia Felice, daughter of the Archduke Ferdinando Carlo and the Archduchess Anna dei Medici, which picture was placed in the empress's own room; and Carlo was given three hundred scudi" (Baldinucci, 1847, 350–51).
2. This information kindly supplied by C. McCorquodale, letter to J. Cadogan, 24 Mar. 1980, curatorial file.
3. Oil on canvas, 103 x 71 cm; dated upper left: 1663. See R. Heinemann et al., *Sammlung Thyssen-Bornemisza*, Castagnola, 1971, I, 114–15, no. 86, II, fig. 266.
4. Inv. no. F.8. Signed: *a.sts 1674, carolus de dulcis floren.* Inscribed: *veni coronaberis.* 96.5 x 76.5 cm. See Kunsthistorisches Museum, *Verzeichnis der Gemälde*, Vienna, 1973, 55–56.
5. These include one formerly in the collection of Robert Scholz-Forni, Hamburg, 98 x 76 cm (sale Cologne, M. Lempertz, 6 May 1953, no. 151; exhibited Wiesbaden, *Italienische Malerei des 17 und 18 Jahrhunderts*, 1935, no. 77); a version with Thos. Agnew & Sons, London, in 1956, 39½ x 31 in., signed *Carolus Dolcius Flori facbt.*, photo in curatorial file; and a smaller version of the composition on copper in the collection of Robert and Bertina Suida Manning, New York, illustrated in Princeton, 1980, 54–55, no. 19. Numerous other reduced versions of the composition, showing only the head and shoulders of the Christ Child, also exist; see, for example, a version in the Alte Pinakothek, Munich, *Katalog der Gemälde-Sammlung der Königlich Älteren Pinakothek zu München*, Munich, 1908, 257, no. 1225, repr.; Baldinucci, 1847, 351, further mentions other versions on wood. Many of these versions seem to have been executed by Dolci's workshop.
6. On Dolci's own attitude toward his pictures as votive offerings, see McCorquodale, 1973, 478.
7. The following scholars have attributed the Atheneum picture to Dolci: D. Mahon, oral communication, no date; E. Waterhouse, oral communication, 26 Mar. 1963; P. Rosenberg, oral communication, 3 Mar. 1971; J. Pope-Hennessy, oral communication, 1972; A. Brejon de Lavergnée, oral communication, 16 Mar. 1977; C. McCorquodale, letter to J. Cadogan, 24 Mar. 1980, curatorial file. Spike in Princeton, 1980, 54, suggests it is a copy.
8. Baldinucci, 1847, 410, says of this practice: "Dopo aver fatta una pittura, rifarne altre della stessa invenzione appunto: le quali però fece sempre con tanta diligenza, imitazione e buon gusto, che si debbono tutte tenere in conto di originali, e non copie." ("After having made a picture, he made others of the same design: which pictures, however, were made with such attention, detail, and good taste, that they should be taken as originals and not copies.") Further evidence for the attention Dolci lavished on later versions is the portrait study for the Munich version of the *Christ Child*, which exists in the Uffizi, inv. no. 1172F, black, red, and blue chalks on white paper, 20.9 x 14.2 cm. Inscribed upper left: *An S: T*, upper right: *1674*, lower left: *Luigi Gualtieri Ani 3*, lower right: *Io Carlo Dolci di Ani 58*; see McCorquodale, 1973, 480.

Domenico Zampieri, called Domenichino (1581–1641)

Domenico Zampieri was born in Bologna in 1581.[1] According to early biographers,[2] he studied conventional academic subjects before being apprenticed in the studio of Denys Calvaert, a Flemish painter resident in Bologna. He soon transferred to the studio of Ludovico Carracci, about 1595; details of his life before his move to Rome in 1602 are scant.

In Rome Domenichino lived with his Bolognese colleagues Francesco Albani and Guido Reni in the monastery of S. Prassede. He painted works for the Aldobrandini and participated in projects of Annibale Carracci's shop, such as the garden casino frescoes of the Farnese Palace. In addition to pictures dated 1603 (*Portrait of a Young Man*, *Christ at the Column*, *Susanna and the Elders*, and *Pietà*),[3] Domenichino painted the Farnese Loggia del Giardino. In 1603–4 Domenichino went to live in the house of the classical theorist G. B. Agucchi and his brother Girolamo, completing various projects for them and with the Carracci shop. In 1608 Domenichino started his first major fresco project, the decoration of the abbey church at Grottaferrata for Cardinal Odorado Farnese, completed in 1610. The *Flagellation of St. Andrew* in the oratory of S. Andrea at S. Gregorio Magno, where Domenichino worked alongside Guido Reni, dates to about 1609; his first large altarpiece, the influential *Last Communion of St. Jerome*, signed and dated 1614, was commissioned in 1611, and the frescoes of the life of St. Cecilia for the Polet Chapel in S. Luigi dei Francesi were commissioned in early 1612 and finished in 1615.

During the later 1610s, Domenichino was active outside Rome, at Fano (1617, 1619) and Frascati (1616–18). On the election of the Bolognese pope Gregory XV in 1621, Domenichino was recalled to Rome to become papal architect. In addition to smaller projects, he was commissioned in 1622 to fresco the choir and the pendentives of the dome of the church of S. Andrea della Valle, a project that was not completed until 1627. He worked here in direct competition with Giovanni Lanfranco, who frescoed an *Assumption* in the dome in striking illusionism recalling Correggio. In addition to numerous other commissions, the frescoes in the church of S. Silvestro al Quirinale date to about 1628, and his design for the portal of the Palazzo Lancellotti to the same time.

On 11 November 1630 Domenichino signed a contract for the decoration of the Cappella del Tesoro di S. Gennaro in the Duomo at Naples. Payments to him in Naples began in June 1631. Work in Naples was hampered by bad relations with his patrons and by the jealousy of local artists, and led to a temporary interruption in his stay, during 1634–35, when he was resident in Frascati and Rome. When he died on 6 April 1641, the chapel was still unfinished.

Domenichino's landscapes are an important but distinctly secondary aspect of his art. Like his mentor Annibale, who created the genre of the ideal landscape,[4] Domenichino painted relatively few landscapes, mostly for cultivated patrons, and all except the earliest ones contain religious or mythological subjects.[5] The chronology of the landscapes, as proposed by Spear, shows his style moving from Annibale's early Bolognese style to a personal interpretation of Annibale's heroic Roman landscapes. The Aldobrandini lunettes, designed about 1603–4 by Annibale for a chapel in the Aldobrandini Palace and painted by him and his workshop, would have been known to Domenichino and would have served as important models for his own landscapes. At the same time, Agucchi, with whom he was living at the time, may have influenced his ideas on landscape.

Domenichino's mature landscape style, as seen in works such as the *Landscape with Hercules and Achelous* and the *Landscape with Hercules and Cacus*, both in the Louvre and dated to about 1622–23 by Spear,[6] or the *Landscape with the Flight into Egypt*, also in the Louvre, from the late 1620s,[7] shows, in Spear's words, "an exalted conception of landscape and man's place in it that transcends the anecdotal, the rural, the rustic, or the pastoral by evoking an order in nature that is superior to reality."[8]

1. The following information is taken from Spear, 1982, to which the reader is referred for a complete account of Domenichino's life; see also Spear, 1989, 5–16.
2. Baglione, 1967, 381; Malvasia, 1967, II, 219.
3. Spear, 1982, I, 128–31, nos. 6–9.
4. Posner, *Carracci*, 1971, I, 113–22.
5. Spear, 1982, I, 79, 81.
6. Spear, 1982, I, nos. 82–83.
7. Spear, 1982, I, no. 96.
8. Spear, 1982, I, 81.

After Domenichino
Landscape with St. John Baptizing

Oil on canvas, 41 x 50.8 cm (16⅛ x 20 in.)

The painting was lined in the eighteenth or nineteenth century; the present stretcher was perhaps substituted for the original at that time.

Condition: good.

Provenance: possibly the "property of a French emigrant," sold in London, Hermon, 8 June 1814, no. 96, as *St. John Baptising Christ*; collection of Charles Butler, by descent to his grandson Patrick Butler, Warrenwood, Hatfield, England; Edward Speelman, London; Vitale Bloch, Paris; bought by the Wadsworth Atheneum in 1950 from Colnaghi & Co., London, for $704.15 from the Sumner Fund.

Exhibitions: Charlottesville, Va., Art Museum of the University of Virginia, *Pictures Jefferson Wanted*, 20–29 Oct. 1961; Kent, 1966; Hartford, 1982.

The Ella Gallup Sumner and Mary Catlin Sumner Collection, 1950.131

After Domenichino, *Landscape with St. John Baptizing*

Two other versions of the *Landscape with St. John Baptizing* exist. One, on copper, formerly in the Holford Collection,[1] has been confused with the Atheneum painting.[2] Another, on canvas, is in the collection of Pierre Rosenberg, Paris.[3] The Paris and ex-Holford versions differ from the Atheneum version in showing two trees at the left, rather than one as in the Atheneum picture, and in details of landscape and foliage.[4]

The Atheneum picture was traditionally attributed to Domenichino,[5] as was the ex-Holford version.[6] Spear has most recently attributed them and the Paris version to a copyist.[7] The handling of paint and the uneasy relationship of figures to landscape make Spear's suggestion most attractive. Alternative attributions to Agostino Tassi[8] and G. F. Grimaldi[9] must be advanced with reservation pending further elucidation of those artists' careers.

A date of about 1635–42 for the Atheneum picture was assigned by Cunningham.[10] Spear has noted the connection of the Atheneum composition with Domenichino's earlier landscapes, of about 1605, when he was living in the house of G. B. Agucchi and was profoundly influenced by Annibale Carracci's Aldobrandini lunettes, in particular the *Flight into Egypt*.[11] The handling of the paint, especially in the leaves, might point to a date in the eighteenth century for the Atheneum picture. J.C.

1. Spear, 1982, I, 315–16.
2. Borea, 1960, 9, fig. 10; 1965, 29, n. 26.
3. 39.3 x 58.4 cm.
4. The Atheneum picture has not been cut down; it preserves its original tacking edges.
5. Cunningham, 1950, 2; *Wadsworth Atheneum Handbook*, 1958, 65; Borea, 1960, 9; 1965, 29, n. 26.
6. Boschetto, 1948, 119, fig. 136.
7. R. E. Spear, review of Borea, 1965, in *Art Bulletin*, XLIX, 1967, 367; Spear, 1982, I, 316–17.
8. D. Stephen Pepper, oral communication, 25 May 1978.
9. C. Whitfield, letter to P. Marlow, 18 May 1978, curatorial file, and oral communication, 15 July 1980. Whitfield points to similarities in the Atheneum picture and a *Landscape with Bathers* in Boston (A. Murphy, *European Paintings in the Museum of Fine Arts, Boston*, Boston, 1985, 45, no. 42.490, as follower of Annibale Carracci), which he notes is a copy of a picture in the Pitti, the latter attributed by Chiarini to Agostino Carracci. Comparison of the Atheneum picture with four landscapes in the Borghese Gallery, whose provenance traces them back to Grimaldi himself (della Pergola, 1955, I, 48–49, nos. 75–76), while revealing points of similarity, also reveals important differences that do not allow an attribution of the Atheneum picture on that basis to Grimaldi.
10. Cunningham, 1950, 2.
11. Spear, 1982, I, 79–80, 138–40, 316. For the Aldobrandini lunettes, see Posner, *Carracci*, 1971, I, 121–22, II, 66–68, nos. 145–50.

Dosso Dossi
(c. 1490–c. 1542)

The father of Dosso Dossi was Niccolò de Lutero, who emigrated from Trent to Ferrarese territory.[1] No documentary evidence exists for the birth date of Dosso, but it is reasonable to assume a date of about 1490; his brother Battista, Dosso's helper, was probably born only a few years later.[2]

Vasari reported that Dosso had been trained by Lorenzo Costa,[3] but there is no documentary or stylistic evidence to support or refute his assertion. That Dosso was trained in Venice seems clear from his early works and is supported by literary evidence.[4] Battista's training in Rome, alleged by the same sources, is equally borne out by the style of his early work.[5] A Roman journey for Dosso is often posited.[6]

Dosso's first documented work dates to April of 1512, when he was paid for painting a picture in the palace of S. Sebastiano at Mantua.[7] His association with the Este court at Ferrara dates to at least 1514, when a long series of payments recorded in the Este account books for various activities begins.[8] The Este accounts also record Dosso's travels, to Venice in 1516, 1517, and 1518, and to Florence in 1517.

Dosso's first documented, extant painting is his altarpiece of the *Madonna and Child with Saints Roch, Lawrence, John the Baptist, Jerome, and Sebastian*, put in place in the Duomo of Modena on 18 June 1522.[9] Further dated, extant works include the frescoes, in collaboration with Battista, for Cardinal Bernardo di Clesio in the Castello del Buonconsiglio at Trent, documented to 1531–32;[10] the *Immaculate Conception* for the Duomo of Modena, formerly in Dresden, also a work of collaboration, of 1532;[11] and the *Nativity*, now in Modena, and the *St. Michael*, now in Parma, of 1533–34.[12] The frescoes in the Villa Imperiale, Pesaro, have also been thought to date from this time.[13] The dismembered *Dispute in the Temple* for the Duomo of Faenza, a work of collaboration, was completed by 1534,[14] while Battista's first documented solo work, the *Nativity* for the Duomo of Modena, dates to 1536.[15]

Starting in 1540 Dosso's activity for the Este court slowed considerably, and Battista assumed greater responsibility. The only extant paintings that can be linked with documents include the *St. Michael* and *St. George* of 1540 in Dresden.[16] In June 1541, Dosso accompanied Battista to Venice, and he made his will in the same year.[17] Thereafter, notice of him in the Este records ceases. He is presumed to have died shortly before the summer of 1542.[18]

Battista continued to work for the Este; from 1543 date tapestry cartoons, one of which may have served for a tapestry in the Louvre,[19] and in 1544 he painted the *Justice* and *Peace* now in Dresden.[20] By December 1545, Battista had died.

Dosso painted religious, mythological, and historical pictures, but he is particularly important as a proponent of the Giorgionesque, pastoral landscape. Although his work was not untouched by Central Italian ideals of the 1520s and 1530s, he adapted his essentially Venetian style to the special needs of a North Italian ducal court. His influence was broad, dominating Ferrarese painting for most of the sixteenth century, and his principal followers include his brother Battista, Girolamo da Carpi, and the Bolognese painter Biagio Pupini.

1. The name Dosso was associated with the father, Niccolò, but the current usage of the son's name, Dosso Dossi, has its origin in the eighteenth century. Contemporary sources refer to Dosso as Giovanni de Lutero. Whether Dosso was born in Ferrara or in the surrounding countryside is not known. For this and much biographical information, see Gibbons, 1968, 24–39 and 275–91; and Mezzetti, 1965, 57–69, for a detailed register of documents.
2. Gibbons, 1968, 25; Longhi, 1956, 80–81, 157–58.
3. Vasari, 1906, III, 139–40.
4. Dolce, 1968 ed., 93; Baruffaldi, 1846, I, 251. See Longhi, 1956, 80–86, for discussion of Dosso's early works; see also Gibbons, 1968, 115–20.
5. Gibbons, 1968, 124–26.
6. Mezzetti, 1965, 18.
7. Mezzetti, 1965, 57.
8. Mezzetti, 1965, 57–69.
9. Mezzetti, 1965, 60.
10. Mezzetti, 1965, 63–64.
11. Mezzetti, 1965, 64.
12. Mezzetti, 1965, 64.
13. Gibbons, 1968, 32–33. Mezzetti, 1965, 32–35, has proposed a date of 1529–30; the frescoes could also date to 1537–38; see Gibbons, 1968, 34–35.
14. Gibbons, 1968, 285, no. 129.
15. Mezzetti, 1965, 65.
16. Mezzetti, 1965, 66.
17. Mezzetti, 1965, 67.
18. Mezzetti, 1965, 68.
19. Gibbons, 1968, 37, 289, no. 191.
20. Mezzetti, 1965, 68.

The Battle of Orlando and Rodomonte

Oil on canvas, 81.8 x 135.7 cm (32 1/4 x 53 7/16 in.)

There is a vertical seam in the center right of the canvas. During a previous lining the canvas was restretched slightly askew. All edges have been trimmed; an old stretcher mark along the top edge suggests that it has been cut by a few inches.

Condition: good, with some retouchings in the figures and the armor.

Provenance: collection William Graham, London, by 1882,[1] sale London, Christie's, 10 Apr. 1886, lot 477, as on panel; possibly B. T. Clifford; earl of Brownlow, Belton House, Grantham, sale London, Christie's, 3 May 1929, no. 4, repr., as Battista; F. Howard; Thos. Agnew & Sons, London, 1931; Oskar Bondy, Vienna, 1933; sale New York, Kende Galleries, 3 Mar. 1949, no. 92, repr., as Dosso Dossi, sold $12,500. Bought by the Wadsworth Atheneum in 1949 from Kende Galleries through J. Weitzner for $12,500 from the Sumner Fund.

Exhibitions: London, Royal Academy, Burlington House, 1875, no. 162; London, Burlington Fine Arts Club, 1894, 18, no. 55, on panel, as Battista; London, Grafton Gallery, *A Catalogue of an Exhibition of Old Masters in Aid of the National Art-Collections Fund*, 1911, no. 30, pl. XXV, on canvas, as Battista; Hartford, 1931, 11, no. 9; Ferrara, Palazzo del Diamanti, *Catalogo della esposizione della pittura ferrarese del rinascimento*, 1933, 169, no. 207, fig. 30; Hartford, *In Retrospect*, 1949, 6, no. 1, repr.; Westport, *Italian Masters*, 1955, no. 16; Zurich, 1956, no. 91, fig. 14; New York, 1958, 37, repr.

The Ella Gallup Sumner and Mary Catlin Sumner Collection, 1949.81

The story of the battle between Orlando and Rodomonte is told in Canto 29 of *Orlando Furioso*, the epic poem by Ludovico Ariosto.[2] Rodomonte, the African king of Sarthia and Algiers, rejected by his love Doralice, quitted the Saracen camp for home, but decided to settle in a village on a river near Montpellier in the south of France. There he encountered Isabel, princess of Galicia, who, escorted by a monk, was taking the body of her slain lover Zerbin to Provence (28:81–102). Rodomonte fell in love with Isabel and tried to seduce her; but she, who had vowed to preserve her virtue, eluded him by a ruse, and he unwittingly killed her. Rodomonte, full of remorse, converted the chapel in which he was living into a tomb for Isabel by surrounding it with great stones. He had a tall tower built for himself nearby, and over the river he built a narrow bridge. He planned to adorn Isabel's tomb with spoils from knights who attempted to cross the bridge. He had already collected many trophies when mad Orlando, naked, arrived at the bridge. The two men engaged in battle and fell into the river below. Orlando swam quickly to shore and ran off, while Rodomonte, hampered by his armor, slowly made his way to land (29:1–49).

The Atheneum picture follows the poem closely. The chapel-tomb is seen in the middle distance, adorned with the armor of fallen knights. One of the shields is inscribed with the name of its owner, as related in the poem. The tower to the left is still under construction, although the sentry who alerted Rodomonte to the approach of a knight is in his perch. At the door to the tower, a moor holds a lance and a page the bridle of the horse that is still dripping wet from having tumbled with its master into the river. On the narrow bridge, Rodomonte, fully armed except for his visor, is locked in combat with the nude Orlando. In the distance a magnificent riverscape with a large town, perhaps Montpellier, is visible.

Francesco Scanelli described a painting in the ducal gallery of Modena:

> Vi sono Quadri con differenti historiati, alcuni con figure intere al naturale, altri di meze, e quantità di bellissime teste, e molti con figure picciole, con paesi, e Architettura . . . e ogni sorte di pensieri e bellissime inventioni di questi eccellenti Maestri, e fra più singolari sara facilment uno, che dimostra in picciolo con ogni esattezza il famoso combattimento, che suppone il Divino Ariosto facesse sopra il ponte Orlando con Rodomonte, e se l'uno lo descrisse con isquisitezza, l'altro l'ha dipinto in ecellenza, perche in questo Quadro vi è l'inventione tanta puntuale, e bene espressa in ordine alle figure, e ad ogni altra cosa, che verisimilmente potè succedere in un tal spettacolo, che meglio non resta a desiderarsi; sono i due Combattenti in atto più convenevole, e proprio per esprimere al ver la lor pugna; sotto al ponte appare l'acqua del fiume in largo spatio, e cosi ben riflessata, che mette terrore a riguardanti per l'apparente prossimo pericolo de' combattenti; appaiono all'intorno eccellentemente fatti e disposti con ordinatissima Prospettiva, belli

> edifici di bene osservata Architettura, e questi sono per ogni parte ripieni con varie capricciose inventioni di spettatori, e in un tal Quadro si può dire, e con ragione ritrorarsi oltre il bellissimo pensiero una rara dispositione, come quello, che dimostra adequatamente le debite distanze, e ciascheduna parte il proprio effetto, e contiene colle figure, Architettura, Prospettiva, Paese, e ogni maggior diligenza, e più bella compitezza, che sia in qualunque altro più eccellente del famoso Dosso, e al pari d'ogni più degno riguardevole vengono ad osservarsi diverse belle copie di questa straordinaria operatione in Ferrara, e una in particolare fra le virtuose curiosità del Cavaliere Gualdi nella Città di Roma, della quale sodisfacendosi come d'originale hebbe a dire dopo haver sentito l'essere del primo, che la disgratia del suo era il non ritrovarsi in luogo dell'altro; ma in effetto se in altre occasioni succede la differenza in riguardo della qualita de' possessori, riconoscerà però il buon intelligente, che nel presente caso, nemeno in questo singolarissima radunanza appaiono simile disordini, e quello, che deve decidee la vista no ha bisogno della dimostratione delle parole.[3]

It was later listed in the inventory of the prince Cesare Ignazio d'Este in 1685 as "un paese de' Dossi con l'istoria della lotta che fece sul ponte Rodomonte et Orlando, con cornice intagliata e dorata larga br. 4 1/2 alta br. 3 on. 8 circa."[4]

Although the Atheneum painting has been identified as the painting described by Scanelli,[5] it is more likely that it is one of the replicas of the Modena painting he noted in Ferrara and Rome.[6] The dimensions of the original, as listed in the 1685 inventory, would be about 228 x 303 cm; even if one allows that these dimensions may include the frame, and that the Atheneum picture has been cut at the top, the width of the Hartford picture, 135.7 centimeters, which seems close to its original dimensions, still falls considerably short of the original.[7]

Visual evidence also suggests that the Hartford picture is a replica of the painting cited in the inventory. The touch in certain areas, particularly the water and rocks at the right and the trees in the middle distance, seems dry and more pedantic than Dosso's usual style. Some scholars have for this reason ascribed the picture entirely to Battista.[8] The landscape in the Atheneum painting is also unusual in Dosso's oeuvre; it is in a steeper perspective and shows a more detailed rendering of buildings and foliage than usual. The landscape style suggests to other scholars that the Atheneum picture is a replica by a northern artist in the style of Patinir.[9] However, certain pictures in Dosso's oeuvre do show a conscious imitation of northern landscape examples, notably the *Landscape with Scenes of Saints* in Moscow, so that there is no reason to assume the landscape in

Dosso Dossi, *The Battle of Orlando and Rodomonte*

the Atheneum painting does not reflect an original design by Dosso.[10] Moreover, landscapes by Battista, such as the *Flight into Egypt* in Coral Gables, Florida, and the *Martyrdom of St. Stephen* in Hamburg, are not nearly so sweeping or atmospheric as that in the Atheneum painting, so that it is unlikely that the design of the Atheneum landscape is by Battista. It is possible that the Atheneum painting is a replica of the lost composition by Dosso formerly in the Palazzo Ducale, Modena, executed by a member of the Dosso shop. A recent cleaning has revealed numerous pentimenti, for example, in the entrance to the castle at the left, where a niche appears to have been painted out. Such changes in design, which are more than minor corrections, might point to the hand of Dosso himself in the evolution of the Atheneum picture, and to a more intimate connection between it and the lost Modena painting.[11]

The dating of the Atheneum painting has varied.[12] A dating in the 1530s is perhaps reasonable. J.C.

1. *Catalogue of Pictures, Ancient and Modern, 35 Grosvenor Place*, 1882, 11, no. 223, as a *Scene from Orlando Furioso*, on panel. On 29 of the same inventory it is noted that the picture was on loan to the South Kensington Museum.
2. First published Ferrara, 1516; 2nd ed. rev., Ferrara, 1521; 3rd ed. enl., Ferrara, 1532. For an English translation, see G. Waldman, London, 1974.
3. "There are pictures of different subjects, some with whole figures life size, others half size, and lots of beautiful heads, and many with small figures with landscapes and architecture . . . and all sorts of ideas and beautiful inventions of these excellent masters, and among the most singular is easily one, which shows in miniature with every detail the famous battle which the divine Ariosto imagines Roland and Rodomonte fought on the bridge; and if the one described it nobly, the other painted it excellently, because in this painting there is the most apt invention, expressed so well in the arrangement of the figures, and in all else, that one could wish for nothing better in the depiction of such a scene. The two combatants are in the most suitable poses to express their struggle vividly; below the bridge appears the

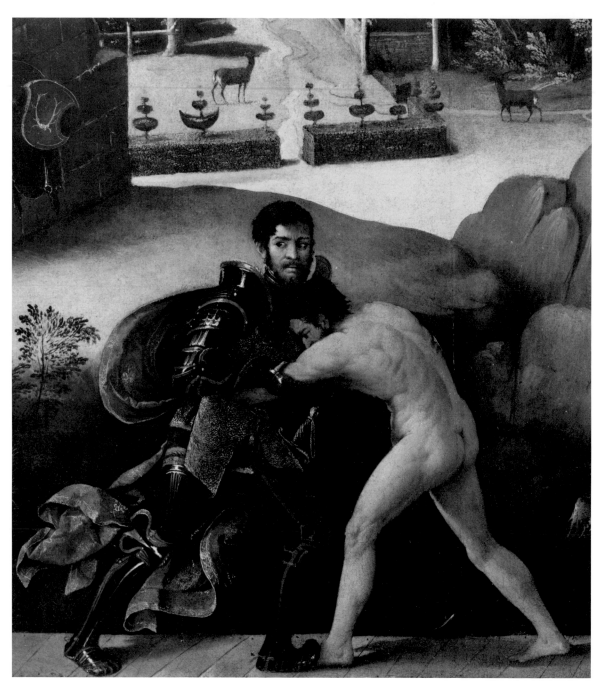

Dosso Dossi, *The Battle of Orlando and Rodomonte*, detail

water of the river in a vast space, and so well rendered that it terrifies the viewer on account of the imminent peril to the combatants; in the distance things are placed with ordered perspective, beautiful structures of well-observed architecture, and these are filled on every side with various fanciful inventions of the spectators, and in such a painting one can discover beyond the particular idea a rare arrangement, such as that which demonstrates the proper distances and each part its own effect, and contains with the figures, architecture, perspective, landscape the greatest care and accomplishment that exists in any other outstanding painting of the famous Dosso, and on a par with other worthy important works; there can be seen various copies of the extraordinary work in Ferrara, and one in particular among the precious curiosities of the Cavaliere Gualdi in the city of Rome, who, satisfied that his was the original, had occasion to say after hearing about the existence of the prime version, that the misfortune of his was its not having been found in the other's place. But if in other instances a difference indeed occurs with regard to quality among collectors, the good intelligent man however will acknowledge that in the present case, not even in this most singular gathering is there disagreement, and he who has to make a decision with regard to the appearance, has no need of words to support it" (Scanelli, 1657, 315–18). Professor Michael Campo of Trinity College has very kindly assisted in the translation of this passage. It was also mentioned by Baruffaldi, 1846, I, 280.
4. Published in Campori, 1870, 318. It was also described in a later inventory, before 1720, published in Venturi, 1882, 313, as "Orlando e Rodomonte in paese."
5. Gardner, 1911, 168, 235; Zurich, 1956, 36, no. 91.
6. Scanelli, 1657, 317–18.
7. Calculations of dimensions are based on Martini, 1883, 205, who lists a Ferrarese braccio as .673607 meters.
8. London, 1894, no. 55; Gardner, 1911, 168, 235; H. Mendelsohn, *Das Werk der Dossi*, Munich, 1914, 133–34 (as one of Battista's earliest works); C. Phillips, "An 'Adoration of the Magi' by Battista Dossi," *Burlington Magazine*, XXVII, 1915, 133–34; F. Antal, "Observations on Girolamo da Carpi," *Art Bulletin*, XXX, 1948, 87; Arslan, 1957, 261, n. 8. The painting is attributed to Dosso by the following: F. Harck, review of London, 1894, in *Repertorium für Kunstwissenschaft*, XVII, 1894, 315; Venturi, 1928, IX, pt. 3, 968, fig. 671; C. Cunningham, "Hartford Thrives on Baroque," *Artnews*, XLVIII, no. 3, May 1949, 28, repr.; Zurich, 1956, 35–36, no. 91; *Wadsworth Atheneum Handbook*, 1958, 37. The Atheneum picture is seen as a work of collaboration by the following: H. Bodmer, *Correggio und die Malerei der Emilia*, Vienna, 1942, xxxix, pl. 102, who attributes the figures to Dosso and the landscape to Battista; A. R. Turner, "Garofalo and a 'Capriccio alla fiamminga,'" *Paragone*, no. 181, 1965, 67, who ascribes the nude to Dosso, the castle and foreground landscape to Battista, and the landscape background to a third hand; Fredericksen and Zeri, 1972, 585, to a follower of Dosso; and P. Kaplan, "Titian's 'Laura Dianti' and the Origins of the Motif of the Black Page in Portraiture (2)," *Antichità viva*, XXI, no. 4, 1982, 13, to Dosso school.
9. R. Buscaroli, *La Pittura di paesaggio in Italia*, Bologna, 1935, 216; Longhi, 1956, 86–87, 120; Mezzetti, 1965, 91, no. 79; Gibbons, 1968, 182–83, no. 31.
10. Gibbons, 1968, 191–92, no. 47, figs. 71–72. Flemish landscapes were well represented in Ferrarese collections; see the listings of paintings by Henri met de Bles and Lucas van Leyden in Campori, 1870, 53, 62–63, 112, 115; see also Gibbons, 1968, 128–29, n. 10.
11. P. Humfrey in Washington, 1986–87, 121, no. 38, remarks on the presence of pentimenti in Dosso's work.
12. Arslan, 1957, 261, places it about 1522; *Wadsworth Atheneum Handbook*, 1958, opposite 36, about 1533; Gibbons, 1968, 128, about 1523.

Domenico Fetti
(1588/9–1623)

This Roman-born painter trained under Ludovico Cardi, Il Cigoli. Rubens's stylistic and compositional influence is seen in an early altarpiece in the Walters Art Gallery, Baltimore, circa 1614.[1] At just about that time Fetti had gone to Mantua as court painter to Duke Ferdinando Gonzaga and keeper of the ducal collections so rich in Venetian old masters, and where Rubens had been active in the first decade of the 1600s. Fetti's fame springs from his much admired and much imitated small religious pictures, particularly biblical scenes and parables, in type not unlike the Atheneum picture, which, however, deals with an early Christian martyrdom. In 1621 Fetti was sent to buy pictures in Venice, where he moved the following year and where he died of fever in 1623.[2]

1. Zeri, *Walters Art Gallery*, 1976, II, 439–41, no. 312, inv. no. 37.1027.
2. See Safarik, 1990, for a complete account.

Martyrdom of Saints Fermus and Rusticus

Oil on wood, 62.5 x 80.6 cm (24⅝ x 31¾ in.)
 The panel has been cradled.
 Condition: deteriorated. Much of the thinly worked paint in the foreground has become transparent and the ground shows through, for example, in the legs of the leftmost martyr. Behind the executioner, who grasps the latter's hair, are two barely visible heads, one of a bearded figure in a turban, the other a baldish man turned in three-quarter's view to the left. There are four angel's heads in the glory above. The underpainting is energetically scored with diagonal strokes in the landscape and architecture, although the latter as executed does not follow the design thus sketched in the wet paint. There are extensive retouches in the sky and adjustments to minimize the transparency of the faces on the right.
 Inscribed on the reverse in white chalk with the donor's Bremen address; in blue crayon: *1799*; in pencil: *48103*
 Provenance: possibly Stefano Ghisi Collection, Venice, by 1648; possibly Grassi Collection, Venice; possibly sold London, Prestage, 2–4 Feb. 1764 (see below). Acquired in Germany by Hans F. Wriedt, Bremen and later of Westport, Conn. Given to the Wadsworth Atheneum in 1955 by Hans F. Wriedt.[1]
 Gift of Hans F. Wriedt, 1955.151

The painting's iconography has been much discussed. Panofsky suggested it depicted the martyrdom of Saints Simon and Jude in Persia. The latter was said traditionally to have been killed with a club or a halberd, and although the method of Simon's execution is not recorded, fifteenth- and sixteenth-century iconographic usage had it that a saw was used, the fate of the leftmost martyr here. Simon and

Jude were executed for overthrowing pagan idols by the force of their prayers. Panofsky read the torso shape in the foreground to be a fragment of one such, but he was unable to explain the little boat in the lower left corner guided by angels.[2] Askew found in Ridolfi's 1648 account of Venetian art a reference to a painting by Fetti of the martyrdom of Saints Fermus and Rusticus in the Venetian collection of Stefano Ghisi,[3] and published the Atheneum picture under that title. Fermus and Rusticus were Roman patricians from Bergamo, martyred outside the walls of Verona after enduring many trials during the exactions imposed on rich Christians circa 303 by Emperor Maximian to sustain the imperial armies. The "torso" in the foreground would be a cuirass cast aside together with the swords as the noblemen are about to be executed. The two passengers in the boat guided by two angels, who had fed Fermus and Rusticus "delicious and aromatic" food during their imprisonment, may be an allusion to the moving of the saints' remains, which were finally enshrined in the Verona cathedral after 1610. Thus the cult of Rusticus and Fermus was a current topic in the second decade of the century in northern Italy. Askew notes that Fetti's patron, Ferdinando Gonzaga, a cardinal before he became duke of Mantua, was a man of "bigoted asceticism, busied in unearthing relics of saints. Fermus and Rusticus, venerated in Bergamo and Verona, were undoubtedly saints well-known to the Duke."[4]

Between 1613 and 1622, Fetti superintended the Gonzaga art collection while painter to the court in Mantua. In the apartment of Isabella d'Este there hung a set of his biblical parables, those remarkable and very individual series of paintings on which his fame rests, paintings that were often repeated by the artist himself or by his workshop. Therein biblical allegories were presented as small-scale genre scenes. Askew places the Atheneum picture in the stylistic context of the last such parables, executed after a trip from Mantua to Venice in July 1621, but before Fetti settled there in September 1622, only to die prematurely in 1623.[5]

Although Ridolfi's near contemporary allusion to a *Martyrdom of Saints Fermus and Rusticus* goes a long way to substantiate Askew's iconographic interpretation,[6] that does not mean the Atheneum picture automatically can be identified with that in Stefano Ghisi's collection, for not unexpectedly this is not a unique version of the theme. Michelini published another, on panel, formerly in the collection of Giulio Ferrario, Milan,[7] which she linked stylistically with the *Martyrdom of St. Agnes* in Dresden.[8] The Atheneum picture is very difficult to appreciate in black and white reproduction, where the composition seems awkward and the spatial effects amateurly realized. As both Askew and Michelini stress, the one speaking of the Atheneum version, the other of the former Milan version, it is the extraordinary color and movement of darks and lights that hold the pictures together and account for the great intensity, one could almost say the fervor of realization, especially in the Hartford picture,[9] even in its diminished condition. From

photographs, Askew thought the Milan version less forcefully composed and less finely painted than the Atheneum version.[10] For Lehmann the Atheneum picture is to be grouped with the Dresden *St. Agnes* and the Munich *Assumption* as workshop.[11] Pallucchini considers the Dresden and Atheneum pictures autograph works of the early 1620s.[12] Safarik's forthcoming Fetti monograph will argue that the Atheneum picture is one of a small group of autograph pictures, produced, he believes, late in the Mantuan years or in Venice, stylistically akin to the *Savior in the Heavens* in a New York private collection and the Dresden *St. Agnes*.[13] Like Askew, he finds the former Ferrario version inferior and assigns it with a number of other works to an imitator, perhaps a studio assistant, cogently pointing out variations in the Ferrario version that could be expected in an adaptation by another hand. For example, the devolution of the composition from right to left in the Ferrario version has been made more "reasonable" by rearranging some figures, thus minimizing Fetti's very individual composition, where clumps of intensely colored figures burst through the remarkable brown chiaroscuro atmosphere. Also, the hilltop town in the Atheneum's middle distance, an allusion to the fortress of S. Pietro, Verona,[14] and perhaps inserted intentionally for a particular patron, has been suppressed. Safarik sees in the Ferrario version a copyist inattentively working through the hands and sleeves of the rightmost martyr.[15] Finally, Safarik points out that in Bartolomeo dal Pozzo's 1718 guide to Verona there is one mention of a *Fermus and Rusticus* by Fetti still in the Ghisi Collection, Venice, and mention of another with many figures in the collection of Francesco Bonduri at S. Stefano, Verona.[16] The first could be a repetition of information cribbed, as was Pozzo's usage, from Ridolfi regarding the picture in the Ghisi Collection in 1648. There is thus no assurance that one is actually dealing with two objects, but there are strong indications such is the case. Safarik unearthed the sale in London on 2–4 February 1764 (two different versions of the catalogue give different lot numbers) of a *Fermus and Rusticus* whose cited provenance is the Ghisi Collection, Venice, and subsequently the Grassi Collection in the same city.[17] This he suggests is the Atheneum picture, while the Bonduri version might be that later in the Ferrario Collection.[18]　　　　　　　　　M.M.

1. C. Cunningham to C. Hofstede, 27 Jan. 1961, curatorial file: "Hans F. Wriedt . . . tells me that he received this picture in exchange for a painting by Courbet which he presented to the Kaiser Friedrich Museum. I believe the exchange took place in the 1920s." On inquiry, no such transaction was recalled either in the Staatlichen Museen or the Staatsgalerie, Berlin (I. Kühnel to the Atheneum, 10 Mar. 1961, curatorial file). Turner, 1955, 1, as *Martyrdom of Two Saints*, with the suggestion they might be Cosmas and Damian. *Wadsworth Atheneum Annual Report*, 1955, 15, 33. *Wadsworth Atheneum Handbook*, 1958, 58, as *Martyrdom of Two Saints*. Fredericksen and Zeri, 1972, 71, 394, 585, as Fermo and Rustico?

2. E. Panofsky to C. Cunningham, 13 Oct. 1955 and 4 May 1956, curatorial file.

Domenico Fetti, *Martyrdom of Saints Fermus and Rusticus*

3. P. Askew to C. Cunningham, 25 May 1957, curatorial file, citing Ridolfi, 1914–24, II, 131. Savini-Branca, 1965, 221.

4. Askew, *Burlington*, 1961, 249.

5. Askew, *Art Bulletin*, 1961, 21–25; *Burlington*, 1961, 246–47.

6. Coor, 1961, 396, rules out Simon and Thaddeus as the martyrs here.

7. Michelini, 1955, 136, fig. 149. Sold in Milan, Galleria Geri, May 1956, as on canvas, 60 x 50 [sic] cm for 680,000 lire. Reproduced in *Art Price Annual, 1955–1956*, II, London, Paris, Munich, 1956, 226. The dimensions, 60 x 50 cm, are clearly a misprint for 60 x 80 cm, as the picture is wider than it is high. Also, a photograph provided to the Atheneum by Comm. Ferrario bears the notation on the reverse "cm. 63 x 81." The picture came to Ferrario from Conte Foresti di Carpi and prior to that was presumably imported into Italy, as there are said to be customs stamps on the reverse (G. Ferrario to the Atheneum, 23 Apr. 1957, curatorial file). Subsequently, the picture was again sold: Milan, Finarte, 15–16 May 1962, no. 85, repr., as "tavola," 63 x 80 cm. Safarik points out that this is the first accurate description of the support, and in fact a horizontal wood split is visible in photographs in the upper left (E. Safarik verbally to M. Mahoney, 12 July 1983).

8. Michelini, 1955, 133, fig. 147.

9. Askew, *Burlington*, 1961, 246–48. Michelini, 1955, 136, and De Logu, 1958, 276, shared Michelini's high opinion of the Ferrario version.

10. Askew, *Burlington*, 1961, 249.

11. Lehmann, 1967, Hartford, 228, no. 47; Dresden (inv. no. 420), 223–24, no. 27; Munich (inv. no. 9340), 233–34, no. 73. The Dresden and Munich pictures are reproduced by Michelini, 1955, 133, 137, figs. 147, 150.

12. Pallucchini, 1981, I, 139, II, 600, pl. 388.

13. E. Safarik, again verbally to M. Mahoney, 12 July 1983, maintains that because the *St. Agnes* is the only known treatment of the theme, it must be identifiable with the picture of that subject cited in a letter written from Venice by Antonio Padera to Conte Gambara on 24 Feb. 1624 [or 1623, for at that very moment Venetian calendar style "1624" was switching to the wider Italian usage "1623"]. The same letter mentions a *Savior in the Heavens*, which could be the picture in the New York collection.

14. Askew, *Burlington*, 1961, 251, first thought the town to be a picturesque adaptation of Montagnana between Verona and Modena. C. Perina, who dates the Atheneum picture after 1621, suggested it was the town of Soave, near Verona (Marani and Perina, 1965, 462, 501, n. 194, pl. 308). It was S. Marinelli who proposed it depicted the Veronese fortress as it then appeared (*Il Seicento . . . a Mantova*, 1985, 75, 82, nn. 11–13).

15. E. Safarik verbally to M. Mahoney, 12 July 1983.
16. B. dal Pozzo, *Le Vite de' pittori, degli scultori, et architetti veronesi*, Verona, 1718, I, 127, "il martirio de' S.S. Fermo, e Rustico del Fetti"; 290, "il martirio de' S.S. Fermo, e Rustico copioso di figure, con gloria d'Angeli . . . del Fetis."
17. London, Prestage, 4 Feb. 1764, general cat. no. 33, sale cat. no. 23, "The Martyrdom of the Saints *Rustico* and *Fermo*, a fine picture described by *Ridolfi*, vol. I, 159. *Grassi* Collection," 26 x 32 in.
18. E. Safarik verbally to M. Mahoney, 12 July 1983 and 27 May 1987. Professor Safarik has generously shared his opinions regarding the Atheneum picture prior to publishing his findings; see Safarik, 1990, 207–12, no. 88.

Girolamo Forabosco (1604/5–1679)

Girolamo Forabosco was born in Venice in 1605; he died 23 January 1679 at the age of seventy-four.[1] He was almost certainly trained by Padovanino in Venice during the 1620s; the portrait of a woman, the so-called Menichina in the Galleria Nazionale d'Arte Antica in Rome, is inscribed 1624 and shows the imprint of Padovanino's style.[2] From 1634 to 1639 he is listed in the *Fraglia dei pittori* in Venice and in the *Tansa* in 1640, 1641, and 1644.[3] By 1653 Forabosco was working in Padua, where he had a workshop;[4] he continued to paint in Venice, however, and retained a workshop there.[4] In 1654 he executed an altarpiece for the chapel of S. Giusto in the patriarchal palace in the Castello section of the city, commissioned by Federico Cornaro, patriarch of Venice.[5] The portraits of Doge Carlo Contarini and his wife date to 1655–56.[6] Two altarpieces for the church of S. Nicolò dei Tolentini in Venice are generally dated between 1654 and 1660, when Boschini mentions them.[7] The huge canvas of the *Miraculous Rescue of a Family from a Shipwreck* in the parish church of Malamocco was painted in 1646.[8]

Although few reference points exist for assembling and dating Forabosco's oeuvre, the contours of his career have emerged through the research of modern scholars. After his initial training with Padovanino, Forabosco seems to have been influenced by Bernardo Strozzi, active in Venice after 1630, and perhaps, later in the 1650s, by the Bolognese Guido Cagnacci. The high quality of his portraits in particular, and his historical position as one of the renovators of the Venetian seventeenth-century school have been widely acknowledged.[9]

1. G. Fiocco, "Girolamo Forabosco ritrattista," *Belvedere*, IX, 1926, 24–28; Moretti, 1986, 224.
2. Safarik, 1983, 264, n. 3, reads the inscription as 1624, while Pallucchini, 1981, I, 180–81, had read it as 1626 or 1627.
3. E. Favaro, *L'Arte dei pittori in Venezia e i suoi statuiti*, Florence, 1975, 148, 161, 164–65, 173, 175, 191.
4. Pallucchini, 1981, I, 180; Moretti, 1986, 224.
5. F. Sansovino, *Venetia città nobilissima et singolare*, ed. G. Martinioni, Venice, 1663, 19.
6. A. de Pace, "Il Ritrovamento di due ritratti dogali del Forabosco," *Arte veneta*, XVI, 1962, 168–71.
7. Boschini, 1966, 544.
8. Vio, 1984, 202.
9. Pallucchini, 1981, I, 185; Safarik, 1983, 255–56.

Lot and His Daughters

Oil on canvas, 122.3 x 138.4 cm (48¼ x 54½ in.)
Condition: fair. There are scattered areas of retouching and an area of damage in the trousers of Lot.
There is an illegible red wax seal on the reverse of the stretcher.
Provenance: von Savigny Collection, Tragas, Gelnhausen, Germany, 1926; Paul Porzelt, New York. Given to the Wadsworth Atheneum in 1953 by Paul Porzelt.
Gift of Paul Porzelt, 1953.214

The story of Lot and his daughters is told in Genesis 19:30–38. After the destruction of Sodom and Gomorrah, Lot and his daughters took refuge in a cave. Believing themselves to be the only survivors, Lot's daughters made their father drunk and lay with him in turn to ensure the family's survival. They each produced sons, Moab, leader of the Moabites, and Benammi, leader of the Ammonites.

The picture was first published by Voss[1] as Forabosco, an attribution that has not been disputed.[2] Pallucchini dates the picture early in Forabosco's career, to between 1625 and 1630.[3] However, the animated brushwork, particularly in the drapery and hair of the figures, and the striking Strozzi-like face of the standing daughter might suggest a dating in the early 1630s.

J.C.

1. H. Voss, "Zum Werk des Girolamo Forabosco," *Belvedere*, IX–X, 1926, 184, fig. 5.
2. A letter from Paul Porzelt to C. Cunningham, 23 Nov. 1953, curatorial file, transcribes letters from H. Voss dated 26 July 1951, and Hans Tietze dated 1 Nov. 1952, confirming the attribution of the painting to Forabosco. Only F. Heinemann, oral communication, 17 Sept. 1974, questioned the attribution to Forabosco, suggesting an attribution to the Venetian school.
3. Pallucchini, 1981, I, 181.

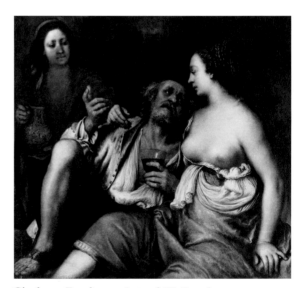

Girolamo Forabosco, *Lot and His Daughters*

Francesco Francia
(c. 1450–1517)

Son of Marco di Giacomo Raibolini, Francia was born in Bologna about 1450.[1] He matriculated in the goldsmiths' guild on 10 December 1482,[2] although a document of 1479 mentions him already as a goldsmith.[3] His surname may derive from his teacher in that art, a Frenchman referred to as "Franze" in a document of 1484;[4] his name may also derive from a variation of Francesco.[5]

Francia's activity as a goldsmith is well documented and suggests that he was very successful in the art; however, the only works surviving that can reasonably be attributed to him are two niello paxes in the Pinacoteca in Bologna, one showing the *Crucifixion* and the other the *Resurrection*.[6] Prints from niello plates can also be attributed to the master and attest to his role in the early history of engraving in Bologna.[7] He also made coins for the ruling Bentivoglio, of which one with the portrait of Giovanni II Bentivoglio survives;[8] later he was made master of the mint by Julius II.[9]

Francia appears to have become a painter somewhat later in life. He matriculated in the painters' guild only in 1503,[10] although he was listed as a painter in the register of the goldsmiths' guild in 1486 and praised in a poem by Angelo Salimbeni in the following year.[11] It is not known who his master was, although pictures that have been identified as from the 1480s, including a *Madonna and Child with St. Joseph* in the Gemäldegalerie, Berlin,[12] and the portrait of Bartolommeo Bianchini in the National Gallery, London,[13] reveal, in addition to his practice as a goldsmith, the influence of Ferrarese masters such as Ercole de' Roberti and Francesco del Cossa, the latter of whom was resident in Bologna in the mid 1470s. In the 1490s begin a series of documented or dated altarpieces that continues up until Francia's death, the most notable of which includes the Bentivoglio altar of 1499 for Giovanni Bentivoglio's chapel in S. Giacomo Maggiore. Francia's later works show the influence of Lorenzo Costa, with whom he is known to have collaborated,[14] and of Pietro Perugino.

1. His birth date is derived from a document of 1483, in which he is elected as a guild official, the minimum age for which was thirty; see Gronau, 1916, XII, 319. Vasari, 1906, III, 533, says Francia was born in 1450. See also Bologna, 1988, 358–60.
2. Orioli, 1892, 133–34, doc. 1.
3. Malaguzzi Valeri, 1896, 84, n. 3.
4. Gardner, 1911, 76.
5. Malaguzzi Valeri, 1896, 84, n. 2.
6. Bologna, 1987, 78–79, nos. 113–14; Bologna, 1988, 348–49, nos. 139–40.
7. A. M. Hind, *A History of Engraving and Etching*, New York, 1963, 68–69; Washington, National Gallery of Art, *Early Italian Engravings from the National Gallery of Art*, 1973, 534–42, nos. B-2–B-12; Bologna, 1988, 323–28.
8. Gronau, 1916, 320; Bologna, 1988, 341–44.
9. Williamson, 1901, 126; Lipparini, 1913, 11.
10. Orioli, 1892, 134, doc. 2.
11. Gardner, 1911, 78; Lipparini, 1913, 10.
12. Inv. no. 125.
13. Inv. no. 2487.
14. See, for example, the *Adoration* in the Bologna Pinacoteca, painted for Anton Galeazzo Bentivoglio, formerly in the church of the Misericordia in Bologna, for which Costa painted the predella, now in the Pinacoteca di Brera, Milan (Bologna, 1987, 81–82, no. 118).

Workshop of Francesco Francia
Madonna and Child with St. Francis

Tempera and oil on panel, 59.2 x 46 cm (23³/₈ x 18¹/₈ in.)
The panel has been cradled. The left edge has been trimmed slightly.
Condition: fair. There is scattered inpainting, especially along a center vertical crack and at the top edge.
A label on the verso reads: 120. The Holy Virgin F. Francia.
Provenance: collection Stanley Mortimer, New York, sale New York, Parke-Bernet Galleries, 2 Dec. 1944, no. 75, repr.; Mrs. T. W. Inglis-Jones, New York; given to the Wadsworth Atheneum in 1960 by Mrs. T. W. Inglis-Jones.
Gift of Mrs. T. W. Inglis-Jones, 1960.259

Pictures of the Madonna and Child before a parapet, with or without accompanying saints, were produced in large numbers in the Francia workshop.[1] At least one other version of the Atheneum picture, without the St. Francis, is known.[2]

While the Atheneum picture is characteristic of Francia's style and faithful to his design, it does not show the fineness of the master's touch, visible in such works as the signed and dated *Gambaro Madonna* of 1495.[3] The Atheneum panel should be attributed to an anonymous member of Francia's shop.[4]

The painting would appear to date from Francia's later career, after 1505.[5] J.C.

1. Vasari, 1906, III, 545, mentions the large number of his works in the homes of Bolognese families.
2. Formerly collection Marcel Cottreau, Paris (sale Paris, Galerie G. Petit, 12 June 1919, no. 10, repr.); this is probably the picture formerly in Leningrad in the collection of Count Bloudoff, illustrated in Venturi, 1914, VII, pt. iii, 941, fig. 698.
3. Seymour, 1970, 220–22, no. 165.
4. The painting was attributed to Francia by Berenson, 1968, I, 148, III, pl. 1612; and to school of Francia by Fredericksen and Zeri, 1972, 585. It was attributed to one of Francia's sons by F. Heinemann, oral communication, 17 Sept. 1974.
5. Berenson, 1968, I, 148, calls the Atheneum picture a late work.

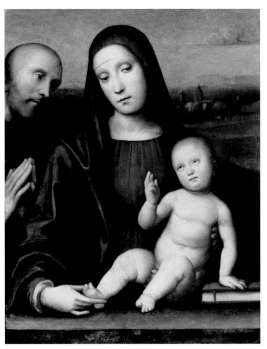

Workshop of Francesco Francia, *Madonna and Child with St. Francis*

Bernardino Fungai
(1460–c. 1516)

Bernardino Cristofano di Niccolò d'Antonio di Pietro da Fungaia was baptized on 14 September 1460.[1] His family came from Fungai, near Siena, and he himself passed an uneventful life in and around Siena. The latest documentary reference to him is in April of 1516, and he is presumed to have died shortly thereafter.

The earliest evidence of his career as an artist is a payment of 28 June 1482, to Benvenuto di Giovanni and his *garzone* Bernardino Fonghai for painting in grisaille figures of prophets in the tribune of the Duomo in Siena.[2] A book cover in the Archivio di Stato, Siena, showing the *Sacrifice of Isaac*, is dated 1485 and has been attributed to Fungai by several scholars,[3] although the style of this work shows the influence of Francesco di Giorgio rather than Benvenuto.[4] The central panel of the *Stigmatization of St. Catherine of Siena* in the Oratorio di Sta. Caterina in Fontebanda is documented to 1496–97 and is generally attributed to Fungai,[5] while the *Coronation of the Virgin with Saints and Angels* in the church of Sta. Maria dei Servi in Siena is documented to 1498–1501.[6] Bernardino's last securely datable work is the signed altarpiece dated 1512 of the *Coronation of the Virgin with Saints Jerome, Sebastian, Anthony of Padua, and Nicholas* from the church of S. Niccolò al Carmine, now in the Pinacoteca in Siena.[7] Another late work, the *Assumption of the Virgin*, also in the Siena Pinacoteca, can be attributed to him on the basis of style.[8] His narrative panels in Leningrad, Moscow, and Houston illustrating scenes from ancient history show another side of his art.

The above works show that Fungai, while conscious of Sienese precedents, was profoundly influenced by Umbrian painters. The *Stigmatization of St. Catherine* shows the clear mark of Signorelli, whose work in the abbey of Monte Oliveto Maggiore dates from 1497 and whose altarpiece of the *Assumption* for S. Agostino in Siena dates to 1498. The *Coronation* suggests knowledge of Ghirlandaio's panel of the same subject at Narni, or rather perhaps Umbrian reflections of it, such as Spagna's copy of 1511 at Todi, and the late *Coronation* evokes works by Perugino, such as the *Crucifixion* in S. Agostino of 1502–6, and by Pinturicchio, active in the Piccolomini library between 1503 and 1506.

1. Bacci, 1947, 27–28, transcribes the document in full.
2. Bacci, 1947, 12.
3. Bacci, 1947, 14; Berenson, 1968, I, 151.
4. Brandi, 1949, 162; L. Kanter in New York, 1988–89, 352, attributes this to an anonymous master who painted tabernacle no. 571 in the Siena Pinacoteca.
5. Bacci, 1947, 50–55, publishes the documents for the panel and later alterations; see Brandi, 1949, 238, n. 130, who argues for Fungai's authorship of the lateral saints and parts of the predella.
6. Bacci, 1947, 89–94, publishes the documents; see also L. Kanter in New York, 1988–89, 353–58, no. 76.
7. Torriti, 1978, 64–66.
8. Torriti, 1978, 72–73.

The Nativity

Tempera and oil on panel, 77.8 x 55.8 cm (30 11/16 x 21 3/16 in.)

The panel has been cradled. The right edge has been trimmed slightly.

Condition: good. There are retouches overall, especially in the Virgin's robe and in the landscape and along the center vertical. The gilding, with the exception of the star on the Virgin's shoulder, is original though worn.

Labels on the verso, lower left: P 56 Bernardino Fungai 53; and in the center: 8. 20. 1.

Provenance: Philip Lehman Collection, New York, by 1928; Robert Lehman Collection, New York, before 1962; given to the Wadsworth Atheneum in 1962 by the Robert Lehman Art Foundation.

Exhibitions: Cambridge, Mass., Fogg Art Museum, 1931, no cat.; New York, Metropolitan Museum of Art, June–Nov. 1944, no cat.; New York, New School, Feb.–Mar. 1946, no cat.; Cincinnati, 1959, 16, no. 57.

Gift of the Robert Lehman Art Foundation, 1962.445

The *Nativity* is one of a number of paintings of the same subject painted by Fungai.[1] The large *Nativity with Saints Vincent and Jerome* in S. Secondiano, Chiusi, shows the same general arrangement of figures and correspondence of certain motifs, such as some of the putti accompanying God the Father.[2] Closer to the Atheneum painting is the *Nativity*, formerly in the collection of the earl of Haddington, which shows the motif of God the Father identical to that of the Atheneum painting.[3] Figures in the painting formerly in the collection of Robin Combe show similarities in drapery and facial types to those in the Atheneum painting,[4] while the motif of God the Father and angels now in the Lindenau Museum, Altenburg, which may have been part of the Combe painting, is identical to that of the Atheneum painting.[5] The *Nativity* in the Metropolitan Museum of Art, New York, shows a similar disposition of figures and similar, though not identical motifs, such as the Christ Child and the shepherds arriving in the background.[6]

The composition of the *Nativity* derives from Sienese paintings of the 1470s, such as the *Nativity* by Girolamo da Cremona in the Yale University Art Gallery[7] and the *Nativity* by Francesco di Giorgio, the central part of which is in the Metropolitan Museum.[8] The landscape and the figure types, however, show the influence of Umbrian painters, especially Pinturicchio. The peculiar rock formations are found in Umbrian rather than Sienese painting, while the spacious valley recalls the landscape backgrounds of Perugino.[9]

The *Nativity* would appear to date from about 1500, based on analogies of figure type and landscape with works from the late 1490s, such as the *Stigmatization of St. Catherine* in Fontebanda, and the *Coronation of the Virgin* in Sta. Maria dei Servi, Siena.

J.C.

1. The Atheneum painting has been attributed to Fungai by Lehman, 1928, pl. LVI; van Marle, 1937, XVI, 484; Berenson, 1968, I, 150; Fredericksen and Zeri, 1972, 585.
2. Illustrated in Berenson, 1968, II, pl. 933.
3. Sale London, Sotheby's, 8 Dec. 1971, no. 35, as Bernardino Fungai.
4. Sale London, Sotheby's, 28 Nov. 1962, no. 68, as Giacomo Pacchiarotto.
5. Zeri, 1980, 14.
6. Zeri, 1980, 14.
7. Seymour, 1970, 214, no. 160.
8. Zeri, 1980, 12.
9. Brandi, 1949, 163.

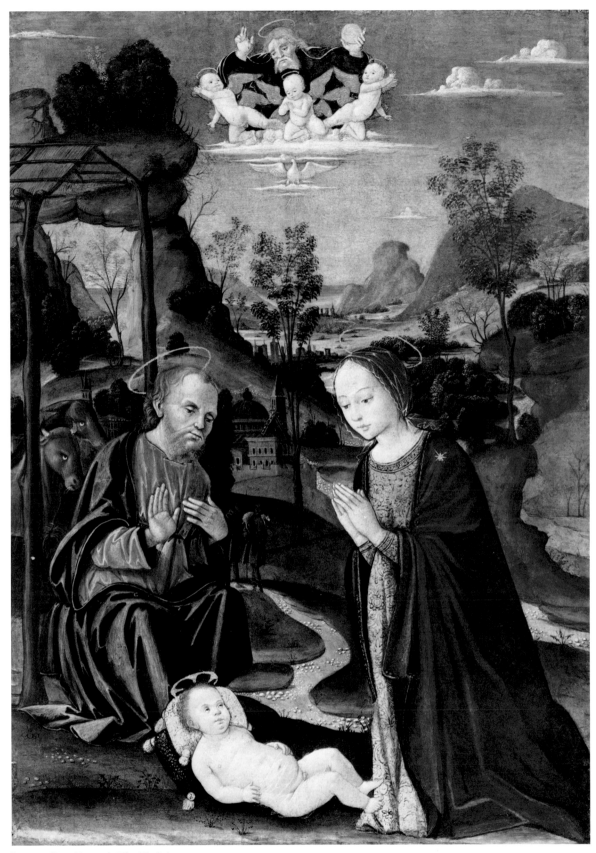

Bernardino Fungai, *The Nativity*

Orazio Gentileschi
(1563–1639)

Born in Pisa, Orazio Lomi, the son of a goldsmith and the brother of the painter Aurelio Lomi, moved to Rome in 1576–78. He lived there with a maternal uncle from whom he took the name Gentileschi. The late Roman mannerist style of his early surviving works of the 1590s was supplanted about 1600 by the impact of Caravaggio, whom Gentileschi knew. Caravaggio's potent influence, which reached its peak from 1605 to 1613, is amply demonstrated by the Atheneum's *Judith with the Head of Holofernes*. Yet even therein are elements revealing the elegance of Gentileschi's Tuscan and Roman mannerist beginnings. His work thereafter displayed an increasingly refined sensibility quite distinct from Caravaggio's. Adam Elsheimer's small paintings on copper were a formative influence as well, and he collaborated with Agostino Tassi on Roman fresco commissions during the second decade of the century. He probably visited Florence between 1615 and 1616. From 1621 to 1624, he was working in Genoa and had contacts with the court in Turin. In 1624 he went to Paris at the request of Marie de' Medici. Finally, from 1625 until his death, he was a court painter in England to Charles I.[1]

1. New York, 1985, 148.

Judith and Her Maidservant with the Head of Holofernes

Oil on canvas, 136.5 x 159 cm (53¾ x 62⅝ in.)

The picture surface is composed of four canvas segments: a strip at the left approximately 13 centimeters wide; a strip at the top approximately 13 centimeters high; and the core made up of two large segments, the right side 48–49 centimeters wide, the left side 97–98 centimeters wide.

Condition: good, with some localized scorching in the background. The shadows in the servant's blue overgarment have broken down.

Provenance: probably Carlo Cambiaso, Palazzo Brignole, Genoa; Sir Hugh Cholmeley. Purchased by the Wadsworth Atheneum in 1949 from the Koetser Gallery, New York, for $12,500 from the Sumner Fund.

Exhibitions: Hartford, *In Retrospect*, 1949, no. 8; Poughkeepsie, 1956; New York, M. Knoedler & Co., 1958, 63; Detroit, 1965, no. 6; Cleveland, 1971–72, no. 30; Worcester, 1972, no. 12.

The Ella Gallup Sumner and Mary Catlin Sumner Collection, 1949.52

This interpretation of the climactic moments of the Judith story is intensely cogitated. In the dark of the night, in his tent, stupefied by wine, Holofernes has been decapitated with his own sword wielded by Judith. She passes her trophy to her servant in the basket in which, one can presume, she had shortly before carried her purified food to the Assyrian's otherwise impure and lecherous feast—pharisaical correctness of observance being a principal element of the Judith story. Thus Israel is saved from Nebuchadnezzar's army, and thus, too, is fulfilled the apocryphal book's earlier assertion Israel could be conquered only "if there is error in this people, and if they sin against their God."[1] The maidservant agitatedly grasps the basket and glances frowningly into the strong source of light, seemingly apprehensive of discovery from without. The heroine does not share her companion's apprehension; rather she is immobile and rapt, staring upward, as resolute now as at the moment when she beheaded the Assyrian general-in-chief, when she prayed, "O Lord God of all power, look in this hour upon the works of my hands for the exaltation of Jerusalem."[2]

It could be argued that the concentrated effect of the triangular composition, so appropriate to the intensity and stealth of the narrative moment, has been vitiated by strips added to the left side (about 13 cm wide) and to the top of the canvas (about 13 cm high). This can best be seen by comparison with a less well-preserved version of the composition without such additions in the Vatican (Fig. 25),[3] first published as by Orazio,[4] thereafter questioned,[5] but more recently thought to be conceivably an autograph replica, perhaps of lesser quality than the Atheneum picture.[6] A third version, with proportions akin to the Vatican composition, belonged to Ugo Jandolo and was said to be a copy. It dropped out of sight in the 1920s.[7] In 1958 Sterling saw an unpublished, otherwise untraced, and perhaps fourth version in Paris, presumably not the Jandolo painting, for he described it as "a good, exact (and same size) 17th-century copy" of the Hartford picture.[8] If his report of the measurements, as well as his observation regarding the antiquity of this seemingly fourth version are each correct, then the strips on two sides of the canvas here, if not autograph, must be additions of a certain age. Bissell believes they are not

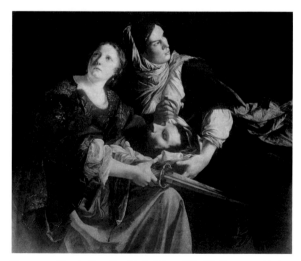

Figure 25. Orazio Gentileschi, *Judith and Her Maidservant with the Head of Holofernes*, Vatican, Pinacoteca

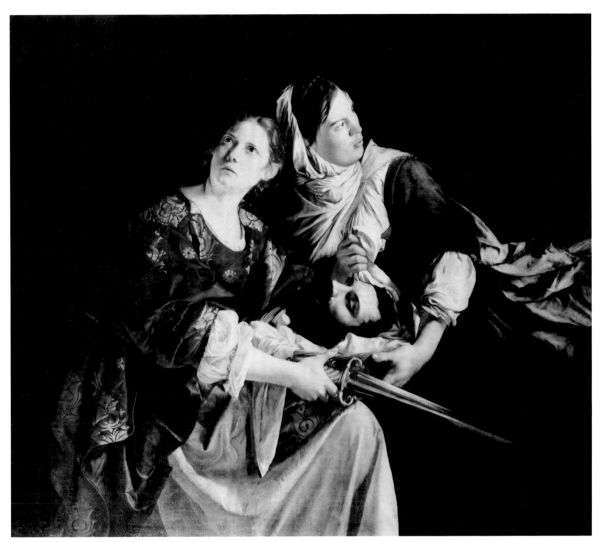

Orazio Gentileschi, *Judith and Her Maidservant with the Head of Holofernes*

original,[9] but caution must be exercised in discounting the possibility they reflect the artist's intention or adjustment. Schleier points out that Orazio's *Crowning with Thorns* in Brunswick—incontrovertibly intact because stretcher marks are preserved on all four edges—was repeated in what Schleier considers to be an autograph replica in a Genoese private collection with a taller format and with more space allowed the eloquently cramped figures both at the top and at the sides.[10] The same author further remarks the *David Contemplating the Head of Goliath* in the Galleria Spada, Rome, has four strips conspicuously added to the original canvas, which itself is apparently made of two joined pieces, like the Atheneum picture, as are the Cleveland *Danae* and the Berlin *Lot and His Daughters* as well. On the lateral strips in the Spada picture Orazio, according to Schleier, enlarged his acutely concentrated initial composition.[11] If Schleier is correct that all these works are autograph, then it is reasonable to conclude Orazio was not averse to enlarging a composition, even at the price of diluting his conception.

The Vatican version, even making allowances for its poor condition,[12] looks clearly to be a studio version. For example, Judith's forearm has been shortened, the drapery seems less crisp insofar as one can assess it in its present state, and the conception as well as the execution of the faces are inferior to the Atheneum's. Judith's features are conventionalized, whereas those in Hartford are so particularized it has been suggested the Hartford Judith is a portrait of Orazio's daughter, Artemisia (see below). However, the Vatican version shows one dramatic intensification that has been so minimized in the Hartford picture as to be almost unnoticeable—be it owing to abrasion or to squeamishly cosmetic removal: the women's arms and garments are liberally splashed with bloody gore.

The provenance of the Hartford painting is tangled, not least by the fact that this was a favored theme both for Orazio and Artemisia, each of whom painted it at least five times.[13] Speaking of the third, the Jandolo version, Voss described it in 1925 as a copy of a painting executed in Genoa and formerly in the palace of Pietro Gentile there.[14] In publishing the superior Vatican version in 1939, Redig de Campos understandably suggested that the Gentile provenance could well be attached to that work.[15] In turn, when the Hartford painting appeared in 1949,[16] Voss assigned it the Genoese provenance from the Gentile Collection.[17] A Genoese provenance is further suggested by van Dyck's drawing after the composition in his Italian sketchbook, the greater portion of which we assume to be the product of his stays in Genoa during his 1621–27 Italian sojourn.[18]

Bissell was the first to point out that Ratti's 1780 Genoese guide mentions not only a *Judith and Servant* by "Gentileschi" in Pietro Gentile's palace, but another *Judith* by "Gentileschi" in the collection of Carlo Cambiaso in the Brignole Palace. Carlo Cambiaso's *Judith* hung in the same room with a half-length figure of a woman playing a violin also by "Gentileschi." Bissell identifies the Cambiaso *Judith* with the Hartford picture and the Cambiaso *Woman Playing a Violin* with the picture now in Detroit.[19] As the Detroit picture is linked circumstantially to the Cambiaso Collection—it was auctioned in London in 1807 as a *St. Cecilia* (attributed to Artemisia Gentileschi), with a provenance from an otherwise unspecified "Cambiaso Palace"—and as, in turn, the same picture is related thematically to the Hartford picture—the principal figure in each being taken from the same model[20]—the proposed Carlo Cambiaso provenance for both seems to be a cogent suggestion.[21]

The Carlo Cambiaso in question might be one of the two elder brothers of Doge Michelangelo Cambiaso (1738–1813), and both the Detroit and Hartford pictures conceivably left Genoa during the dislocations attendant on the republic's relations with revolutionary France and then with Napoleon, in which Doge Michelangelo figured prominently.[22]

An expected corollary of the proposed Genoese provenance is that the Hartford and, by extension, the Detroit paintings were executed by Orazio when he was in Genoa in 1621–24 on his way north.[23] However, current opinion generally finds both paintings to be Roman works executed about 1610–15.[24] Clearly the conception, lighting, and format[25] of the Atheneum picture derive from Caravaggio, but in certain aspects, Caravaggio's influence at its most potent has been tempered, as is readily seen when the Atheneum's picture is compared to the recently discovered, very Caravaggesque treatment of the same theme from Palazzo Capranica, Rome, datable before 1612. Whitfield and Banks suggest this perhaps could be the *Judith* figuring in Orazio's 1612 accusations against Agostino Tassi.[26] In fact, so marked is the contrast between these two pictures that Pepper, who accepts the Capranica painting as that figuring in the 1612 litigation and who assigns it a germinal role in the formation of the work of Artemisia Gentileschi, cannot accept Bissell's view that the Atheneum work dates circa 1611–12.[27] Nor can Gash, who finds the Genoese provenance indicative of a later date.[28]

Bissell notes the resemblance of the Atheneum Judith figure to a female figure in Orazio's portion of the ceiling fresco in the Casino of the Muses in the garden of the present Palazzo Pallavicini-Rospigliosi, Rome (Fig. 26).[29] In this frescoed figure Levey saw the features of the painter's daughter, Artemisia, who was nineteen in 1612 and who probably left Rome by 1613,[30] an extremely provocative suggestion, considering the prominence the Judith theme was to have in the daughter's oeuvre. The head of Holofernes is markedly individualized and must depend as well on a model from life.[31]

M.M.

Figure 26. Orazio Gentileschi, *Female Figures*, Rome, Palazzo Palavicini-Rospigliosi, Casino

1. Judith 5:20.
2. Judith 13:4.
3. Inv. no. 1059, 127 x 147 cm.
4. Redig de Campos, 1939, fig. 1.
5. Moir, 1967, I, 70, no. 10, 75, as a good copy. R. Spear in Cleveland, 1971–72 and 1975 rev. ed., 100, no. 30, n. 4, as doubtful.
6. D. Mahon to C. Cunningham, 11 Oct. 1952, curatorial file, "seems clear enough to me that your picture has advantages [over the Vatican version] in a number of passages." Bissell, 1966, I, 105–10, "safer to regard it as an autograph replica, given its condition." Bissell, 1967, 76, n. 9, as "probably autograph . . . in need of cleaning." Volpe, 1972, 67, inferior to the Atheneum picture. Nicolson, 1979, 52, as a version. Bissell, 1981, 154, no. 26, fig. 44, repeats his 1966 and 1967 opinions.
7. The picture, 110 x 137 cm, belonged to the Roman dealer Jandolo in the 1920s, was exhibited at the Pitti in 1922 (Redig de Campos, 1939, 314, n. 1, who cites Alinari photo no. 45344), and was auctioned in Buenos Aires in 1925 (Bissell, 1981, 154f., fig. 47). Prior to its sale it seems to have been exhibited in Rome, for in the Witt Library there is a reproduction of the Jandolo version, no. 20 in an exhibition identified on the mount as having taken place at the Galleria Jandolo, Rome, in 1924. However, the text under the reproduction is in Spanish.
8. C. Sterling to C. Cunningham, 13 May 1958, curatorial file.
9. Bissell, 1981, 153.
10. E. Schleier in New York, 1985, 155–57, no. 43, where the Atheneum painting is mentioned.
11. New York, 1985, 152–55, no. 42.
12. While the hands are well modeled, the poor state of preservation is apparent in the flesh tones throughout.
13. Bissell, 1966, I, 95–96. The *Judith with the Head of Holofernes* by "Gentileschi," cited in a 1790 inventory of Palazzo Albani alle Quattro Fontane (M. di Macco in *Quaderni sul neoclassico*, V, 1980, 31), would not, as Spike suggests, 1984, 698, n. 10, seem to be a further version of the Atheneum picture, for in the Palazzo Albani canvas, of *imperatore* size, Judith is described as holding Holofernes' head in one hand and resting her other on a rock, while her attendant holds a bloodied sack and the sword.
14. Voss, 1925, 461. The reference is to Ratti, 1780, I, 119, "Palazzo del Sig. Pietro Gentile . . . Primo Salotto . . . Giudetta, e la servente, del Gentileschi."
15. Redig de Campos, 1939, 323. The Vatican painting had been presented to Pius XI in 1938 by Signora Agnese de Angelis vedova Gammarelli.
16. In a letter to C. Cunningham, 5 Feb. 1949, curatorial file, David Koetser wrote, "My brother in London sent a photograph . . . to Professor Longhi, who stated it is a fine and original work by Orazio Gentileschi." *Wadsworth Atheneum Bulletin*, May/Sept. 1949, 3. *Wadsworth Atheneum Annual Report*, 1949, 12, 33.

17. H. Voss in a letter of 11 Jan. 1949 seemingly prepared for Koetser (copy in the curatorial file): "without any doubt the missing original of the *Judith* mentioned in my book . . . of which a very poor old copy [the Jandolo version] has been exhibited in Florence, Palazzo Pitti, in 1922 as 'Scuola di Caravaggio'."
18. Cust, 1902, 27, pl. XLIII, as fol. 118 verso. G. Adriani, 1940, 77, as fol. 115 verso.
19. Bissell, 1967, 73. The reference to Ratti is 1780, I, 263: "Palazzo pur Brignole abitato dal Sig. Carlo Cambiaso"; 265, "Salotto a destra della sala . . . un quadro di Giudetta, del Gentileschi. Una mezza figura di femmina, che suona il violino, dello stesso." Spear in Cleveland, 1971–72, 100, no. 30, gives the provenance for the Hartford picture either as the Gentile or the Cambiaso collections.
20. Bissell, 1981, 156.
21. Bissell, 1981, 153–54, proposes that the *Judith* in the Pietro Gentile Collection was a painting later attributed to Guido Reni. However, an inaccuracy has crept into recent reports of the subsequent provenance of the Hartford picture. It was thereafter in the collection of Sir Hugh Cholmeley (1906–1964, bart. 1949), not Cholmondeley as indicated by Spear (Cleveland, 1971–72, 100, no. 30) and Bissell (1981, 153), nor Cholmely as reported by Moir (Detroit, 1965, 28, no. 6).
22. s.v. "Michelangelo Cambiaso," in *Dizionario biografico degli Italiani*, Rome, 1974, XVII, 128–31.
23. Voss, letter in curatorial file, 11 Jan. 1949, "painted during Gentileschi's stay in Genoa."
24. Moir in Detroit, 1965, 28, early 1610s, close to Orazio's *Mary and Martha*, Munich. Subsequently, Moir inclined to a date toward the end of the decade for the Munich picture (Bissell, 1981, 173, no. 44) and placed the Hartford picture slightly later than 1612 (Moir, 1967, I, 70, no. 10). Bissell, 1967, 73; 1969, 17. Spear in Cleveland, 1971–72, 100, no. 30. Volpe, 1972, 67. Freedberg, 1976, 732; this article is reprinted in *A Dealer's Record: Agnew's, 1967–81*, London, 1981, where the Vatican version is inadvertently captioned as being the Atheneum picture.
25. Schleier in New York, 1985, 155, no. 43, groups what he calls the Hartford and Vatican "versions" with other Orazios that all derive their horizontal compositions and three-quarter-length figures from Caravaggio prototypes.
26. New York, 1984, 26–27, no. 11.
27. Pepper, 1984, 316.
28. Gash, 1985, 257.
29. Bissell, 1967, 74–75. Bissell, 1981, 154. Rome, G.F.N. E34477.
30. Bissell, 1967, 74–75. Levey, 1962, 79–80.
31. Further references to the picture are: *Art News*, XLVIII, May 1949, 28; *Apollo*, LXVII, Mar. 1958, 91; *Wadsworth Atheneum Handbook*, 1958, 63; *Emporium*, Feb. 1959, 87; Paoletti, 1968, 425, perhaps early 1620s; Bissell, 1969, 17; *Connoisseur*, CLXXXI, Nov. 1972, 212; Nicolson, 1972, 52; Fredericksen and Zeri, 1972, 80, 266, 585; Silk and Greene, 1982, 38–39; Gealt, 1983, 236, pl. 4.

Vittore Ghislandi, called Fra Galgario (1655–1743)

Baptized as Giuseppe Ghislandi 4 March 1655, Vittore Ghislandi was born in Bergamo to a family of painters. Thanks to an extremely detailed biography by his friend Count F. M. Tassi, we are very well informed about Ghislandi's life and art.[1] Trained by local painters in Bergamo, first Giacomo Cotta, then Bartolommeo Bianchini, a Florentine long resident in Bergamo, Ghislandi went to Venice in 1675,[2] where he remained thirteen years.[3] He visited his native city in 1688, but he returned to Venice to study with the painter Sebastiano Bombelli. Ghislandi's second sojourn lasted until about 1702–5, when he finally returned to Bergamo and entered the monastery of Galgario in Bergamo as a lay brother, from which he derived his sobriquet.[4]

Although practically nothing documented survives of his long residency in Venice, documented portraits after his return to Bergamo are numerous. These include the *Self-Portrait* of 1712;[5] the *Portrait of Doctor Bernardi*, dated 1717;[6] the pendant portraits of *Count Giovanni Domenico Albani* and *Contessa Paola Calepio Albani* of 1724;[7] the *Self-Portrait* in Bergamo of 1732; and the *Portrait of Francesco Biava* of 1736.[8] In these pictures Ghislandi catered to the insular yet sophisticated taste of the Bergamask upper classes; yet at the same time he revealed his debt to the tradition of penetrating observation and sober characterization that had marked the portraits of Moroni, his predecessor.

Ghislandi was also celebrated outside his native city. He is documented in Bologna, where he was made an honorary member of the Accademia Clementina in 1717, and in Milan numerous times between 1718 and 1733. Cardinal Pietro Ottoboni, then the most important patron in Rome, sought Ghislandi's services, although poor health prevented Ghislandi from accepting the commission.[9] He died in Bergamo in December 1743.

1. Tassi, 1793, II, 57–74. The biographies were written between 1740 and 1760.
2. Tassi, 1793, II, 58–59; see Gozzoli, 1982, I, 10–13, who publishes a register of dates; see also Milan, 1991, 72–80.
3. Tassi, 1793, II, 59.
4. Gozzoli, 1982, I, 11.
5. Gozzoli, 1982, I, 107, no. 42.
6. Gozzoli, 1982, I, 108, no. 46.
7. Gozzoli, 1982, I, 122, 133–34.
8. Gozzoli, 1982, I, 116–17, no. 99.
9. Gozzoli, 1982, I, 11–13; Tassi, 1793, II, 59.

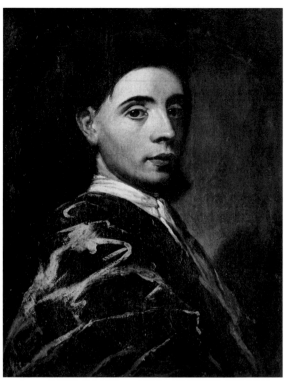

Style of Vittore Ghislandi, *Portrait of a Youth*

Style of Vittore Ghislandi
Portrait of a Youth

Oil on canvas, 49.8 x 39.7 cm (19⅝ x 15⅝ in.)

Originally oval in format, the picture has been made into a rectangle by the addition of newer canvas.

Condition: fair. There are extensive losses in the drapery, hair, and face; the background has been retouched.

Provenance: The previous history of the picture is unknown. Purchased by the Wadsworth Atheneum in 1942 from Adolf Loewi for $3,125 from the Sumner Fund.

Exhibitions: New York, Knoedler Galleries, *Venetian Painting of the Eighteenth Century*, 6–18 Apr. 1936, no. 8; San Francisco, 1941, no. 44.

The Ella Gallup Sumner and Mary Catlin Sumner Collection, 1942.27

Although attributed to Ghislandi in previous literature,[1] the painting is not by Ghislandi's hand, but was perhaps executed by one of his many imitators.[2] J.C.

1. J. Lane, "Current Exhibitions," *Parnassus*, VIII, Apr. 1936, 27, repr.; R. Longhi, "Dal Moroni al Ceruti," *Paragone*, XLI, 1953, fig. 9; Fredericksen and Zeri, 1972, 585.
2. M. Gregori, oral communication, 27 Nov. 1983.

Luca Giordano
(1634–1705)

Giordano is the most prominent and prolific painter of the late seventeenth century in Naples, so prolific and facile that he was nicknamed "Luca fa presto." His style was formed by the influence of Ribera, but approximately about the time of the latter's death in 1652 Giordano made a voyage of stylistic discovery to Rome, Florence, and Venice, where he was indelibly influenced by Pietro da Cortona and the Venetian masters, particularly Veronese and Titian. Back in Naples by 1653, his work oscillated stylistically between his Riberesque origins and what he had learned abroad. The Atheneum's *St. Sebastian* is often considered to reflect this phase. He and Mattia Preti exchanged influences at this time, one in which Giordano demonstrated his tremendous capacity for eclectic synthesis. In 1665 he was again in Florence and Venice. By the late 1670s his fresco cycles in Naples illustrate the grandiloquent, late baroque style which made his fame throughout Europe. His crowning works are the frescoes in Palazzo Medici-Riccardi, Florence, done between 1682 and 1685. It is argued that the Atheneum's *Abduction of Europa* and the *Abduction of Helen* illustrate Giordano's work thereafter, when he was back in Naples, but prior to his departure for Spain in 1692, where he was court painter for ten years. His late works, light and iridescent, anticipate the rococo. Even in his last years, even after his return to Naples in 1702, his prodigious output continued and his reputation prospered until his death.[1]

1. O. Ferrari in London, *Painting in Naples*, 1982, 168–69.

The Abduction of Helen

Oil on canvas, 227 x 193.5 cm (89³/₈ x 76³/₁₆ in.)
 Condition: like *Europa*, fairly good with minor losses especially along the vertical central seam. Both pictures would seem to have aged in the same circumstances, but the surface of this painting has suffered more from flaking.
 Signed and dated on the shadowed face of the rock in the lower right corner: *Giordanus / F 1 . . .*
 Provenance: Leger & Sons, London. Purchased by the Wadsworth Atheneum in 1930 from Durlacher Bros., New York, for $12,000 the two from the Sumner Fund.
 Exhibitions: Hartford, 1930, no. 12, *Europa*, no. 13, *Helen*; Dayton, 1953–54, no. 55, *Europa*; Sarasota, 1958, no. 34, *Europa*; New Haven, 1987, 55, no. 12, *Helen*, as signed and dated "L. Jordanus F. 1686."
 The Ella Gallup Sumner and Mary Catlin Sumner Collection, 1930.2

The Abduction of Europa

Oil on canvas, 227.7 x 193.3 cm (89⁹/₁₆ x 76¹/₈ in.)
 Condition: fairly good despite the large number of minor, localized losses, especially evident along the vertical central seam.
 Signed and dated on the shadowed surface of the rock in the left foreground: *Giordano F 17[?] . . .*
 The Ella Gallup Sumner and Mary Catlin Sumner Collection, 1930.3

Smitten by Europa, Zeus disguised himself as a beautiful bull and enticed the Phoenician princess and her attendants by his mildness. Thus Zeus was able to carry Europa off on his back into the sea and thence to Crete. The legend can be read to reflect a belief that Minoan civilization, or some aspects thereof, had links with Lycia in southwest Asia Minor. In the companion painting, Helen, daughter of Zeus and Leda, and a fertility goddess worshipped by the pre-Dorians as an ancestress of their kings, is here seen in her later Homeric role; her abduction by Paris was the cause of the Trojan War.[1]

 Owing to their size, these early acquisitions have never been exhibited together except at the Atheneum.[2] The attributions have been well received.[3] For Ferrari and Scavizzi these are fundamental works in reconstructing Giordano's mature development.[4] Between 1682 and 1685 the artist had conceived and executed his masterpieces: the gallery and library frescoes in Palazzo Medici-Riccardi in Florence. Thereafter, he returned to Naples, where he remained until his departure for Spain in 1692, beginning a period during which he intensely rethought the Venetian sixteenth- and the more proximate seventeenth-century sources of his ever synthesizing and increasingly virtuoso art. Ferrari and Scavizzi read the date on the *Helen* to be 1686, and thus argue the two document the artist's turning, once again, to Veronese, absorbing his style as well as his iconography. They anticipate such luminous and fluent paintings of this Neapolitan sojourn as Capodimonte's *S. Francesco Saverio* or the *Madonna of the Rosary*.[5]

 The signatures and dates on the *Helen* and the *Europa* (the latter has not yet been reported in the literature) have been examined recently under laboratory magnification. Lamentably, both dates are badly abraded, but an interpretation of that on the *Helen* as 1686 is entirely conjectural. In both cases

Luca Giordano, *The Abduction of Helen*, detail

Luca Giordano, *The Abduction of Europa*, detail

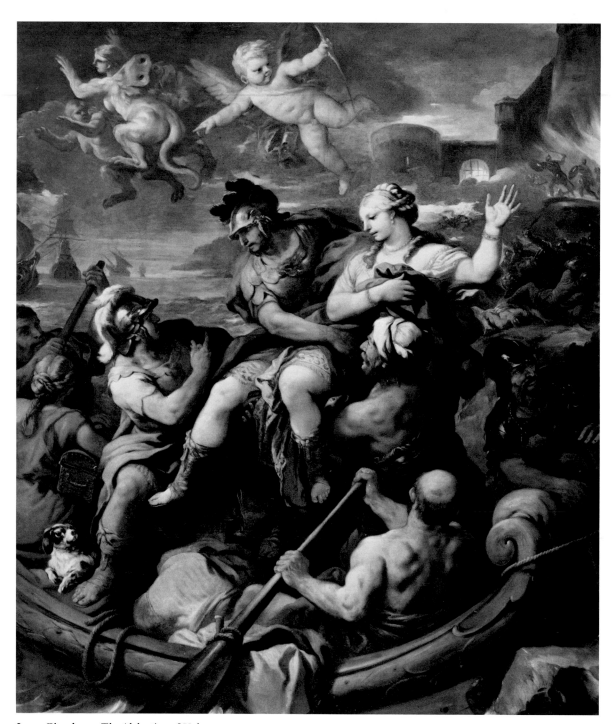

Luca Giordano, *The Abduction of Helen*

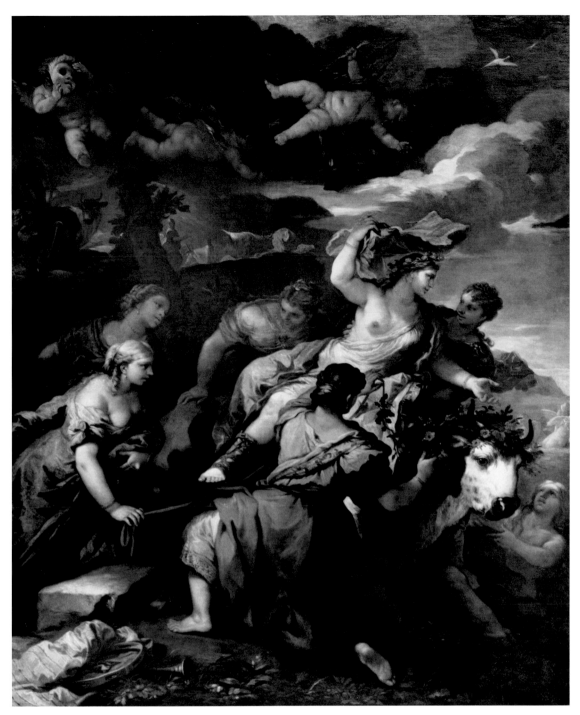

Luca Giordano, *The Abduction of Europa*

only the first digit is clear and the second digit in the *Europa* is suggestive of a 7. While related thematically and of the same size, the Atheneum pictures are not otherwise complementary. The relationship of figures and space in the *Helen*, with large figures pulled up close to the picture plane, is quite different from that in the *Europa*, where moderately sized figures are set farther back into the picture space. These are large-scale works where niceties of compositional responses and congruity of scale in a pair could perhaps have been of secondary importance to an artist reaching for splashy decorative effects. But one wonders if these two might not be a convenient coupling of separately realized analogous themes rather than having been conceived as a pair in the strictest sense. The *Europa* is palpably Veronese-like; Ferrari and Scavizzi compare it to Veronese's treatment of the theme in Palazzo Ducale, Venice.[6] The putti above are much indebted to Titian; one immediately thinks of his treatment of the same theme in the Gardner Museum. The latter was in the Spanish royal collection until 1704[7] and thus could have been a direct inspiration to Giordano if his *Europa* was executed in the early 1700s, a possibility that could not be excluded given the difficulties in reading the dates exactly, except that clearly neither canvas relates to the fervent, extemporaneous style of Giordano's Spanish works. The *Helen*, on the other hand, seems much more indebted to Cortona and is very akin, as Ferrari and Scavizzi point out, to a group of Cortonesque works: the *Finding of Moses* in Raleigh, the Pitti *Galatea*, and two mythologies in the Museo del Castelvecchio, Verona.[8] It is not inconceivable that the artist added the signatures and dates after 1700 to improvise a pairing of stylistically distinct works of an earlier period. M.M.

1. Apollodorus, *Mythographus*, 3, 2ff; Homer, *Iliad*, 3, 87.
2. When offered by Durlacher Bros., 7 Oct. 1929, curatorial file, Voss was quoted as having said, "About the paintings by Luca Giordano there is, of course, no doubt; both are very fine examples of his late style and they show clearly the Venetian influence (namely Paolo Veronese)." When with Leger, London, the *Europa*, "one of a pair," was reproduced in an advertisement in *Burlington Magazine*, LV, no. 316, July 1929. Publications attendant on their acquisition and the 1930 exhibition were *Wadsworth Atheneum Annual Report*, 1929, 5; JRS, 1930, 2–3; and H.-R. Hitchcock, *International Studio*, 1930, 21, repr. *Helen*, 37.
3. Wadsworth Atheneum, *Avery Memorial*, 1934, 29. McComb, 1934, 124. M. Milkovitch in Memphis, 1964, 38. Fredericksen and Zeri, 1972, 86, 470, 478, 584.
4. Ferrari and Scavizzi, 1966, II, 145, figs. 282, 283.
5. Ferrari and Scavizzi, 1966, II, 145, I, 109–34, especially 116–18, where the Atheneum pictures are mentioned. The Capodimonte works are reproduced in III, figs. 288–89.
G. Hersey discusses the *Helen*'s iconography and stylistic sources at length in New Haven, 1987, 139–42, no. 12.
6. Ferrari and Scavizzi, 1966, II, 145. Repr. in A. Orliac, *Véronèse*, Paris, 1939, 116.
7. Wethey, 1975, III, 174.
8. Ferrari and Scavizzi, 1966, II, 87, III, respectively figs. 146, 143, 137, 138. They also (II, 146, III, figs. 284, 285) would link the Atheneum pictures stylistically with the *Raising of the Cross* and the *Multiplication of the Loaves and Fishes*, University Museum, Würzburg, reading the date on the former to be 1686. Vitzthum noted (1970, 243) that the latter date is, in fact, correctly reported in the literature as 1690.

St. Sebastian Nursed by Irene and Her Companions

Oil on canvas, 150.5 x 199.3 cm (59 1/4 x 78 1/2 in.)
Condition: fair. Heavy repairs along two horizontal seams, one across the middle and the other at the top of the picture. Major repairs on the right side of Sebastian's chest, lesser ones at the top of his neck and on his right arm. The impasto has been severely compressed in relining.
Provenance: The previous history of the picture is unknown. Given to the Wadsworth Atheneum in 1936 by Frank Gair Macomber.
Exhibitions: Hartford, 1930, no. 14; Memphis, 1964, 4, no. 1.

Gift of Frank Gair Macomber, 1936.33

Sebastian, a secretly Christianized commander of the Praetorian guard and a favorite of the coemperors Maximian and Diocletian, exhorted two of his similarly converted soldiers to endure imprisonment and martyrdom without faltering. Thus having revealed himself as a Christian as well, Sebastian was condemned to be executed by archers. Left for dead, as seen here, his wounds were tended by Irene, widow of one of his martyred soldiers, and her companions. As Apollo had been thought anciently to inflict the plague, the symbol of which was the arrow, and as the arrow became associated with Sebastian in Christian iconography, the saint was venerated not only as a soldier and martyr of Christ, but his protection came to be invoked against pestilence. After Peter and Paul, he was considered the third patron saint of Rome.[1]

The iconography is straightforward; nothing else about the picture is, even its identity. It was in the Boston collection of Frank Gair Macomber as a Ribera, when Mayer very early on recognized it as a characteristic imitation of that artist by Giordano.[2] Between May 1913 and November 1923, the picture was loaned to the Museum of Fine Arts, Boston, as Ribera,[3] and was again cited by Mayer.[4] As recently as 1966, Ferrari and Scavizzi referred to an untraced *St. Sebastian* in the Boston museum.[5] Macomber lent the painting to the Atheneum for exhibition in 1930 as Luca Giordano[6] and donated the picture to the museum in 1936.[7] The picture remained unnoticed in Hartford, unaccountably attributed to Guido Reni,[8] until 1960 when Longhi reobserved that it was a typical Giordano.[9] Milkovitch exhibited it as an early work, before 1650, under the influence of Ribera,[10] and thereafter it was published by Ferrari and Scavizzi, who were unaware that it was actually the "lost" Boston picture. They dated it circa 1658–62,[11] at a moment, as proposed by Bologna,[12] when Giordano had a Riberesque reprise in the course of evolving his own baroque style, his eclectic amalgam that had been jolted out of its Riberism initially by the artist's circa 1652–53 journey to Rome, Florence, and Venice.

Mayer placed the Atheneum work among a group of Riberesque pictures of Giordano's youth, the key painting of which is the Munich *Deposition of St.*

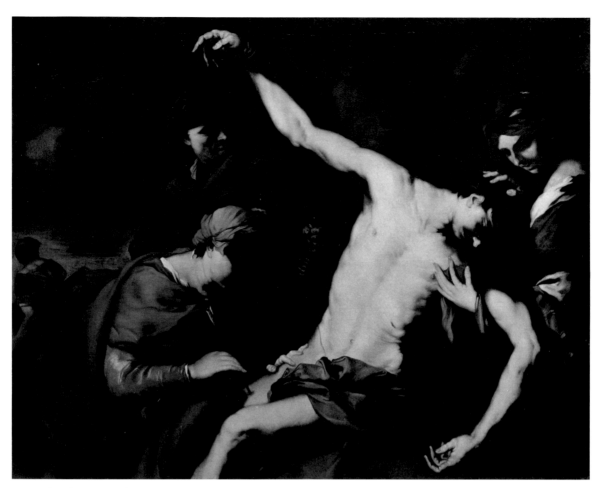

Luca Giordano, *St. Sebastian Nursed by Irene and Her Companions*

Andrew, which, although misleadingly inscribed with a false Ribera signature, is described in a fragmentary 1688 Colonna inventory, drawn up by Giordano himself, as his own work in the manner of Ribera.[13] Analogous youthful works according to Mayer are the Munich *Death of Seneca*; the *Philosophers Disputing* and the *Theologians Disputing*, both in Bordeaux; *Circe and Picus* and *Aesculapius Receiving the Roman Messengers*, both in Brunswick; the Atheneum picture; and two upright *Sebastian and Irenes*, one in Dresden and the other in Dublin.[14] The Brunswick and Bordeaux works do not seem, in fact, to be stylistically relevant. A more telling comparative group of representative youthful works would include the four remaining above plus the *Sebastians* in Schleissheim, Lucca, and Cologne, plus the *Deposition* in the Bauzá Collection, Madrid.[15] All these works are greatly indebted to Ribera. Compare any one with Ribera's signed and dated Capodimonte *Sebastian* of 1651, a work commissioned long before, in 1638, and one which perpetuated, in a way greatly affecting the young Giordano, Ribera's style of that earlier decade.[16] Giordano's pictures in this markedly tenebrist manner are logically expected to be early works, when the

Spaniard was still a living force in Naples (he died in 1652) and before Giordano's first voyage of discovery to the North.

Giordano thereafter did not forget Ribera, whose naturalism was a potent, expressive mode he would call upon again and again, particularly in a group of works Bologna cited as examples of the neo-Riberesque phase in Giordano's development. The key work for that phase is the Vienna *St. Michael*, with its Bolognese-like angel triumphing over a purely Riberesque host of agonized fallen angels.[17] While Bologna's proposal has been well received, the realization that the 1666 date on the *St. Michael* was fictive required a reconsideration of the chronology for the neo-Riberesque phase.[18] Ferrari and Scavizzi proposed circa 1658–62 for this Riberesque reprise,[19] a suggestion Vitzthum found somewhat improvised.[20] More recently, Ferrari speaks of Giordano's oscillating during the decade after his initial return to Naples between a baroque style learned in his travels

and Ribera's naturalism.[21] In this phase, Giordano mitigated Ribera's naturalistic handling of the Sebastian theme with an infusion of grace.[22] The elegant pathos of the Philadelphia *Sebastian and Irene*,[23] as well as its treatment of light and color, are informed by Roman painting as much as by Ribera, and that painting must represent the artist's approach to the theme in the neo-Riberesque phase.[24] No matter how far back the neo-Riberesque phase is pushed, even to 1653, the Atheneum picture stands on the other side of the stylistic divide, with Giordano's Riberesque, youthful works, before he was exposed to the cosmopolitan trends of painting north of Naples.

Then there is the problem of repetitions of Giordanos such as this one. Are they autograph replicas, studio versions, or copies? For example, stylistically analogous to the Atheneum picture is the Ottawa *Crucifixion of St. Andrew*[25] (whose rightmost attendant figure is generically very like, if not exactly, the model for Hartford's Sebastian), of which there are smaller versions in the Louvre[26] and in the Quatara Collection, Milan.[27] A version of the upright Dublin *Sebastian*,[28] a picture compared above with Hartford's, was at Sotheby's, London, in 1976.[29] A smaller version of the Atheneum picture itself was sold at Christie's, London, in 1975.[30] That version is laterally reduced, omitting or having lost Hartford's "fleeing" female figure on the left. To judge from the sales catalogue reproduction, this London version has greater impasto throughout, especially in Irene's drapery and in the torso and limbs of Sebastian. Overall, the Atheneum's picture, in its present condition, with its impasto severely compressed, especially on the nude torso, is lifeless in touch, the drapery mechanical, and the anatomy wanting in structure. This could be a workshop piece, or as Spinosa suggests, a copy of a lost early work.[31]

There are Giordano drawings of the Sebastian theme, all with both the martyr's arms drawn above his head as in the Dresden composition, rather than with one still tied to the tree and the other slumped down as in the Dublin/Hartford type. One is signed by Giordano.[32] They further document the dependence of the young Giordano on Ribera, for even these drawings are made in imitation of Ribera's pen style.[33] M.M.

1. Clement, 1883, 272–74. Cross, 1957, 1254. Cannata, 1968, 790.
2. Mayer, 1915, 310, "the muddy flesh tints and the special blue tone betray the skillful imitator [Giordano]."
3. H. Hall to M. Mahoney, 31 July 1984, curatorial file.
4. Mayer, 1923, 145.
5. Ferrari and Scavizzi, 1966, I, 17–18, in the entry for the Munich *Deposition of St. Andrew*.
6. Hartford, 1930, no. 14.
7. *Wadsworth Atheneum Bulletin*, Oct. 1936, 2.
8. C. Cunningham to R. Longhi, 29 Mar. 1960, curatorial file.
9. R. Longhi to C. Cunningham, 22 Mar. 1960, curatorial file.
10. Memphis, 1964, 4, no. 1.
11. Ferrari and Scavizzi, 1966, II, 67, "tra il sesto e il settimo decennio del secolo."
12. Bologna, *Solimena*, 1958, 34–37.
13. Colonna di Stigliano, 1895, 30, no. 11.
14. Mayer, 1923, 144–45. In Ferrari and Scavizzi, 1966, they are respectively catalogued and illustrated: *Andrew*, II, 17–18, III, 17; *Seneca*, II, 9, III, 4; *Philosophers*, II, 24, III, 34; *Theologians*, II, 24, III, 35; *Circe*, II, 64, III, 115; *Aesculapius*, II, 64, III, 116; Hartford *Sebastian*, II, 67; Dresden *Sebastian*, II, 9, III, 7; Dublin *Sebastian*, II, 11, III, 8.
15. Ferrari and Scavizzi, 1966: Schleissheim, II, 67, III, 122; Lucca, II, 11–12, III, 9; Cologne, II, 11, III, 547; Madrid, II, 66, III, 117.
16. Pérez Sánchez and Spinosa, 1981, no. 203. The Hermitage *St. Sebastian Nursed by Irene and a Companion*, signed and dated 1628 (Vsevolozhskaya and Linnik, 1975, fig. 60), could be cited as an even earlier source. Irene in the latter especially resembles the woman on the right in the Atheneum picture.
17. Bologna, *Solimena*, 1958, 36.
18. Ferrari and Scavizzi, 1966, I, 65, n. 26.
19. Ferrari and Scavizzi, 1966, I, 58–62. See also Ferrari, 1975, 26. Griseri, *Arte antica e moderna*, 1961, 429–30, discusses many of these works as a reprise during the Madrid period, after 1692.
20. Vitzthum, 1970, 240: "As far as Bologna's theory of a second Riberesque phase is concerned, the authors had evidently at first accepted it as solid fact, based on the date 1666. . . . The authors realized that this date had no relevant basis, but they evidently made this discovery too late to reorganize thoroughly their picture of Giordano's early development."
21. London, *Painting in Naples*, 1982, 168. Ferrari (170–71, no. 62) dates the Capodimonte *Resurrection* to 1652–55, wherein, "instead of concentrating on the Spaniard's vigorous realism, as he had in his youth, he now adopted Ribera's painterly freedom."
22. For example, Ribera's Capodimonte *Sebastian* (Pérez Sánchez and Spinosa, 1981, pl. 57) vs. the Dublin and Dresden works by Giordano (Ferrari and Scavizzi, 1966, III, figs. 7, 8).
23. Ferrari and Scavizzi, 1966, II, 65, III, figs. 112–14.
24. The Philadelphia work may be grouped with the Rouen *Good Samaritan* (Ferrari and Scavizzi, 1966, II, 27–28, III, 41), the Berlin *Balaam* (II, 63, III, 111), and the Brunswick mythologies cited above.
25. Hubbard, 1957, 18, inv. no. 4294, 57 x 77 in.
26. De Logu, *Arte*, 1928, 148, fig. 2, inv. no. 1432, 34 x 43 cm, attributed to Preti in 1928.
27. De Logu, *Arte*, 1928, fig. 1.
28. Dublin, 1981, 62, inv. no. 79, 152 x 26 cm.
29. 8 Dec. 1976, no. 40, illus., 156 x 123 cm, 7,500 pounds. This seems to be the picture later with Italo Fiumicelli Antichità, 8 via Edison, 42100 Reggio Emilia (4 Apr. 1978, curatorial file).
30. 31 Oct. 1975, no. 196, illus., 58 x 70 in. (147.5 x 178 cm), 3,500 pounds. This presumably is the picture reproduced in the *Burlington Magazine*, CXX, Mar. 1979, advertisement lxxx, as also with Italo Fiumicelli, Reggio Emilia (see footnote above).
31. Oral communication, 19 Mar. 1979, memorandum in curatorial file. The attribution to Giordano was accepted by Zeri and Fredericksen, 1972, 86, 449, 584.
32. Uffizi, 6685 Santarelli, a single sheet with two studies of the theme on the recto. Repr. in Ferrari and Scavizzi, 1966, I, pl. II opposite 188, II, 251.
33. Vitzthum in Florence, 1967, 56–57, no. 84, who also discusses the above-mentioned signed Uffizi drawing, dismisses as copies Albertina 25508 and Uffizi 6684 (Ferrari and Scavizzi, 1966, II, 251, III, figs. 667, 668), and mentions a *Sebastian* drawing then in a private collection that is without doubt a study for the Dresden picture. The latter is now in the Art Gallery of Ontario, Toronto (Vitzthum, 1971, fig. 25).

Follower of Luca Giordano?, *The Birth of John the Baptist?*

1. E. Waterhouse, "by a close follower" (notes on his visits of 26 and 27 Feb. 1963, curatorial file). M. Milkovitch, "attributed to Luca Giordano," in Memphis, 1964, 38. Not listed by Ferrari and Scavizzi, 1966. Fredericksen and Zeri, 1972, 86, 416, 584, as by a Giordano follower.
2. Luke 1:57–67.
3. Fredericksen and Zeri, 1972, 86, as *Birth of John the Baptist?*
4. Luke 1:19–20.
5. Luke 1:68–79.
6. The latter is paired with a *Nativity of Christ* that curiously includes an armored St. Michael.

Follower of Luca Giordano?
The Birth of John the Baptist?

Oil on canvas, 109.2 x 107.3 cm (43 x 42½ in.)
 Condition: poor. Obscured by discolored and blotched varnish residues and retouchings. Damaged beneath the right hand of the servant behind the nurse bathing the infant. Repaintings on the faces of the angel and the nurse and the servant ministering to Elizabeth.
 Provenance: The previous history of the picture is unknown. Given to the Wadsworth Atheneum in 1914 by Clara Louise Kellogg Strakosch.
 Exhibitions: Kent, 1966, as "attributed to Luca Giordano."
 Gift of Clara Louise Kellogg Strakosch, 1914.16

The picture entered the collection at an early date with no provenance. On the few occasions that it has elicited any comment whatsoever, it has been luke-warmly assigned to the orbit of Luca Giordano.[1]

If the theme is properly identified as the birth of John the Baptist, then his mother, St. Elizabeth, is in the right background, while the aged Zachariah, supported on a cane, gestures toward the infant.[2] Fredericksen and Zeri wonder if that is the correct interpretation of the subject,[3] understandably, for it is at this moment that Zachariah, recovering from the muteness imposed by the angel Gabriel,[4] bursts into the hymn of exultation, the Benedictus, at the fulfill-ment of the Lord's prophecy in the birth of his son.[5] Such does not seem to be happening here.

The picture is difficult to evaluate owing to distort-ing blotches of varnish residue and retouchings. Despite its obvious anatomical gaucheries, there is merit in the handling of color and in such well-brushed passages as that on the right, yet not of suffi-cient quality to suggest that the picture is any more than an imitative variation, in reverse, of a similar nativity, also with a bearded figure supported on a cane, in the Descalzas Reales Convent, Madrid.[6]

 M.M.

Girolamo di Benvenuto
(1470–c. 1524)

Girolamo di Benvenuto was born in 1470 and was the son of the painter Benvenuto di Giovanni. Documents establish his activity in the church of S. Bernardino in Siena in 1499, painting an altarpiece and frescoes, and in the following year his collab-oration with his father in ornamenting funeral biers for the Ospedale della Scala. In 1510, along with Girolamo Genga, Giacomo Pacchiarotto, and Girolamo del Pacchia, he judged a picture by Perugino for the Vieri Chapel in S. Francesco, Siena. Girolamo's frescoes in the church of Fontegiusta, among which the *Assumption* survives, were valued at 270 florins by Pacchia and Domenico Beccafumi in August 1515. In 1517 he dec-orated a baldacchino in the Duomo for the visit of Pope Leo X. He died sometime before June 1524, the date of his estate inventory.[1]

The signed and dated altarpiece of the *Madonna of the Snow* of 1508 in the Pinacoteca in Siena, formerly in the Cappella Sozzini in S. Domenico, Siena, and the documented frescoes from the church of Fontegiusta, form the reference points for the reconstruction of Girolamo's oeuvre. An *Assumption* in the Museo Diocesano, Montalcino, is generally attributed to Girolamo and dated 1498, the year of his father's panel of the same subject, formerly in the Metropolitan Museum of Art in New York.[2] Girolamo's early works are entirely dependent on those of his father, while his late works show the influence of Umbrian painters active in Siena, such as Perugino, Signorelli, and Sodoma. A painter of little originality, Girolamo nonethe-less produced pictures of considerable charm.

1. The documents are published in Milanesi, 1856, III, 47–48, 70, 78–80; and A. Marelli, *S. Maria in Portico a Fontegiusta*, Siena, 1908, 54, n. 39.
2. Inv. no. 10.148; H. Wehle, *Metropolitan Museum of Art: A Catalogue of Italian, Spanish, and Byzantine Paintings*, New York, 1940, 96–98, sale New York, Sotheby's, 1 June 1978, no. 133.

The Adoration of the Child

Tempera and oil on panel, 80.6 x 60.7 cm (31³/₄ x 23⁷/₈ in.)

The panel has been cradled. The left and right edges have been trimmed slightly; the top and bottom may also have been trimmed.

Condition: good. There are many vertical cracks and scattered inpainting overall. Infrared examination reveals numerous changes in design, particularly in the drawing of the manger at the left, the line of the hill, and the folds of the Virgin's drapery.

Provenance: collection Mr. and Mrs. Thomas Lamont; Albert E. and Sophie Lehman Goodhart, New York, to 1952; by bequest to Robert Lehman Art Foundation, New York; lent to the Wadsworth Atheneum in 1962; given to the museum in 1971 by the Robert Lehman Art Foundation.

Gift of Robert Lehman Art Foundation, 1971.23

The Virgin kneels and adores the newborn Christ Child. St. Joseph stands behind her. Also kneeling in adoration are, from the left, St. Jerome, an unidentified saint, and a bishop saint; behind them are, from the left, St. Catherine of Siena, possibly St. Stephen, and St. Anthony of Padua.[1]

The *Adoration of the Child* has been related to a group of pictures of the same theme attributed to Girolamo di Benvenuto.[2] This group of paintings shows the Virgin kneeling on the ground adoring the Child. St. Joseph either kneels or stands behind the Virgin, and in the background is seen the manger with an ox and an ass. The interpretation of the Nativity is based on the description of Pseudo-Bonaventure in the *Meditationes vitae Christi*, who describes the adoration of the Christ Child by the Virgin.[3] The Atheneum picture differs, however, from the paintings in this group in a number of ways that suggest it belongs to a slightly different iconographic tradition. For one, the Child in the Atheneum painting rests His head on a bale of wheat, symbolic of the Eucharist.[4] Moreover, the aureole of light that surrounds the Child in the other versions is missing.[5] The figure of God the Father, which would complete the representation of the Trinity, is also missing.[6] Additionally, in the Atheneum painting an unusually large number of saints accompany Mary and Joseph. The more elaborate presentation of the theme, as well as the indication of pentimenti, suggest that the painting is a product of the master's hand and not a workshop replica.[7]

The painting entered the museum attributed to Benvenuto di Giovanni; it had been attributed to Girolamo di Benvenuto by van Marle,[8] Berenson,[9] Fredericksen and Davisson,[10] and Fahy.[11] Pope-Hennessy has tentatively proposed an attribution to Andrea di Niccolò.[12] Vertova has attributed the Atheneum painting and a number of other paintings

with which it shares iconographical and morphological similarities, including the Baltimore, Montalcino, and New Haven pictures referred to above, to an anonymous artist in Girolamo's workshop, who painted the *Madonna and Child with Saints* in the Bagatti Valsecchi Collection in Milan.[13] Zeri, however, has contested the isolation of this hand from Girolamo's oeuvre.[14]

The *Adoration* is generally considered a late work by the artist.[15] Analogies of facial type, especially of the St. Catherine, and the restrained emotional tenor of the work ally it with Girolamo's documented frescoes of 1515. A date after 1515 seems likely. J.C.

1. Vertova, 1969, 14, n. 11, tentatively identifies the kneeling bishop saint as St. Savino, head of a Benedictine abbey at Pisa and a patron saint of Siena, and the two martyrs holding palms as St. Esuperanzio and St. Marcello, who were martyred with him.

2. This group includes pictures in the Kress Collection at the Philbrook Art Center, Tulsa (Shapley, 1966, 161–62, no. K1287, fig. 447); in the Pinacoteca Nazionale di Siena, inv. no. 342 (Torriti, 1978, 21); in the J. Paul Getty Museum, Malibu, Calif. (Fredericksen and Davisson, 1966, fig. 1); a painting in the Musée Magnin, Dijon (Brejon de Lavergnée, 1980, 73, no. 54); a painting in the Walters Art Gallery, Baltimore (Zeri, *Walters Art Gallery*, 1976, I, 133, no. 90, pl. 70); a painting in the Museo Civico in Montepulciano (van Marle, 1937, XVI, fig. 250); and a painting whose present location is unknown (Berenson, 1970, 59, fig. 86).

3. E. Panofsky, *Early Netherlandish Painting*, Cambridge, Mass., 1966, I, 377–78, n. 3.

4. This may be derived from the homilies of St. Gregory Nazianzus, where the wheat is described as "the grain of His flesh" that nourishes the faithful (Fredericksen and Davisson, 1966, 14). It may also allude to the *Meditations* of Pseudo-Bonaventure, in which St. Joseph lay down a bale of hay before the Virgin (Cornell, 1924, 41; Levi d'Ancona, 1977, 363). A painting of the *Nativity* in the Yale University Art Gallery, New Haven, shows the Child in a pose identical to that in the Atheneum picture with His head resting on a bale of wheat (Seymour, 1970, 195, no. 147, as by an imitator of Girolamo di Benvenuto from the early sixteenth century). Another picture, in the Museo Diocesano in Montalcino, also of the *Nativity* and attributed to Girolamo, shows the Child resting His head on a bale of wheat.

5. The light emanating from the Child in the other versions probably refers to the description of the Nativity by St. Bridget of Sweden (Cornell, 1924, 7–13; Fredericksen and Davisson, 1966, 7–8).

6. It is possible that the panel has been cut or, more probably, that the figure of God the Father was painted on a separate panel that has been lost. In the painting in Baltimore referred to above (Zeri, *Walters Art Gallery*, 1976, I, 133, no. 90), the figure of God the Father is missing, as it is also in the picture from Montalcino.

7. As L. Kanter has observed, oral communication, 23 Apr. 1987, the iconographic innovations may signal the hand of Girolamo's father, Benvenuto di Giovanni. K. Christiansen, oral communication, 11 May 1987, agreed with the attribution to Benvenuto.

8. van Marle, 1937, XVI, 441.

9. Berenson, 1968, I, 187.

10. Fredericksen and Davisson, 1966, 30, 33.

11. Oral communication, 8 May 1984.

12. Oral communication, 7 Nov. 1972.

13. Vertova, 1969, 3–14.

14. Zeri, *Walters Art Gallery*, 1976, I, 133; 1979, 51.

15. Fredericksen and Davisson, 1966, 33, call it one of Girolamo's latest works; Zeri, 1979, dates it between 1515 and 1524.

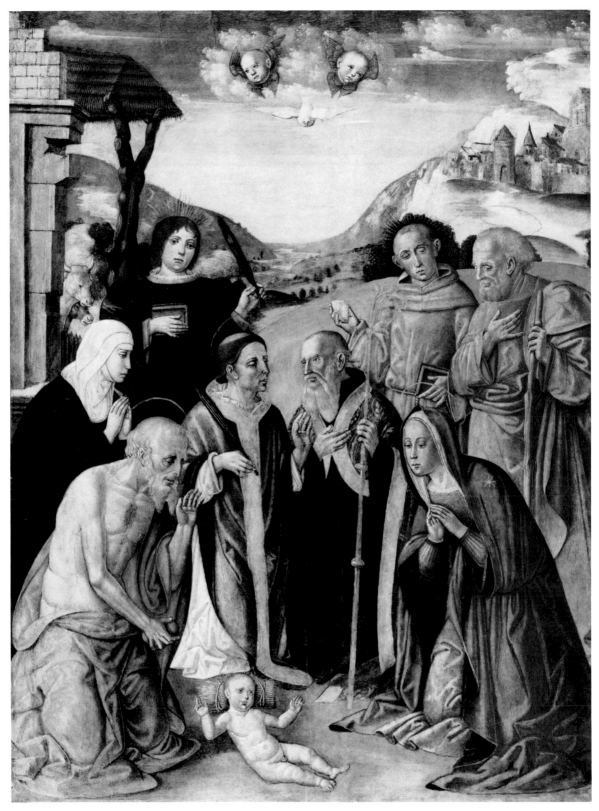

Girolamo di Benvenuto, *The Adoration of the Child*

Pietro Francesco Guala
(1698–1757)

Born in 1698 in Casale Monferrato, in Piedmont, Pietro Francesco Guala passed most of his career around his native city.[1] Early sources report that he went to Bologna to study in about 1722–24,[2] but there is no documentary evidence of this visit, and, indeed, it is likely that he traveled to other places as well, including Venice, Milan, Turin, and Genoa, before his marriage in 1730.[3]

A large number of signed and dated works allows an overview of Guala's career and the development of his style.[4] Early works, such as the *Dream of Jacob* in Balzoa, signed and dated 1722, show influence of G. M. Crespi, while the dramatic *Defeat of the Albigesi* of 1724 in the church of S. Domenico at Casale may show the influence of Magnasco.[5] The frescoes in the Palazzo Sannazzaro, Casale, executed in 1735–36, and in the Palazzo Treville, Casale, painted just afterward, however, show awareness of contemporary decorative works at the court of Turin.[6] Guala's mature style is a personal blending of these tendencies that constitutes an interesting, if provincial, episode in the history of eighteenth-century Italian painting.

Guala was also very active as a portraitist. While again an individualist, his portrait style has affinities with that of Ceruti and Ghislandi.[7]

Guala died in Milan in 1757.

1. The essential source for Guala is Martinotti, 1976; a register of dates is on 194–96. See also R. Carita, *Pietro Francesco Guala*, Turin, 1949; Milan, 1991, 223–24.
2. G. de Conti, *Ritratto della città di Casale*, ed. G. Serrafero, Casale, 1966, as cited in Martinotti, 1976, 8.
3. Martinotti, 1976, 12, 30–34.
4. Martinotti, 1976, 194–96.
5. Martinotti, 1976, 39.
6. Martinotti, 1976, 56–71.
7. Turin, Galleria Civica d'Arte Moderna, *Giacomo Ceruti e la ritrattistica del suo tempo nell'Italia settentrionale*, Feb.–Mar. 1967, 40–41; Martinotti, 1976, 103–27.

Pietro Francesco Guala, *Portrait of a Boy in Armor*

Portrait of a Boy in Armor

Oil on canvas, 80.5 x 64.2 cm (31 3/4 x 25 1/4 in.)
 Condition: good. The painting has been lined and has suffered minor losses, particularly in the shadows.
 Provenance: The previous history of the picture is unknown. Given to the Wadsworth Atheneum in 1960 by Mr. and Mrs. Arthur L. Erlanger.
 Exhibitions: Hartford, 1982.
 Gift of Mr. and Mrs. Arthur L. Erlanger, 1960.390

First assigned to Guala by V. Viale,[1] the attribution has been confirmed by other scholars.[2] The Atheneum painting is typical of his very individual portrait style. A date sometime after 1740 seems likely.

<div align="right">J.C.</div>

1. V. Viale, letter to A. Erlanger, 9 Feb. 1953, curatorial file.
2. G. Testori in Ivrea, Centro Culturale Olivetti, *Mostra di Pier Francesco Guala*, May 1954 (also Milan, Castello Sforzesco, and Turin, Palazzo Carignano, June 1954), 24, no. 13, mistakenly cited as *Ritratto di Signora*; G. Testori, "Introduzione al Guala," *Paragone*, no. 55, 1954, 36, fig. 17; Fredericksen and Zeri, 1972, 585.

Francesco Guardi
(1712–1793)

Francesco Guardi was born into a family of painters in 1712.[1] His ancestors, originally from around Trent, had been notaries, judges, and military men and had been ennobled by Holy Roman Emperor Ferdinand III in 1643; his father, Domenico, born in 1678, had studied painting in Vienna, the capital of the Hapsburg empire, of which the Trentino was then a part. Shortly after the birth in Vienna of Antonio, Francesco's older brother, in 1699, the family moved to Venice, where Maria Cecilia, Francesco's older sister and the future wife of Giambattista Tiepolo, was born in 1702 and Francesco in 1712.

When Domenico died in 1716, Antonio assumed the direction of the workshop; his first securely datable painting, a *S. Giovanni Nepomuceno*, was signed and dated 1717.[2] This picture reveals a provincial idiom, certainly derived from Domenico, none of whose works survive, and gives little indication of the future course of either Antonio's or Francesco's art. Morassi assumes that Antonio later spent time in the workshop

of Sebastiano Ricci, and that he was influenced by Giambattista Tiepolo, who became his brother-in-law in 1719.

Francesco was undoubtedly trained by his older brother and must have come by degrees to assume responsibility in the workshop; a reference to joint work by the Guardi brothers dates to 1731, when Francesco was nineteen. There is, however, no mention of Francesco in the records of payment to Antonio for free copies after older masters done for Maresciallo Schulenburg between 1730 and 1745; and, indeed, the first evidence of Francesco's activity independent of Antonio dates only to 1750. With the death of Antonio in 1760, however, such notices become more frequent. Francesco's name was inscribed in the *Fraglia* in 1761–63, and there is evidence that he enjoyed a certain reputation in Venice as a "buon scolaro del rinomato Canaletto," especially after the death of the latter in 1768. Sometime after 1766 he painted twelve pictures in honor of Doge Alvise IV Mocenigo, after prints by Brustolon;[3] in 1782 Francesco was commissioned to paint six paintings in honor of the visit of Archduke Paul Pavlovitch of Russia to Venice, five of which are known.[4] Four pictures to commemorate the visit of Pope Pius VI to Venice in the same year are now in different collections.[5]

In 1782 Francesco traveled to his ancestral home in Val di Sole; a drawing in the Museo Correr dated in that year is a souvenir of the trip. On this occasion he also painted for his hosts two *capricci*, which were formerly in the Chiesa Collection, Milan.

A portrait of *Andrea Dolfin* dates from 1783.[6] Other commemorative paintings date from the following years: in 1784 a *Mongolfiera*, now in Berlin,[7] and in 1789 *L'Incendio di S. Marcuola*, now in Venice.[8] Francesco's last datable painting, a *Regata sul Canal Grande*, now in Bologna, dates to 1791.[9] Francesco died in Venice on 1 January 1793.

While Francesco enjoyed considerable fame in his life and afterward as a view painter, his work as a figure painter, and the entire oeuvre of his brother Antonio, who seems to have worked exclusively as a figure painter, has been recovered only recently.[10] Given the few facts known about Francesco's youth and the organization of the Guardi workshop, we can only speculate about Francesco's training and early influences. His work as a figure painter followed closely that of Antonio and can be isolated from Antonio's only on the basis of a few signed works; their chronology can be suggested only from stylistic analysis.[11] Morassi's assumption that Francesco painted *vedute* from the beginning of his career, that is, from 1735–40, modeling them on those of Marieschi and Canaletto, the latter of whom he may have studied with, seems reasonable.[12] Certainly, Francesco's mature views are the central works in his oeuvre and constitute the last great flowering of the Venetian view tradition.

1. The reader is referred to the authoritative work by Morassi, 1973, for this and the following information. See also L. Bortolatto, *L'Opera completa di Francesco Guardi*, Milan, 1974; and Gorizia, 1987.

2. Morassi, 1973, I, 316, no. 52, II, fig. 53.

3. Morassi, 1973, I, 175–81, nos. 243–54, II, figs. 268–84.

4. Morassi, 1973, I, 182–84, nos. 255–57, 259–61, II, figs. 285–87, 289–90.

5. Morassi, 1973, I, 184–86, 358–60, nos. 262, 264, 266, 268, II, figs. 291, 293, 295, 297, 298, 299.

6. Morassi, 1973, I, no. 219, II, fig. 236.

7. Morassi, I, no. 310, II, fig. 336.

8. Morassi, 1973, I, no. 312, II, fig. 337.

9. Morassi, 1973, I, no. 308, II, fig. 335.

10. An account of the emergence of Antonio's artistic personality is in Morassi, 1973, I, 19–26.

11. Morassi, 1973, I, 144–60, discusses them thematically.

12. Morassi, 1973, I, 135, 209–10, 215–17; Succi in Gorizia, 1987, 57–82.

View of the Piazzetta, Venice

Oil on canvas, 47.3 x 77.2 cm (18⅝ x 30⅜ in.)

Condition: good. Faint scoring marks are visible in the Library.

Provenance: private collection, England; Durlacher Bros., New York, 1934; purchased by the Wadsworth Atheneum in 1935 from Durlacher Bros. for 3,000 pounds from the Sumner Fund.

Exhibitions: New York, 1934, no. 25; St. Louis, City Art Museum of St. Louis, *Eighteenth Century Venetian Paintings*, 1936, no. 8, repr.; Kansas City, 1937; Springfield, Mass., Museum of Fine Arts, *Francesco Guardi, 1712–1793*, 20 Feb.–21 Mar. 1937, no. 26; Colorado Springs, Colo., Colorado Springs Fine Arts Center, *Venetian Paintings of the Seventeenth and Eighteenth Centuries*, 1938; New York, 1939, no. 173; San Francisco, 1940, 12, no. 159; Baltimore, Johns Hopkins University, *Venice, Carnival, and Divertissements: Three Centuries*, 1941, no. 19, repr.; Hartford, *In Retrospect*, 1949, 10, no. 22; Dayton, 1951, no. 8; Sarasota, John and Mable Ringling Museum of Art, *The Artful Rococo*, 25 Jan.–13 Feb. 1953, no. 20; Hartford, 1956, 18, no. 25; New York, 1958, 90; Sarasota, 1958, no. 39; Allentown, Pa., Allentown Art Museum, *The Circle of Canaletto*, 21 Feb.–21 Mar. 1971, no. 27, repr.

The Ella Gallup Sumner and Mary Catlin Sumner Collection, 1935.62

From the Piazzetta S. Marco, enclosed by the facade of the Palazzo Ducale on the left and the Libreria Marciana on the right, one looks out to the Bacino di S. Marco. The facades of S. Giorgio Maggiore and, further, of the church of the Zitelle on the Giudecca are seen. Small figures fill the piazza, including, on the right, some vendors of chickens.

The Atheneum picture is one of a number of similar versions Guardi painted of this view throughout his career.[1] Scholars agree in placing the Atheneum version late in Guardi's career, in the 1770s, a dating justified by the high-keyed colors and deft, somewhat mechanical touch seen in the painting.[2]

A drawing by Guardi of the same subject, with some of the same figures, is also in the collection of the Wadsworth Atheneum (Fig. 27).[3] Whether this drawing is preparatory to the painting, as supposed by some scholars,[4] or was made after the painting, as supposed by others,[5] is unknown. It seems more likely that the drawing was used as a *ricordo* of a favorite composition that Guardi executed throughout his career. This would not exclude that the Atheneum painting is based roughly on the drawing; drawing and painting date from about the same time. J.C.

Francesco Guardi, *View of the Piazzetta, Venice*

Figure 27. Francesco Guardi, *The Piazzetta, Venice*, Hartford, Wadsworth Atheneum

1. Morassi, 1973, I, 379–81, nos. 364–70, II, figs. 391–97. The Atheneum version is no. 366, fig. 396. The attribution to Guardi has not been questioned; see *Art News*, XXXV, 30 Jan. 1937, 18; J. Clark, Jr., "Guardi's First One Man Show," *Art News*, XXXV, 27 Feb. 1937, 9–10; Constable, 1963, 1–20, repr.; Fredericksen and Zeri, 1972, 584.
2. J. Byam Shaw, oral communication, 29 Apr. 1963, dated it to about 1775; Morassi, 1973, I, 379, no. 366, to 1770–80.
3. 1936.336, pen and ink and brown wash over black chalk, 24.8 x 38.1 cm (9⅝ x 15 in.). See K. T. Parker, *Old Master Drawings*, 1932, VI, no. 21, pl. 8; sale London, Sotheby's, 17 June 1936, no. 54 (from the collection of the earl of Warwick); A. Morassi, *Guardi, tutti i disegni*, Venice, 1975, 137, no. 335, fig. 337.
4. Morassi, 1973, I, 379, no. 366.
5. J. Byam Shaw, oral communication, 29 Apr. 1963.

Giovanni Francesco Barbieri, called Guercino (1591–1666)

Malvasia has left a detailed and generally reliable account of the life and works of Giovanni Francesco Barbieri, called Guercino because of his squint.[1] He was born in Cento, a small town between Bologna and Ferrara, and baptized there on 8 February 1591.[2] Malvasia relates that Guercino was self-taught,[3] and, indeed, the minor local masters with whom he may have studied could only have taught him the technical rudiments of painting.[4] Guercino's admiration for the art of the Carracci, in particular Ludovico,[5] is borne out in early frescoes (1614) in the Casa Provenzale at Cento, which show clear borrowings from the Carraccis' own decoration in the Palazzo Fava in Bologna.[6]

While Guercino's earliest commissions seem to have been for decorative works,[7] he quickly established himself as a painter of altarpieces and history paintings. The *Triumph of All Saints*, painted in 1613 for the church of the Holy Spirit at Cento, now known only through copies, was his first important commission in this genre, secured through the efforts of the canon Antonio Mirandola, who became his mentor.[8] Commissions for other altarpieces followed; the painting of the *Madonna and Child with Saints Joseph, Augustine, Louis, and Francis and a Young Donor* for the church of S. Agostino at Cento, and today in Brussels, dates to 1616 and is a pivotal work of his early style.[9] He soon became known in Bologna,[10] and eventually came to the attention of Cardinal Alessandro Ludovisi, for whom he painted several pictures, including the *Susanna and the Elders* in Madrid.[11] He traveled to Ferrara in 1619 to work for Cardinal Serra, papal legate, for whom he painted several pictures, including the *Samson Captured by the Philistines*, now in the Metropolitan Museum of Art in New York,[12] and to Mantua in 1620 to deliver the painting of *Erminia and the Shepherd* to Duke Francesco Gonzaga.[13] The large altarpiece of the *Investiture of St. William*, painted for the church of S. Gregorio at Bologna, was painted in 1620 and is the major work of his early career.[14]

When his patron Alessandro Ludovisi was elected pope on 9 February 1621, taking the name Gregory XV, Guercino, along with Domenichino and other Bolognese artists, was called to Rome, where some of his most memorable works, including the *Aurora* fresco in the Casino Ludovisi and the altarpiece of the *Burial of St. Petronilla* for St. Peter's, were painted. The death of the pope on 8 July 1623 brought Guercino back to his native Cento, where he worked steadily, producing major works for important patrons. His Roman experience was not forgotten, however, and his style, formerly a personal blend of North Italian pictorial traditions, changed slowly but perceptibly toward a more classicizing idiom, influenced by the artistic climate he would have known in Rome, and in particular the ideas of G. B. Agucchi, secretary to Gregory XV and an influential art theorist.[15] Starting in 1629, an account book kept by Guercino's brother Paolo Antonio documents Guercino's production year by year.[16] A detailed discussion of Guercino's later career and the evolution of his style is provided in Salerno.[17]

From early in his career, Guercino had many students and collaborators. He is known to have collaborated with a certain Lorenzo Genari on frescoes in the Casa Pannini in Cento in 1615–17,[18] and Malvasia mentions Guercino's Accademia del Nudo, started in Cento in 1616, which numbered twenty-three students the next year.[19] After his return from Rome, Guercino maintained a large workshop that was occupied with, among other things, copying his compositions.[20] Among his students were his nephews Benedetto and Cesare Gennari. Ercole Gennari, his brother-in-law, assumed the running of the workshop after the death in 1649 of Guercino's brother Paolo Antonio, and his nephews inherited the contents of the workshop, including drawings, after Guercino's death.[21]

Guercino is one of the principal artists of the generation following the Carracci. Whether in the early baroque naturalism of his youthful career or the classicizing idiom of his late years, his works number among the monuments of seventeenth-century Italian painting.[22]

1. Malvasia, 1841, II, 255–74; see also Bologna, 1968, 2–9, on Malvasia's research methods and his value as a source.
2. Mahon, 1947, 11, n. 1.
3. Malvasia, 1841, II, 256.
4. Malvasia, 1841, II, 256, mentions brief apprenticeships with local painters Paolo Zagnoni, who, as Mahon, in Bologna, 1968, 9, n. 23, points out, lived at the time in Bologna, and Giovanni Battista Cremonini, a decorative painter in Bologna. Malvasia (II, 257) also mentions an apprenticeship with Benedetto Gennari in 1607, after which time, until Gennari's death in 1610, Guercino was his collaborator.
5. Malvasia, 1841, II, 256, relates Guercino's admiration of Ludovico's altarpiece of the *Holy Family with St. Francis and a Donor*, painted in 1591 for the church of the Capucins at Cento, and his *Conversion of St. Paul* of 1587–89, in the church of S. Francesco in Bologna.
6. D. Mahon, "Notes on the Young Guercino I.—Cento and Bologna," *Burlington Magazine*, LXX, 1937, 117–22.
7. R. Roli, *I Fregi centesi del Guercino*, Bologna, 1968. Bologna, 1968, 12–13.
8. Bologna, 1968, 11.
9. Bologna, 1968, 16–17, 51–52, no. 19.
10. Letters from Ludovico Carracci on 19 July and 25 Oct. 1617 confirm Guercino's presence in Bologna and his work for Cardinal Ludovisi; see G. Bottari, *Raccolta di lettere sulla pittura*, 1754, I, 198–99, 208–9, as cited in Bologna, 1968, 45.
11. Malvasia, 1841, II, 258; Bologna, 1968, 46, 53–54, no. 21.
12. D. Mahon, "Guercino and Cardinal Serra: A Newly Discovered Masterpiece," *Apollo*, CXIV, 1981, 170–75.
13. Bologna, 1968, 75–77, 85–87, no. 37.
14. Bologna, 1968, 76, 95–99, no. 43.
15. For Guercino's change of style, see Mahon, 1947, 11–108; for a contrary view, see D. Posner, "The Guercino Exhibition at Bologna," *Burlington Magazine*, CX, 1968, 600–604.
16. The document is now in the Biblioteca Comunale in Bologna, MS B.331, and was first published by J. A. Calvi, *Notizie della vita e delle opere del Cavaliere Gioan Francesco Barbieri detto il Guercino da Cento*, Bologna, 1808; reprinted in Malvasia, 1841, II, 305–43.
17. Salerno, 1988.
18. Bologna, 1968, 12.
19. Malvasia, 1841, II, 258; Bologna, 1968, 13.
20. Bologna, 1968, 127–28.
21. Malvasia, 1841, II, 268; D. Mahon, "Drawings by Guercino in the Casa Gennari," *Apollo*, CI, 1968, 346–57.
22. D. Mahon in Washington, 1986–87, 457–82.

Workshop of Guercino
St. Sebastian with Armor

Oil on canvas, 120.2 x 145.7 cm (47⅝ x 57⅝ in.)

Comparison with the engraving (see note 1 below) suggests that the painting has been cropped at the left, also possibly at the right.

Condition: fair. The painting has been lined at least once and rubbed extensively. There is evidence of retouching throughout, especially in the saint's torso. The landscape at the left has darkened.

An old backing has the arms of the earl of Caledon and is inscribed in ink: N. 69.

Provenance: collection Marchese Alessandro Curti Lepri, Rome;[1] Lord Caledon, London;[2] sale London, Christie's, 9 June 1939, no. 28, bought by Lambert for 21 guineas; purchased by the Wadsworth Atheneum in 1943 from Arnold Seligmann, Rey & Co. for $5,500 from the Sumner Fund.

Exhibitions: Hartford, *Men in Arms*, 1943, no. 4 (lent by

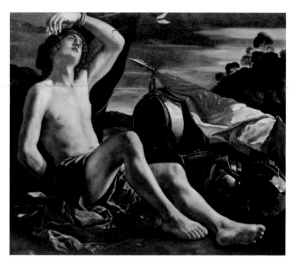

Workshop of Guercino, *St. Sebastian with Armor*

Arnold Seligmann, Rey & Co., New York); Hartford, 1946, 11, no. 29; Northampton, 1947, no. 8; Hartford, *In Retrospect*, 1949, 7, no. 5; Seattle, 1954, no. 5; South Hadley, Mass., Mount Holyoke College, *Drawings by Guercino and His Circle*, 8 Apr.–3 May 1974, no. 24 in catalogue *Five College Roman Baroque Festival*.

The Ella Gallup Sumner and Mary Catlin Sumner Collection, 1943.100

The subject of the wounded St. Sebastian is found in the *Golden Legend* of Jacobus de Voragine. Sebastian was a member of the Praetorian guard under the emperor Diocletian in the third century A.D. When the emperor discovered he was a Christian, he ordered him to be tied to a stake in the Campus Martius and shot with arrows. He was left for dead, but cured by the attentions of St. Irene, he recovered. He was eventually beaten to death. In the Atheneum picture the saint, his wrists bound, reclines against a tree. A single arrow pierces his arm. Discarded armor and a furled red and white banner are piled at his side. In the background is a distant landscape.

Guercino painted St. Sebastian numerous times in his career. The earliest known example is a painting on copper of *St. Sebastian Attended by Two Angels,* which is inscribed on the reverse with Guercino's name and the date 1617.[3] Malvasia describes several pictures of the subject; the wounded St. Sebastian being attended to by several figures was painted in 1619 in Ferrara for Cardinal Jacopo Serra;[4] a St. Sebastian painted in 1642 for Dotter Niccolò Lemmi of Bologna;[5] another painted in 1652 for Cardinal Macchiavelli;[6] a half-length figure, painted, along with a Sofonisba, for Giovanni Donato Coreggio Veneziano in 1654;[7] and another, paired with a Mary Magdalene, painted in 1658 in Rome for Girolamo Pavese.[8]

The Atheneum picture cannot be positively identi-fied with any of the pictures cited in the written sources. Moreover, the style of the Atheneum picture suggests that it was not painted by Guercino himself. The clumsy drawing and crude shading exclude the hand of the master, even if the abraded condition of the paint surface is taken into account. That it was painted by one of Guercino's many students and followers is likely, and, indeed, Lorenzo Genari has been proposed as its author.[9] Mahon suspected that the Atheneum picture was an independent composition by a follower of Guercino, rather than a copy of a lost work by the master.[10]

The date of the Atheneum picture is difficult to determine. The style is based on pictures of Guercino dating to the years following his return to Cento from Rome in 1623. The mobile light and dense compositions of Guercino's pre-Roman works are gone, yet the coloring of the Atheneum picture retains some of the richness of the master's early works. The picture was probably executed by a student who studied with Guercino during the 1620s and would date to this apprenticeship period or later.[11]

Parker associated a drawing in Oxford with the Atheneum picture.[12] Mahon and Turner, however, have associated the Oxford drawing and another drawing at Windsor with the *Martyrdom of St. Laurence* at Ferrara.[13]

J.C.

1. According to an engraving in the Bibliothèque Nationale, Paris, *Oeuvre de Francesco Barbieri dit le Guerchin*, XXXIV, engraved by Giovanni Folo (Bassano 1764–Rome 1836), after the drawing of Agostino Tofanelli (Lucca 1770–Rome 1834); information communicated in a letter from L. Salerno to M. Mahoney, 22 Aug. 1983, curatorial file. The Curti Lepri Collection was sold 29 Mar. 1841. The single known copy of the catalogue was in the collection of Mme Marcel Nicolle, 6 Villa Spontini, Paris, according to Lugt; neither this nor any other copy was located in the course of our research.
2. Cited by Waagen, 1857, 148, as *St. Sebastian reclining against a tree.*
3. Collection of Simon Morrison; Mahon in Bologna, 1968, 44.
4. Malvasia, 1841, II, 259; Salerno, 1988, 131, no. 54, now Bologna, Pinacoteca.
5. Malvasia, 1841, II, 265; Salerno, 1988, 279, no. 198. This painting is now in the Pushkin Museum in Moscow.
6. Malvasia, 1841, II, 269; Salerno, 1988, 359, no. 289. Guercino's account book describes this (333) as "S. Sebastiano con un Puttino di sopra." It is now in the Galleria Palatina, Florence.
7. Malvasia, 1841, II, 270; Salerno, 1988, 411, no 357, tentatively identifies this picture with one in the Museo de Arte de Ponce, Puerto Rico.
8. Malvasia, 1841, II, 271; Salerno, 1988, 411, no. 357; untraced.
9. L. Salerno, letter to M. Mahoney, 26 Sept. 1983, curatorial file; Salerno, 1988, 427. The manuscript list of pictures painted by Benedetto Gennari from his departure for Paris in 1672 and London in 1709, now in Bologna, Biblioteca Comunale, MS B.344, does not contain any reference to a picture of St. Sebastian. The manuscript biographies by M. Oretti, "Notizie de' professori del disegno," Bologna, Biblioteca Comunale, MS B.128, fol. 167, cite a picture painted by Benedetto Gennari: "Per il cardinale Macchiavelli un S. Sebastiano." Without further description it is impossible to identify this with the Atheneum picture or to assess its relationship to the picture by Guercino mentioned by Malvasia; see above, note 6.
10. Letter to C. Cunningham, 1 Apr. 1963, curatorial file.
11. Salerno, 1988, 427, dates it to the middle 1620s.
12. Parker, 1956, II, 449, no. 874.
13. Mahon and Turner, 1989, 28, no. 51.

Gregorio Lazzarini
(1655–1730)

Gregorio Lazzarini was born in Venice in 1655, the son of a barber. His biographer, Vincenzo da Canal, writing only two years after the artist's death, says his father consented to apprentice the boy to the Genoese painter Francesco Rosa, with whom he stayed for two years.[1] After Rosa, Lazzarini studied with Girolamo Forabosco, in da Canal's words, "per correggervi le opere proprie, per apprendere il buon fare,"[2] evidently to mitigate the vigorous chiaroscuro and exuberant brushwork of Rosa in favor of the smooth surfaces and continuous contours of the neo-Renaissance Forabosco. He was also in contact with Pietro della Vecchia and Ludovico David, who were part of an academy in S. Trovaso and undoubtedly nourished the academic and classicizing tendencies Lazzarini had shown.[3]

A large number of surviving works dated by da Canal allows us to trace Lazzarini's career. The earliest certain work is a portrait, perhaps of Antonio Correr, that is signed and dated 1685, now in the National Gallery in London.[4] The large *S. Lorenzo Giustiniani Distributing Alms* of 1691, in the church of S. Pietro di Castello in Venice, shows the classicizing taste and conservative attitude that characterize his career.[5] Further datable works include the *Saints Bernardo, Mauro, Placido, and Scolastica* of 1692, now in Bergamo;[6] and the *Orfeo and the Baccants* of 1698, now in the Ca' Rezzonico, which, with its many convoluted figures, marks the apogee of his classical leanings.[7]

In 1694 he executed six paintings for the Sala dello Scrutinio in the Palazzo Ducale, a certain sign of artistic maturity and success; and, indeed, by the last years of the century his fame was widespread. Commissions from patricians of Venice and the Veneto, as well as numerous foreigners, including the counts Schönborn and the princes of Liechtenstein, poured in. As Pallucchini has remarked, Lazzarini's academic leanings linked him with similar currents that were forming in other centers of Italy.[8]

Lazzarini's works from the first years of the eighteenth century show a more energetic tone and decorative colors, for example, the *Fall of Manna* and *Moses Striking the Rock* of 1706, in the storerooms of the Venetian galleries.[9] Yet the late *Probatica Piscina* of 1719, in the Cini Foundation, shows that to the end the firm drawing and carefully orchestrated groupings he had formulated in his youth persisted.[10]

Lazzarini had assured success with neoclassical critics, among them Zanetti;[11] however, it is ironic, as notes Pallucchini, that today he is best known through his pupil Giambattista Tiepolo, who ultimately rejected the tradition of which Lazzarini was the last faithful exponent in Venice.[12]

1. Da Canal, 1809, 21–22; Pallucchini, 1981, I, 376.
2. Da Canal, 1809, 23.
3. Da Canal, 1809, 24–25.
4. Levey, 1971, 149–50, no. 3933; Pallucchini, 1981, II, fig. 1222.
5. Da Canal, 1809, 42–43; Pallucchini, 1981, I, 377, II, fig. 1220.
6. Pallucchini, 1981, II, fig. 1223.
7. Pallucchini, 1981, II, fig. 1225.
8. Pallucchini, 1981, I, 378.
9. Pallucchini, 1981, I, 378.
10. Pallucchini, 1981, II, fig. 1229.
11. Zanetti, 1771, 441–42; Pilo, 1958, 233–44.
12. Pallucchini, 1981, I, 380.

Gregorio Lazzarini, *The Virgin in Glory with the Trinity and Saints Anthony of Padua, Catherine, John the Baptist, Francis?, and Anthony Abbot (or Roch?)*

The Virgin in Glory with the Trinity and Saints Anthony of Padua, Catherine, John the Baptist, Francis?, and Anthony Abbot (or Roch?)

Oil on canvas, 84.4 x 48.9 cm (33 1/2 x 19 1/4 in.)

The canvas originally had an arched top, which has been made into a rectangle with the addition of canvas spandrels. The top right spandrel is a more recent addition than the left one, perhaps made to replace a deteriorated piece of canvas.

Condition: good. Ultraviolet examination shows many scattered retouches, especially along the bottom edge. The original blue pigment in the Virgin's robe has deteriorated.

Provenance: collection Clara Louise Kellogg Strakosch; given to the Wadsworth Atheneum in 1914 by Clara Louise Kellogg Strakosch.

Gift of Clara Louise Kellogg Strakosch, 1914.9

This picture would seem to be one of the highly finished *modelli* that, da Canal reports, Lazzarini sold toward the end of his life.[1] Such carefully painted sketches are probably records of already finished compositions, rather than preparatory sketches. Unfortunately, the large altarpiece from which the Atheneum picture was evidently made is not mentioned by da Canal, nor has it emerged in recent years.[2] The style, however, with its strongly modeled figures, is characteristic of Lazzarini.[3] It would appear to date from his mature period, after 1710.

J.C.

1. Da Canal, 1809, 47.
2. As A. Rizzi, "Aggiunte a Gregorio Lazzarini," *Antichità viva*, VI, 1973, 14, remarks, the oeuvre of this prolific master is far from being complete.
3. A. Morassi, letter to C. Cunningham, 24 May 1955, curatorial file, confirmed the attribution to Lazzarini.

Pietro Longhi
(1702–1785)

Documents allow only a sketchy view of the life of Pietro Longhi.[1] He was born in Venice in 1702, the son of a goldsmith named Alessandro Falca, and became a pupil of Antonio Balestra, then, in Bologna, of Giuseppe Maria Crespi. He had returned to Venice by 1730, and married in 1732. He was enrolled in the *Fraglia dei pittori* in 1737, where his name appears until 1773.[2] He was also recorded as a member of the Venetian Academy in 1762 and the director of a school of drawing in the Pisani Palace between 1763 and 1766. His death is recorded 8 May 1785.[3]

Among Longhi's earliest surviving pictures are traditional subjects, such as the *S. Pellegrino Condemned to Death* in the parish church in S. Pellegrino, datable to 1729–32,[4] the *Adoration of the Magi* in the Scuola di S. Giovanni Evangelista,[5] and the *Fall of the Giants*, frescoes in the staircase of the Ca' Sagredo, dated 1734.[6] Longhi's biographers report, however, that such works did not find favor, and that he subsequently concentrated on genre pictures of the kind he might have seen in Bologna in the workshop of Crespi.[7] Longhi's depictions of the activities of the bourgeoisie and upper classes of Venice were immediately successful, and he produced them, frequently for important Venetian patrons, with little variation from 1741, the date on the *Concert* in the Gallerie dell'Accademia, Venice, until his death more than forty years later.[8] He also painted portraits, some of which are distinguished, which served as models for his son Alessandro, who became a successful portraitist.

In spite of his limited range, Longhi was praised by contemporaries for his depictions of everyday persons and events. His most notable admirer was perhaps the dramatist Carlo Goldoni, who wrote a sonnet in praise of him.[9] While Longhi's pictorial antecedents are well understood, his links to contemporary Venetian society and to the theater are only now beginning to be studied.

1. The documents are conveniently reprinted in Pignatti, 1969, 51–56. Essential contemporary sources include Orlandi, 1753, 427, and his biography by his son A. Longhi, 1762, n. p.
2. Pignatti, 1969, 49.
3. Pignatti, 1969, 50.
4. Pignatti, 1969, 84, pl. 1.
5. Pignatti, 1969, 104, pl. 2.
6. Pignatti, 1969, 91, pls. 3, 5, 6.
7. Orlandi, 1753, 427; Longhi, 1762, n.p.
8. Pignatti, 1969, 93, pl. 37.
9. Sohm, 1982, 256–73.

The Temptation

Oil on canvas, 61 x 50.2 cm (24 x 17 1/4 in.)

Condition: fair. There are many retouchings, especially in the background and central figure.

Provenance: collection Prince Alberto Giovanelli, Venice; Adolf Loewi, Venice; purchased by the Wadsworth Atheneum in 1931 from Adolf Loewi for $5,000 from the Sumner Fund.

Exhibitions: Venice, *Il Settecento italiano*, 1929, no. 34, repr.; Northampton, 1932; Springfield, 1933, 28, no. 77; Cambridge, Mass., Fogg Art Museum, 1938; New York, New York World's Fair, 1940, no. 33; Hartford, 1956, 19, no. 35, fig. 16.

The Ella Gallup Sumner and Mary Catlin Sumner Collection, 1931.188

A young, smartly dressed lady looks up from her sewing, while a monk holds up his glass to observe.[1] Other women, more plainly clothed, concentrate on sewing, lacemaking, and hat making. The exact meaning of this scene is, as in many of Longhi's works, elusive. The traditional title of the work, *The Seduction*, imputes lecherous intentions to the young monk, but these are not overt.[2] Gestures in Longhi's paintings are frequently ambiguous, although the intensity of the monk's gaze leaves little doubt of the object of his scrutiny. That the monk's emphatic stare goes unnoticed by the other characters has been interpreted as the pictorial equivalent of the dramatic aside.[3]

As Pignatti has noted, Longhi painted other works with shared motifs; in the *Singing Test*, the figure of the monk in the Atheneum picture reappears to watch a lady sing;[4] in the *Visit from a Friar* in the Ca' Rezzonico, a monk gestures to a lady reading. In the *Needlework School*, also in the Ca' Rezzonico, a young man and an old lady selling biscuits interrupt a seamstress (Fig. 28). The setting in this work, with the caged bird above, perhaps signifying virtue intact, is identical to that in the Atheneum picture. It is unlikely that these works were associated in any formal way, but were rather variations on a theme, made at various points in Longhi's career.[5]

Figure 28. Pietro Longhi, *Needlework School*, Venice, Ca' Rezzonico

Pietro Longhi, *The Temptation*

Figure 29. Pietro Longhi, *Lacemakers*, Venice, Museo Correr

A drawing in the Museo Correr, Venice, shows preliminary sketches for the two seated ladies in the left background (Fig. 29).[6] Longhi appears to have interpolated them into his composition without the benefit of a compositional sketch, as was his habit.[7]

Although Longhi's chronology is difficult to establish precisely, a date of 1740–50 is perhaps reasonable.[8] J.C.

1. The distinction in the dress of the young woman in the center has led to her identity as the wife of the owner of a workshop or boutique; see M. Bobbioni, "Contributo a uno studio sulla moda popolare a Venezia e suo territorio durante il XVIII secolo," *Antichità viva*, XX, no. 2, 1981, 32.
2. Bibliography includes A. Rava, *Pietro Longhi*, Florence, 1923, pl. 99, as *La Scuola di lavoro*; H.-R. Hitchcock, Jr., *Wadsworth Atheneum Bulletin*, Oct. 1931, 28, repr.; U. Ojetti, *Il Settecento italiano*, Milan-Rome, 1932, I, no. 63, pl. XLIV; H. Comstock, "Panels by Pietro Longhi from the Giovanelli Collection," *Connoisseur*, XCVII, 1936, 161–62; *Worcester Art Museum Annual*, V, 1946, 60, 62, fig. 10; A. Morassi, "Una Mostra del settecento veneziano a Detroit," *Arte veneta*, VII, 1953, 55; V. Moschini, *Pietro Longhi*, Milan, 1956, 24, fig. 86; F. Valcanover, *Pietro Longhi*, Venice, 1956, 27, pl. 99; Pignatti, 1969, 76, pl. 100; Pignatti, 1974, 92, no. 74, pl. XXV; R. Bagemihl, "Pietro Longhi and Venetian Life," *Metropolitan Museum Journal*, XXIII, 1988, 243.
3. Sohm, 1982, 269.
4. Pignatti, 1969, fig. 198a.
5. Pignatti, 1969, 20–24.
6. No. 474, black and white chalk on brownish paper, 288 x 420 mm; Pignatti, 1969, 109, pl. 99.
7. On Longhi's drawing procedure, see Venice, Sala Napoleonica, *Pietro Longhi dal disegno alla pittura*, 9 Aug.–4 Nov. 1975, exh. cat. by T. Pignatti.
8. Pignatti, 1974, 92, no. 73.

Follower of Pietro Longhi
Portrait of a Violinist

Oil on canvas, 43.2 x 33.2 cm (17 1/2 x 13 1/8 in.)
 Condition: fair. The canvas is covered with yellowed varnish.
 Provenance: The previous history of the picture is unknown.
Given to the Wadsworth Atheneum in 1940 by Julius Weitzner.
 Exhibitions: Westport, Conn., Westport Community Art Association, *Music in Art*, 25 Mar.–13 Apr. 1963, no. 3.
 Gift of Julius Weitzner, 1940.421

The sitter for this modest portrait has not been identified. It has been suggested that it represents the violinist and composer Francesco Geminiani (1679/80–1762), whose portrait by Thomas Jenkins was engraved by James McArdell.[1] Felice Giardini (1716–1796), a violinist and conductor who worked largely in London, has also been suggested.[2] Neither of these identifications can be confirmed, and comparisons of the Atheneum portrait with engraved likenesses are not convincing. The way the sitter holds his bow, turned sideways rather than in a playing position, suggests that he may not be an accomplished musician, but rather an amateur who wished to appear musical. On the other hand, this detail may reflect more on the painter's lack of skill than the sitter's.

When it was acquired, the *Portrait of a Violinist* was attributed to a follower of Pietro Longhi. Although subsequently attributed by Voss to the minor Florentine artist Giovanni Martinelli,[3] the ascription to a follower of Longhi has been confirmed by M. Gregori.[4] The modest quality of the painting makes it unlikely a more precise attribution can be advanced. J.C.

1. H. Linebach, oral communication, 19 May 1948; see F. Giegling, "Francesco Geminiani," in *Die Musik in Geschichte und Gegenwart*, 1955, IV, 1690–96, fig. 1.
2. Note in curatorial file; see C. Cudworth, "Felice Giardini," in *Die Musik in Geschichte und Gegenwart*, 1956, V, 84–88. G. Kinsky, *A History of Music in Pictures*, London, 1929, 212, fig. 3, reproduces a portrait engraving of Giardini by Bartolozzi after G. B. Cipriani.
3. J. Weitzner, letter to A. E. Austin, 1 June 1938, curatorial file.
4. Oral communication, 27 Nov. 1983.

Follower of Pietro Longhi, *Portrait of a Violinist*

Alessandro Magnasco
(c. 1667–1749)

Born in Genoa, Magnasco moved to Milan in 1677. According to his late eighteenth-century biographer, Carlo Ratti, he studied with Filippo Abbiati and painted portraits. The latter activity, otherwise unknown, might be echoed in the Atheneum's later *Medici Hunt*, a picture said by Ratti to contain portraits. In Milan he emerged as a highly original staffage painter, providing the figural components for architectural compositions executed by other artists, some known, such as Clemente Spera, others unknown, as perhaps in the Atheneum's *Presentation in the Temple*. Similarly, he provided figures for landscape compositions by such artists as Antonio Francesco Peruzzini. Collaboration with the latter would seem to have continued into the first decade of the new century, when Magnasco was in Tuscany still contributing to collaborative works, but where he increasingly figures as a precipitating influence in the development of eighteenth-century art, for by that time he had certainly encountered and affected Sebastiano Ricci, a germinal figure in the eighteenth-century efflorescence of Venetian art (see the *Medici Hunt* below). After his return to Milan at the beginning of the second decade of the century, Magnasco's figural style settled into his intensely individual idiom, one so painterly and so animated that it often verges on the frantic. He now set his religious, genre, and fanciful subjects in landscapes of his own execution, ultimately dependent stylistically on Salvator Rosa, but frothed forth with Magnasco's very personal verve. After a prolific maturity spent in Lombardy, he returned to Genoa in 1735. Magnasco's rococo vivacity of spirit and brush is summed up particularly well in a number of late works depicting cultivated pastimes in patrician nunneries, paintings so exaggeratedly stylish in every sense as to verge on the satiric. The Atheneum's *Cloister School* must record such a singular, but now lost work.[1]

1. See, most recently, Milan, 1991, 107–12.

Alessandro Magnasco and a Collaborator (Marco Ricci?)
A Medici Hunting Party

Oil on canvas, 86.0 x 117.3 cm (33⅞ x 46³/₁₆ in.)
 Condition: good. Surface cleaned at the Atheneum in 1983; both landscape and figures are in fine condition.
 Provenance: A. G. H. Ward, Hampstead, London. Purchased by the Wadsworth Atheneum in 1937 from M. Knoedler & Co., New York and London, for $3,500 from the Sumner Fund.
 Exhibitions: Springfield, 1938, no. 14; New York, Durlacher Bros., 1940, no. 11; Baltimore, 1942; Dayton, 1962, no. 44; Louisville, 1967, no. 23; Detroit, 1974, no. 163.
 The Ella Gallup Sumner and Mary Catlin Sumner Collection, 1937.84

Voss first connected this picture with an anecdote in Carlo Ratti's 1797 biography of Alessandro Magnasco, an episode associated with the painter's sojourn in Florence, where he married a Genoese compatriot and where, as an artist of the "nuova maniera," he was well received. Ratti recounts how the grand duke, having taken a liking to Magnasco from whom he had commissioned some landscapes, invited the artist to hunt with him one day. Pursuing their quarry they came upon a court jester concealed in the bushes relieving himself. The huntsmen pretended the buffoon was their prey and turned upon him, forcing the unfortunate jester to let go of his trousers and throw up his arms to plead for mercy. Greatly diverted, the grand duke immediately commissioned Magnasco to record the incident. Magnasco captured the scene dexterously and so exactly, Ratti reports, that portraits of all present were included. When the picture was hung, it was the amusement of the court and all who saw it.[1]

Thus the gesticulating figure partially concealed on the left would be the beleaguered buffoon. The Medici coat of arms in the center foreground reinforces the identification proposed by Voss, who also suggested the man seen in three-quarter view behind the principal male figure on the right is a Magnasco self-portrait.[2] But as Voss further pointed out, Ratti's identification of the principal in these events as Grand Duke Gian Gastone de' Medici (1671–1737) presents problems. Gian Gastone did not succeed to the grand ducal title until 1723, when Magnasco would have been approximately fifty-six,[3] that is, at an age older than one at which he could be expected to have married in Florence, as Ratti says he did. In addition, by the mid 1720s the artist was already long reestablished in Milan, the locus of the major portion of both his early and his mature activity. In fact, from the first, investigators proposed Magnasco's Florentine stay occurred during the first decade of the century.[4] Consequently, Voss proposed Ratti referred to Gian Gastone by his *eventual* title, that is, this picture was executed prior to his succeeding in 1723. But Voss recognized the difficulty then remaining: who is the woman also prominently featured in the picture, for Gian Gastone had no wife with him in Florence.[5] In 1697 he had married the widowed princess of Saxe-Lauenburg, but after ten years living near Prague with this horsy and ugly woman, Gian Gastone returned to Florence, in 1708, alone.[6] Chiarini proposed that the Medici prince in Ratti's account was not the future grand duke, but his remarkable and cultivated elder brother, Ferdinand.[7] Grand Prince Ferdinand de' Medici (1663–1713) was a collector and a patron of musicians, artists, writers, and scholars. For a brief moment, together with his like-minded uncle, Cardinal Francesco Maria, Ferdinand made Florence once again a vital center of Italian culture. To him is owed one of the most splendid bloomings in the family's long tradition of patronage, but its last. At his premature death in 1713, the city lapsed into artistic provincialism; his younger brother eventually succeeded, and, thereafter, the dynasty soon faded into extinction.[8]

Ferdinand's love for the intimate and spontaneous, as well as his love for the hunt, are in perfect accord with Magnasco's realization of the scene here—in that "nuova maniera" that must have precisely appealed to Ferdinand's distaste for the formality of late seventeenth-century official painting. Be that correct, the woman restraining Ferdinand would then be his wife, Princess Violante of Bavaria, and the setting conceivably evokes Pratolino, the grand prince's favorite villa.[9] Chiarini's overall hypothesis is supported by Gregori's reasonable proposal that documents of 1703 demonstrate Magnasco had

arrived in Tuscany by April of that year and had executed the figures in two landscapes painted by Antonio Francesco Peruzzini for Grand Prince Ferdinand.[10]

Chiarini's final suggestion that the man in spectacles to the left of the principal female figure might be a portrait of Sebastiano Ricci is a stimulating one,[11] for it leads to the larger question regarding this painting. While at first sight the work is an agreeably stylish early eighteenth-century courtly conversation piece, it actually is a central document in the current scholarly attempt to reconstruct the evolution of North Italian landscape painting in the early eighteenth century.

Grand Prince Ferdinand's taste favored the Venetian school, both the old and what to him were contemporary masters. Among the latter he was particularly close to Sebastiano Ricci. During the first decade of the century, Sebastiano was entrusted by Ferdinand with important commissions for easel pictures and, together with his nephew, Marco Ricci, came to Florence to execute fresco programs for the grand prince and the Marucelli family.[12] As Sebastiano and Marco were the founders respectively of the eighteenth-century Venetian grand figural and landscape styles, any influences that shaped their contributions to the culminating decades in the mid century of the great Venetian tradition must be important. The formative influence of Magnasco on Sebastiano's figure style has been long acknowledged,[13] and there has been persistent controversy over attributing certain works to one or to the other.[14] The conjunction of both artists in Florence would obviously be a major occasion to kindle or rekindle this exchange, depending upon whether or not it was Sebastiano's first exposure to Magnasco.[15]

However, Chiarini's suggestion that this picture actually records the simultaneous presence of both artists in Florence is not the last piquant hypothesis the painting has elicited.[16] The moment this painting appeared in the late 1930s[17] it was recognized as a work of great interest by Magnasco, even to the extent of being cited as the artist's most important work for the grand ducal court.[18] However, it was immediately pointed out that while Magnasco's individual manner was recognizable in the figures, the conception and treatment of the landscape setting was unusual for his hand, but perhaps to be explained by the fact the artist felt constrained to observe a degree of fidelity to nature in a commission presumably recording an actual event.[19] Alternatively, it was suggested the work is a shared effort: the figures being by Magnasco and the landscape setting by a collaborator.[20] Such collaboration had already been described by Ratti, who spoke of "Perugini," a landscape painter, and of Clemente Spera, who painted ruins and architectural settings, as only two of the many painters in Milan for whose pictures Magnasco supplied the figures.[21] Although many see

the work of two hands here,[22] the identity of the collaborator remains in question. Peruzzini, the landscapist working in 1703 with Magnasco in Tuscany for the grand prince, immediately springs to mind. This must be the "Perugini" mentioned by Ratti and cited in variant spellings in many old inventories as Magnasco's collaborator.[23] The nature of Peruzzini's style was definitely established when Arslan connected a large Temptation of St. Anthony in the Porro Collection near Milan with an entry in a December 1707—and, therefore, presumably authoritatively contemporary—family inventory wherein the artists are identified as "Perugini" and "Rizzi." The former, Arslan reasonably suggests, is Antonio Francesco Peruzzini from Ancona, born supposedly in 1668, active particularly in Milan, and whose specialty was landscape backgrounds.[24] The landscape in the Porro Temptation, an animated interpretation of Salvator Rosa's style, thus is the key work on which further Peruzzini attributions have rested.[25] It is perfectly apparent from the Porro painting and paintings thereafter associated with Peruzzini that the landscape in the Medici Hunt is not to be assigned to this artist's oeuvre as it is now reconstituted.[26] Arslan identified the second painter of the Porro Temptation, "Rizzi," as Sebastiano Ricci. Gregori published evidence of additional contact between Sebastiano and Peruzzini: firstly, the record in an inventory of 1698 of another collaborative painting; and secondly, the startling fact that in Bologna Sebastiano ran off with Peruzzini's daughter.[27] Further contacts between Peruzzini and the Ricci family were discovered by Pilo, who found a record citing "Perugini" as Marco Ricci's teacher.[28] If one accepts that the "Perugini" documented as Magnasco's and Sebastiano Ricci's collaborator as well as Marco Ricci's one-time teacher is one artist, and that he is Antonio Francesco Peruzzini,[29] then herein might lie the explanation of the process by which Salvator Rosa's mid seventeenth-century landscape style infused North Italian landscape painting in the early eighteenth century: via Peruzzini to Marco Ricci, the transfer mediated by the one being in seemingly long-term contact with the other owing to each collaborating with Magnasco and/or Sebastiano Ricci.[30] Chiarini, finally, in addition to proposing the picture here contains a portrait of Sebastiano Ricci, speculated that Marco Ricci is responsible for the landscape.[31] Our knowledge of the dates when Sebastiano and Marco were both in Florence is possibly fragmentary. Sebastiano Ricci and his nephew were certainly there after May 1706 until at least late 1707 to execute their famous fresco commissions.[32] But the fact that Magnasco and Marco Ricci are documented to have both contributed to a painting dated 1705 with a provenance from a prominent Florentine collection[33] suggests there might have been more visits than those documented to date.[34] While the attribution of the landscape here to Marco Ricci has not been unanimously accepted,[35] the artist's identity certainly lies in the nexus of Magnasco, Peruzzini, the Ricci, and their collaborators from 1703 to 1707 in Florence.[36] M.M.

Alessandro Magnasco and a Collaborator
(Marco Ricci?), *A Medici Hunting Party*

1. Ratti, 1797, 159–60. Voss, 1937, 172, accurately transcribes all but the opening sentences. Longhi also connected the Atheneum painting with Magnasco's Florentine period (R. Longhi to C. Cunningham, 22 Mar. 1960, curatorial file).
2. Voss, 1937, 172. Syamken, 1965, 32. Franchini Guelfi subsequently compared the figure here with Carlo Ratti's portrait of Magnasco in Genoa's Accademia Ligustica, a portrait used as the frontis to Ratti's biography of the artist (1977, 75, 111, n. 46, figs. 1, 2). She concluded (13, 75) that the Atheneum figure was "possibly" a self-portrait.
3. Geiger, 1949, 56, republishes the 1749 death certificate in which the artist's age is given as about eighty-two. Scheyer, 1938, 67, and Syamken, 1965, 93–94, n. 17, realized this incongruity and respectively dated the Atheneum picture 1703–8 and 1705–7.
4. For a concise and well-balanced summary of the Magnasco biography and literature, see Franchini Guelfi, 1977, 383–86.
5. Voss, 1937, 172. Geiger, 1949, 24, accepted the identification as Gian Gastone, as does Syamken (1965, 93, 123).
6. Acton, 1958, 211–12, 243–45. Chiarini in Detroit, 1974, 276.

7. Detroit, 1974, 159, no. 163. Franchini Guelfi in *Pittura a Genova*, 1971, 368, had first connected the picture with the tastes of Ferdinand's circle and later (1977, 75) concurred with Chiarini's identification.
8. Haskell, 1963, 228–41. Franchini Guelfi, 1977, 65–71. The onset of Ferdinand's physical decline in 1710 is presumed to have precipitated a decline in patronage and an ensuing exodus by artists, including Magnasco (Franchini Guelfi, 1977, 121).
9. Chiarini in Detroit, 1974, 157–59, no. 163. Chiarini supports this identification by a comparison with a 1688 ivory profile portrait medallion of Violante by Balthasar Permoser, now in the Museo degli Argenti, Florence, Bg.1879.80 (repr. in Detroit, 1974, 380–81, no. 217).
10. Gregori, 1964, 27: "Firenze, 14 aprile 1703/ Il Peruzzino passa qui per più che ragionevole paesista. Ha fatto in Livorno due Paesi per il Ser.mo Principe e un pezzetto piccolo per il sig.r Marchese Salviati. A' suoi Paesi fa le figure un Genovese che fa bene assai." "Peruzzino" is alternatively referred to in these documents as "Perozzini" and "Peruzzini." The "Genovese" is taken to be Magnasco, and the "Ser.mo Principe" is taken to be Grand Prince Ferdinand, as Gian Gastone was out of Tuscany until 1708 and the only other Medici prince, their uncle Francesco Maria (1660–1711), was still a cardinal at the time, being laicized only in 1709 in a brief and fruitless attempt to beget a

Medici heir through marriage to Princess Eleonora Gonzaga of Guastalla. These documents actually speak of Peruzzini's imminent departure for Milan, but in terms that anticipate his return to Tuscany in a few months. Magnasco might also have left Tuscany about then, presumably for a similarly brief time, for the landscapist Carlo Antonio Tavella, in a letter of 3 June 1703, says Magnasco is rumored to arrive soon in Genoa (Bottari and Ticozzi, 1828, IV, letter XXXVI, 59). Chiarini published two further paintings, *Landscapes with Monks*, in Ferdinand's collection and inventoried as collaborative works by "Anto. Peruzzini" and "Alesandro Magnaschi" (Florence, 1969, nos. 122–23).

11. Detroit, 1974, no. 163. The identification is accepted by Franchini Guelfi (1977, 13, 75). The figure here can be compared, perhaps positively, with Sebastiano's fleshy and jowled, albeit unspectacled *Self-Portrait* in Florence, which logically could have been executed during Sebastiano's Florentine stay for the grand ducal collection of artists' self-portraits. Chiarini in Florence, 1969, no. 124, fig. 97, dates this portrait 1704–6; Daniels, *Sebastiano Ricci*, 1976, no. 99, fig. 104, assigns it to circa 1706.

12. For example, Sebastiano supplied a substitute painting to the monks who sold Andrea del Sarto's *Madonna of the Harpies* to Ferdinand. See Haskell, 1963, 235–37.

13. Ratti, 1797, 159.

14. Chiarini, 1971, 146–50, summarizes what he aptly describes as the "ping pong" history of certain Magnasco/Sebastiano Ricci attributions.

15. Pilo, 1976, 42, summarizes the various views regarding the date or dates when Sebastiano and Magnasco could have been together: a sojourn in Milan by Sebastiano in the 1690s; both together in Florence at some time during the first decade of the century; a second visit by Sebastiano to Milan circa 1711–12. All authorities seem to agree that both met in Florence, the Milanese meeting(s) being in contention.

16. Detroit, 1974, no. 163.

17. *Wadsworth Atheneum Bulletin*, Jan. 1937, 2. Publication attendant on the purchase of the picture by the Atheneum included *Art News*, 2 Jan. 1937, 20.

18. Franchini Guelfi, 1969, 474, 476–77, n. 21, 478, n. 39. Newcome, 1979, 157–58. Despite Ratti's circumstantial account and the presence in the painting of the Medici arms, Chiarini suggests the work was commissioned by someone close to the court, for he finds no record of the work in the grand ducal collection nor in contemporary inventories of the Pitti Palace or the Medici villas (Detroit, 1974, no. 163). It is perhaps significant in this regard that Ratti spoke specifically of works by Magnasco hanging in the 1790s on the ground floor of the Pitti Palace, but in the same paragraph speaks of the *Hunt* simply as hanging in a room, with no implication it was a room in the palace (1797, 159–60).

19. Voss, 1937, 171, 177. Geiger, 1949, 24–25. The picture had been unknown to Geiger for his 1914 monograph on Magnasco, and he could only list it, unillustrated and as formerly with Knoedler, London, at the end of World War II in his 1945 publication on the artist (39–40).

20. Magnasco's contribution should be understood to include, as well, the animals and the cloth fencing in the foreground.

21. Ratti, 1797, 159, where, however, he says "Romiti" supplied the *figures* in Magnasco's *landscapes* done for the Palazzo Pitti.

22. Pospisil, 1944, lxxviii. A. Morassi to C. Cunningham, 20 May 1949, curatorial file. Gregori, 1964, 25. E. Fahy to P. Marlow, 22 May 1969, curatorial file. Chiarini in Detroit, 1974, no. 163. Franchini Guelfi, 1977, 75.

23. Gregori, *Paragone*, 1975, 77, n. 2, summarizes such citations.

24. Arslan, *Suida*, 1959, 306, cites the early sources for this information and traces the subsequent corruptions and confusions of the name. Franchini Guelfi, 1977, 56, n. 63, cogently

argues that his birth date is earlier, that he was older than Magnasco (born c. 1667) and Sebastiano Ricci (born c. 1659).

25. Chiarini in Florence, 1969. Chiarini, 1975, 66–67. Gregori, *Paragone*, 1975, 71–77. Genoa, 1976–77, 32–36, figs. 17–20.

26. Franchini Guelfi, 1969, 476, n. 20; 1977, 109, nn. 10, 12, 15, does not concur with certain Peruzzini attributions proposed by Chiarini and Gregori.

27. Gregori, *Paragone*, 1975, 72, n. 17.

28. Bassano del Grappa, 1963, xxx–xxxii.

29. Arslan, *Suida*, 1959, 306, n. 5. It was only in 1823 that the Christian names and birth date were provided by Zani.

30. Pilo, 1976, 92, n. 78, for instance, suggests the possibility that it might have been Peruzzini who brought Magnasco and Sebastiano together in Milan in the 1690s. The importance of Peruzzini is underlined by Franchini Guelfi (1977, 30–33), who stresses his derivation from Rosa and points out that he was not only a collaborator with Magnasco but, in respect to landscape, actually his teacher, for it was not until 1720–25 that we begin to see landscapes solely by Magnasco. Franchini Guelfi (1977, 81) also stresses Peruzzini's influence on Marco Ricci. Chiarini, *Arte veneta*, 1978, 371–75, reassigns to Marco Ricci a number of works traditionally attributed to Rosa. Moretti's (1984, II, 787–96) distinguishing Marco Ricci's landscapes from those of Antonio Marini (1668–1725) introduces a further figure that must have some role in the transmission of Rosa's style to northern Italy.

31. Detroit, 1974, no. 163.

32. Haskell, 1963, 235. Daniels, *Opera completa*, 1976, 8, corrects a still prevalent but incorrect tradition that Sebastiano was briefly in Florence—for fourteen hours—in 1704 to paint the alternative for Andrea del Sarto's *Madonna of the Harpies*.

33. Gregori, 1964, 26, pl. 30. Bianchi di Livorno and Nicolas van Houbraken were the other painters.

34. Pilo, 1976, 45, has already proposed Sebastiano's Florentine sojourn extended from 1703 to 1707.

35. Gregori, *Paragone*, 1975, 78, n. 8, clarifies that she did not intend to imply in an earlier statement (1964, 25–26) that the background here could be attributed to Peruzzini, an interpretation Chiarini in Detroit 1974, no. 163, gave to her observation. Franchini Guelfi, 1977, 75, attributes the landscape to an unknown painter and assigns the work to 1706–7.

36. The above discussion has not exhausted the picture's bibliography, which includes: R. Roli, 1964, [4], as of the Florentine years, with the landscape by another hand; Franchini Guelfi in *Pittura a Genova*, 1971, 384; Fredericksen and Zeri, 1972, 116, 499, 586, as Magnasco.

Alessandro Magnasco?
and a Collaborator
The Presentation in the Temple

Oil on canvas, 74.3 x 110.5 cm (29½ x 43½ in.)

Condition: fair. Damaged on the left and top edges, in the right-hand bay of the architecture, in the white vestments of the figure to the left of the altar, and in the table drapery above the bald figure on the left.

Provenance: a French private collection. Purchased by the Wadsworth Atheneum in 1937 from Galerie Sanct Lucas, Vienna, for $1,120 from the Sumner Fund.

Exhibitions: Vienna, 1937, no. 109, as Sebastiano Ricci; Poughkeepsie, 1939?, as Sebastiano Ricci; Poughkeepsie, 1956, as Sebastiano Ricci; Kent, 1966, as Magnasco.

The Ella Gallup Sumner and Mary Catlin Sumner Collection, 1937.471

Alessandro Magnasco? and a Collaborator,
The Presentation in the Temple

The picture was exhibited in the late 1930s as Sebastiano Ricci and acquired with that attribution.[1] The first commentaries made reference to Magnasco,[2] while retaining the attribution to Sebastiano. In 1958 Longhi published a much larger painting, later acquired by the Art Institute of Chicago, *St. Ambrose Refusing Theodosius Admittance to the Church* (Fig. 30), as a precocious Magnasco created at a very early moment in collaboration with an unidentified architectural painter.[3] Longhi thereafter assigned the

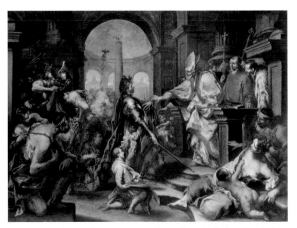

Figure 30. Alessandro Magnasco, *St. Ambrose Refusing Theodosius Admittance to the Church*, Chicago, Art Institute of Chicago

Hartford *Presentation* to Magnasco.[4] Arslan, who likewise felt the Ricci attribution for the latter untenable, was the first to connect the Hartford painting explicitly with Chicago's *St. Ambrose*, pointing out that if they were not by the same hand, they were extraordinarily close. In the Atheneum and Chicago pictures he saw the work of a Milanese painter (or painters) of the first decades of the eighteenth century whose style was based equally on Sebastiano Ricci and Magnasco.[5] Zeri also thought the *Presentation* unquestionably related to the Chicago work, which he accepted as Magnasco, but suspected the *Presentation* was perhaps a workshop copy after a lost original.[6] However, in the Fredericksen and Zeri *Census*, it is listed as Magnasco.[7]

The attribution to Sebastiano Ricci has not lapsed and there have been other suggestions.[8] Pending the discovery of documentary evidence, Franchini Guelfi assigns the Chicago picture and its stylistic sequel in the Atheneum to Magnasco and an unidentified collaborator. She seconds Longhi's observation concerning Magnasco's youthful dependence upon Genoese painting, especially on Valerio Castello. She

notes how these pictures, conceived as late baroque machines, are executed with the scenographic mentality and dissolving touch of the eighteenth century.[9]

The picture, in fact, is weak throughout, especially in the feet and hands of the secondary figures. Judging on the basis of quality alone, but unable to adduce any stylistic argument or alternatives specifically, we believe the possibility first raised by Zeri that the picture is a workshop or derivative repetition cannot be precluded.　　　　　　　　　　　　M.M.

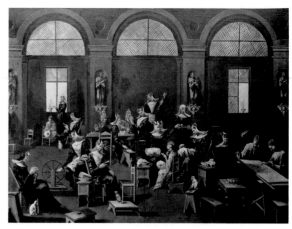

After Alessandro Magnasco, *The Cloister School*

1. The provenance from a French private collection is given in Vienna, 1937, no. 109. *Wadsworth Atheneum Bulletin*, Nov. 1937, 1, as Sebastiano Ricci. A loan to Poughkeepsie, Vassar College, 1939, is mentioned in the curatorial file, but is otherwise unverifiable.
2. Fröhlich-Bum, 1937, 93. The Atheneum photograph used for the first time there and in all subsequent publications to date, save in Pospisil, crops several inches off the bottom of the composition. Pospisil, 1944, xxiii, lvi, no. 66.
3. Inv. no. 1961.43, 155.3 x 213.5 cm. Longhi, 1958, fig. 47. J. M. [anon.], *Chicago Art Institute Quarterly*, LV, Sept. 1961, 50, as entirely by Magnasco. R. Manning in Chicago, 1970, 34, no. 9, repr., as early Magnasco.
4. R. Longhi to C. Cunningham, 22 Mar. 1960, curatorial file, as dating to the artist's Florentine period.
5. W. Arslan to C. Cunningham, 20 Oct. 1961 and 2 Dec. 1961, curatorial file.
6. F. Zeri to C. Cunningham, 5 Mar. 1962, curatorial file.
7. Fredericksen and Zeri, 1972, 146, 274, 585.
8. A. Blunt, oral communication, 23 Feb. 1956, perhaps Austrian; A. Percy, oral communication, July 1968, Venetian eighteenth century; R. Watson, oral communication, Aug. 1968, perhaps early Pittoni; N. Spinosa, oral communication, 19 Mar. 1979, Sebastiano Ricci (memoranda in curatorial file).
9. Franchini Guelfi, 1977, 48–50, figs. 43–44, 46, 59, n. 114. She notes a borrowing from Cerrano's *Miracle of Brother Sebastian of Piacenza* in the Duomo, Milan (fig. 47), in the Atheneum's priest and candle-bearing acolyte (50).

Copy after Alessandro Magnasco
The Cloister School

Oil on canvas, 172.7 x 232.7 cm (68 x 91⅝ in.)
　　Condition: good, except for discolored retouching and repairs in the background.
　　Provenance: Fratelli Grandi, Milan; B. Geiger, 1912. Purchased by the Wadsworth Atheneum in 1937 from Arnold Seligmann, Rey & Co., Paris, for $5,500 from the Sumner Fund.
　　Exhibitions: Geiger's collection of Magnasco's work, formed in 1912–13, was shown, beginning in 1914, successively in Berlin, Paul Cassirer; Cologne, Kunstverein; Frankfurt, Schneider; Paris, Levesque Gallery (Barbasagne); and Munich, Thannhäuser. After World War I, in 1920, the group was shown in Düsseldorf at Flechtheim's before being dispersed. New York, Durlacher Bros., 1940, no. 12; Baltimore, 1942, no. 10.
　　The Ella Gallup Sumner and Mary Catlin Sumner Collection, 1938.260

When accessioned in 1938,[1] the painting came with a certificate of authenticity from Geiger,[2] who had owned the picture and exhibited it extensively beginning in 1914.[3] Subsequently, Pospisil,[4] Geiger himself,[5] Morassi,[6] as well as Fredericksen and Zeri[7] properly recognized that the work is not by Magnasco. The devotional and everyday activities of the convent and monastery were favored themes of the artist, and Franchini Guelfi sees the picture here as a copy of a lost original that belongs to his climactic, latest works in the genre.[8]

Among Magnasco's most vivacious paintings are a small number of very late works depicting the elegant pastimes of aristocratic nuns. They receive callers,[9] play music,[10] read, make lace, embroider, or fashion artificial flowers. The settings are either fine gardens[11] or, as this copy suggests, a convent interior. These are not the industrious sisters or the ardent Capuchins Magnasco usually paints; they are frivolous women, worldly and privileged. The artist's essentially sympathetic attitude toward the religious communities that were so much a part of Italy's life at the time is here superseded by irony bordering on the acidulous.[12] The religious garb in this group of paintings is the same; one immediately notices the extravagantly peaked headdress. The habit cannot be connected with any single order. Franchini Guelfi suggests Magnasco may have prudently mixed elements from the habits of two Lombard orders so as both to make his caustic statement more general and to avoid the risk of being too specific.[13]

Ratti speaks of Magnasco's painting young girls being schooled in "womanly" arts.[14] This would aptly describe the original of such a picture as this. The fact that there are at least three further copies, like the Atheneum picture in all essential respects, suggests the original enjoyed some vogue.[15]　　M.M.

1. *Wadsworth Atheneum Bulletin*, Oct. 1938, 2.
2. B. Geiger, Venice, 25 Aug. 1936, curatorial file, where he identifies the Atheneum picture as the work he had published in 1914, as no. 18.
3. Geiger, 1949, 155–56.
4. Pospisil, 1944, lxi, n. 140.
5. Geiger, 1949, 96.

6. A. Morassi to C. Cunningham, 20 May 1949, curatorial file.
7. Fredericksen and Zeri, 1972, 116, 505, 585, as by a Magnasco follower.
8. F. Franchini Guelfi to J. Cadogan, 15 Oct. 1979, curatorial file.
9. De Logu, 1931, pl. 216, as Italico Brass Collection, Venice. Pospisil, 1944, lxxxv, no. 163, pl. 163, 85 x 70 cm, as private collection. Geiger, 1949, 144, fig. 426, 72 x 56 cm, as [formerly] in a Venetian private collection. To judge from reproductions, the latter is seemingly the same picture as that in Pospisil despite the different measurements cited; it was exhibited in Genoa in 1938 and was on the Roman art market in 1943. Franchini Guelfi, 1977, pl. XXXI, as private collection.
10. Franchini Guelfi in *La Pittura a Genova*, 1971, 380, fig. 256, as private collection, Milan. Franchini Guelfi, 1977, figs. 238–39, private collection.
11. Pospisil, 1944, lxxxii, no. 116, pl. 116, 98 x 74 cm, collection of Professor A. M., Rome. Geiger, 1949, pl. 425, as formerly in the collection of General Majora, Rome. Calamai, 1963, fig. 10, private collection.
12. See Franchini Guelfi (1977, 192–218) for an extended discussion of Magnasco's work in the genre.
13. Franchini Guelfi, 1977, 250, no. 76.
14. Ratti, 1797, 157.
15. In addition to the large Atheneum painting (172.7 x 232.7 cm), there is another in the National Gallery of Canada, Ottawa (84.4 x 104.8 cm, no. 18566, acquired in 1976), in which the Atheneum composition is drastically cut down on the two sides and the bottom, formerly in the Otto Koerner Collection, Vienna (Geiger, 1949, 150). A repetition of the entire Atheneum composition, but in a smaller format, 86 x 130 cm, was exhibited in Geiger's 1914 exhibition as no. 17. In this reduction the right- and leftmost pilasters do not have statue niches. There is no specific evidence for Geiger's identifying this, the so-called *Kleine Klosterschule*, with the *Lavoratorio di monache*, cited in the 1796 inventory of the Carrara Collection (Geiger, 1949, 57–58). In 1954 the *Kleine Klosterschule* was with the Central Picture Galleries, 624 Madison Avenue, New York. It was sold, together with a Geiger expertise, in New York, Parke-Bernet, 4 May 1955, no. 63, as from the Boccalandia Collection, Milan, for $600. Yet another version of this small format, 91 x 152 cm, in an Italian private collection is known to Franchini Guelfi (letter to J. Cadogan, 15 Oct. 1979, curatorial file). A canvas reported as somewhat different in size, 95 x 135 cm, may be the same as the above or be yet a further copy (Pospisil, 1944, lxi, no. 140, as *La Piccola scuola del convento*, formerly in Genoa, then [1944] in Castell'Arquato in the Romondini-Colla Collection).

Michele Marieschi
(1710–1743)

Little is known of the life of Michele Marieschi, who was born in Venice on 8 December 1710, and died there in 1743.[1] Confused until recently with Jacopo Marieschi, who was born in the same year,[2] his oeuvre has emerged clearly in recent years.[3] His father, Antonio, a painter of theater scenes, died in 1721, before the younger artist's education could have been completed. The painter Gaspare Diziani was a witness at Marieschi's wedding in 1737,[4] which information, along with Guarienti's account that Marieschi worked in Germany, as had Diziani,[5] has led to the idea that Diziani was his real master, a supposition which has yet to be confirmed by documentary evidence. Of work during this putative sojourn in Germany we know nothing; Marieschi would in any case have returned to Italy by 3 January 1731, for in that year he collaborated with Francesco Tasso on the building of the *macchina*, or temporary structure, for a festival on the last

Thursday of carnival held every year on the Piazzetta S. Marco.[6] He was in Fano in 1735, where he was engaged, again with Tasso, on the decorations in the church of S. Paterniano, for the funeral of Maria Clementina Sobieski, a Polish princess and wife of James Stuart, the Old Pretender, who had died in Rome on 8 January of that year; the drawings by Marieschi for these decorations were published in 1736.[7]

In 1736 Marieschi was inscribed in the Venetian *Fraglia*; his name appears yearly until 1741. His collection of etchings, *Magnificentiores selectioresque Urbis Venetiarum prospectus quos olim Michael Marieschi Venetus pictor et architectus in plerisque tabulis depinxit, nunc vero ab ipsomet acurate delineante, incidente typisque mandante iterum in XVII aereis tabulis in lucem eduntur 1741*, made, so declares the frontispiece, from his paintings, was published in 1741 and constitutes the sole documented evidence for assembling his painted oeuvre. On the basis of style a credible corpus has been assembled that shows Marieschi to have been active within the tradition of festival scenes and Venetian views practiced by Luca Carlevarijs and Canaletto. His influence on Francesco Guardi, who may have supplied the figures for some of Marieschi's paintings, has often been noted.[8]

1. Mauroner, 1940, 197, publishes the documents for Marieschi's life.
2. On Jacopo, see Longhi, 1762, no pagination.
3. Orlandi, 1753, 380; see also G. Fogliari, "Michele Marieschi pittore prospettico veneziano," *Bollettino d'arte*, 1909, 241–51; Mauroner, 1940, 179–215; Bergamo, Galleria Lorenzelli, *Michele Marieschi*, 1966, exh. cat. by A. Morassi; Pallucchini, *Arte veneta*, 1966, 314–25.
4. Mauroner, 1940, 197.
5. A. Zugni-Tauro, *Gaspare Diziani*, Venice, 1971, 23–24. Diziani had returned to Venice by 1720, however.
6. Padoan Urban, 1980, 225–27.
7. S. Paoli, *Solenni Esequie di Maria Clementina Sobieski regina dell'Inghilterra celebrate nella chiesa di S. Paterniano in Fano. 23 maggio 1735*, Fano, Rome, 1736; see Mauroner, 1940, 213.
8. See, for example, Pallucchini, *Arte veneta*, 1966, 315–18; and Morassi, 1973, I, 134; Gorizia, 1989, and Amsterdam, 1990, 171–93.

After Michele Marieschi
Venice: Regatta on the Grand Canal

Oil on canvas, 61 x 96.8 cm (24 x 38 1/8 in.)
In lining, the original tacking edge was trimmed away; the left edge has been inpainted 1/8 inch.
Condition: good. There are minor retouches over the surface.
Provenance: possibly Doria Collection, Rome;[1] purchased by the Wadsworth Atheneum in 1942 from Arnold Seligmann, Rey & Co., New York, for $1,800 from the Sumner Fund.
The Ella Gallup Sumner and Mary Catlin Sumner Collection, 1942.407

Viewed from the *volta* in the Grand Canal, where it makes a sharp turn to the right, is a Venetian regatta, a race of small boats, and the best-known and one of the most ancient festivals of Venice.[2] Documented from at least the fourteenth century, regattas were organized in honor of visiting dignitaries and for certain feast days. The most lavish of the decorations for a regatta was the *macchina*, a temporary structure at which point the race ended and which housed the judges and the prizes. It is seen at the center left in the Atheneum picture, where the Rio di Ca' Foscari joins the Grand Canal, between the Ca' Foscari and Palazzo Balbi. Also depicted are numerous gondolas

After Michele Marieschi, *Venice: Regatta on the Grand Canal*

filled with spectators and two richly decorated barges of noble families, seen partially at the left and right.

The painting reproduces, with a few minor changes, an etching by Marieschi published in 1741 (Fig. 31).[3] In the painting there are fewer boats; the painter omitted a large, richly decorated barge depicted by Marieschi at the left. Although it is possible that the Atheneum painting is one of those by Marieschi that are recorded in the etchings, it is more likely that the painting was made after the print. The simplification of detail in the painting, and the generally clumsy execution overall reinforce this view. Moreover, the touch of the painting does not accord with any of those paintings that have been attributed to Marieschi up until now. Although no documented

paintings exist from which to build a secure corpus, the level of quality and skill implicit in the etched views and in the assembled painting corpus is far above that of the Atheneum painting and is sufficient to exclude the latter from his hand.

A painting formerly in the Cini Foundation, Venice, recently ascribed to Marieschi, is also related to the print, and may have, alternatively, served as a model for the Atheneum picture.[4]

While it was at one time proposed that the Atheneum picture depicted the regatta held in 1788 in honor of Ferdinand III, prince of Tuscany, the link with the Marieschi print of 1741 makes this late date untenable.[5] A suggestion that the print depicted a regatta held on 4 May 1740 in honor of Frederick

Figure 31. Michele Marieschi, *View of a Regatta at Ca' Foscari*, Venice, Fondazione Giorgio Cini

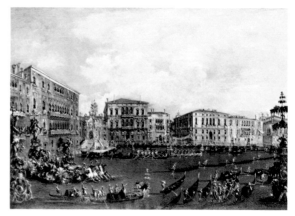

Figure 32. Francesco Guardi, *Festival on the Grand Canal*, Philadelphia, Philadelphia Museum of Art, John G. Johnson Collection

Christian of Poland, prince of Saxony, has also been excluded, as the *macchina* in the Atheneum picture does not correspond to that described in a contemporary account.[6] It is likely that neither the Marieschi print nor the Atheneum picture depicts a specific event. It has been noted in the case of Canaletto's pictures of regattas, for example, that paintings depicting specific regattas often show identifiable coats of arms on the *macchine*.[7] In the Marieschi print, the coat of arms on the *macchina* is blank, while in the Atheneum picture it is so generalized as to defy identification.[8] It is more likely that it is an invention of the artist, and that the painting is simply a depiction of a Venetian festival rather than a record of a precise event.[9]

The identity of the artist who painted the Atheneum picture cannot at present be determined. A suggestion of Giuseppe Heinz the Younger (c. 1600–1678), to whom it was attributed when acquired by the Atheneum, is untenable in view of the connection with the Marieschi print. A further suggestion of Giuseppe Bernardino Bison (1762–1844) is equally unprovable.[10] Nor can an attribution to Francesco Albotto, whom Pallucchini calls the "second Marieschi," be proposed.[11] The author is undoubtedly to be found among the minor masters of Venetian *vedute* who produced such views for travelers throughout the eighteenth and nineteenth centuries.

Another painted copy after the Marieschi print is attributed to Francesco Guardi and is in the Johnson Collection at the Philadelphia Museum of Art (Fig. 32).[12]
J.C.

1. Letter in curatorial file, 16 May 1942.
2. B. Tamassia Mazzarotto, *Le Feste veneziane*, Florence, 1980, 51–56.
3. Gorizia, Palazzo Attems, *Le Incisioni di Michele Marieschi*, 28 Feb.–29 Mar. 1981, 44, no. 18, "Veduta della regata a Ca' Foscari."
4. Gorizia, 1989, 159–60, fig. 182.
5. Constable, 1963, 17.
6. Padoan Urban, 1980, 225.
7. Levey, 1953, 365–66.
8. V. Franco de Baux, letter to L. Horvitz, 5 May 1984, curatorial file.
9. Levey, 1953, 366, notes that copies after Canaletto's regatta paintings, and after engravings of them, were also made, thus demonstrating a market for these generic scenes.
10. Constable, 1963; R. Pallucchini, letter to L. Horvitz, 25 June 1984, curatorial file.
11. Pallucchini, letter in curatorial file, 25 June 1984; Pallucchini, *Arte veneta*, 1966, 318.
12. Morassi, 1973, I, 367, no. 301, II, fig. 329.

Giuseppe Nogari
(c. 1700–1763)

Giuseppe Nogari died in Venice in 1763 at the age of sixty-two; he was probably born there in 1699–1700.[1] According to early biographers,[2] Nogari studied with Antonio Balestra, with whom he may have remained until 1730.[3] Nogari had earned a certain reputation by the 1730s, for in 1741 he is mentioned with Piazzetta as being a favorite among German collectors,[4] and in 1739 he sent work to the royal court in Turin, probably furnishing the four half-length "character heads," as Mariette called them, which are now in the Galleria Sabauda in Turin.[5] In about 1740 Nogari went to Turin, where he stayed for two years working in the royal palace, painting, among other works, a ceiling in the Gabinetto degli Specchi decorated with allegorical figures and, on the walls, portraits of children painted on glass.[6] He also painted allegorical canvases, which are now at Stupinigi, the royal hunting lodge outside Turin.[7]

Nogari had returned to Venice by 1743, when he is documented as having provided half-length figures to Frederick Augustus II, elector of Saxony, through his agent, Count Algarotti, which are now in Dresden.[8] He continued to work for the court of Savoy, however, and was paid in 1748 for three pictures from Venice; one of these is the *Joseph Interpreting Dreams*, signed and dated 1747, formerly Palazzo Reale, Turin.[9] The large *Miracle of S. Giuseppe da Copertino* in the Frari, Venice, dates to 1755, but this was painted as a backdrop to a sculpture of St. Jerome by Alessandro Vittoria and not as an independent work.[10] Further signed but undated altarpieces include the *Giving of the Keys to St. Peter* and the *Annunciation*, both in Bassano.[11] Nogari also painted occasional portraits, such as the *Portrait of the Procuratore Alessandro Zeno* in the Accademia dei Concordi at Rovigo, documented to 1758–59.[12]

Nogari is best known for his small character heads, usually of old men and women, though it can be seen from the above account that he was active in a much broader range. The marked influences in such heads from Flemish and Dutch artists reflect the widespread taste in Italy for the works of Rembrandt, above all, whose influence extended to artists such as G. B. and G. D. Tiepolo.[13]

1. Nogari's death certificate was published by L. Livan in *Annali di Pietro Gradenigo*, Venice, 1942, 99; as cited in Honour, 1957, 154, n. 2.
2. Orlandi, 1753, 235; Longhi, 1762, n.p.
3. Honour, 1957, 154.
4. By C. L. Hagedorn; see N. von Holst, "La Pittura veneziana tra il Reno e la Neva," *Arte veneta*, V, 1951, 133, 137; as cited in Honour, 1957, 154, n. 5.
5. Honour, 1957, 154, n. 6; Gabrielli, 1971, 180–82, nos. 596–97, 600–601.
6. Honour, 1957, 154–55.
7. Honour, 1957, 156.
8. Honour, 1957, 157.
9. Honour, 1957, 157.
10. Honour, 1957, 157.
11. G. M. Pilo, "Una Inedita pala del Nogari a Bassano," *Arte veneta*, XIX, 1965, 180–81.
12. A. Romagnolo, *La Pinacoteca dell'Accademia dei Concordi*, Rovigo, 1981, 212, no. 96.
13. Honour, 1957, 158.

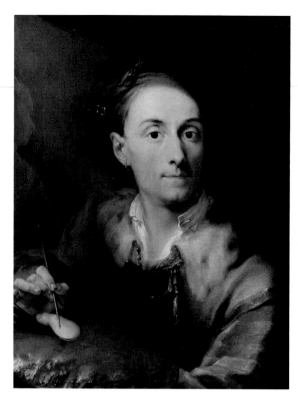

Giuseppe Nogari, *Portrait of a Painter*

1. This inscription is now covered by a lining canvas; a photograph of the inscription is in curatorial file.
2. A drawing, possibly a self-portrait, illustrated in Florence, Loggia Rucellai, *Faces and Figures in Foreign and Italian Drawings from the Sixteenth to the Nineteenth Centuries*, 30 Apr.–31 May 1970, 80, no. 48, is possibly a self-portrait by Nogari and bears a general resemblance to the Atheneum picture.
3. Algarotti writing to P. J. Mariette, in Bottari and Ticozzi, 1822, VII, 386, as cited in Honour, 1957, 157.
4. J. Weitzner, letter to C. Cunningham, 8 June 1948, curatorial file; Fredericksen and Zeri, 1972, 585.

Portrait of a Painter

Oil on canvas, 64.1 x 48.6 cm (25 1/4 x 19 1/8 in.)

Condition: good. The painting has been abraded, especially in the darks. The surface is covered by an old varnish that has altered the relationship of the darks and lights.

Formerly inscribed on back of the canvas: *Gioseppe Nogari, Veneziano G. 1699*.[1]

Provenance: Jacob Heiman; possibly Maziroff Collection; J. Weitzner; bought by the Wadsworth Atheneum in 1948 from J. Weitzner for $1,500 from the Sumner Fund.

The Ella Gallup Sumner and Mary Catlin Sumner Collection, 1948.272

Said to be a self-portrait by Nogari, there is no documented image of the painter with which the Atheneum portrait may be compared.[2] Painted in the "extremely soft manner without outlines, and all in half tints," as Count Algarotti described the heads painted for Frederick Augustus II,[3] the attribution has never been questioned.[4] As Honour has remarked, the style of the character heads was unlike that of Nogari's documented portraits; and, indeed, the Atheneum portrait shows strongly characterized features and a physiognomic type unlike Nogari's other works. Although it is also possible that the Atheneum picture is a portrait of a type, it seems reasonable to accept the traditional identification of it as a self-portrait. J.C.

François de Nomé, formerly called Monsù Desiderio (c. 1593–c. 1640)

Born in Metz, this painter left Lorraine for Rome about 1602, where he worked until about 1610 for Balthasar Lauwers, a follower of Paul Brill and an assistant to Agostino Tassi. His main place of activity and residence after 1610 was Naples, but it is possible that he went to Florence circa 1619 and was influenced there by Jacques Callot. He may also have revisited Rome in the early 1630s and seen the contemporary work of Tassi and Viviano Codazzi. Nomé painted strange and fanciful architectural night scenes, inventions mixing classical and Gothic motifs. Their mood is always restless and sometimes cataclysmic as, for example, when his phantasmagoric architecture is rent by explosions. The oddness of his conceptions is matched by his frenzied technique of painting with a heavy, mannered impasto. In the twentieth century, his work has been greatly appreciated for its proto-surrealistic quality.

He used collaborators for his figures, among them Jacob van Swanenburgh, who was in Naples circa 1606–17, and, more frequently, the Greek-born Belisario Corenzio (c. 1560–after 1640), who may be responsible for the figures in the Atheneum picture.

De Dominici lumped together under the designation "Monsù Desiderio" both Nomé and his compatriot also active in Naples, the topographical painter Didier Barra. The conflation has only recently been untangled.[1]

1. M. Nappi in London, *Painting in Naples*, 1982, 198–99.
J. Thuillier in Rome, *Claude Lorraine*, 1982, 191–92.

Belshazzar's Feast

Oil on canvas, 115 x 207 cm (45 5/16 x 81 1/2 in.)

Condition: fair to poor. What is visible of the surface through a deeply darkened varnish is heavily abraded and severely flattened in relining.

Stenciled on the relining canvas: JS [or SJ]/226/JS [or SJ]

Provenance: Dr. Richard Neumann, Vienna. Purchased by the Wadsworth Atheneum in 1937 from the Galerie Sanct Lucas, Vienna, for $1,125 from the Sumner Fund.

Exhibitions: Vienna, 1937, no. 95, as Monsù Desiderio; Hartford, 1940, no. 12, as Monsù Desiderio and Belisario Corenzio; Sarasota, 1950, no. 14, as Monsù Desiderio; Sarasota, 1956, no. 3, as Monsù Desiderio with figures by Belisario Corenzio; Hartford, 1964, no. 209, as François de Nomé.

The Ella Gallup Sumner and Mary Catlin Sumner Collection, 1937.469

François de Nomé, *Belshazzar's Feast*

Belshazzar, according to the Book of Daniel, was the son of Nebuchadnezzar and the last ruler of Babylon. He gave a great feast during which gold and silver vessels looted from the temple in Jerusalem were profaned during the drunken revelry. A disembodied hand appeared (here in the upper center to the left of the second chandelier) and inscribed on the palace wall words that only Daniel could interpret: *mene, mene, tekel, u-pharsin*—Belshazzar has been weighed in the balance and found wanting; his kingdom would fall. That same night Belshazzar was slain and Darius captured Babylon.[1]

Presumably because the picture was acquired from the Galerie Sanct Lucas in Vienna in 1937,[2] the Atheneum files and the literature have confused it with another painting by Nomé illustrating the St. George legend from the Harrach Collection, Vienna, and exhibited under the auspices of the same dealer in the same year.[3]

The attribution to Nomé was accepted by Suida,[4] Urbani,[5] Sluys,[6] and by Wright,[7] while Fredericksen and Zeri think that it is either by Nomé or by Belisario Corenzio.[8] M.M.

1. Daniel, 5. J. Taylor in Price, 1899, 269–70, discusses who the actual historical figures are likely to have been; Belshazzar was a successor to Nebuchadnezzar, not his son.
2. As from the collection of Dr. Richard Neumann, Vienna (curatorial file). *Wadsworth Atheneum Bulletin*, Nov. 1937, [1], as Desiderio Monsù and Belisario Corenzio.
3. Vienna, 1937, 37, no. 95, Monsù Desiderio, *Fantastic Architecture with a Representation of the St. George Legend*, the figures by Belisario Corenzio, oil on canvas, 87 x 70 cm, dated 1622, loaned from the Galerie Harrach, Vienna, no. 204. That provenance was mistakenly given to the Atheneum picture by Scharf, for example, when the Atheneum picture was exhibited in Sarasota, 1950, although he had the Harrach picture in the same exhibition as no. 61. The correct provenance was cited when the painting was shown in Hartford, 1940.
4. W. Suida to C. Cunningham, 21 Dec. 1946, curatorial file.
5. Rome, Galleria dell'Obelisco, 1950, 16.
6. Sluys, 1961, 136, no. 115.
7. Wright, 1985, 176.
8. Fredericksen and Zeri, 1972, 56, as perhaps Belisario Corenzio; 151, as perhaps Nomé; 263, as Nomé; 585, as Nomé or Corenzio.

Lelio Orsi
(c. 1511–1587)

Lelio Orsi was born in Novellara, between Reggio Emilia and Mantua, in about 1511.[1] A certain amount of biographical information about him has emerged since Thode first attempted to reconstruct his oeuvre.[2] We know that in 1536 he was employed in Reggio painting decorations for the visit of Duke Ercole II d'Este, and in 1544 he painted in the Torre dell'Orologio there.[3] The frescoes from the Castello of Querciola, south of Modena, date to about 1535. In 1553 he was in Venice with counts Camillo and Alfonso Gonzaga, and in 1554–55 he was in Rome. From Novellara he requested drawings after Michelangelo's Pauline Chapel in the Vatican in 1559. During the 1560s he was active locally, producing decorations for houses and villas in Bagnolo and Novellara. In 1563 the frescoes in the Casino di Sopra near Novellara, commissioned by Count Camillo Gonzaga, were begun, now firmly attributed to Lelio Orsi in design, and executed with studio assistance.[4] In 1567 he was involved in the restoration and decoration of the Rocca di Novellara. Already in failing health in 1579, Orsi executed few projects in the following years. He died in Novellara on 3 May 1587.

Of the works of art by Orsi mentioned in documents, few survive that can be attached to him without question. Evidence for his work as a decorator on a large scale is fragmentary.[5] Only one drawing, the so-called *Madonna della Ghiara*, in the sanctuary of the same name in Reggio Emilia, is signed and dated (1569) and can serve as the touchstone for assembling Orsi's figurative oeuvre.[6] This drawing shows the Correggesque facial types and eccentric drapery style that is shared by a group of small cabinet paintings generally attributed to Orsi, including a *Martyrdom of St. Catherine* and a *Dead Christ between Charity and Justice* at Modena, a *Pietà with Saints* in the Galleria Nazionale, Palazzo Venezia, Rome, and the *Saints Cecilia and Valerian* in the Galleria Borghese, Rome.[7] This last is initialed *L.E.O.*, which has been taken as his monogram.[8]

1. His epitaph, composed by his son, records his death in 1587 at age 76. See Reggio Emilia, 1950, xii.
2. H. Thode, "Lelio Orsi e gli affreschi del 'Casino di Sopra' presso Novellara," *Archivio storico dell'arte*, 1890, 366–78; G. B. Toschi, "Lelio Orsi da Novellara," *Arte*, III, 1900, 1–31.
3. For this information and what follows, see Reggio Emilia, 1987–88, 21–38, and register of documents, 264–300; see also Hoffman, 1975, 231–43; Romani, 1984; and Washington, 1984, 130–31, no. 32, 249–64, nos. 82–87.
4. Villani, 1958, 171. Some fragments of these frescoes were acquired by the Galleria Estense in Modena; see "Nuovi acquisizioni," *Bollettino d'arte*, LIX, 1974, 195. See Reggio Emilia, 1987–88, 29, for a dating to about 1558.
5. See the fresco fragments from the Casino di Sopra, illustrated in Reggio Emilia, 1950, nos. 18–35, and the reconstruction of the decoration in the casino in Villani, 1958, 170–76, pls. 61–62. Of the drawings attributed to Orsi of decorative projects, the most likely attribution is a drawing for the facade of his house, Reggio Emilia, 1950, nos. 14–15.
6. Reggio Emilia, Museo della Basilica della Beata Vergine della Ghiara; pen and ink with wash and white highlighting on tinted paper, mounted on canvas and attached to panel. Reggio Emilia, 1950, 46, 136; Hoffman, 1975, 93; Reggio Emilia, 1987–88, 185–87, no. 159.
7. Reggio Emilia, 1950, nos. 17, 37, 40, and 41 bis.
8. Longhi, 1926, 68; della Pergola, 1955, I, 58, no. 98.

Noli me tangere

Oil on canvas, 95.9 x 78.3 cm (37³/₄ x 30⁷/₈ in.)

Condition: good. The surface has suffered small losses overall.

Provenance: collection Achillito Chiesa, Milan (not, however, listed in his sales, New York, American Art Association, 1926–30); Ehrich Galleries, New York, 1932; Durlacher Bros., New York. Bought by the Wadsworth Atheneum in 1936 from Durlacher Bros., New York, for $2,400 from the Sumner Fund.

Exhibitions: Hartford, 1940, no. 13; Hartford, 1948, 27, no. 155; Indianapolis, John Herron Art Institute, *Pontormo to Greco*, 14 Feb.–28 Mar. 1954, no. 32, repr.; Westport, *Italian Masters*, 1955, no. 26; New York, 1958; Sarasota, 1958, no. 59; Hartford, Phoenix Mutual Life Insurance Co. Building, *Plaza/7 Phoenix; Exhibition of Paintings from Public Museum Collections*, 17–27 June 1965; Kent, 1966; Notre Dame, Ind., University of Notre Dame Art Gallery (also Binghamton, N.Y., State University of New York at Binghamton, University Art Gallery), *The Age of Vasari*, Feb.–May 1970, 33, no. 12; Washington, 1986–87, 155, no. 54; Reggio Emilia, 1987–88, 221–22, no. 194.

The Ella Gallup Sumner and Mary Catlin Sumner Collection, 1936.500

The *Noli me tangere* depicts the incident in John 20:14–18. Mary Magdalene went to Christ's tomb after the Resurrection and encountered Him in the garden. She mistook Him for a gardener, whereupon He revealed Himself to her, telling her not to touch Him. He sent her to tell the disciples that He had risen from the dead. In the Atheneum picture, Christ holds a hoe that refers to the Magdalene's misidentification. The garden is shown as a wild terrain with rocky outcroppings; in the background dawn breaks through thick clouds, coloring the sky with eerie, yellow-orange light.

Orsi painted another version of the theme, now in the Galleria Estense in Modena (Fig. 33).[1] In it Christ and the Magdalene are silhouetted against a dark, lush garden, as in the Atheneum picture, but in the Modena picture the Magdalene kneels, as in Correggio's picture of the same theme, now in the Prado but formerly in Bologna.[2]

The painting entered the museum attributed to Lelio Orsi, and the attribution has not been challenged.[3] The Atheneum painting shares with the *Madonna della Ghiara* drawing the tendency for folds to fall in rippling parallels and the delicate Correggesque facial types. It also is similar in style to works generally accepted as Orsi's, such as the *Martyrdom of St. Catherine* in Modena and the *Walk to Emmaus* in London.[4]

The date of the Atheneum painting is difficult to establish in the absence of a firm chronology for Orsi's work. It would seem to be later than the Modena version of the theme, with the latter's pronouncedly Correggesque figure style and compacted space.[5] The muscular, Michelangesque types of the Atheneum painting are seen in other works that are generally thought to postdate Orsi's trip to Rome in 1554–55, such as the documented Casino di Sopra frescoes or the *Walk to Emmaus* in London;[6] and the Christ figure in the Atheneum painting is based on the St. John the Baptist in the *Last Judgment* of the Sistine Chapel.[7]

More recently, Romani has proposed a new

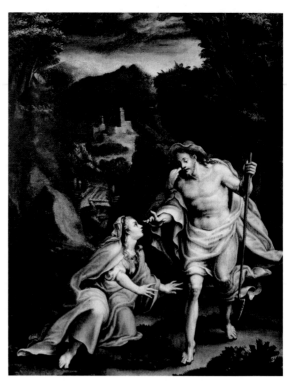

Figure 33. Lelio Orsi, *Noli me tangere*, Modena, Galleria Estense

interpretation of Orsi's oeuvre that places many Correggesque works late in his career, when the artist sought to, in her words, "exorcize the stylistic ghost of Michelangelo to become one of the protagonists of a neo-Correggio movement."[8] Following Romani's hypothesis, the Atheneum picture would date to 1575 or later, when Orsi's recollections of Michelangelo are tempered by renewed interest in Correggio's art.[9] Frisoni agrees with Romani's late dating.[10] J.C.

1. Inv. no. 8022; Pallucchini, 1945, 111, no. 231a, now, according to the museum, attributed to Pietro Maria Bagnadora. A drawing of a *Noli me tangere* was mentioned by G. F. Pagani (*Le Pitture e sculture di Modena*, Modena, 1770, 193) as in the apartments of Francesco III in the ducal palace in Modena, but it has not been noted since. Longhi, 1926, 68, also mentions a drawing for the Atheneum picture in the collection Fourché in Orléans, which entered the local museum and was there attributed to Cignani. This drawing is untraced.

2. Gould, 1976, 224–25, pl. 98A.

3. It was attributed to Orsi by Longhi, 1926, 68; H. Voss, letter in curatorial file, 27 Feb. 1931; I. Kunze, "Lelio Orsi," in Thieme and Becker, 1932, XXVI, 58–59; "Hartford, Four Recently Acquired Paintings," *Art News*, XXXV, no. 18, 1937, 18; Reggio Emilia, 1950, 163.

4. Gould, 1975, 180–81, no. 1466.

5. See DeGrazia in Washington, 1984, 250, who characterizes Orsi's Correggesque works.

6. Gould, 1975, 180; but as R. Salvini remarks, "Su Lelio Orsi e la mostra di Reggio Emilia," *Bollettino d'arte*, XXXVI, 1951, 81, Orsi could have seen evidence of Michelangelo's art before he went to Rome.

7. Romani in Washington, 1986–87, 155, no. 54, says the model is the Adam in the *Last Judgment*.

8. Romani in Washington, 1986–87, 150; see also Romani, 1984.

9. Romani, 1984, 86; Washington, 1986–87, 155.

10. Frisoni in Reggio Emilia, 1987–88, 222.

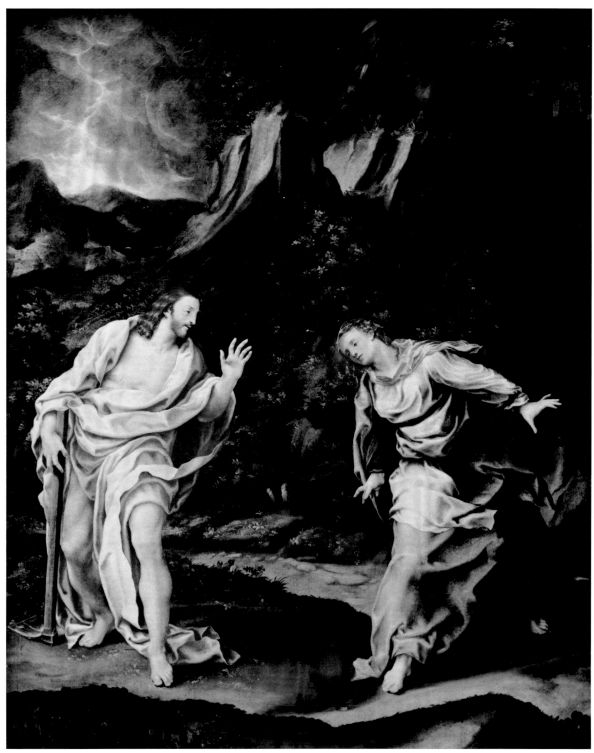

Lelio Orsi, *Noli me tangere*

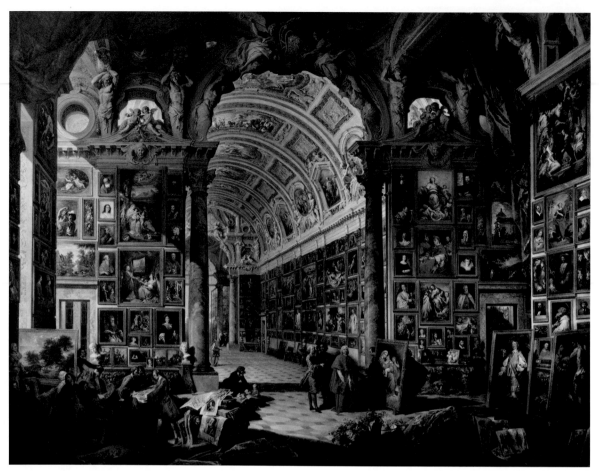

Giovanni Paolo Panini, *The Picture Gallery of Cardinal Silvio Valenti Gonzaga*

Giovanni Paolo Panini
(1691/2–1765)

Born in Piacenza, where he trained with the stage designer Ferdinando Bibiena and with others who specialized in architectural painting, Panini—more recently spelled Pannini—moved to Rome in 1711 and remained there for his entire life. He studied with Benedetto Luti and made his early reputation as a muralist in Roman palaces and villas (Villa Patrizi, 1718; Palazzo Quirinale, circa 1722). His great fame rests upon his views of ancient and modern Roman monuments that he produced in great quantities for foreign visitors. Often the views contain fanciful juxtapositions and inventions, as in the Atheneum's picture, thus linking his *vedute* and *capricci* with the contemporary work of Giovanni Battista Piranesi and Hubert Robert. He also was commissioned to record public events and special ceremonies.[1] It was owing to Cardinal Valenti Gonzaga, the prelate central to the conception of the Atheneum picture, that Panini was knighted by the pope in 1749.[2]

1. Zeri, *Walters Art Gallery*, 1976, II, 518.
2. Arisi, 1961, 102.

The Picture Gallery of Cardinal Silvio Valenti Gonzaga

Oil on canvas, 198.5 x 267.5 cm (78³/₁₆ x 105³/₈ in.)
 Condition: excellent. The picture was cleaned in 1983 (see note 9).
 Initialed and dated in the lower left, on the binding of the book lying on the floor: I.P.P./Romae/1749
 Provenance: Cardinal Silvio Valenti Gonzaga, Rome; Cardinal Luigi Valenti Gonzaga, Rome; Sir George Howland Beaumont, Coleorton Hall, Leicestershire, by 1821/22; by descent to Sir George Beaumont, Coleorton Hall, Leicestershire, sale London, Sotheby's, 30 June 1948, no. 42, bought by Koetser for 1,550 pounds. Purchased by the Wadsworth Atheneum in 1948 from David Koetser, New York, for $16,000 from the Sumner Fund.
 Exhibitions: Hartford, *In Retrospect*, 1949, no. 23; Hartford, *Pictures within Pictures*, 1949, no. 34; Rome, 1959, no. 422; Hartford, 1982.
 The Ella Gallup Sumner and Mary Catlin Sumner Collection, 1948.478

When the painting was bought in Rome in 1821/22 by the English collector and founding donor of the National Gallery, London, Sir George Howland Beaumont (1753–1827), he described it thus in a letter to the sculptor Francis Chantry:

Giovanni Paolo Panini, *The Picture Gallery of Cardinal Silvio Valenti Gonzaga*, detail

The other case contains a work of certainly a very different calibre [from Michelangelo's Taddei tondo], yet I think it interesting, and of considerable merit in its way. It is a view of the Colonna Gallery, with all the pictures hanging in it at the time it was painted, by P. Panini, for the Cardinal Colonna. Panini, although not to be trusted out of doors, painted interiors with great skill. . . . This, Canova tells me, was always considered his masterpiece; at any rate, it is a very amusing picture, and many of the copies are very good, particularly the 'Velasquez' now at Lord Grosvenor's.[1]

Although some of the pictures in Panini's interior here were readily identified with extant works, it was thought the ensemble as a whole was just as notional as the architectural setting, which is actually only loosely inspired by the elaborately baroque gallery of Palazzo Colonna.[2] But Olsen recognized that while the setting was indeed invented, the pictures on the other hand do record part of the much larger collection, presumably housed in various places,[3] of Cardinal Silvio Valenti Gonzaga, whose arms, supported by an allegorical figure of fame, decorate the arch at the top of the picture,[4] which he owned,[5] and in which he is seen standing, together with the artist, in the foreground next to a copy, conceived in full length, of Raphael's tondo *Madonna of the Chair* in the Pitti. The painting type is part of a well-established tradition, especially popular in seventeenth-century Flanders, whereby a collection was recorded in a kind of pictorial catalogue such as this.[6] It is Panini's first essay in the genre,[7] one he was to develop upon with variations, as seen, for example, in the 1756 commission for the French ambassador to Rome, the future duc de Choiseul, where Panini, adapting the convention of the Atheneum picture, depicted in two canvases the monuments of *Roma antica* and *Roma moderna* as a series of paintings hanging and propped against the walls of two sumptuous and similarly imaginary galleries.[8] These bravura performances of perspective,[9] and in the Choiseul pair of *vedute* paintings as well, were also architectural *capricci*. What is

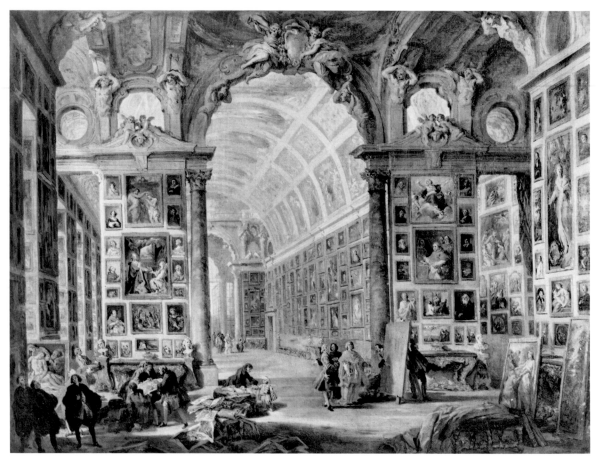

Figure 34. Attributed to Giovanni Paolo Panini,
The Picture Gallery of Cardinal Silvio Valenti Gonzaga, Marseilles,
Musée des Beaux-Arts

surely the amused grandiloquence of the architecture
in the Atheneum picture is intensified by the ceiling
frescoes of the gallery: Creation scenes in the manner
of Michelangelo's Sistine ceiling.[10] A further light
touch is the presence, just to the left of the center, of
the cardinal's dwarf Giovan Battista Mamo, "mirabile
e strodinario nella piacevolezza."[11] The entire picture
is distinguished throughout by the mastery and even-
ness of its execution.

Cardinal Silvio Valenti Gonzaga (1690–1756), of
the illustrious Mantuan family, was a powerful pres-
ence in ecclesiastical, intellectual, and artistic circles
of mid eighteenth-century Rome. He was already
well advanced in papal service under Clement XI and
Benedict XIII, when Clement XII sent him as nuncio
first to Brussels (1731–35) and then to Madrid (1735–
40), made him cardinal in 1738, and appointed him
legate to Bologna. In 1740 his close friend and fellow
amateur of the arts and sciences, the Bolognese
Cardinal Prospero Lambertini, was elected Benedict
XIV (1740–58). Named secretary of state, Valenti
Gonzaga was also later appointed Camerlengo of the
Holy Roman Church and prefect of the Propaganda
Fide in 1745.[12] Tireless in the service of the Church,

Valenti Gonzaga was also a great collector and a
patron of the arts and sciences. Because of his inter-
est, the drawing school of the Accademia di S. Luca,
of which he was made an honorary member in 1742,
was reopened in 1749.[13] He was the moving force
behind the formation and installation of the
Pinacoteca Capitolina, one room of which Panini
designed in 1754 as a circularly planned *accademia del
nudo*, for life drawing. In 1750 Valenti Gonzaga
issued edicts protecting ancient monuments from
being despoiled for building material and regulating
the exportation of works of art. He took a keen inter-
est in the embellishment of the city and preservation
of its monuments. He introduced the teaching of
chemistry and experimental physics at the Sapienza,
the university of Rome, and founded a second chair
in mathematics.[14] Rome and Benedict XIV were well
served by Valenti Gonzaga. Panini's portrait of the
cardinal together with the pope in the Museo di
Roma is perhaps based on a portrait of Benedict XIV

by Pierre Subleyras (1699–1749),[15] another artist patronized by Valenti Gonzaga, and one who between 1747 and 1749 had painted a view of his studio, illustrating therein some of his own paintings.[16] This, Arisi conjectures, could have been an immediate model for Panini's Atheneum picture and its genre.[17]

By 1748 the cardinal had acquired a rustic Roman property just within the Aurelian Wall near the Porta Pia. Here he built a villa according to the plan being studied by the four figures in the left foreground of the Atheneum painting. Some sources credit Panini with the design, but Pietrangeli suggests the building was a collaborative undertaking based essentially on a design by Paolo Posi (1708–1776), a classicizing architect who renovated the attic story of the Pantheon. Panini might have been responsible for the design of the interior and the atrium of the villa, while a French engineer/architect Jacques Philippe Maréchal (d. 1765), who designed the Jardin de la Fontaine at Nîmes, might have given advice, particularly about the garden laid out in the French taste and its waterworks.[18] The villa had obviously been planned when Panini executed this painting, and it is not unlikely that it was in the process of construction in 1749.[19]

Arisi speculates that the figure in black gesturing toward the group examining the architectural plans might be the architect Paolo Posi.[20] Certainly, the very individualized features suggest the figure is a portrait. Among the artistic, literary, and scientific lights of Rome patronized by the cardinal were the physicist François Jacquier and the mathematician Thomas La Seur, two Franciscans, who were instructors at the Sapienza in the posts newly founded by the cardinal[21] and whose likenesses Arisi sees in the two clerics in the lower left corner.[22] On Sundays and holidays the cardinal had *conversazioni* for the intellectual and the artistic lions of Rome,[23] a number of whom might be depicted herein.[24]

Arisi identifies a drawing in Berlin as a study for the prelate at the very rear of the gallery, standing before a column,[25] and found figure studies for the Atheneum picture on thirteen leaves of a Panini sketchbook in the British Museum, published earlier by Croft Murray.[26] The figure holding a palette and brushes is a self-portrait of Panini, who, in October 1749, was made a knight of the papal order of the Golden Spur for the services he had rendered the cardinal.[27]

The picture is repeated, to a degree, in two similarly sized sketches: one now in Marseilles (Fig. 34);[28] the other in the Casita del Príncipe at the Escorial, fragmentarily signed but clearly dated 1761, five years after the cardinal's death (Fig. 35). Urrea Fernández considers the Escorial work a *bozzetto*, differing, like that in Marseilles, from the Atheneum picture mainly in the content of one large painting represented on the extreme left.[29] Jacob van Ruisdael's *Great Oak* is replaced in the sketches by a *Pietà*.[30] Otherwise, their contents differ from the finished painting only slightly. The ceiling decoration is not elaborated. In addition, the hanging of the gallery is somewhat altered in the sketches, and therefore, the repertoire of works illustrated is somewhat different,[31] owing to the two lateral walls to the

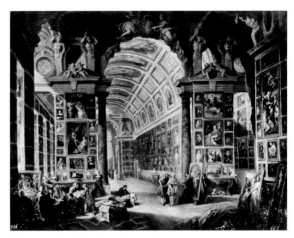

Figure 35. Attributed to Giovanni Paolo Panini, *The Picture Gallery of Cardinal Silvio Valenti Gonzaga*, Escorial, Casita del Príncipe

main gallery being conceived of as high screens in the sketches rather than solid walls pierced by doors as in the painting. And, finally, in the sketches the pope with a small entourage enters the back of the gallery. It was Benedict XIV's custom to make frequent excursions out of the Quirinale, sometimes twice a day, and so great was his esteem for his secretary of state, whom he referred to as a "uomo unico," the pope visited Valenti Gonzaga's villa twice a week after the cardinal had suffered the first of an eventually fatal series of strokes in 1751.[32] Thus the sketch motif could recall a similar papal visit, but such a theme, wherein the cardinal figures more prominently than his pontiff, would surely have been omitted from the painting of 1749 on the grounds of lèse majesté.[33] Wunder believes much of the Escorial sketch could be workshop and that the Marseilles sketch is a rather inferior repetition thereof from the same source.[34]

The cardinal's interest in collecting prints and drawings is evidenced by the prints illustrated in the painting's left foreground after Raphael—*The Miraculous Draught of Fishes*, *The Massacre of the Innocents*, and *God Appearing to Noah*—the print portraits of Raphael and Titian, and a similar likeness of Leonardo held by the figure on the left.[35] He had a scientific library of 40,000 volumes as well as collections of maps, scientific instruments, and Oriental objects. In the villa's gardens were rare and exotic plants, among them the first pineapples in Rome.[36] Note in the painting the floral still life, by the silver urn in the foreground, and, to the right, a bowl with branches of botanical specimens. Among the books are zoological and botanical texts,[37] but most important in the painting are the pictures. Although they entirely cover the walls, skied one above another in the contemporary taste for hanging, these some 200 pictures are but a portion of the 819 works inventoried near and after his death,[38] after which the collection was dispersed, partly in Rome and particularly at two sales in 1763 in Amsterdam.[39]

The following list of pictures that have been identified in the Atheneum painting, and sometimes located as well, is collated, except as noted, from the 1949 Hartford *Pictures within Pictures* exhibition catalogue, from Olsen, and particularly from Pietrangeli (Fig. 36).[40]

3. Titian?
8. Perino del Vaga, *St. Matthew*, Statens Museum, Copenhagen, 1951, no. 725
9. Annibale Carracci, *Madonna and Child*
13. Italian sixteenth century, *Double Portrait*, Gemäldegalerie, Dresden, no. 300
15. Jacob van Ruisdael and Nicolaes Berchem, *The Great Oak*, Carter Collection, Los Angeles[41]
16. Francesco Albani?
17. Bartolomeo Manfredi, *Bacchus and a Toper*, Galleria Nazionale, Rome, no. 1012[42]
19. Jan Brughel the Younger, *A Summer View of a Village*, Landesgalerie, Hannover, no. 88[43]
21. Unknown, *Portrait of a Woman*
23. Giorgio Vasari, *Cardinal Bembo*
24. Federico Barocci, *Noli me tangere*
25. After Raphael, *Julius II*, Galleria Nazionale, Rome, no. 848
26. Jan Miel, *The Dentist*?
27. Jan Miel, *Morra Players with a Donkey*[44]
28. Bonifacio di Pitati, *The Holy Family in Egypt*
29. After Barocci, *Annunciation*, Statens Museum, Copenhagen, 1951, no. 26
30. Unknown, *Adoration of the Kings*
33. After Correggio, *Magdalen Reading*, Galleria Nazionale, Rome, no. 1014
35. Unknown, *Portrait of an Old Man*, Hermitage, Leningrad, 1909, no. 1656
36. Unknown, *Portrait of a Man*
37. Unknown, *Head of St. Michelina*
38. Jacopo Tintoretto, *Portrait of a Man*
39. Bartolomeo Schidone, *The Seven Acts of Mercy*, Statens Museum, Copenhagen, 1951, no. 653
40. After Titian, *Laura Dianti*, National Museum, Stockholm[45]
41. Jan Miel, *Cattle at a Fountain*, Galleria Nazionale, Rome, no. 1021[46]
42. Jan Miel, *Travelers at an Inn*
51. Pierre Subleyras?, *Cardinal Valenti*, Arrivabene Valenti Gonzaga Collection, Venice
52. Unknown, *Madonna and Child*, destroyed, formerly in Christiansborg, Copenhagen
53. Domenico Fetti, *Parable of the Workers in the Vineyard*[47]
63. Agostino Masucci, *Annunciation*, Statens Museum, Copenhagen, 1951, no. 426
64. Unknown, *Madonna and Saints*, private collection, Stockholm
65. Unknown, *Madonna with Saints*, Bergsteen Collection, Stockholm
67. Annibale Carracci?, *Baptism of Christ*, destroyed, formerly in Christiansborg, Copenhagen
78. Giuseppe Ribera, *The Entombment*, Louvre, Paris,[48] or Cigoli, *Deposition*, Galleria Nazionale, Rome, no. 817[49]
80. Unknown, *The Magdalen Contemplating a Skull*
82. Pier Francesco Mola?, *Expulsion from Paradise*, National Gallery, Warsaw, no. 752[50]

98. Possibly Lotto, *Portrait of a Man*
99. Ludovico Carracci, *St. Jerome*
100. Guido Reni?, *Ecce Homo*[51]
101. Ferdinand Voet, *Olimpia Aldobrandini*, Galleria Nazionale, Rome, no. 893, after a portrait attributed to Baciccio in the Doria Gallery, Rome
102. Veronese, *Faith*
103. Giovanni Lanfranco, *The Annunciation*, Hermitage, Leningrad, 1909, no. 201
104. After Raphael, *Madonna of the Chair*
105. Carlo Maratti, *Assumption of the Virgin*
106. Giuliano Bugiardini after Raphael, *Leo X and His Nephews*, Galleria Nazionale, Rome, no. 901, on deposit at Palazzo Venezia[52]
107. Francesco Menzocchi?, *Madonna and Saints*, Statens Museum, Copenhagen, 1951, no. 844
108. Rosalba Carriera, *Continent of Europe*, formerly Gemäldegalerie, Dresden (see no. 113 below)
109. Rosalba Carriera, *Continent of Asia*, formerly Gemäldegalerie, Dresden (see no. 113 below)
110. Lelio Orsi, *Christ Crowned with Thorns*, Musée Fabre, Montpellier
111. Annibale Carracci, *The Three Marys at the Tomb*[53]
112. Rosalba Carriera, *Continent of America*, formerly Gamäldegalerie, Dresden (see no. 113 below)
113. Rosalba Carriera, *Continent of Africa*, Gemäldegalerie, Dresden, no. P32[54]
114. Attributed to Bonifacio Veronese, *Portrait of an Astronomer*, Galleria Nazionale, Rome, no. 859[55]
115. Guido Reni, *St. Peter*
118. After Rubens, *Marie de' Medici*[56]
119. Jacopo Tintoretto?, *Doge Girolamo Priuli*
120. Garofalo, *Vision of St. Augustine*, National Gallery, London, no. 81[57]
123. Velázquez, *Baltasar Carlos on Horseback in the Riding School*, Westminster Collection, England[58]
124. Salvator Rosa, *John the Baptist Preaching*
129. Luigi Primo Gentile, *Don Jaime de Barthos*, Galleria Nazionale, Rome, no. 809
130. Pietro Testa, *Presentation of the Virgin in the Temple*, Hermitage, Leningrad, 1909, no. 261[59]
131. Attributed to Lodovico Carracci, *Portrait of a Man*, Galleria Nazionale, Rome, no. 847[60]
133. Jan Brughel the Elder, *Flowers*
134. After Raphael, *Baldassare Castiglione*, Galleria Nazionale, Rome, no. 876
135. Possibly Guercino, *Christ Carrying the Cross*
136. Titian, *Christ with the Crown of Thorns*
137. L'Ortolano, *St. Margherita*, Statens Museum, Copenhagen, 1951, no. 520
138. Parmigianino, *Lorenzo Cybo*, Statens Museum, Copenhagen, 1951, no. 533[61]
139. Andrea Sacchi, *St. Dominic*[62]
141. Carlo Maratti, *Madonna*
142. Hercules Seghers, *Flowers*
143. Attributed to Raphael, *"The Pharmacist,"* Statens Museum, Copenhagen, 1951, no. 846
144. Leonello Spada, *The Beheading of John the Baptist*
146. Peter Paul Rubens, *The Crucifixion*[63] M.M.

Figure 36. Key to Giovanni Paolo Panini, *The Picture Gallery of Cardinal Silvio Valenti Gonzaga* (from Olsen, 1951)

1. Whiting, 1964, 44–45; F. Whiting to S. Wagstaff, 1 Jan. 1968, curatorial file. References in addition to those cited below: *Wadsworth Atheneum Annual Report*, 1948, 11, 29; *Wadsworth Atheneum Bulletin*, Apr. 1949, 4–5, Nov. 1949, 1; Wunder, 1955, II, 117, no. 1; *Wadsworth Atheneum Handbook*, 1958, 87; Moir, 1967, I, 86; Fredericksen and Zeri, 1972, 156, 498, 585; Gaunt, 1974, no. 41; Chambert et al., 1978, repr. 9; Griseri, 1981, pl. 451; Soria, c. 1982, repr. 26; Silk and Greene, 1982, 70, 71.
2. Correspondence in curatorial file: P. J. Kelleher to C. Cunningham, 4 May 1949; C. Cunningham to P. J. Kelleher, 10 May 1949; R. Wunder to C. Cunningham, 1949; C. Cunningham to R. Wunder, 27 Apr. and 26 May 1949; G. Briganti to C. Cunningham, 6 Sept. 1949. The paintings identified in the above correspondence were published in the Hartford, *Pictures within Pictures*, 1949, exhibition, employing a numbered schematic diagram, 21, that was subsequently used by Olsen, 1951, 93, and Pietrangeli, 1961, opposite fig. 14. In the latter, nos. 108 and 109 plus nos. 112 and 113, respectively to the left and to the right of no. 110, are renumbered 110 a, b, c, d by Pietrangeli, whose nos. 145–47 are out of sequence, stacked vertically, numerically top to bottom, between nos. 65–66 and nos. 67–68.
3. See Cormio, 1986, 54, for some indication of where the pictures were housed.
4. Olsen, 1951, 90.
5. Pietrangeli, 1961, 55, inv. no. 386, "Quadro di palmi 12. per larghezza, e palmi 9. once 4. per altezza, rappresentante la Galleria de' Quadri dell'E.mo Cardinale Valenti, in tela, di Gio: Paolo Pannini."

6. Olsen, 1951, 90–91. *The Gallery of Archduke Leopold Wilhelm in Brussels* by David Teniers the Younger comes to mind as an outstanding example (Vienna, Kunsthistorisches Museum, no. 739). For further examples, see I. Kennedy, "Picture Galleries by Teniers and Panini," *Christie's Review of the Season 1976*, ed. J. Herbert, London, 1976, 49–50. See also Winner, 1957.
7. Arisi, 1961, 194–95, no. 209, figs. 260–62, pl. XII; 1986 ed., 430, no. 400. The author explains (1961, 14) that in contemporary documents and in his own signatures the artist's name is spelled "Panini," not "Pannini," as has become current.
8. Arisi, 1961, 211–15, nos. 245–48, figs. 305–7; 1986 ed., 464–65. For further bibliography, see Arizzoli-Clementel, 1975, 20, n. 16.
9. The Atheneum picture has incised recessional perspective lines in the floor and vault of the gallery. The arches of the vault were also drawn beforehand and slightly adjusted when painted in.
10. Reading the six bays from rear to front: (1) illegible; (2) the Separation of the Waters; (3) the Separation of Night and Day; (4) the Creation of the Sun and Moon; (5) the Creation of Animals; (6) the Creation of Eve? The six grisaille panels flanking these central scenes on each side seem to be New Testament scenes. Those in color beneath, in alternating tabernacle and oval frames, seem to be mythological subjects.
11. Von Pastor, 1943–63, XVI, pt. 2, 35, n. 2. Cormio, 1986, 52, fig. 3.

12. The dates are taken from Cormio, 1986, 63, n. 1, with the exception of Valenti Gonzaga's being made a cardinal, which is from von Pastor, 1943–63, XV, 720–21, where the Brussels nunciature is given (721) as 1731–36. Pietrangeli has the appointment to Camerlengo as 1747 (*Studi*, 1959, 289, where the Atheneum picture is mentioned and repr. as pl. LIII).

13. For Panini's drawing academy, see also von Pastor, 1961, XXXV, 178, 182. Pietrangeli, *Strenna*, 1959, 123–24, where the Atheneum picture is mentioned on 123. See also Arisi, 1961, 228, no. 268, fig. 341.

14. The cardinal's patronage is the subject of Cormio's 1986 article (see especially 50–53), announced as the first publication to be extracted from "Il Cardinale Silvio Valenti Gonzaga collezionista, promotore e protettore delle scienze e delle belle arti nella Roma papale al tempo di Benedetto XIV," tesi di laurea, University of Rome, 1982–83.

15. Arisi, 1961, 195–96, no. 210, fig. 263; 1986 ed., 432, no. 403, 214, pl. 206. Subleyras executed a magnificent three-quarter-length portrait of the cardinal, now in a Roman private collection. Repr. in Arizzoli-Clementel, 1975, 9, where the architectural history of the Villa Valenti Gonzaga is discussed from its origins to the near present. Arisi, 1986 ed., 431, no. 401, subsequently attributed the above-mentioned portrait to Panini.

16. Vienna, Akademie der bildenden Künste, oil on canvas, 125 x 99 cm. Repr. in Rome, 1959, no. 592, fig. 7.

17. Arisi, 1961, 68. Brunetti also alludes to Subleyras's influence, stylistically as well as iconographically, on Panini in the late 1740s (1964, 175, where the Atheneum picture is mentioned, and 193, n. 31).

18. Pietrangeli's argument is first set out in *Studi*, 1959, 291–92, and recapitulated in an expanded version in *Villa Paolina*, 1961, 14–16. The villa subsequently passed to Cardinal Prospero Colonna di Sciarra and was eventually bought in 1816 by Napoleon's exiled sister Pauline, Princess Borghese, who remodeled the structure, especially the interior, and its gardens. Thereafter, it was called Villa Paolina and the Villa Bonaparte, and is now the French embassy to the Holy See. Pietrangeli, 1961, 18–19; Arizzoli-Clementel, 1975, 10–13.

19. Wunder, 1957, 291–92, where the Atheneum picture is mentioned.

20. Arisi, 1961, 227–28, no. 267.

21. Pietrangeli, 1961, 17. Cormio, 1986, 53.

22. Arisi, 1961, 195, no. 209.

23. Von Pastor, 1943–63, XVI, pt. 2, 35. Cormio, 1986, 50.

24. Cormio, 1986, 54, 65, n. 43, suggests a likely list of names and sees in an unspecified figure in the left foreground the likeness of R. G. Boscovich. M. Kiene has in hand an investigation as well as to see if the figures in the Atheneum picture might not be such an illustrious company (verbally to M. Mahoney, May 1987).

25. Arisi, 1961, 195, no. 209; 1986 ed., 430, no. 400. Kupferstichkabinett 17583C.

26. Croft Murray, 1937, 61, as B.M. inv. no. 1858.6.26.655, 190 x 125 mm, fol. 80 exceptionally is in pen and gray wash; otherwise the studies are all in black and red chalks. Arisi, 1961, 195, no. 209, as B.M. inv. no. 197.b.5, fols. 23, 35, 42, 48, 82–86, 91–94, 100, 103, 126; 1986 ed., 430, no. 400. Croft Murray, 1937, 62–64, connected elements of fols. 42, 86, and 100 with other pictures by Panini. Wunder (in unpublished ms. notes kindly provided by the author to the curatorial file) connects fols. 82–85, 88–92, 93 recto and verso, 94, 95 verso, 96, and 97 with the picture and notes there are two further, unlocated drawings, in 1967 in a Virginia collection, that might be relevant: one of a seated prelate, the other of a similar figure standing with his left hand posed upon a console table.

27. Arisi, 1961, 68, 102, 195.

28. Musée des Beaux-Arts, inv. no. 668, photo no. 55726, oil on canvas, 50 x 64 cm, acquired in 1869 from the Borély Collection, Marseilles (H. Wytenhove to M. Mahoney, 16 July 1984, curatorial file). However, an earlier curator of the Marseilles collection described the sketch as a bequest, in 1895, of M. Ducros-Aubert (H. Guillet to C. Cunningham, 25 Jan. 1949, curatorial file). Istituto Centrale per il Catalogo e la Documentazione, Rome, photo no. E44421.

29. El Escorial, Casita del Príncipe, oil on canvas, 48 x 63 cm. Urrea Fernández, 1977, 293, illus., bought by Charles IV, before his accession, for his Casa del Campo at the Escorial. Referred to by Ozzola, 1921, 17, and by Arisi, 1961, 193; 1986 ed., 429, no. 398, illus. Neither author reports either a signature or date.

30. Slive, 1987, 175, where the Atheneum picture is reproduced, 170, fig. 1, and where it is reported that the signature on the Escorial sketch is now hardly legible, but the date is quite clear.

31. Because the hanging in the Marseilles sketch is closer to the Atheneum picture's layout, Arisi considers the Marseilles study a more developed, and later sketch than that in the Casita del Príncipe (1986, 429, no. 397, illus.).

32. Von Pastor, 1943–63, XVI, pt. 1, 29–30, 35.

33. Arisi, 1961, 68. The Escorial sketch is one of a pair, the other subject being *A Cardinal Entering the Portico of St. Peter's*, which Urrea Fernández suggests might be an abbreviated version of a 1750 *Opening of the Porta Santa* (1977, 294, illus.), as does Arisi (1986 ed., 429, no. 399, illus.). That the Escorial pair of sketches, in which Wunder saw the possibility of extensive workshop contribution, are signed (now fragmentarily in the case of the *Picture Gallery*) and dated 1761, five years after the cardinal's death (Slive, 1987, 175, n. 14), suggests both were either signed in the studio long after their execution in the late 1740s or had intentional variants from the large final composition added in 1761. Wunder thought the Marseilles sketch probably a copy of that at the Escorial (Slive, 1987, 175, n. 14).

34. Wunder, 1955, II, 96, 120–21, and verbally to M. Mahoney, 30 Oct. 1989.

35. Cormio, 1986, 59. His prints and drawings were stored in ninety-one boxes designed to look like books.

36. Pietrangeli, 1961, 16–17.

37. The topmost of these volumes piled atop one another in the lower right foreground is open to a double page illustration of American corn.

38. Cormio discovered a 1756 inventory of the cardinal's entire possessions, including paintings. See her 1986 article's appendix, "La Quadreria del Cardinal Valenti Gonzaga, considerazioni in margine al dipinto di G. P. Panini," 54–63, wherein, 54–55, his nephew, Cardinal Luigi Valenti Gonzaga, is designated the heir of his property in Rome; Pietrangeli, 1961, 43–71, had published a subsequent inventory of the pictures alone that is less descriptive than the 1756 inventory, *Quadri tuttavia esistenti nella galleria della ch. mem. dell'E.mo Sig. Cardinale Silvio Valenti*, Biblioteca Comunale, Mantua, misc. 109, 1.

39. Pietrangeli, 1961, 32–37. One hundred twenty-two paintings were sold by DeLeth and DeWinter on 18 May 1763; 158 by DeWinter on 28 Sept. 1763.

40. Hartford, *Pictures within Pictures*, 1949, 21–22. Olsen, 1951, 94–95. Pietrangeli, 1961, 33–37, key opposite fig. 14.

41. Identified by Slive (S. Slive to J. Cadogan, 1 May 1985, curatorial file). See The Hague, 1981–82, 58–59, no. 11. Slive, 1987, 169.

42. Moir, 1967, I, 86, n. 55, II, fig. 102.

43. The 1949 Hartford *Pictures within Pictures* exhibition catalogue cites a similar painting attributed to Joos de Momper in the Marandotti Collection, Palazzo Massimo, Rome. G. van der Osten first identified the Hannover picture and attributed it to de Momper (undated and unsigned note in C. Cunningham's hand in the curatorial file). K. Ertz attributed it and its pair, *A Winter View of a Village*, no. 89, to Jan Brughel the Younger, but Slive accepts only the *Summer View* as Brughel the Younger. He notes there are several versions of the *Summer View*, the best of which, according to H. G. Gmelin, is in the Prado and attributed to Jan Brughel the Younger (Slive, 1987, 173–74).

44. A. Janeck to C. Cunningham, 1 Dec. 1964, curatorial file.

45. Olsen, 1951, 95, 101, n. 35.

46. Traditionally attributed to Cerquozzi, but published along with 26, 27, and 42 as Jan Miel by Hoogewerff (1933, 250–62). By Lingelbach according to A. Janeck to C. Cunningham, 1 Dec. 1964, curatorial file.

47. Known in numerous versions, for example, Dresden, no. 423.

48. As identified by Felton, 1969, 5.

49. As identified by Cormio, 1986, 57, fig. 8.

50. J. Bialostocki to S. Wagstaff, 31 Dec. 1965, curatorial file, suggested an attribution to Gargiulo and later suggested Castiglione?, 28 Dec. 1987, curatorial file.

51. A. di Carpegna to C. Cunningham, 21 Oct. 1957, curatorial file, different from either of two pictures in the Galleria Nazionale, Rome, both from the Corsini Collection.

52. Harris, 1982, 439, speculates the picture came from Charles I's collection to the cardinal as a gift from the duke of Alba. She points out that in this version a likeness of Cardinal Innocenzo Cibo, who commissioned the copy, is substituted for that of Cardinal de' Rossi.

53. According to Hartford, *Pictures within Pictures*, 1949, 22, by Annibale and with versions in Stockholm, Leningrad, and St. Louis.

54. The three companion pastels of allegorical female heads, nos. 108, 109, 112 in the list above, were among the losses suffered by the Dresden collection during World War II, be it by destruction or looting is not specified (Gemäldegalerie Alte Meister, Dresden, *Katalog der ausgestellen Werke*, 1979, 354, and Ebert, 1963, 77).

55. Cormio, 1986, 57, figs. 6–7.

56. Olsen, 1951, 102, n. 118, likens this to the kind of "replica," formerly in Wilhelm II's collection, on deposit? at the Rijksmuseum, citing M. Rooses, *L'Oeuvre de P. P. Rubens*, Antwerp, 1886–92, IV, 217, presumably no. 999, Buccleuch Collection, a head study in which the queen looks over her left shoulder. Huemer, 1977, 148–49, no. 28, fig. 84, as Rubens?, Paris, Galerie Pardo, cites such a composition as a half-length repetition of the unfinished Prado portrait in Madrid (1977, 147–48, no. 27, fig. 83, inv. no. 1685). The background in Panini's *ricordo* is pale and the edge of the collar is reinforced in black, suggesting this might be a reduction, without hands, of the Prado composition.

57. Pietrangeli, 1961, 34, as from Palazzo Corsini.

58. Harris, 1976, 268–69, reproduces the Atheneum picture, fig. 4, and identifies the Valenti Gonzaga *Baltasar* with the picture now in the Westminster Collection; it had been a gift from Luis de Haro (1982, 439).

59. From the church of S. Croce dei Lucchesi, Rome (Pietrangeli, 1961, 34).

60. N. di Carpegna to C. Cunningham, 21 Oct. 1957, curatorial file.

61. Hartford, *Pictures within Pictures*, 1949, 22, cites another version with Wildenstein, New York, in 1948.

62. Misleadingly numbered *148 in Pietrangeli's 1961 diagram.

63. It hangs next to no. 67 in the key.

Antonio Ermolao Paoletti, *Venetian Lady with Parrot*

Antonio Ermolao Paoletti (1834–1912)

Paoletti was born in Venice and was a student of Pompeo Marino Molmenti. He produced genre and narrative paintings, mostly in Venice of Venetian scenes. He also painted decorative works in fresco, including the ceiling of the church of the Madonna dell'Orto.[1]

1. Comanducci, 1973, IV, 2329–30.

Venetian Lady with Parrot

Oil on canvas, 121 x 76.4 cm (47⅝ x 30 in.)
 Condition: good. The paint film is covered with cloudy varnish. The canvas is unlined.
 Signed and dated lower right: *A. Ermolao Paoletti 74*
 Provenance: Guggenheim, Venice; purchased by Elizabeth Hart Jarvis Colt in April 1882 for 1,000 pounds. Bequeathed to the Wadsworth Atheneum in 1905 by Elizabeth Hart Jarvis Colt.
 Exhibitions: Hartford, 1958, no. 14; listed in Williamstown, 1982, 76.
 Bequest of Elizabeth Hart Jarvis Colt, 1905.25

Venetian Lady with Parrot is typical of Paoletti's works, which depict the activities of leisured women in Venice. J.C.

Giuseppe Antonio Petrini
(1677–c. 1757)

Weber published the first documents regarding this Italo-Swiss painter who was born in the canton of Ticino, in Carona, near Lugano.[1] Voss and Suida assembled the first substantial list of his works, a corpus that was greatly expanded by Bassi's archival research that brought the oeuvre to some two hundred recorded paintings, about one half of which are identified.[2]

In connection with a 1960 exhibition of Petrini's works,[3] Arslan published a monographic study on the artist,[4] a pupil of Bartolomeo Guidobono (1654–1709) in Turin, seemingly between about 1700 and 1708. There, or by some means yet to be ascertained, Petrini was exposed to Venetian painting and particularly influenced by Piazzetta,[5] an impression so marked that until recently one of Petrini's masterworks, the *St. Luke* in the Heinemann Collection, New York, passed as a Piazzetta.[6]

1. Weber, 1908, 237–50.
2. H. Voss in Thieme and Becker, 1932, XXXVI, 500–501; Suida, 1930, 269–80; Bassi, 1939, 138–46.
3. Lugano, *Mostra del pittore Giuseppe Antonio Petrini*, 3 Oct.–6 Nov. 1960, exh. cat. by A. Cattaneo and E. Ferrazini.
4. Arslan, *Petrini*, 1960.
5. Castelnovi, 1959, 327–28.
6. Reproduced in Arslan, *Petrini*, 1960, 11, fig. 1, and Fiocco, 1961, fig. 222a. Given to Piazzetta by Borenius, 1923–26, I, no. 24. See most recently Milan, 1991, 162–70.

"Barbary Pirate"

Oil on canvas, 116.8 x 94 cm (46 x 37 in.)

Condition: selectively cleaned, strengthened (e.g., the mustache and beard), and retouched throughout (e.g., in the shadows). The aureole around the entire figure, in reproduction most easily seen around the turban and hand, seems to be the artist's last adjustment between the figure and the background. Damaged (approximately 8 x 4 cm) on the chest, just below the chin. The obverse of the fluttering ribbon is gold with a gold brocade pattern mostly worn away; the reverse is rose.

Provenance: a French private collection. Purchased by the Wadsworth Atheneum in 1968 from Frederick Mont, New York, for $8,000 from the Sumner Fund.

Exhibitions: Amherst, 1974, no. 69, as Mola; Hartford, 1979, no. 12, as anonymous Italian.

The Ella Gallup Sumner and Mary Catlin Sumner Collection, 1968.116

The painting was acquired in 1968 as a *Barbary Pirate* attributed to Pier Francesco Mola. Neither the attribution nor the identification of the subject rests upon any traditional authority, nor does the picture have any firm provenance.[1] The attribution to Mola was accepted with reservation by Harris,[2] and after initial doubts by Cocke as well, who thought it an early work to be compared with the *Prodigal Son* in the Vitale Bloch Collection.[3]

When compared to the Louvre's signed and dated *Barbary Pirate* of 1650, a universally accepted Mola,[4] it is readily apparent the Atheneum painting has no relationship whatsoever to that work, whose dash of execution, placement of the figure in space, and general sense of swagger is quite unlike the much less plastic Atheneum figure, which is pulled right to the front of the picture plane and whose crisp turban bands are also unlike the sumptuous scarves and pelts in the Paris painting. If the Atheneum picture is to be assigned to the early Mola, then it cannot be constructively compared to the Bloch painting, whose idyllic mood as well as modeling are quite different. In fact, neither in Cocke's book nor in the immediately preceding and following literature do we find telling comparisons with Mola.[5]

Clearly this is a fancy picture, a *capriccio*, perhaps one of a group depicting exotic characters. Hence the generic appropriateness of the title, which nonetheless lacks specific justification.

Rather than attributing this work to Mola, who was born near Como, Spike thinks it is by another northern, but eighteenth-century painter, Giuseppe Antonio Petrini,[6] who, in addition to being a prolific painter of altarpieces and frescoes, was chiefly known and esteemed in his time for "mezze figure di carattere."[7] These half-lengths are generally evangelists, apostles, saints, or philosophers, hence the particular iconographic interest of this picture, which stylistically can be compared positively with a number of such half-lengths in Arslan's publication alone. The manner in which the paperlike figure, with broad, simplified drapery, is brought to the very front of the picture space and set off center can be compared with the *St. John the Evangelist* in the Züst Collection, Rancate, initialed "G. A. P." and dated 1741.[8] These features plus the typical aureole of clouds are found again in two *David*s, one in the Banca Ferrazzini, Lugano, and the other in the Züst Collection.[9]

There remains one caveat in totally agreeing with Spike's attribution and here proposing a date of about 1750. Arslan wondered if the number of such half-lengths and their varying quality might not indicate workshop assistance in this popular genre, specifically the intervention of Petrini's son, Marco.[10] Documentary evidence indicates two half-length portraits in the 1960 exhibition were actually by Marco, his first certain works: the portraits of Count and Countess Riva.[11] To judge from reproductions, the set of Count Riva's head, eyes, and the nose, as well as the brushwork, are not unlike the Atheneum picture.

M.M.

Giuseppe Antonio Petrini, *"Barbary Pirate"*

1. A letter, alluding to the French provenance, from Mrs. Mont to the museum states that Sterling, Stechow, and Volpe passed positively upon the attribution to Mola (B. Mont to P. Marlow, 17 Sept. 1968, curatorial file). Waterhouse is said to have confirmed the attribution as well (P. Marlow to E. Schleier, 12 Sept. 1973, curatorial file). *Wadsworth Atheneum Bulletin*, Spring/Fall 1969, 26, as "attributed to Pier Francesco Mola."
2. "The Mont picture seems to be a Mola . . . a little damaged and a touch smoothed up by a skillful restorer, not so meaty a piece of paint as the Louvre or Oxford pictures, but with some fine passages . . . and good overall effect" (A. Harris to S. Wagstaff, 22 Mar. 1968, curatorial file).
3. "To judge from the photo . . . the attribution to Mola was not convincing. The handling appears to be totally different from that in the picture [*Barbary Pirate*] in the Louvre, and it does not appear to connect with any other period of Mola's career" (R. Cocke to S. Wagstaff, 18 Apr. 1968, curatorial file). "Since seeing the canvas I have no doubts about the attribution to Mola. From a photograph I had failed to realize that it is an early work" (R. Cocke to the Atheneum, 17 Dec. 1973, curatorial file).
4. Cocke, 1972, 53, no. 36, fig. 45.
5. Rudolph, 1969; Riccio, 1972; Rudolph, 1972; Harris, 1974; Genty, 1979. The closest comparisons one can make, and they are not at all proximate, are to the *Turk* in the London trade and the *Woman with a Turban* in Capiago (Como), published by Riccio, 1972, figs. 6 – 7.
6. J. Spike verbally to J. Cadogan, 18 Dec. 1979, memorandum in curatorial file.
7. Fiocco, 1961, 455.
8. Arslan, *Petrini*, 1960, 624, fig. 42 on 86.
9. Arslan, *Petrini*, 1960, fig. 45 on 91 and fig. 40 on 83. The latter color plate, as deficient as it is, gives some sense of the artist's idiosyncratic color schemes.
10. Arslan, *Petrini*, 1960, 63–64. P. Rosenberg verbally to J. Cadogan, 22 May 1980, memorandum in curatorial file, suggested a Neapolitan origin for this picture; N. Spinosa verbally to J. Cadogan, 19 Mar. 1979, memorandum in curatorial file, similarly proposed Fracanzano.
11. Arslan, 1961, 61, figs. 1–2.

Giovanni Battista Piazzetta (1683–1754)

Born in Venice, the son of a modest sculptor, on 13 February 1683, Piazzetta first studied painting with Antonio Molinari.[1] Molinari was linked through his own teacher Antonio Zanchi to the Venetian seventeenth-century tradition of dramatic chiaroscuro and volumetric figures; though no works by Piazzetta from his apprenticeship survive, it was perhaps this aspect of Molinari's work that led Piazzetta in 1703 toward Bologna, where he supposedly spent several years studying with Giuseppe Maria Crespi.[2]

Piazzetta had returned to Venice by 1711, when he was inscribed in the *Fraglia dei pittori*, and he presumably began his independent activity as a painter in that year.[3] Unfortunately, very few works from the 1710s survive; Albrizzi describes a small painting, a night scene, in which the figures were illumed only by a lantern;[4] Count Algarotti owned a panel of a *Woman Searching for Fleas* done in collaboration with Bencovich and hence

between 1710 and 1716; it was perhaps such small panels of genre subjects and virtuoso light effects that Piazzetta painted during the decade that would show most clearly his debt to Crespi.[5] From the 1720s on surviving datable works are more numerous. The allegorical *Tomb of Lord Somers*, in collaboration with Canaletto and Cimaroli, was referred to as finished in 1726,[6] and the *Virgin Appearing to S. Filippo Neri* in the church of Sta. Maria della Fava was paid for in 1727.[7] The decoration of the chapel of St. Dominic in the church of SS. Giovanni e Paolo in Venice, including *St. Dominic in Glory* and four ovals in chiaroscuro, must have been under way in 1727, when the ovals were referred to as finished.[8] Other works datable to this time by literary sources include the *Ecstasy of St. Francis* in the Pinacoteca in Vicenza, to 1732, and the *Guardian Angel with Saints Antonio of Padua and Luigi Gonzaga* in S. Vitale in Venice and the *St. James Taken to Be Martyred* in S. Stae, Venice, to before 1733.[9]

The dramatic *Assumption*, now in the Louvre, was commissioned in 1735 by Clemente August, elector of Cologne, and was recognized by contemporaries to mark a new phase in Piazzetta's art.[10] The habitual somber color scheme gives way in this work to a more colorful idiom.

In 1735 Piazzetta signed and dated his self-portrait in black chalk, now in the Albertina; from 1738 dates his only etching, also a self-portrait.[11] Further intimate works from this time include the so-called *Indovina* of 1740, and the *Alfiere*, now in Dresden, bought by Algarotti in 1743.[12]

The demand for Piazzetta's monumental works also continued. From before 1738 dates the great altar of *Saints Vincent Ferrer, Hyacinth, and Lorenzo Bertrando* for the church of the Gesuiti in Venice, and to 1737 the *Beheading of St. John the Baptist* for the Basilica del Santo in Padua.[13] The large *Assumption of the Virgin* in Zbraslav, near Prague, was finished in 1744, and the *Adoration of the Shepherds*, formerly in the cathedral in Würzburg, in 1746.[14] During this period Piazzetta painted also large history paintings, of which few survive.[15]

Apart from Piazzetta's considerable work as a painter, there exists a large body of graphic work. Piazzetta's drawings were frequently made as independent works of art to sell for ready cash. He also made drawings for engravings and was particularly distinguished as a book illustrator.[16]

Piazzetta's workshop was a testament to his talents as a teacher. He was made head of a drawing school in 1750–54,[17] and many of his pupils went on after his death to have independent careers. The altarpiece for the church of the Pietà in Venice was completed by Giuseppe Angeli,[18] and the side altars of the church were each painted by a member of Piazzetta's shop—Domenico Maggiotto, Antonio Marinetti, and Francesco Capella.[19]

Piazzetta died in poverty in 1754. He was buried in Sta. Maria della Fava by his friend Giambattista Albrizzi.[20]

1. The major sources for Piazzetta's life, apart from archival documentation for individual works, are the numerous biographies written within fifty years after his death. The earliest was written by the publisher Giambattista Albrizzi and was published in 1760 as a preface to the *Studi di pittura già disegnati da Giambattista Piazzetta*. Albrizzi knew the artist well and thus this source has special importance. Other important sources include Dezallier d'Argenville, *Abrégé de la vie des plus fameux peintres*, Paris, I, 1762, 318–22; Longhi, 1762, n.p.; Zanetti, 1771, 456–59; Orlandi, 1753, I, 280; and Lanzi, 1815, III, 167–68. Of the modern sources, the fundamental works are Pallucchini, 1934; Jones, 1981; Pallucchini and Mariuz, 1982; and Venice, 1983.
2. While all the biographers refer to this trip to Bologna, Lanzi, 1815, 167, first mentioned his association with Crespi. For Crespi's influence on Piazzetta, see Merriman, 1980, 195, n. 15. Knox, 1983, 510–11, suggests that this trip was brief.
3. Pallucchini, 1934, 1.
4. Albrizzi, 1760, n.p.
5. A. Selva, *Catalogo dei quadri dei disegni e dei libri che trattano dell'arte del disegno della galleria de fu Sig. Conte Algarotti in Venezia*, 1780, 2, as cited in Jones, 1981, 26, n. 30. See, however, Pallucchini and Mariuz, 1982, 77–78, no. 13, for another interpretation.
6. Pallucchini and Mariuz, 1982, 83, no. 32.
7. Pallucchini and Mariuz, 1982, 85, no. 42.
8. Pallucchini, 1934, 2.

9. Pallucchini, 1934, 2; Pallucchini and Mariuz, 1982, 83–87, nos. 33, 48, 49.

10. Pallucchini and Mariuz, 1982, 89–91, no. 63.

11. A. Stix and L. Fröhlich-Bum, *Beschreibender Katalog der Handzeichnungen in der graphischen Sammlung Albertina*, Vienna, 1926, I, 121, no. 253.

12. Pallucchini and Mariuz, 1982, 94, no. 87, 95–96, no. 95.

13. Pallucchini, 1934, 2–3; Pallucchini and Mariuz, 1982, 90–91, no. 65, 100–101, no. 110.

14. Pallucchini and Mariuz, 1982, 102, no. 115, 103, no. 119.

15. Of the history paintings mentioned by the sources, only the *Death of Darius* in the Ca' Rezzonico and the *Mucius Scaevola* in the Palazzo Barbaro-Curtis survive. These are in poor condition and difficult to date precisely. See Pallucchini and Mariuz, 1982, 103–6, nos. 121, 125; see Knox, 1975, 96–104.

16. On Piazzetta's graphic work, see most recently Washington, D.C., National Gallery of Art, *Piazzetta*, 20 Nov. 1983–26 Feb. 1984, exh. cat. by G. Knox.

17. On the nature of this school, see Jones, 1981, 18–20.

18. Pallucchini and Mariuz, 1982, 112, no. 163.

19. Jones, 1981, 17–18; on Piazzetta's students, see most recently Venice, 1983, 119–70.

20. Pallucchini, 1934, 3.

Boy with a Pear in His Hand

Oil on canvas, 45.1 x 37.1 cm (17³/₄ x 14⁵/₆ in.)

Condition: good, except for slight damages around the edges. In some areas the pigment has become transparent and the red ground is visible, for example in the boy's hair.

Inscribed on the back of the lining canvas: *68*.

Provenance: collection Bartholomeo Vitturi, Venice; Maffeo Pinelli, sale Venice, 1785;[1] Dan Fellows Platt, Englewood, N.J.; F. Kleinberger, New York, 1942; Adolf Loewi, Los Angeles; purchased by the Wadsworth Atheneum in 1944 from Adolf Loewi for $2,600 from the Sumner Fund.

Exhibitions: Baltimore, 1944, 50–51, no. 40; Buffalo, Albright Knox Art Gallery, *Eighteenth-Century Italian and French Painting*, 16 Apr.–16 May 1948, no. 21.

The Ella Gallup Sumner and Mary Catlin Sumner Collection, 1944.34

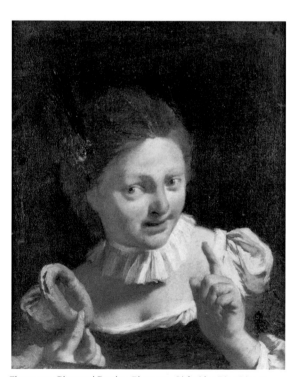

Figure 37. Giovanni Battista Piazzetta, *Girl with a Ring Biscuit*, sale New York, Sotheby's

The *Boy with a Pear in His Hand*[2] was engraved by Marco Pitteri.[3] The inscription on the print, *Piazzetta pin. Archetypüm N. V. Bartholomeo Vitturi Patr. Ven.* and *Pitteri scul.*, documents the early history of the picture as well as the traditional ascription to Piazzetta. Although the attribution to Piazzetta has been upheld in the subsequent literature on the painting,[4] an attribution to Piazzetta's student Domenico Maggiotto has also been proposed.[5]

The pendant to the Atheneum picture, a *Girl with a Ring Biscuit* (Fig. 37), was also engraved by Pitteri with an inscription identical to that of the print of the *Boy with a Pear in His Hand*.[6] The two have identical histories, except that when they were exhibited in Baltimore in 1944, the *Girl with a Ring Biscuit* was still with Adolf Loewi.[7]

Although the Atheneum picture has suffered slightly from general abrasion and the sinking of the pigment into the red ground, it seems reasonable to retain the attribution to Piazzetta himself. Apart from the testimony of the engraving, the picture itself shows none of the soft chiaroscuro and light, pastel colors of paintings traditionally ascribed to Maggiotto.[8] Moreover, the Atheneum picture shows remarkable affinities with pictures firmly attributed to Piazzetta. The face of the boy is very similar to that of the *Standard-Bearer* in Dresden, which was bought by Count Algarotti for the elector of Saxony in 1743.[9]

Several autograph drawings are also related to the Atheneum picture, including the *Young Boy with an Apple* in the Museo Civico del Castello in Milan,[10] in which the youth, shown in profile looking down, grasps an apple; and the *Boy Holding a Lemon* in the J. Paul Getty Museum, in which the youth, wearing a hat and holding his right hand in the same pose as in the Atheneum picture, looks out at the viewer.[11] Further related drawings include that of a boy and a girl holding fruit in the Pierpont Morgan Library, New York,[12] and one in the Kupferstichkabinett in Berlin.[13] While none of these works is preparatory to the Atheneum painting, it seems reasonable to suppose that Piazzetta could have experimented with various combinations of motifs to produce the Atheneum picture.

The Atheneum picture would seem not to be a portrait, but rather a generalized type frequently seen in Piazzetta's oeuvre.[14] Coupled with its pendant, the *Girl with a Ring Biscuit*, it may have significance beyond its depiction of figure types. Jones and Pallucchini and Mariuz have noted the erotic connotations of the fruit held by the boy and the biscuit by the girl. Jones has also cited the idiomatic expression "to fall like a cooked pear" ("cascare come pera cotta"), which means to fall in love; and the proverb "Non tutte le ciambelle riescono col buco," meaning that all does not turn out well.[15] While it cannot be demonstrated that such specific meanings apply to the Atheneum and ex-Loewi pictures, such moralizing and erotic meanings are not unknown in Piazzetta's paintings and seem plausibly applicable to them.

A date of about 1740 has been suggested for the Atheneum painting.[16] J.C.

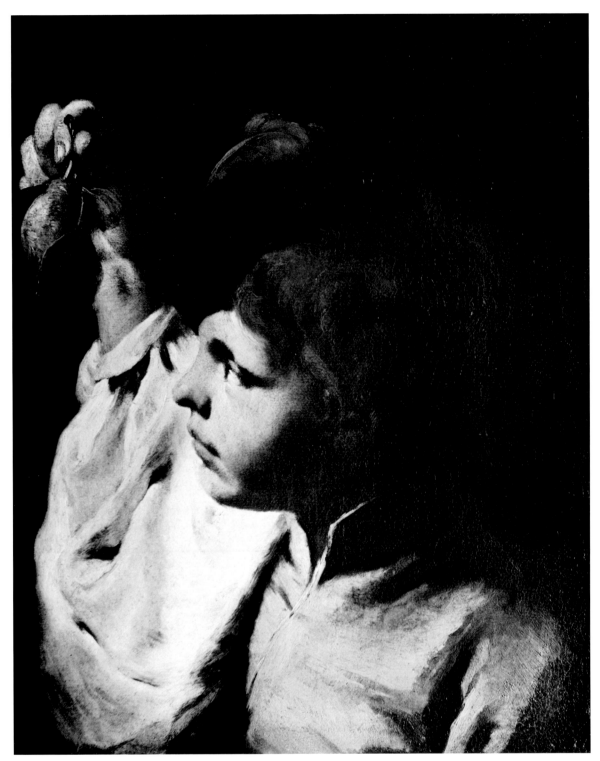

Giovanni Battista Piazzetta, *Boy with a Pear in His Hand*

1. *Catalogo di quadri raccolti dal fu Signor Maffeo Pinelli ed ora posta in vendita*, Venice, 1785.

2. The fruit was identified as a pear from the time the Atheneum acquired it until 1982, when Pallucchini and Mariuz identified it as a lemon. The shape of the fruit, as well as its reddish color, suggest it is a pear rather than a lemon. The leaves, which are broader and less pointed than the leaves of a lemon tree, also argue for the identification of the fruit as a pear. See Levi d'Ancona, 1977, 205–9, 296–99.

3. Rava, 1922, no. 264; Pallucchini, 1934, fig. 103.

4. Pallucchini and Mariuz, 1982, 94–95, no. 88.

5. Jones, 1981, 284–87.

6. Rava, 1922, no. 265; see also Pallucchini, 1956, 36, fig. 86; Jones, 1981, 284–87, no. R29MG; Pallucchini and Mariuz, 1982, 95, no. 89. Both prints are illustrated in Venice, 1983, nos. 108–9.

7. Baltimore, 1944, 50–51, no. 39. The *Girl with a Ring Biscuit* was subsequently sold in New York, Parke-Bernet Galleries, 14 Mar. 1951, no. 23, bought by G. Farkas; sale New York, Sotheby's, 12 Jan. 1989, no. 124, as attributed to Giovanni Battista Piazzetta.

8. Compare, for example, the *Boy with a Flute* in the Ca' Rezzonico in Venice and the *Poultry Seller* in Turin; see Venice, 1983, 156–58, nos. 63–64. It should also be mentioned that Pallucchini in Venice, 1983, 16–17, n. 1, rejects Jones's ascription of the Chicago *Young Pilgrim* to Maggiotto, on which she bases her attribution to Maggiotto of the Atheneum picture and its pendant.

9. Pallucchini and Mariuz, 1982, 94–95, no. 87; they remark that the model for the Dresden picture is the same as for the Atheneum picture.

10. F. Svizzero, "Per Giambattista Piazzetta," *Arte veneta*, XXXI, 1977, 221, fig. 3; Pallucchini and Mariuz, 1982, 95.

11. Black and white chalk on light blue paper, sheet extended at right; 390 x 308 mm; formerly Vivian Smith Collection; sale London, Christie's, 12 Dec. 1985, no. 269. The sale catalogue notes that the face of the boy in the drawing is close to that of the *Boy in a Polish Uniform* in the Museum of Fine Arts in Springfield, Mass.; Pallucchini and Mariuz, 1982, 94, no. 85.

12. J. Bean and F. Stampfle, *The Eighteenth Century in Italy*, New York, 1971, no. 42.

13. No. 5874; Pallucchini and Mariuz, 1982, 95, no. 88.

14. Pallucchini, 1956, 24. G. Knox, letter to J. Cadogan, 20 May 1981, curatorial file, suggested the Atheneum picture was a portrait of Piazzetta's son Giacomo.

15. Jones, 1981, 287.

16. Pallucchini and Mariuz, 1982, 95, no. 88.

Giuseppe Pierotti
(active second half of the nineteenth century)

Little is known of Giuseppe Pierotti, who, with his brothers Francesco and Pietro, was active as a painter and sculptor. Giuseppe exhibited in Parma, Milan, Turin, and Florence between 1870 and 1884.[1]

1. Comanducci, 1973, IV, 2478.

Giuseppe Pierotti
Interior of the Royal Museum, Naples: The Rotunda

Oil on canvas, 82.3 x 63.8 cm (32³/₈ x 25¹/₈ in.)
 Condition: good. There are minor retouches and the varnish has yellowed.
 Signed and dated lower right: *G. P. Pierotti 1864*.
 Inscribed, in pencil, on the stretcher: *Interior of the Pitti Palace Gallery Florence*
 Provenance: Paul W. Cooley, Simsbury, Conn.; purchased by the Wadsworth Atheneum in 1941 from Paul W. Cooley for $500 from the Sumner Fund.
 Exhibitions: Hartford, 1949, *Pictures within Pictures*, not in cat.; Hartford, 1961, 35; Williamstown, 1982, 37–38, no. 53.
 The Ella Gallup Sumner and Mary Catlin Sumner Collection, 1941.408

Inside the Reale Museo Borbonico in Naples, now the Museo Archeologico Nazionale, a young woman is seated, drawing after one of the sculptures.[1] A young man, perhaps her drawing master, observes. The picture presumably shows the museum as it was in 1864, when the picture was painted. J.C.

1. The museum was first conceived by Carlo di Borbone in 1738 as a repository for the rich Farnese collections that Carlo had inherited from his mother, Elisabetta Farnese. The museum was completed only in 1818; in 1860 the collection became the property of the Italian state.

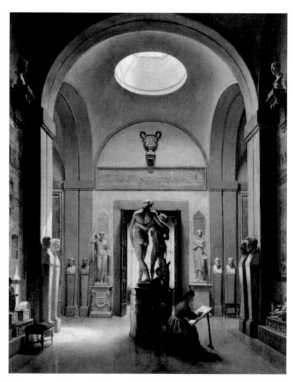

Giuseppe Pierotti, *Interior of the Royal Museum, Naples: The Rotunda*

Sebastiano del Piombo
(c. 1485–1547)

In his first edition of the *Lives*, Vasari, who knew Sebastiano over a long period, says that the painter died in 1547 at the age of sixty-two; he would then have been born in about 1485.[1] His father was Luciano Luciani, and he was probably born in Venice. The sobriquet del Piombo refers to the office of seal keeper for papal letters, conferred on him by Pope Clement VII in 1531.[2]

Little documentary evidence exists for Sebastiano's early years in Venice. Vasari mentions only the altarpiece for S. Giovanni Crisostomo[3] and a portrait, now lost.[4] Nonetheless, several works of considerable stature can be attributed to the young Sebastiano, including the organ shutters for the church of S. Bartolomeo al Rialto, datable to about 1508–9, the *Judgment of Solomon* from the National Trust, Kingston Lacy, begun about 1508–9 and never finished, and the altarpiece for S. Giovanni Crisostomo mentioned by Vasari, painted about 1510–11.[5] The small *Salome* in the National Gallery, London, is dated 1510.[6] Sebastiano's training with the aged Giovanni Bellini, attested to by Vasari, is scarcely apparent in these works, while that with Giorgione, whom Vasari says Sebastiano studied with subsequently, is evident.

In August of 1511 Sebastiano left Venice for Rome in the retinue of the Sienese banker Agostino Chigi.[7] In Rome Sebastiano's first works were the lunette frescoes with Ovidian themes in Agostino's villa, finished by early 1512,[8] the *Portrait of a Woman* in the Uffizi, dated 1512, and the *Portrait of Cardinal Ferry Carondolet* in the Thyssen Collection, Lugano, datable to about 1512–13.[9]

From about this time Sebastiano's extraordinary relationship with Michelangelo began, documented in letters and Vasari's *Vita*.[10] The first picture for which Michelangelo provided drawings was the *Pietà*, now in Viterbo, painted in about 1513–16.[11] The painting of the same subject in Leningrad, most likely Sebastiano's own composition, is dated 1516.[12] In the same year he received the commission to decorate the Cappella Borgherini in S. Pietro in Montorio; the prophets in the spandrels of the external arch were finished by 22 November of that year,[13] but the *Transfiguration* was not finished until about 1519, and the *Flagellation* was executed between about 1520 and 1524.[14] Probably at the end of 1516 or the beginning of 1517 Sebastiano was commissioned to paint the *Resurrection of Lazarus* by Cardinal Giulio de' Medici, the future Clement VII; by 1 May 1519 the picture was finished.[15] In all of these projects, the intervention of Michelangelo is documented by literary and visual evidence.[16]

Numerous documented pictures from the 1520s exist, including the *Flagellation of Christ*, essentially a replica of the S. Pietro in Montorio composition, painted for Monsignor Giovanni Botonti in 1525 and now in Viterbo,[17] and the portrait of Clement VII now in Naples, most likely painted in 1526.[18]

In 1531 Sebastiano was awarded the office of Piombatore, which required him to become a priest and to travel with the papal court. Vasari relates that, with his papal stipend, Sebastiano became lazy,[19] and indeed he produced few monumental works during his late years. The *Pietà* in Seville was commissioned in 1533 by Don Ferrante Gonzaga for Francisco de Los Cobos, and is one of the last instances of Sebastiano's use of drawings by Michelangelo.[20] The *Christ Carrying the Cross* in Leningrad was begun about 1533,[21] while Sebastiano's largest project, the *Visitation* for the tribune of Sta. Maria della Pace, begun perhaps in the mid 1520s, was also unfinished at his death.[22] Sebastiano also continued in these years to produce portraits, among them the portraits of Clement VII in Vienna, Naples, and Parma.[23]

Sebastiano's career, as a Venetian working in Rome and a protégé of Michelangelo, reflects the complex artistic milieu of Rome in the first decades of the sixteenth century.

1. Vasari, 1550, 348.
2. Vasari, 1906, V, 576–77; Sebastiano himself mentions it in letters to Michelangelo (Barocchi and Ristori, 1973, III, 342).
3. Vasari, 1906, V, 566. This altarpiece Vasari attributed to Giorgione in his first edition.
4. Vasari, 1906, V, 565.
5. For detailed discussion of these works, see Hirst, 1981, 4–31; see also the relevant entries in London, 1983–84, 209–11, nos. 95–97.
6. Gould, 1975, 249, no. 2493.
7. Fabio Chigi, in a biography of Agostino Chigi, states that Sebastiano was with the group; see G. Cugnoni, *Agostino Chigi il Magnifico*, Rome, 1881, 29.
8. The poem by Blosio Palladio, *Suburbanum Augustini Chisii*, published 27 Jan. 1512, and cited by Hirst, 1981, 34, n. 8, records that the frescoes were already finished.
9. Volpe and Lucco, 1980, 102–3, nos. 35–36; Hirst, 1981, 95, 98–99.
10. Hirst, 1981, 41–43.
11. Hirst, 1981, 41–45.
12. Hirst, 1981, 46–48.
13. Hirst, 1981, 52, suggests that the reference refers to the cartoons of the prophets, not the frescoes themselves.
14. Hirst, 1981, 53–54.
15. Gould, 1975, 242–46, no. 1; Hirst, 1981, 66–75.
16. See also the discussion of Michelangelo's and Sebastiano's drawings in Hirst, 1981, 148–51.
17. Barocchi and Ristori, 1973, III, 149, letter of 29 Apr. 1525.
18. Vasari, 1906, V, 575; Hirst, 1981, 106.
19. Vasari, 1906, V, 576–77.
20. Volpe and Lucco, 1980, 122–23, no. 94; Hirst, 1981, 131–32.
21. Hirst, 1981, 133.
22. Volpe and Lucco, 1980, 125–26, no. 102.
23. Hirst, 1981, 110–13.

Portrait of a Man in Armor

Oil on canvas, 87.5 x 66.3 cm (34 1/4 x 26 in.)

A copy of the painting in the Palazzo Pitti shows a larger margin at the left and suggests that the Atheneum painting has been trimmed slightly on the left edge.[1]

Condition: good. The painting is thinly painted but in good state. There are minor areas of retouch throughout.

Provenance: collection James Brydges, first duke of Chandos, by 1723, sale London, Cock, Covent Garden, 7 May 1747, no. 68, as Giorgione; Sir Thomas Sebright, Beechwood Park, Hertfordshire, by 1857; Sir Giles Sebright, sale London, Christie's, 2 July 1937, no. 118, bought by Bates for 126 guineas. Purchased by the Wadsworth Atheneum in 1960 from F. Kleinberger & Co., New York, for $35,000 from the Sumner Fund.

Exhibitions: Los Angeles, 1979–80, 56, 159, no. 12.

The Ella Gallup Sumner and Mary Catlin Sumner Collection, 1960.119

In his second edition of the *Vite*, Vasari described a portrait by Sebastiano, of "un non so che capitano armato, che è in Fiorenza appresso Giulio de' Nobili,"[2] that has been identified with the Atheneum

portrait.[3] Borghini also described a similar picture.[4] Richter suggested that the sitter was the Florentine general Francesco Ferruccio,[5] without, however, citing documentation to support this identification. As pointed out by Pallucchini and Volpe, however, this identification does not mesh with Ferruccio's military career, which did not begin until 1529.[6]

The portrait was attributed to Giorgione by Waagen, although he expressed doubts about the attribution,[7] and by Crowe and Cavalcaselle.[8] Richter was the first to suggest an attribution to Sebastiano that has been followed by all later writers.[9]

The format of the Atheneum picture is dependent on portraits by Giorgione, such as one Vasari described in the house of Anton de' Nobili: "un'altra testa d'un capitano armato, molto vivace e pronta, il qual dicano essere un de' capitani che Consalvo Ferrante menò seco a Venezia, quando visitò il doge Agostino Barberigo."[10] A painting in Brunswick thought to be a *Self-Portrait as David* is the only surviving picture of this type generally considered autograph.[11] In the Atheneum portrait the use of the parapet, the full head of hair and gleaming armor,[12] and the suggestion of movement as the shoulders turn in space are reminiscent of Giorgione's portrait, as is the slightly dreamy expression. The pose of the Atheneum portrait, in which the sitter looks over his shoulder, is also related to a portrait convention invented by Giorgione but which survives only in portraits by his followers.[13]

Cleaning of the Atheneum portrait in 1982 at the Metropolitan Museum of Art revealed a second head, undoubtedly of a black page or servant, that was blocked in with underpainting but was ultimately covered by the background color. The inclusion of this secondary figure in the composition calls to mind yet another Giorgionesque portrait convention that is recorded in a painting in the Uffizi, the so-called *Portrait of Gattamelata*.[14] While this painting has been attributed to Giorgione, it is likely to be by one of his close followers. The analogies with the Atheneum portrait are striking; again the use of a parapet, the position of the shoulders and the arms of the sitter, the inclusion of the page and his open-mouthed expression, and the display of military hardware are like in both pictures. The prototype of both the Uffizi painting and Sebastiano's portrait in the Atheneum is undoubtedly a portrait by Giorgione.[15]

The dating of the Atheneum picture has varied. While Richter assigned it a date of about 1516–19,[16] and Dussler and Berenson a date of about 1516–18,[17] Pallucchini thought it about 1515,[18] and Freedberg about 1514.[19] Recently, Pignatti has suggested a date of about 1511,[20] and Volpe a date of about 1512,[21] while Hirst has dated it to about 1513.[22] Only Fritz Heinemann has suggested a date as late as 1530.[23] The evidence of the recent cleaning, in which the compositional analogies with Giorgione are even more explicit than previously, and the animated brush strokes, no longer shrouded in layers of varnish, are apparent, particularly in the face and hair, suggests that the picture should be perhaps dated to just after Sebastiano's arrival in Rome and the same time as the Uffizi *Portrait of a Woman* of 1512. J.C.

1. 1881 inventory (as in the Uffizi), no. 280; 1890 inventory, no. 6037. Freedberg, 1961, 370, also indicates that the painting has been cut, as does Hirst, 1981, 97, n. 29. The copy, painted on canvas, has been cut along the contours of the figure and laid down on panel; worms have subsequently eaten through the canvas, leaving many holes. Compared to the Atheneum portrait, the copy is more smoothly and summarily executed; it subtly alters the angle of the sitter's head, and elongates and accentuates his facial features. The copy is carefully executed and could date to the sixteenth century. It is inscribed on the verso: 2576 and *Copia di Palestrina da Sebastiano del Piombo di Giovanni delle Bande Nere o Ferruccio pubblicata nel Burlington Magazine, 1936.*
2. Vasari, 1906, V, 574.
3. Milanesi in Vasari, 1906, V, 574, n. 2, thought the painting referred to by Vasari was one in the Uffizi (*Galleria di Firenze illustrata*, Florence, 1824, ser. 1, II, 127–32); this attribution was rejected by Crowe and Cavalcaselle, 1912 ed., III, 252, and by P. d'Achiardi, *Sebastiano del Piombo*, Rome, 1908, 329. This painting is now attributed to Dosso Dossi (*Gli Uffizi*, 1979, 251, no. P551). For the identification of the Atheneum portrait with the de' Nobili picture, see Dussler, 1942, 113, n. 41; Pallucchini, 1944, 40–41, 122, 160, n. 35; G. Vasari, *Ragionamenti sopra le invenzioni da lui dipinte*, C. L. Ragghianti, Milan-Rome, 1949, IV, 472, n. 19; J. Rouchette, *La Renaissance que nous a léguée Vasari*, Paris, 1959, 373, n. 2; C. Cunningham, "Portrait of a Man in Armor by Sebastiano del Piombo," *Wadsworth Atheneum Bulletin*, Summer 1960, 15–16; Pallucchini, *Sebastiano*, 1966, fig. IX; A. Chastel, *The Crisis of the Renaissance, 1520–1600*, Geneva, 1968, 29, repr.; Los Angeles, 1979–80, 56, 159; Volpe and Lucco, 1980, 104, no. 39, repr.; Silk and Greene, 1982, 32–33, repr. Hirst, 1981, 97, n. 29, suggested that the subject may be Attilio di Ruberto de' Nobili, who was a captain of the militia of the Florentine republic in 1528, as described in B. Varchi, *Storia fiorentina*, 1838–41, I, 483. Without more precise biographical information about the de' Nobili family, however, this identification cannot be confirmed; see V. Spreti, *Enciclopedia storico-nobiliare italiana*, Milan, 1931, IV, 836.
4. Borghini, 1584, 440.
5. Richter, 1936, 91.
6. Pallucchini, 1944, 122, n. 35; Volpe and Lucco, 1980, 104.
7. Waagen, 1857, IV, 329.
8. Crowe and Cavalcaselle, 1912 ed., III, 253.
9. Richter, 1936, 91. See also Fredericksen and Zeri, 1972, 185, 585; Silk and Greene, 1982, 32–33.
10. Vasari, 1906, IV, 94. Agostino Barberigo was doge from 1496 to 1501; hence, this would have to be a very early portrait by Giorgione for the identification to be correct. Further, as Wendy Sheard has noted, oral communication, 15 May 1986, the provenance of both the Sebastiano portrait and the Giorgione portrait mentioned by Vasari from members of the de' Nobili family lead one to wonder if the two portraits are not in fact the same. The error would not be so difficult to understand; the Venetian, and specifically Giorgionesque, tenor of the Atheneum picture has been remarked by Dussler, 1942, 41; Pallucchini, 1944, 41; and Hirst, 1981, 97.
11. Pignatti, 1971, 71–72, 141–42, pl. 210, calls the painting a copy of a lost Giorgione. The Brunswick painting has been cut down; originally a half-parapet with the severed head of Goliath was visible, as seen in Teniers's engraving for the *Theatrum pictorium*, 1658, no. 25, illustrated in Pignatti, fig. 44.
12. H. Nickel, Metropolitan Museum of Art, New York, oral communication, 8 Mar. 1974, suggested that the armor is North Italian, either Venetian or Milanese, about 1450–1500; Hirst, 1981, 97, n. 28, reports an identification of the armor as Milanese, second half of the fifteenth century. The weapon held by the sitter is a war hammer.

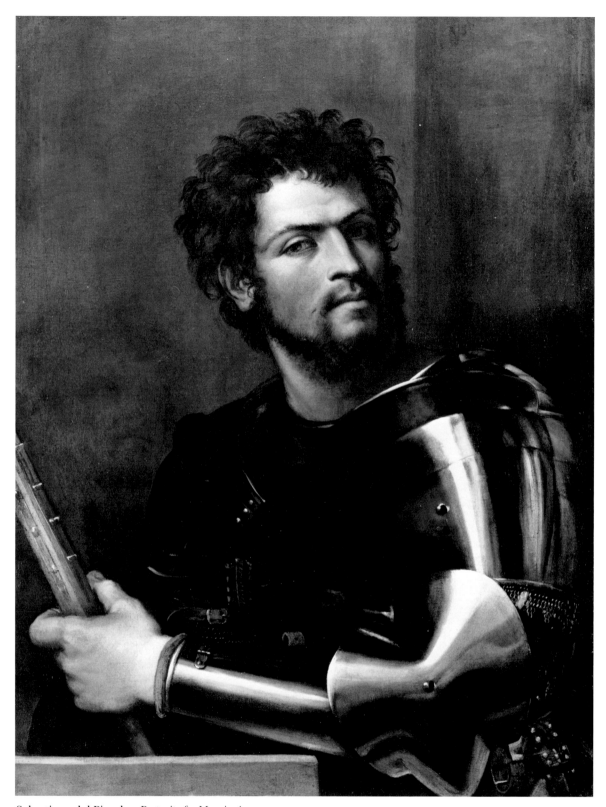

Sebastiano del Piombo, *Portrait of a Man in Armor*

13. In 1525 M. Michiel, *Notizia d'opere di disegno*, ed. T. von Frimmel, 1888, 90, described a portrait in the house of Girolamo Marcello of "M. Ieronimo armato che mostra la schena, insino al cinto, et volta la testa, fo de man de Zorzi da Castelfranco" that has sometimes been identified with a portrait in Vienna; see Pignatti, 1971, 142–43, no. A 64, pl. 127. Another portrait from Giorgione's immediate circle that reflects this invention is the so-called *Portrait of a Fugger*, now in Munich, that is sometimes attributed to Titian; see Wethey, 1971, II, 12–13. See also J. Anderson, "The Giorgionesque Portrait: From Likeness to Allegory," *Giorgione; Atti del convegno internazionale di studio per il 5 centenario della nascita*, Castelfranco Veneto, 1979, 153–55, on the relation of the Atheneum picture to Giorgionesque portrait conventions.

14. Pignatti, 1971, pl. 126; P. Zampetti, *Giorgione e i Giorgioneschi*, Venice, 1955, 82, no. 36.

15. For an account of the Venetian tradition of depicting military heroes preparing for battle, usually assisted by pages, see Fahy and Watson, 1973, 20–22.

16. Richter, 1936, 91.

17. Dussler, 1942, 135; Berenson, 1957, I, 164.

18. Pallucchini, *Sebastiano*, 1966, fig. IX.

19. Freedberg, 1961, I, 370.

20. Pignatti in Los Angeles, 1979–80, 56.

21. Volpe and Lucco, 1980, 104, no. 39.

22. Hirst, 1981, 97.

23. Oral communication, 17 Sept. 1974.

1. The artist is referred to as Giovanni di Marco in documents, though Vasari, 1906, I, 631–34, conflating the lives and works of two or more artists working from the middle fourteenth to the early fifteenth centuries, called him Giovanni dal Ponte. As Milanesi, I, 633, n. 2, recognized, it is difficult to identify which artists Vasari had in mind. Only Vasari's attribution of frescoes in the Scali and Paolo dell'Abaco chapels in Sta. Trinità in Florence can be linked with Giovanni dal Ponte as scholars understand his oeuvre today; see Paatz, 1953, V, 296, 299.

2. Milanesi, in his commentary on Vasari, 1906, I, 633, n. 2, cited Giovanni's birth and death dates; H. Horne, "Appendice di documenti su Giovanni dal Ponte," *Rivista d'arte*, IV, 1906, 169–81, and Horne, "Giovanni dal Ponte," *Burlington Magazine*, IX, 1906, 332–37, published documents on the artist's life, including catasto declarations of 1427, 1430, 1433, and a codicil of 1437. Guidi, 1968, 44–45, publishes confirmation of Giovanni's death date.

3. Guidi, 1968, 45–46, publishes the documents.

4. Guidi, 1968, 30–31.

5. The date has previously been read as 1430, but Guidi, 1968, 37–38, has read it as 1434.

6. Guidi, 1968, 45, transcribes the documents. Destroyed frescoes in the chapel of Paolo dell'Abaco in Sta. Trinità were also painted by Giovanni and Smeraldo in 1429–30; Paatz, 1953, V, 298. Guidi, 1968, 44, n. 41, suggests that Smeraldo's role was confined to decorative elements.

7. See especially R. Salvini, "Lo Sviluppo stilistico di Giovanni dal Ponte," *Atti e Memorie della R. Accademia Petrarca di Lettere, Arti e Scienze*, n.s. XVI–XVII, 1934, 17–44; Shell, 1958; Guidi, 1968, 27–46; Guidi, 1970, 11–23; and C. Shell, "Two Triptychs by Giovanni dal Ponte," *Art Bulletin*, LV, 1972, 41–46.

8. Shell, 1958, 126.

Giovanni dal Ponte
(1385–1437)

Giovanni di Marco, called Giovanni dal Ponte by Vasari,[1] was born in 1385 and died in 1437.[2] He was inscribed in the guild of Medici e Speziali in 1413, after payment of dues in 1410, 1411, and 1413, and he matriculated in the Company of St. Luke, a religious confraternity composed primarily of artists, also in 1413.[3]

Three dated paintings form the nucleus of Giovanni's oeuvre: a polyptych of the *Coronation of the Virgin* in the Musée Condé, Chantilly, dated 1410, but more probably from about 1420;[4] the *Annunciation with Saints*, dated 1434, in the church of Santissima Annunziata, Rosano;[5] and the *Annunciation with Saints* in the Vatican, Pinacoteca, dated 1435. The frescoes in the Scali Chapel in Sta. Trinità, painted by Giovanni and his collaborator Smeraldo di Giovanni, survive in part and are documented to 1434.[6]

A large body of work has been attributed to Giovanni dal Ponte based on these dated or documented works.[7] His career is typical of the traditional painters in Florence in the first decades of the fifteenth century. Trained in a late Gothic tradition, probably by Spinello Aretino, he modified his style in the first decades of the fifteenth century to conform to progressive trends in Florentine painting. The Chantilly *Coronation* shows the influence of works by Lorenzo Monaco and Ghiberti, while a polyptych in the Fitzwilliam Museum records the impact of Masaccio's style. In the later 1420s Giovanni reconciles the linear and decorative properties of his earlier works with sculptural features of Masaccio's art. In Shell's view, this compromise style of the 1430s, visible in the *Annunciation*s of 1434 and 1435, became the basis for the style of artists such as Fra Filippo Lippi and Domenico Veneziano.[8]

Madonna and Child with Saints John the Baptist and Catherine

Tempera on panel, overall painted surface: 114.3 x 67.6 cm (45 x 26 5/8 in.); central panel: 101.6 x 52 cm (40 x 20 1/2 in.)

Condition: good, except for the two angels on the parapet, which have been heavily restored.[1] The scalloped decoration of the lunette appears to be a replacement. The front molding and base are modern.

Provenance: collection R. Langton Douglas, London and New York; Wildenstein & Co., New York, 1947; private collection, New Jersey; Rosenberg and Stiebel, New York. Purchased by the Wadsworth Atheneum in 1982 from Rosenberg and Stiebel.

Exhibitions: Hartford, 1982.

The Ella Gallup Sumner and Mary Catlin Sumner Collection, 1982.2

The Madonna and Child are flanked by St. John the Baptist and St. Catherine of Alexandria. Four music-making angels decorate the lower embrasure; in the upper embrasure are four adoring angels. The dove of the Holy Spirit is shown in the apex of the arch.

The format of the painting is that of a small altarpiece, or *ancona*. The motif of the music-making angels in embrasures is perhaps derived from the Linaiuoli tabernacle by Fra Angelico, commissioned in 1433.[2] Another panel attributed to Giovanni, formerly in the Northwick Collection, shows a similar arrangement.[3]

The painting was attributed to Spinello Aretino when in the collection of R. Langton Douglas; Berenson attributed it to Giovanni dal Ponte,[4] as did Zeri.[5] Shell,[6] Guidi,[7] and Fahy[8] also attribute the painting to Giovanni dal Ponte.

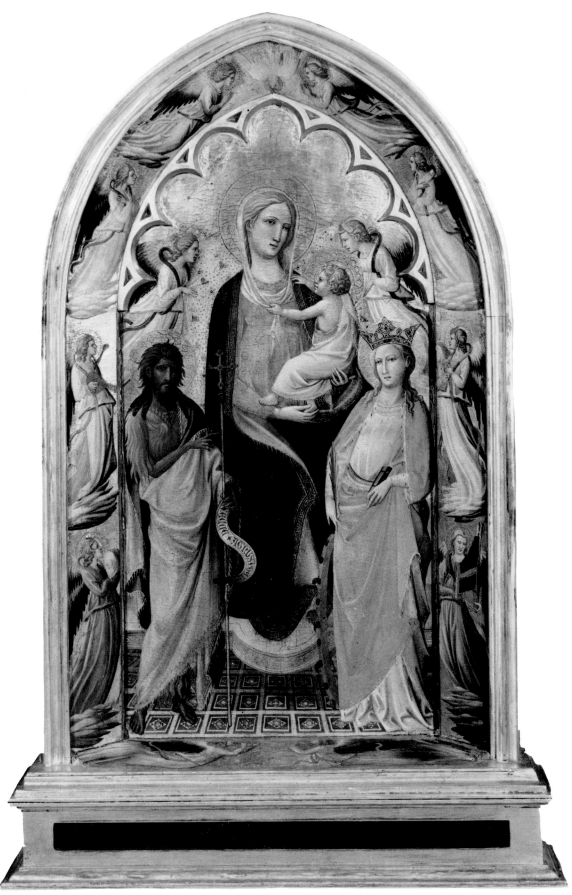

Giovanni dal Ponte, *Madonna and Child with Saints*
John the Baptist and Catherine

The painting has been dated to the early 1420s by Guidi[9] and to about 1430–33 by Shell.[10] A date of about 1434 seems preferable, based on similarities with the Rosano *Annunciation* from that year and allusions to the Linaiuoli tabernacle. The reference to Ghiberti's *St. John* at Orsanmichele is also noticeable in the distinctive drapery of Giovanni's homonymous figure. J.C.

1. A photograph at the Biblioteca Berenson, Villa I Tatti, dated 1947, shows the painting with an elaborate flamelike decoration around the lunette and paired colonettes at the outer and inner edges of the embrasures. It is inscribed on the parapet: *Spinello Aretino*. In a photo of the panel before restoration in 1981, the inner paired colonettes remain.
2. Pope-Hennessy, 1974, 194–95.
3. Guidi, 1970, fig. 7.
4. Berenson, 1963, I, 92, fig. 488.
5. Note on a photograph, Frick Art Reference Library, 23 Nov. 1964.
6. Shell, 1958, 246, no. XXVIII.
7. Guidi, 1970, 21, n. 18.
8. Oral communication, 8 May 1984.
9. Guidi, 1970, 15.
10. Shell, 1958, 246.

Andrea Previtali
(c. 1480–after 1528)

A group of paintings dated between 1502 and 1510 with the signatures *Andreas Bergomensis* or *Andreas Cordelle agi* has been related to another group of paintings, dated from 1512 to 1525, signed *Andreas Privitalus*.[1] Both groups are now assigned to the painter Andrea Previtali from Bergamo.[2] He is thought to have been born about 1480 in Bergamo,[3] and to have gone to Venice about 1490, where he was trained in the workshop of Giovanni Bellini.[4] Several of his pictures from the first decade of the sixteenth century are signed *Discipulus ioanis bellini*. By 1505–6 Previtali was an independent master active in the Veneto, as his altarpieces in Villanova di Camposampiero, near Padua, and in Vittorio Veneto from 1508 suggest;[5] he was back in Bergamo by 1513, when he was commissioned to paint an altarpiece for the Cassotti-Mazzoleni Chapel in S. Spirito in Bergamo.[6] From this time on a series of dated or documented works survives that allows a clear view of Previtali's oeuvre.[7] The latest notice of him is in 1528, when he made an agreement to pay a debt; he perhaps died in the plague of the same year.[8]

Previtali's style was formed on that of Bellini, whose motifs he often paraphrased in his earlier works. Working in his native Bergamo, however, he came under the influence of Lombard styles and, finally, that of Lorenzo Lotto.

1. Meyer zur Capellen, 1972, 94–103, for a register of documents concerning Previtali.
2. Crowe and Cavalcaselle, 1871, I, 271, first proposed assigning the paintings signed *Cordelle agi* to Andrea Previtali, agreed to by B. Berenson, "Le Pitture italiane nella raccolta Yerkes," *Rassegna d'arte*, VI, no. 3, 1906, 35; but Morelli, 1891, 308–9, denied the connection. Kunze, 1937, 261–67, reviewing the group of signed works, convincingly demonstrated the unity of the early group of pictures and its connection with the later works of Previtali.
3. The *Virgin and Child with Saints John the Baptist and Catherine* in the National Gallery, London, is signed and dated 1504; following the inscription is a mark which has been read as 24 and interpreted as the artist's age by Waagen, c. 1854, II, 265, and by Ludwig, 1903, 58–59. Davies, 1961 ed., 451, no. 1409, rejects this interpretation, as does Meyer zur Capellen, 1972, 106–7, who proposes a birth date of about 1476.

4. He perhaps first entered the workshop of the local painter Francesco Simone da Santacroce before transferring to the Bellini shop about 1495; see Meyer zur Capellen, 1972, 23–24.
5. Meyer zur Capellen, 1972, 105–6, 144–45, nos. 21–22.
6. Meyer zur Capellen, 1972, 95, doc. 8.
7. Meyer zur Capellen, 1972, 107–10.
8. Meyer zur Capellen, 1972, 109.

Madonna and Child with a Donor

Tempera and oil on panel, 59 x 77.2 cm (23 1/4 x 30 3/8 in.)
 The panel has been cradled.
 Condition: fair. There are extensive losses, especially along the horizontal cracks in the center of the panel and the upper edge. In the face of the Virgin and the body of the Child, the delicate modeling has been lost, leaving those forms flat. The Virgin's blue robe shows pronounced traction cracks and loss of modeling.
 Inscribed lower right: ANDREAS C A DISCI / IOVANIS BELINI P
 Provenance: possibly collection Ottavio Monza, Vicenza, 1815;[1] Count Picho Antonio Porto, Vicenza, 1903;[2] Charles T. Yerkes, sale New York, Mendelssohn Hall, 5–8 Apr. 1910, no. 189; Julius Böhler, Munich; Samuel Untermyer, sale New York, Parke-Bernet Galleries, 10 May 1940, no. 47 (bought back by Untermyer); Mrs. Stanley L. Richter; given to the Wadsworth Atheneum in 1944 by Mrs. Stanley L. Richter.
 Exhibitions: Hartford, *In Retrospect*, 1949, 13, no. 32.
 Gift of Mrs. Stanley L. Richter, 1944.58

The Madonna and Child bless a kneeling donor. In the background is seen a sweeping landscape with thatch-roofed houses and a palace under construction. In the right background, in front of a ruined palace, is a tree stump with a new branch growing from it, symbolizing Christ's birth and its promise of redemption.[3]

 Previtali painted two other versions of the Atheneum composition. One, in the National Gallery in London, shows the Virgin and Child in the same pose, but the Child holds a flower rather than a fruit, the Virgin sits on a carved stone bench rather than a rough-hewn rock, and the donor is an older cleric (Fig. 38).[4] In the right background of the London picture is a figure of St. Catherine with the wheel; there are also slight differences of detail in the landscape. The Virgin and Child also occur in a picture

Figure 38. Andrea Previtali, *Madonna and Child with a Donor*, London, National Gallery

Andrea Previtali, *Madonna and Child with a Donor*

formerly in a private collection, Berlin, signed *Andreas Cordele agi P.* In the Berlin picture, the Virgin's left hand reaches for a bird, the Child's left hand is extended rather than raised in blessing, and He holds the bird by a string.[5] The background of the Berlin picture shows a landscape different from those in the London and Atheneum pictures.

The form of the signatures in the Berlin and Atheneum versions points to a date before 1510, and the London picture, which is unsigned, most probably dates from this period as well. The figure types and the compositions are strongly reminiscent of contemporary pictures by Giovanni Bellini and suggest that all three pictures were painted while Previtali was active in Venice.[6] The thatch-roofed houses that appear in all three pictures are northern European in style and occur in pictures of the early sixteenth century in Venice, but not in Previtali's other works.[7] The chronological relationship of the three pictures is perhaps indicated by the landscape backgrounds. That in the Berlin picture shows an abundance of detail that is Netherlandish in inspiration and recurs in the *Madonna and Child with a Donor* in the Museo Civico, Padua, that is signed

and dated 1502. In the Hartford and London pictures, the landscapes are more expansive and atmospheric, closer to that in the picture formerly in the collection of the earl of Haddington, Mellerstain, Berwickshire, signed and dated 1506,[8] and to those of Previtali's later style, for example, the *Christ in the Garden* in the Pinacoteca di Brera, Milan, signed and dated 1513.[9] The Atheneum picture is marginally more advanced than the London picture along these lines and may postdate it. A date of around 1504–5 is reasonable for the Atheneum and London pictures.[10]

In three pictures Previtali follows a practice well established in the Bellini shop of reusing motifs.[11] While Bellini had a large workshop, we do not know anything about Previtali's *bottega* during his years in the Veneto. Although the Atheneum picture shows generally less robust modeling in the figures, especially in the Virgin's face and the Child's body, than the London picture, this is more likely due to its slightly later date and condition than to intervention of a workshop hand. J.C.

1. The Monza picture was mentioned by Crowe and
Cavalcaselle, 1871, I, 277, n. 1, as lost; Borenius, in his edition of
Crowe and Cavalcaselle, London, 1912, I, 281, note, assumes
that the Atheneum picture is the painting G. Moschini in *Guida
per la Città di Venezia*, 1815, I, 673, mentions in the possession of
Ottavio Monza at Vicenza; Kunze, 1937, 262, n. 7, says the
signature is different and there is no mention of a donor.
2. Morelli, 1891, 308, note.
3. See Levi d'Ancona, 1977, 386, on the symbolism of the cut
tree that blooms.
4. Davies, 1961 ed., 450, no. 695.
5. Meyer zur Capellen, 1972, 135–36, no. 8; Berenson, 1957, II,
fig. 742.
6. Compare, for example, the *Madonna in a Landscape* of 1510 in
the Pinacoteca di Brera, Milan, illustrated in Berenson, 1957, I,
fig. 259.
7. Meyer zur Capellen, 1972, 29.
8. Illustrated in Berenson, 1957, II, fig. 748; sale London,
Christie's, 30 Nov. 1979, no 101.
9. Illustrated in Berenson, 1957, II, fig. 749.
10. Further bibliography includes Morelli, 1891, 308; Ludwig,
1903, 6; Crowe and Cavalcaselle, 1912 ed., I, 281; B. Berenson,
Venetian Painting in America, London, 1916, 260; *Wadsworth
Atheneum Handbook*, 1958, 37; Heinemann, 1962, I, 136, no. S.
299; Meyer zur Capellen, 1972, 141, no. 16.
11. See F. Gibbons, "Giovanni Bellini and Rocco Marconi," *Art
Bulletin*, XLIV, 1962, 127–29, and the same author's "Practices
in Giovanni Bellini's Worshop," *Pantheon*, XXIII, 1965, 146–53.

Domenico Puligo
(1492–1527)

Domenico di Bartolomeo Ubaldini, called Domenico Puligo,
was born just outside Florence in 1492. According to Vasari,[1] he
was the student of Ridolfo Ghirlandaio; he was inscribed in the
Compagnia di S. Luca, a religious confraternity composed
primarily of artists, in 1525. In about 1513–15 Domenico collab-
orated with Andrea del Sarto and may have participated in
several of his works.[2] Independent works from Puligo's hand
include the altarpiece for the chapel of the Romena family in
Sta. Maria Maddalena de' Pazzi, datable to 1526,[3] the *Vision of St.
Bernard*, mentioned by Vasari[4] and now in the Walters Art
Gallery, Baltimore, datable to about 1520,[5] and the *Virgin and
Child with Saints Quentin and Placidus* in the Ringling Museum,
Sarasota, painted about 1521–22.[6] He also painted a number of
portraits of distinction. He died in Florence in 1527.

Puligo's style combines aspects of Ridolfo Ghirlandaio's, Fra
Bartolommeo's, and Andrea del Sarto's styles with little original-
ity. His pictures are nonetheless attractive for their pastel colors
and appealing emotional content.

1. Vasari, 1906, IV, 462–64; see Gardner, 1986, 6–20, for
Puligo's biography.
2. See Vasari's account of Puligo's relationship with Andrea
(1906, IV, 464); Freedberg, 1963, II, 55, rejects the notion of
Puligo's collaboration, as does Gardner, 1986, 2, 10–14.
3. Luchs, 1977, 102–3; Gardner, 1986, 203–6, no. 30.
4. Vasari, 1906, IV, 465.
5. Zeri, *Walters Art Gallery*, 1976, II, 316–17, no. 204, fig. 143;
Gardner, 1986, 200–3, no. 29, dates it to 1523–24.
6. Tomory, 1976, 39, no. 30; Gardner, 1986, 190–93, no. 26.

Follower of Domenico Puligo
Madonna and Child with St. John and Two Angels

Oil on panel, 91.5 x 70.7 cm (36 1/16 x 27 13/16 in.)
A piece of wood 4.2 centimeters tall has been joined with
screws to the top edge of the panel. The grain of this piece is
horizontal, unlike the vertical grain of the main panel.

Condition: fair. A thick varnish covers the whole surface,
making its condition difficult to assess. There are rubbed areas,
and the varnish has blanched, for example, in the area sur-
rounding the Child's face. Isolated areas of inpainting also mar
the surface, and several knotholes in the panel, for example, in
the Virgin's lower hand, are now visible. The halos are a later
addition.

Inscribed on the scroll held by St. John: [Ecce] *Agnus* [Dei];
on verso of panel: *1536*
Label on verso reads: *Graf Fesztetics . . .* [illegible]
Provenance: collection Graf Samuel von Festetis,
1806–59;[1] sale Berlin, Gesellschaft für Kunst und Literatur,
11–12 Nov. 1908, no. 9, as Andrea del Sarto; private collection,
New York; Edward G. O'Reilly, sale New York, American Art
Association, 23 Jan. 1936, no. 77, as Andrea del Brescianino,
bought by J. Bass for $400;[2] Mrs. Thomas T. Mackie. Given to
the Wadsworth Atheneum in 1960 by Mrs. Thomas T. Mackie.
Gift of Mrs. Thomas T. Mackie, 1960.8

Although acquired as a work of Andrea del
Brescianino, the painting has also been associated
with the works of Domenico Puligo, especially his
paintings in the style of Andrea del Sarto.[3] The pose
of the Virgin's right arm and hand derives ultimately
from the Virgin's pose in Sarto's *Madonna of the Har-
pies* in the Uffizi, Florence, while the pose of the Child
is modeled on compositions by Sarto such as the
Madonna and Child with Elizabeth and St. John in the
Pitti, Florence.[4] Similar adaptations of Sarto exist in
Puligo's work, but the Atheneum picture seems not to
be even as fine as those.

The Atheneum painting is a variant of the
Madonna and Child with St. John the Baptist and an Angel
in the Stanford University Museum and Art Gallery,
Stanford, California, which has been attributed to
Puligo (Fig. 39).[5] Comparison of the Atheneum and
Stanford paintings reveals the more elegant drawing
and firmer modeling of the Stanford picture and
suggests that the Atheneum picture may be a deriva-
tion from it rather than a replica by the same hand.[6]

Zeri has further associated the Atheneum picture
with a number of paintings, including a tondo from
the Kress Collection at Allentown;[7] a *Madonna and
Child with St. John and Two Angels* in the Galleria
Nazionale, Palazzo Spinola, Genoa; a tondo in the
Galleria Sabauda in Turin;[8] a *Portrait of a Man* in
Berlin-Dahlem;[9] and a picture in the Johnson
Collection in Philadelphia.[10] He proposes an attribu-
tion to Raffaello Piccinelli or the young Andrea del
Brescianino.[11]

Given the complicated artistic environment of
early sixteenth-century Tuscany, the question of
attribution is best left open. The Atheneum picture is
probably by a follower of Puligo active in Florence
and Tuscany.[12]

The picture probably dates from the second or
third decade of the sixteenth century. J.C.

Follower of Domenico Puligo, *Madonna and Child with St. John and Two Angels*

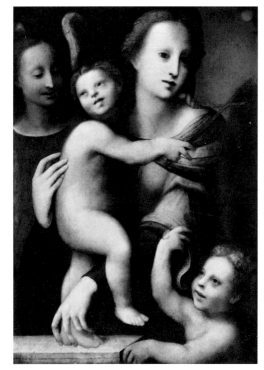

Figure 39. Domenico Puligo, *Madonna and Child with St. John the Baptist and an Angel*, Stanford, Stanford University Museum of Art

1. It was not, however, listed in the catalogue of an exhibition of his pictures in 1859, reprinted in T. von Frimmel, *Lexikon der Wiener Gemäldesammlungen*, Munich, 1913, I, 355–87.
2. The catalogue states that the picture was accompanied by a certificate from Dr. Gustav Glueck, Kunsthistorisches Museum, Vienna, 18 Dec. 1934.
3. The painting was attributed to Puligo by E. Fahy, letter to P. Marlow, 13 Dec. 1971, curatorial file, and to a mediocre artist between Puligo and Bacchiacca by E. Pillsbury, letter to P. Marlow, 4 Oct. 1971, curatorial file.
4. Illustrated in Freedberg, 1963, I, figs. 76, 218. For Puligo's pictures directly dependent on these, see the *Madonna and Child with St. John* in Munich and the *Madonna and Child with St. John* in the Pitti, illustrated in H. Grohn, "Una Madonna di Domenico Puligo," *Antichità viva*, I, no. 6, 1962, figs. 2–3; and Gardner, 1986, 218–20, nos. 36–37.
5. Gardner, 1986, 183–84, no. 22.
6. G. Gardner, letter to J. Cadogan, 4 May 1987, curatorial file, felt the Atheneum picture was not by Puligo; Freedberg, 1963, II, 219, called the Atheneum picture a derivation from Puligo.
7. Inv. no. K. 1733; Shapley, 1968, 223, fig. 275.
8. Gabrielli, 1971, 81–82, no. 118, fig. 79.
9. Inv. no. 239.
10. Inv. no. J. 82; *Johnson Collection*, 1966, 66.
11. Letter to J. Cadogan, 29 May 1984, curatorial file.
12. The Atheneum picture may have been painted by the so-called Master of Volterra, to whom works in the Siena Pinacoteca, among others, are ascribed; see Torriti, 1978, 202, nos. 562–63. Gardner, letter to J. Cadogan, 4 May 1987, curatorial file, does not accept this attribution, though L. Kanter, oral communication, 28 Apr. 1987, agreed with it.

Raffaello Santi, called Raphael (1483–1520)

According to Vasari,[1] Raphael was first trained by his father, the painter Giovanni Santi, and then by Perugino.[2] Among early works are fragments of an altarpiece for Città di Castello, commissioned in 1500, and the *Crucifixion* in the National Gallery, London, of 1503. About 1504 Raphael first visited Florence; although the exact duration of his stay in the city is unknown, his works from this time record the profound impact of Leonardo da Vinci, Fra Bartolommeo, and Michelangelo. By 1509 he had moved to Rome, where he was primarily occupied working in the Vatican and where he created some of the most important monuments of Renaissance painting in the Stanze and the Loggie. On the death of Bramante in 1514, Raphael was appointed papal architect, charged with the reconstruction of the basilica of St. Peter, and keeper of Roman antiquities by Leo X.

Raphael's career, up until his early death in 1520, shows the unfolding of a prodigious artistic intelligence. The works he created, in painting and architecture, comprise the standard against which all later classical movements were judged.

1. Vasari, 1906, IV, 316–17.
2. For the following, see De Vecchi, 1966; Dussler, 1971.

After Raphael
Madonna della Sedia

Oil on canvas, painted diameter: 74.3 cm (29¼ in.); canvas:
76.5 x 76.2 cm (30⅛ x 30 in.)
 Condition: good. The shadows in the child's garment have
changed to a dull purple. A small tear in the lower right corner
has been patched on the verso of the canvas.
 Sticker on stretcher: Alfredo Candida/Gallery of Paintings/
16 Viale Principe Eugenio/Florence
 Provenance: The previous history of the picture is unknown.
Given to the Wadsworth Atheneum in 1897 by Mrs. Charles A.
Robinson and Mrs. Albert H. Olmsted.
 Exhibitions: Hartford, 1982.
 Gift of Mrs. Charles A. Robinson and Mrs. Albert H.
Olmsted, 1897.9

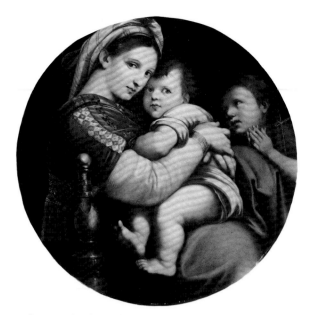

After Raphael, *Madonna della Sedia*

One of many copies produced over several centuries
of Raphael's *Madonna della Sedia*, the Atheneum
painting follows exactly the original, now in the
Galleria Palatina, Palazzo Pitti, Florence.[1] The frame,
in exceptional condition, is also a carved replica of
the eighteenth-century frame on the original.
 Information on the frame and stretcher of the
painting indicate it was sold by, and perhaps painted
by, a certain Alfredo Candida, who had a gallery in
Florence. No information has been found about this
gallery.
 The copy probably dates to the late nineteenth
century.[2] J.C.

1. Raphael painted the *Madonna della Sedia* in about 1514. It
passed to the Medici collections by 1550. Except for the period
from 1799–1815, when the painting was among those exported
to Paris by Napoleon, it has been exhibited in the Pitti Palace
since the beginning of the eighteenth century. See De Vecchi,
1966, 111, no. 109; Dussler, 1971, 36, pl. 84. On the popularity
of the painting, see E. H. Gombrich, *Raphael's Madonna della
Sedia*, London, 1956.
2. It is included in Hartford, 1901, no. 69.

After Raphael
Madonna della Sedia

Oil on metal, 24.7 x 19 cm (9¾ x 7½ in.)
 Condition: excellent.
 Provenance: The previous history of the picture is unknown.
Bequeathed to the Wadsworth Atheneum in 1905 by Elizabeth
Hart Jarvis Colt.
 Bequest of Elizabeth Hart Jarvis Colt, 1905.1180

This copy on metal of Raphael's *Madonna della Sedia*
was presumably painted in the late nineteenth cen-
tury. A pendant of *Christ Carrying the Cross* after an
unknown artist has a sticker on the verso that reads:
W.F. Ahrt/in/Hamburg/Neuerwall 50.[1] The pair were
very likely produced by a German artist and perhaps
acquired by Mrs. Colt in Germany in the late nine-
teenth century. J.C.

1. Accession no. 1905.1181. This painting is probably a copy
after an unknown composition.

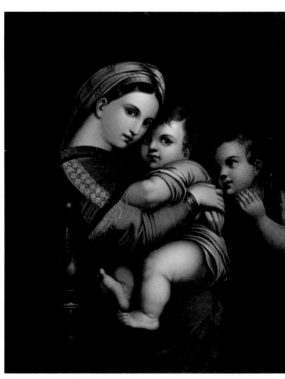

After Raphael, *Madonna della Sedia*

Giuseppe Recco
(1634–1695)

The individual characters of the three principal painters of the Recco family, the seventeenth-century Neapolitan dynasty of still-life specialists, have begun to be defined, albeit recently.[1] Giacomo (1603–before 1634) painted Flemish-style flowerpieces that are direct heirs of late sixteenth-century mannerism, akin to the work of Jan Velvet Brughel, for example, who was in Naples in 1590. Giovanni Battista Recco (1615?–1660?), seemingly the brother of Giacomo, if not the son, was the first in the family to incorporate the examples of Caravaggio and of Spanish realism in his forceful and soberly structured compositions. Giuseppe Recco (1634–1695), the son of the first and probably the nephew of the second, initially painted in the style of his elders, but as he developed, he moved toward the Roman baroque still-life convention—illustrated in the Atheneum's collection by the pair of paintings by Spadino—practiced contemporaneously in Naples by Abraham Brughel and Giovanni Battista Ruoppolo. Stylistically, the Atheneum picture belongs to this latter trend, for the artist is as much interested in the artfully ascending composition as in the description of the glistening textures and colors of the still life.

1. For a summary of the current state of scholarship, see the essay "Still-Life Painting in Seventeenth-Century Naples" by C. Volpe (57–59) plus the Recco biographies and catalogue entries by R. Middione, A. Tecce, and C. Whitfield (218–24) in London, *Painting in Naples*, 1982; also especially see the relevant sections of Salerno, *La Natura morta*, 1984.

Circle of Giuseppe Recco
Still Life with Fish

Oil on canvas, 98 x 135.9 cm (39 x 53½ in.)
 Condition: good.
 Provenance: Galerie Schaeffer, Berlin, circa 1930. Purchased by the Wadsworth Atheneum in 1942 from the Schaeffer Galleries, New York, for $600 from the Sumner Fund.[1]
 Exhibitions: San Francisco, 1941, no. 88, as Giuseppe Recco; New York, Schaeffer Galleries, 1942, no. 25, as Recco.
 The Ella Gallup Sumner and Mary Catlin Sumner Collection, 1942.405

The subject, composition, and treatment are all of the kind generally associated with Giuseppe Recco,[2] yet the picture is insipid. The forms are flaccid and not particularly well rendered in full round or in recession when compared with such works as the *Fish Still Life*, signed and dated 167[4?], in the Gaudioso Collection, Catania, the signed *Platter of Fish* in the Pitti, or the monogrammed *Still Life by the Seashore* in Capodimonte.[3] The Atheneum work seems to form a group with other Recco attributions: a picture in the Pushkin Museum, Moscow (compare particularly the floppy fish in the foreground),[4] a still life with fish in Leeds,[5] and three oblong still lifes in the Gothenburg Art Gallery.[6] Bottari assigned the Atheneum picture to an unidentified follower of Giuseppe Recco, perhaps a Spaniard working in Naples, who is also, in Bottari's mind, responsible for two paintings in the Molinari Pradelli Collection, Bologna.[7] The allusion to a Spanish flavor is interesting. Of Giuseppe Recco's many children, Nicola Maria and Elena were painters. All that is known of Elena is that she was in Spain in the 1690s, invited by Charles II, and that four flowerpieces by her were mentioned in a 1774 Buen

Retiro inventory.[8] Causa thought the Atheneum picture is possibly by Elena,[9] and Spinosa assigns Elena a still life in a Neapolitan private collection[10] that has striking parallels to the Atheneum picture in the sharply tilted perspective and flatness of forms in the full round. But neither the Gothenburg, the Pushkin, nor the Atheneum painting resembles in any compelling way a picture in the Institut für Künste, Donaueschingen, signed "Ha Recco," a work, if the signature is correctly interpreted to be Elena's, around which her oeuvre is to be reconstructed.[11] M.M.

1. Acquired from the Schaeffer Galeries, together with Ceruti's *Boy with a Pug Dog* (then attributed to Maggiotto), the two for $1,000. Later correspondence indicated the Recco was priced at $600, the Ceruti/Maggiotto at $400 (Mrs. H. Schaeffer to C. Cunningham, 13 Mar. 1963, curatorial file). Mrs. Schaeffer recalled having bought it in Munich about 1930 (Mrs. H. Schaeffer to C. Cunningham, 17 July 1946, curatorial file).
2. Fredericksen and Zeri, 1972, 173, 507, 584, as Giuseppe Recco.
3. De Logu, 1962, 194–95, pls. 86, 88, 89. See J. Spike in New York, 1983, 92, for his list of secure attributions.
4. Causa, 1972, fig. 433.
5. Leeds City Art Gallery and Temple Newsham House, *Catalogue of Paintings*, 1954, pt. I, 54, inv. no. 269, Giuseppe Recco, *Still Life*, 37 x 53 in., presented in 1912 by Henry Barran.
6. *Göteborgs Konstmuseum. Maleris amlingen*, 1979, 104, nos. 22–24, as unknown seventeenth-century Neapolitan, each about 44 x 102 cm. The paintings came to the museum by 1864 from Jonas Kjellberg. In a letter to the museum, 16 May 1958, Causa mentioned two further pictures by the same hand in the collection of Conte Zauli Naldi, Faenza. Formerly, he had thought the latter to be late Giuseppe Recco, but now thought that they, together with the Gothenburg triad, would form the core of the work of a new, anonymous master. Causa rejected Carpegna's suggestion that a *Still Life with Fish* in the Corsini (inv. no. 526, exhibited in Rome, 1958, no. 38) was by the same hand as the Gothenburg works. See H. Böstrom to M. Mahoney, 7 July 1983, curatorial file. Causa, 1972, 1048, no. 85, also assigns a picture that we are unable to trace in Warsaw to this group.
7. S. Bottari to E. Bryant, 14 Mar. 1962, curatorial file. Presumably these are the two pictures listed, but not displayed in the 1984 exhibition of the collection (Bologna, 1984, 164).
8. Pérez Sánchez, 1965, 431–32.
9. Verbally to M. Mahoney, Naples, June 1983.
10. Spinosa, 1984, pl. 593.
11. De Logu, 1962, 144, pl. 90, 146. De Logu also gives to Elena a picture belonging to Dottore Mario Zappalà, Catania, and notes Carpegna assigned a picture in Nantes to her. Repr. in Salerno, 1984, 243, fig. 63.1.

Circle of Giuseppe Recco, *Still Life with Fish*

Orazio Riminaldi
(1593–1630)

This short-lived Pisan artist was active in Rome in the second and third decades of the century. The influence of Bartolomeo Manfredi and of Orazio Gentileschi contributed to his somewhat bland Caravaggism, and he was indebted to Simon Vouet as well.[1] Riminaldi moved away from his Caravaggesque idiom of the 1620s in his work on the dome of the Pisa cathedral, a work he returned home to execute in 1628–29 in a manner that wedded Vouet to Giovanni Lanfranco's illusionism.[2]

1. Gregori, 1972, 49. In 1624 Riminaldi was living at the same address as Vouet (39).
2. Gregori, 1972, 46–48. Guidi, 1972, 79–87, ascertains, among other dates, those of his baptism (1593) and death (1630).

Daedalus and Icarus

Oil on canvas, 132 x 96.1 cm (52 1/8 x 37 7/8 in.)
Condition: good. There are pentimenti along the bared shoulder of Daedalus and along his right thumb. About 40 centimeters above his wings and about 10 centimeters above Icarus's there are further broadly stroked pentimenti, seemingly white wings now covered by the dark brown ground.
Provenance: Anne Douglas Hamilton, Oakley House, Norfolk; Samuel Untermeyr, Yonkers, N.Y.; F. Kleinberger & Co., New York.[1] Purchased by the Wadsworth Atheneum in 1944 from Arnold Seligmann, Rey & Co., New York, for $5,000 from the Sumner Fund.
Exhibitions: San Francisco, 1941, no. 21, as Cavallino, lent anonymously by F. Kleinberger & Co., New York; Hartford, 1946, no. 9, as Cavallino; Dayton, 1953–54, no. 137, attributed to Cavallino; Amherst, 1974, no. 15, as Central Italian.
The Ella Gallup Sumner and Mary Catlin Sumner Collection, 1944.38

Daedalus, the legendary artist and superhumanly skillful craftsman, built the labyrinth in Crete for King Minos, who in turn imprisoned him therein, together with his son, Icarus. Here Daedalus girds his son with wings the father has wrought of wax and feathers to escape. Icarus was to soar so close to the sun that the wings melted and he perished.[2] It is conceivable the theme is an allusion to the risks of creative genius.

The painting entered the collection in 1944[3] with an attribution to Bernardo Cavallino; alternative attributions ranged from Giacinto Brandi[4] to Gioacchino Assereto[5] to possibly Nicolas Regnier (Renieri).[6] Longhi first suggested the Atheneum picture was by Orazio Riminaldi,[7] an idea taken up by Gregori, who published an unlocated version of the picture as a work of the 1620s.[8] Fredericksen and Zeri listed it as "attributed to" Riminaldi.[9] Borea considered the Riminaldi attribution a secure one.[10] Nicolson listed it as one of at least three known versions.[11] The pertinent comparison is with *Amor vincit omnia* in the Pitti, one of the artist's key works and one that is derived from Caravaggio's treatment of the theme.[12] The refined rendering of the upraised hand and the flat modeling of the nude set shallowly in space are common to both the Atheneum and Pitti pictures.

There are several versions of the composition, exactly how many is not clear.
1. The Atheneum picture acquired in 1944.
2. The picture published by Gregori in 1972.[13] The light on the face of Daedalus in no. 2 is different, as is his hair, from no. 1. The upraised hand is more distant from the top edge of the picture, and the feathers and drapery at the bottom do not match no. 1.
3. A version that was twice offered in London at Christie's in 1977: first, on 4 Feb., no. 59, fig. 19, when it was bought in; second, on 28 Oct., no. 6; 131.9 x 99 cm, bought by Zanchi, 1,500 pounds.[14] No. 3 differs from no. 2 in that the light falls differently again on the head of Daedalus, the eyes of Icarus are set differently, his back is draped, and the drapery and feathers at the bottom again vary.
4. An unphotographed version reported in 1974 and 1977 to be in the Raoul Ergman Collection, Paris.[15] It was unsuccessfully offered for sale in Paris, Hôtel Drouot, 23 Dec. 1977, no. 6, 130.5 x 95.5 cm. Obviously this is not no. 1 and perhaps neither 2 nor 3.
5. In 1979 Nicolson listed a version with the heirs of Vincenzo Bonello, Valletta, Malta. This might or might not be distinct from nos. 2, 3, and 4.[16]

There are two other prominent seventeenth-century treatments of the Daedalus and Icarus theme. Andrea Sacchi interpreted the story much more lyrically in a composition known in several versions,[17] one of which was exhibited at Colnaghi, New York, in 1984.[18] Van Dyck also painted it, either before[19] or after[20] his Italian sojourn in 1621–26. If the latter, it is conceivable Riminaldi's work might have been known to both artists. In fact, Waterhouse cites the Atheneum picture, which he calls Riminaldi?, as a possible Caravaggesque source for the young van Dyck.[21] Lebrun also painted the subject in an analogous, but different composition.[22] M.M.

1. T. Howe, Jr., *Art News*, 1941, 28–29, repr.
2. Pausanias, *Description of Greece*, 9, 3, 2; 10, 17, 3; Diodorus Siculus, *History*, 4, 30; 1, 97.
3. Arnold Seligmann, Rey & Co., New York, had bought the picture "on the advice of" H. Voss (3 Mar. 1944, curatorial file).
4. H. Voss to C. Cunningham, 10 July 1949, curatorial file, "by Giacinto Brandi. It is obviously influenced by (but *not* directly imitated *from*) Andrea Sacchi's version of the same subject."
5. C. Cunningham to C. Goetz, 28 Apr. 1948, curatorial file, "by the same hand as that which Roberto Longhi published in *Pinacoteca* [I, no. 4, Jan./Feb.], 1928, 221[–25], and attributed to Assereto.... Certainly on the basis of photographs I have little doubt the paintings are by the same hand."
6. R. Enggass verbally to P. Marlow, 27 Sept. 1977, memorandum in curatorial file.
7. R. Longhi to C. Cunningham, 19 Jan. 1966, curatorial file.
8. Gregori, 1972, 49, "apparso sul mercato alcuni anni fa," fig. 61, "ubicazione sconosciuta."
9. Fredericksen and Zeri, 1972, 175, 472, 585. Zeri earlier had queried the aptness of the attribution to Brandi (F. Zeri to C. Cunningham, 5 Mar. 1962, curatorial file).

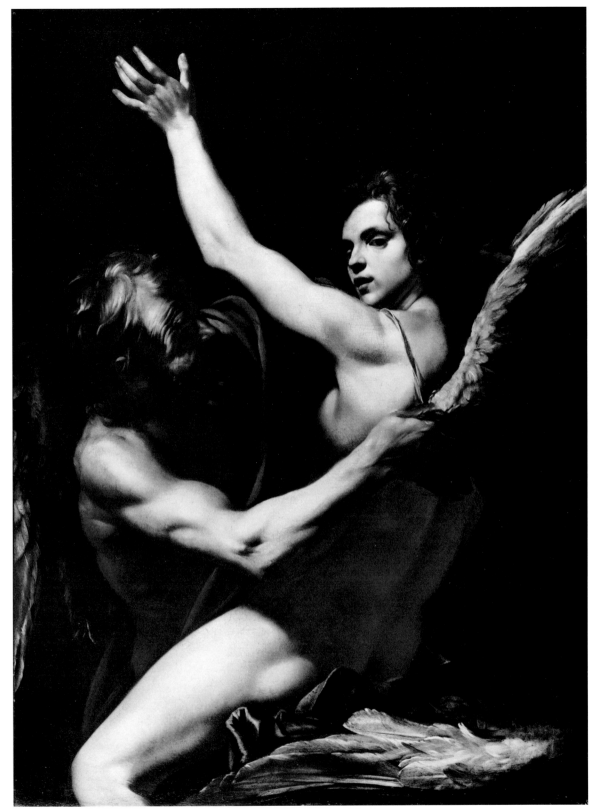

Orazio Riminaldi, *Daedalus and Icarus*

10. Borea, 1972, 155, fig. 15.

11. Nicolson, 1979, 82.

12. Inv. no. 422. Repr. in Moir, 1967, II, fig. 282. Exhibited Florence, 1970, no. 16.

13. Gregori, 1972, 49, fig. 61. Not to be identified, as Nicolson implies, 1979, 82, with the Atheneum version.

14. From a collection "which seems to have been formed in Paris in the 1920s and had in recent years been in store in the Channel Islands. This means our version [3] cannot be that from the Ergman Collection [4]" (F. Russell, Christie's, London, to D. Motta, 1 Feb. 1978, curatorial file).

15. A. Percy to P. Marlow, 22 Apr. and 29 May 1974, curatorial file. A. Brejon de Lavergnée to P. Marlow, Dec. 1977 or Jan. 1978 plus 17 Mar. 1978, curatorial file.

16. Nicolson, 1979, 82.

17. Harris, 1977, I, 81–82, no. 49, repr.

18. New York, 1984, no. 25, illus.

19. A. McNairn's view in Ottawa, 1980, no. 67.

20. S. Barnes verbally to M. Mahoney, 13 July 1984.

21. Ottawa, 1980, x.

22. P. Rosenberg verbally to J. Cadogan, 2 May 1980, memorandum in curatorial file, called attention to a picture now in the Hermitage (Gosudarstvennyi Ermitazh, 1976, I, 207, fig. 68). The painting came from the Walpole Collection at Houghton and was published by Boydell, 1788, II, pl. [8], 75¹/₂ x 51¹/₄ in., engraved by G. S. and I. G. Facius, with an attribution to Lebrun. It appeared thus in the 1916 Hermitage catalogue and is still attributed to Lebrun (S. Vsevolozhskaya to M. Mahoney, 5 Sept. 1983, curatorial file).

Michele Rocca, *Expulsion of Adam and Eve from Paradise*

Michele Rocca
(1666–after 1751)

The little information we have on the life and art of Michele Rocca is contained in the *Vite di pittori, scultori ed architetti* of Nicola Pio, written in 1724.[1] Pio says Rocca, born in Parma in 1666, came to Rome at the age of sixteen and studied with Ciro Ferri, the assistant of Pietro da Cortona. According to Pio, Rocca then returned to Parma to study works of his native school, especially those of Correggio. This must have been in 1687, when Rocca was called upon to appraise some pictures there.[2] Rocca returned to Rome sometime before 1695, when he signed the large altarpiece *St. Francis Receiving the Stigmata*, painted for the church of S. Paolo alla Regola. The *Penitent Magdalene*, documented to 1698, was painted for the high altar of the church of the Magdalene, and is further testament to the success of the young painter in late seventeenth-century Rome.[3] In 1710 Rocca was counted among the Virtuosi del Pantheon, and in 1719 he was elected to the Accademia di S. Luca, where in 1727 he held a minor office.[4] This is the last documentation of his presence in Rome; in 1751 he is noted by M. Osterreich in Venice as an old man of about eighty, who no longer knew his age.[5] The date of his death is not known.

While a considerable oeuvre has been assembled on the basis of style,[6] the scarcity of documented works by Rocca has made a definitive assessment of his development and chronology impossible. It is generally granted that Rocca gave up painting large public altarpieces soon after the dated works from the 1690s and concentrated on small cabinet pictures for sophisticated private collectors. These works, which show considerable unanimity of style, anticipate the taste of later eighteenth-century painting in Italy and France. The reasons for Rocca's conversion to this specialization have been debated; recently the influences of Benedetto Luti and Sebastiano Conca, and of the French painters in Rome such as Le Moyne and C. A. van Loo, have been shown to postdate the first indications of Rocca's "rococo" taste, already evident in his works of the 1690s.[7] Instead, the late production of Maratti, of Luca Giordano, and works of Trevisani are proposed as possible influences; the sophisticated circle of Cardinal Pietro Ottoboni may also have encouraged Rocca in his decorative tendencies.[8] Rocca's study of works in Parma certainly played a part in the formation of his style, and his study of Venetian paintings, especially of Pellegrini, may have influenced other later works.[9]

While painters such as Luti and Conca, and the French painters Boucher and de Troy were artists of considerably greater range and quality than Rocca, he nonetheless plays an interesting, though minor, role in the emergence of eighteenth-century style and sensibility in Rome.

1. Pio, 1977, 111.

2. E. Scarabelli-Zunti, "Memorie e documenti di B. A. Parmegiane, 1651–1700," Parma, Archivio del R. Museo, MS 1, as cited in Sestieri, 1973, 84.

3. Sestieri, 1973, 83, 95, n. 1.

4. Sestieri, 1973, 84, 95, n. 5.

5. M. Osterreich, *Beschreibung des Gemäldekabinetts von J. G. Stein in Berlin*, 1763, as cited by H. Voss, "Michele Rocca, ein vergessener italienischer Rokoko-Maler," *Zeitschrift für bildende Kunst*, 1921, 69.

6. See, in addition to the articles cited above, A. M. Clark, "A Mythological Subject by Rocca," *Bulletin of Rhode Island School of Design; Museum Notes*, XLII, no. 2, 1955–56, 13; Castelnovi, 1959, 333–37; V. Antonov, "Appunti su alcuni quadri italiani del sei- e settecento nel Museo d'Arte Straniera di Riga," *Antichità viva*, X, 1971, 6.

7. Sestieri, 1973, 85.

8. Sestieri, 1973, 87.

9. Sestieri, 1973, 88, 90.

Expulsion of Adam and Eve
from Paradise

Oil on canvas, 51.2 x 38.7 cm (29⅛ x 15¼ in.)
 The original canvas has been lined onto a larger stretcher and extended by about ⅞ inches on all sides, revealing the original tacking edge.
 Condition: good. The paint surface has minor abrasions and losses.
 Provenance: collection Fritz Haussmann, Berlin, by 1931; Schaeffer Galleries, New York, by 1942; Mr. and Mrs. Arthur L. Erlanger, New York; given to the Wadsworth Atheneum in 1959 by Mr. and Mrs. Arthur L. Erlanger.
 Exhibitions: possibly Berlin, *Italian Painting in the Seventeenth and Eighteenth Century*, 1927, no. 124; New York, 1942, no. 28, repr.; Hartford, 1946, 13, no. 39 (lent by Schaeffer Galleries); Northampton, 1947, no. 22 (lent by Schaeffer Galleries).
 Gift of Mr. and Mrs. Arthur L. Erlanger, 1959.249

Adam and Eve, cringing with modesty, are chased from Eden by an angel with a flaming sword.[1] A pendant to the Atheneum picture shows an earlier episode in the Fall, when Eve ate the forbidden fruit.[2]

Expulsion of Adam and Eve from Paradise has been attributed to Rocca since its appearance in the literature.[3] With its light palette, sensuous surfaces, and depiction of refined emotions, the Atheneum painting is typical of Rocca's work.

 The Atheneum picture is probably a mature work of the artist, painted after 1700, although a precise date cannot be advanced. J.C.

1. Genesis 3:24.
2. Genesis 3:6. The pendant was noted by F. Heim, oral communication, Feb. 1972, memorandum in curatorial file. This picture is untraced.
3. H. Voss, "Spätitalienische Gemälde der Sammlung Hausmann in Berlin," *Zeitschrift für bildende Kunst*, LXV, nos. 9–10, Dec. 1931, 165; G. De Logu, "Pittura italiana del '600 e del '700 nella collezione H," *Rivista mensile illustrata d'arte e di cultura*, Dec. 1935, 129; Fredericksen and Zeri, 1972, 585; Sestieri, 1973, 85, fig. 68.

Johann Melchior Roos
(1659–1731)

The brother of Philipp Peter Roos, known as Rosa da Tivoli (1655/57–1706), Johann Melchior was born in Frankfurt, trained with his father, Johann Heinrich (1631–1685), was a member of the Design Academy in The Hague in 1684, and is said to have been in Italy from 1686–90, with Philipp Peter, in Tivoli, where he painted in a manner close to his brother's.[1] Salerno mentions that he was resettled in Frankfurt in 1695, where he was patronized by Count Schönborn.[2] He died in his native city in 1731.

1. Thieme and Becker, 1934, XXVIII, 579–80.
2. Salerno, c. 1977–80, II, 632.

Landscape with Cattle, a Shepherd,
and Ruins

Oil on canvas, 59 x 73.4 cm (23¼ x 28⅞ in.)
 Condition: very good.
 Provenance: possibly Stephen Chester; by descent to his great-nephew, William L. Matson, Hartford. Given anonymously to the Wadsworth Atheneum in 1921.[1]
 Exhibitions: Hartford, 1931, no. 79, as "Jacob Roos . . ., son and pupil of Philipp Peter Roos."
 Anonymous gift, 1920.503

The picture came to the museum with an unverifiable provenance and an attribution to Jakob Roos, born in 1682, son and pupil of Philipp Peter Roos, known as Rosa da Tivoli, in whose manner Jakob painted throughout his career, which centered in Naples. Cunningham reattributed the picture to the Neapolitan Domenico Brandi (1684–1736),[2] basing his judgment on a comparison with two pictures in Modena.[3] However, judging from photographs,[4] those compositions, with large-scaled cattle and figures, bear no relation to the Atheneum picture. Nor does the Atheneum picture bear any resemblance, again judging from photographs,[5] to the key group of Domenico Brandis, commissioned by the Austrian viceroy in Naples, Count Alois Thomas Raimund von Harrach, two of which are dated 1731.[6]

 The Atheneum picture is assuredly by the same hand as a landscape with cattle in the Pallavicini Collection, Rome, a picture that Zeri observed has that typical blending of Rosa da Tivoli, Andrea Locatelli, and Orizzonte generally associated with Domenico Brandi. Zeri thus catalogued the Pallavicini picture as Brandi but pointed out that it is undoubtedly by the same hand as that responsible for pictures sometimes signed on the verso "Ercole Rosa," examples of which are in the Cherubini-Cavalcabò Collection, L'Aquila. Zeri proposed this unknown artist belonged to Rosa da Tivoli's circle and his work was closely parallel to Domenico Brandi's.[7] In both the Pallavicini and Atheneum pictures, each very liquidly brushed, the cows' heads are posed in a rather comically repetitive three-quarter view. This turned out to be the key to identifying the artist, for the same bovine convention appears in a picture signed Johann Melchior Roos.[8] M.M.

Johann Melchior Roos, *Landscape with Cattle,
a Shepherd, and Ruins*

1. Curatorial file.
2. Prota-Giurleo, 1953, 42–51.
3. C. Cunningham to E. T[urner], no date, curatorial file. For the Modena pictures, see Pallucchini, 1945, 235, nos. 545 and 546, each about 73 x 97 cm, a pair of bucolic landscapes acquired in 1922 as Rosa da Tivoli and so accepted by Ricci and Zocca, but as Brandi and Lorenzetti suggested they were by Domenico Brandi, Pallucchini retained that attribution with a question mark.
4. Arch. Fot., Sop. Modena 1021 and 1022.
5. Meyer Photographic Archive, photo nos. 21936, 21937, 24480, 24471, 24479.
6. Heinz, 1960, 20–21. G. Ceci in Thieme and Becker, 1910, IV, 530, cites further signed works in Stuttgart and in the Prado, but their catalogues, respectively of 1962 and 1963, mention no Brandis.
7. Zeri, *Pallavicini*, 1959, 60, no. 73, oil on canvas, 35.8 x 44.8 cm, Istituto Centrale per il Catalogo e la Documentazione, E33349.
8. Repr. in Salerno, c. 1977–80, II, 632, fig. 104.1. Further fine examples of works by the same hand were in the collection of Marchese Alberto Theodoli, Rome.

Salvator Rosa
(1615–1673)

Italy's best-known seventeenth-century landscape and battle painter first trained in his native Naples with his brother-in-law Francesco Fracanzano. Early drawings suggest Rosa and Domenico Gargiulo studied at least nude drawing under the auspices of Aniello Falcone. The years 1635–40 were divided among Naples, Rome, and Viterbo. He moved to Florence in 1640, where he stayed for nine years. There he met Lucrezia, the model perhaps for the Atheneum picture below. Already, he had evolved a very personal interpretation of Claude's landscape style, an interpretation marked by a brooding, restless intensity that set him apart as a proto-romantic in a period when idealized, classicizing landscape was the norm in Italy. Two Atheneum landscapes very much reflect this proto-romantic quality, which was greatly admired. But Rosa was not content with his success in the genre. Particularly after his return to Rome permanently in 1649, he aspired to be recognized as well as a kind of stoic *peintre-philosophe* of moralizing themes frequently executed in a stilted adaptation of Poussin's grave style. The combined effects of his railing against a patronage system that preferred his landscapes to such works, his mordant wit—he wrote extended verse satires—and his permanently irregular domestic arrangements made Rosa something of a proto-*peintre-bohème* as well. His European reputation was never as high as in the Romantic period.

Landscape with Tobias and the Angel

Oil on canvas, 124.2 x 198.5 cm (48⅞ x 78¼ in.)
 Condition: very poor. Extensive losses and repainting throughout the landscape. Extensively retouched in the sky.
 Provenance: Lord Jersey, Osterley Park, Hounslow, by 1854. Purchased by the Wadsworth Atheneum in 1934 from Durlacher Bros., New York, for $3,100 from the Sumner Fund.
 Exhibitions: New London, 1935, no. 23; New York, 1948, no. 11; Oberlin, 1952, no. 13; Amherst, 1974, no. 26; Wellesley, 1979, no. 9; Hartford, 1982.
 The Ella Gallup Sumner and Mary Catlin Sumner Collection, 1934.292

This widely accepted picture,[1] the second attributed to the artist to enter the Atheneum,[2] was described by Waagen as a landscape with Tobit and the angel,[3] hanging in Lord Jersey's gallery at Osterly Park near London. It hung there together with Rosa's *Landscape with Apollo and the Sibyl*, now in the Wallace Collection, a Gaspard Dughet, a pair of Claude *Morning* and *Evening* scenes, and a Poussin *Landscape with the Sleeping Silenus and a Nymph*.[4] What could be a better illustration of English eighteenth-century taste and collecting than this concentration of pictures, representative of different mid seventeenth-century Roman landscape styles, brought together in the splendid neoclassic interiors of the brothers Adam at Osterley? Waagen comments on the Rosa that it is "finely composed, of moderate size, and of very powerful effect." All are apt observations about this picture, which though large (124.2 x 198.5 cm), could have seemed "moderate" in size next to the larger *Landscape with Apollo and the Sibyl* (171 x 258 cm). Unfortunately, its "very powerful effect" is diminished in its present state. The thinly applied brown underpainting has become transparent and the overlying pigments are much damaged and darkened as well as extensively overpainted. The picture is a noble wreck, still conveying, however, the breadth of the artist's powerful conception.

In this scene Tobias, aided by the still unrecognized archangel Raphael, catches the fish with which his father Tobit is to be cured of blindness.[5] The thesis of the Book of Tobit is that the righteous man should sustain himself patiently in troubles, assured that God will deliver him.[6] The subject obviously recommended itself to Rosa, the painter-philosopher, who frequently turned to themes that implicitly extolled stoic self-control in the face of life's adversities and vanities.

Despite its condition, the picture is a large and instructive example of Rosa's fully developed landscape style of circa 1660. The space is obviously composed in a series of receding planes through which the eye is led by the compositional device of a river meandering into the far distance. But quite unlike Claude, who used the same device to achieve a classical effect of order and serenity, Rosa has here inserted a cluster of billowing trees, jagged rocky outcroppings, blasted trunks, and a restless light to achieve that proto-romantic mood for which he was so rightly admired.

Fahy recognized a copy of the present picture in the Fogg Art Museum, Harvard University.[7] M.M.

1. Boetzkes, 1960, listed the painting twice, each time with different measurements: 184, no. 5 and 192, no. 147. Salerno, 1963, 125, no. 45. Fredericksen and Zeri, 1972, 177, 265, 584. Salerno, 1975, 103, no. 238. R. Wallace in Wellesley, 1979, 22–23, no. 9. Graves, 1914, III, 1138–40, lists a *Tobit and the Angel* by Rosa loaned to the British Institution in 1850, no. 60, lent by J. J. Martin; in 1857, no. 58, lent by Lord Methuen; in 1863, no. 60, lent by George Perkins; in 1865, no. 111, lent by Wynn Ellis; in 1867, no. 62, lent by Lord Overstone; to the Royal Academy in 1880, no. 120, lent by G. E. Martin. Wallace, 1979, 23, cites all of these as the provenance of the Atheneum picture. It is not clear which, if any, of the above, apply to the Atheneum work. In addition a *Landscape with Tobit and the Angel* was lent to the British Institution in 1816 by "B. West Esq."—Benjamin West?, British Institution, 1824, 110.
2. K. Askew to A. E. Austin, Jr., 29 Sept. 1934, curatorial file. *Wadsworth Atheneum Bulletin*, Jan./June 1935, 18.

Salvator Rosa, *Landscape with Tobias and the Angel*

3. "Tobit" and "Tobias" are interchangeable Greek forms of the Hebrew "Tobiah" (McKenzie, 1965, 895); hence, perhaps, Waagen's title.

4. Waagen, c. 1854, IV, supp., 270–71. Röthlisberger lists the *Morning* as a copy after Claude (1961, I, 525, no. 262, II, fig. 403) and the *Evening* as an unlocated painting related to *Liber veritatis* 132, dated 1655 (1961, II, 318–19). The Poussin subject does not appear in Blunt, 1966.

5. Tobit 6:1–18.

6. McKenzie, 1965, 895.

7. Inv. no. 1937.181, 56¼ x 77¼ in., gift of Mr. and Mrs. William van Dyke, Detroit.

Lucrezia? as the Personification of Poetry

Oil on canvas, 116.2 x 94.2 cm (45¾ x 37¼ in.)

Condition: good. Lightly retouched on the face and neck, extensively so in the background.

Inscribed on an old relining removed in 1955 and thereafter reattached to the present lining: *No No 30/ La Ricciardi la favorita/ di Salvator Rosa fatta da lui/ come la Sibilla per la casa Niccolini/ a Firenze*

Provenance: Niccolini family, Florence; Rev. John Sanford, about 1832; marquis of Lansdowne, Bowood House, Wiltshire, 1838; by descent until purchased by the Atheneum. Purchased by the Wadsworth Atheneum in 1956 from Thos. Agnew & Sons, London, for 1,400 pounds ($3,500) from the Sumner Fund.

Exhibitions: perhaps Florence, 1729, lent by Marchese Filippo Niccolini (see below); Florence, 1767, lent by Marchese Lorenzo Niccolini; London, British Institution, 1839, no. 113; London, 1925, no. 41; London, *Seventeenth-Century Art*, 1938, no. 301, *Illustrated Souvenir*, pl. 78; Hartford, 1957; New York, M. Knoedler & Co., 1958, no. 61; Cleveland, 1963, no. 63; New York, Wildenstein & Co., 1969, no. 38; London, 1973, no. 10; Sarasota, 1984–85, no. 57, as *Lucrezia as Poetry*.

The Ella Gallup Sumner and Mary Catlin Sumner Collection, 1956.159

The inscription—the Ricciardi woman, Salvator Rosa's favorite, painted by him as the sibyl for the Niccolini household in Florence—on a fragment of the old relining canvas is so glaringly confused in one aspect that its entire content must be weighed carefully. Giovanni Battista Ricciardi (1623–1686), who eventually held the chair of moral philosophy at Pisa, was Rosa's close friend, one whom he met and frequently visited during his Florentine sojourn (1640–49) and with whom he maintained a constant correspondence in the years thereafter, when Rosa had settled in Rome (1649–73).[1] It is this correspondence that is the principal documentary source concerning the artist.[2] The artist's favorite, or more aptly, his common-law wife was Lucrezia Paolini.[3] An absent husband seems to have been the impediment to their marriage, which took place a few day's before Rosa's death. We can presume Rosa met her when he arrived in Florence, because their first son, Rosalvo, was born before August 1641.[4] As the inscription here mistakes Ricciardi for Lucrezia, one must accept that whoever applied the inscription was unknowing of or distant from the actual events. Thus there is no authority, except this old but, in one instance, demonstrably garbled tradition, that Lucrezia is actually the model here, that she is portrayed as a sibyl,

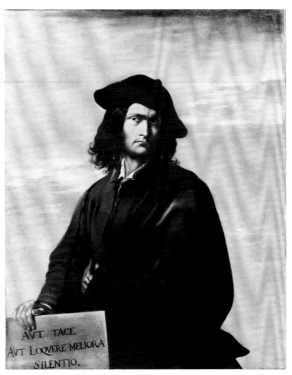

Figure 40. Salvator Rosa, *Self-Portrait*, London, National Gallery

and that the picture was commissioned for the Niccolini family in Florence.

That Rosa did use Lucrezia as a model is confirmed by Passeri, who speaks of her as being of "bello aspetto" and "buona qualità."[5] The same woman in the Atheneum picture is perhaps the model for a stylistically contemporary, but much less individualized personification of poetry in the Galleria Nazionale, Rome,[6] and Lucrezia's name is traditionally cited in discussion of a very particularized and compelling portrait in the same collection.[7] There is, however, no external evidence for such identifications; associating Lucrezia's name with such pictures is only an agreeable and logical inference.[8]

Salerno suggested this is not a sibyl but a personification of poetry,[9] as did Levey.[10] Langdon noted the pen, book, and laurel crown are the traditional attributes of poetry set out in Ripa's 1611 *Iconologia*.[11] Indeed, the picture was exhibited in 1767 (see below) as a female figure representing poetry.

While there is no doubt that the picture belonged to the Niccolini, there is no evidence other than the inscription that it was painted for the family. It was lent by Marchese Lorenzo Niccolini to a Florentine exhibition in 1767, together with the famous *Self-Portrait* in the National Gallery, London (Fig. 40).[12]

Levey notes the London picture is probably slightly reduced in height, there being about one half of an inch of painted canvas overlapping the stretcher top,[13] so that both pictures are now of the same size: Atheneum, 116.2 by 94.2 centimeters; London, 116 by 94 centimeters.[14] This plus their common provenance naturally led to their usually being called a pair ever since the Reverend John Sanford purchased them about 1832 from the Niccolini for 91 pounds the two, brought them to England, and sold them in 1838 to the marquis of Lansdowne.[15] They became separated when the *Self-Portrait* was presented to the National Gallery in 1933 and the *Lucrezia* left the Lansdowne Collection to be acquired by the Atheneum in 1956.[16] When they were reunited at the London Rosa exhibition in 1973, it was apparent they could not be called pendants in the strictest sense— their palettes are so incongruent. Levey suggests they are perhaps companion pieces[17]—"due quadri compagni" was what they were called in the 1767 exhibition, terminology that certainly reflects their shared history, traceable at least to the eighteenth century, and aptly responds to their congruent intensity of expression, characteristic of the artist in every phase of his career, but does not preclude their being parallel conceptions of different decades.[18]

Salerno noted that the force of the pictures, each so dryly painted and tightly drawn, lies in the juxtaposition between the realism of the model and the abstract associations of each characterization. The woman here is intensely a presence yet a symbol. Salerno observes this penchant for the real is rooted in the artist's Neapolitan beginnings[19] and is here admixed with Rosa's budding intellectual and literary aspirations. Thus he dates the picture about 1641–42.[20] For Langdon, too, "the sharply focused figure, the clear contours and light background, and the enigmatic, half withdrawn, half defiant, expression are all characteristic of Rosa's portrait style in the 1640s."[21] She notes that such allegorical personifications are common in the works of the Florentines Francesco Furini, Giovanni Martinelli, and Lorenzo Lippi, whose influence is strongest here.[22]

Roworth's view is that the inscriptions were added much later, probably late in the eighteenth century or early in the nineteenth. Recalling that the Atheneum picture was exhibited in 1767 simply as a woman representing poetry—only the London picture was identified then as a self-portrait—she suggests the identification of the two as the brooding painter and his beautiful mistress-model as an oracular sibyl is a romantic superimposition upon pictures that, although they perhaps do draw upon idealized elements of the artist's and Lucrezia's features, were each conceived firstly according to the seventeenth-century taste for allegorical personifications. Finally, she suggests the London painting, with its inscription that can be translated as "Either keep silent or speak better than silence," can be understood as a form of "visual rhetoric" versus the "silent poetry" of the Atheneum picture.[23] M.M.

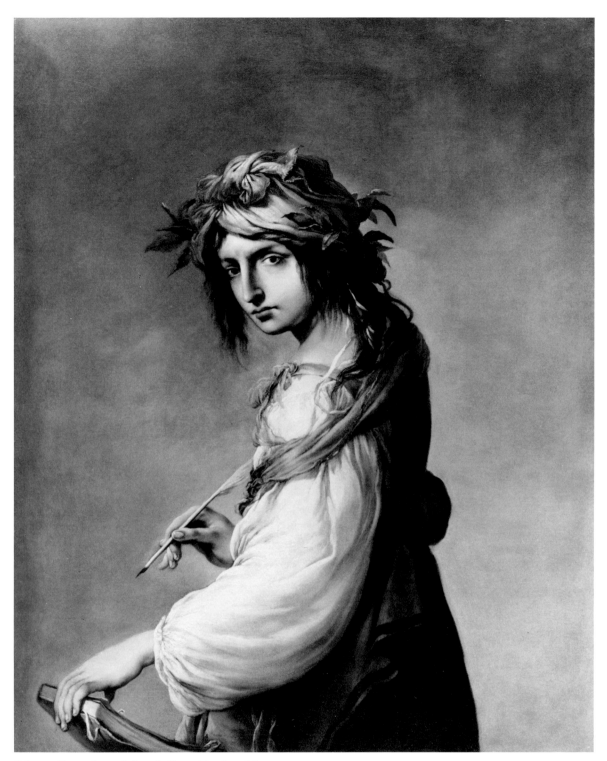

Salvator Rosa, *Lucrezia? as the Personification of Poetry*

1. De Rinaldis, 1939, letters XL–XLIV. Limentani, 1950, 33. Meroni, *Lettere*, 1978, 91–96, where Ricciardi's will and estate inventory are published.

2. In addition to De Rinaldis, 1939; Limentani, 1950; and Meroni, *Lettere*, 1978, cited above, see also Cesareo, 1892; Limentani, 1953, 37–58; Limentani, 1973, 255–73; and Meroni, *Prospettiva*, 1978, 68–70.

3. H. Langdon in London, 1973, 22, and Festa, 1982, 102, n. 3.

4. Passeri, 1934, 391, nn. 2 and 4. Mahoney, 1977, I, 68–70, where the Atheneum picture is mentioned, as well as on 475–76, no. 49.5.

5. Passeri, 1934, 391.

6. Galleria Nazionale d'Arte Antica, inv. no. 2352, 75 x 62 cm. Salerno, 1975, no. 31, color pl. VI.

7. Salerno, 1975, no. 117, color pl. XLI, 65 x 50 cm.

8. A problem raised as well by Roworth, first in 1985, 406, in connection with this picture and the Metropolitan Museum's *Self-Portrait* (see note 12 below).

9. Salerno, 1963, 35, 108, 116–17; 1975, 87, no. 33.

10. Levey, 1971, 200–202.

11. H. Langdon in London, 1973, 22–23.

12. Inv. no. 4680. Levey, 1971, 201, n. 7, based on information provided by E. Gardner; see also M. Davis to C. Cunningham, 22 Feb. 1957, curatorial file: Florence, SS. Annunziata, *Il Trionfo delle bell'arti rendetto gloriosissimo*, 1767, 21, "Due Quadri compagni di mano di Salvator Rosa, che in uno un figura di Filosofo, l'Autore ha ritratto se medesimo, nell'altro in figura di Femina ha rappresentata la Poesia, dell'Ilustr. Sig. Marchese Lorenzo Niccolini." The London painting is inscribed on the back "Rosa, no. 29, Salvator Rosa, Il suo proprio Ritratto fatto/da lui per la Casa Nicollini [sic] a Firenze." An ancestor, Marchese Filippo Niccolini had lent two paintings to the same Accademia di S. Luca loan exhibition, in 1729, identified only as a *Mezza figura* and a *Testa di filosofo*. Roworth, 1988, 106 and 122, n. 22, suggests these might be the Atheneum and London pictures, citing *Nota de' quadri e opere di scultura esposti per la festa di San Luca dagli Accademici del Disegno Nella loro Capella, e nel Chiostro secondo il Convento de' PP. della SS. Nonziata di Firenze l'anno 1729*, Florence, 1729, 27–28, and Borroni Salvadori, 1974, 27.

Meroni, *Lettere*, 1978, 7–8, believes the Metropolitan Museum's *Self-Portrait*, inv. no. 21.105, to be a portrait of Ricciardi, as was first proposed by Fredericksen and Zeri (1972, 177, 517, 606), and by extension, Meroni sees the London picture as a portrait of Ricciardi as well. In Ricciardi's estate inventory, published by Meroni, *Lettere*, 1978, 93–95, doc. CLXXVI, there figures "Il ritratto del Sig. D.re Gio. Batta senza cornice" and "un quadro grande con cornice di albero bianche dipintovi un filosofo che scrive sopra una testa di morto." Meroni, *Lettere*, 1978, 105, doc. CLXXXVI, also found a passage in an unpublished literary history of Tuscany by Giovanni Cinelli Calvoli (1625–1705), in which Cinelli Calvoli says, "da [Rosa] ricevé [Ricciardi] in dono molto pitture di pregio fra le quali è bellissima quella ov'è il Ricciardi in abito filosofico ritratto in atto di contemplare un teschio umano, nel cui quadro son queste parole scritte: 'Salvator Rosa dipinse nell'Eremo e dono a Gio Batta Ricciardi suo amico.'" Meroni infers this is the *Filosofo* picture mentioned in the 1687 estate inventory and now in the Metropolitan Museum. Thus the estate inventory's "filosofo che scrive sopra una testa di morto" becomes "il Ricciardi in abito filosofico in atto di contemplare un teschio umano." The discrepancy between "a philosopher writing upon a skull" and "Ricciardi, in philosopher's garb, contemplating a skull" leads Roworth, 1988, 105–6, to suggest that despite the fact Cinelli Calvoli knew both Rosa and Ricciardi (Meroni, *Lettere*, 1978, doc. CLXXXV; 1981, 67, n. 2), Cinelli Calvoli had not seen the picture, that he was speaking second hand. Thus she discounts Meroni's identification of the Metropolitan Museum and London pictures as Ricciardi, noting, 105, that whoever drew up the estate inventory, presumably someone likely to have been familiar with the household, specified Ricciardi's likeness in one picture but not in the second. Her argument is buttressed by the fact Ricciardi's heirs considered it a Rosa self-portrait and lent it as such, "autorittrato in atto di scrivere sopra un teschio di morto," to the 1767 exhibition, to which the Niccolini sent the

Atheneum and London pictures. The 1767 loan probably was the same picture also lent earlier as a Rosa *Self-Portrait* in 1706 and 1729 (Roworth, 1988, 109, 123, nn. 28, 29, citing Borroni Salvadori, 1974, 119–20).

13. Levey, 1971, 200–201.

14. Levey, 1971, 200–201.

15. It was mentioned by Jameson, 1844, 309, no. 40, companion to no. 39, Lansdowne Collection, Bowood House, as a *Portrait of the Marchesa Ricciarelli*. Waagen, 1854, III, 157, Lansdowne Collection. The fifth marquis of Lansdowne called it a portrait of the Marchesa Ricciarelli in the 1897 *Catalogue of Pictures Belonging to the Marquess of Lansdowne, K. G., at Lansdowne House, London, and Bowood, Wilts.*, 94, no. 102. Nicolson, 1955, 213, no. 41. The *Lucrezia* was exhibited at the British Institution, 1839, no. 113, by Sanford as Marchese Ricciardi of Volterra (Graves, 1914, III, 1137). The London, 1938, exhibition label attached to the verso indicates the picture was lent from Bowood.

16. At the time of its purchase, Geoffrey Agnew spoke of the picture's coming to the firm from Lansdowne House (G. Agnew to C. Cunningham, 19 Apr. 1956, curatorial file). References not otherwise cited: C. Cunningham, 1957, 3, no. 4; *Wadsworth Atheneum Handbook*, 1958, 61; Boetzkes, 1960, 192, no. 159; Kuh, 1962, 33–34; Paoletti, 1968, 427–29; Fredericksen and Zeri, 1972, 177, 505, 585; Crombie, 1973, 502; Silk and Greene, 1982, 48–49; Cadogan, 1985, 4, as *Lucrezia as Poetry*.

17. Levey, 1971, 200–201.

18. Mahoney, 1977, I, 471–77, group 49, for example, assigned the London portrait to the mid 1650s based on the style of related drawings, whereas Roworth, 1988, 114–21, argues on iconographic and biographical grounds it was painted in 1657.

19. M. Kitson cites Ribera's 1637 *Girl with a Tambourine* in the Drey Collection as an illustration of the bridge between Rosa's *Lucrezia* and Caravaggio (in London, 1973, 68–69, no. 113, repr. in *Apollo*, LXXVI, 1962, 398).

20. Salerno, 1963, 35; *Arte illustrata*, 1973, 409; *Burlington*, 1973, 827.

21. In London, 1973, 23.

22. Langdon, 1975, 144.

23. Roworth, 1988, 106–7, 123, n. 27.

The Tribute Money

Oil on canvas, 44.5 x 60.7 cm (17 1/2 x 23 7/8 in.)

Condition: good, as recent cleaning has confirmed, though perhaps overpainted in the upper right sky; if not overpainted, then this portion of the picture has lost its spatial balance with the rest.

Provenance: Haussmann Collection, Berlin; Schaeffer Galleries, New York; Henry T. and Beatrice Kneeland, Bloomfield, Conn. Given to the Wadsworth Atheneum in 1986 by Beatrice Kneeland.

Exhibitions: New York, 1942, no. 29; Northampton, 1947, no. 12.

Gift of Beatrice Kneeland in memory of Henry T. Kneeland, 1986.269

The picture, for many years in a local private collection, has seldom been exhibited or studied.[1] In 1935 Voss listed it as a pendant to a *Baptism of Christ* then in the Scholz-Forni Collection, Hamburg,[2] that subsequently entered the Kunsthalle there.[3] At Voss's 1935 writing the Atheneum picture belonged to Haussmann in Berlin,[4] and then passed to the Schaeffer Galleries, New York,[5] who mistakenly

Salvator Rosa, *The Tribute Money*

described the pendant *Baptism* in Hamburg as belonging to Voss.[6]

Both the Kunsthalle's *Baptism of Christ* and the Atheneum's *Tribute Money* are repeated in a pair of unlocated oblongs, where each composition is enlarged laterally with more landscape elements and figures. These are described on 1985 Witt Library mounts as "paper on canvas."[7] Rosa did, in fact, repeat oil on canvas compositions in oil on paper layed on canvas,[8] but the autograph status of the oblongs cannot be evaluated from the available photographs and thus the relationship of one of them to the Atheneum picture.

The theme is from Matthew 17:24–27. Although the painting of some individual figures is summary to a degree, the friezelike arrangement of the gravely posed foreground figures is very effective and speaks of Rosa's style after his return to Rome in 1649. He increasingly strove thereafter to achieve the dignified effects of Poussin's style. The central seated figure gesticulating to the right and the armored figure behind leaning upon a halberd are akin generically to the figural types and poses in Rosa's etched series of *Figurine* of the mid 1650s.[9] M.M.

1. Salerno, 1975, 98, no. 132, not illustrated.
2. Voss, 1935, 2.
3. Inv. no. 735, oil on canvas, 45.5 x 61.5 cm. Hentzen, 1969, 452, pl. 131, c. 1650–60. Salerno, 1975, 98, no. 133, illus.
4. Voss, 1935, 2.
5. The introduction of the gallery's 1942 exhibition catalogue cited above describes the exhibited works as mostly coming from a single [Haussmann?] collection.
6. New York, 1942, no. 29, an error repeated by H. T. Kneeland to H.-W. Schmidt, 30 Mar. 1954, copy in the curatorial file, where the former owner is described as Friederich Hausmann [sic], New York.
7. Photographs from the Dr. Alfred Scharf Bequest to the Witt Library.
8. *The Angel Leaving the House of Tobit*, oil on paper layed on canvas, 96 x 135 cm, Joseph McCrindle Collection, New York. See Salerno, 1963, pl. 72; 1975, 99, no. 177, repr.; Mahoney, 1977, I, 578, n. 5.
9. Bartsch, 1870, XX, nos. 35, 38, 47, 66.

After Salvator Rosa
Night Scene with Two Figures

Oil on canvas, 51.8 x 38.7 cm (20³/₈ x 15¹/₄ in.)
 Condition: good.
 Provenance: Holford Collection, Dorchester House,
London, sale London, Christie's, 15 July 1927, no. 140, bought
by Durlacher Bros. for 55 guineas. Purchased by the Wadsworth
Atheneum in 1930 from Durlacher Bros., New York, for $900
from the Sumner Fund.
 Exhibitions: Hartford, 1930, no. 43; Middletown, 1930;
Hartford, 1931, no. 37; possibly Junior League of Pittsburgh,
1934; possibly Vassar College, Poughkeepsie, 1935; Hartford,
1940, no. 14; Northampton, 1947, no. 13; New York, 1948, no.
6; Kent, 1966.
 The Ella Gallup Sumner and Mary Catlin Sumner Collection, 1930.1

The painting came from the Holford Collection,
Dorchester House, formerly in Park Lane, London.[1]

Such scenes as this were romantically interpreted
in the eighteenth and nineteenth centuries to depict
bandits and brigands, among whom Rosa was sup-
posed to have lived—just one of the dashing myths
that accrued to his memory in those centuries when
Rosa's reputation was at its highest. Like the sixty-two
Figurine, small etchings of soldiers and genre figures
of the mid 1650s, pictures such as these seem to have
no specific program. They are generalized tours de
force to display the artist's ability to generate a mood,
ambiguous and oftentimes disquieting as here.
Speaking of the *Figurine*, Wallace writes: "They do
not illustrate any text yet discovered, and as a result,
they remain elusive, furtive, implying more than they
state, evocative of a larger context which seems to
hover just beyond the range of the viewer's compre-
hension. Consequently, the *Figurine*, in general, and
the soldiers in particular have an air of mystery, con-
spiracy, and what might be called a romantic incom-
pleteness. Being incomplete, they can act as a kind of
a *tabula rasa* upon which the romantic imagination
can wander wild, fancy free, spinning out its fanta-
sies. It is not surprising, for example, that in the
eighteenth and nineteenth centuries Rosa's soldiers
were transformed into *banditti*."[2] The scene here is
not unlike the suggestive but elusive interplay of the
participants in two *Figurine*: Wallace nos. 19 and 63.[3]
However, it is not impossible nor is it improbable that
at times Rosa intended a specific content in such
compositions. For example, in the Pitti there is a
painting, similar in size and style to the Atheneum's,
generally called *"Fear"*; a peasant warns two philoso-
phers away from a dangerous road in a threatening

After Salvator Rosa, *Night Scene with Two Figures*

landscape. This, Salerno points out, is an allegory
of the superiority of simple, natural sense over
learning.[4]

Until the late 1940s the painting was exhibited
widely, and the attribution was well received.[5] But
after initially publishing it as Rosa,[6] Salerno dropped
the painting in his subsequent monograph,[7] feeling
that it could not be autograph.[8] It is, in fact, more
likely the work of a *pasticheur* who was familiar with
Rosa's technique in oils and who probably based his
conception on loosely analogous etchings in the
Figurine series.[9]
 M.M.

1. *The Holford Collection, Dorchester House*, Oxford, 1927, II, 25,
no. 140, pl. 125, with no earlier provenance cited. A second
Rosa in the Holford catalogue, *A Romantic Landscape*, no. 139, is
said to have been purchased in 1842 by Farrar from Lord
Wharncliffe's [sic for Warncliffe] collection (25). A. Paff,
Durlacher Bros., London, mistakenly informed A. E. Austin, Jr.,
18 Nov. 1929, curatorial file, the Atheneum picture had been
purchased by Buchanan in 1842 from Lord Wharncliffe [sic], a
garbled as well as erroneous provenance sometimes cited for the
picture. Hitchcock, 1930, 22–23. *Wadsworth Atheneum Bulletin*,
1933, 31. Wadsworth Atheneum, *Avery Memorial*, 1934, 31.
2. R. Wallace in Wellesley, 1979, 41.
3. Wallace, 1979, 150, 198–99.
4. Pitti, inv. no. 1101, 50 x 20 cm. Salerno, 1975, 90, no. 71,
color pl. 23.
5. McComb, 1934, 86, 126, fig. 87, as an early work. Boetzkes,
1960, 194, no. 190, with an incorrect acquisition date.
Fredericksen and Zeri, 1972, 177, 584.
6. Salerno, 1963, 143.
7. Salerno, 1975.
8. L. Salerno to M. Mahoney, 11 July 1983, curatorial file.
9. For example, nos. 19, 51, 60, 62, or 63, as illustrated in
Wallace, 1979.

Giovanni Camillo Sagrestani
(1660–1731)

Gabburri reports that Sagrestani studied with Antonio Giusti and Romolo Panfi in Florence, and that he then traveled to Rome, Venice, Parma, and Bologna, where he was a pupil of Carlo Cignani.[1] He returned to Florence at an undetermined date and remained there the rest of his life.

A considerable number of signed and dated paintings allows a general view of Sagrestani's oeuvre and the development of his style. The eight small paintings in Sta. Maria Margherita de' Ricci date from about 1708; the *Marriage of the Virgin* in S. Spirito dates to 1713; the ceiling fresco of *St. Philip Neri in Glory* in S. Firenze is dated 1714; and, among late works, the *Martyrdom of St. Andrew* in the church of Mantellate and a *Crucifixion* in S. Firenze were painted in 1726–29.[2] Sagrestani's works show above all the influence of Luca Giordano's frescoes in the Palazzo Medici-Riccardi of 1682–83;[3] he may also have learned from the works of Sebastiano Ricci, who visited Florence about 1700. He included the lives of both artists in his own unfinished *Vite*.[4] Sagrestani may have been impressed by French painting toward the end of his life; Gabburri reports that he copied engravings after Simon Vouet.[5] Sagrestani's designs for tapestries of the *Four Parts of the World* also recall the tapestry designs of Lebrun.[6]

Although attacked by classicist critics, Sagrestani's works exemplify the change in style and taste from the seventeenth to the eighteenth centuries.[7] He had several students, among them Matteo Bonechi (1672–c. 1759) and Antonio Nicola Pillori (c. 1687–1763).

1. Gabburri, 1719–41, III, 1203; see also F. Borroni Salvadori, "F. M. N. Gabburri e gli artisti contemporanei," *Annali della scuola normale superiore di Pisa*, Classe di lettere e filosofia, ser. iii, IV, no. 4, 1974, 1507.
2. See Certaldo, Palazzo Pretorio, *Arte in Val d'Elsa dal secolo XII al secolo XVIII*, 28 July–31 Oct. 1963, 120–21.
3. See A. Marabottini, "Un Piccola Problema di pittura fiorentina tardobarocca," *Quaderni dell'Istituto di Storia dell'Arte Medievale e Moderna*, 1975, I, 39–44.
4. Florence, Biblioteca Nazionale, Codice Palatino 451; see A. Matteoli, "Le Vite di artisti dei secoli XVII e XVIII di Giovanni Camillo Sagrestani," *Commentari*, XXII, 1971, fasc. ii–iii, 187–240.
5. Gabburri, 1719–41, III, 1203.
6. M. Maragnoli, "La Pittura fiorentina nel settecento," *Rivista d'arte*, VIII, 1912, 83. On the tapestry designs, see also D. Traversi, "Due 'Boscherecce' tessute nell'arazzeria medicea," *Antichità viva*, XV, no. 4, 1976, 34–37.
7. Gabburri, 1719–41, III, 1203, emphasizes that Sagrestani was dedicated to *la macchia*, and never learned the fundamental rules of painting and drawing.

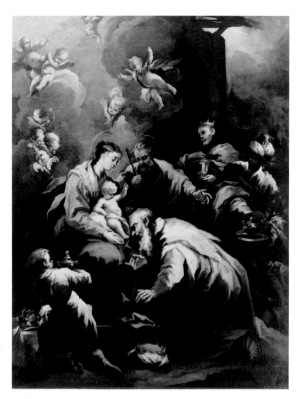

Follower of Giovanni Camillo Sagrestani,
Adoration of the Magi

Follower of Giovanni Camillo Sagrestani
Adoration of the Magi

Oil on canvas, 191.5 x 146 cm (75³/₈ x 57¹/₂ in.)
Condition: fair. There are many small losses over the surface.
Provenance: The previous history of the picture is unknown. Given to the Wadsworth Atheneum in 1911 by Herbert Randall.
Gift of Herbert Randall, 1911.23

The *Adoration of the Magi* was attributed to Luca Giordano by George H. Story when it was given to the Atheneum. Further attributions included those to G. B. Pittoni[1] and Matteo Bonechi.[2] M. Gregori suggested another of Sagrestani's pupils, Antonio Nicola Pillori.[3] The attribution to a follower of Sagrestani seems reasonable pending the clarification of Bonechi's and Pillori's oeuvres. J.C.

1. F. Richardson, letter to E. Turner, 13 Oct. 1958, curatorial file.
2. R. Longhi, letter to C. Cunningham, 22 Mar. 1960, curatorial file, and F. Zeri, letter to C. Cunningham, 5 Mar. 1962, curatorial file.
3. M. Gregori, letter to C. Cunningham, 6 June 1964, curatorial file; oral communication, 29 Nov. 1983. See also Florence, Palazzo Strozzi, *Settanta pitture e sculture del '600 e '700 fiorentino*, Oct. 1965, 61, no. 43, exh. cat. by M. Gregori.

Carlo Saraceni
(c. 1579–1620)

Formed in the tradition of Jacopo Bassano, Romanino, and Savoldo in his native Venice—hence he was also called Carlo Veneziano—Saraceni moved to Rome about 1598, attracted to all the current, if contradictory, styles there: the late mannerism of the Cavaliere d'Arpino, the nascent classicism of Annibale Carracci and his followers, as well as the naturalistic works of Adam Elsheimer. In the first decade of the century, Saraceni painted small-scale religious and biblical subjects set in and dominated by naturalistic landscapes. As Ottani Cavina points out, such works, demonstrating the northern mentality of the *petit-maître* so alien to the Italian tradition, led to Saraceni's becoming a focus for northern artists in Rome, particularly a group of Frenchmen: Jean le Clerc, Guy François, the Pensionante del Saraceni, and Philippe Quantin. In fact, some scholars argue that the Atheneum picture below is by one of these associates: Guy François. Although cited as a Caravaggio follower as early as 1606, it was only in the second decade of the century that Saraceni became an affecting and eloquent participant in the then current Roman revival of Caravaggio's chiaroscuro style of religious painting. Called to Venice in 1619, Saraceni died there in 1620.[1]

1. A. Ottani Cavina in New York, 1985, 188.

Carlo Saraceni or Guy François
The Holy Family in St. Joseph's Workshop

Oil on canvas, 113.3 x 84.3 cm (44⅝ x 33³/₁₆ in.)
 Condition: good. There are minor damages on the Madonna's skirt and minor spot losses throughout. A right-angled tear to the right of the plane among the tools on the shelf has been repaired. There is what might be a pentimento on the left hand of the angel in the lower right foreground.
 Provenance: M. A. Dehaspe. Purchased by the Wadsworth Atheneum in 1963 from Frederick Mont, New York, for $57,000 from the Sumner Fund.
 Exhibitions: Cleveland, 1971–72, no. 60; Paris, 1982, no. 29.
 The Ella Gallup Sumner and Mary Catlin Sumner Collection, 1963.496

The painting was acquired in 1963 as Saraceni[1] and figures prominently in Ottani Cavina's 1968 oeuvre catalogue of the artist as a work done in Rome slightly after 1615 in a stylistic phase distinct from his earlier Roman development as a painter principally of small-scale works under the influence of Adam Elsheimer.[2] Ottani described the Atheneum picture as one of the most beautiful paintings of the early seventeenth century by an artist at the zenith of his powers,[3] a work where Caravaggesque naturalism as well as the academic norms of the period are both tempered by this Venetian-born painter's mood of poetic innocence.

In sentiment and theme the picture is analogous to the *Madonna and Child with St. Anne* in the Galleria Nazionale d'Arte Antica (Palazzo Barberini), Rome, a painting designed for a Roman chapel whose reconstruction began in 1610.[4] Yet the clarity of light and the crisp description of form, drapery, and still life here have overall affinities to what is presumed to be a later work, *The Ecstasy of St. Francis*, mentioned in the artist's will,[5] and known in two accepted versions, one in Munich[6] and the other in the Redentore, Venice.[7] Because of its closeness to the two latter, Spear suggested an advanced date in the artist's brief career for the Atheneum picture, 1615–20.[8] Both Nicolson and Volpe supported the attribution to Saraceni, the latter endorsing a date circa 1615.[9] Bissell did not challenge the attribution,[10] which is accepted by Fredericksen and Zeri[11] as well as by Pallucchini.[12]

Yet from the moment of its first appearance, the attribution to Saraceni drifted toward the circle of Saraceni's French followers who grouped themselves around the francophile master in Rome. The work of the most Caravaggesque of these was first reconstructed by Longhi, who genially dubbed this otherwise anonymous figure the "Pensionante del Saraceni," Saraceni's lodger.[13] Moir thought the Atheneum painting to be by another such associate, Jean le Clerc, who was with Saraceni when he died of the plague in Venice in 1620.[14] More recently, French scholars have proposed the picture is by yet a third French follower of Saraceni, Guy François (before 1580–1650), who was in Rome by 1608, where he seems to have been particularly impressed by the work of Guido Reni and Saraceni before he returned by 1613 to his native Le Puy-en-Velay, in the Auvergne, to remain in the south of France thereafter.[15]

Rosenberg noted close thematic (the head of Joseph), stylistic, and spatial correspondences between the Atheneum work and a *Holy Family with St. John the Baptist* acquired in 1969 for the museum in Brest and attributed to Saraceni. The difference in quality that seems to be apparent in comparing photographs of the Brest and Atheneum pictures is perhaps owing to what Rosenberg describes as the indifferent state of the painting in Brest.[16] In her catalogue of the 1974 Guy François exhibition in Le Puy, Pérez wrote that the Atheneum picture seemed to stand outside Saraceni's oeuvre, yet did not show clear affinities with the work of the French master, except for the facial type of the Virgin and the picture's marked concern for anecdotal detail.[17] Pérez thereafter felt the question of François's Italian activity, and specifically the attribution of the Atheneum and Brest pictures moot.[18] Cuzin and Rosenberg identified the former owner of the Atheneum picture, M. A. Dehaspe, who said it came from the region of Le Puy. This plus the argued resemblance of the Atheneum picture to a Saracenesque oval fragment of a *Madonna and Child with Two Saints* (or donors?) in a private collection in Le Puy, given to Guy François and dated on the verso 1615, led those authors to attribute the Atheneum picture to the

Carlo Saraceni or Guy François, *The Holy Family
in St. Joseph's Workshop*

same artist.[19] The 1615 fragment is reported to be badly preserved and seems, in reproduction, to be a less telling comparison than the *St. Bonaventura in His Study* in Noyon, which, if Pérez has attributed it correctly to Guy François, certainly keeps alive the question of attributing both the Corsini *St. Cecilia* and the Atheneum picture to the same master.[20] Pérez illustrated a *Penitent St. Magdalen* she gives to Guy François in a Paris private collection that is similarly important in discussing these pictures,[21] as is the *Martyrdom of St. Cecilia* in the Manning Collection, New York, given by Spike to Saraceni,[22] plus the *St. Leocadia in Prison* in the cathedral of Toledo,[23] and the *Penitent Magdalen Praying* in the Lemme Collection, Rome, given by Marini to Saraceni.[24] Pettex Sabarot listed the Atheneum picture as Guy François.[25] Rosenberg so exhibited the work in the 1982 Paris/ America seventeenth-century French painting exhibition with some trepidation,[26] but he stands by his attribution,[27] as does Cuzin.[28] The Italian attribution is not without new defenders, such as Ficacci in his Guy François monograph,[29] as well as long-standing adherents to the traditional attribution.[30] M.M.

1. *Wadsworth Atheneum Bulletin*, Spring 1964, 23. Shapley, 1979, I, 112, "Saraceni's masterpiece."
2. Ottani Cavina, 1968, 103, no. 20. The date contrasts to the unargued proposal of circa 1608 that appeared when the acquisition was twice listed in the *Art Quarterly*, XXVII, 1964, 109, 206, repr. 209. Another early reference is Paoletti, 1968, 425, fig. 5.
3. Ottani Cavina, 1968, 48–49.
4. Ottani Cavina, 1968, 114, no. 58, pl. 75.
5. Ottani Cavina, 1968, 90–91.
6. Alte Pinakothek, inv. no. 113. Ottani Cavina, 1968, 107, no. 36, fig. 105.
7. Ottani Cavina, 1968, 125, no. 86, figs. 106–8.
8. In Cleveland, 1971–72, 160–61, no. 60, and 1975 rev. ed., 160–61, no. 60. Nicolson, too, preferred a date at the end of the second decade of the century, and "therefore out of the reach of Guy François," see below, who had returned to France by 1613 (1974, 612, n. 25).
9. Nicolson, 1970, 312; 1979, 87. Volpe, 1972, 73, and acknowledged by Spear, 1972, 158, and repeated in Cleveland, 1975 rev. ed., 229.
10. Bissell, 1971, 248.
11. Fredericksen and Zeri, 1972, 183, 276, 585.
12. Pallucchini, 1981, I, 93, II, fig. 239.
13. Longhi, *"Ultimi studi,"* 1943, 23–24. For a recent summary of thinking regarding the Pensionante del Saraceni, see J. Spike in New York, 1983, 48–49.
14. Moir, 1967, II, 135, a view rejected by Spear in Cleveland, 1971–72, no. 60, and mentioned by Enggass, 1973, 461.
15. A. Brejon de Lavergnée, and J.-P. Cuzin in Rome, *I Caravaggeschi*, 1973–74, summarize the biography (32–33). Under their controversial presentation of the Palazzo Corsini *St. Cecilia and the Angel* as a work by Guy François (34–37, figs. 35 and 37), an attribution put forward by Rosenberg, they report the same authority's cautious opinion that the Atheneum picture is a Roman work by François, an idea reinforced by its provenance from Le Puy (36). The Atheneum picture is mentioned as a source for the Pensionante's style (75). [Page references are to the Italian edition of the catalogue.]
16. Inv. no. 70.1.1, 126.5 x 88 cm. Rosenberg, 1971, 107, fig. 2. P. Rosenberg in Paris, *Brest*, 1974–75, 21, no. 14, repr.
17. Le Puy, 1974, 25–26.
18. Pérez, 1974, 472, n. 6.
19. P. Rosenberg in Paris, *Brest*, 1974–75, no. 14. Cuzin and Rosenberg, 1978, 193–94, the fragment is fig. 18; Dehaspe speaks of the Atheneum picture's coming from a region "au sud de l'Ardèche," letter of 3 Jan. 1975 (196, n. 24). The latter information thus supersedes Nicolson's claim there was no evidence the Atheneum picture comes from the region of Le Puy (1974, 612, n. 25). Pérez suggests the date on the verso of the oval fragment might be eighteenth-century (Le Puy, 1974, 140, no. 44).
20. Pérez, 1975, 223–24, fig. 2, and where the Atheneum picture (fig. 3) is referred to as "attributed to Saraceni."
21. Alluded to by Cuzin and Rosenberg, 1978, 196, n. 23. Pérez, 1981, 80, fig. 3 on 79; the Atheneum picture is cited on 81.
22. Princeton, 1980, no. 43, illus., in Spike's opinion, close to Saraceni's 1606 *Rest on the Flight into Egypt* in Frascati. Waddingham, 1985, 219–24, published what he suggests is a more successfully resolved version of the Manning *Martyrdom of St. Cecilia*.
23. Madrid, 1970, no. 170, illus.
24. Marini, *Artibus*, 1981, fig. 13.
25. Pettex Sabarot, 1979, 424.
26. Paris, 1982, English ed., 21, 53, 246–47, no. 29. Goldstein, 1982, 330. Rosenberg also advanced the Guy François attribution tentatively in his essay "Longhi e il seicento francese," in Previtali, 1982, 215, fig. 28.
27. Rosenberg, 1982, 24, n. 8, 25, n. 11.
28. Cuzin, 1982, 529.
29. Ficacci, 1980, 17, 26, n. 15, fig. 5.
30. A. Ottani Cavina verbally to M. Mahoney, July 1983. Wright, 1985, 184, speaks of the Atheneum's picture as a disputed attribution, for the work "seems characteristic of both artists."

Ippolito Scarsella, called Lo Scarsellino (c. 1551–1620)

In his *Vite de' pittori e scultori ferraresi*, Girolamo Baruffaldi (1675–1753), writing in the early eighteenth century, reports Scarsellino's birth date as 1551.[1] Although no documents to corroborate Baruffaldi have come to light, this date accords well with evidence surviving for Scarsellino's later career. According again to Baruffaldi, Scarsellino was sent at seventeen to Bologna, where he reportedly spent twenty-two months studying "the famous works of that school, especially the miracles of the Carracci and other important teachers."[2] From Bologna Scarsellino went to Venice, where his father, the painter Sigismondo Scarsella, had studied with Veronese and where the younger painter too entered his shop and remained about four years.[3] All told, Scarsellino spent five years and ten months away from Ferrara,[4] returning to his native city in about 1574. He was, according to Baruffaldi, immediately busy with important

commissions in Ferrara for local churches and the ruling Este family; he also sent works to Modena, Mantua, Rome, and other cities.[5]

Except for a trip to Venice, which is undocumented but related by Baruffaldi,[6] Scarsellino seems to have remained in Ferrara for the rest of his career. He died 23 October 1620.[7]

While numerous works are attributed to Scarsellino through documents and contemporary or later literature, his oeuvre has been clarified primarily through analysis of style.[8] The problem of his chronology is particularly vexed, as few securely dated paintings exist that can be used as reference points. Those that are include the *Crucifixion*, dated 1600, in the monastery of Corpus Domini in Ferrara[9] and the *Holy Family with Saints Barbara and Carlo Borromeo* in the Gemäldegalerie in Dresden, painted for Duke Cesare d'Este in 1615.[10]

Other paintings for which circumstantial evidence exists include the small *Holy Family* in the Borghese Gallery, in 1592 mentioned in an inventory of Lucrezia d'Este;[11] the ceiling decorations, now in Modena, painted between 1592 and 1593 for the Palazzo dei Diamanti in Ferrara;[12] the *Saints Peter and Paul* in Copparo, datable to 1594, the year in which the church was consecrated;[13] and the fresco of the *Rape of Elias* in the apse of S. Paolo in Ferrara, generally dated to 1595–96, based on a contract published by Baruffaldi,[14] but perhaps finished by 1592, as proposed by Novelli.[15] The testament of early sources has provided dates for the following works: the eight small panels with the *Story of Job*, now in Hannover, dated 1600 by Baruffaldi, which formed part of a frame for a picture of Job by the sixteenth-century painter Panetti in S. Giobbe, Ferrara;[16] the *Martyrdom of St. Margaret* in the Istituto della Provvidenza in Ferrara, painted for Margherita Gonzaga in 1604 according to Guarini;[17] the *Last Supper* in Gualdo, formerly in the refectory of S. Guglielmo in Ferrara, said by Brisighella to have been painted in 1605;[18] and the *Adoration of the Eucharist* in the church of Sta. Chiara della Cappuccine in Ferrara, datable to 1609, according to Guarini, the year in which the church was consecrated.[19]

Within this framework, a picture of Scarsellino's career has emerged. It is generally thought that his early works were influenced by the late sixteenth-century decorative style of his older Ferrarese contemporaries Bastianino and Bastarolo, but tempered already by awareness of the works by sixteenth-century artists Dosso Dossi and Parmigianino.[20] Scarsellino's immersion in Dosso was remarkable enough to have been noted by his contemporaries, who called him a "modern Dosso."[21] Scarsellino's four-year apprenticeship in Venice was crucial for its exposure to a still viable tradition of naturalism formulated in the early years of the sixteenth-century. Scarsellino's approximation of Venetian style, particularly of Veronese, was also noted by contemporaries, who called him, according to Baruffaldi, "Paolo de' Ferraresi."[22] In the 1580s his style, informed by Venetian naturalism, parallels that of the Carracci in Bologna. Scarsellino surely had contact with them through their joint contributions to the Palazzo dei Diamanti decorations in 1592–93.[23] Scarsellino's mature style of the 1590s differs, however, from that of the Carracci in appearance and in fundamental novelty; while Annibale's naturalism signals the new idiom of the baroque, Scarsellino's remains an intelligent but more superficial revitalization of late sixteenth-century forms.[24] The *Crucifixion* of 1600 shows the large forms and vital brushwork characteristic of his style, but in format and tenor of emotion it is reminiscent of Counter-Reformation images by such artists as Bastarolo.[25] Scarsellino's works of the first two decades of the seventeenth century continue to refer to—and sometimes even depend on—Venetian art of the sixteenth century; at the same time, his imitation of mature works by the Carracci, particularly Ludovico, active in Bologna until his death in 1619, and of the more fully baroque works of his slightly younger contemporary Carlo Bononi, is evident in his late work, such as the *Holy Family* of 1615.[26]

The example of Scarsellino was important to the work of emerging artists of the next generation, particularly Guercino, as has been clarified by Mahon.[27]

1. Baruffaldi, 1846, II, 66. Baruffaldi's manuscript was written between about 1702 and 1722; see note on 24.
2. Baruffaldi, 1846, II, 67–68. As Boschini points out (68, n. 1), it is unlikely that Scarsellino could have seen many works by the Carracci in the late 1560s, as their earliest works date to about a decade later.
3. Baruffaldi, 1846, II, 57, 67–68.
4. Baruffaldi, 1846, II, 68.
5. Baruffaldi, 1846, II, 69. Novelli, 1964 ed., 5–6, notes that Scarsellino was well known in his lifetime and cites references to the painter by G. C. Gigli in 1615 and G. C. Mancini in 1619–21.
6. Baruffaldi, 1846, II, 85. C. Volpe in Bologna, 1959, 240, has proposed that Scarsellino also traveled as far as Cremona and Brescia.
7. Although Baruffaldi, 1846, II, 103, says he died in 1621, his epitaph gives the date as 1620; see note on 104 for a transcription; see also Novelli, 1964 ed., 26.
8. Novelli, 1964 ed., has made the most thorough contribution; but see also Volpe in Bologna, 1959, 238–48; Freedberg, 1971, 397–99; and Washington, 1986–87, 196–200.
9. Novelli, 1964 ed., 33, no. 61, fig. 34.
10. Novelli, 1964 ed., 29, no. 23, fig. 51.
11. Novelli, 1964 ed., 40, no. 152, pl. V.
12. Novelli, 1964 ed., 37, nos. 120–22, figs. 15 a–b; see also Novelli, 1955, fig. 25.
13. Novelli, 1964 ed., 28, no. 20; repr. in 1955, fig. 26.
14. Baruffaldi, 1846, II, 72–73.
15. Novelli, 1964 ed., 32, no. 51, pls. IX, X.
16. Baruffaldi, 1844, I, 193; Novelli, 1964 ed., 34, nos. 81–88, figs. 29–30, pls. XIII–XIV.
17. M. Guarini, *Compendio historico dell'origine, accrescimento, e prerogative delle chiese . . . di Ferrara*, Ferrara, 1621, as cited in Novelli, 1964 ed., 33, no. 59, fig. 35.
18. C. Brisighella, "Descrizione delle pitture e sculture che adornano le chiese, et oratori della città di Ferrara," Bologna, Biblioteca Comunale, MS B. 175, 180, as cited in Novelli, 1964 ed., 34–35, no. 89, fig. 36.
19. Guarini, 1621, 167, as cited in Novelli, 1964 ed., 30, no. 36, pl. XVI.
20. It has not been fully explained how and why Scarsellino should have turned to these older artists, especially Dosso; it is noteworthy, however, that Annibale Carracci engaged in the same creative retrospection, particularly of Correggio's paintings, at approximately the same time; see Posner, *Carracci*, 1971, I, 25–34.
21. G. C. Gigli, *La Pittura trionfante*, Venice, 1615, 24, as cited in Novelli, 1964 ed., 6.
22. Baruffaldi, 1846, II, 69.
23. Posner, *Carracci*, 1971, II, 28, no. 65, pl. 65.
24. On Scarsellino's relation to the Carracci, see C. Volpe in Bologna, 1959, 239; Novelli, 1964 ed., 8; Freedberg, 1971, 398–99.
25. Frabetti, 1972, 22, 55–56, no. 72, fig. 36.
26. Bologna, 1959, 240; Novelli, 1964 ed., 19.
27. D. Mahon, "Notes on the Young Guercino. I.—Cento and Ferrara," *Burlington Magazine*, LXX, 1937, 183–84.

Fame Conquering Time

Oil on canvas, 171 x 131 cm (67³/₈ x 51¹/₂ in.)
 Condition: good.
 Provenance: unknown private collection; bought by the Wadsworth Atheneum in 1985 from Matthiesen Fine Art, London.
 Exhibitions: London, *From Borso to Cesare d'Este*, 1984, 101, no. 56; Washington, 1986–87, 200, no. 75.
 The Ella Gallup Sumner and Mary Catlin Sumner Collection, 1985.50

The winged figure of Fame soars over the cowering figure of Time, who clutches an hourglass. The figures, easily recognizable from their attributes, convey the notion that the fame of deeds endures beyond a single lifetime.[1]

Fame Conquering Time is one of few allegories by Scarsellino to survive.[2] And yet we know he must have painted many of them; Baruffaldi describes an elaborate allegory of Ferrara extending her hand to the River Po, painted in chiaroscuro and placed above a triumphal arch erected for the entrance of Pope Clement VIII into Ferrara in 1598.[3] The Atheneum picture, undoubtedly painted for a private collector, is not cited in any of the contemporary literature or later guidebooks of Ferrara.

The attribution of *Fame Conquering Time* to Scarsellino seems beyond question, however. His characteristic palette, figure types, and facture are evident in the painting. It is more difficult to assign a date, especially in view of Scarsellino's obscure chronology. The large, full forms and the confident handling suggest a date of at least 1600, when Scarsellino's mature style had been formed, as evident in the *Crucifixion* in Ferrara, dated 1600. And yet there is not yet the monumentality of form and pronounced chiaroscuro of works such as the *Holy Family* in Dresden of 1615, which may show the influence of Ludovico Carracci and Bononi. The decidedly Venetian flavor of *Fame Conquering Time* may provide a clue, however; the figure strikingly silhouetted against a luminous sky, and her voluminous, freely brushed drapery are akin to works by Veronese and Tintoretto.[4] Although Scarsellino's debt to Venetian painting is a constant in his style throughout his career, he was perhaps more than ordinarily aware of it in the decade between 1600 and 1610, as, for example, in the *Martyrdom of St. Margaret* of 1604, which Novelli has shown to be directly dependent on a picture by Veronese,[5] or the *Last Supper* in Gualdo, datable to 1605, in which the light effects are strongly reminiscent of Tintoretto and Bassano.[6] It was perhaps at this time that Scarsellino returned to Venice for an extended visit, as related by Baruffaldi.[7] A tentative date between 1600 and 1610 may be proposed for *Fame Conquering Time*, although the possibility of a later date may be entertained.[8] J.C.

1. Ripa, 1603, 142–43, describes Fame as a winged figure of a woman in fluttering draperies, holding a trumpet. Time was generally depicted as an old man with a variety of attributes, one of which is an hourglass. See also van Marle, *L'Iconographie de l'art profane*, 1932, II, 171–73, 175–76.
2. The decorative works for a ceiling in the Palazzo dei Diamanti included an allegory of *Fame*, now in the Galleria Estense, Modena; see Novelli, 1964 ed., 37, no. 121, fig. 15b.
3. Baruffaldi, II, 1846, 75; also cited by A. Faustini, *Aggiunte alle historie del Sig. Gasparo Sardi*, Ferrara, 1646, IV, 163, V, 22, 36, as cited in Novelli, 1955, 88.
4. Although no works can be proposed as specific models, Veronese's *Perseus and Andromeda* in the Musée des Beaux-Arts in Rennes shows a dramatically silhouetted figure similar to Scarsellino's Fame; see Pignatti, 1976, I, 203–4, no. A262, II, fig. 942.
5. Novelli, 1964 ed., 33, no. 59, fig. 35, has noted Scarsellino's dependence on Veronese's *Martyrdom of St. Afra* in the church of S. Eufemia, Brescia; see Pignatti, 1976, I, 173, no. A33, II, fig. 745.
6. Novelli, 1964 ed., 34–35, no. 89, fig. 36.
7. Baruffaldi, 1846, II, 85.
8. London, *From Borso to Cesare d'Este*, 1984, 101; and Washington, 1986–87, 200, suggest a date of between 1610 and 1620.

Francesco Solimena (1657–1747)

Trained by his father, Angelo, in the South Italian naturalistic tradition, Solimena arrived in Naples in 1674, where he particularly responded to the work of Luca Giordano and Mattia Preti as well as such imported influences as those of Giovanni Lanfranco and Pietro da Cortona. By the 1680s he had distilled from all these sources his individual baroque manner, whose firmly constructed forms and whose palette, warmed by intense chiaroscuro, stood in contrast to the animation and light of Luca Giordano's style. Giordano's place as the principal painter in Naples was taken by Solimena in the 1690s, after Giordano's departure for Spain. A trip to Rome in 1700 brought Solimena into direct contact with the late baroque classicism of Carlo Maratti. By the beginning of the new century, Solimena's reputation was an international one. He dominated Neapolitan painting until the mid eighteenth century.[1]

1. I. Maietta in London, *Paintings in Naples*, 1982, 245–46.

The Roman Senators Anicus and Tertullus Entrusting Their Sons, Maurus and Placidus, to St. Benedict

Oil on canvas, 76.5 x 153.8 cm (30¹/₈ x 60⁹/₁₆ in.)
 Condition: fair. Numerous minor pinpoint retouchings throughout.
 Provenance: The previous history of the picture is unknown. Purchased by the Wadsworth Atheneum in 1937 from Arnold Seligmann, Rey & Co., New York, for $500 from the Sumner Fund.
 Exhibitions: Kent, 1966.
 The Ella Gallup Sumner and Mary Catlin Sumner Collection, 1937.4

The painting is in some way related to one of Solimena's now destroyed contributions to the decoration of the cathedral in the abbey of Monte Cassino, founded in the sixth century by St. Benedict and subsequently regarded as the parent institution of the

Scarsellino, *Fame Conquering Time*

Francesco Solimena, *The Roman Senators Anicus and
Tertullus Entrusting Their Sons, Maurus and Placidus,
to St. Benedict*

Benedictine order. It was here that Benedict promulgated his rule that gave Western monasticism its definite form.[1] For the choir walls beyond the high altar Solimena designed four very large works, oils on canvas, depicting a prominent episode from Benedict's early ministry in Subiaco, another later at Monte Cassino, and two subsequent events in the history of the order:

1. first to the right of the high altar: Ratchis, king of the Longobards, his wife, Tasia, and his daughter Ratrude invested by Pope St. Zaccaria with the Benedictine habit;

2. second to the right: the miracles of St. Maurus in France;

3. first to the left: Anicus and Tertullus entrusting their sons, Maurus and Placidus, to St. Benedict;

4. second to the left: the martyrdom in Sicily of St. Placidus, his sister St. Flavia, and his two brothers by Saracen pirates.[2]

The scope of this undertaking, itself but one portion of Solimena's work at Monte Cassino, led Bologna to speculate that all the artist's work at the abbey progressed very slowly, spanning from about 1697 to 1707, and with much studio assistance.[3] All were lost in the Allied bombardment of February 1944, when the abbey was effectively completely destroyed. In old architectural photographs of the cathedral's interior, one can glimpse a small portion of the series and thus estimate the original pictures to have been each on the order of two meters high.[4]

However, a complete record of the four compositions survives in four canvases ascribed in the 1812 Esterházy catalogue to Solimena and now in the Budapest Museum.[5] Each measures 75 by 153 centimeters. The Atheneum picture measures 76.5 by 153.8 centimeters, and thus is obviously connected with its counterpart (53.492) in the Budapest set. As far as one can judge from photographs, the compositional differences between the two are negligible—variations in the silhouettes of trees and the shapes of clouds, for example.

Bologna, who had available for consideration only two of the Budapest set—*St. Maurus in France* and *St. Placidus Martyred*—thought them *bozzetti* for the destroyed originals.[6] In addition, Bologna similarly accepted as *bozzetti* two further repetitions in Toulon: *St. Maurus in France* and *King Ratchis*, respectively 77 by 156 centimeters and 77 by 136 centimeters.[7] Pigler thought the Toulon works inferior to the Budapest set, which he, too, described as sketches for the Monte Cassino ensemble, reversing his earlier opinion that the Budapest set were workshop products.[8] From an old photograph, Bologna knew a third *Anicus, Tertullus, and Sons*, which he judged to be a copy. This may or may not be the Hartford picture,

which appeared in the late 1930s.[9]

The location of the original in the cathedral, skied, high to the left of the viewer, must have enhanced the spatial effect of this complicated but very controlled processional composition. Also, the artist's typical play of light against dark, reddened hues must have added vivacity to the already dramatic parade. The red bolus ground of the Atheneum picture has become very prominent and the pigments have much darkened, diminishing its impact. Yet, from photographs, the Budapest set and the two Toulon works seem no more animated in the treatment of light or the handling of brush. Thus it would seem prudent to reserve judgment regarding their relative merits. Fredericksen and Zeri list the Hartford picture as autograph.[10] Spinosa, with some justification, called it workshop.[11] It is, in fact, an unprepossessing work. The brushwork and the chromatic lights that are meant to flicker animatedly across the composition are listless, speaking of a facile studio assistant's turning out reductions of a popular theme.

Because of the importance of Monte Cassino to the Benedictine order and later communities that observed the Benedictine rule, it is not surprising that the Monte Cassino pictures were replicated. And as monastic orders enjoyed a great resurgence in Catholic southern Germany and Austria in the late seventeenth and early eighteenth centuries, after the Ottoman expansion into Europe had been definitively turned back at the battle of Vienna in 1683, it is similarly not surprising to find such replicas in southern Germany and Austria. In addition to the above-mentioned Esterházy set, there is a further version of *Anicus, Tertullus, and Sons* in the Romanesque abbey of Heiligenkreuz, near Vienna, in the Wienerwald. This Cistercian foundation—Cistercians being a reformed branch of the Benedictines—had been sacked by the Turks and was elaborately redecorated in the early eighteenth century.[12] The quality of the Heiligenkreuz version is again impossible to assess from reproductions, but it surely is an adaptation from the original composition. The left third of the composition is cut off. The picture terminates on the left with the mounted rider and the figures immediately beneath have been altered from the original composition so that the male figure sprawling elegantly in the foreground could still be included. It is this version's mistaken title, *Benedict Welcoming King Totila to Monte Cassino*—clearly a confusion with the *King Ratchis and St. Zaccaria* of the Monte Cassino series—that led to the Hartford picture's being similarly entitled *Visit of the Gothic King Totila to St. Benedict*.[13]

It is logical to expect *bozzetti* and *modelli* to have been developed by Solimena for such an important and huge commission. Logically, it is very likely, as

well, given the prominence of the series, that replicas, autograph or studio, would have been made, too. Spinelli published a third *bozzetto* of the Ratchis composition that has survived at the reconstructed Monte Cassino, but, again judging from his reproduction, the quality does not suggest it is Solimena's autograph first idea.[14]

The scene in the Atheneum painting depicts an episode in Benedict's early career, at Subiaco, where he founded his first twelve monasteries and where he attracted his first followers. Two men of high rank, as the elaborate attendance indicates, are arriving in Subiaco from Rome: Senators Anicus and Tertullus with their sons, Maurus and Placidus, whom their fathers here entrust to Benedict to educate. Maurus was eleven and presumably can be identified with the kneeling youth seen from the rear. Placidus was five to seven and is probably the small, inattentive boy behind the two kneeling senators. As two of the other scenes in the Monte Cassino choir series indicate, each child was to distinguish himself in the order of their mentor.[15] Legend has it that Placidus was sent to establish monasteries in Sicily, where he was martyred, while the tradition is that Maurus went to France in 543 for a similar purpose and with greater success. Maurus is the patron saint of the charcoal burners and is invoked against the gout. The seventeenth-century Benedictine reform congregation, the Maurists, was named after him. M.M.

1. Jameson, 1852, 7–24.
2. *Descrizione*, 1751, 76. Caravita, 1870, III, 370–71.
3. Bologna, *Solimena*, 1958, 109–10, 285.
4. For example, Alinari photo no. 11457 or Spinelli, 1982, 156, fig. 114.
5. Pigler, 1968, 651–53: *King Ratchis*, inv. no. 53.493; *St. Maurus in France*, inv. no. 542; *Anicus, Tertullus, and Sons*, inv. no. 53.492, repr. pl. 129; *St. Placidus Martyred*, inv. no. 522. As Pigler explains, the Esterházy ensemble became separated for a time and thus only two (522 and 542) were available for inclusion in the 1954 Hungarian edition of his museum catalogue.
6. Bologna, *Solimena*, 1958, 249. For his Budapest inv. nos. 522 and 523, read correctly 542 and 522.
7. Bologna, *Solimena*, 1958, 109, figs. 146 and 147. *Ratchis* (as *The Abdication of Charles V*), inv. no. 956.38.1; *Maurus* (as *St. Benedict Curing the Sick*), inv. no. 956.38.2, both gifts of Captain Granet in 1850 (C. Cordina-Etienne to M. Mahoney, 1983, curatorial file).
8. Pigler, 1968, 652, under no. 53.493. Pigler, 1923–26, 225 and xi.
9. Bologna, *Solimena*, 1958, 110. The painting arrived in Hartford by mid May 1936 but was purchased only in May 1937.
10. Fredericksen and Zeri, 1972, 190, 378, 584, as *St. Benedict and Totila*.
11. N. Spinosa, oral communication, 19 Mar. 1979, memorandum in curatorial file.
12. Frey and Grossman, 1926, 193, no. 76, oil on canvas, 73 x 98 cm, pl. 146. Formerly attributed to Martino Altomonte.
13. Seligmann & Rey called the picture *The Foundation of the Dominican Monastery of Monte Cassino*. It was Suida, when connecting the picture with that at Heiligenkreuz, who called it *St. Benedict Receives King Totila* (W. Suida to C. Cunningham, 21 Dec. 1946, curatorial file).
14. Spinelli, 1982, 166–67, color pl. 125.
15. Jameson, 1852, 40–44.

Giovanni Paolo Castelli, called Spadino (1659–1703)

Confusing biographical references, imprecise attributions, and art historical speculations based upon both have obscured this artist's oeuvre and career until recently.[1] He was active in Florence in the late 1680s and thereafter resident in Rome. His contact with Flemish and Dutch painters also resident there presumably accounts for the palpable northern flavor of his work.[2] His brother Bartolomeo (1641–1686) and Giovanni Paolo's son of the same name (1676–1738) were also still-life painters and it is reasonable to assume that Giovanni Paolo collaborated with each, although their separate hands are yet to be fully distinguished.[3] Such was the lack of precise knowledge regarding this family and late seventeenth-century Roman still-life painters in general, that in the nineteenth century small still lifes were referred to generically as "Spadinos."[4]

1. O. Michel, 1978, with an extensive bibliography, wherein are fully cited the major contributions regarding the reconstruction of his oeuvre not otherwise mentioned here: Incisa della Rochetta, 1954; Mortari, 1959; Zeri, 1959; Bottari, 1964; Faldi, 1964. See the equally valuable G. Michel, 1976–78/1978–80. See Salerno, *Natura morta*, 1984, 256–69, nos. 73.1–7 for illustrative works, especially the Capitoline *Still Life*, signed and dated 1703 (no. 73.20).
2. His godfather was the Fleming Johann Hermans; his brother Bartolomeo had contacts with Adrian Honing, and for a time Abraham Brughel lived nearby (O. Michel, 1978, 727; G. Michel, 1976–78/1978–80, 28–30; Röthlisberger, 1964, 16–18). Salerno points out Abraham Brughel's and Spadino's works are easily confused (*Natura morta*, 1984, 266).
3. For example, four still lifes in the Spada Collection identified by Zeri with old inventory attributions to "Spadino" (Zeri, 1954, 128–29, figs. 174–77) are to be grouped, according to Bologna, with two works known to him in Rome, both initialed "B. S." and on the reverse of one inscribed "di Bartolomeo Spadino" (F. Bologna in Bergamo, 1968, in the discussion of pl. 48). Zani misleadingly spoke of there being two artists named Spadino, but the research of the Michels reveals there were three. The elder Bartolomeo is even called Spadino in documents, the surname first adopted in favor of Castelli by Giovanni Paolo, and one that became accepted usage by the younger Bartolomeo (G. Michel, 1976–78/1978–80, 27). Hence, O. Michel suggests the group defined by Bologna are works of the latter (1978, 726).
4. G. Michel, 1976–78/1978–80, 19.

Spadino, *Still Life of Fruit with Pomegranates and a Large Glass Compote*

Spadino, *Still Life of Fruit beneath a Large Cluster of Grapes*

Still Life of Fruit with Pomegranates and a Large Glass Compote

Oil on canvas, 65.5 x 50 cm (25^{13}/16 x 19^{11}/16 in.)

Still Life of Fruit beneath a Large Cluster of Grapes

Oil on canvas, 64.4 x 49.3 cm (25^3/8 x 19^3/8 in.)
Condition: both good. In 1951.162, green leaves at the top have blanched and the lower left grapes have become transparent.
Provenance: The previous history of the pictures is unknown. Bequeathed to the Wadsworth Atheneum in 1951 by Mrs. Charles Beach.
Exhibitions: Westport, 1958, no. 23, 1951.161 as Pace; Allentown, 1959–60, nos. 18 and 19, 1951.161 and 1951.162 as Michelangelo di Campidoglio; New Orleans, 1962–63, no. 43, 1951.161 as Michelangelo Pace; Kent, 1968, 1951.162 as Spadino.
Bequest of Mrs. Charles Beach, 1951.161 (*Still Life of Fruit with Pomegranates and a Large Glass Compote*); 1951.162 (*Still Life of Fruit beneath a Large Cluster of Grapes*)

The pair was accessioned as the work of the mid seventeenth-century Roman Michele Pace, called Michelangelo di Campidoglio.[1] Longhi first proposed they were by a later Roman master active in the 1670s.[2] Bottari identified the hand as indisputably Spadino's, in his late phase, comparable with two works in the Museo Comunale in Prato.[3] The attribution has been well received,[4] for the pair compares favorably with certain elements in the three signed and dated works that are the cornerstones on which the artist's work is to be reconstructed.[5] The colors and particularly the deeply receding, plum-toned shadows are analogous to one of this triad, a work of 1703 formerly in the Nigro Collection, Genoa.[6] The placing of the compositions on a rocky outcrop with abbreviated hints of a landscape background is similar again to the former Nigro picture as well as to another painting of the defining three: a signed and dated still life of 1701 in the Reccamadoro-Ramelli Collection, Fermo.[7] The Fermo picture also includes a transparent glass compote as in the Atheneum painting. M.M.

1. Cunningham, 1951, 2.
2. R. Longhi to C. Cunningham, 22 Mar. 1960, curatorial file.
3. S. Bottari to E. Bryant, 14 Mar. 1962, curatorial file. Bottari, 1967, 427. The Prato works are Sop. Foto., Florence, nos. 96961 and 96929.
4. Dania, 1967, 70. Fredericksen and Zeri, 1972, 191, 507, 585. O. Michel, 1978, 728.
5. De Logu, 1962, 186–87.
6. De Logu, 1962, color pl. 101. Oil on canvas, 85 x 73 cm, Rome, G.F.N. E43296. Sold with an unsigned pendant at Finarte, Milan, 24 Nov. 1965, nos. 36a and 36b (New York, 1983, 112, n. 3).
7. De Logu, 1962, color pl. 56. Oil on canvas, 90 x 154 cm, Rome, G.F.N. E43462.

Bernardo Strozzi (1581–1644)

Born in Genoa, Strozzi is said to have trained there under Pietro Sorri, when he was in Genoa, and with the native-born Cesare Corte. About 1597 he became a Capuchin friar, but about 1610 was allowed to leave the order, while remaining a priest, to care for his mother. At her death in 1630 he joined the canons regular of the Congregations of the Most Holy Savior of the Lateran and was made a monsignor in 1635. All this time he had been active as a painter in and around Genoa and thereafter in Venice, where he settled probably by 1631 for the rest of his life. He is sometimes called Il Cappuccino or Il Prete Genovese owing to his religious associations.[1]

1. Levey, 1964, 211.

St. Catherine of Alexandria

Oil on canvas, 175.5 x 123.2 cm (69^1/8 x 48^1/2 in.)
There is a strip of canvas approximately 22 centimeters wide along the left side.
Condition: good. The ghost of a veil seems to be draped from the crown, falling behind the saint's right arm, perhaps attached to her bracelet with the red bow, and then dropping beneath her right arm.
Provenance: Genoese private collection, perhaps Doria; Marcello Tozzi, Genoa, sale Milan, Galleria Geri-Boralevi, 11–14 Feb. 1920, no. 60; Italico Brass, Venice. Purchased for the Wadsworth Atheneum in 1931 from Italico Brass, Venice, for $16,000 from the Sumner Fund.
Exhibitions: Milan, Galleria Geri-Boralevi, Sept.–Oct. 1920; Florence, 1922, no. 156, as in a private collection, Venice; New York, Durlacher Bros., 1932, no. 11; New York, Durlacher Bros., 1934, no. 6; Cleveland, 1936, no. 167; Kansas City, 1937; Buffalo, Albright Knox Art Gallery, picture of the month for February 1938; Toledo, 1940, no. 45; San Francisco, 1941, no. 107; Baltimore, 1944, no. 6; Worcester, 1948, no. 6; Hartford, *In Retrospect*, 1949, no. 7; Toronto, 1950, no. 43; New York, 1958, 59; Sarasota, 1958, no. 73; Dayton, 1962, no. 56; Seattle, 1962, no. 64; Middletown, 1966.
The Ella Gallup Sumner and Mary Catlin Sumner Collection, 1931.99

The picture, together with a *St. Cecilia* now in Kansas City (Fig. 41), was first published by Fiocco as a major work of the 1620s recording the artist's emergence from late mannerism.[1] Mortari's more recent views and monographic study place the picture as a preeminent one in a group that shows the particularly strong influence of Federico Barocci. Thus she dates it circa 1610–15, while the artist was still in Genoa and before he had absorbed the naturalistic trends of more contemporary painting elsewhere, which exposure, when wedded to his obviously already fully developed mastery of the brush and of color, was to produce his mature style.[2] The whole group, mostly of female saints, all share an exotically refined palette, highly stylized, paperlike creased drapery, and the same elegantly transported expression, be it taken from the same model or simply the repetition of an idealized facial convention.[3] An early drawing

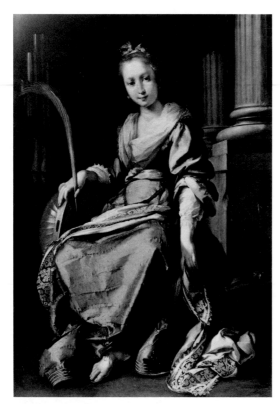

Figure 41. Bernardo Strozzi, *St. Cecilia*, Kansas City, Nelson-Atkins Museum of Art

Figure 42. Bernardo Strozzi, *St. Catherine of Alexandria*, Zurich, Bührle Collection

in Genoa of a seated female figure has been cited as a generic source for such seated figures.[4] This painting was among A. Everett Austin's first purchases with the Sumner Fund, so much of whose income in future years was to be directed to the acquisition of pictures illustrating the development of Caravaggesque painting. It is a monument to his catholic taste and the good fortune of the collection in Hartford that his enthusiasm extended to this picture, which illustrates so delicately and with such consummate mastery all that was swept aside by the newest trends in Bolognese and Roman painting of the time.

As is common in Strozzi's oeuvre there are several repetitions of this work with slight differences in each. Five variants are known. The literature is bedeviled with confusion about the two best known of these: the Atheneum picture and the version in the Bührle Collection in Zurich (Fig. 42). To judge from photographs and color plates both are of equal quality, but Strozzi varied his gamut of scintillating colors in each. The confusion springs from the fact that both belonged to the Venetian dealer Italico Brass by 1930.[5] Critics not realizing this have mixed up the provenance and exhibition history of the one with the other. The five versions can be briefly described as follows:

1. Wadsworth Atheneum. 175.5 x 123.2 cm. Formerly in a Genoese private collection, perhaps Doria (see below); Marcello Tozzi, Genoa, sold Milan, Galleria Geri-Boralevi, 11–14 Feb. 1920, no. 60, repr. (according to Mortari, 1966, 137); Italico Brass, Venice, exhibited in Florence in 1922 and *not* in Paris in 1935; purchased with the Sumner Fund by the Atheneum from Italico Brass in 1931.[6]

2. Bührle Collection, Zurich, 165 x 129.5 cm. Antonio Scarpa, Motta di Livenza, sold Milan, Sambon, 14 Nov. 1895; Aldo Noseda Collection, sold Milan, Galleria Pesaro, Dec. 1929, no. 169, repr.; Italico Brass, Venice, *not* exhibited in Florence in 1922 but shown at the Grand Palais in 1935; acquired in 1956.[7]

3. Formerly with Pietro Accorsi, Turin. 162 x 109.5 cm. Paired with a *St. Cecilia*. Acquired by Prince Filippo d'Assia as a gift for Hitler; exported by order of Ciano; recovered for the Italian state in 1948 and deposited at the Palazzo Vecchio, Florence.[8]

4. Formerly in the Charles Loeser Collection, Florence. Inherited in 1928 by his daughter Matilda Loeser Calnan; stolen from the Loeser villa in World War II. Mortari holds it to be slightly later than the previous three, about 1615 and more baroque.[9] Unlocated.

5. With E. and A. Silberman Galleries, New York, in 1951. 119 x 85 cm. In 1951 the picture had been in the possession of the firm for many years. It came from Vienna. According to the dealer's information, the picture previously had been auctioned in 1864 when a large part of the collection in the royal palace in Budapest was sold prior to rebuilding the palace.[10] Unlocated.

Not only was this composition repeated, as seen, with variations, but it was paired with a *St. Cecilia*, as the Accorsi pictures. When Fiocco first published the Atheneum work, he linked it with a *St. Cecilia*, both coming from a patrician Genoese collection and both

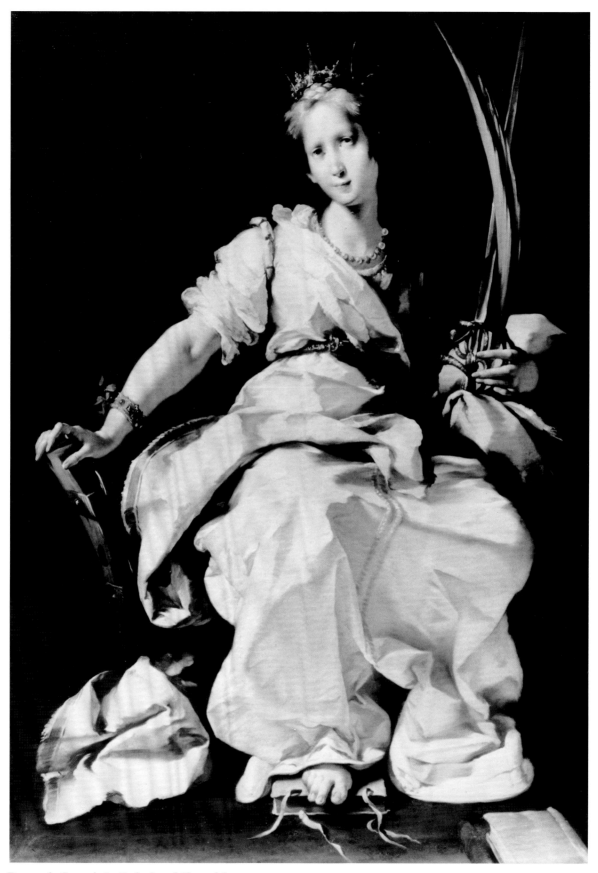

Bernardo Strozzi, *St. Catherine of Alexandria*

shown at Galleria Geri-Boralevi in 1920. Both these pictures were acquired by Italico Brass; the one coming to Hartford in 1931, the other acquired by the Nelson-Atkins Museum of Art, Kansas City, in 1944.[11] Fiocco refers to the *St. Cecilia* in a caption as "già Casa Doria."[12] If his information is correct, the inference is that both the Kansas City *St. Cecilia* and the Atheneum's *St. Catherine* were once in a Doria collection in Genoa.

By 1930 Italico Brass owned both version 1 and version 2 of the *St. Catherine*. The sale of one of these to the Atheneum was negotiated in 1930 through Harold Parsons, advisor to both the Cleveland and Kansas City museums. In his initial directions to Parsons, Brass very specifically offered version 2 for sale, a picture, Brass said, that competed with, if indeed was not superior to version 1, which was not for sale ("non vendible"). Photographs of both versions were sent to Parsons to illustrate the point.[13] The sale of version 2 was effected.[14] But apparently Parsons omitted to tell Austin there were two versions of the painting belonging to Brass and blunderingly led Austin to believe version 1 was offered. Austin, who had before him the Alinari photograph no. 956 of version 1, captioned "Esp. 1922 (i.e., exhibited at the Pitti in 1922), Venezia, Proprietà Brass," was understandably taken aback when there arrived in Hartford version 2, of whose existence he had not been informed and which varies in minor but very apparent ways from version 1.[15] Ever after the tale persists that the director's indeed brilliant eye thwarted the dealer's chicanery in substituting one picture for another. Certainly Brass was blameless.[16] What in fact happened, after Parsons's mix-up was realized,[17] was that, in order to demonstrate his goodwill toward Austin, Brass offered the Atheneum either version,[18] going so far as to ship version 1 to the museum in order that Austin compare the two and choose one.[19] M.M.

1. Fiocco, 1921, both from a patrician Genoese collection and both shown at the Galleria Boralei [sic] in Sept.–Oct. 1920 (7). These are surely the full-length *St. Cecilia* and *St. Catherine of Alexandria* he lists later as shown at the Galleria Geri-Boralei [sic] in 1920 (20). See also his "Strozzi" in Thieme and Becker, 1938, XXXII, 207, where the gallery is properly identified as Geri-Boralevi.
2. Mortari, 1955, 311–12, 330, as between 1615 and 1620. Subsequently, Mortari, 1966, 25, 137–38, fig. 111, color pl. 3, placed the picture before Strozzi's naturalistic phase, which she proposes began circa 1615 (26–27). In addition to Barocci's, Procaccini's and Cerano's influences are to be seen in the Atheneum picture in Spike's view (Princeton, 1980, 116).
3. Mortari, 1966, figs. 101, 103, 105–8, 110–12.
4. Gabinetto dei Disegni del Comune, no. 2912. Mortari, 1966, 25–26, 221, fig. 443, either in Palazzo Bianco (25) or in Palazzo Rosso (221). See also Ivanoff, 1959, no. 50, repr. 144 and Matteucci, 1966, fig. 3, as in Palazzo Rosso.
5. Fiocco lists two *St. Catherines* in the Brass Collection in his "Strozzi," in Thieme and Becker, 1938, XXXII, 209, information which by the time of the volume's publication, 1938, was partially out of date, for one of them had already passed to the Atheneum.
6. References not otherwise cited elsewhere: Ojetti, 1924, pl. 271, as Brass Collection, Venice; Nugent, 1925, I, 54, repr. 52, as Brass Collection, Venice; Hitchcock, 1931, 15–16; *Wadsworth*

Atheneum Annual Report, 1931, 5; *Art News*, XXX, 23 Jan. 1932, 6; Venturi, 1933, pl. 581, mistakenly citing the provenance of the Italico Brass/Bührle picture and Frizzoni's 1895 reference thereto; McComb, 1934, 127; Wadsworth Atheneum, *Avery Memorial*, 1934, 32; Tietze, 1939, no. 111, as purchased 1931 from [sic] the Sumner Collection; Rome, *Opere d'arte recuperate in Germania*, 1950, 40–41, no. 19; *Wadsworth Atheneum Handbook*, 1958, 59; *Emporium*, CXXIX, Feb. 1959, 87, repr. in a review of the 1958 New York exhibition; Hartford, Trinity College, Austin Arts Center, 1965, repr. on the cover of the dedication program; Matteucci, 1966, 3, no. 1, as probably executed in the first decade of the century; M. Milkovitch in Binghamton, 1967, 99; Paoletti, 1968, 425, fig. 4, a Venetian work, between 1631–34; P. Torriti in *La Pittura a Genova e in Liguria*, 1971, datable to the 1610s; Fredericksen and Zeri, 1972, 193, 384, 584; *Stiftung Sammlung Bührle*, 1973, 336–37, no. 147, mistakenly saying the Bührle version was exhibited in Florence in 1922 and published by Ojetti, 1924, as pl. 271; Pallucchini, 1981, I, 156, fig. 452, first years of the second decade of the century; Silk and Greene, 1982, 40.
7. Mortari, 1966, 193–94, fig. 108.
8. Mortari, 1966, 179, fig. 106, a reproduction that crops the painting at the bottom; for a complete reproduction, see Rome, 1950, where Siviero exhibited the pair and published the documents, wherein Ciano intervened to overrule the Belle Arte's protest that the pair be exported at all and at the risible valuation of 50,000 lire. After the pair were deposited in the Palazzo Vecchio, Florence, they were reproduced by G. de Juliis (Florence, 1984, 162–63, nos. 90 and 91), who considered the *St. Catherine* inferior in quality to the Hartford and Zurich versions (162).
9. Mortari, 1966, 105, fig. 110.
10. A. Silberman to C. Cunningham, 15 Mar. 1951, curatorial file. Mortari, 1966, 157.
11. Inv. no. 44.39, 172.7 x 122.6 cm (68 x 48¼ in.). Fiocco, 1921, 7, 20. Mortari, 1966, 187, as formerly in a Venetian private collection, fig. 105. *Nelson Gallery–Atkins Museum Handbook*, 5th ed., 1973, I, 112, illus. The painting came to Kansas City in 1940 for consideration, was sent to the Alien Property Custodian, New York, in December 1941, and was purchased by the museum on 21 Aug. 1944 (G. Mott to M. Mahoney, 7 June 1984, curatorial file). G. de Juliis, who cites further versions of the composition in the Thyssen-Bornemisza Collection, Lugano, and in the Accademia degli Agiati, Rovereto, also pairs the Atheneum's picture with the Kansas City work (Florence, 1984, 163, no. 91).
12. Fiocco, 1921, pl. 3.
13. I. Brass to H. Parsons, 1 Aug. 1930, copy in curatorial file, wherein Brass quotes the text of these original terms set forth in a letter from Brass to Parsons of 29 Dec. 1929. The photograph of version 2 was in color; that of version 1, described as labeled "esposto nel 1922 a Pitti," sounds like Alinari 956 discussed below.
14. H. Parsons to A. Austin, 12 Feb. 1930, and I. Brass to A. Austin, 14 Feb. 1930, curatorial file.
15. A. Austin to H. Parsons, 25 July 1930, curatorial file: "when you came to see me with *the* [italics added] photograph of the Strozzi 'Saint Catherine,' which you thought Brass would be willing to sell, I was under the impression, of course, that it was the original which Brass lent to the exhibition at the Pitti Gallery in 1922 and as photographed by Alinari and not the replica, which arrived day before yesterday. I never thought of there being *two* [italics added] pictures of this same subject and a comparison of the photographs even, will show the differences in quality, which is very apparent. Of course, under the circumstances, I could not ask the museum to accept the picture which Brass sent and I would be very grateful to you if you will write me a letter clearing up in some way the misunderstanding and telling me what I should do."
16. As is apparent when Brass quotes to Parsons the text of the original terms as he does in the above-cited letter of 1 Aug. 1930, curatorial file.
17. H. Parsons cable to A. Austin, 1 Sept. 1930, curatorial file, acknowledging he, Parsons, "had completely misinterpreted Brass original letter always supposed picture identical one seen

[presumably by himself at some point] Venice would not have recommended unseen picture."
18. I. Brass to H. Parsons, 1 Aug. 1930, copy in curatorial file.
19. H. Parsons cable to A. Austin, 14 Oct. 1930; version 2 was returned in April 1931, H. Parsons to A. Austin, 24 Apr. 1931 (Wadsworth Atheneum Archives, Austin Papers). (Thus the pair was broken; the *St. Cecilia* was eventually to go to Kansas City a decade later.) Future researchers are herewith alerted to another pitfall: a provenance citation for the Brass/Bührle *St. Catherine* as having been purchased on 19 Feb. 1926 from H. Hebing, Briennerstrasse, Munich. This fiction refers to version 2. It appears on the 27 June 1930 U.S. consular declaration (curatorial file) when version 2 was being shipped from Italy and is cited as being exempt from export duty because it had been temporarily imported into Italy, thus concealing the actual Italian provenance cited in the text above: in the Noseda Collection until 1929.

A Monk Tuning a Harp

Oil on canvas, 32.2 x 27.2 cm (12 3/4 x 10 3/4 in.)
 Condition: fair. There is a small tear in the center of the canvas.
 Signed and dated upper left: *A. Tamburini, 1888*
 Provenance: collection Elizabeth Hart Jarvis Colt. Bequeathed to the Wadsworth Atheneum in 1905 by Elizabeth Hart Jarvis Colt.
 Exhibitions: Hartford, 1958, no. 57; Hartford, Wadsworth Atheneum, *Salute to Italy: One Hundred Years of Italian Art*, 20 Apr.–28 May 1961, not in cat.; listed in Williamstown, 1982, 76.
 Bequest of Elizabeth Hart Jarvis Colt, 1905.24

A Monk Tuning a Harp is typical of the genre pictures of monks produced by Tamburini. J.C.

Arnaldo Tamburini
(b. 1843)

Arnaldo Tamburini was born in Florence in 1843. He is best known as a genre artist and portraitist. His portraits of Victor Emmanuel II and of Umberto I are in the Museo Civico in Pisa, while his genre scenes, often showing monks at leisure, still appear on the art market.[1]

1. Comanducci, 1973, V, 3219.

Arnaldo Tamburini, *A Monk Tuning a Harp*

Giovanni Battista Tiepolo
(1696–1770)

Born in Venice probably 5 March 1696 to a family of modest means,[1] Giovanni Battista Tiepolo was, according to an early biographer, first taught by Gregorio Lazzarini, a successful painter of late seicento Venice.[2] Lazzarini's smooth, classicizing manner apparently held little attraction for the young painter, who soon, according again to da Canal, "si dipartisse dalla di lui maniera diligente, giacche tutto spirito e foco, ne abbraccio una spedita e risoluta."[3] Tiepolo's name is first found in the *Fraglia* in 1717, by which date he was most likely an independent painter. His novel style found immediate favor; the *Crossing of the Red Sea*, of which only the sketch survives, was exhibited in 1716 and highly praised;[4] and he was quickly given important commissions by Doge Cornaro, in Palazzo Sandi and in various churches.[5] The most important works of his youth, in which his distinctive style is readily apparent, are the frescoes in the cathedral and episcopal palace in Udine. On 4 June 1726, permission was granted to commission from the "celebrated" artist frescoes in the chapel of the Holy Sacrament in the cathedral; the frescoes in the palace were perhaps begun the year before.[6] In his easel pictures, such as the early *Repudiation of Hagar*, signed and dated 1717 or 1719,[7] and the later pictures for the Palazzo Dolfin in Venice, generally dated between 1725 and 1730,[8] Tiepolo's style is less aggressively novel than in his frescoes and shows lingering influence of the dramatic chiaroscuro style of seventeenth-century Venetian painters such as Piazzetta.
 During the 1730s and 1740s, Tiepolo had many commissions throughout northern Italy.[9] In these works Tiepolo's bold compositions and daring illusionism mark a new era in mural painting.
 His easel paintings were also in great demand during this time and show traits similar to those developed in the decorative cycles. Altarpieces such as the *Martyrdom of St. Agatha* in Padua, painted in 1736;[10] the *Pope Clement Adoring the Trinity* in Munich, probably finished by 1739;[11] the *Martyrdom of St. John, Bishop of Bergamo* in the cathedral in Bergamo of 1743;[12] and the *Adoration of the Magi*, executed for the Benedictines of Schwarzach, in south-central Germany, in 1753, and now in the Alte Pinakothek in Munich[13] show the artist's fully matured talent for interpreting traditional religious themes in new ways. The historical paintings of his youth and early maturity show the same quality and invention.
 In December of 1750 Tiepolo arrived in Würzburg, invited there by the prince-bishop, Carl Philip von Greiffenklau, to undertake the decoration of the great hall in the Residenz, the recently completed work of the architect Balthasar Neumann. The frescoes, on the theme of the life of the emperor Frederick

Barbarossa, were finished 4 July 1752. Tiepolo signed another contract on 29 July for the ceiling fresco of the great stairway, which was finished in 1753. These frescoes, surely Tiepolo's best work, show on an immense scale the power of Tiepolo's decorative imagination and the perfection of his technique.

Tiepolo left Würzburg 8 November 1753 to return to Venice, where he was immediately called upon to fresco the ceiling of the church of the Pietà.[14] Among the most notable works of this time are the fresco decorations of the Villa Valmarana in Vicenza, executed in collaboration with his son Giovanni Domenico in 1757.[15]

In 1762 Tiepolo was invited by Charles III of Spain to decorate the royal palace in Madrid, a decorative project that occupied almost the whole of what remained of his life.[16] The project was finished with the assistance of his sons by 1767, when he was then commissioned to paint seven canvases for the church of St. Pascal at Aranjuez, which were ready in 1769.[17] The growing influence of Mengs at the royal court led to the removal of Tiepolo's paintings and their replacement with works by Mengs, Bayeu, and Maella; they remain traceable, along with most of their preparatory sketches, and are an eloquent document of Tiepolo's late style as well as of his creative resilience.

Tiepolo died in Madrid 27 March 1770 at the age of seventy-four. His son Lorenzo remained in Madrid, while Giovanni Domenico returned to Venice.

1. Morassi, 1962, 230.
2. Da Canal, 1809, 31–32. Da Canal's manuscript was written in 1732. See Barcham, 1989, 11–14, on Tiepolo's apprenticeship.
3. "He abandoned his master's painstaking manner, inasmuch as, all spirit and fire, he adopted one resolute and rapid." Da Canal, 1809, 32; trans. in Morassi, 1955, 8.
4. Da Canal, 1809, 32; Morassi, 1962, 230; Pallucchini and Piovene, 1968, 83, 85–86, no. 1.
5. Morassi, 1955, 9–11; Morassi, 1962, 60–61, 230.
6. Morassi, 1962, 52–53.
7. Pallucchini and Piovene, 1968, 87, no. 13.
8. Pallucchini and Piovene, 1968, 91–92, no. 48.
9. These include the ceiling decorations for the Palazzo Archinto in Milan, documented to 1731 and now destroyed (Morassi, 1962, 231; Pallucchini and Piovene, 1968, 94–95, no. 61); the frescoes in the Palazzo Dugnani, also in Milan, executed shortly after the Palazzo Archinto decoration in 1731 (Morassi, 1962, 231; Pallucchini and Piovene, 1968, 95, no. 62); the decoration of the Colleoni Chapel in Bergamo, documented to 1732–33 (Morassi, 1962, 231; Pallucchini and Piovene, 1968, 97–98, no. 81); the ceiling fresco of the church of the Gesuati in Venice, finished in 1739 (Morassi, 1962, 233; Pallucchini and Piovene, 1968, 103–4, no. 122); the ceiling fresco of the Palazzo Clerici in Milan, datable to 1740 (Morassi, 1962, 233; Pallucchini and Piovene, 1968, 105, no. 132); the decoration of the Villa Cordellina at Montecchio Maggiore, near Vicenza, finished in 1743 (Morassi, 1962, 234; Pallucchini and Piovene, 1968, 107–8, no. 147); and the splendid decoration in the Palazzo Labia in Venice, undocumented but generally thought to have been executed between 1747 and 1750 (Morassi, 1962, 59; Pallucchini and Piovene, 1968, 113, no. 187).
10. Morassi, 1962, 232; Pallucchini and Piovene, 1968, 101, no. 110
11. Morassi, 1962, 30; Levey, 1971, 223–25, no. 6273.
12. Morassi, 1962, 233; Pallucchini and Piovene, 1968, 108, 150.
13. Morassi, 1962, 235; Pallucchini and Piovene, 1968, 118, 202.
14. Morassi, 1962, 235; Pallucchini and Piovene, 1968, 119, no. 216.
15. Morassi, 1941, 251; Morassi, 1955, 31–33; Morassi, 1962, 236; Pallucchini and Piovene, 1968, 122–24, no. 240.
16. Morassi, 1962, 238–39; Pallucchini and Piovene, 1968, 130–32, no. 279.
17. Morassi, 1962, 239; Pallucchini and Piovene, 1968, 134–35, no. 299.

Susanna and the Elders

Oil on canvas, 56.2 x 43.4 cm (22 1/8 x 17 1/4 in.)

Condition: good. There is some loss of modeling in Susanna's torso, and minor retouches throughout.

Provenance: collection Böhler and Steinmeier, Munich; Albert Keller, New York; Schaeffer Galleries, New York, to 1946; Mr. and Mrs. Arthur L. Erlanger, New York; given to the Atheneum in 1954 by Mr. and Mrs. Arthur L. Erlanger.

Exhibitions: Kent, 1966; Baltimore, Baltimore Museum of Art, *From El Greco to Pollock: Early and Late Works by European and American Artists*, 22 Oct.–8 Dec. 1968, 62, no. 43; Birmingham, 1978, 72, no. 5.

Gift of Mr. and Mrs. Arthur L. Erlanger, 1954.196

In the apocryphal Old Testament story, Susanna, wife of Joakim, was accustomed to walking in the garden adjoining their house.[1] Two elders who came frequently to consult with her husband saw her and fell in love with her. One day the elders hid themselves in the garden as Susanna prepared to take her bath. The elders entreated her to lie with them and, as she refused, they accused her of adultery. Just as Susanna was being taken off to be put to death, a young man named Daniel came to her defense. In front of the assembled Israelites, he questioned the two elders separately, and it was revealed that their account of Susanna's adultery was false. Susanna was set free and the elders were killed.

In the Atheneum picture Susanna is about to descend into the fountain, when she is accosted by the two elders and offered jewels for her favors. Her raised hand indicates her refusal, just as her downcast eyes register her dismay.

The painting probably had a pendant showing *Bathsheba at the Bath*, a similar tale of lust and adultery.[2]

Since the publication of the *Susanna and the Elders* by Morassi in 1949, the attribution has not been in dispute.[3]

Less easily resolved is the date of execution. Following the remarks of older writers such as Moschini,[4] critics have emphasized the influence of Piazzetta's dramatic chiaroscuro style on the young Tiepolo. Morassi noted the influence of Piazzetta, and more modestly of Bencovich, and even of Tiepolo's first teacher Lazzarini, in the Atheneum picture; and he likened the way in which form was defined by the sweep of the loaded brush, for example, in the head and arms of the left elder, with the figure of Abraham in the *Repudiation of Hagar*, signed and dated 1717 or 1719. He dated the picture to about 1718.[5] Other writers, however, likened the female types to the four mythological canvases in the Accademia in Venice, datable to about 1720–22, and assigned a date of about 1722–23 to the Atheneum picture.[6] Later authors have followed the later dating for the Susanna.[7]

A somewhat different view of Tiepolo's early career has been advanced by George Knox.[8] While noting recent discoveries that the Ospedaletto *Sacrifice of Abraham* cannot be dated conclusively to 1716, the date traditionally assigned to it;[9] and that the *St. Bartholomew* in S. Stae, in which the vigorous athleticism of the figures and dramatic chiaroscuro betrays the undeniable influence of Piazzetta, must date to after 1722,[10] Knox associates a number of

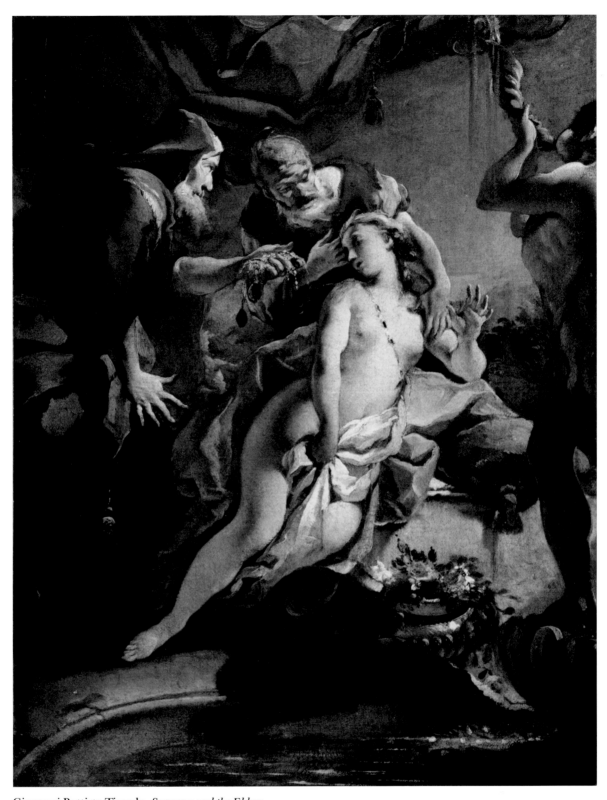

Giovanni Battista Tiepolo, *Susanna and the Elders*

pictures formerly dated much later because of their bright, Ricci-like colors, with a single decorative scheme that he contends was executed for the Ca' Zenobio in Venice in about 1717.[11] Knox thus outlines the earliest phase of Tiepolo's stylistic development as one in which he attempted complex compositions and handles paint much like contemporary Venetians—especially Ricci—and like Rubens. Only about 1722, in Knox's view, does the influence of Piazzetta become paramount, as seen in the S. Stae *St. Bartholomew* and the Brera *Madonna del Carmelo*.

If we accept the revised chronology for Tiepolo's early works as proposed by Knox, the *Susanna and the Elders* in the Atheneum would fall into the period around 1717. The bright colors of the Atheneum picture—turquoise blue, yellow, and rose—are closer to the palette of Sebastiano Ricci that is remarkable in the Ca' Zenobio cycle than to Piazzetta. Moreover, the composition of the Atheneum picture, in which the fountain figure at the right is in shade, thereby establishing a diagonal view into the space and a middle ground for the action of the figures, is not unlike the compositional devices seen in the larger and more complex pictures of the *Triumph of Aurelian* in Turin and the *Zenobia before Aurelian* in Madrid, both dated by Knox to 1717.[12]

Barcham, however, rejects Knox's chronology and retains a date of about 1722.[13] J.C.

1. Book of Daniel and Susanna, 1–64.
2. Morassi, 1962, 14, reports that a contemporary copy of the Atheneum picture was on the market in Venice in 1955, along with its pendant, *Bathsheba at the Bath*. Morassi felt that the latter was a copy of a lost pendant to the Atheneum picture. According to Evan Turner, undated letter to C. Cunningham in curatorial file, who saw the pair of pictures owned by Francesco Pospisil in the Palazzo Sagredo, Campo S. Sofia, Venice, the pictures were surely pendants and very close in style, size, and quality to the Atheneum painting. The Pospisil paintings reportedly had belonged to an English painter named Forbes then living in Venice.
3. Morassi, 1949, 75–76; C. Buckley, *Wadsworth Atheneum Bulletin*, 2nd ser. no. 54, Feb. 1955, 1; Morassi, 1962, 13–14; Pallucchini and Piovene, 1968, 88, no. 26, pl. II; A. Mariuz and G. Pavanello, "I Primi affreschi di Giambattista Tiepolo," *Arte veneta*, XXXI, 1985, 109.
4. Writing in 1809, Moschini, ed. da Canal, as cited in Morassi, 1955, 7, said, "Eager to imitate whatever was popular in his own day, [Tiepolo] emulated now the showy manner of Bencovich, now the strong shadowings of Piazzetta."
5. Morassi, 1949, 75–76.
6. Pallucchini and Piovene, 1968, 88, no. 26. Pallucchini, wrongly contending that Morassi had thought the *Susanna* a sketch, declared it a finished work.
7. Birmingham, 1978, 42, 72, no. 5.
8. Knox, 1979.
9. The date was deduced from da Canal's account that Tiepolo painted at the age of nineteen some "apostoli . . . sopra le nicchie della chiesa dell'Ospedaletto," and it is inscribed on the book of the *Saints Peter and Paul*; see Morassi, 1962, 56–57. See, however, Knox, 1979, 417; F. Z. Boccazzi, "Per il catalogo di Giambattista Pittoni: Proposte e inediti," *Arte veneta*, XXVIII, 1974, 179–204; and B. Aikema, "Early Tiepolo Studies," *Mitteilungen des kunsthistorischen Instituts in Florenz*, XXV, 1982, 339–50.
10. Knox, 1979, 417; L. Moretti, "La Data degli apostoli della chiesa di S. Stae," *Arte veneta*, XXVII, 1973, 318–20.
11. Knox, 1979, 414–17.
12. Knox, 1979, 414.
13. Barcham, 1989, 39–42, 53–55; Levey, 1986, 9–20, also retains a traditional chronology for Tiepolo's early years.

Giovanni Domenico Tiepolo (1727–1804)

The eldest son of Giovanni Battista Tiepolo was born in Venice on 30 August 1727.[1] Giovanni Domenico was taught the art of painting by his father and became his principal assistant. His first independent commission of note was the paintings of the *Stations of the Cross* for the oratory of the Crucifixion attached to S. Polo in Venice, one of which is dated 1747, and after which he made a set of etchings published in 1749.[2] Other independent commissions, such as two ceiling paintings and several altarpieces for the oratory, datable to the same years, show a style heavily dependent on his father's, but with certain individual traits, such as a singular treatment of details and structuring of space.[3] The *St. Francis de Paul Healing an Obsessed Man*, S. Francesco di Paola, Venice, dated 1748, and the *St. Oswald Appealing to the Holy Family to Heal a Youth* for the parish church of Merlengo, near Treviso, signed and dated 1750, show the high level of competence achieved by Giovanni Domenico on the eve of the Würzburg sojourn.[4]

Giovanni Domenico accompanied his father to Würzburg in 1750, where his participation in the grand decoration of the Kaisersaal is certain though difficult to isolate. He was probably employed entirely executing frescoes according to detailed drawings, including cartoons, that had been prepared by his father. Of the few drawings attributable to Domenico from the Würzburg period, the grander part are copies after his father's inventions, rather than independent creations.[5] Domenico seems to have assumed a principal role only in the three large overdoors in the Kaisersaal, one of which, *Emperor Justinian*, is signed and dated 1751.[6] Several independent works by Domenico were also done during the Würzburg period, including the *Christ in the House of Simon the Pharisee* and the *Institution of the Eucharist*, now in the Alte Pinakothek in Munich and signed and dated 1752.[7]

After his return to Italy, Domenico took on ambitious independent commissions. The frescoes in the choir of SS. Faustina e Giovita at Brescia date to about 1754–55, and show Domenico's continued dependence on his father's style.[8] A more original sensibility is visible in the frescoes for the guest rooms of the Villa Valmarana near Vicenza, signed by Domenico and dated 1757.[9] Here Domenico's interest in genre subjects and his appreciation of the intimate details of everyday life is first apparent. From this point on the thirty-year-old Domenico seems to have assumed a more independent and equal role in the family workshop; he perhaps became the specialist for genre subjects and peasant types, and he was entrusted with most of the monochrome decorations.[10] This special role of Domenico continued in the work in the Oratorio della Purità at Udine in 1759, where Giovanni Battista painted the ceiling and the altarpiece. Domenico had charge of the grisaille historical scenes, one of which, *Christ and the Children*, is signed by him and dated 1759.[11] At the Villa Pisani at Strà, Domenico painted monochrome scenes between windows in the ballroom and Giovanni Battista painted the ceiling in 1761–62.[12] At this time Domenico also began the decoration of the family villa at Zianigo, near Mirano, with grisaille scenes.[13]

When Giovanni Battista was called to Madrid by Charles III

in 1762, Giovanni Domenico again accompanied him. With the father's increasing age, the collaborative work is even more difficult to unravel than at Würzburg; it seems reasonable to assign a large role to Giovanni Domenico in the execution of the ceilings of the royal palace and the seven altarpieces for the church of S. Pascal at Aranjuez. While in Spain Domenico continued his production of genre works; paintings such as *The Charlatan, The Toothpuller, The Ballad Singer,* and *The Triumph of Punchinello,* formerly in the Blake Collection, Kansas City, are datable to 1765.[14]

Giovanni Domenico left Spain after his father's death, returning to Venice on 12 September 1770. He enjoyed a great reputation and had many important commissions, including the *Abraham and the Angels* for the Scuola della Carità, datable to 1773;[15] two monochrome canvases, the *Oration of Cicero* and the *Crowning of Demosthenes* for the Sala del Senato in the Doges' Palace, dated 1775;[16] and three altarpieces for Padua.[17] The small *Institution of the Eucharist* in the Accademia was painted in 1778 as his masterpiece for the Venetian Academy, of which he was president in 1780–83.[18] Domenico's last commissions of note were the ceiling fresco of the *Glory of Pope Leo IX* in S. Lio in Venice and the ceiling decoration of the Sala del Gran Consiglio in the Doges' Palace at Genoa, which is destroyed but of which the *modello* survives, both datable to 1783.[19]

Domenico's last years were principally occupied with the decorations of his own villa at Zianigo; he painted practically nothing for outside commissions, perhaps because, after the death of his father, the fundamental stimulus for his art was gone, but perhaps also because of the change in taste toward a more severe classicism. He died at the age of seventy-seven, in 1804, having lived to see the fall of the Venetian republic and the passing of an age his own and his father's art had served so well.

1. For this and the following information, see Mariuz, 1971; and Zampetti, 1974, IV, 100–102.
2. Mariuz, 1971, pls. 1–18.
3. Mariuz, 1971, pls. 19–24.
4. Mariuz, 1971, pls. 25–27.
5. Byam Shaw, 1962, 25–27.
6. See von Freeden and Lamb, *Die Fresken der Würzburger Residenz,* Munich, 1956, 29; also Mariuz, 1971, pls. 29, 31, 33. *Modelli* for the *Emperor Constantine* and the *Saints Ambrogio and Teodosio* are in the Mainfränkisches Museum in Würzburg (Mariuz, 1971, pls. 30, 32); drawings associated with the figures are also in a sketchbook in the Museo Correr in Venice (Byam Shaw, 1962, 23, n. 3).
7. Mariuz, 1971, 127, pls. 41–42; these may be the paintings associated with a commission from the prince-bishop for four overdoors for the dining room of the castle of Veitshöchheim.
8. Mariuz, 1971, 114, pls. 73–76, has also proposed that Giovanni Battista may have designed the vault fresco and supplied drawings for groups of figures.
9. Mariuz, 1971, 148–50, pls. 121–33. The date was traditionally read 1737; Morassi, 1941, 251, was the first to propose a reading of 1757, and to articulate the importance for these frescoes in Giovanni Domenico's career.
10. Byam Shaw, 1962, 13, n. 4.
11. Mariuz, 1971, pls. 157–64.
12. Mariuz, 1971, pls. 179–82.
13. Mariuz, 1971, pl. 151. The frescoes in this villa, which were executed by Domenico over many years, are now in the Ca' Rezzonico in Venice.
14. Venice, 1951, 145–46, nos. 103–5.
15. Mariuz, 1971, pl. 265.
16. Mariuz, 1971, pls. 272–73.
17. These include *The Holy Family and Saints Francesca Romana and Eurosia,* in the church of S. Nicolò, formerly in S. Agnese, signed and dated 1777, and two altarpieces in the Duomo, one of which, *St. Gerolamo Emiliani in Prayer,* is signed and dated 1778; Mariuz, 1971, pls. 278–79.
18. Mariuz, 1971, pl. 274.
19. Mariuz, 1971, pls. 318, 322.

The Last Supper

Oil on canvas, 66.5 x 42.7 cm (26³/₁₆ x 16⁷/₈ in.)

Condition: fair. There are extensive losses, particularly in the center right section where a T-shaped tear has been repaired. Wrinkling of the paint film, probably in drying, has been flattened in lining.

Labels on the verso of the stretcher have the following numbers: 259; 9073; and 2223.

Provenance: collection Baroness Nathaniel de Rothschild, Paris, by descent to her granddaughter, Baroness Leonino de Rothschild; Durlacher Bros., New York; bought by the Wadsworth Atheneum in 1931 from Durlacher Bros., for $29,000 from the Sumner Fund.

Exhibitions: Springfield, 1933, 29, no. 85; New York, 1934, no. 16; Northampton, 1936, no. 40; Chicago, 1938, no. 34; New York, 1939, no. 373; Hartford, 1948, 15, no. 74; Venice, 1951, 175, no. 126; Hartford, 1956, 22, no. 53, fig. 23; New York, 1958, 86; Sarasota, 1958, no. 84; Hartford, 1963, 10, no. 42.

The Ella Gallup Sumner and Mary Catlin Sumner Collection, 1931.106

In the *Last Supper* the artist has chosen the moment when Christ reveals his betrayal; his pronouncement is greeted by gestures of amazement and disbelief by his disciples, one of whom, at the right, rises from his seat; another, at the left, leans back, both hands on the table, and stares at Christ. Judas, however, is not prominently identified.

Both Giovanni Battista and Giovanni Domenico painted the *Last Supper* several times in their careers. Giovanni Battista painted an altarpiece in the parish church of Desenzano, near Verona, in about 1738, in which the event takes place under a large barrel vault.[1] Generally dated to the 1740s is the version in the Louvre (Fig. 43), which may form with four other canvases a series of the Passion.[2] The canvas of the *Last Supper* in the church of the Maddalena in Venice, signed *Tiepolo* and indistinctly dated, is generally attributed to Giovanni Domenico and dated 1775.[3]

The Atheneum painting is close to Giovanni Battista's Louvre version of the subject, and it has on this basis frequently been attributed to him.[4] Certain

Figure 43. Giovanni Battista Tiepolo, *Last Supper,* Paris, Musée du Louvre

departures in the Atheneum picture from the Louvre version, such as the enclosed space and the placement of the table perpendicular to the picture plane, have led other scholars to attribute the Atheneum picture to Giovanni Domenico.[5] While the brilliant, calligraphic handling of the figures and the dizzying perspective of the scene are close to autograph compositions of Giovanni Battista, the enclosed space and the closely packed figures are characteristic of Giovanni Domenico.[6] One might conclude that the younger artist, taking the Louvre painting as his model, modified it to suit his own temperament. The capable handling is indicative of the skill Giovanni Domenico had acquired as a mature artist.

A studio replica of the *Last Supper* was formerly in the castle of Duino, property of the Principe Torre e Tassi.[7]

The Atheneum picture is generally dated to the late 1750s.[8]

A drawing of plates in the Museo Correr, Venice (Fig. 44), has been associated with the Atheneum picture,[9] but the correspondence is not exact and the drawing may be preparatory to the altarpiece in Desenzano, as Knox has asserted.[10] J.C.

Figure 44. Giovanni Battista Tiepolo, *Study of Plates*, Venice, Museo Correr

1. Morassi, 1962, 10, fig. 49; Pallucchini and Piovene, 1968, 104, no. 123. M. Levey, review of Morassi, 1962, in *Art Bulletin*, XLV, 1963, 295; and Knox in Venice, 1979, 70, date the picture to about 1750.
2. Morassi, 1955, 21–22; Morassi, 1962, 38; Pallucchini and Piovene, 1968, 112, no. 179.
3. Mariuz, 1971, 143; Venice, 1979, 136.
4. The following have attributed the Atheneum picture to Giovanni Battista: A. E. Austin, Jr., "The Last Supper by G. B. Tiepolo," *Wadsworth Atheneum Bulletin*, IX, 1931, 22–23; Siple, 1932, 110, pl. 1A; W. Suida, letter to A. E. Austin, Jr., 25 May 1945, curatorial file; F. Watson, letter to C. Cunningham, 7 Feb. 1952, curatorial file; F. Watson, review of Venice, 1951, in *Burlington Magazine*, XCIV, 1952, 44; *Wadsworth Atheneum Handbook*, 1958, 86; J. Byam Shaw, oral communication, 29 Apr. 1963; Martini, 1964, 299. G. Knox, oral communication, 3 Apr. 1981, noted that the drawing style and the perspective are not like Giovanni Domenico's.
5. M. Goering, letter in curatorial file, 30 Apr. 1938; A. Morassi, *Emporium*, 1941, 276; Lorenzetti in Venice, 1951, 175, no. 126; M. Levey, letter to C. Cunningham, 7 Jan. 1957, curatorial file; Morassi, 1962, 14; Paoletti, 1968, 429; Mariuz, 1971, 120.
6. F. Watson, letter in curatorial file, 7 Feb. 1952, tentatively proposed that the picture was a work of collaboration, in which Giovanni Domenico supplied the architectural setting.
7. W. Suida, letter to C. Cunningham, 25 May 1945, curatorial file.
8. Morassi, 1941, 279; J. Byam Shaw, oral communication, 29 Apr. 1963, suggested a date in the late 1750s; Mariuz, 1971, 120, suggested a date in the late 1750s or early 1760s.
9. J. Byam Shaw, oral communication, 29 Apr. 1963; G. Knox, oral communication, 3 Apr. 1981.
10. Venice, 1979, 73, no. 43.

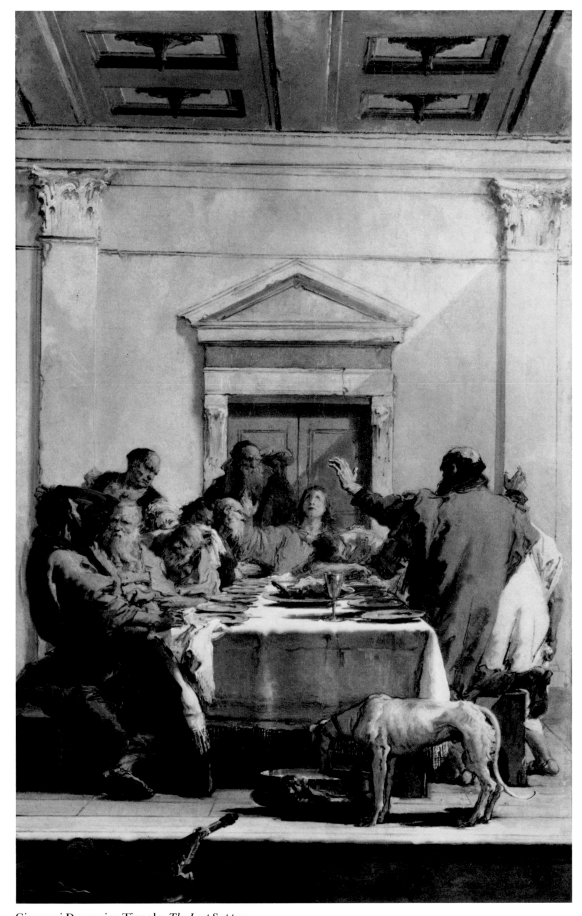

Giovanni Domenico Tiepolo, *The Last Supper*

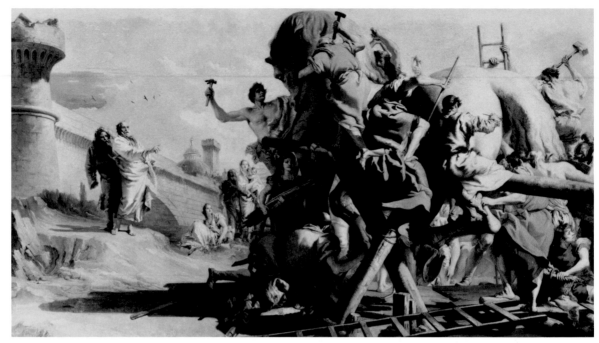

Giovanni Domenico Tiepolo, *The Building of the Trojan Horse*

Figure 45. Giovanni Domenico Tiepolo, *Building of the Trojan Horse*, London, National Gallery

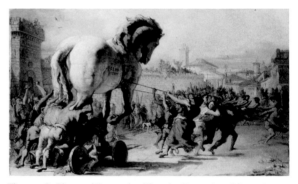

Figure 46. Giovanni Domenico Tiepolo, *Procession of the Trojan Horse into Troy*, London, National Gallery

The Building of the Trojan Horse

Oil on canvas, 192.5 x 357.6 cm (75⁷/₈ x 140⁷/₈ in.)

Condition: fair. Extensive retouching along the top and right edges has discolored. There are numerous local losses.

Provenance: collection Prince Pignatelli, Venice; Comtesse de Romrée de Vichenet, Château de Fervoz, Gambloux, about 1865; Galerie Sedelmeyer, Paris, 1911; possibly Demotte, Paris, 1930; Tomás Harris, London, by 1940; bought by the Wadsworth Atheneum in 1950 from the Spanish Art Gallery, London, for $35,000 from the Sumner Fund.

Exhibitions: Paris, Galerie Sedelmeyer, 1913; Paris, Lennie Davis Gallery, 1923; San Francisco, 1940, 13, no. 169, repr.

The Ella Gallup Sumner and Mary Catlin Sumner Collection, 1950.658

The story of the Trojan horse is told in the second book of Virgil's *Aeneid*, in which the fall of Troy is recounted.[1] In the Atheneum picture, the Greeks are furiously constructing the wooden horse outside the gates of Troy, while groups of figures look on. As Levey has pointed out, the two figures at the left may be Agamemnon and Odysseus disguised as an old man.[2] The pointing figure might also be Epeus, the builder of the horse. Levey has also noted the indication of a stream or riverbed that separates the foreground group from the two left figures. Its significance is unknown.

A sketch for the Atheneum picture in the National Gallery, London, shows only slight differences from the finished work (Fig. 45).[3] There are minor changes of figure pose and grouping, and the foreground is extended in the final picture.

A second sketch in the National Gallery showing

the *Procession of the Trojan Horse into Troy* suggests that the Atheneum picture was one of a group of pictures on the theme (Fig. 46).[4] A third sketch, showing the battle between the Trojans and the Greeks who had hidden in the horse, was in 1930 with d'Atri, Paris, and is at present untraced.[5]

The Atheneum picture was originally attributed to Giovanni Battista,[6] but a consensus has emerged favoring the attribution to Giovanni Domenico.[7] The figure types as well as the handling are characteristic of Domenico.

On the basis of drawings related to the Atheneum painting and surely preparatory to it, the *Building of the Trojan Horse* has been dated to the 1770s.[8] J.C.

1. Virgil, *Aeneid*, II, 1–270.
2. Levey, 1971, 238–39, no. 3318. Levey also suggests the left-hand figure may be the Greek Sinon, who deceived the Trojans by telling them he had been left behind when the Greeks sailed away; but Sinon was a young man, so the identification seems unlikely.
3. Inv. no. 3318, oil on canvas, 38.8 x 66.7 cm (15 1/4 x 26 1/4 in.); Levey, 1971, 238–39, no. 3318.
4. Levey, 1971, 239–40, no. 3319.
5. Reproduced in *Pantheon*, V, 1930, 199–200, as by Giovanni Battista. The finished pictures of the series, attributed to Giovanni Domenico, are referred to as with the Parisian dealer Demotte. The d'Atri sketch was exhibited as Giovanni Battista in Chicago, 1938, 27–28, no. 28.
6. C. Mauclair, *Journal des arts*, June 1912; *Ten Masterpieces of G. B. Tiepolo*, 1913, no. viii; W. Heil, "Masterworks from World's Great Past Displayed on Treasure Island," *Art Digest*, XIV, no. 8, 1 July 1940, 7; A. M. Frankfurter, "Master Paintings and Drawings of Six Centuries at the Golden Gate," *Art News*, XXXVIII, no. 38, 13 July 1940, 13; C. Cunningham, *Wadsworth Atheneum Bulletin*, 2nd ser. no. 24, Apr. 1951, 1.
7. A. Morassi, letter to C. Cunningham, 12 Mar. 1954, curatorial file; Levey, 1971, 238–39; *Wadsworth Atheneum Handbook*, 1958, 86; Morassi, 1962, 14; Knox, 1966; Mariuz, 1971, 120; Fredericksen and Zeri, 1972, 585; Knox in Venice, 1979, 130.
8. Knox, 1966, 13–14; Mariuz, 1971, 120; Knox, 1979, 130–32; nos. 86–90.

Christ Healing the Blind

Oil on canvas, 73 x 103.8 cm (28 3/4 x 40 7/8 in.)
 Condition: good. The varnish layer is uneven from a selective cleaning.
 Signed and dated lower left: *Domo Tiepolo Fel 1752*[1]
 Provenance: Laporte Collection, Linden (Hannover), Germany, by 1910; Julius Böhler, Munich; Adolf Loewi, Los Angeles; bought by the Wadsworth Atheneum in 1952 from Adolf Loewi for $3,500 from the Sumner Fund and by exchange.
 Exhibitions: Venice, 1951, 165, no. 116; Milwaukee, Milwaukee Art Institute, *The Story of Medicine in Art*, 11 Sept.– 25 Oct. 1953, 18, no. 146; Hartford, 1956, no. 54.
 The Ella Gallup Sumner and Mary Catlin Sumner Collection, 1952.289

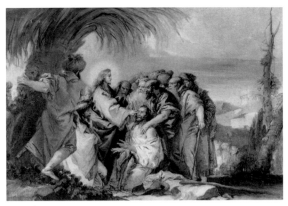

Figure 47. Giovanni Domenico Tiepolo, *Christ Healing the Blind*, New York, Didier Aaron, Inc.

As Christ and his followers left the town of Jericho on their way to Jerusalem, they encountered two blind men sitting by the roadside. The blind men cried out for help, whereupon Christ, laying his fingers on their eyes, cured their blindness.[2] The Atheneum picture shows Christ performing the miracle under a palm tree on one kneeling blind figure; the figure kneeling just to the left of Christ is perhaps the second blind man. Standing disciples crowd in to see the miracle, while at the right further onlookers are visible.

The *Christ Healing the Blind* is a pendant to *Christ and the Adulteress*, also formerly in the Laporte Collection and now untraced.[3] Sketches for the pair are also known — that for the *Christ Healing the Blind* is with Didier Aaron, New York (Fig. 47);[4] that for the *Christ and the Adulteress* was in 1929 in the collection of the Baroness Essen in Rome and is at present untraced.[5] Two paintings of *Christ and the Adulteress* and *Christ Healing the Blind* dating from the late career of Giovanni Domenico were formerly in the Sedelmeyer Collection, Paris.[6]

As one of the few signed and dated[7] early works by Giovanni Domenico, when his style is so closely dependent on that of Giovanni Battista, the *Christ Healing the Blind* is an important indicator of the young artist's maturity as well as his stylistic independence from his father. The differences between the Atheneum picture and the sketch are instructive; in the sketch the figures form a tightly packed mass that dominates the scene; in the finished work the space is made more ample by the extension of the right foreground and the enhancement of the figure seen from behind at the left who hugs the palm tree. The diagonal arrangement of figures into space and the amplitude of the setting is thus emphasized in the Atheneum picture; this kind of integration of figures and ample space is of course a fundamental trait of Giovanni Battista's art. The handling of paint, which is boldly applied with rich impasto, is also close in style and skill to Giovanni Battista's contemporary works, such as the *Adoration of the Magi* in Munich. The colors, featuring bright reds, yellows, and blues, also emulate Giovanni Battista's color schemes from the Würzburg period.

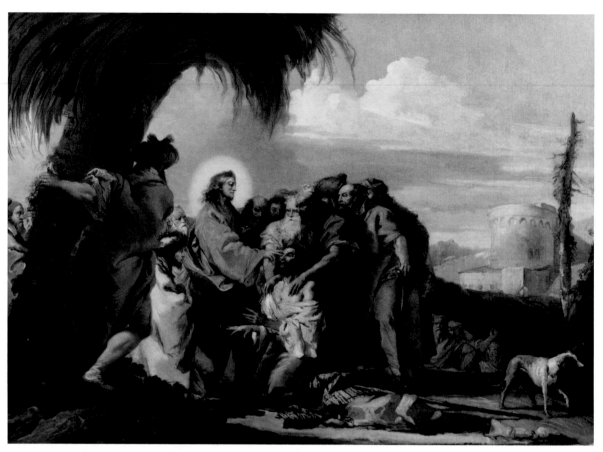

Giovanni Domenico Tiepolo, *Christ Healing the Blind*

In spite of the thorough assimilation of Giovanni Battista's style seen in the *Christ Healing the Blind*, certain features that become characteristic of Giovanni Domenico's style are already evident in the Atheneum picture. The tendency to group figures so that they appear as a barely differentiated shape, especially evident in the sketch, is not entirely eliminated in the finished work and is a characteristic of his independent paintings.[8] Peculiarities of facial types and gestures, such as the flat skull and wide-set eyes of the blind man, or the excessively straight nose of Christ's profile, are also visible in the Atheneum picture and are characteristic of Domenico's other works.

J.C.

Giovanni Domenico Tiepolo, *Christ Healing the Blind*, detail

1. The last digit of the date is ambiguous. It can most plausibly be read as a 2 or a 4; we believe it is a 2. See also note 7 below.

2. Matthew 20:29–34.

3. Sack, 1910, 307, fig. 322; Precerutti-Garberi, 1960, 273, reported the *Christ and the Adulteress* in a private collection in Paris; Mariuz, 1971, 119–20, was unaware of its location. It is said to measure 72.5 x 105 cm.

4. See Mariuz, 1971, 126, with further bibliography.

5. Mariuz, 1971, 135.

6. Sack, 1910, 314–15, pls. 334, 336, dated to about 1775; Precerutti-Garberi, 1960, 278–79, n. 25; Morassi, 1962, 43. They reportedly measure 48 x 57 cm.

7. The date has been variously reported in the literature. Sack, 1910, 307, reported a date of 1752, which was followed by Lorenzetti in Venice, 1951, 165, no. 116. When the picture came to the Atheneum, the date was reported as 1754, while the article by C. Cunningham in the *Wadsworth Atheneum Bulletin*, Oct. 1952, 1, following its acquisition, reported a date of 1751. Precerutti-Garberi, 1960, 273, also stated that both the *Adulteress* and the *Christ Healing the Blind* were signed and dated 1752. P. Marlow, letter to E. Fahy, 7 May 1970, curatorial file, proposed a correction of the date as 1754, which was accepted by Fahy, letter to P. Marlow, 11 May 1970, and published as such in Fahy and Watson, 1973, 26. Mariuz, 1971, 126, however, reported a date of 1751, and M. Bonicatti, "Il Problema dei rapporti fra Domenico e Giovanbattista Tiepolo," *Atti del congresso internazionale di studi sul Tiepolo*, Venice, 1971, 30, 38, n. 40, a date of 1752.

8. Byam Shaw, 1962, 17, aptly said of Domenico: "And most characteristic of all, we recognize in almost every picture he ever devised a singular lack of feeling for composition in space, for the solidity of bodies, for the third dimension. His faces are masks, his profiles silhouettes; and sometimes on the flanks of his compositions, in the middle-distance, there is a serried row of spectators with the heads strangely aligned, one overlapping another, but without depth or intervening space, like a handful of playing cards."

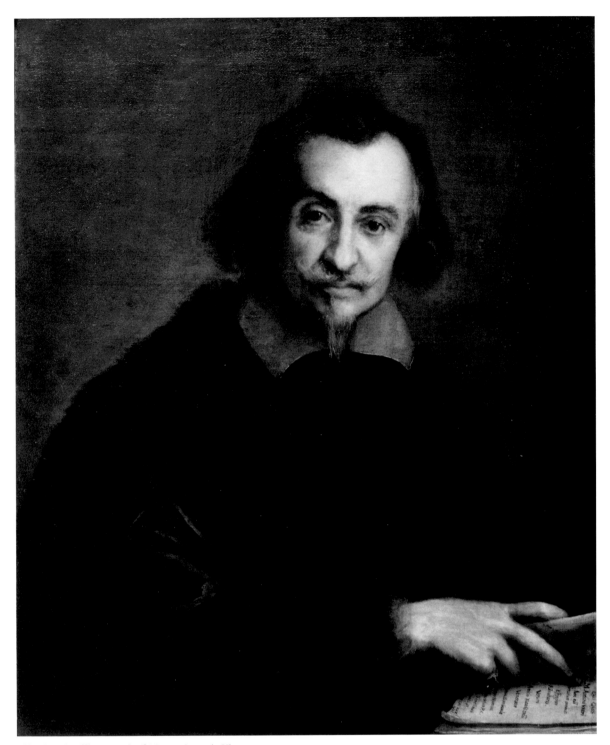

Tiberio Tinelli, *Portrait of Marco Antonio Viaro*

Tiberio Tinelli
(1586–1638)

Ridolfi tells us that Tinelli was born in Venice in 1586 and died there in 1638.[1] Trained briefly by Giovanni Contarini,[2] he entered the studio of Leandro Bassano, where he imitated the master's portrait style. Although several religious works by Tinelli survive, including the organ wings of Sta. Maria della Celestia, painted, according to Ridolfi, when the artist was about thirty,[3] and the *Madonna and Child in Glory with St. Anthony of Padua and the Sup. Luigi Morosini* in the Duomo of Rovigo, described by Ridolfi,[4] he was active chiefly as a portraitist. From Ridolfi's list of the artist's many eminent sitters, it is clear that he became the most fashionable portraitist in Venice during the 1620s and 1630s. He was invited to the court of Louis XIII of France and created a knight of the order of St. Michael.[5] Of the long list of portraits mentioned by Ridolfi, only two are signed, the *Portrait of Count Lodovico Vidmano* in the National Gallery of Art, Washington,[6] and the Atheneum painting; the latter is the sole dated portrait of the artist.

Tinelli's many sympathetic and introspective portraits have been seen as the link between Leandro Bassano's portrait style and the fully baroque portraits of Forabosco.[7]

1. Ridolfi, 1914–24, II, 278.
2. Ridolfi, 1914–24, II, 278; Pallucchini, 1981, I, 107.
3. Ridolfi, 1914–24, II, 278.
4. Ridolfi, 1914–24, II, 282.
5. Ridolfi, 1914–24, II, 281.
6. Shapley, 1979, I, 458–60, II, fig. 328.
7. Pallucchini, 1981, I, 108.

Portrait of Marco Antonio Viaro

Oil on canvas, 80 x 66 cm (31 1/2 x 26 in.)
 Condition: fair. The paint film has been abraded overall.
 Inscribed, signed, and dated on book: Qui Quis / M. Antoni Viari / hoc est Virtutum omnium / Effigiem / Admiraris / Verum / Amicis tutantu Deu / Venerator / Petrus Bombarda / Tanto Numini / Devotus P.C. / Tib. Tinellius / Eques P. / MDCXXX / VII[1]
 Provenance: collection Lord Savile, Rufford Abbey, Nottinghamshire (not, however, listed in his sale London, Christie's, 18 Nov. 1938); Galerie Sanct Lucas, Vienna; A. F. Mondschein & Co., London. Purchased by the Wadsworth Atheneum in 1939 from A. F. Mondschein & Co., for $1,250 from the Sumner Fund.
 Exhibitions: Kent, 1966.
 The Ella Gallup Sumner and Mary Catlin Sumner Collection, 1939.243

Ridolfi mentions a portrait by Tinelli of "Marco' Antonio Viaro, e nelle case sue di S. Benedetto" that is surely identifiable with the Atheneum portrait.[2] Nothing further is known of Viaro.

The portrait, the only signed and dated work of the master, was painted at the end of his life, and shows Tinelli's debt to Leandro Bassano, as well as his study of the Genoese portraits by van Dyck.[3] J.C.

1. "Whoever looks at this portrait may admire in it the image of Marco Antonio Viaro, the model of all virtues, and truly a guardian deity to his friends; his admirer Pietro Bombarda, with great respect, Tiberis Tinelli, knight, painted 1637."
2. Ridolfi, 1914–24, II, 282.
3. Waterhouse, 1969, 133, fig. 114; Pallucchini, 1981, I, 108, II, fig. 292.

Jacopo Tintoretto
(1518–1594)

Jacopo Tintoretto was born in 1518, as deduced from the notice of his death on 31 May 1594, in which he is declared to be seventy-five years old.[1] Although his surname was Robusti, he took his name from the occupation of his father, a dyer (*tintore*).

Tintoretto's master is not known. He is said to have studied briefly with Titian,[2] who clearly influenced him the most, but apprenticeships with Bonifacio, Schiavone, and Paris Bordone have also been suggested.[3] The influence of Central Italian artists, such as Michelangelo, may also have been transmitted through prints or casts.[4]

Although Tintoretto is known to have been an independent master as early as 1539,[5] his earliest documented work is the *Last Supper* of 1547 at S. Marcuola, Venice.[6] Works before 1547 that have been plausibly identified include the large *Sacra Conversazione*, inscribed *Iacobus* and dated 1540.[7] After 1547 Tintoretto's documented works are numerous. His most noteworthy commissions include the canvases for Sta. Maria dell'Orto from the middle 1550s, the decoration of the Sala dell'Albergo in the Scuola di S. Rocco executed between 1565 and 1567 and the other rooms between 1577 and 1585, and numerous works for the Palazzo Ducale. Active almost exclusively in Venice, he ran a large workshop with the participation of his sons and daughter.

1. First published by F. Galanti, "Il Tintoretto," *Atti della Reale Accademia di Belle Arti*, Venice, 1876, 76–77, no. 2; see also Pallucchini and Rossi, 1982, 125.
2. Ridolfi, 1648, II, 13.
3. Tietze, 1948, 32.
4. Borghini, 1584, 551, says that he was influenced by Michelangelo.
5. D. von Hadeln et al., *Archivalische Beiträge zur Geschichte der venezianischen Kunst aus dem Nachlass G. Ludwigs, italienische Forschungen*, Berlin, 1911, IV, 126.
6. Pallucchini and Rossi, 1982, 155, no. 127.
7. Pallucchini and Rossi, 1982, 132–33, no. 11.

The Contest between Apollo and Marsyas

Oil on canvas, 140.5 x 239 cm (55 1/4 x 94 1/4 in.)
 The painting, originally an oval, has been made into a rectangle by the addition of corners.
 Condition: generally good, with a few scattered retouches. There are many pentimenti, including that in Apollo's left arm, the viola, Marsyas's right leg, Athena's left arm and head, and the foreground judge's foot.
 Provenance: collection Pietro Aretino, by 1545 (see below); Sir Dudley Carlton, The Hague;[1] duke of Abercorn; Sir William Bromley Davenport, sale London, Christie's, 28–29 July 1926, no. 149, bought by Gordon for 2,205 guineas; Thos. Agnew & Sons, London; Stephen Courtauld; Thos. Agnew & Sons, London, 1949; bought by the Wadsworth Atheneum in 1950 from Thos. Agnew & Sons for $16,820 from the Sumner Fund.
 Exhibitions: London, Royal Academy, *Old Masters*, 1892, no. 117; Toronto, Art Gallery of Toronto, *Titian, Tintoretto, Paolo Veronese, with a Group of Sixteenth-Century Venetian Drawings*, Feb.–Mar. 1960, no. 6; Hartford, 1982; London, 1984, no. 100, repr.
 The Ella Gallup Sumner and Mary Catlin Sumner Collection, 1950.438

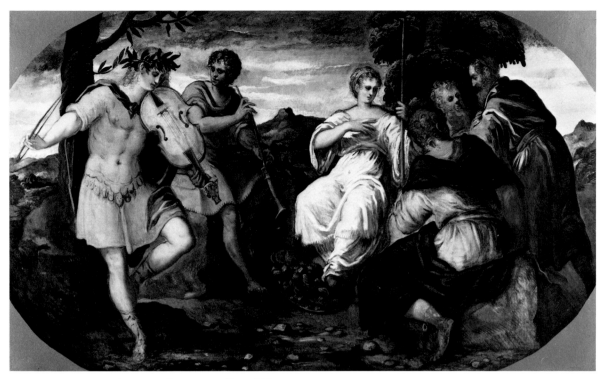

Jacopo Tintoretto, *The Contest between Apollo and Marsyas*

Marsyas, a satyr, took up the flute discarded by Athena and learned to play with great skill, so much so that he challenged Apollo to a contest to see who was the better musician.[2] The contest was judged by the Muses, and Apollo was the victor. Marsyas was flayed alive as his punishment.

In the Atheneum picture Apollo, crowned with laurel, indicative of his patronage of the arts, plays on his instrument, a *lira da braccio*, while Marsyas, seated to the right, listens.[3] Marsyas holds a shawm, an early double-reed instrument.[4] Athena, dressed in white and recognizable by her shield and spear, is seated to the right of center, while three judges sit in an arc at the right. In the center background are seen the twin peaks of Mount Helicon, the home of Apollo and the Muses.[5]

Scholars have assumed that Tintoretto painted the *Contest between Apollo and Marsyas* and its now lost pendant, *Mercury and Argus*, for Pietro Aretino.[6] In a letter of 15 February 1545, Aretino wrote to Tintoretto thanking him for the paintings:

> E belle e pronte e vive in vive, in pronte e in belle attitudini da ogni uomo che di perito giudicio sono tenute le due istorie: una in la favola di Apollo e di Marsia, e l'altra in la novella di Argo e di Mercurio, da voi così giovane quasi dipinte in meno spazio di tempo che non si mise in pensare al cio che dovevate dipingere nel palco de la camera, che con tanta sodisfaizone mia e d'ognuno voi m'avete dipinta. . . . Certamente la brevità del fare consiste ne lo intendere altri quel che si fa, nel

modo che lo intende il vostro spirito intendente il dove si distendono i colori chiari e gli oscuri.[7] Aretino refers to the paintings in another letter of January 1551 as "le figure del soffitto."[8] While Aretino nowhere describes precisely these paintings, several factors point to an identification of the Atheneum painting with that painted for Aretino. The format of the *Contest between Apollo and Marsyas*, an elongated oval, is commonly found in Venetian ceiling paintings; and the style of the painting, freely executed with dynamic, curving contours and numerous pentimenti, would seem to accord with the hasty execution mentioned by Aretino. It is also generally agreed that the date of about 1545 implied by Aretino's letter accords well with the style of the Atheneum painting; the bright colors and free handling of paint are particularly close to Schiavone, whose influence is felt in other works by Tintoretto of approximately the same date.[9] That the composition is arranged frontally, instead of foreshortened, or seen *di sotto in sù* as was commonly the case in Venetian ceiling decorations and, indeed, seen in the earlier set of ceiling paintings Tintoretto painted for the Conti Pisani di S. Paterniano and now in the Galleria Estense in Modena, including an *Apollo and Marsyas*,[10] has been taken as evidence against the identification of the Atheneum painting with Aretino's works;[11] however, a reversion to the Central Italian tradition

of *quadri riportati*, or a decoration creating an illusion of framed pictures covering the ceiling, would have been entirely appropriate for a commission from Aretino, who championed Central Italian artistic ideals.[12]

Further evidence for the identification of the Atheneum painting with Aretino's commission lies with the subject itself. A recent interpretation of the picture relates it to Aretino's professional ambitions and self-image.[13] The decision to show the contest of Apollo and Marsyas, and not its gruesome outcome as in most other representations of the theme,[14] perhaps can be understood as a reference to Aretino's mastery of two modes of poetry, the encomiastic mode, praising the ideal in man, and the realistic mode, exposing his baseness. The antithesis between string and wind instruments had since antiquity symbolized the opposition of musical modes, the paean and the dithyramb, and in the Renaissance this symbolism was extended to high and low modes of poetry.[15]

The personification of the judges at the right in Tintoretto's painting may also relate to Aretino. The older, bearded judge in the rear, and the younger judge, seated with his back to the spectator, may allude to Aretino's role as advisor to young poets and artists. The third judge, leaning forward with his head in profile, may be a portrait of Ariosto[16] and may relate to Aretino's conscious imitation of Ariosto's courtly language. It has also been identified as a portrait of Aretino himself.[17]

The *Contest between Apollo and Marsyas* and its pendant relate to other pictures painted by Tintoretto early in his career. The paintings for the Casa Pisani now in Modena illustrate themes from Ovid and include both these subjects.[18] While they are depicted in steep foreshortening, the *Apollo and Marsyas* is like the Atheneum painting in its depiction of the musical contest. Another picture variously identified as a *Contest between Apollo and Marsyas* or a *Judgment of Pan* is in Coral Gables, Florida (Fig. 48).[19] The picture, which is on canvas but much smaller than the Atheneum picture, shows striking similarities to it in composition and detail; the pose of Apollo echoes in reverse that of the god in the Atheneum picture, and the lower torso of the bearded, seated judge in the foreground mirrors the pose of the young judge at

the right in the Atheneum picture. While the exact subject of the Florida picture is not clear, and indeed the subjects of the Apollo and Marsyas and Apollo and Pan were often conflated,[20] the absence of a figure that can be identified with Midas might point to identification of the scene as the contest of Apollo and Marsyas.[21] Pallucchini and Rossi have identified a *Mercury and Argus* as a possible pendant to the Florida picture, further supporting the identification of the Florida picture as *Apollo and Marsyas* and its link to the Atheneum painting.[22] The Florida picture, whether a preliminary study for the Hartford picture or an independent work, was certainly executed at about the same time as the Hartford picture and can be taken as a version of it.[23]

Von Hadeln[24] identified a study in Christ Church, Oxford, as a preliminary drawing after an antique sculpture for the figure of Apollo in the Atheneum picture. The drawing, more recently attributed to studio of Tintoretto,[25] shows only a general similarity to the painted figure. Maxon[26] pointed to the Apollo in the Grimani Collection as Tintoretto's source for the Apollo; again the similarities are only approximate. Tintoretto undoubtedly was inspired by antique sculpture in designing his figures; Ridolfi describes Tintoretto's efforts to obtain casts from antique sculpture.[27] J.C.

Figure 48. Jacopo Tintoretto, *Apollo and Marsyas*, Coral Gables, Fla., University of Miami, Lowe Art Museum

1. Sir Dudley Carlton was British ambassador to The Hague in 1616–25. The *Contest between Apollo and Marsyas* was described under no. 11 in an inventory of his collection dated 1 Sept. 1618, as "The Contention of Mars and Apollo concerning music by Tintoretto Vecchio," measuring 5 x 7 piedi d'Anversa; Carlton evidently also had the pendant to the picture, listed as no. 12, as "the history of Jupiter and Semele by Tintoretto Vecchio" with the same measurements. The inventory is published in W. N. Sainsbury, *Original Unpublished Papers Illustrative of the Life of Sir Peter Paul Rubens*, London, 1859, 46–47.

2. Ovid, *Metamorphoses* VI, 382–400.

3. The *lira da braccio*, a predecessor of the violin, is characterized by its waisted profile, five finger-board strings, and two off-board drones, all visible in the instrument Apollo holds. See Diagram Group, 1976, 209. For the significance of the *lira da braccio*, see E. Winternitz, *Musical Instruments and Their Symbolism in Western Art*, London, 1967, 86–98; for discussion of Tintoretto's depiction of instruments, see Weddigen, 1984, 74–78.

4. Diagram Group, 1976, 46.

5. Palladino, 1981, 332.

6. H. Thode, *Tintoretto*, Bielefeld-Leipzig, 1901, 25–27 (tentatively identified as painted for Aretino); F. P. B. Osmaston, *The Art and Genius of Tintoret*, London, 1915, II, 183; E. von der Bercken and A. L. Mayer, "Beiträge zur Entwicklungsgeschichte Tintorettos," *Münchner Jahrbuch der bildenden Kunst*, X, 1916–18, 247; von Hadeln, 1922, 212; E. von der Bercken and A. L. Mayer, *Jacopo Tintoretto*, Munich, 1923, I, 54, 248; M. Pittaluga, *Il Tintoretto*, Bologna, 1925, 188, 271; Venturi, *Storia*, 1929, IX, iv, 405; E. von der Bercken, "Jacopo Tintoretto," in Thieme and Becker, 1939, XXXIII, 189; Coletti, 1940, 4; von der Bercken, 1942, 43, 112, no. 158, pl. 18; Tietze, 1948, 353, pl. 3; R. Pallucchini, *La Giovinezza del Tintoretto*, Milan, 1950, 93–94, 157, n. 56; "Apollo and Marsyas by Jacopo Tintoretto," *Wadsworth Atheneum Bulletin*, 2nd ser. no. 21, Jan. 1951, 1; E. Newton, *Tintoretto*, New York, 1952, 55; Berenson, 1957, I, 173; *Wadsworth Atheneum Handbook*, 1958, 32; Aretino, 1960, III, ii, 472–73; Maxon, 1962, 56–60; R. Pallucchini, "Jacopo Tintoretto," *Encyclopedia of World Art*, 1965, XIII, col. 940; Schulz, 1968, 25, 117, no. 46; R. Pallucchini, "Inediti di Jacopo Tintoretto," *Arte veneta*, XXIII, 1969, 38, 53, n. 30; De Vecchi, 1970, 88, no. 28; Fredericksen and Zeri, 1972, 585;

A. L. Lepschy, *Tintoretto and His Critics*, London, 1972, 55;
R. Pallucchini, "Per gli inizi veneziani di Giuseppe Porta,"
Arte veneta, XXIX, 1975, 162; A. Gentili, *Da Tiziano a Tiziano: Mito e allegoria nella pittura veneziano del Cinquecento*, Milan, 1980, 148, 181; Lepschy, 1983, 15–16.

7. "All connoisseurs agree that the two fables, that of Apollo and Marsyas and the tale of Argus and Mercury, are beautiful, lively and effortless, as are the attitudes adopted by the figures therein: these you, so young, have painted to my great satisfaction and indeed to everybody else's, for the ceiling of my house, in less time than normally might have been devoted to the mere consideration of the subject. Certainly the brevity of the execution depends upon knowing exactly what one is doing; so that one sees, in the mind's eye, exactly where to place the light colours and where the dark." Aretino, 1957, II, 52–53; trans. in Lepschy, 1983, 16.

8. Aretino, 1957, II, 385. On Aretino's house, see Cairns, 1966, 193–205.

9. Pallucchini and Rossi, 1982, I, 20–21.

10. Pallucchini and Rossi, 1982, I, 134–35, nos. 21–34.

11. F. Arcangeli, "La 'Disputa' del Tintoretto a Milano," *Paragone*, no. 61, 1955, 11, 30–31; A. Pallucchini, *Tintoretto*, Florence, 1969, 11, 28; Pallucchini and Rossi, 1982, I, 25.

12. London, 1983–84, 212, no. 100. Rearick, 1984, 68, however, disagrees.

13. For this interpretation and what follows below, see Palladino, 1981, 329–36.

14. For example, Titian's *Punishment of Marsyas* in Kromeriz; see Wethy, 1975, III, 153–54, and Tintoretto's own approximately contemporary depiction of Apollo roping Marsyas to a tree, illustrated in Pallucchini, 1982, 124–26. See also Winternitz, 1959, 190, n. 17.

15. Winternitz, 1959, 187; Palladino, 1981, 331.

16. See the portrait of Ariosto in the woodcut designed by Titian for the 1532 edition of *Orlando Furioso* (Pierpont Morgan Library, inv. no. 800/E–2/46/B).

17. Schulz, 1968, 117, n. 4; compare the profile portrait of Aretino in the 1534 edition of *La Cortigiana*, frontispiece, and copied many times; see also Aretino, 1960, III, ii, figs. 36, 38, 41. Schulz's identification is supported in London, 1983–84, 212, no. 100.

18. Pallucchini and Rossi, 1982, I, 134–35, nos. 23, 28.

19. Shapley, 1973, 50–51, no. K343, 22.6 x 54.6 cm; Pallucchini and Rossi, 1982, I, 139–40, no. 61.

20. Palladino, 1981, 331.

21. Tietze, 1951, 60, n. 3, noted the absence of Midas, but still identified the scene as the *Judgment of Midas*.

22. Pallucchini and Rossi, 1982, I, 140, no. 62.

23. Tietze, 1951, 59–60, noted Tintoretto's habit of painting many variants of a composition, rather than evolving his compositions in a series of sketches. He thought the Florida picture was painted after the Atheneum picture, as did Pallucchini, 1950, 96. Shapley, 1973, 51, has suggested the Florida picture is part of a group of decorative pictures, perhaps made for furniture, formerly in the collection of Count Seilern. That the Florida picture is on canvas and about 11 centimeters narrower than the other paintings seems to rule out its inclusion in this group. For another version of the theme recently attributed to Tintoretto and dated to the mid 1540s, see Pallucchini and Rossi, 1982, I, 147–48, no. 100.

24. Von Hadeln, 1922, 212.

25. Byam Shaw, 1976, I, 207, no. 767.

26. Maxon, 1962, 59–60.

27. Ridolfi, 1914–24, II, 6.

Workshop of Jacopo Tintoretto
Hercules and Antaeus

Oil on canvas, 153 x 102.5 cm (60¼ x 40⅜ in.)

The weave of the canvas is at about a 50-degree angle from the base, suggesting that the picture is a fragment of a larger composition, perhaps a decorative ensemble, that has been reoriented. The edges are ragged, and the painting has been lined.

Condition: good. The upper right corner is largely inpainted.

A sticker on the verso reads: 80.

Provenance: collection Sir Charles Capel Wolseley, Scanes Hill, Sussex; Durlacher Bros., New York, 1928; bought by the Wadsworth Atheneum in 1928 from Durlacher Bros. for 6,000 pounds ($29,250) from the Sumner Fund.

Exhibitions: Hartford, 1928, no. 11; Toronto, 1935, 9, no. 25; Iowa City, University of Iowa Fine Arts Building, *Exhibition of Figure Painting*, Nov. 1936, no. 56; New York, 1939, no. 379; New York, Durlacher Bros., *A Loan Exhibition of the Paintings of Jacopo Robusti, Il Tintoretto*, 20 Feb.–18 Mar. 1939, no. 2; Washington, D.C., Phillips Memorial Gallery, *Emotional Design in Painting*, 7 Apr.–5 May 1940, no. 1; Hartford, 1946, 15, no. 55; Columbus, Ohio, Columbus Gallery of Fine Arts, *The Age of Titian*, 6 Oct.–10 Nov. 1946, 15, no. 18, pl. 4; St. Louis, City Art Museum, *Forty Masterpieces: A Loan of Paintings from American Museums*, 6 Oct.–10 Nov. 1947, 90–91, no. 38, repr.; Hartford, *In Retrospect*, 1949, 7, no. 4; Indianapolis, Art Association of Indianapolis, John Herron Art Museum, *Pontormo to Greco: The Age of Mannerism*, 14 Feb.–28 Mar. 1954, no. 58, repr.; Sarasota, 1958, no. 67.

The Ella Gallup Sumner and Mary Catlin Sumner Collection, 1928.2

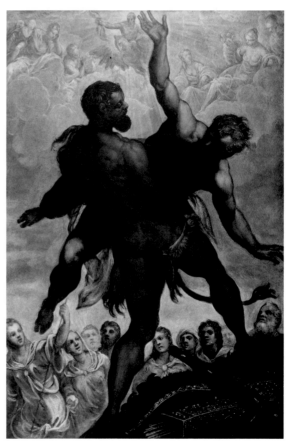

Workshop of Jacopo Tintoretto, *Hercules and Antaeus*

On his return from Hesperides, Hercules is forced to wrestle with the giant Antaeus of Libya, son of Terra and Neptune. Antaeus is invincible as long as he is touching the ground, receiving his strength from his mother Earth. Hercules holds him above the ground, crushing him against his own body until Antaeus is defeated.[1]

Traditionally ascribed to Jacopo,[2] the painting has more recently been ascribed to Domenico Tintoretto.[3] It is difficult, however, to relate the *Hercules and Antaeus* to the documented works of Domenico Tintoretto, and an ascription to the workshop of Jacopo is preferable.

The *Hercules and Antaeus* is generally dated to about 1570.[4] J.C.

1. Philostratus, *Imagines* II, 21.
2. A. E. Austin, Jr., "A Painting by Tintoretto," *Wadsworth Atheneum Bulletin*, VI, no. 1, Jan. 1928, 1–4; *Bulletin de la Revue de l'Art*, Paris, 1928, 114; "Hartford Makes First Sumner Purchase," *Art News*, XXVI, no. 16, 1928, 1–2; *Wadsworth Atheneum Annual Report*, 1929, 12; Berenson, 1932, 560; Venturi, 1933, III, pl. 550; Hartford, 1934, 34; A. M. Frankfurter, "The Great Venetians: Paintings in American Collections," *Art News Annual*, XXXVI, 1938, pl. 28; von der Bercken, 1939, 193; A. M. Frankfurter, "Tintoretto on 57th Street," *Art News*, XXXVII, Feb. 1939, 6–8, 20; Coletti, 1940, 26; *Magazine of Art*, XXXIII, no. 5, 1940, 286; von der Bercken, 1942, 111, fig. 131; Shoolman and Slatkin, 1942, 312, fig. 320; E. Herzog, "Zwei philostratische Bildthemen der venezianischen Malerei," *Mitteilungen des kunsthistorischen Instituts in Florenz*, VIII, 1958, 112–17, fig. 1; De Vecchi, 1970, 112, no. 186; Fredericksen and Zeri, 1972, 584; Jaffé, 1977, repr. pl. 184.
3. Paoletti, 1968, 422. J. Maxon, letter in curatorial file, 18 Dec. 1950, thought the principal figures by Domenico and the background figures by a workshop assistant; H. Tietze, letter in curatorial file, 8 Sept. 1950, thought the painting a typical work of Domenico Tintoretto. Pallucchini and Rossi, 1982, I, 245, no. A44, ascribe the work to Domenico.
4. Venturi, 1933, III, pl. 550, dated it to shortly after 1568; Coletti, 1940, 26, to about 1570; von der Bercken, 1942, 111, to about 1564–70; De Vecchi, 1970, 112, no. 186, to 1569–70; Jaffé, 1977, pl. 184, to about 1550; and Pallucchini and Rossi, 1982, I, 245, no. A44, to about 1588–90.

Tiziano Vecellio, called Titian (c. 1477–1576)

Born about 1477 in Pieve di Cadore, Titian came to Venice to study at an early age.[1] What he might have learned from his reputed teachers, the aged Giovanni Bellini and Giorgione, is debated, as is the corpus of his early works. His first documented work, the frescoes in the Scuola del Santo in Padua, date to 1511; while the great altarpiece of the *Assumption* in the

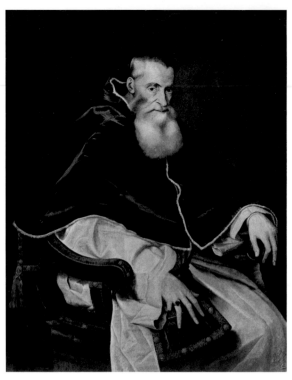

After Titian, *Portrait of Pope Paul III*

church of the Frari in Venice, datable to between 1516 and 1518, established his reputation as one of the greatest Venetian painters.

From this point on, Titian's career unfolds with astonishing speed and breadth; his genius was always recognized, and he numbered among his patrons popes, princes, and European monarchs. The esteem in which he was held accounts for the wealth of documentation relating to his oeuvre, as well as its high survival rate. It also explains the numerous copies after his works, both by his students and followers.

1. The conflicting accounts of Titian's birth date and training have been summarized by Gould, 1975, 265–66.

After Titian
Portrait of Pope Paul III

Oil on canvas, 120 x 95.9 cm (47⁵/₁₆ x 37³/₄ in.)
Condition: poor. There are many losses and general abrasion. Discolored inpaintings are visible in the drapery.
Labels on the reverse of the stretcher read: Museum of Fine Arts/759; Jane Newell Moore.
Provenance: collection Jane Newell Moore, 1907; William Maxwell, Rockville, Conn. Given to the Wadsworth Atheneum in 1942 by the estate of William Maxwell.
Exhibitions: Houston, University of St. Thomas, *Builders and Humanists. The Renaissance Popes as Patrons of the Arts*, 17 Mar.–8 May 1966, no. 48.
Gift of the Estate of William Maxwell, 1942.418

The Atheneum painting is one of many copies of Titian's *Portrait of Paul III* in the Galleria Nazionale at Capodimonte in Naples.[1]

According to Vasari, Titian painted a portrait of Paul III Farnese in Bologna in 1543.[2] From this portrait he made a replica for Cardinal S. Fiore.[3] Vasari notes that at the time of writing, in 1568, both versions were in Rome, the original in the collection of Cardinal Farnese, the other with the heirs of Cardinal S. Fiore.[4] Vasari also notes that many copies were made that were scattered over Italy.

The painting described by Vasari has been identified with the portrait of the pope, bareheaded, that is in Naples. The replica was identified with another portrait of the pope, somewhat older and wearing the papal biretta, also in Naples.[5] More recently, the identity of the replica with the second Naples copy has been challenged, and the replica for Cardinal S. Fiore is presumed lost.[6]

The poor condition of the Atheneum picture does not allow precise dating.[7] J.C.

1. The identification was made by E. Tietze-Conrat, "Titian's Portrait of Paul III," *Gazette des Beaux-Arts*, 6th ser. XXIX, 1946, 80, n. 22. For further information on the painting in Naples and its copies, see Wethey, 1971, II, 122–24, no. 72, pls. 115–17 and figs. 258–62.
2. Vasari, 1906, VII, 443.
3. Vasari, 1906, VII, 443. Milanesi, 443, n. 1, identifies this cardinal as Guido Ascanio Sforza.
4. Vasari, 1906, VII, 443.
5. See J. A. Crowe and J. B. Cavalcaselle, *Life and Times of Titian*, London, 1881, II, 90.
6. Wethey, 1971, II, 123–24, nos. 72–73.
7. F. Heinemann, oral communication, 17 Sept. 1974, thought the painting was by Cesare Vecellio, the great-grandnephew of Titian.

Gaspare Traversi
(1722?–1770)

Traversi's formation in the decorative tradition of Neapolitan painting is obscure, as are the details of his entire life, despite the fact he was one of the country's outstanding eighteenth-century painters of anecdotal narratives and portraits. Spinosa sees in his first dated works of 1749, scenes from the life of the Virgin in Sta. Maria dell'Aiuto, Naples, reflections of Francesco Solimena plus elements of seventeenth-century naturalism. This latter was developed markedly in three pairs of pictures, one dated 1752, now in S. Paolo fuori le Mura, Rome. Caravaggism was to remain a potent influence in his work, as seen in the Atheneum picture below, which is thought to follow closely upon the paintings in S. Paolo. This persistently refreshed naturalism, plus the appearance of his name in Roman and Emilian inventories, while absent from inventories of Neapolitan families, suggest his career developed mainly in Rome,[1] where, in fact, he is recorded in church records from 1755 until his death there in 1770.[2]

1. N. Spinosa in Detroit, 1981, I, 148–51.
2. Heimbürger Ravalli, 1982, 25–26.

The Quarrel

Oil on canvas, 128.3 x 180.6 cm (50 1/2 x 71 1/4 in.)

Condition: fair. Extensive pentimenti throughout, presumably made more apparent by heavy cleaning, for example, at the top of the central female's right index finger, on her right cheek, and on the thumb and third finger of her left hand. Her hair is repainted, as is the hair, cap, and profile of the right background figure. The faces of the two right foreground figures are retouched. This heavy cleaning and repainting, coupled with an unsystematic removal of darkened varnish, make it difficult to ascertain the overall condition of the original surface.

Provenance: Sir Montague L. Meyer, Avon Castle, sale London, Sotheby's, 3 Apr. 1946, no. 131, as G. Traversi, bought by Wengraf for 205 pounds; Lili Fröhlich-Bum. Purchased by the Wadsworth Atheneum in 1948 from Durlacher Bros., New York, for $4,000 from the Sumner Fund.

Exhibitions: Hartford, 1956, no. 56; Naples, 1979, no. 107; Detroit, 1981, no. 49.

The Ella Gallup Sumner and Mary Catlin Sumner Collection, 1948.118

Two finely dressed men have fallen out over a gaming board. The Wichmans interpret the game to be chess and suggest the scene is a seventeenth-century interpretation of an iconographic usage traceable to a fifteenth-century French illustration of a scene from *Renaud de Montauban*, which had become, in the intervening time, part of the folk tradition.[1] Grunfeld and Kruijswijk describe the game as checkers.[2] The pieces, like the board, are brown and light brown.

This large picture is an arresting combination of realism and stylization. The features of the man drawing a pistol are a wonder of intensely observed realism. A close second is the equally coarse-featured, intervening woman, whose face reminded Bologna of Terbrugghen.[3] Yet the rise and fall of the foreground composition, pulled so close to the picture plane and so arbitrarily interrupted at the edges, is acutely artificed. The background figures spring to the fray in a very notional space. Just such juxtaposed incongruities account for this artist's fascination. Traversi's pictures do not have the serene appeal of Chardin's genre scenes or the easy topicality of the English conversation piece.[4] Heimbürger Ravalli has suggested some depict familiar scenes from the contemporary theater, a proposal that would account for their anecdotal as well as their stylishly staged quality,[5] but she has not traced any specific source in the Neapolitan theater of about 1750–52 for the Atheneum picture.[6] The four principals are to be recognized, again according to Heimbürger,[7] in other pictures by the artist; for example, the same young woman appears in *The Arts: Drawing* in Kansas City.[8]

In 1939 Ortolani mentioned a *Quarrel* in the collection of the duc de Trévise, Paris, and another

Gaspare Traversi, *The Quarrel*

belonging to Professor Nicolò Castellino, Naples.[9] Neither can be the Atheneum picture, which in 1939, Fröhlich-Bum said, was and had been for some time in the collection of Sir Montague L. Meyer, Avon Castle, hidden under an attribution to Hogarth, before it passed to Lili Fröhlich-Bum.[10]

Traversi's earliest dated works, the three scenes from the life of the Virgin in Sta. Maria dell'Aiuto, Naples, of 1749, are pallid distillations of Francesco Solimena and his successor, Francesco Mura. Only what might be a self-portrait cast as St. Luke in the *Assumption* from the series anticipates the artist's fully personal style seen in the ensemble of six biblical and New Testament subjects, one of which is dated 1752, preserved in but not painted for the monastery at S. Paolo fuori le Mura, Rome.[11] Since they were first discussed by Longhi,[12] all critics[13] have commented upon the tenebrist palette and the revival of seventeenth-century Caravaggesque realism in these six works, be it mediated by Traversi's Neapolitan antecedents or precipitated by his perhaps settling in Rome, where he might have been established from either 1752 or 1754 onward.[14] Longhi also knew the Atheneum picture when it belonged to Fröhlich-Bum

and is said to have considered it among the artist's most beautiful paintings.[15] Spinosa, too, when the picture was exhibited in Naples in 1979–80, and in Detroit and Chicago in 1981–82, spoke of it as one of Traversi's most successfully realized works of his early maturity, dating it immediately after the S. Paolo group.[16]

Heimbürger Ravalli sees very close compositional affinities between the Atheneum picture and two of the S. Paolo fuori le Mura group: the *Raising of Lazarus* and the *Raising of the Widow's Son at Naim*. All have compositions firmly arranged on a triangle whose apex recedes into the picture space. Subordinate figures in all three are arranged in the background behind this angular foreground composition. She notes that the tipped angle of the head on the rightmost girl in the Atheneum picture, a very curious angle indeed, is also seen in the heads of the sister of Lazarus and of the widow's son. She would thus date the Atheneum picture 1752.[17] M.M.

1. Wichman, 1960, 311, no. 131, as "Der Streit beim Schachspiel."

2. Grunfeld, 1975, 86. K. Kruijswijk to M. Mahoney, 23 June 1983, curatorial file.

3. Bologna, 1980, 84.

4. Antal, 1962, 205, sees an influence from Hogarth in Traversi's work. For a discussion of possible English influences on the artist, also see Bologna, 1980, 56–58.

5. Heimbürger Ravalli, 1982, 32–38.

6. M. Heimbürger Ravalli to M. Mahoney, 14 June 1983, curatorial file.

7. M. Heimbürger Ravalli to M. Mahoney, 14 June 1983, curatorial file.

8. Nelson-Atkins Museum of Art, inv. no. 1961.71, a pendant to *The Arts: Music*, inv. no. 1961.70. Shapley dates the pair circa 1750 (1973, 117, figs. 213–33).

9. Thieme and Becker, 1939, XXXIII, 361.

10. L. Fröhlich-Bum to C. Cunningham, 1 Jan. 1949, curatorial file. The painting was brought to the Atheneum's attention by the Tietzes who "thought it one of the most brilliant paintings of its class" (H. Tietze to C. Cunningham, 21 Jan. 1947, curatorial file). When purchased from Durlacher Bros., New York, in May 1948, the former owner's name was erroneously cited as "Mayer." *Wadsworth Atheneum Bulletin*, Sept. 1948, 4. *Wadsworth Atheneum Annual Report*, 1948, 11, 29. Cunningham, Jan. 1949, 1. Cunningham, 1949, 182–85, repr. Fredericksen and Zeri, 1972, 205, 497, 585.

11. Heimbürger Ravalli, 1982, 15–24, figs. 6–15. It is the *Raising of Lazarus* that is signed and dated (39, n. 3). The six are actually three pairs, as suggested by their iconography and by the larger size of two (16–17, and Barocelli, 1982, 82, n. 37).

12. Longhi, 1927, 150–52, figs. 9–13.

13. See Bologna, 1980, 70–71, n. 3, for bibliography.

14. Heimbürger Ravalli, 1982, 24–30.

15. L. Fröhlich-Bum to C. Cunningham, 1 Jan. 1949, curatorial file: "I forwarded a photograph . . . to Roberto Longhi . . . and he said in his answer: 'sono molto grato per la splendida fotografia del nuovo Traversi. Pare anche a me uno dei quadri più belli del maestro. Che caratteri e che régisseur!' "

16. In Naples, *Civiltà*, 1979–80, 218, no. 107, "tra le opere di più articolata caratterizzazione espressiva," with the provenance incorrectly as "Mayer" and the London sale date incorrectly as 13 Apr. 1946.

17. M. Heimbürger Ravalli to M. Mahoney, 14 June 1983, curatorial file.

Paolo da Venezia
(active 1333–c. 1362)

The earliest documentary evidence for Paolo da Venezia's life is a signature and date of 1333 on a picture of the *Dormition of the Virgin* in the Museo Civico, Vicenza. Two years later his name appears in a memorandum written by a notary from Treviso, Oliviero Forzetta.[1] This document mentions Paolo as brother of Maestro Marco, and it notes that Paolo had made two drawings on paper of the *Death of St. Francis* and the *Death of the Virgin*. The only other written document for Paolo's life is a deposition of 30 March 1341, written in the artist's own hand, from which we learn that Paolo lived in the parish of S. Luca, Venice, where many workshops of Venetian painters were located.[2] Authentic dates on surviving paintings include one of 1340 on a painting of the *Madonna Enthroned with Ten Angels* in the Aldo Crespi Collection, Milan, and one of 1347 on a painting of the *Madonna and Child Enthroned with Eight Angels* at Carpineta di Cesena, Chiesa Arcipretale di Sta. Maria.[3] Paolo also signed his name with those of his sons on two paintings, the so-called Pala Feriale, or cover for the Pala d'Oro, dated 22 April 1345, with sons Luca and Giovanni;[4] and the *Coronation of the Virgin* in the Frick Collection, New York, dated 1358, with son Giovanni only.[5] Dated paintings that are not signed but have been reasonably associated with Paolo include the *Madonna Enthroned* in the

convent of the Canossiane at S. Alvise, Venice, dated indistinctly 1336 or 1339;[6] the polyptych with the *Madonna and Saints* in the church of S. Martino in Chioggia, dated 1349;[7] and the polyptych formerly in the cathedral at Piran, dated 1355.[8] The lunette in the basilica of Sta. Maria Gloriosa dei Frari, Venice, of the *Madonna and Child Adored by the Doge Francesco Dandolo and His Wife Elisabetta Contarini*, has been reasonably attributed to Paolo and can be dated on external evidence to 1339–40.[9]

Paolo is thought to have been born between 1292 and 1300, and he is referred to as deceased in a document of 1362.[10]

Paolo da Venezia is considered the founder of Venetian painting. His oeuvre strikes a balance between Byzantinizing trends from the East and artistic developments on the terra firma and beyond the Alps. The specific sources of his style and the corpus and chronology of his early work are debated among scholars. One group sees his early pictures in a Byzantinizing idiom, from which he gradually moves to a more Gothic style under the influence of Giotto's frescoes in the Arena Chapel in Padua and contact with Bolognese painters of the school of Vitale da Bologna.[11] More recently, this view has been challenged by Muraro, who removes the early Byzantinizing works from Paolo's oeuvre and attributes them to the Master of the Washington *Coronation of the Virgin*, whom he identifies with Paolo's brother Marco.[12] Muraro's thesis is based partly on a reading of the Forzetta document that places Marco at the head of a *bottega* in which Paolo worked.[13] Paolo's mature style is generally conceded to have emerged with the Pala Feriale, the commission for which, along with that of the Dandolo lunette, would seem to signal Paolo's position as official painter to the Venetian state. From 1350 on his style is characterized by a renewed Byzantinization, yet on the basis of the profound experience of Gothic painting of the preceding two decades. During this time Paolo's workshop becomes more active, and trips for the artist to Bologna and Constantinople are posited. Muraro also suggests that Paolo moved his workshop to Dalmatia, based on commissions executed for Dubrovnik and Trogir and documents in the State Archive, Dubrovnik.[14]

1. First published by Rambaldo degli Azozni Avogadro, "Trattato della zecca e delle monete che ebbero corso in Trevigi, fin tutto il secolo XIV," in G. A. Zanetti, *Monete e zecche d'Italia*, Bologna, 1785, IV, reprinted in Muraro, 1970, 82–83.

2. This was first published by B. Cecchetti, *Archivio veneto*, XXXIII, 1887, 310; reprinted in Muraro, 1970, 83.

3. See Muraro, 1970, 83, for transcriptions.

4. Muraro, 1970, 84.

5. Muraro, 1970, 85; the Frick *Coronation* has been associated recently with a panel of saints at S. Severino by H. Kiel, "Das Polyptycyon von Paolo und Giovanni Veneziano in Sanseverino Marche," *Pantheon*, XXXV, 1977, 105–8.

6. Muraro, 1970, 83.

7. Muraro, 1970, 106–7.

8. Muraro, 1970, 118–19.

9. Muraro, 1970, 33–35, 126–27.

10. Muraro, 1970, 85.

11. Pallucchini, 1964, 18–55.

12. Muraro, 1970, 22–25, 156–57.

13. For another interpretation of the Forzetta document, see G. Gamulin, review of Muraro, 1970, in *Arte veneta*, XXIV, 1970, 255–67.

14. Muraro, 1970, 61, 84.

Workshop of Paolo da Venezia
The Angel of the Annunciation

Tempera on wood, with frame, 38 x 11.7 cm (14⁷/₈ x 4⁵/₈ in.); painted surface, 26.6 x 7.2 cm (10³/₈ x 2⁷/₈ in.)

The Virgin Annunciate

Tempera on wood, with frame, 38.7 x 12 cm (15¹/₄ x 4³/₄ in.); painted surface, 26.5 x 10.2 cm (10³/₈ x 4 in.)

The sides of each panel have been cut down slightly.

Condition: both good. There is a small damage above the head of the Angel and near the foot; there are retouchings at the left edge of the sleeve and back of the robe. Similar retouchings are in the figure of the Virgin. The letters of the inscriptions have been reinforced.

Inscribed on the Angel: AVE GRACIA PLEN[A] DE [TE]C; on the Virgin: ECCE ANCILLA DNI

On the verso of the Angel are four stamps: paper no. [?] 21/6/40. British and Foreign Shipping Co. Ltd. 5, Rose and Crown Yard, London, #2678/2B. Gozzadini stamp no. 47. On the verso of the Virgin are three stamps: 21/6/40. British and Foreign Shipping Co. Ltd. #2678/2A. Gozzadini stamp no. 47

Provenance: Gozzadini Collection, Bologna, sale Bologna, A. Rambaldi, 12–13 Mar. 1906, 18, no. 50, attributed to Dino di Sano; Cloister of St. Paul, Lavant Tal, Austria, 1906–34?; refugee property, London, 1934–40; A. F. Mondschein, London, 1940; bought by the Wadsworth Atheneum in 1941 from A. F. Mondschein for $1,200 the two from the Sumner Fund.

Exhibitions: Hartford, 1967; Hartford, 1982.

The Ella Gallup Sumner and Mary Catlin Sumner Collection, 1941.156 (*The Angel of the Annunciation*); 1941. 157 (*The Virgin Annunciate*)

The two panels originally formed part of a large altarpiece. The original context and arrangement of the panels can be gauged from the intact polyptych of St. Lucy in the bishop's chancellery at Krk (Veglia), in which panels of the *Angel of the Annunciation* and the *Virgin Annunciate* flank a panel of the *Crucifixion*. All three panels surmount the central compartment of the altarpiece, which shows St. Lucy. The dimensions of the Krk *Annunciation* panels are close to those of the Atheneum panels, 28.5 x 13 cm.

When in the Gozzadini Collection, the panels flanked a lunette of the *Holy Trinity Adored by Saints*. The three panels surmounted a diptych of the *Crucifixion with Saints* and a *Coronation of the Virgin*.[1] The diptych is now in the collection of Yale University Art Gallery, New Haven, attributed to Simone dei Crocefissi.[2] The tall finials of the *Angel of the Annunciation* and the *Virgin Annunciate* visible in the photograph in the Gozzadini catalogue were reportedly removed by the dealer Mondschein after he acquired them by 1940.[3]

Volpe has suggested that the Atheneum panels originally were part of the polyptych attributed to Paolo da Venezia in the church of S. Giacomo Maggiore in Bologna (Fig.49).[4] This polyptych, which was dismembered possibly in the nineteenth century, was rearranged with the upper tier of half-length saints set below the main tier of full-length saints. The central panel of the main tier, now lost, was replaced with a reliquary of the Holy Cross. The top

tier, which probably was composed of a *Crucifixion* flanked by the *Annunciation*, as at Krk, or figures of saints, as in the polyptych of S. Francesco and Sta. Chiara in the Accademia, Venice, is also lost. The whole was surmounted by a polyptych of the *Coronation of the Virgin with Saints* signed by the Bolognese painter Jacopo da Paolo.[5] The altarpiece was restored in 1946 by the Soprintendenza alle Gallerie di Bologna.[6] The second altarpiece was removed and the original order of the tiers restored.

Volpe proposes that the Atheneum panels flanked a now lost central panel of a *Crucifixion* on the top tier of the Bologna altarpiece. He cites as evidence the Bolognese provenance of the Atheneum pictures, and he reports modern additions to the Atheneum panels to support his thesis. We do not know, however, when the panels entered the Gozzadini Collection. Moreover, the panels, though shaved down at the sides, are composed of single pieces of wood; the frame moldings are the projecting edges left when the surface to be painted was carved away, and they were gessoed and gilded at the same time. The gilding on the framing moldings is original and in good condition. Hence, the modern additions that Volpe cites are illusory.

In favor of a reconstruction of the Bologna polyptych with the Atheneum panels are the dimensions of the central portion of the polyptych, 69 centimeters, which easily allow for collocation of the Atheneum panels with a third, central image. The curved molding that originally surmounted the rayed lunette, and which Volpe notes showed four corbels that probably supported four small pilasters, is still visible in old photographs, though as Volpe notes, it was not incorporated into the restored arrangement of the altarpiece.[7] However, four projections in the molding below this curved molding corresponding to the missing corbels survive in the polyptych. The dimensions between these projections, 16 centimeters between the two on the left and 15.5 centimeters between the two on the right, also allow for placement of the Atheneum panels in their current form and the addition of frame moldings or small pilasters.[8] As we lack definitive evidence that the Atheneum panels belong with the S. Giacomo polyptych, Volpe's hypothesis can be accepted only with hesitation.

The Atheneum panels were first attributed to Paolo da Venezia by Roberto Longhi, who, however, was unaware of their location.[9] Berenson[10] and Fredericksen and Zeri also attribute the panels to Paolo,[11] as do opinions recorded in the Atheneum files.[12] Most recently, Muraro has assigned the panels to the workshop of Paolo da Venezia.[13]

Compared to securely documented works, such as the panel at Carpineta (signed and dated 1347) or that in the Crespi Collection (signed and dated 1340), the figures in the Atheneum panels appear slightly awkward. The folds of the draperies are stiff, and the handling is less deft. Muraro's attribution to Paolo's workshop seems justified.

The date of the Atheneum panels would appear to be in the middle 1340s, when elongated figures with small heads become common in works by Paolo and his shop.

Both the attribution to Paolo's shop and the dating

Workshop of Paolo da Venezia,
The Angel of the Annunciation

Workshop of Paolo da Venezia,
The Virgin Annunciate

in the mid forties lend additional weight to Volpe's identification of the Atheneum panels with the polyptych in Bologna. The polyptych shows evidence of considerable shop intervention and has been dated most reasonably to the fifth decade of the fourteenth century.[14] J.C.

1. *Collection de tableaux et objects d'art qui appartenaient au Comte Sénateur Jean Gozzadini*, Bologna, 1906, pl. VIII, no. 50.
2. Inv. no. 1959.15.3. Seymour, 1970, 102, no. 71.
3. Volpe, 1967, 90, n. 18.
4. Volpe, 1967, 87–91.
5. Illustrated in Sandberg-Vavalà, 1930, 161, pl. IA.
6. Volpe, 1967, 87.
7. Sandberg-Vavalà, 1930, 161, pl. IA.
8. Professor Ottorino Nonfarmale kindly made the polyptych available for study during restoration in 1982.
9. R. Longhi, *Viatico per cinque secoli di pittura veneziana*, Florence, 1946, 46.
10. Berenson, 1957, 1, 128.
11. Fredericksen and Zeri, 1972, 585.
12. On the bill of sale, it was reported that Suida and Venturi certified the pictures as authentic; a note from Gronau, 21 June 1935, on the back of a photo in curatorial file, also attests to its authenticity. Letters in curatorial file of 12 Oct. 1956 from M. Laclotte, and of 10 and 20 June 1959 from Zeri to C. Cunningham also uphold the attribution, as do oral communications from Sir John Pope-Hennessy, 7 Nov. 1972, and E. Fahy, 8 May 1984. The panels were published as by Paolo in the *Wadsworth Atheneum Handbook*, 1958, 27.
13. Muraro, 1970, 110.
14. Muraro, 1970, 110–11.

Paolo Veronese
(c. 1528–1588)

Paolo Caliari, called Veronese from his native city of Verona,[1] was born probably in 1528; the notice of his death on 19 April 1588 lists his age as sixty, while another document of 1529 lists him as a year old.[2] A document of 2 May 1541 lists "Paulus," aged fourteen, as "discipulus seu garzonus" to the painter Antonio Badile;[3] although Vasari says Veronese was trained by Caroto,[4] Ridolfi[5] and Borghini[6] say he was trained by Badile, and, indeed, he married Badile's daughter in 1566.[7]

Veronese's earliest works reflect his provincial training and his experience of the art of North Italian artists, such as Parmigianino, and of Giulio Romano's frescoes in Mantua. The Bevilacqua altarpiece in Verona, formerly in S. Fermo Maggiore, is probably that listed by Ridolfi and dates to about 1548.[8] Already by the time he painted the *Holy Family with St. John the Baptist, St. Anthony Abbot, and St. Catherine* for the Giustiniani Chapel in S. Francesco della Vigna in Venice, datable to 1551,[9] Veronese shows familiarity with Venetian art, though he did not take up residence in the city until about 1553.[10] According to Ridolfi,[11] Veronese went to Rome with Girolamo Grimani, Procuratore di S. Marco, probably in 1560; this voyage seems not to have altered the course of his career.

In Venice Veronese's most important works include the decoration of the church of S. Sebastiano, executed between about 1555 and 1570, works for the Palazzo Ducale (the Sala del Consiglio dei Dieci [1553–56, with G. B. Zelotti and G. B. Ponchino], the Sala del Maggio Consiglio [1577, 1588], the Sala del Collegio [1575–77], the Libreria Vecchia di S. Marco [1556–

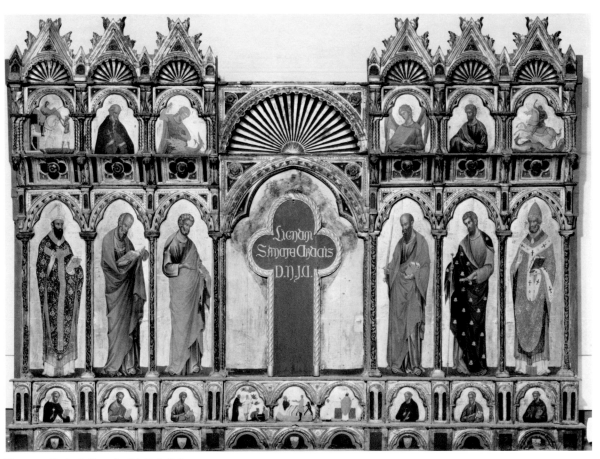

Figure 49. Paolo da Venezia, *Polyptych*, Bologna, S. Giacomo Maggiore

57, with others]), and numerous commissions for churches and private palaces.[12] He continued to work outside Venice as well; his decoration of the Villa Barbaro at Maser, from about 1561,[13] is his masterpiece of secular decoration. Veronese's trial before the Inquisition to answer charges of lack of decorum in his vast *Last Supper*, painted in 1573 for SS. Giovanni e Paolo, the consequence of which was a renaming of the picture as the *Feast in the House of Levi*, lends a rare insight into Veronese's personality.[14]

Veronese is, with Titian and Tintoretto, considered one of the greatest painters of the Venetian sixteenth century. His color, his technique, and his ability to decorate on a vast scale were especially influential for Italian and French artists of the eighteenth century. Beginning in the 1560s, he had a large shop, including his brother Benedetto and later his sons Gabriele and Carletto; some pictures signed *Haeredes* (heirs) of Veronese attest to their continuance of the workshop after the death of the master.[15]

1. See Pignatti, 1976, I, 12, for discussion of Veronese's name. The surname Caliari was first used in 1555.
2. For a discussion of Veronese's birth date, see Ridolfi, 1914–24, I, 297, n. 1, 349, n. 1; Pignatti, 1976, I, 251, doc. 1, 260, doc. 69.
3. Pignatti, 1976, I, 251, doc. 3.
4. Vasari, 1906, V, 290.
5. Ridolfi, 1914–24, I, 298.
6. Borghini, 1584, 561.
7. Pignatti, 1976, I, 254, doc. 30.
8. Ridolfi, 1914–24, I, 298; Pignatti, 1976, I, 103, no. 1.
9. Pignatti, 1976, I, 104, no 5; Cocke, 1980, 24, no. 3.
10. C. Gould, "Paolo Caliari," in *Dizionario biografico degli Italiani*, Rome, 1973, XVI, 702; Pignatti, 1976, I, 26.
11. Ridolfi, 1914–24, I, 310 and n. 3. Rearick in Washington, 1988–89, 24, doubts that Veronese visited Rome.
12. Pignatti, 1976, I, passim.
13. Pignatti, 1976, I, 117.
14. Pignatti, 1976, I, 81–82; see P. Fehl, "Veronese and the Inquisition," *Gazette des Beaux-Arts*, 1961, 325–54. Cocke, 1980, 16, proposes an alternate view.
15. D. von Hadeln, "Benedetto Caliari," in Thieme and Becker, 1911, V, 390–91.

Workshop of Paolo Veronese
The Marriage of the Virgin

Oil on canvas, 80.5 x 71.5 cm (31 3/4 x 28 3/16 in.)

There are two lining canvases in addition to the original canvas. The canvas has been trimmed slightly at the bottom and possibly, to a lesser extent, at the sides and top.

Condition: good. The paint film has suffered general abrasions and retouch, notably in the Virgin's left hand, in the garment of the clinging child, and in the drape of the man at the right. The pentimento of a column or pilaster is seen above the niche at the upper left.

Provenance: possibly Marco Ottoboni, Venice;[1] possibly Gonzaga Collection, Mantua, by 1665;[2] possibly Corsini Collection, Rome, by 1750;[3] unknown collection, England, sale by private contract, 24 Jan. 1801, no. 37, as from the Corsini Palace; Ottley Collection, sale London, Christie's, 16 May 1801, no. 37;[4] Walsh Porter Collection, sale London, Christie's, 14 Apr. 1810, no. 31, bought by W. Buchanan; possibly unknown French collection, by 1864;[5] Galerie Sanct Lucas, Vienna; purchased by the Wadsworth Atheneum in 1937 from the Galerie Sanct Lucas for 1,500 pounds from the Sumner Fund.

Exhibitions: Hartford, *Fifty Painters of Architecture*, 1947, 19, no. 49; Sarasota, 1958, no. 86; Poughkeepsie, Vassar College Art Gallery, *Sixteenth-Century Paintings from American Collections*, 16 Oct.–15 Nov. 1964, no. 20; Birmingham, 1973, no. 34; Hartford, 1982.

The Ella Gallup Sumner and Mary Catlin Sumner Collection, 1937.470

Veronese and his workshop painted the *Marriage of the Virgin* several times.[6] The Atheneum picture is closest to an engraving by Gaspar ab Auibus Citadelensis,[7] dated 1577, which preserves the general outlines of the Atheneum composition while recording considerable differences of figure pose and setting (Fig. 50).[8] A drawing in the Gabinetto dei Disegni in the Uffizi is almost identical in composition and detail to the engraving (Fig. 51).[9] It is reasonable to assume that either the drawing was made for the engraving, or that the drawing was made for a lost painting, the finished design of which is recorded in the engraving.

The relationship of the Atheneum painting to the Uffizi drawing and the engraving is ambiguous. The repetition of certain motifs—the architectural details, the pose of the priest and of Joseph—link them; but the number of figures and their distribution vary widely. The more spacious composition of the Atheneum painting and the looser, more harmonious distribution of figures suggest an independent origin. It is likely that the Atheneum picture is an independent variant of the composition recorded in the drawing and the engraving.[10]

Cocke attributed both the Uffizi drawing of the *Marriage of the Virgin* and the Atheneum picture to Veronese's brother Benedetto Caliari.[11] However, as the relationship of the Atheneum picture to the Uffizi drawing and the engraving is ambiguous, and as Benedetto's artistic personality is not yet well defined, an attribution of the Hartford picture to the workshop of Veronese seems preferable.[12]

A date of about 1577, the year of the engraving, accords well with the style of the *Marriage of the Virgin*.[13]

J.C.

1. The Atheneum painting is perhaps to be identified with the painting seen by Ridolfi (1648) in the Venetian house of Marco Ottoboni, "gran Cancellier Veneto," during the seventeenth century; see Ridolfi, 1914–24, I, 339, noted by von Hadeln as lost; cited also by Boschini, 1660, 331. E. Olszewski, "Cardinal Pietro Ottoboni (1667–1740) in America," *Journal of the History of Collections*, I, 1989, 38–39, notes that the painting does not appear in the inventory of Marco Ottoboni's son, Pope Alexander VIII, and must have remained in the Ottoboni palace in Venice.
2. Cocke, 1984, 379, identifies the Atheneum picture with a picture of the *Marriage of the Virgin* by Veronese in the collections of the duke of Mantua, where it is listed in an inventory of 1665; see also A. Luzio, *La Galleria dei Gonzaga venduta all'Inghilterra nei 1627–28*, Milan, 1913, 315, who records "nella seconda camera," "un quadreto del Sposalitio della Madonna di Paolo Veronese senza cornici," without, however, citing dimensions. Cocke's reference to a Veronese in the 1709 inventory, measuring 6 by 5 *quarte*, equivalent to 103 by 85 cm, refers to a *Madonna* by the artist, not a *Marriage of the Virgin*, as has been pointed out by E. Rowlands, letter to J. Cadogan, 8 Dec. 1988, curatorial file.
3. As Cocke, 1984, 379, notes, the *Marriage of the Virgin* may be the picture that passed to the Corsini Collection in Rome, where it is listed as from the Mantuan collections in a 1750 inventory; see G. Magnanimi, "Inventarii della collezione romana dei Principi Corsini," *Bollettino d'arte*, XLV, 1980, no. 7, 104.
4. In the 1801 sale catalogues, the dimensions of the picture, 31 1/2 x 28 in., are close to those of the Atheneum picture.
5. The Atheneum picture may be identified with the picture sold in Paris in 1864, described in terms similar to those in the Ottley

Figure 50. After Paolo Veronese, *Marriage of the Virgin*, Paris, Bibliothèque Nationale

Figure 51. Attributed to Carletto Caliari, *Marriage of the Virgin*, Florence, Gabinetto dei Disegni

sale catalogue and measuring 80 x 70 cm; see *Chronique des Arts*, no. 50, 31 Jan. 1864, 33, as "Vente du Cabinet Fr. V."

6. Depictions of the theme include a canvas in S. Polo, Venice, which seems not to be autograph (Pignatti, 1976, I, 214, no. A339, attributed to Benedetto Caliari, as the *Meeting of Joachim and Anna*); a grisaille, part of the complex of paintings for the organ in the church of S. Antonio, Torcello (now in the Museo Provinciale), attributed to workshop of Veronese by Piovene and Marini, 1968, 110, no. 134, and Pignatti, 1976, I, 209, no. A302, II, fig. 975; and a version with the International Art Galleries, London, in 1930, reproduced in *Apollo*, XI, 1930, fig. ix.

7. Perhaps to be identified with Gasparo, an engraver active in Venice in about 1565, as cited in Benezit, IV, 627.

8. Paris, Bibliothèque Nationale, *L'Oeuvre de Paolo Caliari*, BC 15, t. 2, pl. 14, no. 16.

9. Inv. no. 17233F, attributed to Carletto Caliari; pen and brown ink and brown wash over black chalk, 28.3 x 29.9 cm. Inscribed, lower left, in brown ink: *Carlo V*; upper right, brown ink: *43*. The drawing has been laid down. See Cocke, 1973, 145–46, pl. 14a. Except for cropping at the left and bottom edges, the drawing differs from the engraving only in the background left: in the engraving the entablature with Corinthian capitals is continued behind the portico, and the hand of the sculpture is missing; in the drawing the architectural detail of the entablature is only partly sketched in pencil, and the hand of the sculpture is complete.

10. A drawing in black chalk, heightened with white on blue paper, 14 1/2 x 9 1/2 in., inscribed *Benetto:V:C.*, showing the exact composition as the Atheneum painting but including additional portions of the architectural setting, was reported by L. Fröhlich-Bum in a letter to C. Cunningham, 10 Mar. 1956, curatorial file. Though Fröhlich-Bum thought the drawing preparatory to the Atheneum painting, the lack of variation between the drawing and the Atheneum painting, as well as the pedestrian style of the drawing, suggests that the drawing was made after the painting rather than as a preparatory sketch for it.

11. Cocke, 1973, 145–46.

12. The Hartford picture has been attributed to Veronese by P. Caliari, *Paolo Veronese*, 2nd ed., Rome, 1909, 224; G. Fiocco, note in curatorial file, 20 Aug. 1932; G. Gronau, note in curatorial file, 22 July 1937; *Wadsworth Atheneum Bulletin*, XXX, no. 2, 1937; W. Suida, letter to C. Cunningham, 21 Dec. 1946, curatorial file; E. Waterhouse, oral communication, 2 Mar. 1957; *Wadsworth Atheneum Handbook*, 1958, 31; Piovene and Marini, 1968, 116, no. 175; and E. Fahy, oral communication, 8 May 1984. It has been attributed to Veronese's workshop by Berenson, letter to C. Cunningham, 23 Mar. 1950, curatorial file; R. Pallucchini, oral communication, 1968; Fredericksen and Zeri, 1972, 139; and Rosand in Birmingham, 1972–73, 34.

13. Fiocco, note in curatorial file, 20 Aug. 1932, suggested a date of about 1560.

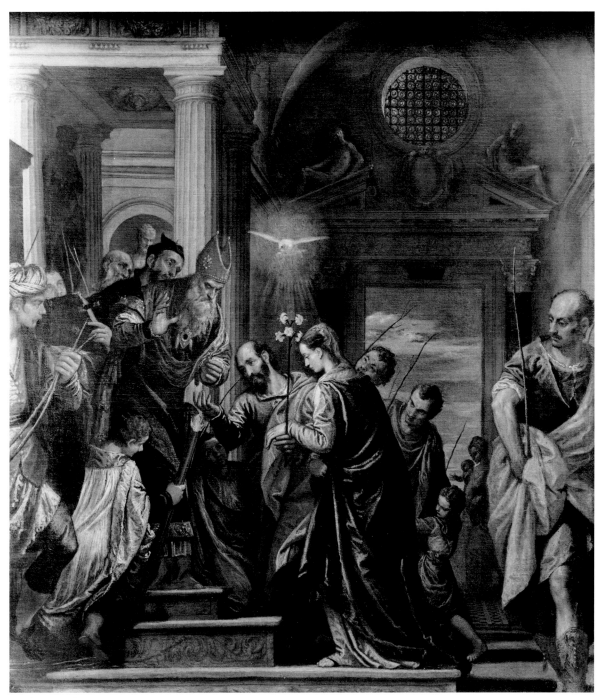

Workshop of Paolo Veronese, *The Marriage of the Virgin*

Jacopo Zucchi
(c. 1540–1596)

Jacopo Zucchi was born in Florence about 1540 and died in Rome in 1596.[1] He was a student of Vasari,[2] and he is documented as his collaborator, with Stradano and other artists, on the ceiling of the Sala Grande of the Palazzo Vecchio in Florence between 5 July 1563 and 24 November 1565.[3] He accompanied Vasari to Rome in 1570, and assisted him in three chapels in the Vatican between 1570 and 1571.[4] Zucchi settled permanently in Rome in 1572.[5] His most important works there include ceiling paintings in the Palazzo di Firenze with the *Allegories of the Four Elements*, datable to 1574–76;[6] the tribune of S. Spirito in Sassia, executed 1582–83; figures in the Sala Vecchia degli Svizzeri in the Vatican in 1583; and altarpieces in S. Spirito in Sassia in 1585–86 and 1587–88.[7] The sumptuous decoration of the Salone in the Palazzo Rucellai (now Ruspoli) dates to 1585–86.[8] Zucchi's last works are the paintings in the Aldobrandini Chapel in Sta. Maria in Via, documented to 1595 or early 1596.[9]

Documented or dated easel pictures from Zucchi's hand include the *Gold Mine* of 1570–71 in the Studiolo of Francesco I de' Medici in the Palazzo Vecchio; the two paintings of the *Holy Family* in Toulouse and a private collection, datable to 1584;[10] and the *Amor and Psyche* of 1589 in the Villa Borghese.[11]

Zucchi is particulary interesting as a member of the generation of Medici court artists following Vasari, and as an influence on mannerist artists of northern Europe, such as Bloemaert.

1. Although Baglione, 1733 ed., 44, states that Zucchi died during the pontificate of Sixtus V (1585–90), already Milanesi had questioned that view, stating that the artist died about 1604; see Vasari, 1906, VII, 618. Recently discovered documents allow a date of 1596; see Mortari, 1973, 79. These documents confirm the assertion by Francesco Zucchi, Jacopo's brother, in a letter of 1608, that Jacopo had served Grand Duke Ferdinando de' Medici for twenty-three years; see Saxl, 1927, 119. Zucchi's birth date is probably close to the traditional date of 1540, as suggested by Vasari, who said in the 1568 edition of the *Lives* (1906, VII, 618) that Zucchi was twenty-five or twenty-six years old; see Pillsbury, 1974, 434, n. 1. Recently discovered documents record Zucchi's work in the Palazzo Vecchio from 5 June 1557; see Pillsbury, 1976, 145, n. 72.
2. Vasari, 1568, mentions Zucchi several times as his student: 1906, VII, 99, 309, 618, VIII, 354, 620.
3. Pillsbury, 1976, 145, doc. 2.
4. P. Barocchi, *Vasari pittore*, Milan, 1964, 68–70.
5. A. Calcagno, *Jacopo Zucchi e la sua opera in Roma*, Rome, 1933, 2.
6. Vollmer, 1947, 578.
7. Pillsbury, 1974, 434–44.
8. Saxl, 1927.
9. Mortari, 1973, 79.
10. E. Pillsbury, "The Cabinet Paintings of Jacopo Zucchi: Their Meaning and Function," *Monuments et mémoires publiés par l'Académie des Inscriptions et Belles-Lettres*, LXIII, 1980, figs. 9–10.
11. Vollmer, 1947, 578.

The Bath of Bathsheba

Oil on panel, 57 x 144.7 cm (44⅞ x 114 in.)

Condition: excellent. There is a loss approximately 10 centimeters wide in the upper left; a horizontal crack in the center of the panel has been inpainted. Some pigment changes are noticeable, especially in the reds. Numerous pentimenti are visible, in the profile of the left nude, the fountain, and the architecture, among others.

Provenance: Monte di Pietà, Rome;[1] Italian embassy, Berlin;[2] Jean-Pierre Spezzaballi, Clichy;[3] Heim Gallery, Paris; bought by the Wadsworth Atheneum in 1965 from Heim Gallery for $35,000 from the Sumner Fund.

Exhibitions: Berlin, Akademie der Künste, *Gemälde alter Meister aus Berliner Besitz*, 1925, no. 441.

The Ella Gallup Sumner and Mary Catlin Sumner Collection, 1965.1

The story of Bathsheba is told in the second book of Samuel (11:2–17). Bathsheba was the attractive wife of Uriah the Hittite. King David saw her in her bath and thought her very beautiful. He seduced and impregnated her. David then arranged to have Uriah killed in battle, for which he was compelled to do penance to the Lord. In Zucchi's interpretation, Bathsheba is portrayed as a wealthy woman, attended at her bath by four maidservants. David observes Bathsheba from a loggia overlooking the bath.

The painting was formerly attributed to Vasari. The attribution to Zucchi was made in the 1925 Berlin exhibition and by Vollmer.[4] The *Bath of Bathsheba* is similar to works by Zucchi from the early 1570s, such as the *Gold Mine* in the Studiolo of Francesco I in the Palazzo Vecchio, Florence, and the *Allegories of the Four Elements* in the Palazzo di Firenze, Rome.[5] The *Bath of Bathsheba* shares with these works the vivid local coloring—lavenders, greens, grays, light browns, golds, and crimsons—porcelain surfaces, and twisting poses of the large, sculptural figures.

A sketch in the Louvre contains an earlier idea for the *Bathsheba* composition (Fig. 52).[6] In the Louvre drawing, the positions of David and Bathsheba are reversed; David stands on a raised platform in the right foreground, while Bathsheba and her maidens occupy the middle ground at the left. The architectural setting with the fountain, loggia, and landscape

Figure 52. Jacopo Zucchi, *Bath of Bathsheba*, Paris, Musée du Louvre

Jacopo Zucchi, *The Bath of Bathsheba*

showing soldiers camped remains fundamentally the same.

A *terminus post quem* for the execution of the painting is suggested by the similarity of the pose and hair style of the bather on the left with those of Giambologna's bronze statuette of *Astronomy* in Vienna, modeled in early 1573.[7] The dimpled buttocks, wide hips, and stocky legs of Zucchi's figure have their source in the central figure in the *Four Witches* engraving by Dürer.[8] E.P.

1. Since 1895 known as the Galleria Nazionale d'Arte Antica, manuscript inventory, about 1890, no. 1349/890.
2. On loan from the Italian government, 1905–c. 1945.
3. According to R. Siviero, Rome, letter in curatorial file, 26 Nov. 1965.
4. Vollmer, 1947, 579.
5. Illustrated in L. Berti, *Il Principe dello studiolo*, Florence, 1967, fig. 66; and H. Voss, "Jacopo Zucchi, ein vergessener Meister der florentinisch-römischen Spätrenaissance," *Zeitschrift für bildende Kunst*, n.s. XXIV, 1913, 151–52, figs. 3–6.
6. Inv. no. 20768. Pen and brown ink, brown and pink washes over black chalk, laid down, 11.7 x 13.6 cm. See C. Monbeig-Goguel, *Inventaire général des dessins italiens. I: Vasari et son temps*, Paris, 1972, 221, no. 362. Pillsbury, 1974, 10–12, first connected the Louvre sheet with the Hartford painting.
7. London, 1978, 92–93, no. 12.
8. Bartsch, 1866, VII, no. 75; W. Strauss, ed., *The Illustrated Bartsch*, New York, 1980, X, 67. For other copies of Dürer, see Pillsbury, 1974, 8–9, 26, n. 25.

Unknown Umbrian, circa 1300 (Maestro delle Palazze)
The Youngest Magus

Detached fresco, irregularly shaped, mounted on heavily sized canvas; sight dimensions of canvas: 47.6 x 27.4 cm (18 13/16 x 10 7/8 in.)

Condition: poor. There are major losses of pigment in the torso of the figure, revealing red underdrawing. The face is relatively well preserved, except for losses in the bridge of the nose.

Provenance: convent of Sta. Maria inter Angelos, Spoleto;[1] Baron Ernesto Bayet, Cavallasca, Lieto Colle, Como, 1921; Bernardo Bazzani, Bergamo, 1921;[2] possibly private collection, Belgium;[3] René Gimpel, Paris. Given to the Wadsworth Atheneum by René Gimpel in 1928.

Exhibitions: Hartford, 1943, no. 66.

Gift of René Gimpel, 1928.276

The *Magus* is a fragment of a fresco of the *Nativity* formerly in the now deconsecrated convent of Sta. Maria inter Angelos near Spoleto. The Clarissan convent was founded in 1229[4] and was known as Il Palazzo delle Donne or Sta. Maria inter Angelos. The Clarissans were transferred to S. Gregorio Minore in Spoleto by a bull of Pope Boniface IX in 1403.[5]

The *Nativity* formed part of the decoration of an oratory or chapel on the upper floor. The chapel measured about 45 by 18 feet.[6] The other frescoes were, starting on the left wall facing the altar end, the *Crucifixion*, the *Last Judgment*, the *Last Supper*, the *Mocking of Christ*; on the end wall *Christ Crucified* and another lost fresco; and on the wall at the right, the *Nativity* and the *Annunciation*. Drapery was painted below all the frescoes, except for the *Crucifixion* and the *Last Judgment*, which reached to the floor.[7] As Davies has remarked, the space was not completely frescoed; the left wall was approximately two-thirds covered and the right wall about one-third covered.[8]

The *Nativity* and other frescoes were detached in 1921. Now in the collection of the Worcester Art Museum are the *Crucifixion*, the *Last Supper*, part of the *Christ Crucified*, and part of the *Nativity*.[9] The *Last Judgment* and the *Annunciation* are in the collection of Raymond Pitcairn, Bryn-Athyn, Pa.[10] The *Mocking of Christ* was removed in 1964 and is now exhibited in the former monastery of Sta. Agata, Spoleto.[11]

After the frescoes were removed there remained traces of underdrawing. These were for the most part removed and exhibited in 1964 and are also exhibited in Sta. Agata.[12] They show in some of the frescoes changes in design.[13]

The Atheneum fragment formed part of the *Nativity* fresco. Other fragments of the *Nativity* besides the Atheneum fragment are *St. Joseph* in the collection of the Worcester Art Museum (Fig. 53),[14] the *Christ Child* in the Museum of Fine Arts, Boston (Fig. 54),[15] and a *Shepherd* in the Fogg Art Museum, Cambridge, Mass. (Fig. 55).[16] A photograph of the whole composition before the fresco was divided shows that there were losses before the fresco was removed, notably in the face of the Virgin, and that

other fragments are still missing (Fig. 56).[17] The fresco was perhaps divided by René Gimpel, who gave fragments to the museums of Boston and Cambridge as well as the Atheneum.[18]

The fresco originally showed the Virgin in a reclining position, in the cave of a mountain, the Christ Child in a cradle at her side. She leans over to bless a shepherd, while St. Joseph sits below with his head in his hand. The Atheneum figure was originally at the lower left and has been plausibly identified as the youngest of the Magi, based on the conical headdress he wears and the covered vessel he carries.[19] Coor-Achenbach points to related examples in the Kahrié Djami at Istanbul and a twelfth-century pulpit at S. Leonardo in Arcetri, Florence.[20] Generally, the Magi were seen traveling in a procession to the manger, the youngest the last in line. Davies also points to similarity in treatment with a *Nativity* fresco from S. Francesco at Assisi and a mosaic of the same subject in Sta. Maria in Trastevere in Rome.[21] Although the Spoleto fresco conforms in general to Nativities of this time, there are several unusual features, such as the Virgin blessing the shepherd.[22]

As Davies has remarked, the frescoes of the cycle are close in style, and decorative patterns, such as borders and halos, are similar in all the frescoes;[23] hence, the cycle was probably painted within a fairly short time. Davies suggests that the somewhat incoherent iconographic scheme betrays lack of planning.[24] The evidence of the underdrawing would

Unknown Umbrian, circa 1300 (Maestro delle Palazze), *The Youngest Magus*

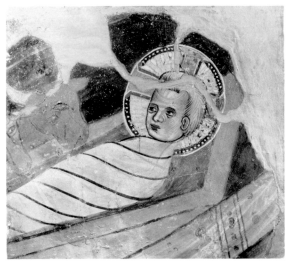

Figure 54. Maestro delle Palazze, *Christ Child*, Boston, Museum of Fine Arts

Figure 53. Maestro delle Palazze, *St. Joseph*, Worcester, Worcester Art Museum

Figure 55. Maestro delle Palazze, *Shepherd*, Cambridge, Mass., Harvard University, Fogg Art Museum

Figure 56. Maestro delle Palazze, *Nativity*, formerly Spoleto, Sta. Maria inter Angelos

seem to confirm this assumption.

The style of the frescoes has been recognized as Italo-Byzantine.[25] Henniker-Heaton associated them with the style of Cavallini in Rome.[26] Other scholars have associated them with Cimabue's influential works in the upper church of S. Francesco in Assisi.[27] An attribution to a local painter, Rainaldictus of Spoleto, has been advanced,[28] but this has been rejected by most scholars.[29] A similarity to the style of the Cesi master, who worked in southern Umbria around 1300, has been recognized.[30]

The date of the frescoes is not determined. The provincial style would indicate a date well after comparable frescoes at Assisi. An iconographic clue is provided by the fresco of the *Last Judgment*, which includes a depiction of the *Madonna della Misericordia*, the earliest representation of which is thought to date from the late thirteenth century.[31] Scholars have dated them in the late thirteenth or early fourteenth centuries.[32]

J.C.

1. The property passed to the Italian state and was sold in 1871 to Francesco Cianni, then to his son Guglielmo.
2. Information on the history of the frescoes is contained in a typescript in the files of the Worcester Art Museum. Davies, 1974, I, 474, n. 60, supposes that the information was supplied in 1948 by Professor Achille Bertini Calosso, Soprintendente ai Monumenti e alle Gallerie dell'Umbria, Perugia.
3. "Trafugamento di Affreschi a Spoleto," *Il Messaggero*, 26 July 1922, 6.
4. Iacobilli, 1971 ed., 670–71, as cited in Davies, 1974, I, 469, 473, n. 32.
5. Davies, 1974, I, 473, n. 33; Iacobilli, 1647, gives the date as 1320.
6. Toscano, 1963, 204; Davies, 1974, I, 469.
7. Davies, 1974, I, 470.
8. Davies, 1974, I, 469.
9. Inv. nos. 1924.25, 1924.24, 1924.20, and 1932.1 respectively; Davies, 1974, I, 465–75, II, 641–42.
10. Reproduced by Rowland, 1931, fig. 4.
11. L. Gentili et al., *L'Umbria, Manuali per il territorio: Spoleto*, Rome, 1978, 216.
12. Perugia, 1964, 7.
13. Perugia, 1964, 7; Davies, 1974, I, 470.
14. Inv. no. 1932.1.
15. Inv. no. 24.115.
16. Inv. no. 1928.151.
17. Taylor, 1932, 78; Coor-Achenbach, 1953, 14, fig. 5.
18. Taylor, 1932, 80, suggests that Gimpel divided the fresco.
19. Coor-Achenbach, 1953, 12–13.
20. These are illustrated in H. Kehrer, *Die heiligen drei Konige in Literatur und Kunst*, Leipzig, 1908–9, repr. ed. New York, 1976, II, 99, fig. 97, 144, fig. 156.
21. Davies, 1974, I, 469.
22. Rowland, 1931, 226; see also Millet, 1916, 99–114, for a discussion of the attitude of the Virgin in fourteenth-century Italian Nativities.
23. Davies, 1974, I, 470.
24. Davies, 1974, I, 470.
25. Van Marle, 1923, I, 407–8.
26. Henniker-Heaton, 1924, 68.
27. Especially Rowland, 1931, 229–30; see also P. Toesca, *Storia dell'arte italiana*, 1927, I, 1043, n. 52; Venturi, 1931, pl. X; and G. M. Richter, review of Venturi, 1931, in *Burlington Magazine*, LIX, 1931, 251.
28. Taylor, 1932, 92–98.
29. Coor-Achenbach, 1953, 11, n. 2; R. van Marle, *Le Scuole della pittura italiana*, 1932, I, 421, n. 1, agrees with Venturi, 1931, in attributing the works to the Umbrian school.
30. M. Meiss, "Reflections of Assisi: A Tabernacle and the Cesi Master," in *Scritti di storia dell'arte in onore di Mario Salmi*, 1962, II, 110, postulates that the Cesi master may have been trained in the shop of the Maestro delle Palazze.
31. For a history of this image, see R. Offner, *A Corpus of Florentine Painting*, 1956, VI, sec. 3, 62–63; for a possible twelfth-century representation, see Florence, Fortezza da Basso, *Firenze Restaura*, 18 Mar.–4 June 1972, 109.
32. Van Marle, 1923, I, 407, to 1280–90; Rowland, 1931, 230, to 1290–1300; Coor-Achenbach, 1953, 11, n. 1, to shortly after 1300; Toscano, 1963, 204, to late thirteenth century; Fredericksen and Zeri, 1972, 584, as thirteenth century.

Unknown Venetian, 14th Century (Master of the Pesaro Crucifix)
The Crucifixion and Madonna and Child

Tempera on panel, 51.2 x 39.2 cm (20½ x 15½ in.)

The panel was formerly engaged by framing elements; these have been removed, leaving an ungessoed edge on all sides. The gesso at these edges has been shaved down. The painting has been cradled.

Condition: fair. The panel is abraded overall. A knothole is visible in the lower center.

Provenance: possibly formerly in an unidentified Umbrian church; Enrico Marinucci, sale New York, Anderson Galleries, 7 May 1923, 37, no. 144, bought by Ehrich Galleries, New York, for $425; Percy Colson, London; Durlacher Bros., London and New York, 1933–34. Purchased by the Wadsworth Atheneum in 1934 from Durlacher Bros. for $2,900 from the Henry and Walter Keney Fund.

Gift of Henry and Walter Keney, 1934.7

In the upper tier is the Crucifixion with St. John the Evangelist and the Virgin; the walls of Jerusalem are visible in the distance. In the lower tier is the Madonna and Child holding a bird. The bird, sometimes identified as a goldfinch, traditionally symbolized the soul; it can also symbolize the Resurrection.[1]

The format and imagery are related to Venetian painting of the middle and late fourteenth century. A small panel showing in the upper part the *Crucifixion* before a crenellated wall and below a half-length *Madonna and Child* is in the Galleria Nazionale, Parma, where it is generally attributed to Paolo da Venezia or his workshop and dated to the fourth or fifth decade of the fourteenth century.[2] The depiction of the wall and the rocky mount with two chief mourners is common in Byzantine pictures of the Crucifixion and further suggests a Venetian source for the imagery of the Atheneum panel.[3]

The painting was first attributed to the Tuscan school of the thirteenth century by van Marle;[4] this attribution was upheld by F. Mason Perkins.[5] Offner suggested an attribution to the Venetian school about 1350;[6] this was agreed to by Meiss, who suggested an attribution to Venetian school of the fourteenth century.[7] Berenson, on the other hand, suggested an attribution to a provincial painter around Bologna.[8] Fredericksen and Zeri retained the attribution to the Venetian school of the fourteenth century;[9] while Pope-Hennessy noted that the crude style and eccentric figure types point to a provincial painter working in the Venetian terra firma.[10]

Recently, M. Boskovits has suggested an attribu-

Unknown Venetian, 14th Century
(Master of the Pesaro Crucifix), *The Crucifixion
and Madonna and Child*

tion for the Atheneum picture to the Master of
the Pesaro Crucifix, who was active in Venice and
in the centers of the Adriatic Coast in the second
half of the fourteenth century;[11] this attribution
has been endorsed by van Os.[12] A comparison of the
Atheneum panel with the *Crucifixion* in Pesaro, from
which the master takes his name, shows striking simi-
larities. The modeling of Christ's torso, the drapery,
and the peculiar physiognomies of the figures are
alike in both pictures. The attribution is advanced,
however, pending further research on this master's
career. J.C.

1. Friedmann, 1946, 7–10.
2. Sandberg-Vavalà, 1930, 178; Pallucchini, 1964, 31; Muraro,
1970, 118.
3. Sandberg-Vavalà, 1930, 177; Millet, 1916, 396–460, illus-
trates many examples of this formula.
4. Van Marle, 1923, I, 360, fig. 195. It was repeated in Hartford,
1934, 23, illus.
5. Undated oral communication, recorded in curatorial file.
6. Undated oral communication, recorded in curatorial file.
7. Letter to E. Turner, 1 Dec. 1958, curatorial file.
8. Letter to C. Cunningham, 23 Mar. 1950, curatorial file.
9. Fredericksen and Zeri, 1972, 584.
10. Oral communication, 28 Apr. 1981.
11. Letter to J. Cadogan, 1 Sept. 1984, curatorial file. On this
artist, see also C. Volpe, "La Donazione Vendeghini Baldi a
Ferrara," *Paragone*, XXVIII, 1977, 74–75, no. 329; H. van Os,
"Discoveries and Rediscoveries in Early Italian Painting," *Arte
cristiana*, LXXI, 1983, 74; and G. Bolzoni and T. Ghezzi, "Una
Madonna veneziana del 1400 nella Pinacoteca di Brera: una
ricerca," *Arte cristiana*, LXXI, 1983, 291–94. Not all of the attri-
butions advanced in the literature are convincing, and no chro-
nology of this master's work has been attempted.
12. Letter to J. Cadogan, 15 Jan. 1987, curatorial file.

Unknown, 14th Century
The Deposition

Tempera on panel, 40.5 x 49.9 cm (15 15/16 x 19 7/16 in.)
 Condition: poor. The panel has been cut slightly at the
bottom edge and reinforced by two vertical supports at the back.
There is extensive cleavage around two horizontal splits in the
panel. The panel was prepared with a thick layer of gesso. Score
marks are visible where the artist fixed his design. The verso was
also gessoed at a later date, perhaps when the battens were
added. There is a plug in the left side.
 Provenance: The previous history of the panel is unknown.
Given to the Wadsworth Atheneum in 1949 by Henry
Schnakenberg.
 Gift of Henry Schnakenberg, 1949.617

The style of the *Deposition* is Italo-Byzantine, but its
execution could well postdate the fourteenth century,
when this style was most widely practiced.[1] As
M. Boskovits noted, the foreshortened pose of the
man on the ladder, or the Magdalene's headdress,
indicates a date of at least the sixteenth century.[2] It
was perhaps painted by a Greek painter. The
extremely crude execution and low quality do not
permit a more specific attribution.[3] J.C.

1. S. Bettini, *La Pittura di icone cretese-veneziana e i madonneri*,
Padua, 1933. L. Puppi, "Il Greco Giovane e altri pittori 'madon-
neri' di maniera italiana a Venezia nella seconda metà del
Cinquecento," *Prospettive*, X, 1962, fasc. 26–27, 25–46, 100,
illustrates a great many of these pictures produced in the six-
teenth century in Venice.
2. M. Boskovits, letter to J. Cadogan, 13 Jan. 1987, curatorial
file, suggests a date of the late sixteenth century.
3. J. Stubblebine, letter to C. Menzi, 26 Mar. 1974, curatorial file,
has suggested that the picture is not Italian. M. Boskovits, letter
to J. Cadogan, 13 Jan. 1987, curatorial file, thinks it is by a Greek
madonnero.

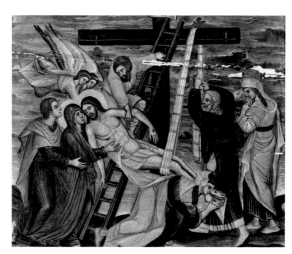

Unknown, 14th-Century Style, *The Deposition*

Unknown Florentine, circa 1430
Virgin Annunciate

Tempera on panel, 23.1 x 12 cm (9 x 4³/₄ in.)

The panel has been cradled. The top and bottom edges have been trimmed, and both sides further cut down; the upper left corner has been renewed.

Condition: good. There are scattered retouches overall. The halo may have been regessoed and regilt.

On the verso of the panel is a label that has been torn that reads: D Ruel/Rue la/k, 398 fift/no. 1938/La Vierge de l'Annonciation iss

Provenance: collection Emil Gavet, sale Paris, Georges Petit, 5 June 1897, 194, no. 755, as Taddeo Gaddi, bought for 600 francs; Durand-Ruel, Paris, 1897–1901; Mary Wheelwright, Boston, 1901–40; A. F. Mondschein, New York, 1940–42, bought by the Wadsworth Atheneum in 1942 from A. F. Mondschein for $700 from the Sumner Fund.

Exhibitions: Hartford, 1942, no. 76.

The Ella Gallup Sumner and Mary Catlin Sumner Collection, 1942.417

Unknown Florentine, circa 1430, *Virgin Annunciate*

The panel is a fragment, possibly from a predella to an altarpiece. The original would have shown the angel Gabriel to the left. F. Zeri[1] has identified a panel depicting the *Nativity* in an English private collection, formerly Matthiesen of London, that may have been part of the same predella as the Atheneum painting.[2]

When the Atheneum panel was acquired, it was attributed by R. Langton Douglas to the Master of S. Miniato, a Florentine painter in the second half of the fifteenth century who was influenced by Filippo Lippi, Botticelli, and Cosimo Rosselli.[3] W. Suida proposed an attribution to a follower of Fra Angelico.[4] B. Berenson disagreed with the attribution to the Master of S. Miniato,[5] but later changed his mind;[6] while M. Meiss suggested an attribution to Paolo Schiavo.[7] F. Zeri attributed both the Hartford and former Matthiesen panels to the immediate circle of Bicci di Lorenzo, perhaps the young Neri di Bicci.[8] Fredericksen and Zeri list the painting as by an anonymous Florentine of the fifteenth century.[9] More recently, Everett Fahy has proposed an attribution to Stefano d'Antonio, a collaborator of Bicci di Lorenzo.[10] Miklos Boskovits has further pointed to the generally higher quality of the Atheneum picture compared to Stefano d'Antonio's known works; Boskovits also remarks on the picture's divergence in style from Bicci di Lorenzo. He proposes an attribution to Florentine school, second quarter of the fifteenth century or to milieu of Fra Angelico.[11]

The eclectic style of the Atheneum panel prevents a specific attribution. The awkward articulation of the Virgin's head and neck, and the eccentric drapery indicate a painter of modest talent generally influenced by Fra Angelico.

The panel probably dates to the third or fourth decade of the fifteenth century.[12] J.C.

1. Letters to C. Cunningham, 4 Apr. 1962, curatorial file, and J. Cadogan, 27 July 1984, curatorial file.
2. The panel measured 8³/₄ x 19¹/₂ in. It was formerly in the collection of Matthiesen of London (Copper neg. 126241). According to S. Maison of the Matthiesen Gallery (letter to C. Cunningham, 11 July 1962, curatorial file), the negative was destroyed in 1943 and the location of a print or the panel is unknown today.
3. According to A. E. Austin, Jr., in the unpublished catalogue of the Sumner Collection, 5, no. 3.
4. Letter to C. Cunningham, 21 Dec. 1946, curatorial file; Suida suggested the same painter is the author of an *Annunciation* in the Gambier Parry Collection, Courtauld Institute, and an *Annunciation* in the Lanckoronski Collection, Vienna; see van Marle, 1928, X, 198–99, fig. 130, 479, fig. 287.
5. Letter to C. Cunningham, 23 Mar. 1950, curatorial file.
6. Berenson, 1963, I, 146.
7. Letter to C. Cunningham, 5 Oct. 1953, curatorial file.
8. Letters to C. Cunningham, 4 Apr. 1962, curatorial file, and J. Cadogan, 27 July 1984, curatorial file.
9. Fredericksen and Zeri, 1972, 586.
10. Letter to J. Cadogan, 6 Apr. 1984, curatorial file. For Stefano d'Antonio, see W. Cohn, "Maestri sconosciuti del quattrocento fiorentino, II—Stefano d'Antonio," *Bollettino d'arte*, XLIV, 1959, 61–68; and Zeri, *Walters Art Gallery*, 1976, I, 33. F. Zeri, letter to J. Cadogan, 27 July 1984, curatorial file, disagrees with the attribution to Stefano d'Antonio.
11. Letter to J. Cadogan, 1 Sept. 1984, curatorial file. Boskovits also points to similarities of the Atheneum panel with the Master of the Judgment of Paris.
12. F. Zeri, letter to C. Cunningham, 4 Apr. 1962, curatorial file, suggested a date toward 1435.

Unknown North Italian, circa 1510–20
The Fall of Phaeton and the Metamorphosis of the Heliades

Oil on panel, 43.7 x 59.7 cm (17¼ x 23½ in.)

The panel has been cradled. The bottom and sides have been cut down slightly.

Condition: poor. There is extensive cleavage in the center horizontal band and retouching in the area around a knothole under the face of the left Heliade. The painting is covered with a thick layer of yellowed varnish.

Provenance: collection Viscount Bernard d'Hendecourt, London, 1921 (not, however, listed in his sale London, Sotheby's, 8 May 1929); Durlacher Bros., New York. Purchased by the Wadsworth Atheneum in 1934 from Durlacher Bros., for $450 from the Sumner Fund.

Exhibitions: possibly Poughkeepsie, Vassar College, May 1935; New York, Brooklyn Museum, *European Art, 1450–1500*, 8 May–8 June 1936, no. 11; New York, Museum of Modern Art, *Fantastic Art, Dada and Surrealism*, Nov. 1936, 203, no. 46, repr. as no. 45; Hartford, 1946, 12, no. 38.

The Ella Gallup Sumner and Mary Catlin Sumner Collection, 1934.291

Phaeton, son of Helios, wished to drive his father's chariot across the skies and, finally, after much pleading, he was allowed to do so.[1] However, on account of his lack of skill in driving, he lost control and the chariot passed too close to the earth, setting a conflagration. Jove struck the chariot with his thunderbolt to save the world from destruction. Phaeton fell in flames into the river Eridanus, far from his home. Phaeton's mother and three sisters roamed the earth in search of him, and when they found him they mourned for so long that the sisters became rooted into the ground and turned into poplar trees. Cycnus, a friend, also came to mourn; he was turned into a swan.

The picture shows, at the left, Phaeton falling into the river. At the center right is his tomb; to the left are the three Heliades turned into poplars and in the foreground Cycnus as a swan. The bare branches and parched earth show the effects of the fire set by Helios's chariot.

The painting was probably painted as part of a *cassone* or other furnishings. It is related in style and subject matter to the tradition of North Italian decorative painting, especially in the Veneto. Ridolfi describes such paintings by Giorgione:

> [He painted] "rotelle, armari e molte casse in particolare, nella quali faceva per lo più favole d'Ovidio. Vedevasi ancora il temerario Fetonte condottiere infelice del carro del Padre suo fulminato da Giove, gli assi e le ruote sparse per lo Cielo."[2]

These have not been positively identified, but a number of panels, generally thought to be *cassone* paintings,[3] by contemporaries of Giorgione and by the young Titian are known and indicate the survival of this decorative painting tradition in the Veneto in the early sixteenth century.[4]

The Atheneum panel, because of its excessively crude execution and somewhat primitive style, can be linked only indirectly to this group of Giorgionesque

Unknown North Italian, circa 1510–20, *The Fall of Phaeton and the Metamorphosis of the Heliades*

Figure 57. Attributed to Niccolò Giolfino, *The Story of Phaeton*, Florence, Museo Horne

Figure 58. Attributed to Niccolò Giolfino, *The Story of Phaeton*, Florence, Museo Horne

works. It is linked more closely with a group of small pictures, painted in Verona, probably for furniture or other decoration, that depicts the story of Phaeton. Two small pictures in the Museo Horne, Florence, attributed to the Veronese painter Niccolò Giolfino, show episodes from the story of Phaeton (Figs. 57–58).[5] The similarities with the Atheneum picture, especially the meandering river and spindly trees, suggest that the author of the Atheneum painting was familiar with these or similar pictures. Two further pictures attributed to Giolfino showing *Phaeton Asking to Drive His Father's Chariot* and *Phaeton Driving the Chariot of the Sun* in the collection at Villa I Tatti, Settignano, show earlier episodes in the story of Phaeton.[6] Like these, the Atheneum painting may have formed part of a decorative series on the Ovidian theme. It was perhaps painted in Verona in the first decades of the sixteenth century.[7] J.C.

1. Ovid, *Metamorphoses*, II.
2. [He painted] "wheels, weapons, and many boxes, on which he painted mostly the fables of Ovid. One sees again the foolhardy Phaeton, unhappy driver of his father's chariot, struck by Jove's lightning, the axles and wheels scattered through the sky" (Ridolfi, 1914–24, I, 98).
3. Schubring, 1923, 176, doubts that these are *cassone* paintings, but suggests they are fragments of painted room decorations or other types of painted furniture. Ridolfi, 1648, I, 98, also mentions "recinti da letto, e gabinetti" that Giorgione painted in Venice.
4. Berenson, 1957, I, 86, lists several "Giorgionesque furniture paintings"; those attributed to Giorgione have been discussed by Pignatti, 1971, 124–25, no. A22, 129–30, no. A34, 131–32, nos. A40–A41, 143–44, nos. A65–A66. The attributions to the young Titian are discussed by A. Morassi, "Esordi di Tiziano," *Arte veneta*, VIII, 1954, 191–98; by Pallucchini, 1969, I, 8–10; and by Wethey, 1975, III, 16–17. A painting by Carpaccio now in the Johnson Collection, Philadelphia, is thought by Schubring, 1923, 392, no. 764, to show the story of Phaeton. The story has also been identified as Ceyx and Alcyone by J. Lauts, *Carpaccio*, London, 1962, 247, no. 65, pl. 86.
5. F. Rossi, *Il Museo Horne a Firenze*, Florence, 1966, 148, figs. 73–74. These have been identified as scenes from the life of Dionysus by M. Contaldo, "Novità e precisazioni su Nicola Giolfino," *Arte veneta*, XXX, 1976, 75. On the tradition of *cassone* painting in Verona, see Schubring, 1923, 158–62.
6. Berenson, 1968, I, 171.
7. There is no consensus among scholars for the attribution of this painting. W. Suida, letter to C. Cunningham, 21 Dec. 1946, curatorial file, related it to mythological paintings by a pupil of Carpaccio. Berenson, letter to C. Cunningham, 23 Mar. 1950, formerly curatorial file, suggested the Venetian school, perhaps the shop of the elderly Giovanni Bellini; also Berenson, 1957, I, 36, as close follower of Giovanni Bellini; Fritz Heinemann, in a letter to C. Cunningham, 26 July 1956, curatorial file, proposed the Bellini follower Pietro Paolo da Santa Croce. Roberto Longhi, in a letter to C. Cunningham, 22 Mar. 1960, suggested an attribution to "some unknown painter between Ferrara and Cremona, about 1520." F. Zeri, in a letter of 1 Mar. 1962, proposed an attribution to the Veronese painter Michele da Verona; Fredericksen and Zeri, 1972, 584, suggest an attribution to a follower of Michele da Verona. On a visit to the Atheneum, 17 Sept. 1974, Heinemann suggested an attribution to the school of Verona between 1510 and 1520, but not Michele da Verona.

Unknown North Italian, early 17th Century
Fruit Stall

Oil on canvas, 130.5 x 195.6 cm (51 3/8 x 77 in.)
　　Condition: fair. The painting is heavily abraded overall; there are numerous local losses, especially in the shadows.
　　Dated upper center: 1601
　　Provenance: collection A. Grisar, London. Bought by the Wadsworth Atheneum in 1939 from Durlacher Bros., New York, for $1,600 from the Sumner Fund.
　　Exhibitions: New York, 1944; Hartford, 1963, 7, no. 8, pl. 1.
　　The Ella Gallup Sumner and Mary Catlin Sumner Collection, 1939.210

The *Fruit Stall* is related to paintings by the Cremonese painter Vincenzo Campi, in which figures are surrounded by displays of fruits, vegetables, meats, poultry, or fish. The most famous of these comprise two series: the first, a *Fruit Vendor* and *Fish Vendor* in the Pinacoteca di Brera, with a *Poulterer* and *Kitchen Scene* in the Accademia di Brera; and the second, a *Fruit Vendor*, three scenes of *Fish Vendors*, and a *Poulterer* commissioned in 1580 for the Augsburg banker Hans Fugger for his castle at Kirchheim, and still *in situ*.[1] Campi evolved this genre based on his experience of similar pictures by the Flemish painter Pieter Aertsen and his nephew Joachim Bueckelaer, who introduced the genre in Antwerp and Amsterdam in the 1550s and 1560s.[2] Campi could have seen pictures by the Flemings in his travels in Emilia in the 1570s; it is known that paintings by Bueckelaer were in the Farnese collections in Parma.[3] Unlike their models, however, Campi's paintings generally omit the biblical scenes and eschew complex moralizing themes.[4] They are not, however, simple genre scenes. It has been suggested that the Brera *Fruit Vendor*, for example, is a personification of Autumn, similar to the allegorical representations of the seasons produced in the workshop of Jacopo Bassano and his sons.[5] The Kirchheim series has been interpreted as an exercise in low humor that plays on the erotic associations of the various foods.[6] The Brera series seems also to partake of this humorous content, but the contrast of the three other pictures in the series with the *Fruit Vendor*, whose calm demeanor and

Figure 59. Vincenzo Campi, *Fruit Seller*, formerly New York, Colnaghi

Unknown North Italian, early 17th Century, *Fruit Stall*

gesture of holding a bunch of grapes aloft perhaps identify her as a personification of chastity, would seem to invest them with a moralizing content in addition to their humor.[7] It has, moreover, been suggested that the Brera series is an allegory of the four elements, earth, water, air, and fire.[8]

The Atheneum *Fruit Stall* is most closely related to the *Fruit Seller* by Campi dated 1583 with the Galleria Previtali in 1989, and a similar picture formerly with Colnaghi in New York (Fig. 59).[9] The New York picture is a version of the Kirchheim *Fruit Vendor* with the addition of a male figure and other details.[10] In the Atheneum picture the relative scale of the figures to the still life and the background is similar to that in the New York picture. The juxtaposition of the two figures, the woman's somewhat awkward seated position, and the man's ambiguous standing pose as he leans toward her are also alike. Details such as the cart holding baskets of vegetables, the large lily, the grapes hanging from the vine, even the long-handled pot that the maid in the Atheneum picture uses to wash lettuce are also found in the New York picture.

As in Campi's pictures, the Atheneum picture has meaning beyond its obvious genre subject. While the deportment of the figures is more seemly than some of Campi's lewd characters, many of the fruits and vegetables have erotic connotations. The apples and onions prominently displayed at the right, for example, have been linked with love and lust,[11] and the cherries at the left with libidinousness. The large lily, seemingly out of place, was thought to have aphrodisiac powers,[12] while the beans, squash, and cucumbers have other erotic associations. Moreover, the peacock feather in the man's hat may imply lustful ambitions,[13] and the large beetle[14] is an ancient Egyptian

symbol of virility.[15] The large bunch of grapes above the woman's head may refer to the grape harvest and the wine it produces, traditionally associated with lasciviousness;[16] or it may allude to the maid's chastity.[17]

Beyond these meanings, the Atheneum picture may also be an allegory of the elements water and air. The man holds a pipe and points to his throat or windpipe.[18] His peacock feather may allude to Juno, goddess of the wind. The maiden's activity of pouring water over lettuce is an obvious reference to water, and the lemons, melons, and onions are associated with water. If this interpretation is correct, then the Atheneum picture probably had a pendant depicting the elements earth and fire.[19]

The attribution of the Atheneum picture has been varied. Although acquired as Vincenzo Campi,[20] already Voss had questioned the attribution, noting that as the picture is dated 1601 and Campi died in 1591, it was more likely by a close follower of Campi.[21] Mahon suggested one of the Procaccini as the artist,[22] while Spike attributed it to G. B. Crespi, Il Cerano.[23] C. Volpe thought the figures were by Camillo Procaccino and the still life by Panfilo Nuvolone,[24] while M. Gregori thought it by an anonymous Cremonese artist.[25] Both the figures and the still life seem to be by one hand, however, and the attribution to Cerano seems most attractive. The background of the Atheneum painting, which shows a triumphal arch and a large vaulted hall, is curiously Roman and may reflect Cerano's voyage to Rome in about 1596–98.[26] J.C.

1. Zamboni, 1965, 133–40; New York, 1983, 22–24.

2. J. Sievers, "Joachim Bueckelaer," *Jahrbuch des preussischen Kunstsammlungen*, XXXII, 1911, 185–212; R. Genaille, "L'Oeuvre de Pieter Aertsen," *Gazette des Beaux-Arts*, XLIV, 1954, 267–88.

3. Zamboni, 1965, 137.

4. See J. A. Emmens, " 'Eins aber ist nötig'—Zu Inhalt und Bedeutung von Markt- und Küchenstücken des 16. Jahrhunderts," in *Album Amicorum J. G. van Gelder*, The Hague, 1973, 93–101, for a discussion of the moralizing content of these paintings; see also K. Craig, "Pieter Aertsen and *The Meat Stall*," *Oud Holland*, XCVI, 1982, 1–15.

5. B. Wind, "Genre as Season: Dosso, Campi, Caravaggio," *Arte lombarda*, XLII, 1975, 71; for the Bassano workshop, see most recently Rearick, 1968, 241–49.

6. Wind, 1977, 108–14.

7. New York, 1983, 25–26; on grape symbolism, see de Jongh, 1974, 166–91.

8. New York, 1983, 26.

9. Gregori, 1989; New York, Colnaghi, *Seventeenth- and Eighteenth-Century Still-Life and Hunting Paintings*, Oct.–Nov. 1983, no. 1. According to C. Whitfield, letter to J. Cadogan, 2 May 1984, curatorial file, the picture was formerly in the Molinari Collection, Cremona (1885), and in a private collection, France; it is listed as lost in Perotti, 1932, 104. A replica of the New York picture is in the collection of Silvano Lodi; see Munich, 1984–85, 26, no. 3. Marini, 1986, 18, mentions yet other versions.

10. Campi is known to have repeated his compositions; the Brera and Kirchheim *Poulterers* are exact replicas. A version of the New York picture, almost identical except for the omission of the lily and the inclusion of an additional platter of vegetables at the left, was sold in London, Sotheby's, 3 Dec. 1969, no. 105, 146 x 216 cm (57 1/2 x 85 1/4 in.).

11. Wind, 1977, 113, n. 19.

12. Wind, 1977, 113, n. 21.

13. Wind, 1977, 113, n. 17.

14. W. Linsenmaier, *Insects of the World*, trans. L. Chadwick, New York, 1972, 142–44, illustrates beetles with large antlers similar to the one depicted in the Atheneum picture.

15. J. C. Cooper, *An Illustrated Encyclopaedia of Traditional Symbols*, London, 1978, 145.

16. Wind, 1977, 112.

17. In Dutch art, holding a bunch of grapes by the stem was a specific reference to maidenly or marital chastity; see de Jongh, 1974. It is not clear that grapes had a similar meaning in Italian art, although the same gesture is found in Campi's Brera painting of the *Fruit Vendor*. See New York, 1983, 24–26.

18. In a similarly pointed gesture, the man in the New York picture puts his finger in his ear. Whitfield relates this figure to the sense of hearing and the woman to the sense of touch. It is also possible that the Atheneum painting is an allegory of the senses, and that the man's gesture also refers to hearing and the woman's to touch. A seasonal allegory seems unlikely for the Atheneum picture, however. The fruits and flowers do not seem to refer to a particular season.

19. New York, 1983, 19, n. 1, reference fig. 3.

20. Austin, 1939, 8.

21. K. Askew, letter to A. E. Austin, 20 Oct. 1938, curatorial file.

22. Undated oral communication.

23. Letter to J. Cadogan, 5 Jan. 1981, curatorial file; New York, 1983, 19, n. 1.

24. Letter to J. Cadogan, 29 Dec. 1982, curatorial file. Volpe noted that the collaboration of Procaccino and Nuvolone in 1601 would be significant for the careers of these artists.

25. Oral communication, 27 Nov. 1983.

26. Milan, Palazzo Reale, *Il Seicento lombardo*, 1973, 23–24.

Unknown North Italian, 17th Century
Spring

Oil on canvas, 99.3 x 139.7 cm (39 x 55 in.)

Summer

Oil on canvas, 99.3 x 140.3 cm (39 x 55 1/2 in.)

The paintings have been lined, in the course of which the original edges, which show damage, may have been slightly trimmed.

Condition: fair. Both paintings are heavily abraded and show many areas of discolored retouches. The backgrounds in particular are very thinly painted and damaged.

Provenance: The previous history of the pictures is unknown. Purchased by the Wadsworth Atheneum in 1939 from Renou and Colle, Paris, for $1,400 the pair from the Sumner Fund.

Exhibitions: New York, 1944; Hartford, *Still-Life Painting*, 1947, nos. 21–22, no cat.; New London, 1954 (*Summer* only); Sarasota, 1958, no. 1; Houston, Museum of Fine Arts, *The Human Image*, 9 Oct.–23 Nov. 1958, no. 37, fig. 37 (*Spring* only); Allentown, 1960, 18, nos. 5–6, figs. 1–2; Hartford, 1963, 11, no. 48 (*Summer* only); Rochester, N.Y., Xerox Corporation, *By Design: Curious Deceptions in Art and Play*, 19 Jan.–20 Apr. 1975, no. 32 (*Summer* only); Toronto, Ontario Science Center, *Deceptions: In Art, Nature, and Play*, 17 June–10 Oct. 1977, no. 13, pl. 10 (*Summer* only).

The Ella Gallup Sumner and Mary Catlin Sumner Collection, 1939.212 (*Spring*); 1939.213 (*Summer*)

In each painting, a figure composed of fruits and flowers appropriate to the season reclines in a landscape. *Spring* is made of asparagus, peas, roses, daffodils, and other early-blooming fruits and vegetables. *Summer* is composed of peaches, turnips, plums, wheat, and the other produce of mid summer.

Allegorical representations of the seasons like the Atheneum pictures were first painted by the Milanese painter Giuseppe Arcimboldo for Holy Roman Emperor Maximilian II in about 1568.[1] While Arcimboldo's images had very precise, complex meanings intimately related to Hapsburg political ambitions,[2] the genre, independent of the specific meaning of the originals, flourished into the nineteenth century.[3] The Atheneum pictures belong to this Arcimboldesque tradition.

That the *Spring* and *Summer* were once part of a set of the four seasons is suggested by their relation to a similar series in the Pinacoteca Civica Tosio Martinengo in Brescia (Figs. 60–63).[4] Canvases of *Spring* and *Summer* closely related to the Atheneum pictures are complemented by corresponding depictions of *Autumn* and *Winter*.[5] Considerable differences distinguish the Brescia pictures from the Atheneum pictures, however. Apart from differences in detail, the Atheneum compositions show an uneasy integration of parts; the figures dominate the compositions, and the backgrounds are thinly painted and dull. No middle-ground feature unites foreground and background, as, for example, the sheep in the Brescia *Spring* or the ducks in the Brescia *Summer*. The backdrops to the figures, depicted as rocks or stone walls

Unknown North Italian, 17th Century, *Spring*

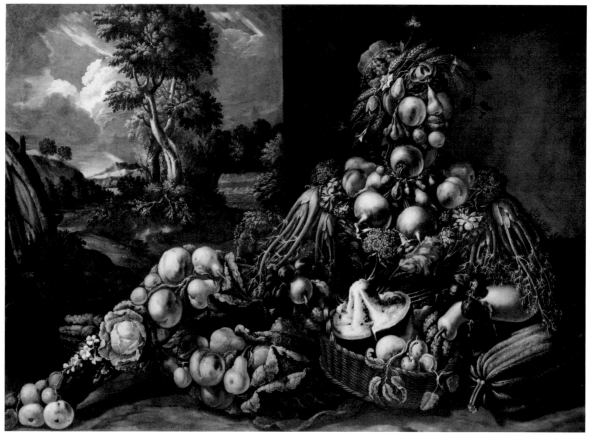

Unknown North Italian, 17th Century, *Summer*

Figure 60. Attributed to Giuseppe Arcimboldo, *Spring*, Brescia, Pinacoteca Civica Tosio Martinengo

Figure 61. Attributed to Giuseppe Arcimboldo, *Summer*, Brescia, Pinacoteca Civica Tosio Martinengo

Figure 62. Attributed to Giuseppe Arcimboldo, *Autumn*, Brescia, Pinacoteca Civica Tosio Martinengo

Figure 63. Attributed to Giuseppe Arcimboldo, *Winter*, Brescia, Pinacoteca Civica Tosio Martinengo

in the Brescia pictures, are merely undifferentiated walls in the Atheneum pictures. The awkward compositions of the Atheneum pictures compared to those of the Brescia paintings suggest that the Atheneum series must have followed the Brescia series, or that the Atheneum pictures were executed by a less talented follower of Arcimboldo using the same model as the artist of the Brescia pictures.

The Atheneum paintings have frequently been attributed to Arcimboldo himself because of their obvious relation to his inventions.[6] And yet neither in style nor format do they correspond with the few pictures that can certainly be assigned to him.[7] The figures in the Atheneum paintings have also been attributed by Legrand and Sluys[8] to Francesco Zucchi, the brother of the Florentine painter Jacopo Zucchi, who, Baglione says, invented the genre of seasons depicted of compositions of fruits and flowers.[9] However, as Zucchi's only documented work bears little relation to the Atheneum pictures, the attribution is untenable.[10] These same authors' attribution of the Atheneum paintings to a Fleming working in Italy is perhaps closer to the mark.[11] Attributions recently advanced to a follower of Arcimboldo cannot be refined in the present state of knowledge of the genre.[12] J.C.

1. Kaufmann, 1976, 278. While various precedents for the kind of composite heads painted by Arcimboldo exist, Kaufmann, 282, argues for Arcimboldo's invention of a new genre of visual conceit. For further discussion of Arcimboldo's sources, see S. Alfons, *Giuseppe Arcimboldo*, Malmo, 1957, 9; P. Preiss, *Giuseppe Arcimboldo*, Prague, 1967, 23; J. Shearman, *Mannerism*, Harmondsworth, 1967, 204.
2. Kaufmann, 1976, 275–96 passim.
3. Legrand and Sluys, 1954, 210–14.
4. The companion pieces to the Atheneum pictures were at one time on the Paris art market and subsequently in the collection of Edward James, New York. They are at present untraced.
5. Inv. no. 956–959, attributed to Giuseppe Arcimboldo. See G. Panazza, *Pinacoteca Civica Tosio Martinengo Brescia*, Milan, 1973, 57, *Winter* only illustrated. Legrand and Sluys, 1954, 213, state that the Brescia pictures were formerly in the sacristy of the church of S. Lorenzo a Verolanuova and previously in one of the castles of the princes Gambara. Geiger, 1954, 143, states that the pictures were formerly in the church of S. Lorenzo a Verolanuova; he also mentions the James pictures.
6. They were acquired as by Arcimboldo and published with that attribution in Austin, 1939, 8; *Art News*, Sept. 1947, 9 (*Summer* only repr.); Geiger, 1954, 143, figs. 71–72; Gaunt, 1974, no. 26 (*Summer* only repr.).
7. See, for example, the *Seasons* in Vienna, in Geiger, 1954, 148; Freedberg, 1971, 410; Kaufmann, 1976, 275–96 passim; T. Kaufmann, "Arcimboldo au Louvre," *Revue du Louvre et des Musées de France*, XXVII, 1977, 337–42.
8. Legrand and Sluys, 1954, 214; F. Legrand and F. Sluys, *Arcimboldo et les arcimboldesques*, Paris, 1955, 94, pls. 38a–b, 43a; they attribute the landscapes to another hand.
9. Baglione, 1733 ed., 97.
10. Zucchi's painting of the *Madonna Adored by St. James Major and a Donor* in S. Giacomo degl'Incurabili in Rome is illustrated in Pillsbury, 1974, fig. 11. For other attributions to him, see Legrand and Sluys, 1954, 210–12. Salerno, *La Natura morta*, 1984, 54, mentions an Arcimboldesque head inscribed *F.Z.p.*, which he attributes to Zucchi.
11. "Têtes composées du XVIe siècle à nos jours," *Beaux-Arts*, 17, no. 617, 1953, 1, 8–9.
12. F. Porzio, *L'Universo illusorio di Arcimboldi*, Milan, 1979, figs. 84–87, attributes the Brescia series to a seventeenth-century follower of Arcimboldo.

Unknown Florentine, 17th Century
St. Sebastian

Oil on canvas, 68 x 50 cm (26⁷/₈ x 20³/₁₆ in.)

 Condition: fair. Many small losses and discolored restorations are visible. An old, cloudy varnish obscures the shadows.

 Sticker on stretcher: 19—Saint Sébastien percé de flèches; there is also an illegible German stamp.

 Provenance: collection Prince J. Poniatowski; unknown collection, sale Munich, Helbing, 29 Nov.–1 Dec. 1921, no. 574, repr., as Guido Reni?; Julius Böhler, Munich; S. M. Singer, Vienna; Galerie Sanct Lucas, Vienna; bought by the Wadsworth Atheneum in 1937 from Galerie Sanct Lucas for $150 from the Sumner Fund.

 Exhibitions: Vienna, 1937, 23, no. 10, as Biliverti.

 The Ella Gallup Sumner and Mary Catlin Sumner Collection, 1937.468

The pose of the St. Sebastian relates to the well-known compositions of the subject by Guido Reni,[1] to whom the Atheneum picture was attributed when it was acquired in 1937.

 It is generally suggested that the *St. Sebastian* can be attributed to a Florentine artist of the seventeenth century, but as yet no one artist has been definitively connected with it.[2] The handling of the paint, especially of the highlights, and the green-blue sky are strongly suggestive of a Florentine origin and are particularly reminiscent of Cigoli's *St. Francis* in the Galleria Corsini; at the same time, the pose of the saint relates to that in paintings of the same theme attributed to Biliverti in the Galleria degli Innocenti[3] and to Matteo Rosselli in the Collegiata, Impruneta. The painting is perhaps not attributable to a specific hand until the oeuvres of the major figures of Florentine baroque painting are more closely studied.　　J.C.

1. For example, the full-length picture of the *Martyrdom of St. Sebastian* in the Pinacoteca Nazionale, Bologna, or the three-quarter-length version of the subject in the Prado in Madrid; see D. S. Pepper, *Guido Reni*, London, 1984, nos. 54, 194, figs. 79, 222. Reni's pose was probably ultimately indebted to Raphael's *St. Cecilia*.
2. W. Suida, letter in curatorial file, 21 Dec. 1946, reported that the picture had been attributed by H. Voss to Biliverti; R. Longhi, letter in curatorial file, 31 Jan. 1960, attributed the picture to a Tuscan artist near to Cristofano Allori; E. Waterhouse, oral communication, 26 Mar. 1963, thought the picture Florentine, perhaps Cigoli; D. Mahon, oral communication, no date, thought it Florentine; M. Gregori, oral communication, 29 Nov. 1968 and 23 Nov. 1983, thought the picture may be an early work by Carlo Dolci; E. Fahy, letter in curatorial file, 24 Mar. 1969, agreed with Gregori; A. Brejon de Lavergnée, oral communication, 16 Mar. 1977, thought the picture perhaps by Matteo Rosselli or Biliverti, after a composition by Guido Reni.
3. Bellosi, 1977, 243, no. 73.

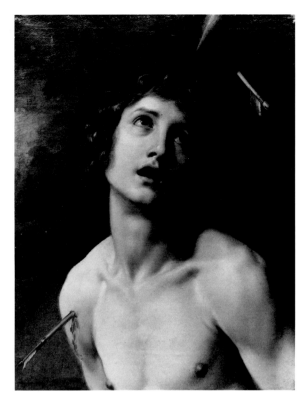

Unknown Florentine, 17th Century, *St. Sebastian*

Unknown Italian, 17th Century
Portrait of an Ecclesiastic

Oil on canvas, 96.4 x 73 cm (37¹⁵/₁₆ x 28³/₄ in.)

 Condition: good. The painting of the robe, between the tabs of the collar, has been reinforced.

 Inscribed at the top of the letter: *Al Sig. . . L* ["a" or "or"] *don A. . . h*; at the bottom of the letter: *Al Me*[1?]*/Il./Pesa. . .*

 Provenance: sale London, Christie's, 1 June 1962, no. 29, as Strozzi, bought by J. H. Weitzner for 178 pounds 10 shillings. Purchased by the Wadsworth Atheneum in 1962 from J. H. Weitzner, New York, for $3,500 from the Sumner Fund.

 The Ella Gallup Sumner and Mary Catlin Sumner Collection, 1962.600

The picture passed through the salesroom as a *Portrait of a Divine* by Strozzi and was acquired by the Atheneum as a *Portrait of a Savant* by Pietro da Cortona.[1] Initially, Briganti concurred, thinking it one of Cortona's rare portraits, done a little later than a pair of circa 1626: the portrait of Cardinal Giulio Sacchetti in Palazzo Sacchetti, Rome, and that of his brother Marcello in the Borghese Gallery, Rome.[2] Waterhouse thought this a plausible proposal, particularly when one compared the hands.[3]

 The prominence of the hands in the Atheneum picture in fact suggests something very like the dark, triangular, but more spacious composition in the Marcello Sacchetti portrait, but the resemblance does not spring to the eye, as spatially the Atheneum com-

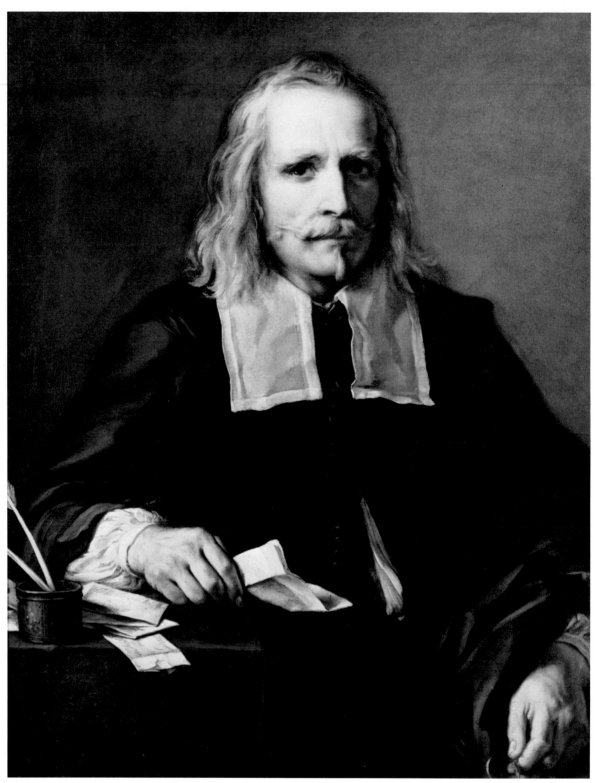

Unknown Italian, 17th Century,
Portrait of an Ecclesiastic

position is more constricted. In all three the sitter is close to the picture plane, head turned slightly, gazing intently at the viewer. The brushwork in the Atheneum picture is softer than in the two Sacchetti portraits, or in an awkward early Cortona portrait head from the same collection,[4] or in the Minneapolis portrait of Cardinal Pietro Maria Borghese,[5] or in a *Portrait of a Man* with Heim, London, in 1966.[6] However, this might be owing to the subject here, a man much older and more grizzled than the above-mentioned subjects.[7] Paoletti felt the Cortona attribution far from convincing, doubting even its Roman origins, and cited an anonymous suggestion it might be Neapolitan.[8] For Fredericksen and Zeri the attribution was uncertain,[9] and when examining the photograph more recently, Zeri firmly demurred from associating the painting with Cortona.[10] Vitzthum rejected the Cortona attribution outright.[11] Finally, in the 1982 revised edition of Briganti's monograph, Trezzani and Laureati rejected the attribution, at the same time acknowledging the painting's undoubtedly Cortonesque quality.[12] Spike listed the work as "circle of Pietro da Cortona."[13]

The inscription might refer to a patrician family, the Almerici (or Almerighi) of Pesaro, although Zicari found no trace of such a family in the archive there.[14]

M.M.

1. *Wadsworth Atheneum Bulletin*, Spring 1963, 22, as Pietro da Cortona.
2. G. Briganti to C. Cunningham, 10 Dec. 1962, curatorial file. For the Sacchetti portraits, see Briganti, 1982, 173–74, no. 18, fig. 54, 174–75, no. 19, fig. 51. The Palazzo Sacchetti picture is Rome, G.F.N. E13980; the Borghese painting (inv. no. 364) is Rome, G.F.N. E55588. Each are 130 x 98 cm.
3. E. Waterhouse to C. Cunningham, 20 Nov. 1962, curatorial file: "I don't think I should have hit on Pietro da Cortona's name straight off myself, but it seems to me to agree pretty well with the two Sacchetti portraits in the treatment of the hands—which is almost all one has to go by in portraiture."
4. Now in the Archivio Capitolina, Rome. Rome G.F.N. E39804. Briganti, 1982, 167, no. 10, fig. 285.
5. Institute of Arts, inv. no. 65.39, 132.5 x 97.5 cm. Briganti, 1982, 349–50, no. A8, fig. 298.
6. London, Heim Gallery, 1966, no. 7, illus., 116 x 101 cm, where the Atheneum picture is cited as a newly discovered work.
7. The touch in Cortona's 1664 Uffizi *Self-Portrait*, done when he was sixty-eight, is, in fact, soft like that in the Atheneum's picture. The Uffizi picture, 71 x 57 cm, is reproduced by M. Chiarini in Florence, 1969, no. 43, fig. 33.
8. Paoletti, 1968, 426–27, fig. 8. J. Paoletti to M. Mahoney, 10 July 1985, curatorial file.
9. Fredericksen and Zeri, 1972, 165, 519, 585.
10. F. Zeri verbally to M. Mahoney, 3 July 1983.
11. W. Vitzthum to S. Wagstaff, 2 Dec. [no year], curatorial file.
12. Briganti, 1982, 394–95.
13. Sarasota, 1984–85, 210, app. no. 42.
14. I. Zicari to C. Cunningham, 5 Dec. 1963, curatorial file.

Unknown, possibly Italian, 17th Century,
Drunken Silenus

Unknown, possibly Italian, 17th Century
Drunken Silenus

Oil on copper, 7.1 x 22.2 cm (2⅞ x 8¾ in.)
Condition: good, except for some local flaking.
Provenance: Mrs. Gurdon W. Russell. Given to the Wadsworth Atheneum in 1918 by Mrs. Gurdon W. Russell.
Gift of Mrs. Gurdon W. Russell, 1918.1403

The drunken Silenus is shown riding on an ass, surrounded by revelers holding musical instruments and wine vessels. The quality of the picture is so poor that positive identification of author or date is difficult. The plaque, possibly a fragment of a larger frieze, perhaps decorated a box or some other object. J.C.

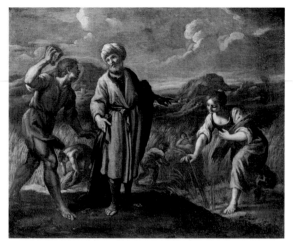

Unknown Italian, 17th Century, *Ruth and Boaz*

Unknown Italian, 17th Century
Ruth and Boaz

Oil on canvas, 51.3 x 64.8 cm (20³/₁₆ x 25¹/₂ in.)
Condition: fair. There are many retouches, especially in the lower left corner.
Provenance: collection Daniel Wadsworth, Hartford.
Exhibitions: Hartford, Wadsworth Atheneum, *Daniel Wadsworth, Patron of the Arts*, 21 Apr.–6 Sept. 1981, pl. 63.
Bequest of Daniel Wadsworth, 1848.21

The story of Ruth and Boaz is told in the Book of Ruth. Ruth and her widowed mother-in-law traveled to Bethlehem at the beginning of the harvest. Ruth went into the grain fields to glean after the reapers. Boaz, who owned the fields, noticed her and asked who she was. Speaking with her, he allowed her to continue and promised her protection and refreshment. Boaz eventually married Ruth.

The Atheneum picture shows the moment when Ruth, about to be molested by one of the workers, is noticed by Boaz. In the background the other reapers are seen; one takes a drink from a bottle.

The painting, which would appear to have been painted in the seventeenth century, perhaps in Rome, has not been precisely attributed.[1] The manner in which the forms are built up in layers suggests that the picture is by an artist of modest skill, rather than being a copy of a lost composition. J.C.

1. It is attributed to Schiavone in Hartford, 1901, no 47. R. Longhi, undated note in curatorial file, thought it was close to Filippo Lauro; Fredericksen and Zeri, 1972, 585, attribute it to Italian school, seventeenth century.

Unknown Bolognese, circa 1730–40
Fantastic Architectural Perspective

Oil on canvas, 96.2 x 74.2 cm (37⁷/₈ x 29¹/₄ in.)
Condition: good. There are minor retouches over the surface.
Provenance: collection Prince Demidoff, Palazzo S. Donato, Florence; sale Florence, 15 May 1880, nos. 787–90, *Vues de palais et de ruines*, as Gaspari Diziani; unknown private collection, England, by 1942;[1] Frederick Mont; purchased by the Wadsworth Atheneum in 1942 from A. F. Mondschein, New York, for $1,750 from the Sumner Fund.
Exhibitions: Hartford, 1956, 15, no. 4; Sarasota, 1958, no. 2; Baltimore, Baltimore Museum of Art, *The Age of Elegance: The Rococo and Its Effects*, 1959, no. 180.
The Ella Gallup Sumner and Mary Catlin Sumner Collection, 1942.346

Fantastic Architectural Perspective is one of a group of four pictures formerly in the collection of Prince Demidoff. A second picture was purchased with the Atheneum picture by Frederick Mont from a country English sale;[2] it was still in Mont's collection in 1948; another, possibly to be identified with the second Mont picture, was in the collection of A. Everett Austin, Jr. (Fig. 64).[3] The fourth picture is untraced.

Amid magnificent buildings, small figures engage in enigmatic activities. A man in Turkish dress, at the left, rushes to meet a page carrying a heavily ladened tray. Two figures at the right, accompanied by a small

Figure 64. Unknown Bolognese, *Fantastic Architectural Perspective*, New York, collection of Mr. and Mrs. Marco Grassi

Unknown Bolognese, circa 1730–40,
Fantastic Architectural Perspective

Figure 65. Stefano Orlandi, *Garden and Buildings with Figures*, Milan, Pinacoteca di Brera

dog, engage in conversation, while a woman is at a window in the mid ground, and a man gestures from a balcony in the background. The architecture shows the classical vocabulary of ancient and Renaissance architecture, but it is here used with a feeling for mass and inventive detail characteristic of late baroque architecture. In the foreground, silhouetted against the lighted background, is depicted Giovanni Bologna's sculpture of *Hercules and Antaeus*.[4]

The Atheneum picture is part of a tradition of architectural painting that developed in the late seventeenth century in Bologna and had a rich history through the late eighteenth century. Arising out of actual theater scene painting as practiced in the seventeenth century, the Atheneum picture shows the new concept of space, the *scena per angolo*, developed by the Galli-Bibiena family, a dynasty of Bolognese scenographers.[5] In the *scena per angolo*, the one-point perspective system used almost exclusively by seventeenth-century scenographers is replaced by a space design using two or more vanishing points, which are generally to the side, beyond the stage space. The protruding or receding sides of the scenic architecture occupy center stage, as it were, and the illusion of depth is created by lighting the backdrop more brightly than the front of the stage. The consequences of this invention were dramatic: whereas central-point perspective preserved the continuity of the actual space, the theater, with the fictive space, the stage, with the *scena per angolo* this unity of space was broken. The stage became thereby divorced from the actual space of the spectator, a world apart. From this development came a new genre of easel paintings — architectural perspectives, ruins, ideal views, and landscapes — many, like the Atheneum painting, adopting the same perspective and lighting systems as stage painting. Their function was primarily decorative, although they were sometimes used in private homes as scenery for miniature theaters.[6] It is likely that the Atheneum picture, and the other three of the series, had such a decorative function.

The attribution of the Atheneum picture has centered on the painter Vittorio Maria Bigari (1692–1776), to whom it was attributed by Suida in 1946.[7] However, compared to the generally accepted pictures by Bigari now in the Pinacoteca, Bologna, the Atheneum picture shows denser, more complex, and heavier architecture and a more robust color scheme;[8] indeed, Roli has rejected the attribution of the Atheneum painting to Bigari, proposing instead an artist close to Francesco Bibiena.[9]

The artist Stefano Orlandi (1681–1760), a frequent collaborator of Bigari, has also been proposed as the author of the Atheneum painting.[10] However, Orlandi's easel pictures are undocumented and no firmly attributable paintings exist with which to compare the Atheneum painting. There are certain similarities between the latter and the *Giardino ed edifici con figure* attributed to Orlandi in the Brera Gallery, Milan, especially in the general tone and chiaroscuro (Fig. 65).[11] Yet the touch of the Brera picture is more precise and lacks the animated highlights found in the Atheneum painting.

Giovan Gioseffe Santi (1644–1719) has also been proposed as the artist of the Atheneum picture, based on comparison with two perspectives by this artist in the Pinacoteca Civica, Imola.[12] This attribution seems less convincing than that to the generation of Bigari and Orlandi.

A date of between 1730 and 1740 for the Atheneum picture, as proposed by Roli, is reasonable.[13]

J.C.

1. F. Mont, letter to C. Cunningham, 25 Apr. 1949, curatorial file.
2. Memorandum in curatorial file.
3. It subsequently belonged to Mrs. Helen Austin, Hartford (1958), and was bought by Marco Grassi, New York, in 1986.
4. See London, 1978, 132–33, no. 87. The sculpture differs slightly from Giovanni Bologna's model in the position of Antaeus's left arm and of Hercules' right hand; but it seems likely that it is to this sculpture that the artist refers.
5. See most recently D. Lenzi, "La 'veduta per angolo' nella scenografia," in Bologna, Museo Civico, *L'Arte del settecento emiliano. Architettura, scenografia, pittura di paesaggio*, 8 Sept.–25 Nov. 1979, 147–55.
6. Roli, 1977, 205.
7. Undated oral communication.
8. On Bigari, see most recently Roli, 1977, 209, 232–33. The three paintings in Bologna are the *Convito di Baldassare*, the *Disputa tra Filippo di Macedonia e Alessandro*, and a *Sacrificio a Venere*, illustrated in Roli, figs. 393a–b and 395a.
9. Roli, 1977, 212, n. 17; also letter to L. Horvitz, 2 Feb. 1984, curatorial file.
10. The attribution was first proposed by Richard Wunder, note in curatorial file, 29 June 1955; and E. Landi, letter to L. Horvitz, 26 Apr. 1984, curatorial file.
11. On Orlandi, see Roli, 1977, 209, 283, pl. 391b; and E. Landi, "Stefano Orlandi (1681–1760): incontro per un centenario," *Carrobbio*, VII, 1981, 208–17.
12. D. Miller, letter to P. Marlow, 9 Apr. 1969, curatorial file.
13. Letter to L. Horvitz, 2 Feb. 1984, curatorial file.

Unknown, possibly Venetian 18th Century,
The Discourse of Diogenes

Unknown, possibly Venetian 18th Century,
The Banquet of Diogenes

Unknown, possibly Venetian, 18th Century
The Discourse of Diogenes

Oil on canvas, 66.3 x 90 cm (26¹/₈ x 35⁷/₈ in.)

The Banquet of Diogenes

Oil on canvas, 66.2 x 91.4 cm (26¹/₁₆ x 36 in.)

Condition: good, except for discolored varnish. Sticker on the verso of each stretcher reads: S.E.1782
 Provenance: The previous history of the paintings is unknown. Purchased by the Wadsworth Atheneum in 1940 from Arnold Seligmann, Rey & Co. for $800 the pair from the Sumner Fund.
 Exhibitions: Boston, Museum of Fine Arts, *Animals in the Arts*, 31 Oct.–8 Dec. 1946; Sarasota, 1956, no. 17; Sarasota, 1958, 81, no. 22 (1940.412 only); Portland, Oregon, Portland Art Museum, *Primates in Art*, 1–27 Aug. 1972.
 The Ella Gallup Sumner and Mary Catlin Sumner Collection, 1940.412 (*The Discourse of Diogenes*); 1940.413 (*The Banquet of Diogenes*)

Diogenes (404–323 B.C.) was a Greek philosopher who gave up civilized living to inhabit a barrel, looking for man with a lantern.[1] In the *Discourse of Diogenes*, the philosopher is depicted as an ass, seated in a barrel, who is conversing with other animals, books strewn at his feet, while an owl holds a lantern above. In the *Banquet of Diogenes*, a frog serves a watermelon to Diogenes, while a dog, holding a rope, prevents a cat from offering him wine.
 The Atheneum pictures relate to two other pictures of identical dimensions and scale in the Worcester Art Museum showing grotesque scenes with animals.[2] Although some of the animals in the Atheneum pictures are repeated in the Worcester paintings, the figure of the ass in the barrel is missing. Yet another painting of Diogenes as an ass in a barrel, certainly by the same hand as in the Atheneum pictures though larger, is in the Ringling Museum, Sarasota, and is inscribed *Diogenes nella botte*.[3]
 The Atheneum, Worcester, and Sarasota pictures belong to a large group of satirical genre pieces that were probably produced in Venice, perhaps in the eighteenth century.[4] One in the group, in the Hotel Danieli at Venice,[5] satirizes the fistfights that occurred between factions of the Castellani and Nicolotti on certain Venetian bridges. These fistfights were suppressed in 1705; nonetheless, the memory of them lingered in the popular imagination, fed by prints.[6] Hence, the paintings could have been produced in the seventeenth or eighteenth centuries.[7]
 The Atheneum paintings were attributed to Pier Leone Ghezzi when they entered the museum;[8] this attribution has been generally rejected,[9] as has a more recent suggestion of the Brescian painter Faustino Bocchi.[10]
 In representing a world in which animals perform human tasks, the pictures clearly convey a satirical meaning.[11] However, the didactic and moral tone of the fables of Aesop, for example, perhaps the best-known expression of this kind of role reversal, is lacking in the group of pictures of which the Atheneum paintings are a part. Instead, the pictures are merely amusing, and perhaps fulfilled a decorative role.[12] As Davies has remarked, in the context of the other pictures, it is unlikely that Diogenes is the protagonist of the series, but instead served as yet another example of the world reversed.[13] J.C.

1. Diogenes Laërtius, *Lives of Eminent Philosophers*, VI, 20–81. See also F. Kossoff, "Parmigianino and Diogenes," *Sixteenth-Century Journal*, X, no. 3, 1979, 85–96.
2. Inv. nos. 1939.22 and 1947.4; see Davies, 1974, I, 486–88, II, 644.
3. Tomory, 1976, 118, no. 121.
4. Wescher, 1966, 50–52. Another picture belonging to the group was sold in Monaco, Sotheby's, 26 June 1983, no. 435.
5. The pictures in the Hotel Danieli were formerly in the collection of Mrs. Eustice Corcoran, from which collection the Sarasota picture also comes; see Wescher, 1966, 51; and Tomory, 1976, 118.
6. Davies, 1974, I, 487.
7. Tomory, 1976, 118, dates them to the eighteenth century; Baroncelli, 1965, 92, dates them to the seventeenth century.
8. Austin, 1940, 8.
9. Davies, 1974, I, 488, n. 3; Tomory, 1976, 118.
10. Baroncelli, 1965, 93–94; Fredericksen and Zeri, 1972, 585.
11. Wescher, 1966, 50.
12. Wescher, 1966, 50, suggests that one of them, in which a coffee shop is shown and inscribed *Qui si beve il caffè*, decorated the walls of a coffeehouse.
13. Davies, 1974, I, 487.

Unknown, possibly Tuscan School, circa 1770
View of Pisa

Oil on canvas, 125 x 157.8 cm (49 1/2 x 62 3/16 in.)

Condition: uneven. The sky is abraded, overcleaned, and extensively repainted. By contrast, the city view and landscape are in remarkably good condition. The picture, which is seamed down the middle, was surface-cleaned at the Atheneum in the autumn of 1983, and retouchings, especially in the sky, were corrected.

Provenance: Tower Collection, Weald Hall, Brestwood, Essex; M. de Beer, London. Purchased by the Wadsworth Atheneum in 1947 from Durlacher Bros., New York, for $6,500 from the Sumner Fund.

Exhibitions: Hartford, *Architecture*, 1947, no. 33, as Panini; Dayton, 1951, no. 16, as Panini; Newport, 1964, no. 18, as Panini; Chicago, 1970, no. 64, as anonymous Tuscan?, 18th century.

The Ella Gallup Sumner and Mary Catlin Sumner Collection, 1947.362

The high vantage point for this view of Pisa is more or less from atop the Guelph tower. To the left, down the road, are the Ghibelline tower, the baptistry, the cathedral, and the leaning tower. In the lower right is the Cittadella bridge, the Porta a Mare, S. Paolo a Ripa d'Arno, and the southern bank of the Arno. On the opposite bank are the sheds of the arsenal, from one of which a galley is being launched. Tow lines are stretched across the river and teams of men haul them along the opposite bank toward Sta. Maria della Spina. Ross Watson identified the banner on the prow of the galley as that of the military order of St. Stephen, founded by Grand Duke Cosimo I.[1] The same arms, a white Maltese cross on a red ground, are displayed on the north nave wall of S. Paolo a Ripa. The scene could record a festival day of the order, such as August 2. Conceived along the lines of the Order of Malta, the goal of the Cavalieri di S. Stefano Papa e Martire was to drive Muslim pirates and marauders from the sea.[2] Above the scene here, supported by a glory of angels and allegorical figures, are the arms of the city of Pisa with its botonée white cross on a red field, not to be confused with the arms of the order itself.[3]

The painting came from an English collection in 1947, as Panini.[4] Only Arisi accepted that attribution,[5] finding precedents for it in two genre views of circa 1745.[6] He sees Panini's hand not only in the *macchiette* but also in the allegorical figures above, which he compares to figures in a pair of religious themes in the Brooklyn Museum[7] and to a Panini heraldic design for a 1747 frontispiece.[8] When the picture left the English collection, it was accompanied by a paint-ing effectively identical in size and attributed to Panini as well, the *Festival outside the Church of Montenero with a View of Leghorn in the Distance*. However, the latter's composition, the scale of its figures, and its point of view are completely different from those of the Atheneum picture.[9] The *Festival at Montenero* was acquired by the Albright-Knox Gallery, Buffalo (Fig. 66).[10]

Dudley Tooth reportedly saw the two pictures at an unspecified English country sale and recalled with almost certainty their being signed by the Palermo painter Giuseppe Tesca (1750–1805).[11] Middeldorf speculated this could conceivably have been a mis-reading of Giuseppe Zocchi (1711–1766), who made designs, of landscapes among other subjects, for execution in *pietre dure* in Florence.[12] Middeldorf thought them by two different, unknown Tuscans.[13] Wunder did not accept the Panini attribution and reported Ozzola's suggestion that Giuseppi Bottani (1717–1784) was the author of the Pisan view.[14] Brunetti thought them by two different hands.[15] Longhi thought the Atheneum picture might be by an English painter in Tuscany, perhaps Thomas Patch (1720–1782).[16] Arisi thought the Buffalo painting most probably by Bottani.[17] Constable dismissed Patch, but entered another Englishman, Joseph Goupy (c. 1680–1766 or later), but only as the remotest speculation. To Constable the paintings are by two hands. While retaining the possibility that Bottani might have done the Buffalo picture, he was not convinced of any connection between that artist and the *View of Pisa* and pointed out how shadowy a figure Zocchi is.[18] Briganti saw them as pendants and spoke of them simply as anonymous eighteenth-century works, not being happy with the traditional attribution or later hypotheses.[19] And, finally, Fredericksen and Zeri listed the Atheneum picture as "attributed to Panini,"[20] and that in Buffalo as "attributed to Bottani."[21]

Eventually, the pictures were reunited in 1970 for an exhibition. Comparing the originals, Gregori proposed they are in fact by the same hand and that while they obviously were not pendants, owing to their compositional incongruities, they might perhaps be "souvenirs," executed to a standard size by an anonymous master working around Pisa and

Figure 66. Unknown Italian, *Festival outside the Church of Montenero with a View of Leghorn in the Distance*, Buffalo, Albright-Knox Art Gallery

Unknown, possibly Tuscan, circa 1770, *View of Pisa*

Leghorn, neighborhoods much frequented by foreigners, especially British, in the eighteenth century. She also thinks the *View of Pisa* entirely by this one hand. Dissimilarities of scale therein between the city landscape with its tiny staffage and the allegorical group above leap to the eye, and one immediately thinks the allegorical figure group might be by a collaborating artist. But Gregori feels that passages in the larger-scaled, allegorical group at the top of the Hartford picture show parallels with the drapery treatment on foreground figures in the Buffalo picture. And in sum, Gregori dates the two pictures to circa 1770–75, on the basis of costume and because of

their affinities with *vedute* by Franco Battaglioli (c. 1710–after 1796), Antonio Joli (1700–1777), and by Patch.[22] The argument that only one artist's hand is seen throughout the Atheneum picture appears convincing. The touch of the brush in both the larger-scaled figures above and in the *macchiette* below is uniformly delicate.

In reviewing the above exhibition, Anthony Clark proposed that one is dealing with a single, unidentified Tuscan master trained in Rome and that the *View of Pisa* was the centerpiece in a triad of pictures, the rightmost being that in Buffalo and the leftmost being lost.[23] Given the incongruities of spatial conception and figural scale between each, this seems a labored suggestion. It could be argued that the boldness of conception and sparkling sense of atmosphere in the Buffalo picture are fundamentally distinct from the more timid sensibility that generated the Atheneum narrative. M.M.

1. R. Watson, Aug. 1968, memorandum in curatorial file.
2. The order was founded January 1561 to commemorate Cosimo's victory at Marciano on St. Stephen's day (2 Aug.), 1554, a victory that confirmed Medici control over Tuscany. The order was sanctioned by Pius IV in February 1562, the official date of its inception. Besides the arsenal, the order was housed in the center of Pisa in the Palazzo dei Cavalieri, a medieval structure refurbished by Vasari, plus the adjacent church also designed by Vasari with a facade by Cosimo's illegitimate son, Giovanni (Arnone, 1954, 59; Salmi, 1932, 18–19, 37–43).
3. Buonanni, 1741, no. 112.
4. M. de Beer to C. Cunningham, 28 Feb. 1947, K. Askew to C. Cunningham, 28 Oct. 1947, curatorial file. Cunningham, 1947, 1, as Panini. *Wadsworth Atheneum Annual Report*, 1947, 10, as Panini.
5. Arisi, 1961, 206–7, no. 238, figs. 292–94; 1986 ed., 449, no. 442.
6. Arisi, 1961, 181–82, nos. 181–82, French private collection. Figs. 236–37 reproduce no. 182. Both are reproduced in Arisi, 1986 ed., 418, nos. 372–73.
7. Arisi, 1961, 205–6, nos. 234–35, figs. 288–89. Inv. nos. 55.19 and 55.20.
8. Arisi, 1961, 207, fig. 391, the arms of France and Saxony, etched by C. Gallimard and published in Rome on the occasion of the dauphin's marriage.
9. Both were offered to the Atheneum by de Beer for 2,400 pounds (letter in curatorial file, 28 Feb. 1947).
10. Nash, 1979, 172, repr. 173. Inv. no. 47.2, 48³/₈ x 62¹/₂ in. He adopts Gregori's 1970 attribution: anonymous Tuscan, circa 1770s. The Atheneum picture is mentioned.
11. C. Cunningham to U. Middeldorf, 10 June 1954, curatorial file.
12. U. Middeldorf to C. Cunningham, 14 July 1954, curatorial file. C. Cunningham to W. G. Constable, 23 Feb. 1961, curatorial file.
13. U. Middeldorf to C. Cunningham, 1 May 1948 and 21 Apr. 1954, curatorial file.
14. R. Wunder to C. Cunningham, 29 Apr. 1949, curatorial file. C. Cunningham to E. Schenck, 28 June 1951, curatorial file, quoting Wunder.
15. E. Brunetti to C. Cunningham, 16 Dec. 1959, curatorial file.
16. R. Longhi to C. Cunningham, 31 Jan. 1960, curatorial file.
17. Arisi, 1961, 207; 1986 ed., 449, no. 442.
18. Constable, 1963, 17–20. Constable's (19) point of reference between the Buffalo painting and Bottani is the signed *Merca di Maccarese* in the Museo di Roma, a branding scene witnessed by fashionable folk (Rome, G.F.N. E44440).
19. Briganti, 1968, 144, fig. 108 (det.); 1970 English ed., fig. 108 (det.).
20. Fredericksen and Zeri, 1972, 156, 495, 585.
21. Fredericksen and Zeri, 1972, 566.
22. Chicago, 1970, 158, no. 64.
23. Clark, 1970, 420, "Dr. Gregori seems tempted by the idea of a British artist, which to me is even more unlikely than an attribution to Taddeo Kunz, which Professor Schleier has talked me out of."

Unknown Italian, 18th Century
Stormy Coast with Castle

Oil on canvas, 97.2 x 135.3 cm (38¹/₄ x 53¹/₄ in.)
Condition: fair. The paint film has been flattened in a lining. Small tears in the center and center right have been repaired.
Provenance: private collection, London (as Salvator Rosa);[1] collection of Mr. and Mrs. Arthur L. Erlanger; given to the Wadsworth Atheneum in 1959 by Mr. and Mrs. Arthur L. Erlanger.
Exhibitions: San Francisco, California Palace of the Legion of Honor (also Santa Barbara, Santa Barbara Museum of Art), *Painters by the Sea*, 1–30 July 1961, no cat.; Cambridge, Mass., Busch-Reisinger Museum, Harvard University, *Rivers and Seas: Changing Attitudes toward Landscape, 1750–1962*, 26 Apr.–16 June 1962, no. 2; Newport, R.I., 1964, no. 21; Memphis, Tenn., 1966, 53, no. 82.
Gift of Mr. and Mrs. Arthur L. Erlanger, 1959.409

There is no consensus among scholars for the attribution of this picture, which entered the museum as by Marco Ricci.[2] Both Mina Gregori and Carlo Volpe suggested the name of Giuseppe Antonio Pianca (1703–1757), which may point toward a Genoese origin for the painting.[3] J.C.

1. David Koltser to C. Cunningham, curatorial file.
2. F. Heinemann, oral communication, 17 Sept. 1974, did not think the picture was by Ricci.
3. M. Gregori, oral communication, 29 Nov. 1968; C. Volpe, letter to J. Cadogan, 29 Dec. 1982, curatorial file. See also Varallo Sesia, Palazzo dei Musei, *Giuseppe Antonio Pianca*, 8 July–26 Sept. 1962.

Unknown Italian, 18th Century
St. John the Baptist

Oil on canvas, 95.9 x 73.6 cm (37³/₄ x 29 in.)
Condition: fair. There are considerable paint losses, particularly at the bottom edge.
Provenance: collection of Samuel J. Wagstaff, Jr., New York; given to the Wadsworth Atheneum in 1982 by Samuel J. Wagstaff, Jr.
Gift of Samuel J. Wagstaff, Jr., 1982.70

When given to the museum the picture was attributed to Vincenzo Damini, with whose works its color and facture can be compared. Mary Newcome Schleier has suggested the picture may be by the Lombard painter Giuseppe Antonio Pianca (1703–1757), certain aspects of whose style are close to Magnasco.[1] J.C.

1. Letter to J. Cadogan, 7 Oct. 1987, curatorial file.

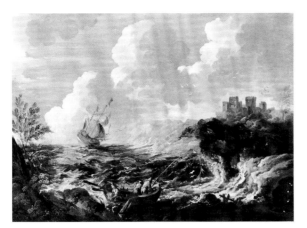

Unknown Italian, 18th Century,
Stormy Coast with Castle

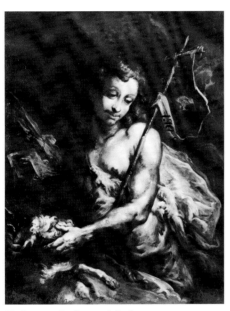

Unknown Italian, 18th Century,
St. John the Baptist

Unknown, possibly Italian, 18th Century,
The Audience

Unknown,
possibly 18th-Century Italian
The Audience

Oil on canvas, 27.5 x 34.4 cm (10⅝ x 13⁹/₁₆ in.)

Condition: good. The canvas seems to have been cut down on three sides, if only for relining. X rays suggest only the right edge is intact.

Provenance: The previous history of the picture is unknown. Purchased by the Wadsworth Atheneum in 1940 from Julius Weitzner for $150 from the Sumner Fund.

Exhibitions: Hartford, 1940, no. 6, as "Angiolo Caroselli?"; Kent, 1966, as Caroselli.

The Ella Gallup Sumner and Mary Catlin Sumner Collection, 1940.33

The subject of the picture is as difficult to pin down as its attribution. Panofsky suggested it might represent condemned witches watching one of their own kind being burned.[1] Gombrich thought it might depict the interior of a madhouse.[2] Weitzner proposed an attribution to the Roman Angelo Caroselli (1585–1652).[3] It bears no resemblance to that artist's works published by Ottani[4] nor to those published by Salerno, the latter being proximate to the Atheneum picture only in their demonic subject matter.[5] Longhi thought this "horrible picture" perhaps by the German Wolfgang Heimbach (c. 1620s–1678), who was in Italy in the 1640s.[6] Fredericksen and Zeri call it Italian eighteenth-century and wonder if it is not a fragment.[7] Pepper suggested it might be Milanese.[8] A possible stylistic source for the Atheneum picture is the work of Giovanni Francesco Cipper, of German or Tirolese origin, hence his nickname "Todeschini." He was active around Brescia and Bergamo in the first decades of the eighteenth century.[9] M.M.

1. E. Panofsky to J. Soby, 8 Feb. 1948, curatorial file.
2. E. Gombrich to C. Cunningham, 10 Sept. 1949, curatorial file.
3. *Wadsworth Atheneum Bulletin*, Mar. 1940, 2, as Angiolo Caroselli?.
4. Ottani, 1965.
5. Salerno, 1970, figs. 9–14, especially figs. 11 and 12. In the background of the Atheneum picture, a barely discernible figure, the third from the left, holds what is perhaps a mirror.
6. R. Longhi to C. Cunningham, 31 Jan. 1960, curatorial file.
7. Fredericksen and Zeri, 1972, 229, 507, 585.
8. K. Ahrens to D. Parrish, 25 Apr. 1978, curatorial file.
9. See, for example, Tognoli, 1976, nos. 13 (fig. 18), 40 (fig. 106), 57 (fig. 124), 55 (fig. 138), and 48 (fig. 149).

Unknown, possibly Italian, 18th Century, *Acrobats Performing at the Commedia dell'Arte*

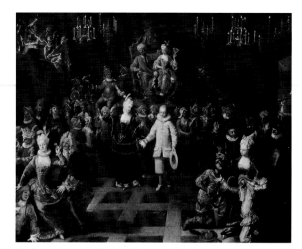

Unknown, possibly Italian, 18th Century, *Sultan's Ball*

Unknown, possibly Italian, 18th Century
Acrobats Performing at the Commedia dell'Arte

Oil on canvas, 73.2 x 92.3 cm (28⅞ x 36⅜ in.)

Sultan's Ball

Oil on canvas, 73 x 92.5 cm (28¾ x 36½ in.)

Condition: fair. There are many scattered retouches.

Provenance: Arnold Seligmann, Rey & Co., 1939; Arnold Seligmann-Helft Galleries, 1948; purchased by the Wadsworth Atheneum in 1948 from Arnold Seligmann-Helft Galleries for $2,800 the pair from the Sumner Fund.

Exhibitions: Hartford, 1940, no. 44, repr. (1948.276 only); New York, Arnold Seligmann-Helft Galleries, *Fine Old Paintings*, Feb. 1948, nos. 6–7; Sarasota, John and Mable Ringling Museum of Art, *Art, Carnival, and the Circus*, 23 Jan.–17 Feb. 1949, nos. 12–13; Sarasota, John and Mable Ringling Museum of Art, *Reflections on the Italian Comedy*, 21 Jan.–23 Feb. 1951, 10, no. 18 (1948.275 only); Hartford, 1964, 50, no. 211 (1948.276 only); Middletown, Conn., Davidson Art Center, Wesleyan University, 19 Apr.–1 May 1971, no. 12 (1948.275 only).

The Ella Gallup Sumner and Mary Catlin Sumner Collection, 1948.275 (*Acrobats Performing at the Commedia dell'Arte*); 1948.276 (*Sultan's Ball*)

These two pictures depict performances of the commedia dell'arte, the popular comedy troupes that traveled throughout Europe during the sixteenth, seventeenth, and eighteenth centuries.[1] While the exact meaning of the scenes is not known, the familiar characters of Harlequin, Punchinello, and others are identifiable by their costumes.

Although the commedia dell'arte flourished for centuries, it is possible to gauge the approximate date of these pictures by the costumes of the female spectators. In particular, the high, peaked head ornaments seen in the *Acrobats Performing at the Commedia dell'Arte* have been identified as *fontanges*, headpieces formed by brass wire on which were intertwined ribbons and curls of hair. Such headpieces were popularized by Mlle de Fontanges, one of the mistresses of Louis XIV, and spread to the courts of Europe in the late seventeenth and early eighteenth centuries.[2]

Where the pictures were done is more difficult to establish. Although they were originally attributed to Claude Gillot,[3] they have more recently been thought to be by an Italian artist.[4] Other scholars have denied that the pictures are Italian at all, without, however, suggesting plausible alternatives.[5] At the present state of our knowledge of the minor theater and festival artists of the early eighteenth century, it seems prudent to leave the question of attribution open. J.C.

1. For a general account of the commedia dell'arte, see the *Enciclopedia dello spettacolo*, Rome, 1956, III, 1185–1226.
2. C. Sterling, note in curatorial file, Mar. 1963, identified the *fontanges* and suggested a date of about 1685–1705. E. Croft Murray, letter to C. Cunningham, 31 May 1959, curatorial file, confirmed the identification and also suggested a date early in the eighteenth century. See also Davenport, 1948, II, 519.
3. Hartford, 1940; Davenport, 1948, II, 658, no. 1767.
4. G. de Batz, letter to C. Cunningham, 7 June 1948, curatorial file, suggested Carlevarijs as the artist; A. Clark, letter to E. Turner, 21 Apr. 1959, curatorial file, tentatively proposed Giuseppe Heinz the Younger, a German artist active in Venice; C. Sterling, note in curatorial file, Mar. 1963, suggested an artist at the court of Turin; R. Pallucchini, letter to L. Horvitz, 25 June 1984, curatorial file, rejected the attribution to Carlevarijs and noted certain French influences.
5. E. Croft Murray, letter to C. Cunningham, 31 May 1959, curatorial file, suggested they might be Dutch eighteenth-century.

Antonio Francisco Bayeu y Subías
(1734–1795)

Antonio Francisco Bayeu y Subías, born in 1734 into a prosperous family of Saragossa, was first placed in a school conducted by Piarist fathers, where he followed a course of instruction generally intended for an ecclesiastical career.[1] At the age of eleven, as his interest and talent for drawing and art became apparent, he was enrolled in a private art school recently opened by the German émigré Juan Andrés Merklein, whose daughter, Sebastiana, Bayeu would later marry.

Bayeu went on to study with José Luzán y Martínez. Progressing through traditional training, in 1758 he entered the competition at the Royal Academy of S. Fernando in Madrid and won first prize with a *Tyranny of Gerion*. Although awarded a stipend to study with Antonio González Velázquez, whose work he had admired six years earlier when the older artist had come to Saragossa with a commission to execute frescoes for the church of El Pilar, the association ended abruptly with Bayeu returning to Saragossa. In 1763 Anton Raphael Mengs requested that Bayeu again come to the capital to assist with the tapestry designs of the royal tapestry manufactory, and the decoration of the royal palace undertaken by the new king, Charles III.

Francisco Bayeu's success was almost immediate. Mengs nominated him as academician of merit at the Academy of S. Fernando, and with continued patronage of the king and the court, he was named Pintor de Cámera del Rey in 1767; he became director of the academy in 1788. During the interim years, he received commissions from churches and convents in Madrid and Aranjuez, and for the palace churches of La Granja, Saragossa, and Toledo. In much of this work he was assisted by his brother Ramón (1746–1793), whose career followed a remarkably similar pattern, although not with equal acclaim. Their brother-in-law, Francisco de Goya, also from Saragossa and a pupil of Luzán, later studied in Francisco Bayeu's drawing classes at the academy, and was to assist in the designing of tapestry cartoons for the royal manufactory at Sta. Barbara, a project with which the Bayeu brothers were occupied for many years.

Paintings for tapestry designs, altarpieces, and frescoes for religious establishments and palaces comprise the greatest portion of Francisco Bayeu's work. Portraits occur with far less frequency, although as a favored court painter, his sitters included members of the royal family and the nobility, as well as his own family. The strongest influence upon his style came from González Velázquez, whose study in Rome with Corrado Giaquinto reinforced the rococo spirit and the grand Italian manner which dominated the arts of Spain. Something of an effete, neoclassical manner, derived from Mengs, is apparent, especially in Bayeu's more finished public work. *Modelli*, such as the *Apparition of Christ and the Virgin to St. Francis at the Porciuncula* in Dallas, which was submitted to the royal competition for altarpieces in the church of S. Francisco el Grande in Madrid, are more fluid in execution and design, and are indicative of Bayeu's more personal style. The tapestry cartoons, often playfully decorative, are also infused with a brighter and more lyrical spirit than are those paintings destined for formal or official purposes. Francisco Bayeu died in Madrid in 1795. His works continued to enjoy the fame and success they had known during his lifetime.

1. The most recent comprehensive study of this period of Spanish painting is the exhibition catalogue, Dallas, 1982–83.

Antonio Francisco Bayeu y Subías, *Portrait of Don Pedro Arascot*

Portrait of Don Pedro Arascot

Oil on canvas, 114.3 x 80.0 cm (45 1/8 x 31 1/2 in.)

The painting has been relined. The original edge of the canvas is visible along the upper border; the remaining three margins have been slightly cropped.

Condition: good. The surface has been covered with a heavy yellow varnish. Examination under ultraviolet light has confirmed the authenticity of the inscriptions and revealed minor retouches on the figure's right hand, the bottom opening of the coat, and along the side and lower borders.

Signed lower left: *Franco Bayeu*; dated lower right: *1786*
Inscribed upper left: AETATIS SUAE XXXXV
Inscribed bottom: EL D.R D.N PEDRO ARASCOT SANCHEZ CO-LOMA PEREZ CALVILLO, ABOGADO DE LOS R.S CO/NSEJOS Y DE LA RL AVDIENCIA DE ARAGON, SECRETARIO PERPETUO DE LA REAL SVMILLERIA DE/CORPS DEL REY NTRO SENOR, Y SV GEN-TILHOMBRE DE BOCA Y CASA ANO 1786.

Provenance: private collection, Switzerland;[1] collection Daan H. Cevat, London; bought by the Wadsworth Atheneum in 1965 from Daan H. Cevat for $5,500 from the Sumner Fund.

Exhibitions: London, Royal Academy, *Goya and His Times*, 1963–64, no. 19; Corpus Christi, Art Museum of South Texas, *Spain and New Spain*, 15 Feb.–30 Apr. 1979, no. 12.

The Ella Gallup Sumner and Mary Catlin Sumner Collection, 1965.2

The sitter is shown with an identifying inscription indicating his full name, titles, and coat of arms. Pedro Arascot, a moderately important court official, was a lawyer who served as counselor to the king and also enjoyed several honorary positions relating to the personal service of the monarch.[2] Little is known of him, however, beyond the information supplied by

the portrait itself. The Arascot, of French origin, became a distinguished family of Aragonese nobles.[3] In 1790, four years after the completion of this portrait, Pedro Arascot was made a member of the Order of Charles III.[4]

Francisco Bayeu produced relatively few portraits, some of which are often confused with the early work of his brother-in-law, Francisco Goya. Because this portrait is clearly signed and dated, it is an important addition to Bayeu's oeuvre.[5] In style and format the portrait of Arascot is reminiscent of the work of the neoclassicist Anton Raphael Mengs, Bayeu's artistic mentor, whose dominant influence is also apparent in the younger artist's frescoes.[6] The compositional scheme is derivative of a type frequently used by Mengs for official portraits of court nobility. Further ties to Mengs are the smooth, enamel-like finish and the juxtaposition of pure, bright colors, such as the blue of Arascot's jacket and the touches of gold in the lavish decorative trim.[7]

1. D. Cevat to C. Cunningham, 27 Jan. 1965, curatorial file.
2. The office of *sumiller de corps*, French in origin, was introduced into Castile by the House of Burgundy; it entailed responsibility for the royal chamber. The second title, *Gentilhombre de Boca y Casa*, a combination of two originally separate positions, referred at this date to those who accompanied the king at public and religious functions. See *Enciclopedia universal ilustrada*, Madrid and Barcelona, 1927, LVIII, 862–63; 1924, XXV, 1282–83.
3. García Carraffa, 1953, VIII, 145–46, s.v. "Arascot." The only readily identifiable portion of the coat of arms is the lower right quadrant, displaying the emblem of the Coloma family; García Carraffa, 1955, XXV, no. 1.134, illus. 4.
4. The order was founded in 1771 by Charles III and was dedicated to the Virgin of the Immaculate Conception, recently established by the king as the principal patroness of his realm. Membership was considered a means of rewarding distinguished royal vassals. See L. Vilar y Pascual, *Diccionario histórico, genealógico y heráldico de las familias ilustres de la monarquía española*, Madrid, 1959, I, 326. For Arascot's membership in the order, see García Carraffa, 1953, VIII, 416; also V. de Cadenas y Vincent, *Indice de apellidos probados en la Orden de Carlos Tercero*, Madrid, 1965, 37.
5. The Atheneum portrait is discussed in the following articles: D. Sutton, "The Royal Academy Exhibition; Goya: Apostle of Reason," *Apollo*, LXXIX, 1964, 68, fig. 2; "La Chronique des Arts," *Gazette des Beaux-Arts*, LXV, Apr. 1965, 3; M.-L. d'Otrange-Mastai, "The Connoisseur in America: Bayeu Portrait for Wadsworth," *Connoisseur*, CLIX, June 1965, 144–45, repr.; "Purchases for the Museum's Collections: Annual Report 1965," *Wadsworth Atheneum Bulletin*, Spring 1966, 27, pl. IV; Faison, 1968, 473, fig. 10. For an evaluation of Bayeu as a portraitist, within the context of his work as a whole, see P. Lafond, "Les Bayeu," *Revue de l'art ancien et moderne*, XXII, 1907, 202–3; Sambricio, 1955, 23–25; Sánchez Cantón, 1965, 205. Among the finest examples are the portraits of Bayeu's daughter Feliciana in the Prado, Madrid (Sambricio, 1955, pl. 38), and his wife, Sebastiana, in the Museo Provincial, Saragossa (Sambricio, 1955, pl. 42), as well as a self-portrait in the Casa Torres Collection, Madrid (Sambricio, 1955, pl. 39).
6. For a discussion of Mengs's portraiture, including a division into compositional types, see Honisch, 1965, 16–24. Bayeu is

known to have possessed copies of two portraits by Mengs, of Carlos de Borbón and María Luisa de Parma. Sambricio, 1955, 30, repr.; F. J. Sánchez Cantón, *Antonio Rafael Mengs*, Madrid, 1929, nos. 33–34, pl. XVII. Comparable works by both artists are Bayeu's *L'Homme au gilet rouge* (repr. in Castres, *Le Musée Goya*, 1961, no. 27) and Mengs's portrait of Manuel Salvador Carmona (repr. in J. J. Herrero, *Retratos del Museo de la Real Academia de S. Fernando*, Madrid, 1930, no. 60, pl. XXII); or the self-portrait of Bayeu in the collection of the marqués de Toca (repr. in Sambricio, 1955, pls. 40–41) and those by Mengs in the Uffizi, Florence (Honisch, 1965, no. 79, fig. 23), and in the collection of the duke of Alba, Madrid (Honisch, 1965, no. 162, fig. 14).
7. Relevant comparisons are the three portraits of the sons of Charles III, Gabriel (Honisch, 1965, no. 141, fig. 21), Antonio Pascual (Honisch, 1965, no. 142, fig. 22), and Javier (Sánchez Cantón, 1929, no. 26, pl. XIII), all in the Prado, Madrid; the portrait of Leopold, duke of Tuscany (Sánchez Cantón, 1929, no. 62, pl. XXVII), also in the Prado; and that of Fernando de Silva Álvarez de Toledo, 12th duke of Alba (Sánchez Cantón, 1929, no. 93, pl. XLV), in the collection of the duke of Alba.

Mariano Fortuny y Carbo (1838–1874)

Fortuny was born at Reus in Catalonia in 1838. At the age of fourteen he began his formal training in Barcelona with Mila y Fontanals, whose Catalonian "Nazarene" style he soon rejected. Awarded a scholarship in 1857 to study in Rome, Fortuny remained there for twenty months; in 1859 he traveled to Morocco, where he was sent by the city council of Barcelona to record the Spanish-Moroccan War. His scenes of the war and of North Africa are characterized by an intense realism unlike the romantic views of the Arab world portrayed by his contemporaries. The following decade shaped the direction of his short career. In 1860 he was in Paris, where he was influenced by the art of Ernest Meissonier; in 1862 he was back in Morocco. Discovered by the Parisian dealer Goupil, Fortuny received early recognition, and in 1867 he married Cecilia de Madrazo. In 1870 he returned to Spain. Following a last trip to Morocco, he settled in Rome, where he died in 1874 at the age of thirty-six.[1]

1. E. Sullivan, "Between Goya and Picasso: Aspects of Spanish Painting, c. 1830–c. 1930," *Arts Magazine*, LIV, no. 2, Oct. 1979, 134–44. See also Barcelona (also Reus and Madrid), *Primer centenario de la muerte de Fortuny*, 1974–75, exh. cat. by J. Ainaud de Lasarte; Castres, *Mariano Fortuny et ses amis français*, 1974, exh. cat. by Claudie Ressort.

Sketch of a Head

Oil on canvas, 56 x 40.9 cm (22 x 16 1/2 in.)
 Condition: good. The surface is obscured by dirty varnish.
 Signed lower left: *Fortuny*
 Inscribed lower right:
A nostro parare la presente opera è
del' artista Sig Mariani Fortuny
 V. Palmorli
Per attestare l'autenticità
 S. Valdes
 Belisario Gioja
 Provenance: The previous history of the picture is unknown. Collection George H. Story. Bequeathed to the Wadsworth Atheneum in 1923 by George H. Story.
 Exhibitions: Hartford, 1958, no. 29.
 Bequest of George H. Story, 1923.249

Mariano Fortuny y Carbo, *Sketch of a Head*

Figure 67. Mariano Fortuny y Carbo, *Nude*, Madrid, Museo del Prado

The attribution of *Sketch of a Head*, first published in 1958, has not been in dispute.[1]

Another oil sketch of a nude and bearded old man by Fortuny is in the Prado (Fig. 67).[2] The Madrid painting is also a vignette, and it displays the same lively treatment of hair and beard as that in the Atheneum's sketch.[3]

1. Gaya Nuño, 1958, 150, no. 787.
2. *Museo del Prado. Catálogo de las pinturas*, Madrid, 1972, no. 2612, *Viejo desundo al sol*, 74 x 56 cm; signed, with an inscription similar to that on the Atheneum canvas. A signed preparatory drawing for the Madrid painting is in the Museo de Arte Moderno, Barcelona (MAS photo no. C. 87986).
3. Another portrait of a man by Fortuny that bears resemblance to the Hartford sketch is in the Concord Art Association, Concord, Mass. (FARL photo no. 830 L). The Concord painting represents a man fully clothed and in profile.

José García Hidalgo (1650–1717)

José García Hidalgo first studied printing in Murcia with Mateo Gilarte and Nicolás de Villacis, before journeying to Italy where he studied briefly in Rome in the studios of Giacinto Brandi, Pietro da Cortona, and Carlo Maratta.[1] Benezit reports that because of poor health, García Hidalgo returned to Spain, where he was attached to the studio of Juan Carreño de Miranda.[2] His best-known commission was a series of twenty-four works illustrating the life of St. Augustine for the cloister of S. Felipe el Real, Madrid. Between 1674 and 1711, he worked primarily in Madrid in the service of Charles II and Philip V, the latter appointing him Pintor de Cámara in 1703.

In 1700 García Hidalgo purchased a house in Valencia, where he was to receive a variety of commissions: S. Juan del Hospital, S. Andrés, S. Bartolomé, S. Domingo, the monastery of Sta. Ursula, the Misericordia, S. Agustín.[3] Although he was never considered a great master, his illustrated textbook *Principios para estudiar el nobilísimo y real arte de la pintura*, published in Madrid in 1693, became a standard reference for young painters.[4] This treatise was both practical and theoretical, combining over one hundred etchings[5] with a prologue in which he argues for the nobility of painting and for its inclusion among the liberal arts.[6]

1. Thieme and Becker, 1920, XIII, 176–77.
2. Benezit, IV, 1976, 13.
3. Ceán Bermúdez, 1800, II, 164–69.
4. E. Lafuente Ferrari, "Cuadros de maestros menores madrileños," *Arte Español*, no. 1, 3rd ser., Jan. 1941.
5. For a discussion of the use of such patternbooks in Europe, see E. H. Gombrich, *Art and Illusion*, Washington, 1956, 146–78.
6. García Hidalgo, 1965, pls. 4–12. García Hidalgo also maintained a small academy in Madrid during the late seventeenth and early eighteenth centuries. The activities of his school are shown on the frontispiece (pl. 1) of the *Principios*, where students are depicted sketching a nude male model.

Death of St. Joseph

Oil on canvas, 109.2 x 168.6 cm (43 x 66³/₈ in.)

Condition: good. The edges of the canvas have been retouched. There are small inpainted losses over the surface.

Signed and dated lower left center: *D. joseph. Garzia fact 1688.*

Provenance: The previous history of the picture is unknown. Collection Mrs. Catherine Goodrich Dutton. Given to the Wadsworth Atheneum in 1888 by Mrs. Catherine Goodrich Dutton.

Gift of Mrs. Catherine Goodrich Dutton, 1888.1

Formerly entitled *Death of St. Francis Xavier*, this painting actually depicts the death of St. Joseph.[1] The earliest accounts of Joseph's death are two Coptic apocryphal gospels written in Egypt during the fourth or fifth century A.D.,[2] which describe the husband of the Virgin as lying in bed, groaning and fearful of approaching mortality. Christ, comforting him as the Virgin mourns, beseeches God to send a host of angels and the archangels Michael and Gabriel, so that they may conduct Joseph's soul safely to heaven.[3] García Hidalgo depicts the moment before the death, when Christ bestows a final blessing as God awaits Joseph's soul.

This theme did not appear in Western art until after 1340, when Isidorus Isolanus published an abridged Latin version of the death of St. Joseph.[4] The theme was frequently depicted in Italy, France, and Spain during the seventeenth and eighteenth centuries.[5]

García Hidalgo may have adapted for his own composition of the *Death of St. Joseph* an engraving of the subject by Nicolas Dorigny, which was published in Rome in 1688,[6] and is a copy of the painting *Death of St. Joseph* by Carlo Maratta.[7] When in Rome as a student, García Hidalgo met and was encouraged by Maratta,[8] and it is likely that he used such examples of Maratta's work as models. Maratta's composition is aligned vertically, however; the bed of Joseph is set diagonally into the picture plane rather than horizontally along it as it is in García Hidalgo's composition, and Christ stands at the right rather than sitting at the left. The same figures are present in both works, including Joseph, Christ, the Virgin, the archangel Michael, and a host of cherubim, who carry large draperies down from billowing clouds.

Another possible source for García Hidalgo's *Death of St. Joseph* is the version of the subject painted by Maratta in 1652 for Alaleona Chapel, S. Isidoro, Rome.[9] The posture of Christ, who is seated to the left, resembles that in the painting by García Hidalgo.

Many of the features and expressions in the *Death of St. Joseph* can be traced to the later engravings for García Hidalgo's *Principios*, thus confirming García's authorship of the painting. These resemblances include that of the archangel Michael in the *Death of St. Joseph* and a similarly clad Michael in the *Principios*,[10] as well as numerous engravings of cherubs like those in the painting.[11]

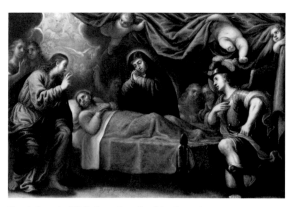

José García Hidalgo, *Death of St. Joseph*

1. For a list of paintings depicting the death of St. Joseph, see Pigler, 1956, I, 434–39, and E. Kirschbaum, *Lexikon der christlichen Ikonographie*, Rome, 1974, VII, 219–21.
2. M. R. James, *The Apocryphal New Testament*, Oxford, 1924, 84.
3. F. Robinson, *Coptic Apocryphal Gospels*, Cambridge, 1896, 136–40.
4. Mâle, 1932, 322.
5. Pigler, 1956, I, 434–39. Compare also the *Death of St. Joseph* by the Mexican painter Miguel Jerónimo Zendejas, in the church of S. José, Puebla, Mexico. Reproduced in M. Toussaint, *Colonial Art in Mexico*, trans. and ed. E. W. Weismann, Austin and London, 1967, 318.
6. Dorigny's engraving of Maratta's *Death of St. Joseph* was published in Rome in 1688 by Giovangiacomo Rossi at the church of Sta. Maria della Pace with the privilege of the pope. The original copper plate for this print is now in the Calcografia Nazionale, Rome. See C. A. Petrucci, *Catalogo generale delle stampe tratte dai rami incisi posseduti dalla Calcografia Nazionale*, Rome, 1953, 55, no. 539.
7. This *Death of St. Joseph* by Maratta is in the Kunsthistorisches Museum, Vienna, no. 534 (Pigler, 1956, I, 436). Reproduced in O. Kutschera-Woborsky, "Ein kunsttheoretisches Thesenblatt Carlo Marattas und sein aesthetischen Anschauungen," in *Mitteilungen der Gesellschaft für vervielfältigende Kunst*, Beilage der *Graphischen Künste*, Vienna, 1919, 18, nos. 2–3, fig. 8.
8. García Hidalgo, 1965, 7, with introductory articles by Juan Contreras y López de Ayala, Francisco Javier Sánchez Cantón, and Antonio Rodriguez Monino.
9. Pigler, 1956, I, 436.
10. García Hidalgo, 1965, pl. 119.
11. García Hidalgo, 1965, pls. 52–57.

Francisco José Goya
y Lucientes
(1746–1828)

Born in the small town of Fuendetodos, near Saragossa, on 30 March 1746, Francisco Goya was the son of José Goya, a master gilder of altarpieces, and Gracia Lucientes, whose family belonged to the lesser nobility. After serving a traditional four-year apprenticeship with José Luzán y Martínez (1710–1785) in Saragossa, the seventeen-year-old Goya went to Madrid to enter the scholarship competition at the Royal Academy of S. Fernando. Failing to garner even one vote and losing the competition in 1766 as well, Goya is presumed to have returned to Saragossa, where he began working on a series of frescoes in the Sobradiel Palace. About 1769 he journeyed to Italy, where he is documented in Parma and Rome. He returned to Saragossa in the summer of 1771 and resumed work as a frescoist in the church dedicated to the Virgin of El Pilar. Later, in 1780–81, he would also fresco the cupola and pendentives there.

At least by 25 July 1773, when he married Josefa Bayeu, sister of the painters Francisco and Ramón, who were also natives of Saragossa, Goya was back in Madrid, but his next commission took him home again, where he executed a mural cycle in the nearby Carthusian monastery of Aula Dei. Late in 1774 Anton Raphael Mengs, probably at the recommendation of Francisco Bayeu, summoned Goya to Madrid to participate in a project for the royal tapestry manufactory of Sta. Barbara — an undertaking which occupied him throughout the 1780s. By 1792 Goya had completed sixty-three cartoons for tapestries to be woven for the Escorial and the palace of El Pardo. During these years, with royal favor and introductions, Goya began his life-long preoccupation with portraits, numbering among his sitters the influential, noble Alba, Altamira, and Osuna families and members of the royal Spanish Bourbons. In 1780 Goya was unanimously accepted into the Academia de S. Fernando, becoming its vice-director in 1785, and director in 1790; in July 1786 he was named painter to King Charles III; in April 1789, following the ascension of Charles IV, Goya became painter of the household; in 1799 he was appointed first court painter.

Suffering a complete physical collapse in 1792, Goya was left totally deaf; a convalescence in Cádiz at the home of his friend and art collector Sebastian Martínez encouraged him to begin work again and probably caused him to consider working seriously in the print medium. His series of *Caprichos* were drawn and engraved in 1797 and 1798. Three of Goya's best-known, and controversial, paintings were completed during these years: the *Family of Charles IV*, the *Naked Maja*, and the *Clothed Maja*, the latter two commissioned by Manuel Godoy, chief minister and favorite of the queen, María Luisa of Parma. With civil unrest, and the eventual overthrow of Charles IV in 1808 and the Napoleonic invasion of Spain (1808–14), Goya was stirred to express himself politically through his paintings and a series of engravings entitled *Disasters of War*, completed between 1810 and 1820. Between 1815 and 1816, he finished his third series of

prints, the *Tauromaquia*; by 1819 he also completed the series known as the *Proverbios* (which Goya referred to as the *Disparates*), which he had begun in 1813. The visionary, often hallucinatory nature of these *folies* is paralleled in the expressive, haunting works Goya painted in 1820–22 on the walls of his own house, the Quinta del Sordo (Deaf Man's House) on the outskirts of Madrid. Detached in 1873 and now in the Museo del Prado, these works from Goya's "Black Period" indicate the depth of his concern for human suffering and disorientation.

Increasingly disturbed by the repressive government (1819–33) of Ferdinand VII, Goya sought royal permission to leave the country. Retaining his official court position, he moved to Bordeaux in 1824, where he died on 16 April 1828.[1]

1. The bibliography for Goya is extensive. Among the recent publications are the following: Licht, 1979; Gassier and Wilson, 1981; Dallas, 1982–83; Muller, 1984; and Madrid, 1988.

Gossiping Women

Oil on canvas, 59 x 145.5 cm (23^{4}/16 x 57^{1}/2 in.)[1]

Condition: good. There are losses along the edges and scattered inpainting overall.

Provenance: collection marquesa de Bermejillo del Rey, Madrid; Kurt M. Stern; vicomte de Hendecourt, Paris;[2] Durlacher Bros., New York; purchased by the Wadsworth Atheneum in 1929 from Durlacher Bros. for $38,250 from the Sumner Fund.

Exhibitions: Springfield, 1933, no. 97; Brooklyn, Brooklyn Museum of Art, *Seven Spanish Paintings*, 1935, no. 26, repr.; New York, Metropolitan Museum of Art, *Francisco Goya: His Paintings, Drawings, and Prints*, 1936, no. 2, repr.; Philadelphia, Philadelphia Museum of Art, *Spanish Art*, 1937; San Francisco, California Palace of the Legion of Honor, *Goya Exhibition*, 1937, no. 6, repr.; New York, 1939, no. 151, repr.; Chicago, Art Institute of Chicago, *The Art of Francisco Goya*, 1941, no. 13, repr.; Toledo, 1941, no. 86, repr.; New London, 1948, no. 16; New York, Wildenstein & Co., *Goya Exhibition*, 1950, no. 5, repr.; Basel, Kunsthalle, *Goya-Ausstellung*, 1953; Richmond, Virginia Museum of Fine Arts, *Francisco Goya*, 1953, 1, repr.; Baltimore, Baltimore Museum of Art, *Man and His Years*, 1954, no. 85; New York, Metropolitan Museum of Art, *Paintings by Goya from American Collections*, 1955; Hartford, 1956, no. 21; New York, 1958, 88, repr.; Sarasota, 1958, no. 36; Portland, Oreg., Portland Art Museum, *Seventy-five Masterworks*, 1967–68, no. 5, repr.; The Hague, Mauritshuis, *Goya*, 1970, no. 3, repr.; New York, Spanish Institute, *Works by Goya*, 1970; Paris, Orangerie des Tuileries, *Goya*, 1970, no. 4, repr.; Dallas, 1982–83, 51, no. I–5; Miami, Center for the Fine Arts, *In Quest of Excellence*, 1984, 105, no. 7.

The Ella Gallup Sumner and Mary Catlin Sumner Collection, 1929.4

Although the precise date of the execution of *Gossiping Women* is not known,[3] the painting has always been associated with the tapestry cartoons Goya produced for the royal manufactory of Sta. Barbara between 1776 and 1780, and for a short time after his appointment as painter to the king in 1786.[4] The broad and undefined features of the maja facing the viewer, the informal disposition of masses on the canvas, and Goya's choice of an outdoor genre scene recall such tapestry cartoons as *El Parasol* of 1777. Still, the less decorative, darker tonalities and the simpler, more

Francisco José Goya y Lucientes, *Gossiping Women*

liquid handling of paint in *Gossiping Women* suggest a later date, now estimated by most authorities as 1791.

Because of its similarity in size, theme, and technique to the *Sleeping Woman* in the MacCrohon Collection, Madrid, Trapier concluded in 1964 that it and *Gossiping Women* might well be two of the three overdoors painted by Goya for his friend Sebastian Martínez, whom he visited in Cádiz in 1792.[5] That Goya did execute such a set of overdoors is recorded by Nicolás de la Cruz y Bahamonde in his *Viage de España, Francia e Italia*, in 1812. Cruz's description, however, is brief in the extreme: "The portrait of Martínez by Goya is very good; there are three caprices or overdoors by him."[6]

More recently, Gudiol has proposed that the third component of the set, a picture of smaller size but apparently cut down to its present dimensions, might be *El Sueño* (*Sleeping Woman*) in the National Gallery, Dublin.[7]

As with many of the tapestry cartoons, Goya began his *Gossiping Women* by preparing the canvas with a red ocher ground. He then modeled the composition in black "and finished with light colors of very thick pigments applied in a most spontaneous manner."[8]

1. Mayer, 1924, no. 631, pl. 22, gives larger measurements of *Gossiping Women*, 69 x 155 cm. The picture has not been cut down, and it is likely that Mayer included the frame in the dimensions.
2. K. Stern, letter in curatorial file, 14 Apr. 1946. Stern makes no mention of dates in his letter, but it may be assumed that these transactions took place between 1924, when Mayer published the work as being in a Madrid private collection, and 1929, when the Wadsworth Atheneum purchased it from Durlacher Bros. Desparmet Fitz-Gerald, 1928–30, no. 179, pl. 141, states that the picture had come to the marquis de José Salamanca [sic] from the "Ancienne Collection Salamanca."
3. Mayer, 1924, no. 631, dated it between 1787 and 1792. Fitz-Gerald, 1928–30, no. 179; Gudiol, 1969, no. 321; and Gassier and Wilson, 1971, no. 307, have assigned it to either 1791 or 1792.
4. Mayer, 1924, 179; V. de Sambricio, *Tapices de Goya*, Madrid, 1946, 173; Trapier, 1964, 9; Gudiol, 1969, 87. The royal manufactory closed in 1780 and reopened in 1783, but Goya did not make any more cartoons for it until after his appointment as painter to the king. See Gassier and Wilson, 1971, 71. Bibliography, in addition to that cited elsewhere, includes the following: "Brooklyn Museum Opens Great Exhibition of Spanish Masterpieces," *Art Digest*, Oct. 1935, 5–6; "Spanish Paintings in Brooklyn," *Antiques*, Nov. 1935, 206, repr.; *American Magazine of Art*, Dec. 1935, 744, repr.; H. Clifford, "Great Spanish Painters: A Timely Show," *Art News*, 17 Apr. 1937, 11; Shoolman and Slatkin, 1942, pl. 434; "Goya — Precursor of the Impressionists," *Think*, Dec. 1950, 16–17; F. Rau, *Goya*, Lisbon, 1953, no. 117, repr.; Gaya Nuño, 1958, no. 918; *Wadsworth Atheneum Handbook*, 1958, 88; Faison, 1968, 473.
5. Trapier, 1964, 8–9. The MacCrohon *Sleeping Woman* measures 59 x 145 cm, almost identical in size to the Atheneum picture. See Gudiol, 1969, no. 322.
6. Cruz y Bahamonde, 1812, XII, 340.
7. Gudiol, 1969, 87 and no. 323. The English edition of this catalogue, 1971, mistranslates this passage, and claims that the paintings are earlier than the paintings done by Goya for Martínez. In the Spanish text Gudiol uses the verb *proceder*, "to come from," which the translator mistakes for *preceder*, "to precede or come before." *El Sueño* measures 44 x 76 cm.
8. J. Gudiol, *Goya*, New York, 1941, 37.

Domenikos Theotocopoulos called El Greco (1541–1614)

Although he is always considered a major figure of Spanish painting, El Greco was born in Candia (Herakleion), capital of the island of Crete, where on 6 June 1566, he signed a notary document, identifying himself as a painter. Another document of December 1566 refers to one of his paintings offered in a lottery; however, on 18 August 1568, he was in Venice, sending drawings to a Cretan cartographer. On 16 November 1570 Giulio Clovio, a painter of miniatures in Rome, wrote a letter of introduction on El Greco's behalf to Fulvio Orsini, librarian of his patron Cardinal Alessandro Farnese; the letter requested lodging at the cardinal's Roman palace for "un giovane candiota, discepolo di Tiziano." On 18 September 1572, El Greco was admitted to the Accademia di S. Luca in Rome, paid his dues of two scudi, and registered as a miniaturist. At the age of thirty-seven, he is first recorded in Spain on 2 July 1577.[1]

Aside from Clovio's letter, there is no evidence to document El Greco's studies with Titian in Venice; moreover, the most important early stylistic influence upon him is that of the paintings of Tintoretto. His work during the years in Rome was characterized by the classical restraint, balance, and elegance more often associated with Veronese. But all the phases of his career are dominated by characteristics uniquely his own. Intense colors — glazed green, blue, yellow, rose-pink — shimmer with phosphorescent highlights, stylized figures pose with theatrical gestures, and abstract patterns of light create designs related to the *maniera* popular in Italy. These features were to become exaggerated during his mature years in Spain, with the structural and technical elements of this composition eventually reaching a fervor of emotional and spiritual intensity.[2]

Failure to win support and commissions in Rome undoubtedly caused El Greco to consider other alternatives. The Spanish king, Philip II, was actively seeking artists from Italy to employ on his vast project of building and decorating the Hieronymite monastery of S. Lorenzo del Escorial. Further, an acquaintance of El Greco's in Rome was Luis de Castilla, the son of the dean of the cathedral chapter of Toledo. It may be no coincidence that Diego de Castilla had just embarked on the program for a new convent in Toledo, S. Domingo el Antiguo, for which he commissioned three altarpieces from El Greco. El Greco completed these paintings by September 1579; he had already completed, three months before, a *Disrobing of Christ* for the sacristy of the cathedral of Toledo. Royal patronage came with a summons from Philip II to paint a *St. Maurice* for the Escorial, but the work met with the monarch's disapproval. Consequently, El Greco received no further royal commissions and his principal work was for churches and convents in Toledo and Madrid, and devotional paintings and portraits for private clients. He prospered in Toledo and was part of a learned group of scholars in this great intellectual center. Probably his best-known work is the monumental *Burial of Count Orgaz*, painted for the church of S. Tomé, Toledo, in 1586–88. According to Davies, "It is also one of his earliest interpretations of the destiny of man according to Neoplatonic concepts of cosmic hierarchy, illumination and the ascent of the soul."[3]

During the ensuing years, El Greco's compositions became more dramatic and intense, with traditional elements of design and foreshortening of figures giving way to two-dimensional, formal, iconic patterns, drastic distortion to anatomy and elongation of figures, and often dazzling arrays of color. In addition to religious subjects he painted some of the strongest and most vibrant portraits in the history of art, such as that of Giacomo Bosio now in the Kimbell Art Museum, Fort Worth. His artistic activity continued to the end of his life.

1. For the most complete biographical information, see Brown in Toledo, 1982, 15–33.
2. Of great significance for understanding El Greco's color is the *Baptism of Christ* from the Fondation San Juan Bautista, Hospital Tavera, Toledo, which was exhibited in Paris, 1987, no. 13, 118–20. When the frame is removed, wide borders of canvas from the compositional boundaries to the edges of the stretcher display passages of colors where El Greco wiped his brush and mixed paints. The painting was displayed without the frame at the Hospital Tavera following the Paris exhibition.
3. D. Davies, *El Greco*, Oxford and New York, 1976, 7.

Virgin and Child with St. Anne

Oil on canvas, 92.6 x 82.2 cm (35 3/8 x 31 5/8 in.)
 Condition: good. There are small retouches over the surface.
 An illegible seal is visible on the relining.
 Provenance: Comdr. R. L. Allport, Lee, Kent, England; Appleby Bros., London; Tomás Harris, London; Durlacher Bros., New York; bought by the Wadsworth Atheneum in 1946 from Durlacher Bros. for $45,000 from the Sumner Fund.
 Exhibitions: London, 1938; Hartford, *In Retrospect*, 1949, no. 18; Bridgeport, 1962, no. 2; Winnipeg, Manitoba, Winnipeg Art Gallery, *Mother and Child*, 14 May–13 Aug. 1967, no. 66; Hartford, 1982.
 The Ella Gallup Sumner and Mary Catlin Sumner Collection, 1946.46

The Virgin, clad in a red tunic and blue mantle, supports the Christ Child on her lap. Her right hand rests on St. Anne's shoulder. St. Anne wears an orange mantle and a sheer, white wimple, and bends over the Child as she wraps Him in swaddling clothes.[1]

Among the more tender and intimate themes painted by El Greco during the first two decades after his arrival in Spain in 1577 was a series of Holy Family groups, of which this *Virgin and Child with St. Anne* is an example.[2] These scenes always express the loving bond between the Virgin and Child, although other members of Christ's family are often included. Variations of this theme include the Holy Family (Mary, Joseph, and Christ), in which Mary is often depicted as the "Virgen de la Leche" (nursing Virgin), or the Holy Family with St. Anne, and the Holy Fam-

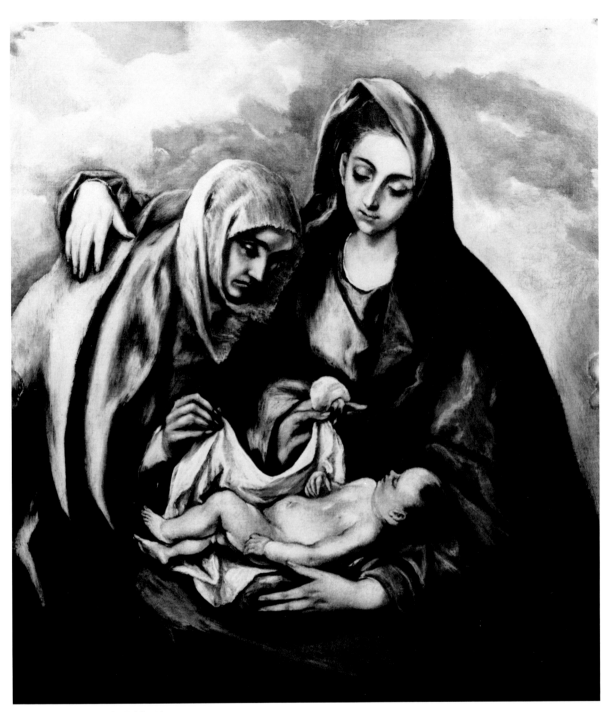

El Greco, *Virgin and Child with St. Anne*

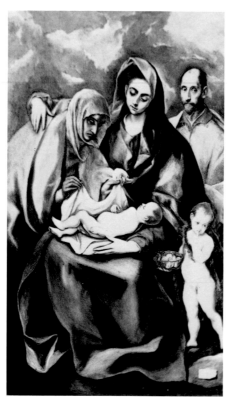

Figure 68. El Greco, *Madonna and Sleeping Christ Child with St. Anne*, Toledo, Museo de Santa Cruz

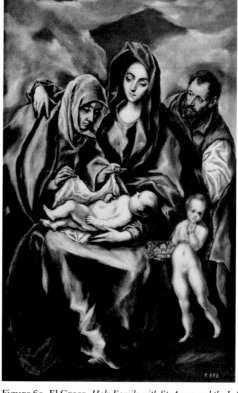

Figure 69. El Greco, *Holy Family with St. Anne and the Infant Baptist*, Madrid, Museo del Prado

ily with St. Anne and the infant Baptist. The *Virgin and Child with St. Anne* is the only known version in which only these three figures appear.[3]

An important iconographic feature of the *Virgin and Child with St. Anne* is the sleep of the infant Christ, which alludes to His future Crucifixion and Death. The lifting of the veil by St. Anne serves as a prefiguration of the shroud. Giovanni Bellini and Vivarini popularized this theme in Venice and El Greco's employment of it shows his thorough absorption of Venetian ideas, gained while a student there in the late 1560s.[4]

It has been suggested that the figures of the *Holy Family* in the Hispanic Society in New York[5] may be actual portraits of El Greco's companion, Jeronima de las Cuevas, their son, Jorge Manuel, and of El Greco himself.[6] A similar analysis also applies to the Atheneum painting. Another possible model has been proposed for St. Anne on the basis of her resemblance to the same saint in the *Holy Family* by Juan Fernández de Navarrete in the Escorial, a painting perhaps seen by El Greco.[7]

In the *Virgin and Child with St. Anne*, El Greco repeats a frequently used device, and isolates the figural group by placing it against a simple background of stormy sky filled with steely gray clouds. The faces of both St. Anne and the Virgin are colored and modeled in El Greco's typical manner: the eyes and lips are not painted with a hard edge, abruptly separating them from the surrounding flesh tone, but they merge imperceptibly with the surrounding pas-

sages. The texture of the Virgin's hair is suggested by El Greco's usual method of laying his orange-brown strokes over a darker ground.

The composition is closely related to that of the central grouping of figures in three other paintings by El Greco: Museo de Sta. Cruz, Toledo; Museo del Prado, Madrid; and National Gallery, Washington.[8] The Toledo *Madonna and Sleeping Christ Child with St. Anne*,[9] probably executed about 1580–85,[10] is a full-length representation of St. Anne, the Virgin, and Christ, with the infant Baptist at the lower right (Fig. 68). The Madrid *Holy Family with St. Anne and the Infant Baptist*,[11] probably from 1595–1600,[12] resembles the composition of the painting in Toledo, but with the addition of the figure of Joseph behind the Virgin's left shoulder (Fig. 69). The Washington *Holy Family with St. Anne and the Infant Baptist* is a smaller version of that in Madrid and is perhaps a study for it (Fig. 70).[13] The Atheneum's *Virgin and Child with St. Anne* resembles most closely that of the Museo de Sta. Cruz in Toledo, and may have been painted about the same time.[14] In both paintings the figures have greater weight and solidity than do those of the Prado painting, in which El Greco used highlights to express spirituality rather than sculptural form.[15]

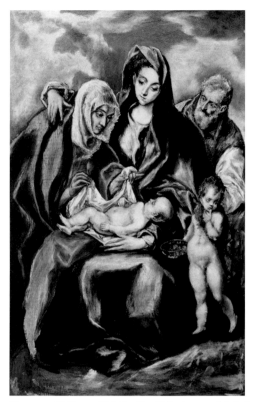

Figure 70. El Greco, *Holy Family with St. Anne and the Infant Baptist*, Washington, D.C., National Gallery of Art, Samuel H. Kress Collection

1. It is possible that the woman covering Christ is St. Elizabeth, Mary's cousin and the mother of St. John the Baptist. She often appears in Holy Family groups painted by Italian artists (e.g., Raphael's *Canigiani Madonna* in the Alte Pinakothek, Munich). The inclusion of the infant Baptist in paintings by El Greco, similar to the *Virgin and Child with St. Anne*, strengthens this identification.
2. A *Madonna and Sleeping Christ Child with St. Anne*, Museo de Sta. Cruz, Toledo; the *Holy Family with St. Anne and the Infant Baptist*, Museo del Prado, Madrid; the *Holy Family with St. Anne and the Infant Baptist*, National Gallery, Washington.
3. Wethey, 1962, II, 63.
4. Wethey, 1962, II, 59.
5. Reproduced in Trapier, 1958, fig. 22.
6. A. L. Mayer, *El Greco*, Berlin, 1931, 82.
7. Trapier, 1958, 30.
8. El Greco often returned to a theme, copying it almost line for line, with the addition of other figures, such as the infant St. John or Joseph in the Holy Families; see M. Soccio, *El Greco*, ed. Natalia Cossio de Jiménez, Barcelona, 1972, 59.
9. Reproduced in Wethey, 1962, I, pl. 99.
10. Wethey, 1962, II, 62.
11. Reproduced in Wethey, 1962, I, pl. 100.
12. Wethey, II, 59.
13. Reproduced in Wethey, 1962, I, pl. 102.
14. Wethey, 1962, II, 62.
15. Bibliography, in addition to that cited above, includes: T. Borenius, "From Greco to Goya," *Burlington Magazine*, LXXIII, 1938, 275–77; "From Greco to Goya in London," *Art News*, XXXVII, 3 Dec. 1938, 14, 24; *Wadsworth Atheneum Bulletin*, Apr. 1946; "Recently Found El Greco in Hartford," *Art News*, XLV, May 1946, 9; Soria, 1947, 268; "Hartford Thrives on Baroque," 1949, 28–29; J. Camón Aznar, *Dominico Greco*, Madrid, 1950, 584, fig. 441; Gaya Nuño, 1958, 194; Wethey, 1962, I, fig. 101, II, 63, no. 94; G. Manzini, *L'Opera completa del Greco*, Milan, 1969, 99; J. Gudiol, *Domenico Theotocopoulos, El Greco, 1541–1614*, London, 1973, 350, no. 150, fig. 177; Toledo, 1982, 235.

Juan de Juanes
(c. 1510–1579)

The most prominent artists in Valencia during the sixteenth century were members of the Maçip family. Vicente Maçip, born about 1475, was a direct disciple of the Maestro de Cabanyes. Between 1522 and 1524 Vicente worked for the cathedral of Valencia; between 1523 and 1530 he completed the most notable work of his career, the high altar for the cathedral of Segorbe, on which he was assisted by his son, Joan de Joanes (born c. 1510), known as Juan de Juanes. Upon Vicente's death in 1550, the shop continued to prosper. Underscoring their close collaboration, there often appears to be little difference between the paintings of father and son, as in the *Immaculate Conception*, now with Banco Urguijo, Madrid, which is dated by José Albi Fita to 1531–35[1]. Of the children of Juan — Vicente (c. 1555–1621), Dorotea (d. 1609), and Margarita (d. 1613) — both Vicente and Margarita studied the craft of painting. Vicente Maçip, alias Joanes (or sometimes Vicente Joan Maçip), began assisting his father in 1578 and continued in the family tradition following Juan's death in 1579.

1. Madrid, 1979–80, 50, no. 8 (218 x 183.5 cm). For a review of the exhibition, see F. Tello, "Exposiciones en Madrid," *Goya*, no. 155, Mar.–Apr. 1980, 300–304.

Circle of Juan de Juanes
Virgin of the Litanies

Oil and tempera on panel, central panel: 46.8 x 37.3 cm (18³/₈ x 14⁵/₈ in.); right int. panel: 59.4 x 20.8 cm (23³/₈ x 8¹/₄ in.); left int. panel: 59.4 x 22.1 cm (23³/₈ x 8⁵/₈ in.); right ext. panel: 59 x 20.3 cm (23¹/₄ x 8 in.); left ext. panel: 59 x 20.3 cm (23¹/₄ x 8 in.)

Condition: poor. Many small areas of the panels have been restored. Ultraviolet examination shows the Virgin's face to be almost entirely repainted. The other figures' faces have been moderately repainted, those of St. John the Baptist and God the Father the least so. The lettering of the mottos has also been repainted. The inscribed name J. JUANES. is old, but it remains uncertain whether it was painted by Juanes, a follower, or a later restorer.

Inscribed,[1] central panel,
lower left: J. JUANES.
around central figure:

 STELLA MARIS
 PORTA CELI
 OLIVA ESPECIO INCE PIS
 LILIUM INTER SPIN SPECULUM SI
 PLANTACIO ROSE
 UETUS CONCLUSUS
 ELLETA UT SOL
 VIRGA JESE FLORUIT
 SICUTCUT CEDRUSE
 TURIS FORTITUDINIS
 FONS ORTORUM
 CIVITAS

Provenance: The previous history of the picture is unknown. Clara Louise Kellogg Strakosch. Given to the Wadsworth Atheneum in 1914 by Clara Louise Kellogg Strakosch.

Gift of Clara Louise Kellogg Strakosch, 1914.13

The central panel of the *Virgin of the Litanies* triptych depicts the Virgin on the crescent moon, flanked by symbols and mottos of the litanies. The Holy Trinity crowns her from above. The right and left interior panels depict respectively *St. Martin and the Beggar* and the *Adoration of the Magi*. The right and left exterior panels depict respectively *St. John the Evangelist* and *St. John the Baptist*.

The imagery of the central panel specifically refers to the doctrine of the Immaculate Conception, which maintains that Mary was free from original sin from the moment she was conceived, and hence attests to her purity.[2] Heatedly debated from the founding of the Order of the Immaculate Conception in 1511 — following a vision experienced by Beatriz Selia of Portugal — the subject gained partial official sanction under Pope Gregory XV Ludovisi in 1622 and again in 1626, when Pope Urban VIII Barberini dedicated a new Capuchin church in Rome to Sta. Maria della Concezione. A final papal decree was issued only in 1854.

The iconographic symbols and the accompanying Latin mottos which praise the Virgin are often drawn from Old Testament sources.[3] They were derived from Marian litanies in use during the fifteenth and sixteenth centuries, one of which was approved by the Church in 1587 as the Litany of Loreto.[4]

The theme of the Virgin surrounded by the symbols of the litanies occurs prior to this triptych in the form of Spanish engravings of 1513 and 1534, printed in Saragossa, and of 1503–18, printed in Valencia.[5] It occurs in France in the *Heures de la Vierge à l'usage de Rome*, printed in Paris in 1505 by Thielman Kerver,[6] and in the *Heures à l'usage de Rouen*, published in Paris in 1503 by Antoine Verard.[7] It is found at Cahors Cathedral in the Chapelle de Nôtre-Dame, constructed in 1482.[8] A fifteenth-century prototype in Spain occurs on a panel from a retable of the Iglesia de Cerco, Artajona, Navarre, painted in 1497.[9]

The triptych of the *Virgin of the Litanies* may have been painted by a close follower or apprentice in the shop of Juan de Juanes.[10] The central panel of the Atheneum triptych derives from similar paintings by Juan de Juanes. These include the *Immaculate Conception* of the Iglesia de la Compañía de Jesús, Valencia,[11] the *Virgin "Tota Pulchra"* of the Colegio del Sagrado Corazón de Jesús, Valencia,[12] the *Virgin "Tota Pulchra"* in the church at Sot de Ferrer, Castellón de la Plana,[13] and the *Holy Virgin* of the Rocamora Collection, S. Cugat de Vallés.[14]

Although the painter of Hartford's *Virgin of the Litanies* was acquainted with the figural style of Juanes, he often cramped the facial features and exaggerated their musculature. This work lacks the grace and strength of drawing traditionally ascribed to Juan de Juanes.[15] It was probably painted between 1540 and 1560.

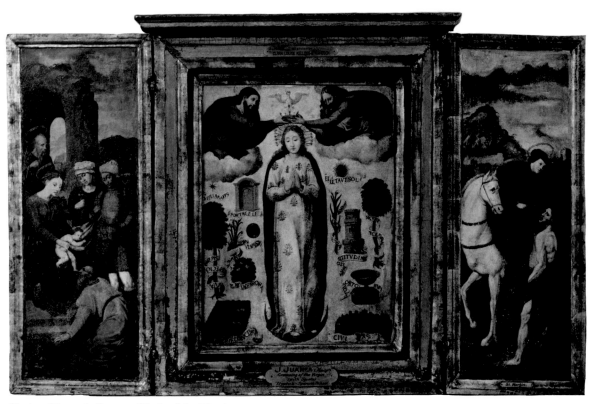

Circle of Juan de Juanes, *Virgin of the Litanies*

1. Vloberg, 1958, 476, notes that a common title for paintings with this iconography is "Virgin of the Litany," a reference to the late sixteenth-century Litany of Loreto. The title *Virgin of the Litanies*, however, suggests that the symbols and mottos were derived from various Marian litanies in use during the fifteenth and sixteenth centuries. The mottos of the *Virgin of the Litanies* are given below in their typical Latin form:

STELLA MARIS (Star of the Ocean)

PORTA COELI (Gate of Heaven) Genesis 28:17

OLIVA SPECIOSAE (Olive Tree) Ecclesiasticus 24:13–14

SICUT LILIUM INTER SPINAS (Lily among Thorns)
 Canticles 2:2

SPECULUM SINE MACULA (Unblemished Mirror) Wisdom 7:26

PLANTATIO ROSAE (Rose Garden of Jericho)
 Ecclesiasticus 50:6–7

HORTUS CONCLUSUS (Garden Enclosed) Canticles 4:12

ELECTA UT SOL (Sun) Ecclesiasticus 50:6–7

VIRGA JESSE FLORUIT (Rod of Jesse) Isaias 11:1

SICUT CEDRUS EXALTATA (Cedar of Lebanon)
 Ecclesiasticus 24:13–14

TURRIS DAVIDICA CUM PROPUGNACULIS (Tower of David)
 Canticles 4:4

FONS HORTORUM (Well of Living Waters) Canticles 4:15

CIVITAS DEI (City of God) Psalm 86:3

2. M. Levi d'Ancona, *The Iconography of the Immaculate Conception in the Middle Ages and Early Renaissance*, New York, 1957, 9.

3. Vloberg, 1958, 476.

4. U. Chevalier, *Nôtre-Dame-de-Lorette*, Paris, 1906, 328.

5. Trens, 1947, 152.

6. Mâle, 1925, 211, fig. 111.

7. Reau, 1957, 81.

8. Reau, 1957, 81.

9. Trens, 1947, 152.

10. The painting was published as Juanes in Gaya Nuño, 1958, 215. C. R. Post, however, letter in curatorial file, 4 May 1954, thought it by a Valencian follower of Juanes. The painters in Juanes's workshop included his son, Vicente Joan, his daughters, Margarita and Dorotea, as well as Fray Nicolás Borras, Cristóbal Llorens, Fray Nicolás Factor, Cristóbal Zarineña, Juan Zarineña, Francisco Zarineña, and Francisco Peralta. Paintings are known only by Borras and the Zarineñas, but none resembles this triptych. See F. Vilanova y Pizcueta, *Biografía de Juan de Juanes*, Valencia, 1884.

11. Reproduced in A. Ubeda, *Juan de Juanes*, Barcelona, 1943, LXIII. See also Madrid, 1979–80, 74, no. 56.

12. Reproduced in Trens, 1947, fig. 87.

13. Reproduced in Trens, 1947, fig. 88; Madrid, 1979–80, 62, no. 32.

14. Foto MAS 30.

15. Antonio Palomino Velasco, *Las Vidas de los pintores y estatuarios eminentes españoles*, London, 1742, 19, said of Juanes's style, "it was the sweetest style, the sovereign drawing, the singular beauty!"

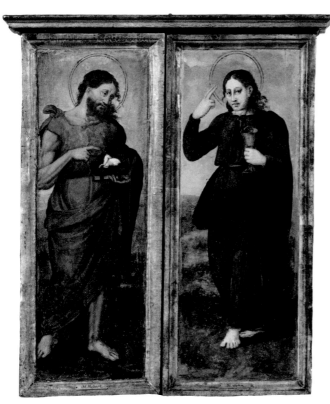

Circle of Juan de Juanes, *Virgin of the Litanies*, exterior panels

Eugenio Lucas the Elder (1817–1870)

The correct birth date and parentage of Eugenio Lucas were published in 1981 by José Manuel Arnaiz.[1] Born in Madrid, 9 February 1817, the son of Julian de Lucas of Jebalera, Cuenca, and Juana Velázquez of Obispo de Béjar was baptized the following day in the parochial church of Sta. Cruz, with the given name of Eugenio. Lucas was previously believed to be the son, born in Alcalá de Henares, of Francisco Lucas and María Padilla, both of Madrid; this recent finding explains the signature of the artist, which frequently is written Eugenio Vz Lucas.[2]

No documentation is known about the early years of the painter until the 1841 exposition of the Real Academia de S. Fernando, Madrid, when he exhibited four works, two *caprichos* and two with figures in fancy costumes.[3] In 1844 Lucas married María Hernández Muños of Madrid; within the year the young painter went to Paris. Lucas signed and dated a sketch in 1847, *On the Balcony*, Hispanic Society of America, New York, based on the painting *Celestina and Her Daughter* by Goya, which had been exhibited at the Liceo Artístico y Literario Español in 1846.[4] Lucas exhibited again at the academy in 1847 and 1849. During this time he also worked on mural decorations with allegorical subjects for the new Teatro Real, which opened for the birthday of Queen Isabel II in 1850 (destroyed 1857).[5]

On 23 September 1851, the queen and her consort, Don Francisco de Asís, granted Eugenio Lucas the title of Pintor de Cámara, as a landscape painter. This honor was followed on 12 July 1853 with a nomination as Caballero de la Real y Distinguida Orden de Carlos III.[6]

Eugenio Lucas's early oeuvre is complex, including still lifes painted in an Italianate manner, landscapes, portraits, genre subjects, bullfight scenes, and free copies after such artists as Goya, Murillo, Velázquez, Teniers, and van Dyck. Inquisition subjects and those of demonic brutalities begin in the early 1850s, and are found periodically in the later years. A painting entitled *Scene of Witchcraft*, now in the Museo Lázaro Galdiano, Madrid, is considered by Arnaiz to be a companion to the Atheneum's paintings. Also oil on panel and depicting a vanitas theme, this painting is signed and dated 1852.[7]

Later still lifes appear more northern in character; genre subjects are diverse in nature with fancifully costumed majas, caricatures, figures in the manner of Goya's "Black Period," church interiors and exteriors, and festivals, all painted with a rich palette and calligraphic brushwork. An overall liquid appearance often produces the effect of energy and impermanence. The paintings also have the sense of an oil sketch, with forms melting into each other.

The relationship between the paintings of Eugenio Lucas and Goya is a complex one, with the *City on the Rocks*, Metropolitan Museum of Art, New York, serving as a primary example. First attributed to Goya, the painting has been discussed by López Rey.[8]

Lucas's success was assured following the Paris Universal Exhibition of 1855, where he exhibited an *Uprising in the Puerta del Sol of the July 1854 Revolution* and the *Bullfight: The Divided Bull Ring* of circa 1854. The French critics praised his work, as they had Goya's, and thereafter his paintings were eagerly acquired.[9]

It was also during this period that Lucas established a relationship with Francisca Villamil López, a young woman from Madrid. Their son Eugenio would also become a painter, working in his father's style. Lucas was to remain loyal to the crown in the political unrest that continued in Madrid for over a decade and that resulted in the overthrow of the government of Isabel II in 1868.

On 11 September 1870, Eugenio Lucas died in Madrid of pulmonary congestion at the age of fifty-three, and was buried in a niche in the courtyard of S. Benito in the Sacramental de S. Martín. His remains were subsequently removed to the cemetery of Sta. María la Real de la Almudena, where his son Eugenio Lucas y Villamil was buried in 1918.[10]

1. Arnaiz, 1981, 595. In addition to a biography, Arnaiz includes facsimiles of archival documents pertinent to the life of the painter. A fully illustrated oeuvre catalogue accompanies the text, as well as a chapter devoted to technical studies.
2. Arnaiz, 1981, app. III, bibliog., 281–84. The major study in English is by Trapier, 1940. Also see J. Maxon, introduction in New York, Durlacher Bros., *A Loan Exhibition: Eugenio Lucas y Padilla, 1824–1870*, 1956.
3. Arnaiz, 1981, 10.
4. Trapier, 1940, 5.
5. Arnaiz, 1981.
6. Arnaiz, 1981, 17.
7. Although the Hartford paintings are not in the index, they are in the illustrated catalogue: 332, nos. 84 and 85, repr. 333, signed and dated *Scene of Brutality*, 332, no. 83, repr. 333, and in color, illus. 41 on 59.
8. López Rey, 1956, 40–41, 68–69.
9. Arnaiz, 1981, 374, no. 160, color illus. 9 on 22; 366, no. 147, color illus. 9 on 23.
10. Arnaiz, 1981, 34.

Abduction by Satan

Demonic Ritual

Oil on panel, each 50.8 x 36.8 cm (20 x 14½ in.)

Condition: good. Cracks are developing on the thick paint under the flying bird in the foreground of 1936.9 and in the head of the man holding a bottle in 1936.10.

Provenance: Bayo Collection, Madrid; purchased by the Wadsworth Atheneum in 1936 from Arnold Seligmann, Rey & Co., New York, for $400 each from the Sumner Fund.

Exhibitions: Hartford, 1940, no. 35 (1936.10 only); New London, 1948, no. 21 (1936.10 only); New York, Durlacher Bros., *Paintings and Drawings by Eugenio Lucas*, 28 Feb.–24 Mar. 1956, nos. 26–27.

The Ella Gallup Sumner and Mary Catlin Sumner Collection, 1936.9 (*Abduction by Satan*); 1936.10 (*Demonic Ritual*)

These two panels by Eugenio Lucas the Elder, and their companion in the Museo Lázaro Galdiano, Madrid,[1] depict scenes of the occult with vanitas elements and demonic rituals.[2] Until recently, the Hartford paintings were attributed to Eugenio Lucas the Younger, known as Eugenio Lucas y Villamil. The Madrid *Scene of Witchcraft* is of the same approximate size, 52 x 37.5 cm, and is also oil on panel. The signature on the Madrid painting, *E. Lucas*, and the date, 1852, firmly establish the correct attribution and date for the Hartford panels.

The oeuvre of Eugenio Lucas the Younger (1863–1918) has often been confused with that of his father; in fact, López Rey discusses this relationship, using the Atheneum painting 1936.10 as an example of the complexity of the problem, while maintaining the attribution to the younger artist.[3] López Rey's summary of the difficulties inherent in the study of these paintings and his attempt to understand Goya and Lucas the Elder in his own particular historical context is central to the issue.[4]

Given the vanitas theme of the Madrid painting, the former title of Atheneum no. 1936.9, *Chastisement of Luxury*, may be appropriate. In a similar manner, 1936.10, entitled *Demonic Ritual*, can be seen as an allegorical depiction of earthly delights. In this painting, a woman at the center of the composition is being restrained, while a seminude male demon approaches as if to assault her. A woman wearing a

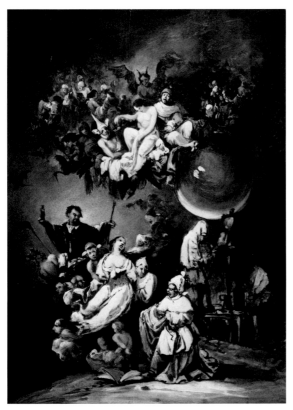

Eugenio Lucas the Elder, *Abduction by Satan*

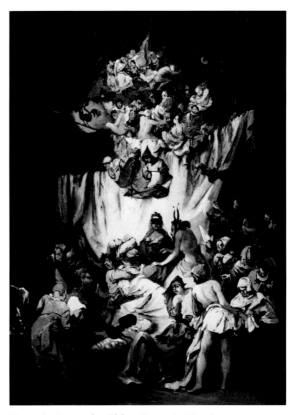

Eugenio Lucas the Elder, *Demonic Ritual*

blindfold (Justice?) stands calmly in the background between the two figures.

Although such paintings may have a literary source, vanitas and demonic scenes were popular in Spain. Certainly, Goya's six scenes of witchcraft, painted in 1798 for the duke and duchess of Osuna for their villa near Madrid, may have been known by Lucas.[5] Like Goya, Lucas may have based much of his conception of the subject on Moratín's popular commentary and publication of the *Auto de fe*, a manuscript account of a witch trial during the Inquisition.[6]

1. The third painting, *Escena de Brujería*, oil on panel, 37.5 x 52 cm, is in the Museo Lázaro Galdiano, Madrid. A sketch of the lower half of the *Abduction by Satan*, with slight modifications, is in the Metropolitan Museum, New York, there attributed to Eugenio Lucas the Elder (no. 42.186.2, 10 x 15 1/2 in., brown wash and white chalk). According to a letter from G. E. Dix of Durlacher Bros., New York, 31 March 1956, E. Trapier attributes the drawing to the elder Lucas. E. Haverkamp-Begemann, in examining the drawing in relation to a photograph of the painting, believed that the sketch, much larger than the corresponding section of the painting, was made from the painted composition, and was not preparatory to it (oral communication). As Begemann has pointed out, the drawing is squared on the upper corners, indicating the termination of the intended composition. The drawing, therefore, is not a fragment of a larger composition, but an independent study of a portion of the painting. Also, the Metropolitan sheet is executed in a sketchy manner, and it displays areas that are not clear as to what they represent, while the painting reveals more detail.
2. Previously entitled the *Chastisement of Luxury* (1936.9) and *Walpurgisnacht* (1936.10); see Arnaiz, 1981, 332, no. 83, pl. 41.
3. López Rey, 1956, 40–41, 68–69.
4. Further bibliography on the Lucases includes R. Balsa de la

Vega, *Lucas*, Madrid, 1911; Trapier, 1940; J. A. Gaya Nuño, *Eugenio Lucas*, Barcelonà, 1948; J. Baticle, "Eugenio Lucas [y Padilla] et les satellites de Goya," *Revue du Louvre*, no. 3, 1972, 163–75.
5. See Nordstrom, 1962, 153–71 (all six paintings are illustrated). Two of Goya's series, the *Witches' Sabbath* and the *Sorcery That Failed*, are now in the Museo Lázaro Galdiano, Madrid. Although they must have remained in Madrid since they were painted, it is not known when they were taken to the Lázaro Collection (Mayer, 1924, 174, nos. 548, 550, and J. Camón Aznar, *Museo Lázaro Galdiano*, Madrid, 1965, illus. in slides nos. 79, 80). Like Goya, Lucas depicts the devil with horns of a he-goat. Nordstrom, 1962, 162–63, looks to fourteenth-century manuscript illuminations for a source for this image, but it is hardly necessary, since this was a common representation of the devil in later centuries: compare the illustrated examples from the seventeenth and eighteenth centuries in the exhibition catalogue, *Les Sorcières*, nos. 90 and 249. This catalogue illustrates also an anonymous seventeenth-century drawing, no. 83, in which a woman is being held and forcibly raped by the devil, as seems to be the case in the Atheneum's panel 1936.9.
6. E. F. Helman, "The Younger Moratín and Goya: On *duendes* and *brujas*," *Hispanic Review*, XXVII, 1959, 103–11. Moratín's account (*Auto de fe, celebrado en la ciudad de Logrono en los dias 6 y 7 de Noviembre de 1610* in *Obras de D. Nicolás y D. Leandro Fernández Moratín*, Madrid, 1857, 6–7–631) recalls the scenes in the paintings by Lucas (1936.9 and 1936.10), especially where Moratín describes the trial with its he-goat and acolyte devils, bats, owls, and other diabolical creatures of the night. An article by N. Cohn, "Was There Ever a Society of Witches?," *Encounter*, 255, Dec. 1974, 26–41, seeks to prove that an organized society of witches never existed in Western Europe, and that there was never a witches' Sabbath. Whatever the case, Cohn shows us that the belief in organized meetings of witches had a revival around 1830 and grew in force throughout the nineteenth century. He describes (27–28) the "representative picture" of the witches' Sabbath as it existed in the nineteenth century. The two paintings by Lucas under discussion (1936.9 and 1936.10) correspond only partially to this description, and it seems likely that Lucas has here created his own unique conception of the Sabbath.

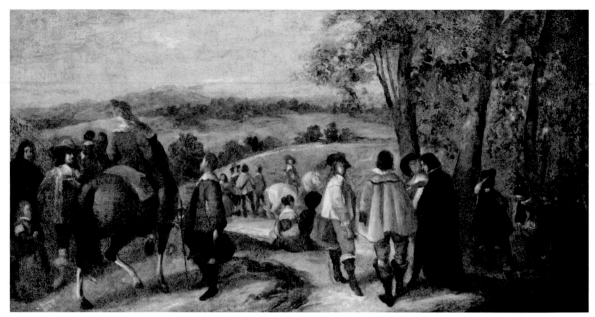

Juan Bautista Martínez del Mazo, *A Rural Landscape*

Juan Bautista Martínez del Mazo (c. 1612–1667)

Born at Cuenca, Mazo is remembered primarily as the pupil, assistant, and son-in-law of Diego Velázquez, whose daughter, Francisca, he married on 21 August 1633. Presumed painter to Prince Baltasar Carlos (d. 1646), Mazo probably accompanied the court to Pamplona and Saragossa in 1646; the *View of Saragossa*, attributed to Velázquez and Mazo and now in the Prado, is dated 1647. In 1657 Mazo is recorded in Naples. His last work is in portraiture, which is markedly influenced by the paintings of Velázquez, following whose death (1660) Mazo was appointed Pintor de Cámara in April 1661. The *Portrait of a Painter's Family* in the Kunsthistorisches Museum, Vienna, affirms his personal style, which is best known through royal portraits. The only other signed and dated work, the *Queen Mariana of Spain in Mourning* in the National Gallery, London, of 1666, set a standard for future court portraits, especially those of Juan Carreño de Miranda. Mazo's most original contribution was in landscape painting, where the luminous atmosphere is made timeless by the soft colors and transitional light, and the scenes personal through the casual gestures and interactions of the small-scale figures who populate them. Mazo died in Madrid on 10 February 1667, at the height of his success and popularity.[1]

1. For the life of Juan Bautista Martínez del Mazo, see Palomino, 1987, 210–11; Princeton, 1982, 80–81; Paris, 1987, 164–67.

A Rural Landscape

Oil on canvas, 50.4 x 102.8 cm ($19^{11}/_{16}$ x $40^1/_8$ in.)
 Condition: fair. The paint film is much abraded with losses throughout, especially in the sky. X rays suggest that the present composition was painted over an earlier design, a view of a city.
 Provenance: possibly collection Thomas Purves, London, 1849, as by Velázquez;[1] Sir John Agnew, London, sale London, Christie's, 25 July 1958, as by Mazo; private collection, England; Central Picture Galleries, New York; bought by the Wadsworth Atheneum in 1963 from Central Picture Galleries for $1,500 from the Sumner Fund.
 The Ella Gallup Sumner and Mary Catlin Sumner Collection, 1963.497

Mazo's distinctive contribution to Spanish art rests with his landscape paintings. Of these, the most successful are the topographical views, the *View of Saragossa* and the *Stag Hunt of the Tabladillo in Aranjuez*, both now in the Prado, which combined an ample representation of landscape features with genrelike scenes of outdoor activity.[2] It is with the style of these paintings, especially the *View of Saragossa*, and not with Mazo's Italianate landscapes, that *A Rural Landscape* can be associated.[3] Indeed, no less than six figures[4] in the Atheneum painting appear to have been taken, with certain variations, from the *View of Saragossa* of 1648. It has previously been assumed that Velázquez intervened in the foreground figures of the latter painting.[5] Could he have had a hand in *A Rural Landscape*? Evidence of style would seem to exclude his hand and, indeed, recent scholarship has tended to affirm Mazo's competence as witnessed by his contemporaries,[6] and to dismiss the possibility of aid from his father-in-law.[7] Because

so little is known about Velázquez's circle or Mazo's shop practice, however, it is reasonable to attribute the Atheneum painting to Mazo or his workshop.[8] In view of its small[9] size and its execution on an older, reused canvas, it is likely that the painting was originally intended as a sketch or study[10] for another, possibly larger, picture. The X rays suggest that the original picture on the canvas was a detailed bird's-eye view of a fortified city, perhaps Madrid.[11] The cityscape appears to be by an earlier hand.

1. Curtis, 1883, 321.
2. See E. Lafuente Ferrari, *Breve historia de la pintura española*, Madrid, 1953, 323. The *Saragossa* view is signed by Mazo. The *Stag Hunt* was inventoried by Mazo as his painting in 1666. Museo del Prado, *Catálogo*, Madrid, 1952, 381.
3. These landscapes, such as the *Arch of Titus* and *A Palace Garden*, both in the Prado, exhibit the influence of Claude Lorrain and may have been executed while Mazo traveled in Italy in 1657. Trapier, *Gazette des Beaux-Arts*, 1963, 306. Also M. Caturla, "Sobre un viaje de Mazo a Italia hasta ahora ignorado," *Archivo Español de Arte*, XXVIII, 1955, 73–75.
4. "Among these are the two men in the distance behind the rider on the white horse, the Cavalier who holds a glove in one hand as he talks to friends, the little girl at the left, the man with a plumed hat in the wooded area at the right, and the girl who offers him a tray of gleaming fruit" (Trapier, *Wadsworth Atheneum Bulletin*, 1963, 8). Trapier also identifies the horse in the foreground as a copy of that in Velázquez's *Surrender of Breda*.
5. An assumption first made by the connoisseurs in the mid nineteenth century. Its history is fully documented in Pantorba, 1957, 119–25.
6. Trapier, *Gazette des Beaux-Arts*, 1963, 302, states: "It is unlikely that he would have needed help from his Master to finish a painting so much in his own genre and so little in that of Velázquez."
7. See, for example, Trapier, *Gazette des Beaux-Arts*, 1963, 296, who states that Mazo "never bathed his scenes in blue and silvery atmosphere, nor flooded them with sunlight as did Velázquez. The bold impressionistic handling of light and shadow, the fresh, sparkling tonality of Velázquez are missing in his works. When the Master painted the two views of the Villa Medici, Rome (Madrid, Prado), the figures merged with the background, being brushed in so lightly that they appear almost transparent. His assistant, on the other hand, leaves nothing to the imagination when depicting small figures, drawing as carefully as a miniaturist and pointing up trivial details."
8. This was the view taken by Trapier, *Gazette des Beaux-Arts*, 1963. Bibliography, in addition to that cited elsewhere, includes A. E. Pérez Sánchez, "Baldasare de Caro en vez de Juan Bautista del Mazo," *Archivo Español de Arte*, no. 152, 1965, 330–31, repr. pl. IV facing 341.
9. All of Mazo's works in the Prado, for instance, measure more than a meter in height. The *View of Saragossa* is 1.81 x 3.31 m. The *Hunt of the Tabladillo* measures 2.49 x 1.87 m. See Museo del Prado, *Catálogo*, Madrid, 1972, 402, 749. It is also certain that *A Rural Landscape* has not been cut. Losses on the right and left edges probably indicate an earlier tacking edge.
10. Two small canvases attributed to Mazo and exhibited in Edinburgh, National Gallery of Scotland, *Spanish Paintings*, 18 Aug.–8 Sept. 1951, nos. 38, 39, are of special interest in determining the function of the Atheneum painting. According to Harris, 1951, 310, these sketches in oil, which resemble *A Rural Landscape* in style, size, and condition, are by Mazo and decidedly not by Velázquez. Furthermore, she identifies the left figure in no. 39 with the standing lady in the *Fountain of the Tritons*,

Aranjuez, a painting variously attributed to Velázquez, Mazo, and an unknown hand. See Museo del Prado, *Catálogo*, 1963, no. 1213, 747; Trapier, *Gazette des Beaux-Arts*, 1963, 309, and Harris, 1951, 311. Even if not by Mazo, however, the two studies would still tend to establish a practice of oil sketching within Velázquez's circle, preparatory to the execution of final works. Mazo's use of an old, obviously undesirable painting for *A Rural Landscape* would also appear to strengthen this conclusion.
11. The heavy fortifications suggest an important city, and their features correspond with Madrid's appearance in the 1560s; see E. Haverkamp-Begemann, "The Spanish Views of Anton van den Wyngaerde," *Master Drawings*, VII, 1969, 375–99. The architecture, however, is reminiscent of Saragossa and the view may well be one of that town from its land side (pl. 13). It does not resemble any other Spanish city recorded by Wyngaerde or in the *Civitates orbis terrarum*, 6 vols., Cologne, 1572–1618, published by G. Braun and F. Hogenberg.

Luis Egidio Meléndez (1716–1780)

Recognized today as one of the finest still-life painters of eighteenth-century Spain, Luis Meléndez received no acclaim during his lifetime, and his career, which began with great promise, ended in disappointment and poverty.[1] Two self-portraits, one from 1746, when the artist was thirty years of age, and a second just over twenty-five years later, within little more than five years of his death, illustrate clearly the extremes of his situation.

Luis's father, Francisco, was born at Oviedo, in the north of Spain in 1682. At an early age, along with his brother Miguel Jacinto, Francisco went to Madrid to continue his art studies. Following a traditional path, Miguel worked in the capital and, by 1712, was appointed court painter to Philip V. In contrast, Francisco left Madrid in 1699, traveling first to Marseilles and Genoa before continuing on to Milan, Venice, and Rome. In 1700 he joined the Spanish army and continued his artistic training while serving in Italy for the next seven years. Later, while in Naples, he met and married María Josefa Durazo y Santo Padre Barrille y Rodrígues, a native of Villamaurel near Granada; three of the couple's children were born in Naples: Clara in 1712, Ana in 1714, and Luis in 1716. In 1717 the family moved to Madrid, where, in 1725, Francisco was appointed to the position of king's painter of miniatures. The three older children, along with their brother José Agustín, who was born in 1724, eventually were to study painting with their father.

Philip V, grandson of Louis XIV of France and first Bourbon king of Spain, wishing to emulate the French court in the Spanish capital, invited many French artists to Madrid. In 1737 Louis-Michel van Loo became Spanish court painter, with the young Luis Meléndez assisting in this illustrious studio for six years, engaged with the commission of royal portraits. Although Francisco Meléndez had first petitioned Philip V in 1726 to establish an academy of art, it was not until 1744 that the monarch granted permission for the formation of a preparatory *junta* to create an experimental academy which might then become a royal academy. Juan Domingo Olivieri, favorite of Queen Elizabeth Farnese, Italian second wife of Philip, was named director general, instead of Francisco, who was given the powerless post of honorary master director. First on the list of twelve accepted students in 1745 was Luis Meléndez. By 1747, however, Francisco had resigned his post, having become even more disgruntled with his position, especially when his work was not favored with commissions; on 8 March 1748 he publicly denounced the *junta*. Francisco was censured and expelled from the academy; three months later, Luis was denied entrance.

With the loss of his student position and with no prospects for a travel grant, Luis Meléndez followed the pattern his father had set almost fifty years earlier and went to Italy to perfect his art, first spending several years in Rome. Moving to Naples, then one of Europe's largest cities, Luis became active in the court of

Prince Carlos, eldest son of Philip V and Elizabeth Farnese, who had been proclaimed king of the Two Sicilies in 1735. (He would become Charles III of Spain in 1759, at the death of his half-brother.) Carlos, keenly interested in the arts and in beautifying his capital, founded a royal academy of art in 1751. Undoubtedly, the famous still-life painters of Naples — Luca Forte, Paolo Porpora, Giuseppe Recco, and Giovanni Battista Ruoppolo — caught Meléndez's attention, for it is their work, more than any other, that inspired the direction and style Luis's own art would later take. In Naples, Luis married the Spaniard María Redondo, a native of Ziruelas, Guadalajara.

In 1753 Francisco Meléndez called his son back to Madrid to assist with a large commission from Ferdinand VI (elder half-brother of Prince Carlos), the illumination of choir books for the chapel of the new royal palace. Upon completion of this project five and a half years later, neither an appointment to the Royal Academy of S. Fernando, which Ferdinand had founded in June of 1752, nor a commission from the new king, Charles III, ensued. Without royal patronage, Luis turned to what would become the major part of his oeuvre, the painting of still lifes. All of his dated work in this genre is from 1759 to 1774. Curiously, although he was awarded no royal contracts and his petitions to the king were in vain, thirty-eight years after Luis's death, forty-five of his still lifes were recorded as hanging in the dining room of the royal palace in Aranjuez.

Facing financial ruin, the physically ailing Luis Meléndez filed a declaration of poverty in June 1780; a month later, he died. His widow, in turn, filed a similar declaration of poverty nine months later. It is assumed that she died soon thereafter, although no record of her death has been found. The couple left no heirs.

1. Tufts, 1985.

Still Life: Pigeons, Onions, Bread, and Kitchen Utensils

Oil on canvas, 64.4 x 84.2 cm (25^1/$_8$ x 32^7/$_8$ in.)

Condition: good. There is some inpainting in the lower right quadrant under the slanted loaf of bread and in and around the beak of the top bird. A tear immediately above the garlic on the table has been repaired. Another onion to the right of the visible white onion has been painted out.

Inscribed on bowl in lower right: LsMz[1]

Provenance: private collection, England;[2] D. A. Hoogendijk & Co., Amsterdam; bought by the Wadsworth Atheneum in 1938 from D. A. Hoogendijk & Co. for $950 from the Sumner Fund.

Exhibitions: Hartford, 1938, no. 37; New London, 1948, no. 15; Westport, *Spanish Masters*, 1955, no. 19; Dallas, Meadows Museum (also Raleigh, North Carolina Museum of Art, and New York, National Academy of Design), *Luis Meléndez: Spanish Still-Life Painter of the Eighteenth Century*, 22 Mar.–19 May 1985, 108, no. 28.

The Ella Gallup Sumner and Mary Catlin Sumner Collection, 1938.256

This *Still Life* has been attributed to Meléndez since its appearance in the literature.[3] Of primary concern to Luis Meléndez in his still-life paintings is the form of the various objects depicted. Volume and mass, especially of round objects, provide spatial harmonies which stress the basic austerity and simplicity of the compositions. In turn, the surface of each item is given critical attention to reinforce the truthful observation of the natural world. Light always enters from the left, casting the objects in a brightness which further accents the intricacies and subtleties of the surface description, such as of the earthenware pitcher, the bread, feathers, and the onion skins and roots. Shadows slowly engulf objects from the right, frequently causing them to stand out in splendid, three-dimensional isolation.

Because of this clarity of observation and individual concentration, the objects in his still lifes tend to possess a monumentality which transforms the most mundane of kitchen fare into universal statements. Many of the same utensils — pots and pans — are used again and again, but always in new and inventive juxtapositions. Fruit, such as pears, plums, figs, cherries, apricots, and melons — watermelons and cantaloupes — are found more frequently than vegetables. Round loaves of bread are often depicted; dead game, seldom. Meléndez's colors are usually subdued, and his light is never harsh.

Frequently, the brushwork is vigorous, with areas of impasto used to stress surface texture and to catch the light, providing a sculptural richness to the forms. Line, clearly stated and circumscribing each object, provides not only the individual contours but also the links from one passage to another. This is a marked contrast in spatial understanding from his great forebears in still-life painting, Juan van der Hamen y Léon and Francisco Zurbarán.

The artist's initials on this painting were not known until 1969, when Eleanor Tufts urged the Atheneum's conservator to clean the section where they were found on the round bowl. The picture can be dated to about 1772.[4]

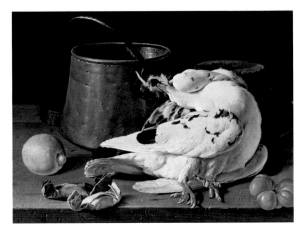

Figure 71. Luis Egidio Meléndez, *Still Life with Game*, Raleigh, North Carolina Museum of Art

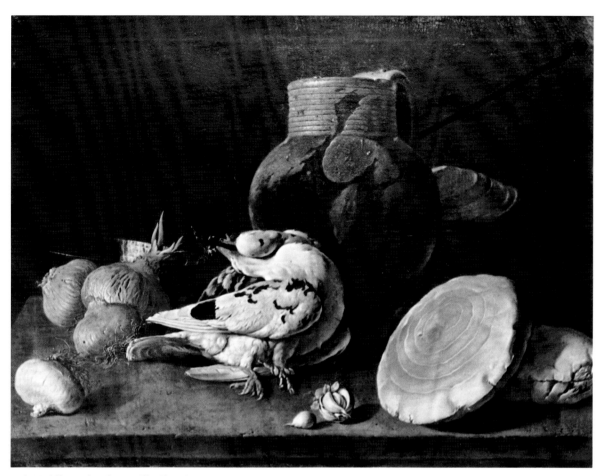

Luis Egidio Meléndez, *Still Life: Pigeons, Onions, Bread, and Kitchen Utensils*

1. Meléndez signed three of his canvases at the Prado (nos. 904, 915, 931) "Menendez." Documents relating to the painter, however, reveal that he preferred "Melendez" until 1770, when he completed *Watermelon, Bread, and Pastry*, Prado no. 915. Thereafter, "Menendez" appears in Prado nos. 904 and 931, both dated 1771, as well as in a letter to the king of 1772 and his declaration of poverty of 1780. Both Thieme and Becker and the Prado catalogue prefer the earlier spelling. The full name is Luis Egidio Meléndez de Rivera Durazo y Santo Padre. In some instances (e.g., Prado nos. 904, 906, 915, 931, 937), the order of the two given names is reversed. See Soria, 1948, 215. Also Tufts, 1972, 63.

2. D. A. Hoogendijk, letter in curatorial file, 30 July 1946.

3. Soria, 1948, 215–17; Gaya Nuño, 1958, no. 1787; *Wadsworth Atheneum Handbook*, 1958, 91; F. J. Sánchez Cantón, *Ars hispaniae*, Madrid, 1965, XVII, 221–28; M. Sánchez de Palacios, *Bodegones en el Museo del Prado*, Madrid, 1965; E. Tufts, "Still Life with Pigeons by Luis Meléndez," *Wadsworth Atheneum Bulletin*, Spring/Fall 1969, 60–69; E. Tufts, "A Stylistic Study of the Paintings of Luis Meléndez," Ph.D. diss., New York University, 1970; R. Tórres Martín, *La Naturaleza muerta en la pintura española*, Barcelona, 1971, 182, repr.; Tufts, 1972, 63–68; E. Tufts, "A Second Meléndez Self-Portrait: The Artist as Still Life," *Art Bulletin*, LVI, 1974, 1–3; E. Tufts, "Luis Meléndez, Still-life

Painter sans pareil," *Gazette des Beaux-Arts*, VI, Nov. 1982, 142, 143–48; Madrid, Museo del Prado, *Luis Meléndez. Bodegonista español del siglo XVIII*, Dec. 1982–Jan. 1983, exh. cat. by Juan J. Luna, illus. on 39; Tufts, 1985, 95–96, no. 65, pl. 65.

4. Of the eighteen dated paintings by Meléndez in the Prado, the four which exhibit elements also present in the Atheneum painting are dated 1772. No. 902 features the same jar but with a broken dish and spoon covering it. No. 908, *Still Life with Two Partridges, Onions, and Dishes*, contains similarly positioned birds, although these are viewed from a different perspective. The bowl in the back of the Hartford painting is also seen here. No. 930 exhibits that same bowl but with an inverted plate covering it, that is, more like the Atheneum painting. No. 918 presents the jar again, with broken dish and spoon on top, much like no. 902. An undated *Still Life* in the North Carolina Museum of Art, Raleigh, shows two doves in the same position and with the same markings as those in the Atheneum picture (Fig. 71).

Bartolomé Esteban Murillo (1617–1682)

Bartolomé Esteban Murillo was baptized in Seville on 1 January 1618, the youngest and last child born to Bartolomé Esteban, a barber-surgeon, and María Pérez Murillo, who came from a family of painters and silversmiths.[1] At the age of nine, Murillo was orphaned and at fifteen began an apprenticeship with the painter Juan del Castillo, a maternal relative. His first known painting, the signed *Virgin Presenting the Rosary to St. Dominic*, Archbishop's Palace, Seville, dated to about 1638–40, demonstrates the skills the young painter developed under the direction of his master, as well as characteristics of the painters of the Sevillian school, such as Juan de Roelas and Zurbarán, whose influences lingered through Murillo's early period.

In 1645 Murillo married Beatriz Cabrera and received his first major public commission, a series of eleven paintings for the small cloister of the monastery of S. Francisco in Seville. In these paintings, dispersed during the Spanish War of Independence (1808–14), Murillo incorporated the popular, naturalistic style with his graceful figures and smoldering colors, compositional features which were to evolve throughout his career. The Atheneum's *St. Francis Xavier*, from about twenty-five years later, exemplifies these qualities. Other departures from earlier, more balanced, classical designs are the asymmetrical placement of figure and background elements, and a light source that energizes and intensifies the portrayal of his images. Murillo's subjects, and his figures, although ranging from peaceful composure to glorious ecstasy, from playful genre scenes to those of religious decorum or regal beauty, are interpreted with an understanding of visual truth which he often enhances to a higher state of perfection.

Murillo visited Madrid in 1655, where he must have studied with care the great paintings in the royal collection. Elements of Titian, Rubens, Ribera, and Velázquez strengthened his rapidly developing personal style. In 1660, with Juan de Valdés Leal, he cofounded the Academy of Seville; but having little sympathy for the "modern" attitudes and styles of his colleagues, Murillo left the academy to teach in his own studio. At the height of his creative powers he executed the four lunettes for the church of Sta. María la Blanca, Madrid, in 1665, and the cycles painted in Seville for the Capuchin monastery and the Hospital de la Sta. Caridad, dating to the later 1660s. It was during his final large-scale project, the paintings for the high altar of the Capuchin church in Cádiz in 1682, that Murillo was fatally injured in a fall from a scaffold.

Murillo was one of the greatest interpreters of Catholic religious themes of the baroque era. His compositions are not marked by the excesses associated with the dynamics and volumetrics characterizing Rubens's work or the florid theatrics often employed by the Italian painters of the second half of the century, such as Luca Giordano. In contrast to Ribera, who chose somber subjects and depicted the sublime triumph of martyrdom, or Zurbarán, who rendered time eternal in his depiction of discrete matter as analogous to abstract sensibility, Murillo captured the universal message found in the parables, lives of the saints, or acts of charity, and translated these into recognizable human forms and situations. The beggar children and the Holy children that he depicted had an appeal to his own generation as well as to succeeding ones. Paintings from his later years are frequently lighter and brighter in color and gentler in mood than those from his earlier years, and demonstrate his ability to adjust his personal artistic expression to the changes in late baroque art which would culminate in the rococo.

1. The most accessible source in English is London, 1983; see also Angulo Íñiguez, 1980.

St. Francis Xavier

Oil on canvas, 216.8 x 160.7 cm (85 3/4 x 63 1/4 in.)

Condition: good. There is scattered inpainting. A large crescent-shaped damage in the upper right has been filled.

There are two labels on the reverse of the frame, both by the same hand:

The St. Francis Xavier by Murillo This picture was purchased by Mr. O'Neil of Miss Grant sister to the late Lt. Col. Grant, who imported it into England from Spain. I purchased it of Mr. O'Neil in the year 1833.

St Francis Xavier by MURILLO this picture was seized and taken by Joseph King of Spain (brother of Napoleon 1st) from Madrid and was rolled up and in his carriage at the battle of Vitoria April 21st 1813. Colonel Grant commanding the English cavalry perceiving a carriage retreating across the plain at the rapid pace ordered some of his troopers to pursue and on doing so it was found to be King Joseph's carriage and in it was found this picture which Colonel Grant sent to his two sisters in England after keeping it some years, sold it to Charles O'Neil Esq. of London from whom I bought it in the year 1833 H.W. Sawbridge Erle-Drax. St Francis Xavier was buried in the principal Cathedral in Goa in the East Indies he is disentombed periodically in procession, his body is placed in a marble sarcophagus and the principal events of his life are carved on the outside having relation to his conversion of the Hindoos—

Olantigh Towers H. W. Sawbridge Erle-Drax

Provenance: possibly collection Juan Francisco Eminete, Seville; Francisco Artier, Madrid, before 1724;[1] marqués de Santiago, Madrid, before 1782;[2] Mr. Campbell or Lt. Col. Grant;[3] Mrs. Grant, Greek St., Soho, before 1819;[4] Charles O'Neil, London, before 1831;[5] H. W. Sawbridge Erle-Drax, Olantigh Towers, Kent; J. C. W. Sawbridge Erle-Drax, Olantigh Towers, Kent, sale London, Christie's, 10 May 1935, no. 115, bought for 399 guineas; Tomás Harris, London; Arnold Seligmann, Rey & Co., New York; purchased by the Wadsworth Atheneum in 1937 from Arnold Seligmann, Rey & Co. for $8,000 from the Sumner Fund.

Exhibitions: Manchester, Royal Institution, 1831;[6] New York, New York World's Fair, 1940, no. 121; Hartford, *In Retrospect*, 1949, no. 19; Hartford, 1982.

The Ella Gallup Sumner and Mary Catlin Sumner Collection, 1937.3

St. Francis Xavier, canonized in 1622, was a Jesuit missionary famed for his conversions in India and Japan.[7] Murillo represented him twice, combining devotional and narrative images based on events from the saint's life. In both cases, he is dressed in a Jesuit habit: a belted black gown with a shoulder-length cloak and raised white collar; he also bears the general attributes of a missionary — a pilgrim's staff, book, crucifix, and a rosary.[8] The foreground shows the saint in a landscape setting, leaning on his staff while gazing upward toward a ray of light issuing from a break in the clouds. The beam strikes him on the chest, erupting into flame. Francis Xavier opens his cloak to cool the fire. The ray of light and the ensuing flame are symbolic of divine inspiration as well as of the evangelical fervor of missionary activity.

This representation corresponds to the traditional image of Francis Xavier, based ultimately on one of two portraits commissioned in 1583 by a visitor to Goa, where the saint's miraculously preserved body is kept; one of these was sent to Rome and reproduced numerous times in engravings as well as in painted copies. The portrait determined not only the

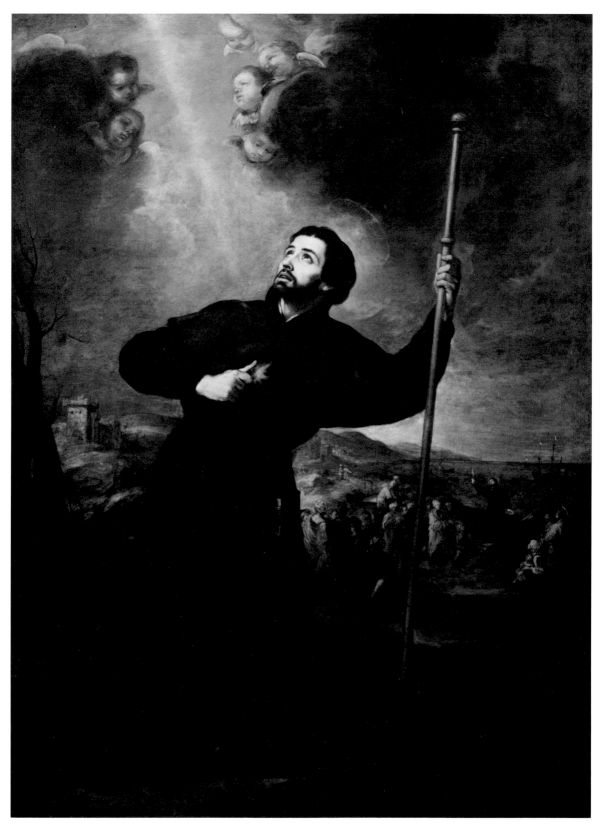

Bartolomé Esteban Murillo, *St. Francis Xavier*

essential physical features of the saint — large, intense dark eyes, short black hair, beard, and mustache — but also the gesture of opening his cloak and gazing upward toward the source of divine inspiration.[9]

St. Francis Xavier also reappears in the background raising a crucifix and preaching to a group of natives, turbaned and in exotic costumes. It has not yet been possible to identify this scene with any of the specific events or miracles attributed to him.[10] A similar combination of a devotional foreground image with a more informal scene of the saint preaching in the background is found in an engraving by Antonie Wierix, likely to have been available to Murillo.[11] Yet the background scene itself may be more closely related to an engraving by Geert Edelinck after Jerome Sourley, which only shows Francis Xavier preaching.[12]

Stylistically, the Hartford painting belongs to about 1670, Murillo's late period, characterized by a thin, fluid, and broadly painted technique.[13] This is most apparent in the misty backgrounds, often punctuated with similar interpretations of exotic architectural settings, found in contemporary full-length representations of saints by Murillo. Compare, for example, *St. Francis de Paul*, collection Princess Labia, Cape Town; *St. Francis Embracing the Crucified*, Museo Provincial, Seville;[14] *St. John the Baptist*, Seville;[15] and *St. Augustine Contemplating the Virgin and the Crucified Christ*, the Prado, Madrid.[16] For an example of a background populated with small figures in a narrative composition, unusual in Murillo's work, see the *Patrician John and His Wife before Pope Liberius*, and the *Feeding of the Five Thousand*,[17] part of a series painted for the Hermandad de la Caridad, Seville.[18] A partial copy of the Atheneum painting is in the Detroit Art Institute.[19]

1. Palomino de Castro y Velasco, 1724, 421.

2. R. Cumberland, *Anecdotes of Eminent Painters in Spain during the Sixteenth and Seventeenth Centuries*, London, 1782, II, 126.

3. It is not certain precisely how the painting left Spain. According to Davis, 1819, xxviii, note, it was "purchased at Madrid by Mr. Campbell of the Marquis of Santiago"; Curtis, 1833, 241, no. 308: "purchased about 1809 by Mr. Campbell, who was Buchanan's agent in Spain." However, the work is not mentioned in Buchanan, 1824. A second means of export is given by two labels on the reverse of the frame. This version is supported by A. O'Neil, *A Dictionary of Spanish Painters*, London, 1833, I, 265. M Bryan, *A Biographical and Critical Dictionary of Painters and Engravers*, London, 1816, II, 110, states that the *St. Francis Xavier* was in the collection of the marquis of Santiago at Madrid. This would appear to contradict both the Campbell and Grant histories, which cite the painting as leaving Spain about 1809 and in 1813. However, Bryan's description is clearly a paraphrase of Cumberland, and is probably not based on direct knowledge of the painting itself.

4. Davis, 1819, xxviii: "at present in the possession of his [Mr. Campbell's] sister Mrs. Grant"; lxiii: "Mrs. Grant . . . says she can produce the MS. receipt for the price paid for it"; Curtis, 1833, 241: "from him [Mr. Campbell] it passed to his sister, Mrs. Grant."

5. Passavant, 1833, 184: "gehört Herrn C. O'Neil"; Curtis, 1833, 241: "Mrs. Grant sold it to Charles O'Neil."

6. Passavant, 1833, 184.

7. For an exhaustive biography of the saint, see Schurhammer, 1955–73.

8. J. Braun, *Tracht und Attribute der Heiligen*, Stuttgart, 1943, 269–70; J. Timmers, *Symboliek en Iconographie der Christelijke Kunst*, Roermond, 1947, 845, 915.

9. For a discussion of the problems concerning the "life portrait" of Francis Xavier, see Schurhammer, 1965, 213–15, pls. V–X. To these examples should be added a Spanish copy from the seventeenth century in the Museo Arqueológico Artístico Episcopal, Vich; photo MAS 1284 and FARL 808–1 h3. The specific moment recorded has been traced by Schurhammer to an episode on Goa first noted by H. Tursellinus, *De vita Francisci Xaverii*, Rome, 1594, IV, 7; Spanish translation by Pedro de Guzmán, Valladolid, 1600 (Schurhammer, 1973, 528–29, n. 16). A full-length version of this portrait, similar to that employed by Murillo, was displayed in the churches of Rome on 22 May 1622, the date of the canonization of Francis Xavier and other Jesuit saints. For the importance of the canonization ceremony in determining the official iconography of newly created saints, see Mâle, 1932, 98–100.

10. For a discussion of some of these as represented by Rubens, including their literary and artistic sources, see G. Smith, "Rubens Altargemälde des Hl. Ignatius von Loyola und des Hl. Franz Xaver für die Jesuitenkirche in Antwerpen," *Jahrbuch der Kunsthistorischen Sammlung in Wien*, II: XXIX, 1969, 39–60.

11. The resemblance was noted by M. Soria, "Some Flemish Sources of Baroque Painting in Spain," *Art Bulletin*, XXX, 1948, 255–56, n. 36, who pointed out the importance of northern prints for Spanish baroque painting. Reproduced in Schurhammer, 1965, pl. LXXVII, fig. 6.

12. Schurhammer, 1965, pl. LXXIII, fig. 5, and 603. There are distinct similarities in the overall composition as well as individual features: the figure of Francis Xavier, raising his crucifix and standing on a slightly elevated ground, is surrounded by a group of natives. Included in both works are a seated mother and child, to the right; farther to the left is a pair of figures viewed from behind, one wearing a turban. Also similar are the tree to the left and the outline of the coast in the background, including a distant view of exotic architecture to the left of Xavier and a boat moored offshore to the right. A more populated version of the same compositional type is found in a roughly contemporary painting attributed to an anonymous Catalonian artist and now in the Ermita de Sta. Catalina, Torroella de Montgri, province of Gerona; photo MAS 23233–C and FARL 848a.

13. This is the opinion of Soria, 1947, 452, Gaya Nuño, 1958, 244, no. 1882, and Angulo Íñiguez, 1980, II, 254, no. 309. Bibliography, in addition to those references cited elsewhere, includes the following: L. Alfonso, *Murillo*, Barcelona, n.d., 191, n. 2, 202, and nn. 1, 3; P. Lefort, *Murillo et ses élèves*, Paris, 1892, 88, no. 304; *Apollo*, III, 1935, 56, repr.; A. Mayer, "Anotaciones y aportaciones al arte y a las obras de Murillo," *Revista Española de Arte*, XIII, 1936, 47, repr.; Benezit, 1953, VI, 282; *Wadsworth Atheneum Handbook*, 1958, 66, repr.; Faison, 1968, 467; J. Gaya Nuño, *L'Opera completa di Murillo*, Milan, 1978, 107, no. 230.

14. Angulo Íñiguez, 1980, II, 254–55, no. 310, III, figs. 408–9; II, 71–72, no. 72, III, figs. 246–47. Mayer, 1913, fig. 102, as 1670–80; fig. 150, as c. 1674.

15. Angulo Íñiguez, 1980, II, 65, no. 62, III, fig. 234. Mayer, 1913, figs. 134, 136, as c. 1674–76.

16. Angulo Íñiguez, 1980, II, 229–30, no. 272, III, fig. 344.

17. Angulo Íñiguez, 1980, II, 43, no. 40, III, figs. 201–4; I, 79, no. 80, figs. 264, 265. D. Angulo Íñiguez, "Las Pinturas de Murillo de Sta. María la Blanca," *Archivo Español de Arte*, XLII, 1969, 13–42, illus. VIII, 17–18, as 1662–65.

18. Brown, 1970, 165–77, fig. 33, as 1667–70.

19. Accession no. 1909.23. A half-length figure appears within a painted oval frame on a rectangular canvas (22 1/2 x 18 1/2 in.). The pose is nearly an exact replica of the Hartford composition, although in the Detroit painting the staff is held closer to the body and between the two knobs. Written backward from the figure's mouth are the words SATIS EST DNE SATIS EST, the traditional motto of Francis Xavier. Soria, 1947, II, 453, as an "old copy" identical to Curtis, 1833, 239, no. 300y. Reproduced in *Illustrated Catalogue of One Hundred Paintings of Old Masters Belonging to the Sedelmeyer Gallery*, Paris, 1894, I, no. 65. Other variants of the composition are listed by Angulo Íñiguez, 1980, II, 254, no. 309, III, fig. 347.

Francisco Ribalta (1565–1628)

After three centuries of confusion and heated regional argument, the true origins of Francisco Ribalta were published in 1947 and 1951.[1] Born in Solsona, a small Catalan town in Lérida, Francisco Juan Ribalta was baptized on 2 June 1565, third child of Francisco and Magdalena. Between 1571 and 1573, this prosperous, middle-class family moved to Barcelona; by 1581 both parents had died. The following year, the sixteen-year-old Francisco was in Madrid, where he signed and dated his earliest known work, the *Preparations for the Crucifixion*, now in the Hermitage, Leningrad. Although in Madrid for over a decade and a half — a period of great artistic activity in the new capital of Spain (the court moved from Toledo in 1561) and especially at Philip II's major undertaking of the building and decoration of the monastery of S. Lorenzo at El Escorial — Ribalta is not known to have received royal commissions and no paintings from this period have survived.[2] During these years in Castile, he married Inés Pelayo, and their son, Juan, later to assume major responsibilities in his father's studio, was born.

Francisco Ribalta is documented in Valencia in April 1599, when as a resident, he enrolled in the city's Confradía de la Virgen de los Desamparados, a society of priests and laymen devoted to community service.[3] Kowal proposes that this transferal of the Ribalta household from Madrid may have been initiated by the call of the archbishop of Valencia, Juan de Ribera, for the most knowledgeable artists to assist in the decorative program of his newly constructed Colegio de Corpus Christi and its church.[4] Commissions in Valencia came slowly; the first significant one was awarded in 1603 for the high altar dedicated to St. James the Apostle in the parish church at Algemesí. Beginning in 1605, Ribalta became occupied with the painting of altars for the Colegio de Corpus Christi in Valencia, projects which would continue over several years. In 1607 he was elected a *consejero* of the Colegio de Pintores and was selected to paint an altarpiece for the chapel of the goldsmiths' guild in the church of Sta. Catalina Mártir, a task with which he was employed over the next four years.

With the death of the archbishop, Ribalta's most influential patron, in January 1611, the painter's career took a new direction; many important commissions were received from Valencian churches and religious orders. For the remaining seventeen years of his life, Ribalta continued to incorporate the latest and best of the new styles coming from Italy; in so doing, he developed an independent and personal mature style which made him the foremost painter in Spain and the head of the most active studio in Valencia. Prominent among his canvases from these years are those of the revered cleric Father Simó (1578–1612), who died in Valencia shortly after having mystical visions of Christ's last days. Ribalta's *Vision of Father Simó* in the National Gallery, London, signed and dated in 1612, exemplifies this growth and expressive power. His most famous paintings and probably his finest achievements are the *St. Francis Embracing the Crucified Christ*, painted about 1620, from the church of the Sangre de Cristo, and *St. Bernard's Vision of the Crucified Christ*, probably painted about 1620 for the Carthusian monastery of Porta Coeli near Bétera, province of Valencia, both today in the Museo del Prado, Madrid.

Kowal proposes an Italian journey for Ribalta, sometime between mid 1618 and late 1619, and indicates a strengthening of Ribalta's interest in naturalism and tenebrist lighting by a first-hand knowledge of the paintings of Caravaggio and his followers in Italy.[5] Further, Kowal postulates a trip to Madrid in the early 1620s, on which Juan possibly accompanied his father.[6] Francisco Ribalta's last major commission came from the monastery of Porta Coeli. There, between 1625 and 1627, undoubtedly with the assistance of his shop, Ribalta produced the paintings and gilt the wooden structure of the main altar of the church.[7]

One canvas from the series of saints painted for this elaborate altar is of *St. Luke Painting the Image of the Virgin Mary*, now in the Museo Provincial, Valencia. Ribalta used his own features for those of the evangelist. This study of the sixty-year-old artist preserves for us the penetrating gaze and keen, sharp features of one of Spain's most important early baroque painters. On 13 January 1628, at the height of his technical powers and productivity, Francisco Ribalta was suddenly stricken, and died. Within the year, on 9 October 1628, Juan Ribalta also died.

1. J. Madurell Marimon, "Francisco Ribalta, pintor catalán," *Anales y Boletín de los Museos de Arte de Barcelona*, V, 1947, 9–31; and A. Sole Llorens, "El Pintor Francisco Ribalta, hijo de Solsona," *Anales y Boletín de los Museos de Arte de Barcelona*, IX, 1951, 83–104. A detailed analysis of the controversial "patria" and date of birth is presented with all pertinent references and documents by Kowal, 1981. See also Valencia, 1987, repr. 167.

2. Kowal, 1981, I, 25–29, indicates the stylistic influences of the paintings of Juan Fernández de Navarrete (El Mudo) (d. 1579) and notes possible followers of El Mudo with whom Ribalta might have trained. For other paintings from this period listed in the literature, see Kowal, 1981, I, 31–38. See also Palomino, 1987 ed., 91–92.

3. Kowal, 1981, I, 40, n. 15, indicates Ribalta's presence in Valencia by February 1599; see doc. nos. 12, 13.

4. Kowal 1981, I, 50–53.

5. Kowal, 1981, I, 128–34.

6. Kowal, 1981, I, 134–35.

7. Kowal, 1981, I, 135–36.

The Ecstasy of St. Francis of Assisi: The Vision of the Musical Angel

Oil on canvas, 108 x 158.1 cm (42¹/₂ x 62¹/₄ in.)

Condition: fair. There is extensive flaking along the sides and upper edge and considerable inpainting over the surface.

Provenance: possibly collection López Martínez, Jerez de la Frontera, by 1812 (see note 6 below); private collection, London, sale London, Sotheby's, 25 Apr. 1956, no. 172, sold for 800 pounds sterling; J. Weitzner, New York; purchased by the Wadsworth Atheneum in 1957 by exchange from J. Weitzner.

Exhibitions: Indianapolis, John Herron Museum of Art (also Providence, R.I., Museum of Art, Rhode Island School of Design), *El Greco to Goya*, 10 Feb.–24 Mar. 1963, no. 63, repr.; Jacksonville, Cummer Gallery of Art, *Seven Hundred Years of Spanish Art*, 28 Oct.–30 Nov. 1965, no. 29, repr.

The Ella Gallup Sumner and Mary Catlin Sumner Collection, 1957.254

Ribalta produced two known compositions for the theme of St. Francis and the musical angel, each of which exists in several forms. An inferior copy of the Hartford *Ecstasy* is in the Musée Goya, Castres, France.[1] A second painting, in the collection of Wallace Simonen, São Paulo, Brazil, is of higher quality than that in Castres but is probably also a copy; it reproduces the Hartford composition in nearly every detail.[2]

By Ribalta's own hand is the *Vision of St. Francis* in the Prado, painted about 1620 for the Capuchin convent of the Sangre de Cristo outside Valencia (at which date he painted for the refectory a now lost *Last Supper*).[3] In 1801–2 it was removed from its location near the high altar of the convent church to the royal collection in Aranjuez by Charles IV, who provided the Capuchins with a replica by Vicente López, now in the Museum of Valencia.[4] A second, badly damaged copy of the painting in the Prado is in the palace of the Infante Alfonso de Orleans, at Sanlúcar de Barrameda, province of Cádiz.[5]

With the exception of the *Vision of St. Francis* in the Prado and its copy by López, any of these paintings could be identical to the one described by Nicolás de la Cruz y Bahamonde in the house of López Martínez, in Jerez de la Frontera, in 1812: "un S. Francisco moribundo con un Angel asistido por un Capuchino, de Ribalta."[6] Darby originally assumed that the painting in Cádiz was the one seen by Cruz; when the Hartford *Ecstasy* came to light, she suggested it more closely approximated the description, which clearly specifies a Capuchin attendant.[7] The existence, however, of two probable copies after the Atheneum's composition further complicates the situation; Cruz's description is too meager to permit a definitive conclusion.

In the collection of José Navarro, Madrid, are seven sheets of drawings related to both of Ribalta's compositions for the theme of St. Francis and the musical angel.[8] They consist primarily of studies for the figure of the saint, shown reclining in a number of positions, as well as several variations of the musical angel. Although individual motifs occasionally coincide, none of the drawings provides exact comparisons with either of Ribalta's two finished compositions; therefore, it is possible that further sketches or even paintings may exist. The drawings are the following:

Photo MAS G/22201: two sheets, each with the figure of St. Francis reclining on a bed. One of these shows the saint seated on a horizontally disposed bed, similar to that of the Hartford composition. In the second, St. Francis lies on his side as a lamb climbs to the front of the bed. A similar lamb, placed on the opposite side of the bed, appears in the *Vision of St. Francis* in the Prado.

Photo MAS G/22202: a sheet of individual motifs: three feet, foreshortened; two hands, a table, two views of a chair, the reclining figure of a monk, placed on a diagonal and raising his left hand in a gesture similar to that of the Hartford composition.

Photo MAS G/22203: a sheet of figure studies. St. Francis is shown lying in a bed, in a seated position, and as a reclining figure, approached from the upper right by an angel playing a violin.

Photo MAS G/22204: a compositional sketch. An angel, playing a violin, stands on a cloud; below and to the right, St. Francis reclines on a mat.

Photo MAS G/22205: a sheet of individual motifs and figural groups. Below, St. Francis reclines in a bed; two feet and a pair of folded hands, all similar to those of the full-scale figure. Above these, an angel strumming a lute appears to St. Francis, who leans upward toward the angel and holds what is probably a skull.

Photo MAS G/23342: a compositional sketch. An angel, playing a violin, appears to St. Francis, shown reclining on a bed to the lower right.

The attribution of these sheets to Ribalta is rendered problematic by the wide range in quality and technique of the drawings traditionally associated with his name.[9] It is likely, however, that the same hand is responsible for all of the studies described above as well as for both of the finished paintings. Ribalta's authorship of the Prado *Vision of St. Francis* has never been doubted.

The drawings are executed with rough strokes of the pen; modeling is limited to a few shaded areas indicated by clusters of diagonal or parallel lines. This technique is common among the artists of the Escorial, whose influence is also apparent in Ribalta's early paintings. Among the drawings attributed to Ribalta, the sketches for the *Piedad* in the Louvre,[10] and *St. Bruno* in the Academy of S. Carlos, Valencia,[11] appear closest to the studies for the *Ecstasy*. There is only a limited resemblance between the musical angels and those in the *Coronation of the Virgin* in the Prado.[12]

The renewed popularity of St. Francis of Assisi in the period following the Council of Trent was characterized by the appearance of new subjects focusing on the saint's mystical and visionary experiences rather than the picturesque narrative episodes favored by artists of the Middle Ages and the Renaissance.[13] Ribalta's work illustrates an event deriving from early

Franciscan legends as told by St. Bonaventure but not represented in art until the late sixteenth and early seventeenth centuries.[14] According to tradition, a musical angel appeared to St. Francis as he lay ill at Rieti in 1225, a year before his death, and was suffering from the stigmata received the previous year on Mt. Alverna. The divine music, which fulfilled the saint's desire to hear music from his youth, relieved his physical pain and induced a state of spiritual ecstasy.[15]

The episode of St. Francis and the musical angel was a popular one in the circle of the Carracci and soon spread by the medium of engraving to other Italian centers. In most cases, the consolation of St. Francis by an angelic musician is placed in a landscape setting, and the composition is limited to the two essential figures.[16]

As stated by Kowal, Ribalta's interest in the subject is evidenced by the unpublished drawings in the Navarro Collection, Madrid; further, these sheets indicate another potential source of inspiration coming from Raphael Sadeler the Younger's engraving of *St. Francis's Vision of the Musical Angel*, after the painting by the Italian Capuchin monk Paolo Piazza (1557?–1621).[17]

Ribalta's two versions of the subject, more so that in Hartford than in Madrid, probably also owe some-thing to earlier formulations. The first example may well be that by the Sienese Francesco Vanni in the Pinacoteca Rizzi, Sestri Levante, whose painting was engraved by Agostino Carracci in 1595. A painting by Giuseppe Cesare, Il Cavalier d'Arpino, of similar date, 1593–95, is now in the Musée de la Chartreuse, Douai. The figural types of both the angel and St. Francis bear a clear relationship in gesture as well as form with those of the Hartford painting.[18] Annibale Carracci also painted the subject, now known only through an engraving by Gerard Audran.[19] Common to both this work and the Hartford painting are the domestic interior setting and the general compositional scheme: St. Francis is shown reclining in bed while an angel appears at the upper left. Although the actions and identities of the accompanying figures are somewhat different, their placement is similar.[20] Ribalta has also included the traditional attributes of St. Francis, together with some introduced in the post-Tridentine period: the Capuchin habit and the skull on which he meditated,[21] the carafe of pure water,[22] the mendicant's alms basket, and the small white lamb.[23] The cross and the print of Calvary were conducive to religious contemplation; they recall the Crucifix before which St. Francis is often shown at prayer.

Both of Ribalta's compositions for the ecstasy of St.

Francisco Ribalta, *The Ecstasy of St. Francis of Assisi: The Vision of the Musical Angel*

Francis belong to his last period (1612–28), after he had abandoned the mannerist style of the Escorial school, especially that of Juan Fernández Navarrete (d. 1579),[24] in favor of a more Caravaggesque mode, emphasizing monumental forms, simplified compositions, and dramatic "tenebrist" lighting.[25] Also typical of the late period are the sober brown color scheme, relieved only by the green and red of the musical angel, the thin, fluid application of paint, and the interest in the texture and tangibility of mundane objects.

Kowal dates the *Ecstasy of St. Francis* slightly later than the *Vision of St. Francis* in Madrid, and its companion, *St. Francis Embracing the Crucified Christ*, both painted circa 1620.[26] The composition is more accomplished, incorporating a larger number of elements with no loss of clarity or dramatic impact. Ribalta's conception of the subject is also more sophisticated, for he now emphasizes physical agony and the consolation provided by spiritual ecstasy rather than the naive simplicity of a monk surprised in his sleep.[27] The closest stylistic relationship to the *Ecstasy* is provided by works attributed to Ribalta in the final years of his life, a period complicated by the collaboration of the artist's son, Juan, and other members of the studio. Particularly convincing comparisons are the portrait of Ramón Llull in Barcelona[28] and a number of the saints painted for the retable of Porta Coeli.[29] Compare especially the figures of St. Peter, and the evangelists Matthew, John, and Luke.

1. Entitled *St. François d'Assise conforté par les anges* (118 x 198 cm); reproduced in Castres, *Le Musée Goya*, 1961, no. 26, and attributed to Ribalta or his atelier. The painting was subsequently described as a copy of Hartford's painting by Gaston Poulain, director of the Musée Goya, in a letter to C. Cunningham, 3 Aug. 1964, curatorial file.
2. Photo MAS G/A 16445–48.
3. No. 1062 (62 x 84 in.). Reproduced in Darby, 1938, fig. 28; in color by C. G. Espresati, *Ribalta*, Barcelona, 1948, pl. XLIV. The document is quoted by Darby, 238, app. II: 37.
4. Darby, 1938, 116, n. 22; Kowal, 1981, I, 112–19, II, 426–28.
5. Photo MAS C-47519 and FARL 811b.
6. Cruz y Bahamonde, 1812, XII, 499.
7. Darby, 1938, 285; 1957, 1–2.
8. Photographs of the drawings were acquired in 1950 by MAS, Barcelona, which was unable to provide further information concerning their ownership. Kowal, 1981, I, 328–29.
9. Compare the selection in A. L. Mayer, *Handzeichnungen spanischer Meister*, Leipzig and New York, 1915, figs. 23–25; Sánchez Cantón, 1930, pls. CLVI–CLXIV.
10. Darby, 1938, figs. 25–26.
11. Sánchez Cantón, 1930, pl. CLXII. A study for the altarpiece painted for the monastery of Porta Coeli, now in the Museo Provincial, Valencia. Both the drawing and the finished study were attributed by Darby to Juan Ribalta, 1938, 128–29, figs. 43, 45.
12. Sánchez Cantón, 1930, pl. CLVI.
13. The classification of the iconography of St. Francis into two distinct historical periods was made by Reau, 1958, 519, 529–30; for the second group, see Askew, 1969, 280–306. An earlier study, useful for Franciscan iconography is Mâle, 1932, 177, and Mâle's reference to the illustration of the history of the Seraphic order, "Historium Seraphiae Religionis Liber a Petro Radulphio Tossianensi," Venice, 1586, in *Acta sanctorum*, oct. II, 756. See also G. Andrisani, "Caravaggio: iconografia francescana," *Il*

Seicento napoletano, riflessioni sulle mostre del 1985 e relativa iconografia francescana, Quaderni della "Gazzetta di Gaeta," 1986, 50–51.
14. *Aura legenda major B. Francisci*, Florence, 1509, 2nd ed., Lyons, 1596, pt. I, chap. V, par. 11.
15. The textual references to this episode, and their representations in Italian painting, are discussed in detail in Askew, 1969, 298. Of all the accounts, only the *Fioretti* clearly specify that an angel appeared to St. Francis; in the other versions, only the divine music itself was heard.
16. See the examples listed in Askew, 1969, 300–301, which she relates to a painting by Annibale Carracci in the collection of Denis Mahon, London, circa 1586–87, figs. 43a and 200.
17. Kowal, 1981, I, 117, 204, n. 16, who also presents Darby's (1938, 150–51) suggestions of possible sources.
18. See the exhibition catalogues Rome, 1973, 83–84, no. 14, repr.; Dunkerque (also Douai, Lille, Calais, Paris), *De Carrache à Guardi: La Peinture italienne des XVIIe et XVIIIe siècles dans les musées du Nord de la France*, 1985–86, 68–69, no. 16, repr. Both catalogues also have a general discussion of the subject and its development in the late years of the sixteenth century.
19. New York, Metropolitan Museum of Art, c. 1594–96. See Askew, 1969, 301, fig. 43b.
20. An attendant Capuchin monk, probably Brother Leo, is barely visible in the background of the painting in the Prado (no. 1062); he reappears in the foreground of the painting in Hartford, where he is shown reading and oblivious of his companion's vision. His placement in front of the bed recalls the monk in the Italian composition; the pair of angels behind the bed are reminiscent of the two additional monks in Carracci's lost painting.
21. Reau, 1958, III, 529, attributes the introduction of the skull to El Greco and Ribera.
22. This is a reference to another vision of St. Francis: an angel holding a carafe full of clear water, symbol of sacerdotal purity, appears to the saint as he hesitates on a decision to enter the priesthood. Reau, 1958, 531; Mâle, 1932, 172–73.
23. For a discussion of the special associations of St. Francis and the lamb, with their Christological implications, see E. Armstrong, *Saint Francis: Nature Mystic*, Berkeley, 1973, 106–13.
24. For an evaluation of Ribalta's early period, including his work in Madrid and the first five years in Valencia, see Darby, 1938, 71–106. Representative works are the *Nailing to the Cross*, signed at Madrid and dated 1582 (Hermitage, Leningrad; repr. Darby, 1938, fig. 2), and the altarpiece of Santiago in the parish church of Algemesí, 1603–10 (Darby, 1938, figs. 10–15).
25. The relevant works are discussed and reproduced by Darby, 1938, 107–35. The influences of the Carracci, Caravaggio, and Ribera have been suggested to explain the dramatic stylistic change of Ribalta's late period. See Ainaud de Lasarte, 1947, 345–413; and H. Soehner, "Forschung und Literaturbericht zum Problem des spanischen Caravagismus," *Kunstchronik*, X, 1957, 31–37. For a recent revival of Palomino's suggestion that Ribalta visited Italy, see J. Mateo, "Estancia en Italia e influencias italianas de Ribalta," *Seminario de Arte Aragonés*, X–XIII, 1961, 165–79.
26. Valencia, Museo Provincial; Darby, 1938, fig. 29. The figures of the musical angels in these two works are particularly close. Ribalta's two versions of the vision of the musical angel are compared by Darby, 1957, 8, who also considers the painting in Hartford later in date; see also Kowal, 1981, I, 113–15.
27. Kowal, 1981, I, 115–17, carefully notes the differences in the compositions, with a more complex and mature arrangement of the various elements of design in the Hartford version. Other changes are the less mannered angel, two small, subsidiary angels in the background, additional still-life elements, more dramatic chiaroscuro, a repositioning of the lamb and the figure of Brother Leo, and greater attention to the age and physical qualities of St. Francis.
28. Museo de Arte de Cataluña; repr. Ainaud, 1947, 356–57. Compare especially the detail of the head with that of the saint in Hartford's painting.
29. Darby, 1938, 122–31, figs. 32–43, 46. Now in the Museo Provincial, Valencia. Darby attempted to sort out the various hands, but the problem does not yet appear to be solved.

Jusepe de Ribera
(1591–1652)

Jusepe de Ribera, second of three sons of Simó de Ribera, a shoemaker from Rusafa, Valencia, and Margarita Cuco, was baptized on 17 February 1591, in the church of Sta. Tecla, in Játiva, Spain. No evidence supports an apprenticeship for the youth in the studio of Francisco Ribalta, leading painter in Valencia, although art historical literature since Antonio Palomino's *El Parnaso español pintoresco laureado* (1715–24) usually indicates it; moreover, the date of Ribera's departure from Spain is also not known but is generally believed to have occurred after 1607.[1]

Ribera is first documented in Rome in April 1615, where he is recorded in the *Status animarum* of Sta. Maria del Popolo as a resident of via Margutta. The following March, he is listed again, only having moved across the street. On 7 May 1616, he paid dues of 12 scudi to the Accademia di S. Luca, Rome. During his stay in Rome, Ribera painted a series of five half-length figures representing the *Senses*, a *Deposition of Christ*, and another painting—all mentioned as being of great beauty by Giulio Mancini in his *Considerazioni sulla pittura*, written in Rome, 1614–21.[2] According to Mancini, Ribera left Rome rather precipitously, hounded by creditors. Recent investigations suggest that Ribera may have joined the retinue of Don Pedro Téllez Girón, duke of Osuna and Spanish ambassador to Rome prior to his appointment as viceroy of Naples in 1616.

Within months of his arrival in Naples in November of 1616, Ribera had married Caterina Azzolino y India, daughter of the prominent but unimaginative painter Gian Bernardino Azzolino.[3] Ribera's success in Naples seems to have been immediate: in July 1616 he had received payment for a *St. Mark*, commissioned by the prominent Genoese patron Marcantonio Doria; in 1622 he is listed in his sister-in-law's dowry as owning, by 1620, a large house in Naples and a country estate; on 29 January 1626, he was appointed by Pope Urban VIII Barberini to the Order of Christ of Portugal, with the installation occurring in Rome. Although a number of works can be assigned by style to the first years in Naples, Ribera's first dated paintings are from 1626: a *Drunken Silenus*, presumed to have been painted for the vastly wealthy Flemish merchant, art collector, and resident of Naples, Gaspar Roomer, and a *St. Jerome and the Angel* for the church of the Trinità delle Monache in Naples. The paintings, the one eminently profane, and the other profoundly spiritual, summarize significant aspects of the developing baroque style, as well as Ribera's own craft. The figures in both paintings are realized through a Caravaggesque naturalism which has been heightened by bold and vigorous brushwork and a heavy, rich impasto. In addition to these technical innovations, Ribera presented his subjects by carefully manipulating the compositional space, permitting the figures to occupy a three-dimensional world which involves the actual space of the spectator. Ribera's figures are always scaled to correspond to the visual and spatial relationships of the viewer. The resultant forms contain a physical presence equaling reality; hence, they are structurally solid and intellectually believable. This framework of objective truth enables the painter to incorporate elements of a religious or spiritual intensity, which, because of the association, also seem genuine.

Ribera's career flourished in the ensuing decades and he is known to have had an active and productive studio. Chief among his patrons was the Certosa di S. Martino, the greatest and wealthiest religious establishment in Naples. Among his private patrons were the succeeding viceroys of Naples, especially the duke of Alcalá (1629–31), and the count of Monterrey (1631–37). Great quantities of Ribera's paintings were taken back to Spain by these nobles for their own collections and for the collection of Philip IV. One of Ribera's greatest works, an *Immaculate Conception*, dated 1635, painted for the large central position of the high altar of the convent church of Las Agustinas Descalzas in Salamanca, surely inspired compositions of the same subject by Murillo and Coello. Ribera's artistic influence was great in Spain as, indeed, it was in Italy and northern Europe.

Toward the end of his life, in 1646, Ribera completed a major altarpiece of the *Escape of St. Januarius from the Fiery Furnace* for the most sacred room in Naples, the treasury of St. Januarius in the cathedral. This work was commissioned from Ribera in 1641, following the death of Domenichino (1581–1641), who had been working on the treasury project for almost a decade.

Ribera's last, great masterpiece, the *Communion of the Apostles*, Certosa di S. Martino, commissioned in 1638 but not finished until 1651, summarizes his significant contribution to the art of his age. The following year, in early September, he died, presumably at his country estate outside of Naples. The exquisitely beautiful *Mystical Marriage of St. Catherine* in the Metropolitan Museum of Art, New York, painted in 1648, epitomizes the great variety of his figural interpretation and his technical brilliance.

1. For Ribera's bibliography, see Felton, 1971; Spinosa, 1978; Fort Worth, 1982–83.
2. See *Sense of Taste* commentary.
3. Giuseppe de Vito, "Una commissione a Ribera nel luglio del 1616 e la probabile data del suo de finitivo trasferimento a Napoli," *Scritti di storia dell'arte in onore di Raffaello Causa*, Naples, 1988, 175–77. The date of the marriage between Ribera and Caterina Azzolino y India is given here as 10 Nov. 1616, replacing the previously held date of 15 Sept. 1616.

Mocking of Christ

Oil on canvas, 204.5 x 153 cm (80½ x 60¼ in.)

Condition: fair. There are small areas of retouching and a larger restoration on the left foot. Two small patches have been made on the right side.[1]

A label on the upper horizontal stretcher bears the number *1714* written in black ink. Another label is inscribed: *I. 402/Case II/11/Estas*

Provenance: archbishop of Canterbury; Frank Gair Macomber, Boston, after 1910. Given to the Wadsworth Atheneum in 1936 by Frank Gair Macomber.

Exhibitions: Boston, Museum of Fine Arts, 1910–23 (on loan from Frank Gair Macomber); Hartford, 1930, no. 41.

Gift of Frank Gair Macomber, 1936.32

This painting depicts the moment prior to Christ's Crucifixion in which the soldiers of the Roman governor, having stripped Christ of his own clothes, drape him with a scarlet robe, crown him with thorns, and mockingly call him king of the Jews.[2] Painted in a sharply defined, dramatically tenebrist style, the complex composition focuses on Christ seated in the center. The heavy drapery is held at one end by a swarthy, leering man in a torn shirt who kneels on the right before Christ. Above him another man, wearing a loose shirt and thrusting the reed toward Christ's bound hands, emerges from the shadows. A third figure, in shadow except for his rag-wrapped head and his hands, one grasping a reed and the other raised and tightly clenched, hovers over and behind Christ. Other figures are almost lost in the background at the top right.

The painting is characterized by its smooth surface, sharply contrasting lights and darks, and broad areas of color. In opposition to the ragged and dark-skinned peasant tormentors, Christ is pale, with

Figure 72. Jusepe de Ribera, *Mocking of Christ*, Milan, Pinacoteca di Brera

youthful, refined features. His mustache is sparse and his beard is only a thin outline around the jaw, obscured by a black shadow.

At least twelve paintings of the same basic theme, and with similar composition, have been attributed to Ribera at one time or another. These paintings are divided into three groups: those with compositions identical to the Hartford version, those with some of the same elements, and those with a reversed Christ, a laughing youth, and slightly different poses of the secondary figures.[3]

Two paintings are virtually identical in size and composition to that in the Atheneum. The first, in the Pinacoteca di Brera, Milan, is in poor condition, and the area around its signature and date appear to have been patched and repainted (Fig. 72). It is much lighter than the Hartford version, and its figures are wholly visible, although the shadows fall in exactly the same places. Brushstrokes are also more apparent and the modeling is more subtle. Both Layna Serrano and Born consider the version at Hartford a copy of the Brera painting,[4] though Layna does not accept either of the two as original Riberas. Felton accepted the Brera version in an article published in 1976.[5]

The second painting in this group is in the Musée des Beaux-Arts, Caen (Fig. 73). Like the Brera version, the background is light and all the figures are fully rendered. The figure in the upper right-hand corner stands in front of a column, which is absent in both the Brera and the Hartford versions. Felton rejects the attribution of the Caen version as autograph.[6] Two other paintings in this group share essentially the same composition as the Hartford version, but in reverse, and with differences in detail and style.[7]

In the second group, a composition of *Christ at the Column* in the Galleria, Turin, depicts only the figures of Christ and two captors found in the Hartford painting.[8] The sharply defined contours and contrasts in this painting, as well as the similar portrayal of Christ's delicate facial features, are the closest in handling to the Hartford *Mocking of Christ*.

The third group of variants consists of five paintings in which Christ, facing toward the left, rests His right hand on His thigh, while His left arm is raised by one of the captors behind Him. The mantle is flung over Christ's head and shoulder by the soldiers. The face of a young boy leers at the spectator to the right of Christ, in place of the crouching peasant in the Hartford example. On the left is a bearded man with a rag around his head, who inscribes the cross, and above him stands another figure. In the center background are the heads of two mourning figures, probably Mary and St. John the Evangelist.[9]

Both Layna Serrano and Felton discuss the paintings in these three compositional groups as variants of the version in the church of Sta. María at Cogolludo, which both consider the probable original version by Ribera (Fig. 74).[10] Felton dates the Cogolludo painting around 1624, on the basis of similarities to Ribera's etching of the *Martyrdom of St. Bartholomew* from that year, citing the analogous multifigured composition, the similar figures, the drapery of the loincloth, and the leg positions of Christ and Bartholomew.[11] According to Felton, the strong, unmodulated chiaroscuro is characteristic of Ribera's earlier works, not those of the late 1630s, despite the signature of the Brera version, and the acceptance of the date by Mayer[12] and Trapier.[13]

Actually, the degree of intended chiaroscuro is difficult to discern because most of the paintings are in poor condition, or known to us only through photographs. A photograph of the Atheneum painting, taken before 1946, indicates that it has darkened significantly since it was cleaned in 1949. A *Martyrdom of St. Andrew* in Budapest, signed and dated 1628, is close in composition and size to the Cogolludo version, but seems more subtly modeled and detailed than any of the versions of the *Mocking of Christ*.

In spite of Mayer's belief that the Hartford *Mocking of Christ* was "painted by the master between 1630 and 1640,"[14] Felton believes that it is from an earlier moment in the artist's career. The painting was cleaned in 1989–90, revealing a vastly different surface than has been seen for several decades.

The *Mocking of Christ* was heavily overpainted during previous restorations, and much of the figure of Christ was totally concealed. Although remaining

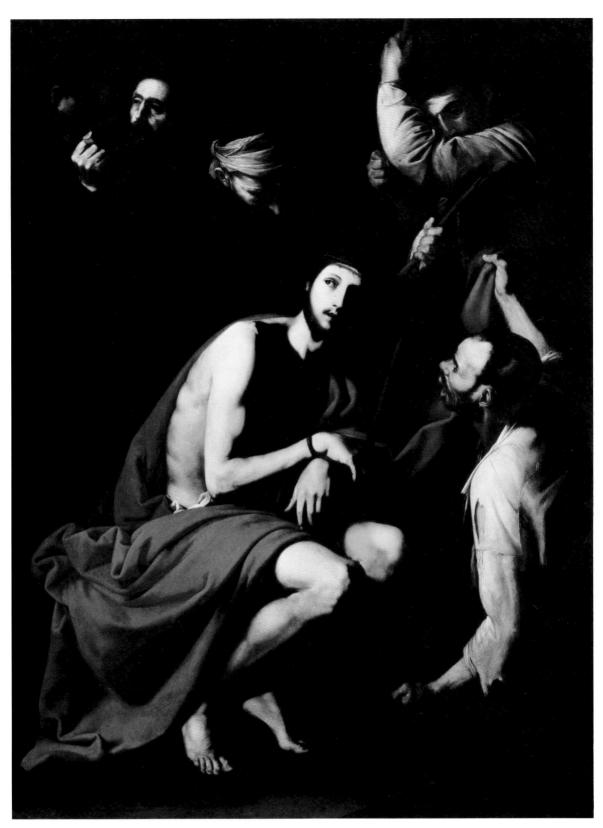

Jusepe de Ribera, *Mocking of Christ*

Figure 73. Attributed to Jusepe de Ribera, *Mocking of Christ*, Caen, Musée des Beaux-Arts

Figure 74. Jusepe de Ribera, *Mocking of Christ*, Cogolludo, Spain, Church of Sta. Maria

in a considerably darkened state, the painting demonstrates much more of the original color and brushwork, and a critical comparison with the Brera picture is now possible. More definitive comparisons will need to be made when the Brera painting is cleaned.

Ribera painted the head of each figure in the Hartford composition with a different emphasis of brushwork and impasto, similar to the manner in which he painted the *Martyrdom of St. Lawrence* now in the Nelson Atkins Museum, Kansas City. This latter work, in almost pristine condition, is believed by Felton to be a youthful work by Ribera, of about 1615, if not earlier.[15] The head to the left above Christ is analogous to the turbaned figure in the *St. Lawrence*, with the brushstrokes deliberately left coarse and overlaid with lighter colors to produce the effect of naturalistic wrinkles and highlights.

The most graphically depicted figure is the man to the right. Ribera has used a broad range of colors, from the lightest flesh tones to ruddy reds, for the modeling of the ear, eye, mouth, and hands. He painted the eyelashes with individual strokes of black and used dark slate gray, parallel, diagonal strokes for wrinkles on the neck and the creases at the wrist. The thickness of the paint is three-dimensional, adding to the visual presence of this figure. His garments are brushed with vigorous strokes following the natural contours and patterns of the fabric, reminiscent of the figures in the early paintings illustrating the *Five Senses*. This is the best preserved figure in the composition and most clearly indicates Ribera's authorship.

The standing figure to the right, hidden in partial shadow, is a Caravaggesque form, especially from the Lombard master's Neapolitan period, comparable to works such as the *Flagellation* from S. Domenico Maggiore, Naples, and now in the Museo di Capodimonte. Although the figure of Christ is more softly modeled and enveloped in heavy shadow, the pose is similar to that in the etchings depicting St. Jerome, from the late 1610s to the early 1620s, as well as to a painting of St. Jerome in the collection of Dr. Carlo Croce, Philadelphia, believed to be from about 1620. There is also a figural correlation between this composition and the famous etching of 1624 depicting the *Martyrdom of St. Bartholomew*, a subject Ribera is known to have painted during his earlier years. The background figures are visible only in good light, with the paint having sunk significantly into the heavy ground.

Although the Brera canvas is signed and dated, the date is not clear. Even a detail photograph fails to clarify the final two digits. The overall condition of the Brera example is better than that in Hartford,

and the technical aspects, such as the brushwork and detailed definition of the figures, is generally superior. Since Ribera, as well as other artists of the period, executed replicas of his own works, the existence of these two almost identical compositions is not surprising. Differences do occur, such as the kneeling figure to the right who wears sandals in the Brera painting and stocking shoes in the Hartford example. Condition plays a significant role in the determination of primacy; however, the superior concentration on technical details as demonstrated in the Brera painting, and a correspondingly more generalized sense, as if the artist were responding to having done it all before, in the Hartford picture, indicates that the *Mocking of Christ* in the Brera was painted first. The establishment of a possible date is not easy; nevertheless, because of the relationships to other paintings, such as those at Osuna probably from about 1620, Felton suggests that the Brera and Atheneum paintings are from the early years of the 1620s.

1. A photograph which entered the Frick Art Reference Library, New York, before 1946, reveals much more of the figures than can now be seen, and indicates a significant darkening in the painting since its cleaning in 1949. Two X rays taken in April 1974, one of the head of Christ and the other of his crown and the hand of the figure behind him, indicate that the canvas is coarse and fairly tightly woven. The paint surface is riddled with irregular *craquelures*, and the face of Christ seems to be more subtly modeled than is now apparent.

2. "And they stripped him and put on him a scarlet cloak; and planting a crown of thorns, they put it upon his head; and a reed into his right hand; and bending the knee before him they mocked him saying, 'Hail, King of the Jews!' " (Matthew 27:28–29).

3. (A) Identical compositions: (1) Milan, Pinacoteca di Brera (200 x 150 cm); ex-collection de Mari, Florence, 1780–1968. Signed and dated *Jusepe de Ribera espanol F 1638* (date questioned). Reproduced in Ojetti, 1924, 246; (2) Caen, Musée des Beaux-Arts (205 x 151 cm), acquired from the sale of the La Roque Collection in 1837. Photo FARL; (3) Naples, S. Pietro ad Aram (Spinosa, 1978, no. 217, illus. on 126); (4) Naples, Sta. Maria in Portico (Spinosa, 1978, no. 219, illus. on 126); (B) Variants on A: (1) Seville, Palacio de las Dueñas; ex-collection duke of Alba? Reproduced in J. Camón Aznar, *La Paion de Cristo*, Madrid, 1949, pl. 73; (2) St. Louis Academy of the Sacred Heart (177 x 129 cm); ex-collections Fusz de Penaloza and John Queeney, St. Louis; acquired by the Musée du Louvre, Paris, as Francisco Fracanzano. Signed and dated *Jusepe de Ribera español F. 1650*; (3) Turin, Galleria. Photo MAS 9295; (C) Composition with reversed Christ and different secondary figures: (1) Cogolludo, Spain, church of Sta. María (223 x 174 cm); believed to have been in the collection of Don Fernando Afán Enrique Ribera, duke of Alcalá (viceroy of Naples, 1629–31); inherited by his daughter whose husband was the marqués de Cogolludo. Reproduced in Trapier, 1952, fig. 18; (2) Mexico City, Museo de S. Carlos (210 x 168 cm). Reproduced in Carillo y Gariel, *Las Galerias de S. Carlos*, Mexico, 1950; (3) Le Mans, Musée des Beaux-Arts (229 x 182 cm); purchased in Seville, 1850, not reproduced; (4) Paris, ex-collections Louis Massignon, and Manzi, Joyant et Cie. (60.8 x 58.3 cm). Reproduced in *Archivo Español de Arte*, XXV, 1952, pl. IX. (5) Madrid, duke of Montealegre. Photo FARL. Another *Crowning with Thorns* is described in the sales catalogue for the Pourtales-Gorgier Collection 27 Mar.–1 Apr. 1865, no. 198. It measured only 35 x 24 cm and was allegedly signed "Jusepe de Ribera, 1631." The

description in the catalogue is too vague to pinpoint the painting's relation to the other compositions. An annotation beside the entry indicates that it was bought by a "compte Rober."

4. Layna Serrano, 1949, 291; Born, 1945, 217.
5. Layna Serrano, 1949, 291; Felton, 1976, 34, illus. 5.
6. Felton, 1971, x, 229.
7. See note 3, A, nos. 3 and 4.
8. See note 3, B, no. 3.
9. See note 3, C.
10. Layna Serrano, 1949, 213–26; Felton, 1971, 161, fig. A–6.
11. Layna Serrano, 1949, 163.
12. Mayer, 1915, 310.
13. Trapier, 1952, 34–35.
14. Mayer, 1915, 310. The Atheneum version is discussed further in the following: Mayer, 1923, 200 (listed under authentic works; no discussion); Born, 1945, 216–17, fig. 3; B. de Pantorba, *Ribera*, Barcelona, 1946, 25, as by Ribera; Layna Serrano, 1949, 291; Gaya Nuño, 1958, no. 2283; Felton, 1971, x–15, 418–19; Felton, 1976, 31–43; Spinosa, 1978, 125, no. 215.
15. Felton, 1991, 71–81.

Protagoras

Oil on canvas, 124.1 x 98.3 cm (48⁷/₈ x 38¹¹/₁₆ in.)

Condition: fair. The painting is generally abraded overall, and the darks have lost definition. There is scattered inpainting, especially in the background. X rays show that the white highlights of the hair and beard were thickly applied over the dried paint surface, not *alla prima*.

Signed and dated lower right: *Jusepe de Ribera espanol F. 1637*
Label on stretcher: *Aus der fürstlichen Gallerie/in Wien/No 376*

Provenance: Prince Karl Eusebius von Liechtenstein, Liechtenstein; with Newhouse Galleries, New York; purchased by the Wadsworth Atheneum in 1957 from Newhouse Galleries for $15,750 from the Sumner Fund (see also note 1).

Exhibitions: New York, 1958; Sarasota, John and Mabel Ringling Museum of Art, *Baroque Painters of Naples*, 3 Mar.–4 Apr. 1961, 10, repr., as *A Greek Philosopher*; Fort Worth, 1982–83, 154–55, no. 17.

The Ella Gallup Sumner and Mary Catlin Sumner Collection, 1957.444

In the Spring 1958 issue of the *Wadsworth Atheneum Bulletin*, Evan H. Turner presented a detailed discussion of a series of *Philosophers* painted by Jusepe de Ribera.[1] Since that writing, new evidence has appeared to document the attribution to Ribera (which has been doubted, although the paintings are signed and dated), and photographs are now available of the entire series (Figs. 75–81).[2]

At least by the time of their citation in the catalogue of 1767, the series was in the collection of the prince of Liechtenstein, where it remained until the late 1950s.[3] Turner carefully leads the reader through a somewhat confusing array of entries for these paintings found in successive catalogues of that famous collection. Although the identifications remained the same, the entry numbers were changed when the paintings were rehung between 1767 and 1780, when the next catalogue was issued.[4] The 1767 catalogue lists these figures as (531) *Aristotle*, (532) *Plato*, (533) *Crates*, (534) *Anaxagoras*, (535) *Diogenes*, and (536) *Protagoras*. The last complete catalogue, that of 1931, was based on the one from 1873 by Falke; however, a new set of inventory numbers was assigned, and only three figures were identified — A55 *Diogenes*, A57 *Archimedes* (a "renaming" of the *Aristotle*), and A377 *Anaxagoras*; the remaining paintings were designated as: A372, A374, A376: "an old man," followed by a description, and "(Unknown Philosopher)."[5]

Until the recent publication by E. Nappi in *Ricerche sul seicento napoletano*, the early history of these paintings was not known.[6] His discovery of a document in the archives of the Banco dello Spirito Santo, Naples, firmly establishes that these *Philoso-*

phers were commissioned from Ribera in 1636, directly by Prince Karl Eusebius von Liechtenstein (1611–1684) through his agents. The archival notation reads:

> A.S.B.N., Banco dello Spirito Santo, giornale del 1636, matr. 270, partita di ducati 100, estinta il 7 maggio. A Lorenzo Cambi e Simone Verzone D. 100. E per lui a Giuseppe de Ribera, dite se li pagano per ordine del conte Carlo Felesbergh et esserno in conto di D. 500 per il valore di dodici quadri d'altezza e di palmi cinque e palmi quattro di larghezza in ognuno dei quali ci ha da essere dipinto un filosofo di sua propria mano che ha pigliato a fare per servito di don Carlo Felisbergh et quelli han da consegnare a loro sei mesi et mancando de consignare debbia restituire tutto il denaro ad ogni loro piacere.

The principal residence of Prince Karl Eusebius von Liechtenstein was Schloss Feldsberg, then in Lower Austria, now in Czechoslovakia; it was here that he eventually housed his collection in a long gallery that was specially vaulted for that purpose in 1654.[7] In this document for the commission, the prince is referred to as Carlo Felesbergh. In the same article with this document, Nappi also published a similar payment document from the Banco dello Spirito Santo of 5 May 1636, pertaining to Artemisia Gentileschi.[8] Cambi and Verzone again acted as agents, and their patron this time is written as "eccellentissimo principe Carlo de Loctenten."

The commission for twelve paintings was a large one and came during the most active period of Ribera's career. As we read in the document, Ribera was required to paint these works by his own hand. One suspects that this was more than a usual formality and was prompted by prior knowledge of Ribera's sizeable studio. The stipulation for all twelve paintings to be realized within six months from 7 May 1636, under penalty of refunding all sums paid, was obviously not met; along with his signature, which was in a variety of forms, Ribera dated three paintings 1636 and three others 1637.

In the 1985 issue of *Ricerche sul seicento napoletano*, Antonio Delfino published an additional document from the Banco dello Spirito Santo which is pertinent to this commission.[9] Another payment to Ribera by the same agents, Lorenzo Cambi and Simone Verzone, sheds further light on the progress of the commission, and confirms that a payment of fifty ducats, made on Monday, 20 April 1637, brought the payment to 250 ducats, or half the amount promised the previous year for the completed commission of twelve paintings. As stated, Ribera had delivered only six of the paintings; the additional six paintings were expected at a later date and would be paid for then. The inclusion of only six paintings of *Philosophers* in the Liechtenstein Collection would indicate that arrangements were made to reduce the commission, or that Ribera tired of the series and never delivered the additional works to his illustrious patron. This second document reads:

Jusepe de Ribera, *Protagoras*

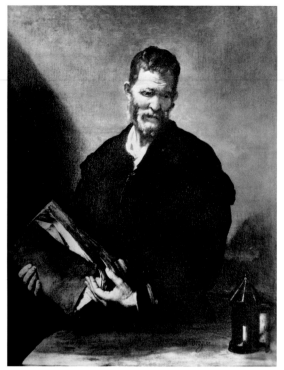

Figure 75. Jusepe de Ribera, *Diogenes*, Private collection

Figure 76. Jusepe de Ribera, *Plato*, collection of Mr. and Mrs. R. Stanton Avery, on loan to the Los Angeles County Museum of Art

Figure 77. Jusepe de Ribera, *Diogenes*, Dresden, Gemäldegalerie

Figure 78. Jusepe de Ribera, *Anaxagoras*, Private collection

Figure 79. Jusepe de Ribera, *Crates*, Private collection

Figure 80. Jusepe de Ribera, *Archimedes*, Madrid, Museo del Prado

Figure 81. Jusepe de Ribera, *Aristotle*, Indianapolis, Indiana Museum of Art

A.S.B.N., Banco dello Spirito Santo, giornale di cassa, matricola 277, lunedì 20 aprile 1637, f. 356: A Lorenzo Cambi, e Simone Verzoni D. cinquanta, e per lui a Gioseppe de Ribera disse sono a complimento di D. Duecentocinquanta, atteso l'altri D. 200 l'ha ricevuto per mezzo de banco, e detti sono in conto de D. cinquecento . . . [sic] valore de dodeci quatri . . . [sic] che li fa, delli quali quatri n'hanno di gia recevuto sei, e li altri sei celi deve consignare ad ogni loro piacere, e per lui a Giosoppe de fusco per altri tanti.

Three of the paintings — *Protagoras*, *Aristotle*, and *Plato* — now in museum collections in the United States, were reunited in the exhibition *Jusepe de Ribera, lo Spagnoletto (1591–1652)* held at the Kimbell Art Museum from December 1982 to February 1983.[10] Exhibition catalogue entries for these paintings were based on the 1767 Liechtenstein catalogue. The three paintings not in the exhibition are privately owned. One of these, the *Diogenes*, was illustrated in a 1938 souvenir catalogue of the Liechtenstein Collection, as well as in the Fort Worth exhibition catalogue.[11] Although the other two paintings, now recognized as *Crates* and *Anaxagoras*, have stickers on the back with the words "Kunstmuseum Luzern 1948," they do not appear in the catalogue of the exhibition of paintings from the Liechtenstein Collection held there from 5 June to 31 October 1948.[12] Since the *Diogenes*, *Crates*, and *Anaxagoras* are inscribed on the paintings themselves with the appropriate identification, and since the descriptions in the 1931 catalogue distinguished one composition from another, we are now able to match with certainty each figure with these entries, as well as with those found in the 1767 catalogue of the Liechtenstein Collection.

The most elaborate form of Ribera's signature appears on the *Diogenes*: *Josephf a Ribera yspan/ Valentinus civitatis/ Settabis academicus/ Romanus , F, / 1636*. That on the *Anaxagoras* reads: *Josephf a Ribera yspanus valentinus/, F, 1636*. And that on the *Crates* reads: *Josephf de Ribera espanol /, F, 1636*. One could presume that the *Diogenes* (Fig. 75), the painting with the most detailed signature, recording Ribera's Valencian origins, his birthplace of Játiva, and his membership in the Roman Academy of St. Luke, was the first to be painted, with the next two following in the sequence given above. True to his most typical signature, Ribera maintains his Spanish nationality — a point of pride to associate himself with the Spanish who occupied the kingdom of Naples.

The commission for such a prominent, international patron as the prince of Liechtenstein was surely gratifying to the artist. Initially, Ribera may have considered these portrayals of *Philosophers* as an assignment similar to the production of his well-known half-length images of *Saints*, which are frequently of this approximate size. Although the Liechtenstein commission specified works of five *palmi* (112.5 cm) in height by four *palmi* (90.0 cm) in width, the actual canvases are now between 123 and 126 centimeters in height and between 96 and 100 centimeters in width. The commission must soon have caught Ribera's imagination, and he

approached each composition with great originality and invention.

All six compositions are similar; each is of a three-quarter-length male figure occupied with a book. Five of the six figures stand behind or beside a table; only the *Plato* (Fig. 76) is without this spatial device. Although the paintings were undoubtedly designed for unity of idea and harmony within a visual context, independently they exhibit extraordinary power and physical presence. The viewer is confronted by each of these philosophers, not only through the vigorous naturalism which Ribera has employed for the realization of actual detail, but also through the psychological impact of each of these Ancients.

Each *Philosopher* has been carefully understood as a specific individual; Diogenes (Fig. 75), for example, is portrayed as a gaunt, middle-aged man with reddish-brown hair and a graying beard. Holding a folio volume in his right hand, the weathered philosopher riffles its pages with his left thumb and gazes solemnly at a lantern placed diagonally on the extreme right edge of the table in front of him. The name *diogene* is inscribed just to the left of the lantern. In another version of *Diogenes* which Ribera painted in 1637, the philosopher is portrayed as a keen-eyed, robust, younger man who vigorously holds forward a candle-lit lantern in his left hand (Fig. 77).[13]

The white-haired and white-bearded Anaxagoras (Fig. 78), shown in profile left and standing to the right of a table, gazes intently at a large volume which he has raised in order to scrutinize some geometric drawings, which are revealed on the partially visible page. On the table beneath his extended left arm is a long, loosely folded scroll of paper on which are similar drawings; to its right, at the center, the name *anassagora* is inscribed. The brown jacket which the ragged old man wears has been repaired many times with patches of cloth — gray, dark brown, and one of teal blue at the top of the shoulder.

The Crates (Fig. 79), unlike his fabled ugliness, has a strong head and handsome face. His quiet, thoughtful eyes confront the viewer in a forthright and questioning stare. In his right hand he holds a long paper lettered in a pseudo-Greek text; with his left index finger he points to a line of similar letters at the top of a page of illustrations in a large volume open on the table in the foreground. To the far right is inscribed *crate tebano*. In general, this composition is like the *Archimedes*, which is signed and dated 1630, the earliest dated painting by Ribera of a *Philosopher* (Fig. 80).[14]

The heads and hands of these sages are particularly fine examples of Ribera's brilliant technical method. Over the dark ground with which he generally primed his canvases, Ribera first structured each head with a rich brown underpaint. Lighter, flesh-tinted pigments were then employed to model the substance of the forms. Working rapidly in a wet-on-wet technique, Ribera used coarsely bristled brushes which gouged through the various layers of flesh

tones, thereby revealing the successively darker and subtle colors which approximate the natural appearance of furrowed brows, lined faces, deeply textured hair and beards, and gnarled, worn hands. The process gives a sculptural plasticity to the structures, producing a three-dimensional surface that allows the natural, external light to play across the passages, setting up patterns of light and shadow which reinforce those created by the artist with the heavy impasto of the paint itself.

Through his creative and technical genius, Ribera has realized in this series of *Philosophers* images of great power and individuality. Thanks to the diligent archival work of Nappi and Delfino, these paintings once again find a secure place in Ribera's oeuvre.

1. Commentary by Craig Felton; reproduced from *Burlington Magazine*, CXXVIII, 1986, 785–9. E. Turner, "Ribera's Philosophers," *Wadsworth Atheneum Bulletin*, Spring 1958, 5–14. Bibliography, in addition to those works cited below, includes the following: Viardot, 1844, 257; Mayer, 1908, 184, 188; 2nd ed., 1923, 201; Stix and Strohmer, 1938, 153, fig. 150; B. de Pantorba, *José de Ribera*, Barcelona, 1946, 25; "Noticias de arte," *Goya*, XXIII, 1958, 335; *Goya*, XXVIII, 1959, 268–70; *Archivo Español de Arte*, XXXII, 1959, repr. between 168–69; D. Fitz Darby, "Ribera and the Wise Men," *Art Bulletin*, XLIV, 1962, 279–307, n. 73; Faison, 1968, 466–77; C. Felton, "Ribera's 'Philosophers' for the Prince of Liechtenstein," *Burlington Magazine*, CXXVIII, 1986, 785–89, fig. 6. The provenance of the other paintings in the series, once they left the Liechtenstein Collection, is as follows: (1) *Aristotle* (called *Archimedes*), with Newhouse Galleries, New York, 1957; Dr. G. H. A. Clowes, Indianapolis, 1957 (the Clowes Collection was incorporated with the Indianapolis Museum of Art as the Clowes Fund Collection; (2) *Plato*, with Newhouse Galleries, New York, 1957; private collection, New York, 1957–73; with Newhouse Galleries, Mr. and Mrs. R. Stanton Avery, on extended loan to the Los Angeles County Museum of Art; (3) *Diogenes*; (4) *Crates*; and (5) *Anaxagoras* all left the Liechtenstein Collection presumably in the late 1950s and are now in separate, private collections. Pertinent discussion for the other paintings now in American museum collections is found in Fort Worth, 1982–83, 152–59, nos. 18, 19.

2. In Felton, 1971, 419–20, these paintings were listed with works rejected from the canon of authentic paintings; at that time, Felton had seen only the paintings in Hartford and Indianapolis and old photographs of the *Plato*, *Diogenes*, and *Anaxagoras*. Felton concluded that the Hartford and Indianapolis paintings lacked the rich surface texture and vigorous brushwork of the others in the series; and although of high quality, evidenced a smoother handling of the paint. At a later date, after further study, Felton accepted these works as authentic and then included the three now in American museum collections in the Jusepe de Ribera exhibition at the Kimbell Art Museum (Fort Worth, 1982–83, 152–59). Spinosa, 1978, 139, also removed these paintings from the oeuvre of the artist and placed them in a category of "other works attributed to Ribera" (nos. 401, 403, 412, 452, 455, 456, with 452 and 456 not illustrated). In a written communication, after seeing the Hartford and Indianapolis paintings, Spinosa reconsidered these attributions and accepted Ribera's authorship (Fort Worth, 1982–83, 153). In his review of the Ribera exhibition, D. M. Kowal, "Jusepe de Ribera, lo Spagnoletto," *Art Journal*, XLIII, 1983, 186–90, rejected the attribution of the Hartford *Protagoras* and Avery *Plato*, saying, however, that the Indianapolis *Aristotle* "seems admissible."

3. V. Fanti, *Descrizione completa di tutto ciò che ritrovasi nella galleria di pittura e scultura di sua altezza Giuseppe Wenceslao del S.R.I. principe regnante della casa di Leichtenstein*, Vienna, 1776, 105. The paintings are all listed as being 47½ inches in height by 37½ inches in width.

4. J. Dallinger, *Description des tableaux et des pièces de sculpture, que renferme la gallerie de Son Altesse François Joseph chef et prince regnant de Liechtenstein*, Vienna, 1780, 160–69.

5. J. von Falke, *Katalog der fürstlich liechtensteinischen Bilder-Galerie im Gartenpalais der Rossau zu Wein*, Vienna, 1873. These catalogue numbers for the paintings are from the 1931 publication, A. Kronfeld, *Führer durch die fürstlich liechtensteinische Gemäldegalerie in Wien*, Vienna, 1931, 22 (A55), 23 (A57), 84 (A372, A374), 85 (A376, A377); the catalogue of 1925 (also by Kronfeld) does not list these *Philosophers*, and the Ribera numbers in the 1931 catalogue are there used for other works. The first major publication on the paintings of Ribera is that by Mayer, 1923; although the Liechtenstein *Philosophers* are listed with the "original works" by Ribera (as *Anaxagoras*, *Archimedes*, *Diogenes*, and three other *Philosophers*), Mayer indicates that they were not in the Vienna residence at the time of his writing and that he did not have an opportunity to examine them again. He further suggests that they might be in one of the other palaces. Mayer's identifications are the same as the 1931 (and 1873) catalogues. His initial work was his dissertation in 1907 for the university of Leipzig; obviously, he saw the paintings about that time and based his identifications on the 1873 catalogue, neither referring to the 1767 one, nor recording the identification of *Crates*. Further, in his catalogue of dates and works (197), Mayer lists the *Anaxagoras* as 1636, the *Diogenes* and three others as 1637, and one *Philosopher* as 1631.

By the time of the 1931 Kronfeld catalogue, the paintings were supposedly reexhibited in Vienna. Trapier, 1952, does not mention these *Philosophers*. Gaya Nuño, 1958, lists all six (with corresponding Kronfeld numbers given here in parentheses) as: 2306 *Anaxagoras* (377), 2313 *A Philosopher* (374), 2323 *Diogenes* (55), 2324 *Archimedes* (as being in Indianapolis) (57), 2327 *A Philosopher* (372), 2328 *A Philosopher* (376).

6. Nappi, 1983, 73–87. The author would like to emphasize that J. Spike is responsible for bringing his attention to the documents published by E. Nappi and deserves full credit for their initial interpretation.

7. R. Baumstark, *Masterpieces from the Collection of the Princes of Liechtenstein*, trans. R. E. Wolf, New York, 1981, 9–15. See also R. Baumstark in New York, Metropolitan Museum of Art, *Liechtenstein: The Princely Collection*, 26 Oct. 1985–1 May 1986, xi–xxvii.

8. Nappi, 1983, 76.

9. A. Delfino, "Documenti inediti per alcuni pittori napoletani del seicento," *Ricerche sul seicento napoletano*, Milan, 1985, 104.

10. Fort Worth, 1982–83.

11. Stix and Strohmer, 1938, 38, no. 19. See also Fort Worth, 1982–83, 153, fig. 150.

12. Luzern, Kunstmuseum, *Meisterwerk aus den Sammlungen des Fürsten von Liechtenstein*, 5 June–31 Oct. 1948.

13. Mayer, 1923, 99, pl. XIV, fig. 16; Trapier, 1952, 134, fig. 86; Spinosa, 1978, 110, no. 110; see also Florence, Palazzo Pitti, *Dresda sull'Arno. Da Cranach a Van Gogh e oltre. Cento capolavori dalla pinacoteca di Dresda*, 4 Dec. 1982–4 Mar. 1983, 151, no. III.16.

14. Fort Worth, 1982–83, 150, fig. 147; Spinosa, 1978, 98–99, no. 40.

The Sense of Taste

Oil on canvas, 113.8 x 88.3 cm (44¹³/₁₆ x 34¾ in.)

Condition: fair. There are scattered small losses overall, especially in shaded areas. A rectangular damage in the upper left corner has been patched. Areas of paint loss are especially noticeable in the right arm and left lower sleeve.

There is an unidentified coat of arms in red wax on wood inserted into the back of the stretcher.

Provenance: possibly Prince Youssoupoff, Moscow and St. Petersburg; Duveen Bros., New York; purchased from Duveen Bros. for $10,500 from the Sumner Fund.

Exhibitions: Hartford, 1963; Cleveland, 1971–72, no. 55; London, *Painting in Naples*, 1982; Fort Worth, 1982–83, no. 3.

The Ella Gallup Sumner and Mary Catlin Sumner Collection, 1963.194

A series of five paintings by Jusepe de Ribera, each with a half-length figure representing one of the five senses, was first recorded by Giulio Mancini, physician to Pope Urban VIII Barberini and astute art critic of the various styles emerging during the first two decades of the seventeenth century in Rome. In a text entitled *Considerazioni sulla pittura*, written between 1614 and 1621, Mancini referred to Ribera's work with the following statement:

> He made many things here in Rome, and in particular for . . . [Mancini failed to add the name], the Spaniard, those having five half-figures representing the five senses, very beautiful, a Christ Deposed and another, which in truth are things of most exquisite beauty.[1]

The attribution to Ribera of the Atheneum's *Sense of Taste* did not occur until 1966, when Roberto Longhi published his research on the series;[2] the *Sense of Touch*, now in the Norton Simon Museum, Pasadena, Calif., was attributed to Ribera in 1967, when Erich Schleier published his findings (Fig. 82).[3] It is believed that both paintings may have been in the collection of Prince F. F. Youssoupoff of Moscow and Leningrad prior to the 1917 Revolution, and from there passed through Duveen in New York.[4] Subsequently, they were variously attributed to Velázquez, Antonio Puga, and Pietro Novelli ("Il Monrealese," a Sicilian follower of Ribera).[5] In his 1966 article, Longhi reported having been shown a series of paintings by a Paris dealer in 1963, works individually labeled: TACTVS, ODORATVS, AVDITVS, VISSVS, and GVSTVS, and which Longhi recognized as copies because of the lack of quality in their execution. (These paintings later passed through the Dorotheum in Vienna to Europahaus, a commercial establishment on the outskirts of Vienna.) Longhi, remembering the Mancini text, and the *Sense of Taste* which he had seen in Hartford, correctly reattributed this painting to Ribera, published for the first time

the compositions of Ribera's series, and thereby established what have been recognized as the master's earliest verifiable works. The *Sense of Sight*, now in the Franz Mayer Collection, Mexico City (Fig. 83), was published in the catalogue of the Academia de S. Carlos, Mexico City (where the Franz Mayer Collection was then shown), as by Gerard Douffet.[6] In the *Wadsworth Atheneum Bulletin*, Winter 1969 (actually published in 1972), Craig Felton included a photograph of the *Sense of Sight*, reattributing the painting to Ribera, although not knowing its location in Mexico City, which information was added by Richard Spear in an article published in 1972.[7]

In March 1985, a painting of the *Sense of Smell* came onto the New York art market; it is now in a private Spanish collection (Fig. 84).[8] We also illustrate here the copy of the unknown original *Sense of Sound* from Europahaus, Vienna (Fig. 85).

Ribera's series of the *Five Senses*, with individual, naturalistic, portraitlike figures, breaks with the traditional format of these subjects.[9] More typically, in the late sixteenth century, such allegorical studies were usually rather elaborate; those painted and etched by the Dutch artist Jacob de Backer (active c. 1560–c. 1591), show large nude or seminude figures placed in landscape settings, with appropriate symbols of the senses occupying prominent places in the composition.[10] Perhaps Ribera took his ideas from such works as Annibale Carracci's famous *Bean Eater* or *Drinker*, or Caravaggio's half-length subjects, such as the *Young Bacchus* or *Boy Bitten by a Lizard*, which have allegorical or sensual meanings.[11]

Ribera's concentration on the physical qualities of his subjects, presented with careful, visually accurate observation of form and structure, causes his images to approximate a reality that is both direct and personal. Undoubtedly, he was influenced by the teachings of the Jesuits, who followed the *Spiritual Exercises* of their founder, St. Ignatius of Loyola, canonized on 22 May 1622. St. Ignatius stressed an understanding of the physical world, as experienced through the application of the five senses, in order to attain a unity with realms of the spirit.[12]

In all of the paintings of this series, Ribera has chosen ordinary individuals for his models, stressing their physical peculiarities. The *Sense of Taste* is represented as a corpulent, unshaven gypsy, wearing small gold loop earrings. His gray shirt, soiled and tattered, pulls and stretches around his substantial body. A decorated ceramic bowl filled with eels or squid has been placed in front of him on a wooden table. In front of the bowl is a small, hard-crust roll and a paper cone filled with olives, which spill out onto the table. To our right is placed the inverted stopper of a wine carafe, which this middle-aged man holds in his left hand. He raises a glass filled with red wine, as if to toast the meal which he is about to consume with obvious relish. Light, with a corresponding shadow, enters the composition from the upper left.

In both the *Sense of Touch* and the *Sense of Sight*, Ribera used thick, rather opaque paint to model his figures. The flesh coloring is predominantly ruddy,

Jusepe de Ribera, *The Sense of Taste*

surfaces are textured, and sculptural volume is achieved through careful manipulation of light and dark passages. Ribera is also a superb draughtsman. Wrinkles and lines of the flesh are formed by vigorous tracking of the brush, which generally gouges through the surface layers of paint to reveal the darker layers of underpaint. This technique, which Ribera seems to have been among the first to develop (Guido Reni was also to employ it), is the opposite of that used by Caravaggio, who worked from the light to the dark colors, across the surface of the canvas, instead of from the underpainting to the top-most layers.[13] These elements of style and technique are consistent with those paintings by Ribera which are generally considered to be from the years following the execution of the *Taste* in 1614–16, such as the *St. Sebastian, St. Jerome, St. Peter,* and *St. Bartholomew* at the church of the Colegiata of Osuna, Spain. It is presumed that these latter paintings were commissioned by Don Pedro Téllez Girón, grand duke of Osuna, who was Spanish ambassador to Rome prior to his appointment as viceroy of Naples in 1616.[14] Also, it has been suggested that Jusepe de Ribera traveled from Rome to Naples with the ducal court, thereby beginning his long and distinguished career under the patronage of successive vice-regents.

The *Sense of Taste* demonstrates the most subtle modeling of all of the works in this series. Delicate variations of gray tones produce an almost opalescent quality to the shirt; flesh tones dissolve into the shadows around the head and hands. Details, such as the frayed collar, the stitching that holds the sleeves onto the shirt, the tear on that sleeve, the textures of cloth and food, the stubble of the beard, the lines suggesting the fatty bulk of neck and hands, all heighten the physical presence and visual impact of the figure.

1. Mancini, 1956–57, I, 149–50.
2. Longhi, 1966, 74–78. Bibliography, in addition to that cited elsewhere, includes the following: E. Mauceri, "News of Sicily," *L'Arte,* III, 1900, 340; V, 1902, 194–96; G. Frizzoni, "La Leggenda di S. Cristoforo interpretata da Tiziano e dal Monrealese," *Bollettino d'arte,* 1909, 321–25; E. Mauceri, "Southern Pictures in the Art Gallery of Bologna," *Dedalo,* XXVI, 1930, 779–83; J. Milicua, "En el centenario de Ribera, Ribera en Roma; el manuscrito de Mancini, *Archivo Español de Arte,* XXV, 1952, 309–22; review of Longhi, 1966, in *Archivo Español de Arte,* XXXIX, Apr. 1966, 32; Paoletti, 1968, 425–26, pl. 7; Felton, 1969, 2–11; Felton, 1971, 147–55; "High Flavors," *Apollo,* XCVI, 1972, 247; Spear, 1972, 149–58; Felton, 1976, 31–43; E. Young, "Spanish Paintings from Gothic to Goya," *Connoisseur,* Nov. 1976, 181; Spinosa, 1978, 92, no. 2, pl. I; Felton, 1991, 71–81, fig. 16, with X ray of head, fig. 18. There are several copies or versions of the Atheneum picture: (1) Florence, collection Rampini (94 x 79 cm); ex-collection Rossi, Forlì; reproduced in Longhi, 1966 and Felton, 1969. (2) Leningrad, Hermitage, no. 5328 (104 x 87 cm); ex-collection J. Braz; photo in curatorial file. (3) formerly Murcia, collection d'Estoup, two versions; this collection has been dispersed. (4) New York, collection Adela Holzer. (5) Luca Giordano, *Philosopher,* Vienna, Kunsthistorisches Museum (124 x 102 cm); reproduced in Ferrari and Scavizzi, 1966, III, fig. 38.
3. E. Schleier, "Una Postilla per i Cinque Sensi del Giovane Ribera," *Paragone,* no. 223, 1968, 79–80. Oil on canvas, 116 x 88.3 cm (45 3/4 x 34 3/4 in.).
4. The provenance of the Atheneum painting is unclear. In a letter to C. Cunningham, 15 Apr. 1966, V. Loevinson-Lessing questioned the Youssoupoff provenance, and noted that the paintings of *Senses* were not listed in the catalogue of the Youssoupoff Collection. Varido, 1844, does not mention any of these paintings in his discussion of the Youssoupoff Collection; certainly, they could have been acquired later.
5. A. Mayer, "Genrebilder der Velázquez-Schule," *Belvedere,* XIV, 1929, 261–62, attributed a painting of this subject in the Youssoupoff Collection to Puga; M. Soria attributed the Atheneum and Norton Simon paintings (then with Duveen) to Pietro Novelli (C. Cunningham to E. Schleier, 4 Jan. 1966, curatorial file); E. Trapier, letter to C. Cunningham, 12 Mar. 1964, curatorial file, rejected the attribution to Ribera. The Velázquez attribution is an old one.
6. The history of the *Sense of Sight* (oil on canvas, 119 x 89 cm [45 x 35 in.]) has been partially established from photographs in the Hispanic Society of America, New York, and the Frick Art Reference Library as follows: sale Paris, Hôtel Drouot, c. 1941, as Velázquez; with Bensimon, New York, 1952; Franz Mayer Collection (there is indication from the Frick photograph that it was acquired by Franz Mayer about 1956), on loan to the Academia de S. Carlos, Mexico City, until 1982. See also *Maestros europeos en las galerias de S. Carlos de Mexico,* 1963, pl. 38. The *Sense of Taste, Touch, Sight,* and *Smell* are all in identical frames. All were in New York City at some time, but there is no evidence that they all came through Duveen, or that they were ever together.
7. Felton, 1971, 3, repro. 19; Spear, 1972, 149–50.
8. New York, Christie's, 14 Mar. 1985, lot 139, as school of Ribera. The painting came from a private collection, New York. It was subsequently offered through Piero Corsini, Inc., of New York. For a review of the Corsini exhibition, 1–29 Nov. 1986, see K. Christiansen, "New York Old Master Paintings," *Burlington Magazine,* CXXXIX, 1987, 211–12, fig. 83. The *Sense of Smell,* oil on canvas, measures 114.3 x 88.3 cm; see also Felton, 1991, figs. 14, 17, 20, 21.
9. Fort Worth, 1982–83, 92–95.
10. Fort Worth, 1982–83, fig. 110.
11. New York, 1985, 236–46; Washington, 1986–87, 264–65, nos. 84–85.
12. *The Spiritual Exercises of St. Ignatius,* trans. A. Mottola, New York, 1964.
13. Fort Worth, 1982–83, 65.
14. Fort Worth, 1982–83, 103–5.

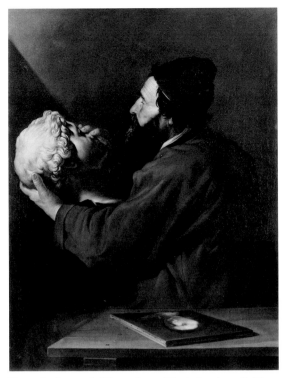

Figure 82. Jusepe de Ribera, *Sense of Touch*, Pasadena, Calif., Norton Simon Museum

Figure 83. Jusepe de Ribera, *Sense of Sight*, Mexico City, Franz Mayer Collection

Figure 84. Jusepe de Ribera, *Sense of Smell*, Private collection

Figure 85. After Jusepe de Ribera, *Sense of Sound*, formerly Vienna, Europahaus

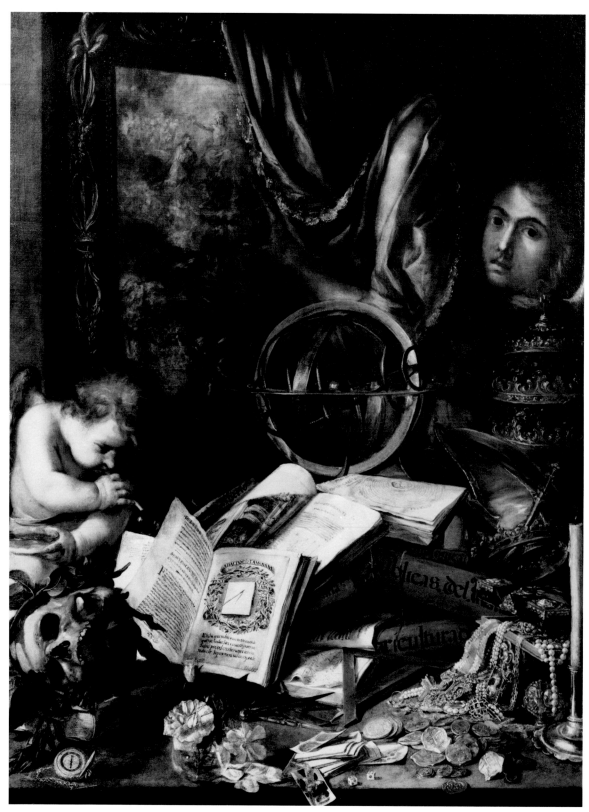

Juan de Valdés Leal, *Vanitas*

Juan de V. Niza Leal, called Juan de Valdés Leal (1622–1690)

Juan de Valdés Leal was baptized in the church of S. Esteban, Seville, on 4 May 1622. It is assumed that he served the traditional apprenticeship in Seville, although no records document the first twenty-five years of his life; Palomino implausibly suggests that Valdés studied with Juan de las Roelas (1558–1625). Some affinity exists with the paintings of the Cordoban Antonio del Castillo (1616–1668); however, Kinkead stresses that this was a matter of the slightly younger Valdés being aware of the latest styles and that both young artists share a common ground in the paintings of Zurbarán.[1] On 21 April 1647, Valdés posted bans to wed Isabel Martínez de Morales of Córdoba, which marriage took place on 14 July 1647. (On 13 May 1647, Valdés had already rented a house in Córdoba; on 7 June, he received a commission for twelve small copper panels from Don Francisco de Torquemada to be painted over the following six months.) His earliest known work is a large *St. Andrew*, Córdoba, church of S. Francisco, signed and dated 1649. From at least 1652 to 1653, when the last of the series is dated, Valdés was occupied with a cycle of large paintings of the history of the Order of Sta. Clara for the Franciscan convent of Sta. Clara in Carmona, paintings which indicate the range and promise of his mature works. In 1655 he began the innovative designs for the twelve paintings of the altarpiece (still intact) of the church of the Shod Carmelites in Córdoba; a monumental *Ascension of Elijah*, featured as the centerpiece, is a pivotal painting in Valdés's career. Just prior to beginning this canvas, Valdés went to Madrid — a journey which significantly affected his artistic development, bringing a noticeable awareness of canvases by Titian and Rubens. An *Allegory of Vanity*, in the Uffizi Gallery, Florence, since 1962, painted about 1655–56, is Valdés's first treatment of this subject and, according to Kinkead, clearly depends on the *Allegory of Perishability* of about 1650 of Antonio de Pereda (1611–1678), which was presumably in Madrid[2] and is now in the Kunsthistorisches Museum, Vienna. These works have explicit bearing on the Atheneum's *Vanitas*, dated 1660.

In July 1656, the painter and his family moved to Seville, where the high baroque style was beginning to gain dominance through the work of Murillo and Francisco Herrera the Younger. The Academy of Seville was founded in 1660, and Valdés Leal was appointed deputy and served as president from 1663 to 1666. During the years 1656–60, Valdés Leal received two important commissions: six scenes from the life of St. Jerome and a cycle of at least twelve canvases of Hieronymite saints for the monastery of S. Jerónimo de Buenavista, and for the altarpiece of the high altar in the chapter house of the Knights of Calatrava, S. Benito de Calatrava. Other single canvases also date from these years. These works demonstrate the energy and breadth of his composition and the quick and fleeting touch of his loaded brush. Vibrant and daring color choices and juxtapositions heighten the intensity of his dramatic interpretation. Valdés's best-known work, the *Hieroglyphs of Death and Salvation* (*In ictu oculi* and *Finis gloriae mundi*) were executed in 1672 for the Hermandad de la Sta. Caridad in Seville; the largest part of this decorative cycle was awarded to Murillo.[3]

By the early 1680s, Valdés was stricken with a debilitating illness which diminished his ability to work. His studio gradually came under the direction of his son, Lucas (b. 1661). Upon his death in October 1690, Valdés left only a modest estate.[4]

1. Kinkead, 1978, 2, 72.
2. Kinkead, 1978, 79–80, 96–97, nn. 23–24.
3. Brown, 1970, 165–77.
4. Kinkead, 1978, 304, 317–18, nn. 81–82.

Figure 86. Juan de Valdés Leal, *Allegory of the Crown of Life*, York City Art Gallery

Vanitas

Oil on canvas, 130.4 x 99.3 cm (51³/₈ x 39¹/₁₆ in.)

Condition: excellent. There are small scattered paint losses throughout.

Signed and dated on the right page of the open book to the right of the skull: *1660 Ju⁰ de baldes Leal F A.*; inscribed on the book under the skull:

TRE NO

DIFERECIAE LOTENPOR . . . / . . . STER ;[1] on the page bearing the signature: PO/TENTIA/ADACTUM TAMQUAM/TABULA/RASA [on scrolls]; the verse below: *En la que tabla rasa tanto excede/que uee todas las cosas en portencia/solo el pincel cosoberana ciencia/reducir la potencia ial acto puede*;[2] on the left page, center: SENTENCIA QVE DIO . . .;[3] the books above:[4] . . . *ia De alberto*;[5] below, left to right: . . . *notomia*;[6] *Sebianano*;[7] . . . *ologica*;[8] . . . *epublica del* . . .;[9] . . . *gricultura De* . . .[10]

Provenance: possibly collection Hospital de la Caridad, Seville; Tomás Harris, London, 1938; Durlacher Bros., New York, 1939; acquired by the Wadsworth Atheneum in 1939 from Durlacher Bros. for $3,000 from the Sumner Fund.

Exhibitions: London, *From Greco to Goya*, 1938, no. 20, repr.; Toledo, 1941, no. 78, repr.; New London, 1948, no. 12; Hartford, *In Retrospect*, 1949, no. 17; Hartford, *Pictures within Pictures*, 1949, no. 26; New London, 1954; Sarasota, 1958, no. 50; Newark, Newark Museum, *The Golden Age of Spanish Still-Life Painting*, 10 Dec. 1964–26 Jan. 1965, no. 28, repr.; Middletown, 1966; Princeton, 1982, 108, no. 44.

The Ella Gallup Sumner and Mary Catlin Sumner Collection, 1939.270

Vanitas[11] is the pendant to the *Allegory of the Crown of Life* in the Art Gallery of the City of York, England (Fig. 86).[12] The York picture shows a man seated at a table, reading a book, and holding a rosary in his hand. An angel behind him holds an hourglass in one hand, and with the other points to a crown above, surmounted by the words QVAM REPROMISIT DEVS. The phrase, as Trapier has pointed out,[13] comes from the Epistle of St. James, 1:12.

Nordstrom postulates that the York painting is representative of the virtues of life: the crown is the crown of life, promised by God to those who are virtuous and who avoid the other crowns of worldly vanity, such as the royal crown and scepter, the bishop's miter, and the papal tiara,[14] which are portrayed in the Hartford *Vanitas*. As Mallory says:[15] "The *Allegory of the Crown of Life* alludes to the promise of eternal life and the road to it through faith, devotion, and sacrifice. [The] vanitas presents the obstacles placed on the path to salvation and reminds us of the final retribution for our sins."

Tancred Borenius, who was first to link the two paintings, identifies the man in the York painting as Don Miguel Mañara,[16] later director of the Hermandad de la Sta. Caridad in Seville, and commissioner of Valdés Leal's most famous works, *The Hieroglyphs of Death and Salvation*.[17] More recently J. Brown has challenged this identification.[18]

Structurally and thematically, the Hartford *Vanitas* is directly related to the York *Allegory*. The idea represented here has its roots in the vanitas of the scholar, such as scenes of St. Jerome in his study, and is well known in such prints as Dürer's *Melencolia I*.[19] The most direct source for this pair of paintings is Antonio de Pereda's *Dream of Life* in the Royal Academy, Madrid,[20] painted in the early 1650s. This canvas, with its similar vanitas elements,[21] was surely known to Valdés Leal when he created his pendants.[22]

The painting unveiled by the angel in the Hartford picture is a Last Judgment scene[23] that warns one of what awaits both those who follow a secular existence with its earthly rewards and those who devote their lives to the worship of god, such as the man in the York picture.

1. Identified by Trapier, 1956, 24, as Juan Eusebio Nieremberg's *Diferecia etre lo temporal y eterno*. For a more detailed discussion of this iconography, see Trapier, 1960, 31–34. In neither publication, 1956 or 1960, does Trapier give places and dates for these references.

2. As Trapier, 1956, 24, has pointed out, this passage is from Vicente Carducho's *Diálogos de la pintura*, Madrid, 1633, pl. 6, illustrated in Trapier, 1956, fig. 14. George Kubler has kindly offered the following translation of this page from the Latin above: "The possibility for action is as a fresh sheet"; and the Spanish quatrain below: "The fresh sheet, seeing all things as possibilities, is surpassed alone by the brush's sovereign science to turn possibility into action." For another illustration to Carducho's text, with a brief history of the manuscript, see G. Kubler, "Vicente Carducho's Allegories of Painting," *Art Bulletin*, XLVII, 1965, 439–45. On the tabula rasa concept in Spanish painting and its relationship to Carducho's Latin phrase, see W. Jordan, *The Meadows Museum, Southern Methodist University*, 1974, Dallas, 20, who writes: "This Latin phrase relates Aristotle's fundamental doctrine of potentiality versus actuality to the painter's confrontation with the perfectly blank canvas upon which the creation of anything is possible, the only limitations being his imagination and his free will to act."

3. Trapier, 1956, 24, writes: "Rodríguez Monino has observed that Valdés Leal depicted folio 229 out of its proper place and facing the plate. He believes the artist made this substitution to show the putto blowing his bubble in derision at the solemn text of the royal decree in the artist's lawsuit contained in the book's *Sentencia que dió el Real Consejo de Hacienda en el pleit de los pintores*."

4. Trapier, 1960, 32, was able to identify the page with the architectural decoration. She compares it with a page from Vignola's *Le due regole della prospettiva . . . con comentarij del P. P. M. Ignacio Danti*, Rome, 1611.

5. Trapier, 1956, 25, associates this inscription with the book *Alberti Dureri clarissimi pictoris et geometrae de symmetria partium in rectis formis humanorum corporum*. Nordstrom, 1959, 136, suggests that it is perhaps not a work of Dürer as Trapier supposes. He suggests that it could be Leon Battista Alberti's *De re aedificatoria*, translated into Spanish and published in Madrid in 1582 by Lozano.

6. Trapier, 1956, 25, identifies this as Montaña de Montserrate's *Libro de la anothomia del hobre*.

7. Trapier, 1956, 25, suggests that this is perhaps a work by Sebastiano Serlio.

8. Trapier, 1956, 25, who reads this as "strologica," identifies the transcription with Antonio de Najera's *Suma astrologica y arte para ensenar hacer pronosticos de los tiempos*.

9. Trapier, 1956, 24, suggests this to be Fray Jerónimo Román's *Republicas del mundo*.

10. Trapier, 1956, 25, suggests the book to be Alonso de Herrera's *Obra de la agricultura*. The only open book that remains unidentified is that under the armillary sphere, showing a circular chart of the cosmos. It is similar to the pre-Copernican plan shown by A. Kore, *From the Closed World to the Infinite Universe*, New York, 1958, fig. 1. This chart, and the armillary sphere above, here stand as representations of the universe of wordly vanities.

11. Bibliography, in addition to that cited elsewhere, includes the following: *Art News*, XXVIII, 14 Oct. 1939, 9, repr.; Soria, 1947, 565–66; *Wadsworth Atheneum Handbook*, 1958, 64, repr.; Gaya Nuño, 1958, no. 2752, pl. 199; J. Hernández Perera, *La Pintura española y el reloj*, Madrid, 1958, 37–38, repr. on XIV; Guinard, 1967, 401; "Fantasy and Flair," *Apollo*, LXXXVIII, 1968, 408, fig. 3; D. T. Kinkead, "An Important Vanitas by Juan de Valdés Leal," in *Hortus Imaginum: Essays in Western Art*, Lawrence, 1974, 156, fig. 109.

12. 1961, no. 810, illus. The dimensions of the York canvas, according to a letter from the museum, are incorrect in the catalogue, and should be read as 130.5 x 99 cm (51 1/2 x 39 in.). The painting, therefore, is almost identical in size to the Atheneum painting.

13. Trapier, 1956, 29. Trapier believed the first word to be "QVIM (!) [sic]," but it can be read from a clear photograph as QVAM.

14. Nordstrom, 1959, 133, 137. To this list might be added the poet's laurel wreath on the skull. See also Kinkead, 1978, 80–81, and Princeton, 1982, 108.

15. Princeton, 1982, 108.

16. Borenius, 1938, 146–47.

17. For this commission, together with an account of Mañara's life and patronage of the arts, see Brown, 1970, 165–77.

18. See Trapier, 1956, 28; Nordstrom, 1959, 127–28. Although before 1660 — the date on the Atheneum painting — Mañara had lost two brothers, one sister, and both of his parents, it was not until 1661 that his wife died. That year he retired from secular life and made a full confession of his sins (Brown, 1970, 267–69). It is, therefore, unlikely that his conversion occurred as early as 1660. Brown points out (266) that Mañara was mistakenly identified with the legendary Don Juan Tenorio, the *Burlador de Sevilla*, hero of Tirso de Molina's seventeenth-century play. For a discussion of the sources of this confusion, see Lipschutz, 1972, 111.

19. See Borenius, 1938, 147, and Nordstrom, 1959, 128. Nordstrom notes (137) that the Hartford and York paintings contrast with each other in about the same way as Dürer's famous engravings, *St. Jerome* and *Melencolia I*.

20. Madrid, Real Academia de Bellas Artes de S. Fernando, 1965, 66, no. 639. A similar painting by Pereda of c. 1654 is in Vienna, Kunsthistorisches Museum, 1973, 133, pl. 137, reproduced also in Gallego, 1968, pl. 25.

21. Practically every element in the Hartford painting can be accounted for in Pereda's earlier Madrid painting, such as the man resting his head on his hand (for this as a symbol of Melancholy, see E. Panofsky and F. Saxl, *Dürers 'Melancholia' I. Eine quellen- und typen-geschichtliche Untersuchung*, Leipzig and Berlin, 1923, and Nordstrom, 1959, 128), the background angel painting out a message, a bishop's miter, crown and scepter, papal tiara, cards, coins, a timepiece, the skull with its laurel wreath, the glass vase of flowers, etc. An original element added by Valdés Leal is the combination of the putto blowing bubbles with the human skull. The concept here represented is that of *Homo bulla* — man as a bubble — an iconographic motif that has its basis in Italy, and greatest popularity in Holland (see H. Goltzius's print of this subject; Trapier, 1956, fig. 12). For the history of this motif, see H. Janson, "The Putto with the Death's Head," *Art Bulletin*, XIX, 1937, 423–49, and the reply to this by W. Stechow, "Homo Bulla," *Art Bulletin*, XX, 1938, 227. For the use of this motif in seventeenth-century Holland, see E. de Jongh, *Zinne- en minnebeelden en de schilderkunst van de seventiende eeuw*, Openbaar Kunstbezit, The Netherlands, 1967, 81. For the origin of vanitas in the seventeenth century, see D. Merrill, "The 'Vanitas' of Jacques de Gheyn," *Yale University Art Gallery Bulletin*, XXV, Mar. 1960, 4–29. The most complete discussion of the dual meaning of the vanitas elements in the painting in the Atheneum is given by Gallego, 1968, 201.

22. Although, as Trapier 1956, 17, has pointed out, Valdés Leal did not visit Madrid until 1674, it is likely that he knew Pereda's painting. The date of the *Dream of Life* has not been securely determined (for a discussion of the problems of dating it, see E. Tormo, *Antonio de Pereda: La Vida del artista*, Valladolid, 1916, 60–66). It seems certain, however, that it dates before 1660. A. L. Mayer in Thieme and Becker, 1932, XXVI, 398, dates it as early as the 1640s. Soria in Kubler and Soria, 1959, 282, said that it was executed around 1655, and that the Hartford and York paintings were influenced by the emblem books and by the similar themes that Pereda painted from 1640 and 1660 (283).

23. Trapier, 1956, 22, says that the painting may have been inspired by a work of the same subject by Marten de Vos, now in the Museo Provincial de Bellas Artes, Seville (1967, 47, no. 2, as 2.60 x 2.63 m, signed and dated 1570). It was mentioned by Ford, 1855, 193, as a stumbling block to the priests, "who could not say mass quietly before them [i.e., the female nudes in the painting]." The painting was probably in Seville since the sixteenth century, and it was taken to the provincial museum from the cloister of St. Augustine in Seville (V. Dirksen, "Die Gemälde des Marten de Vos," diss., Parchim, 1914, no. 45). The de Vos painting is reproduced in M. Estella's "Marten de Vos. Algunas obras de Marten de Vos en España," *Archivo Español de Arte*, 45, 1972, 66–71, pl. I, fig. 2. This painting, however, has an arched top, although many of the elements in it are similar to the arrangement in the Hartford picture-within-a-picture. Perhaps closer is the *Last Judgment* that Estella attributes to Marten de Vos and illustrates as fig. 1 (present location unknown, sale Cologne, 10 May 1916). The motif of the "unveiled painting," as in Valdés Leal's *Vanitas*, was previously used in Holland as a clue to the meaning of the painting, such as in Gabriel Metsu's *Woman Reading a Letter* in the Sir Alfred Beit Collection, Blessington, Ireland. On the iconography of this motif, see E. de Jongh, "Réalisme et réalisme apparent dans la peinture hollandaise du dix-septième siècle," in Brussels, Palais des Beaux-Arts, *Rembrandt et son temps*, 1971, 177. In his *Lady Weighing Gold* in the National Gallery, Washington, Vermeer used a painting of the Last Judgment to add a moralizing message to the scene, just as is the case in Valdés Leal's *Vanitas*, though here it is made even more explicit (L. Gowing, *Vermeer*, New York, 1952, 44, 135).

Francisco de Zurbarán
(1598–1664)

On 15 January 1614, at the age of fifteen, Francisco de Zurbarán left the small Extremaduran village of Fuente de Cantos, Badajoz, to begin an apprenticeship with Pedro Díaz de Villanueva in Seville.[1] Nothing of this all-but-forgotten master's work is known and Zurbarán's earliest, extant painting, an *Immaculate Conception*, in the collection of Felix F. Valdés, Bilbao, from 1616, indicates the most standard achievements, with any personal style apparent only in retrospect; nevertheless, Seville was the most important center of painting in Spain and Zurbarán surely became acquainted with Francisco Pacheco and the young Velázquez. The following year, with his studies in Seville concluded, Zurbarán settled in Llerena, a town some sixty miles to the northwest, and married the twenty-eight-year-old María Paez Jiménez. In 1625, a year or so following her death, Zurbarán was married to Beatriz de Morales, a prosperous woman almost thirteen years his senior, who brought with her dowry a large townhouse where they lived until 1629.

These were productive years for the young painter, with his first major commission coming from the Dominican church of S. Pablo in Seville. The contract of 17 January 1626, specified fourteen episodes from the life of St. Dominic and seven single figures of church fathers and saints. An additional painting was added in 1627, a *Crucifixion*, now in the Art Institute, Chicago, which is one of the masterpieces of Spanish baroque painting. Isolated and strongly illuminated against the impenetrable darkness of a deep void serving as background, the massive, sculptural figure of Christ hangs from a rough-hewn cross. Caravaggesque naturalism, with careful selection of details and pose, and a rugged, almost brutal realism produce an image which is classically heroic yet profoundly human. The following year, Zurbarán painted the Atheneum's *St. Serapion*, part of a large commission for the monastery of the Merced Calzada, also in Seville. As a result of these significant commissions and accomplishments, the city council of Seville resolved on 27 June 1629 to invite Zurbarán to take up permanent residence in their city. Although the painters' guild, led by Alonso Cano, visited him on 23 May 1630 to demand that he submit to their qualifying exam, Zurbarán wrote a response to the city council which negated this hostile action of the local artists. Other commissions ensued, and in 1634, Philip IV ordered a series of canvases on the *Labors of Hercules* and two battle scenes, part of the decorative ensemble for the Hall of Realms of the Buen Retiro Palace in Madrid. Association with the painters at court and the great royal collections seem to have had little effect upon Zurbarán, and although he was nominated honorary painter to Philip IV, in six months he returned to Seville where his life and career were securely established. His two most important commissions and greatest achievements came late in the 1630s: the altarpiece for the church of Nuestra Señora de la Defensión, Jerez de la Frontera — the individual paintings for which are now in various museums;[2] and for the Hieronymite monastery of Guadalupe in Extremadura, a series of eight large paintings of members of the order, placed in the sacristy, and an altarpiece and two scenes from the life of St. Jerome in the adjoining chapel.[3]

The death in 1639 of Zurbarán's second wife marked a change in his personal and professional lives. Although he remarried in 1644 and began a new family (six children are recorded), paintings and documents from these years are few in number. Zurbarán's prestige was waning, and he was increasingly overlooked in favor of his young rival, Murillo. In May 1658, he went alone to Madrid, perhaps hoping to regain a prominence and the commissions that were eluding him in Seville. At the end of that year, he testified to Velázquez's nobility and, perhaps through the influence of this old friend, began to develop some patronage. During the final six years of his life, his paintings are characterized by a quiet, gentle, spiritual reserve with the theme of the Virgin and Child predominating. He died on 27 August 1664, and soon passed into anonymity.

1. For this information and the following, see Brown, 1974; see also J. Baticle in New York, 1987, 53–68.
2. Liedtke, 1988, 153–62.
3. See Brown, 1978, 111–27.

St. Serapion

Oil on canvas, 120.2 x 104 cm (47^{5}/16 x 40^{15}/16 in.)
 Condition: fair. The surface is very abraded overall. X rays show that the saint's left hand has been completely renewed. Further areas of retouching include areas on the saint's ear, jaw, and neck.
 Inscribed, signed, and dated on a painted piece of paper near the right edge: *B. Serapius./ franco de Zurbaran fabt. /1628*
 Provenance: monastery of the Shod Mercedarians, Seville, 1800?; Alcázar, Seville, 1810, inv. no. 227; Julian Williams, Seville, until about 1832; Richard Ford, Seville and London (sale London, Rayny's auction rooms, 9 June 1836, no. 33, for 5 pounds, 10 shillings); Sir Montague John Cholmeley (d. 1874); Sir Hugh Arthur Henry Cholmeley (d. 1904); Sir Montague Aubrey Rowley Cholmeley (d. 1914); Sir Hugh John Francis Sibthorp Cholmeley, Easton Hall, Grantham, Lincolnshire; Koetser Gallery, New York, 1947–51; bought by the Wadsworth Atheneum in 1951 from Koetser Gallery for $15,000 from the Sumner Fund.
 Exhibitions: Seattle, 1954, no. 24; New York, 1958, 62; Madrid, 1964–65, no. 10; New York, Wildenstein & Co., *The Italian Heritage*, 17 May–29 Aug. 1967, no. 64, repr.; Hartford, 1982; New York, 1987, 102, no. 5.
 The Ella Gallup Sumner and Mary Catlin Sumner Collection, 1951.40

St. Serapion was painted for the monastery of the Shod Mercedarians in Seville.[1] In an anonymous manuscript of 1732 the *sala de profundis* of the monastery is described as containing two paintings of martyred monks by Zurbarán, "facing each other near the door to the refectory."[2] Ponz in 1777 referred to the same paintings in a more detailed description of the room.[3] Unfortunately, it is impossible to form a precise reconstruction of the original setting of the works, because the building has been greatly transformed since the seventeenth century; it is now the Museo Provincial de Bellas Artes of Seville.[4] Matute, in his corrections to Ponz, says that of the two paintings of martyred saints only one remains, the *St. Serapion*.[5] In 1800 Ceán Bermúdez mentioned only the *Serapion* in the *sala de profundis*, and he does not describe a companion painting.[6] The painting in the Atheneum was listed in the 1810 inventory of paintings collected at the Alcázar in Seville.[7] Sometime after this date Julian Williams, the English consul in Seville, acquired the painting and sold it to Richard Ford before the latter left for England in 1833. The painting was purchased by Sir Montague John Cholmeley from the sale of Ford's collection in

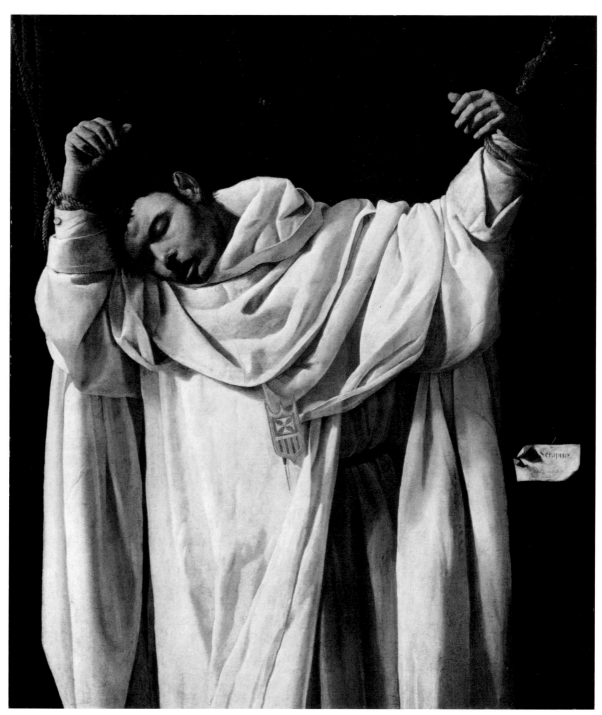

Francisco de Zurbarán, *St. Serapion*

London in 1836, and it remained in the Cholmeley family, practically unknown, for almost a century.[8]

A painting now in the collection of Rumeu de Armas, Madrid, is thought to be a fragment of the lost pendant to the Serapion;[9] it certainly depicts the same model, but shows him alive and with an intense upward gaze.[10] Perhaps Zurbarán intended to show Serapion in life and in death, an appropriate iconographical scheme for the *sala de profundis*, a room used as a repository for the bodies of deceased monks before burial.[11]

Thanks to an eighteenth-century biography,[12] much is known of Serapion's life. Born in Scotland in 1178, he accompanied his father on the Third Crusade when only eighteen years old. The saint joined the Mercedarian order in 1222, dedicating his life to combating the enemies of Christianity. In 1240 he was held by the Moors in Algiers as ransom for eighty-seven prisoners. For preaching the gospels to the followers of Mohammed and converting many to Christianity he was brutally tortured and killed. Tied to a tree as Zurbarán here depicts him, his joints were broken and his intestines removed; finally, he was decapitated.[13] The artist avoids a vivid depiction of these cruelties and presents a painting of utmost calm and sublime spirituality.

1. It is not, however, mentioned in the contract of 29 August 1628, in which he agreed to execute twenty-two paintings depicting the life of St. Peter Nolasco within one year. Guinard, 1960, 94, suggests it was a trial piece executed before the contract was signed. See also New York, 1987, 102. Bibliography, in addition to that cited elsewhere, includes the following: C. Cunningham, *Art News*, L, no. 7, Nov. 1951, 31, repr.; *Art Digest*, XXVI, no. 5, 1 Dec. 1951, 31, repr.; C. Cunningham, "Saint Serapion by Francisco de Zurbarán," *Wadsworth Atheneum Bulletin*, Oct. 1951, 1; *Pictures on Exhibit*, XIV, no. 1, Nov. 1951, 64; *DU. schweizerische Monatsschrift*, XVI, June 1956, 18, repr.; "The Wadsworth Atheneum," *Arts Magazine*, XXXI, Feb. 1957, 42, repr.; J. Gudiol, "Zurbarán," in *Encyclopedia of World Art*, New York, 1957, XIV, col. 969, pl. 480; Gaya Nuño, 1958, no. 2991, pl. 147; *Wadsworth Atheneum Handbook*, 1958, 62, repr.; "Hartford. Opera de Wadsworth Atheneum esposte a New York," *Emporium*, 129–30, 1959, 87, repr.; H. W. Janson, *Key Monuments of the History of Art*, New York, 1959, pl. 847; Kubler and Soria, 1959, 245, pl. 128A; *Fine Arts Philatelist*, VIII, no. 3, 1962, 42; "El Pintor de los frailes blancos," *MD [en Español]*, I, no. 7, 1963, 36, repr.; Torres Martín, 1963, no. 28a, repr.; D. Sutton, "A Master of Austerity: Francisco de Zurbarán," *Apollo*, LXXXI, 1965, 322–25, fig. 2; M. Kitson, *The Age of the Baroque*, New York, 1966, fig. 63; J. Morris, "Iconography of Saints," in *New Catholic Encyclopedia*, New York, 1966, XII, fig. 5c; *Zurbarán. I Maestri del colore*, Milan, 1966, pl. I; D. Brown, *The World of Velásquez*, New York, 1969, 98, repr.; H. W. Janson, *History of Art*, rev. ed., New York, 1969, 432, fig. 648; F. Marti-Ibáñez, ed., *The Adventure of Art*, New York, 1970, 422, repr.; J. Held and D. Posner, *Seventeenth- and Eighteenth-Century Art*, New York, 1972, pl. 22; Lipschutz, 1972, 201, repr.; T. Frati and M. Gregori, *L'Opera completa di Zurbarán*, Milan, 1973, no. 34, pl. V; G. Barrière, "Un Miracle unique en Europe: L'Empris du Caravage sur l'Espagne," *Connaissance des Arts*, 263, Jan. 1974, 87, repr.; N. Glendinning, "A Collector's Passion for Spain," *Country Life*, 13 June 1974, pl. 4; Brown, 1974, 69, pl. 5; X. de Salas, *An Illustrated Inventory of Famous Dismembered Works of European Painting*, Paris, 1974, 135, fig. 7; J. Gallego and J. Gudiol, *Zurbarán,*

1598–1664, New York, 1977, 74, no. 9, fig. 13; F. Pérez Rivera, *Introducción a la literatura espanola*, rev. ed., New York, 1982, 213, repr.; D. and S. Preble, *Artforms: An Introduction to the Visual Arts*, 3rd ed., New York, 1985, pl. 56.

2. *Memoria de las admirables pinturas que tiene este Convento, Casa Grande de Nuestra Senora de la Merced, redemptora de cautivos de la Ciudad de Sevilla*, Seville, 1732 (original MS destroyed; copy of 1789 by M. de Ayora in Biblioteca Colombiana, Seville, "papeles varios, 40," published by F. J. Sánchez Cantón, "La Vida de San Pedro Nolasco: Pinturas del Claustro del Refectorio de la Merced Calzada de Sevilla," *La Merced*, XXIV, no. 1, 1922), as cited by Guinard, 1947, 172–73: "los dos martires que están uno frente de otro, cerca de la puerta del Refectorio."

3. Ponz, 1777, carta 3, par. 48: "Por el clerigo Roelas se tienen un San Joaquin y San Jose en la sala del *De Profundis*, y por Francisco de Herrera el viejo, una Nuestra Senora de cuerpo entero con el Nino en brazos. Cerca de la puerta del refectorio hay dos santos martires, de Zurbaran; ye de un discipulo de este, llamado Jua Martinez de Gredilla, es la pintura del testero de dicho refectorio."

4. For a history of the building, see Hernández Díaz, 1967, 9. In 1810 the building suffered a grave fire that took five years to repair. Other major renovations in the design occurred in 1724, 1841, 1868–98, and 1942–45. The founders signed a constitution for the museum on 6 September 1835. From the documents (nn. 1, 2, 4, and 9), it seems possible that the two companion paintings hung opposite each other on the two walls of the *sala de profundis*. These were perpendicular to the door entering into the refectory. Perhaps the *testero*, or painting on the head wall, as mentioned by Ponz, was a canvas hanging above this door. See also New York, 1987, 95–101.

5. Matute y Gaviria, 1887, 377: "No se encuentra ya en la Sala del *De profundis* la *Señora* de Herrera de que habla Ponz, ni más que uno de los martires de Zurbarán, que es *San Serapio*, colocado frente de la puerta del refectorio con la firma de 1623." Guinard, 1947, 173, before the Atheneum's painting was known to him, concluded in a discussion of this text that Matute probably made an incorrect reading of the inscription, which perhaps read 1629. Peman, 1949, 207–8, was the first to identify the Hartford painting, then in the London art market, as that described by Matute. Unfortunately, the exact date of Matute's manuscript, published fifty-seven years after his death in 1830, gives no hint of the year it was composed. Matute mentions an event of 1801 (77), giving us this as the earliest possible date.

6. Cean Bermúdez, 1800, 49, as by Zurbarán in the monastery of the Merced Calzada, Seville, "S. Serapio en la sala De profundis."

7. Gómez-Imaz, 1917, 141, as "Originales de Zurbarán" in room no. 7, no. 227: "Otro de 1 1/4 de alto y 1 de ancho, S. Serapio." Guinard, 1960, 259, argues that this might be a reference to another version because the dimensions do not correspond precisely to the present measurements of the Hartford painting. Since the old Sevillian or Castilian *vera* is equal to .835 meters (see Doursther, 1976, 568), the Alcázar painting was 104.375 x 83.5 cm. This does not precisely match the present dimensions, but the proportion of height to width is similar. The discrepancy in size might be explained by the fact that many of the measurements taken in the Alcázar seem to have been made by sight,

and that the smallest unit of measurement in the catalogue was ¼ *vera*. M. Soria defended his belief that the painting at the Atheneum is the same as that in the inventory of the Alcázar in a letter in curatorial file, 30 Nov. 1957. Historians such as Guinard, on the other hand, reject this theory, believing that the Alcázar inventory lists another version that was taken with other paintings *en bloc* from the monastery of the Merced Descalzada rather than the Merced Calzada (see also Peman, 1949, 208, and Sanz-Pastor in Madrid, 1964–65, 107, no. 10). An old copy or version of the painting, now in the museum at Gien (Loiret), was published by R. Jatteau in *Le Journal de Gien*, 15 May 1969, 9, repr. It is given as a work of Ribera, and described as such by Jules Fauchet in his *Histoire de l'arrondissement de Gien* of 1879 (as cited in Jatteau). Fauchet says that the painting was given by the duchess of Dalmatia to the church of Nevoy, where it was then located. Since the duchess was the wife of Hector Soult, son of Nicolas Soult, marshal of France, it is argued that the painting was taken from Spain by the elder Soult in the early nineteenth century, passed to his son and finally to the latter's widow, who presented it to the church in Nevoy before her death in 1882. Nicolas Soult was in Spain by 1808 (Lipschutz, 1972, 31) and left Seville in August of 1813 (Ford, 1855, 170). As Lipschutz points out (370, n. 13), many paintings by Zurbarán are still in the possession of Soult's descendants. The picture in Gien measures 112 x 91 cm, making it closer than the Hartford canvas to the painting listed in the Alcázar inventory. It is therefore possible that the Atheneum's painting did not go to the Alcázar, but remained in Williams's collection until it was sold to Ford. If this is the case, it is possible that the painting in Gien was in the Alcázar and was later brought to France by Nicolas Soult.

8. A clipping from the Ford sale catalogue is attached to the painting's stretcher. As this clipping and the sales catalogue indicate, the painting is "from the collection of Mr. Williams, at Seville." Precisely when Julian Williams acquired and sold the painting is not certain. Guinard, 1960, 94, who believes it was not the Hartford painting that appeared in the Alcázar in 1810, speculated that Williams acquired the work after 1808. At any rate, it was probably removed from the convent before 1810, because a great fire occurred there in that year (Hernández Díaz, 1967, 9). Unfortunately, the first publication to tell us that the painting was no longer in the *sala de profundis* appears too late to be of any help in this matter: El Conde de la Vinaza, *Adiciones al diccionario histórico de los más ilustres profesores de las bellas artes en España de Don Juan Augustín* Ceán Bermúdez, Madrid, 1894, IV, 71. That Williams once owned the painting is certain from the statement in the auction catalogue and the description of his collection by J. Amador de los Rios, *Sevilla pintoresca, o descripción de sus más celebres monumentos artísticos*, Seville, 1844, 473: "También han desaparecido de esta colección algunos lienzos del pintor estrimeno, contandose entre ellos el martirio de San Serapio." Richard Ford, who considered Williams the major connoisseur of Spanish paintings in Seville (B. Ford, *Richard Ford en Sevilla*, Madrid, 1963, 14, and R. Ford, *A Handbook for Travellers in Spain*, London, 1855, I, 166), must have purchased the painting from him before his return to London via Madrid in September 1833 (R. Prothero, ed., *The Letters of Richard Ford, 1797–1858*, New York, 1905, 11, 133). It is interesting to note that Julian Williams was one of the founders of the museum in Seville, established in the same building that formerly housed the *St. Serapion* (Hernández Díaz, 1967, 10). A copy of the Ford catalogue (Lugt 14389) in the Rijksbureau voor Kunsthistorische Documentatie, The Hague, indicates by annotation that the painting, no. 33, was sold for 5 pounds, 10 shillings. According to a typescript copy in the National Gallery, London, made from a catalogue containing manuscript notes by Richard Ford himself, the buyer's name for lot 33 is annotated "M. Cholmondeley," the older spelling for Cholmeley.

9. Soria, 1955, 140, no. 29, fig. 18, as perhaps a companion to the *St. Serapion* in Hartford; the canvas was seen as a fragment before it was linked to the Hartford painting (J. A. Gaya Nuño, *Zurbarán*, Barcelona, 1948, 70, as executed in 1629). M. Caturla in Madrid, 1953, 50, was the first to think of the paintings as pendants. The two works are of the same scale; if the dimensions of the Armas fragment (69 x 56 cm) were expanded to equal the size of the painting in the Atheneum (120.2 x 104 cm), the result would be a knee-length portrait. Examination of the edges of the canvas at the Atheneum show that the original size was slightly smaller than that given here. X rays of the upper left and right corners show that the original tacking edges were about one inch smaller than at present. The original edge of the bottom left corner is clearly visible under the frame, showing that the painting was not cut here. One need not imagine a seated figure for the original appearance of the picture in the Armas Collection, as does Sanz-Pastor in Madrid, 1964–65, 105, no. 9. The inventory at the Alcázar (see note 7) lists immediately after the *Serapion*: "228. Otro de igual tamano, un Santo mercenario." It is tempting to think of this as the picture in the Armas Collection, before it was cut down. However, Matute, 1887, says that the companion painting was missing, and Ceán Bermúdez, 1800, fails to mention a pendant to the *Serapion*. This leads one to believe that the companion paintings were separated before 1810; if so, it is unlikely that they would be reunited at the Alcázar.

10. Caturla in Madrid, 1953, 50, and Madrid, 1964–65, 27, imagines that the figure in the Armas portrait looks up at some celestial apparition. Perhaps this apparition was visualized by one of the paintings that Ponz, 1777, describes. Another painting by Zurbarán of possibly the same model and representing another Mercedarian martyr is in a private collection in Rome (photo Vasari, no. 4 B 375).

11. Soria, 1953, 140; Guinard, 1960, 94. The Latin *profundis* is from *prŏfundo,-ĕre*, "to stretch at full length." The bodies of the monks were laid here before burial. Perhaps in juxtaposing portraits of the saint alive and deceased Zurbarán was responding to Fray Alonso Remón's *Relacion de la ejemplar vida y muerte del cavallero de Gracia*, Madrid, 1620.

12. Harda y Muxica, 1727. See D. Angulo Íñiguez, "Francisco de Zurbarán. Martires Mercenarios," *Archivo Español de Arte*, XIV, 1941, 368, in reference to another Zurbarán painting of Serapion now in the Jacques Lifschitz Collection, New York. Guinard, 1960, 262, no. 432, repr., gives Fray Alonso Remón's *Historia general de la Orden de la Merced* of 1618 as a source for Zurbarán's conception of Serapion's martyrdom. For further information and bibliography on the saint's life, see P. Guerin, *Les Petits Bollandistes. Vies des saints*, 2nd ed., Paris, 1876, XIII, 409–10; J. E. Stadler, *Vollständiges Heiligen-Lexikon*, Augsburg, 1882, V, 245–55; J. Dubris and P. Antin, *Vies des saints et des bienheureux*, Paris, 1935–52, XI, 445–46; H. Delehaye et al., *Propylaeum ad acta sanctorum. Decembris . . . martyrologium romanum*, Brussels, 1940, 522; B. Ignelzi in *Bibliotheca sanctorum*, Rome, 1968, XI, cols. 853–55. The cult of St. Serapion was approved by Urban VIII on 23 March 1625.

13. See especially Harda y Muxica, 1727, 230, and *Bibliotheca sanctorum*, col. 854.

Workshop of Francisco de Zurbarán,
Hanging Martyred Monk

Workshop of Francisco de Zurbarán
Hanging Martyred Monk

Oil on canvas, 62.9 x 41.6 cm (24³/₄ x 16³/₈ in.)

Condition: fair. A heavy coat of darkened varnish obscures the original appearance. X rays show the original tacking edges.

Provenance: collection Unshod Mercedarians, Seville; possibly Alcázar, Seville, 1810; possibly part of the collection of King Louis-Philippe of France; possibly Chanoine de Teruel; possibly sale London, Christie's, 6–7, 13–14, 20–21 May 1853; Durlacher Bros., New York; given to the Wadsworth Atheneum in 1939 by Durlacher Bros.

Exhibitions: Westport, *Spanish Masters*, 1955, no. 8.

Gift of Durlacher Bros., New York, 1939.479

The picture originally formed part of a series painted by Zurbarán and his assistants[1] for the monastery of the Unshod Mercedarians in Seville.[2] In 1724 Palomino noted that there were paintings by Zurbarán in the cloister of this monastery,[3] while Ponz in 1777,[4] and Ceán Bermúdez in 1800[5] specifically describe a series of religious martyrs in this location. The 1810 inventory of sequestered paintings collected in the Alcázar in Seville lists thirty-eight paintings by Zurbarán of similar dimensions, all representing Mercedarian martyrs.[6] Sixteen of these entered the collection of Louis-Philippe of France, and additional canvases in the series were acquired for the king by Baron Taylor.[7] The group of sixteen paintings was exhibited in the Galerie Espagnole of the Louvre,[8] and was dispersed in the sale of the king's collection in 1853.[9]

The painting in the Atheneum was probably one of those in the Alcázar inventory, although this is not certain since the inventory does not list the canvases individually.[10] Likewise, it is impossible to tell whether it was in the group that went to France and was later sold from the collection of Louis-Philippe.[11]

1. Soria, 1955, 173, says that Angulo Íñiguez, 1941, 365–73; 1944, 9; 1947, 146, and Guinard, 1947, 161–202, rightly stress that the series was executed by Zurbarán's workshop. He had expressed the same opinion in a letter in curatorial file, 30 Nov. 1943. Guinard, 1960, 263, no. 436, illus., however, lists the series, including the Atheneum picture, in his catalogue of accepted works by Zurbarán; R. Torres Martín, letter to E. Bryant, 23 Aug. 1960, curatorial file, also stated the series was painted by Zurbarán. Zurbarán surely had assistants at this time (c. 1636, according to Soria, 1953, 173), and it is possible that they collaborated with the master in this commission, or even executed the works after Zurbarán's designs. Ponz, 1777, 789–90, mentions a "condiscípulo" of Zurbarán, Francisco Reina; Ponz also notes that a painting by Zurbarán's pupil, Juan Martínez de Gredilla, hung in the refectory of the monastery of the Mercedarians in Seville.
2. E. Harris in London, From Greco to Goya, 1938, 44, was the first to suggest the derivation of the series. The first attempt to reconstruct the original commission from surviving works was made by Angulo Íñiguez, 1941, 365–73; 1944, 9, 20; 1947, 146, followed by the research of Soria, 1953, 173; Caturla, 1959, 342; and Guinard, 1960, 261.
3. Palomino, 1724, ed. M. Aguilar, Madrid, 1947, 938: "También son de su mano las pinturas del claustro de los Mercenarios Descalzos."
4. Ponz, 1777, IX, carta 3, pars. 50, 109: "ademas diferentes martires en el claustro del Convento."
5. Ceán Bermúdez, 1800, 49: "muchos quaritos de religiosos martires en el claustro baxo, pintados con suma gracia y facilidad."
6. Gómez-Imaz, 1917. The inventory was published, unfortunately without the dimensions, by Lipschutz, 1972, 302. The following is taken from the Gómez-Imaz inventory: "179. Cinco quadros de $^2/_3$ de alto y media de ancho varios martires de la religion Mercenaria . . . 337. Siete quadros de $^3/_4$ de alto y $^1/_2$ v.a de ancho, Santos martires . . . 362. Siete quadros de $^3/_4$ de alto y $^1/_2$ v. a de ancho, Santos martires . . . 380. Diez y nuebe quadros de $^3/_4$ de alto y $^1/_2$ de ancho, Santos mercenarios martires." These groups of five, seven, seven, and nineteen paintings, respectively, have been taken as the original series removed from the cloister and collected for export to France. All the paintings in the series that have survived are approximately 62 x 42 cm. The first group ($^2/_3$ x $^1/_2$ veras) falls a bit short of this, while the remaining paintings ($^3/_4$ x $^1/_2$ veras) fit the modern measurements more closely. Since the old Sevillian or Castilian vera is equal to .835 meters (Doursther, 1976, 568), the first group measures 59 x 41.25 cm and the remaining, 62.62 x 41.25 cm. This discrepancy can be explained by the carelessness of the recorder, or perhaps by the introduction of another recorder. It is also possible that many of the paintings in the inventory were measured by sight. The Hanging Martyred Monk in the Atheneum, measuring 62.9 x 41.6 cm fits the format and general dimensions of the series.
7. A search through Paul Guinard's notes on the records of Baron Taylor revealed no specific mention of the Atheneum's painting. A small St. Serapion which was originally in the same series (formerly P. de Boer, Amsterdam [Catalogue de tableaux anciens, Amsterdam, 1937, no. 32, illus. as St. Andrew]; now collection Jacques Lifschitz; see Soria, 1955, no. 163b) can be traced back to Taylor. It is fully described by Achille Jubinal and listed as one of Taylor's acquisitions from Spain in Notice sur M. Le Baron Taylor et sur les tableaux espagnols achetés par lui d'après les ordres du roi, Paris, 1837, 28–29. The sixteen paintings which appeared in the Louis-Philippe sale (see note 9) were all acquired, according to the catalogue, from a Chanoine de Teruel.
8. See Baticle and Marinas, 1981, 242; Notice de tableaux de la Galerie Espagnole exposés dans les salles du Musée Royal au Louvre, nos. 364–79. The numbers are bracketed under the description, "Premiers missionnaires aux Indes, martyres. Haut o m. 60 c. – Larg. o m. 41c." From this it is impossible to tell which paintings of the original series were exhibited in Paris. For other paintings in this series that formed part of the collection of Louis-Philippe in the Galerie Espagnole, see Baticle and Marinas, 1981, 237–43.
9. London, Christie's, Catalogue de tableaux formant la célèbre Galerie Espagnole de S. M. feu le Roi Louis-Philippe, 6–7, 13–14, 20–21, May 1853, nos. 213–17, 260–64, 448–53 (all on canvas). Nos. 213 and 448 are described as "Un des premiers missionnaires envoyés aux Indes, martyr." The remaining are simply termed "Un missionnaire," and are said to have been acquired from a Chanoine de Teruel. An annotated copy of the catalogue in the New York Public Library indicates the prices of these paintings, and gives the dimensions of nos. 260, 449–53, as 60 x 41 cm.
10. For further bibliography, see Gaya Nuño, 1958, no. 3040; Caturla, 1959, 343, repr.; Torres Martín, 1963, no. 172; Baticle and Marinas, 1981, 242.
11. Soria, 1953, no. 163t, and Guinard, 1960, no. 463, both list the Hanging Martyred Monk as from the collection of Louis-Philippe, but neither author states his source.

Bibliography

F. Abbate, "L'Attività giovanile del Bacchiacca," *Paragone*, no. 189, 1965, 26–49.

G. Achenbach, "The Iconography of Tobias and the Angel in Florentine Painting of the Renaissance," *Marsyas*, III, 1943–45, 71–86.

H. Acton, *The Last Medici*, London, 1958.

C. Adelson, "Bacchiacca, Salviati, and the Decoration of the Sala dell'Udienza in Palazzo Vecchio," in *Le arti del principato mediceo*, Florence, 1980, 141–200.

G. Adriani, *Anthon van Dyck italienisches Skizzenbuch*, Vienna, 1940.

D. Ahl, "Fra Angelico: A New Chronology for the 1420s," *Zeitschrift für Kunstgeschichte*, XLIII, 1980, 360–81.

J. Ainaud de Lasarte, "Ribalta y Caravaggio," *Anales y Boletín de los Museos de Arte de Barcelona*, nos. 3–4, 1947, 345–413.

G. Albrici, "La Vera 'Malinconia' di Castiglione," *I Quaderni del conoscitore di stampe*, no. 16, Mar.–Apr. 1973, 40–43.

G. Albrizzi, *Studi di pittura già dissegnati da Giambattista Piazzetta*, Venice, 1760, n.p.

G. Algeri, "G.B. Castiglione," in *Dizionario biografico degli Italiani*, Rome, 1979, XXII, 84–86.

Allentown, Pa., Allentown Art Museum, *Four Centuries of Still Life*, 12 Dec. 1959–31 Jan. 1960.

J. Alsop, *The Rare Art Traditions: The History of Art Collecting and Its Related Phenomena Wherever These Have Appeared*, Princeton and New York, 1982.

Amherst, Mass., Amherst College, Mead Art Building, *Major Themes in Roman Baroque Art from Regional Collections*, 1974.

Amsterdam, Rijksmuseum, *Painters of Venice*, 15 Dec. 1990–10 Mar. 1991, exh. cat. by B. Aikema and B. Bakker.

L. Angelini, *I Baschenis*, 2nd ed., Bergamo, 1946.

D. Angulo Íñiguez, "Francisco de Zurbarán. Martires mercedarios, San Carlos Borromeo," *Archivo Español de Arte*, no. 46, 1941, 365–76.

D. Angulo Íñiguez, "Cinco nuevos cuadros de Zurbarán," *Archivo Español de Arte*, no. 61, 1944, 1–9.

D. Angulo Íñiguez, "Tres nuevos martires mercedarios del taller de Zurbarán," *Archivo Español de Arte*, no. 78, 1947, 146.

D. Angulo Íñiguez, *Murillo*, 3 vols., Madrid, 1980–81.

Ann Arbor, University of Michigan, Museum of Art (also Grand Rapids, Grand Rapids Art Gallery), *Italian, Spanish, and French Paintings of the Seventeenth and Eighteenth Centuries*, 1951–52, exh. cat. by H. B. Hall.

F. Antal, *Hogarth and His Place in European Art*, London, 1962.

F. Arcangeli, "Sugli inizi dei Carracci," *Paragone*, no. 79, 1956, 17–48.

P. Aretino, *Lettere sull'arte di Pietro Aretino*, ed. E. Camesasca, commentary by F. Pertile, 3 vols., Milan, 1957–60.

F. Arisi, *Gian Paolo Panini*, Piacenza, 1961; 2nd ed., Rome, 1986.

P. Arizzoli-Clementel, "L'Ambassade de France près le Saint-Siège: Villa Bonaparte," *Revue de l'Art*, no. 28, 1975, 9–23.

J. M. Arnaiz, *Eugenio Lucas: Su Vida y su obra*, Madrid, 1981.

C. Arnone, *Ordini cavallereschi e cavalieri*, Milan, 1954.

E. Arslan, *I Bassano*, Bologna, 1931; 2nd ed., 2 vols., Milan, 1960.

E. Arslan, "Appunto su Caravaggio," *Aut Aut*, I, no. 5, 1951, 444–51.

E. Arslan, "Una Natività di Dosso Dossi," *Commentari*, VIII, 1957, 261–63.

E. Arslan, "Contributo a Sebastiano Ricci e ad Antonio Francesco Peruzzini," in *Studies in the History of Art Dedicated to William E. Suida on His Eightieth Birthday*, London, 1959, 304–11.

E. Arslan, "Nota caravaggesca," *Arte antica e moderna*, no. 6, 1959, 191–218.

E. Arslan, *Giuseppe Antonio Petrini*, Lugano, 1960.

E. Arslan, "A Painting by Jacopo Bassano," *Wadsworth Atheneum Bulletin*, Winter 1960, 1–3.

E. Arslan, "Nota sulla mostra di G. A. Petrini," *Arte lombarda*, VI, 1961, 60–62.

E. Arslan, "Opere del Grechetto a Genova, a Milano, e a Firenze," *Arte lombarda*, supp. to vol. X, 1965, Studies in Honor of G. N. Fasola, pt. 2, 169–78.

N. Artioli and E. Monducci, *Le Pitture di San Giovanni Evangelista in Reggio Emilia*, Reggio Emilia, 1978.

P. Askew, "Fetti's 'Martyrdom' at the Wadsworth Atheneum," *Burlington Magazine*, CIII, 1961, 245–52.

P. Askew, "The Parable Paintings of Domenico Fetti," *Art Bulletin*, XLIII, 1961, 21–45.

P. Askew, "The Angelic Consolation of St. Francis of Assisi in Post-Tridentine Italian Painting," *Journal of the Warburg and Courtauld Institutes*, XXXII, 1969, 280–306.

Atti convegno di studi su Corrado Giaquinto, Molfetta, 3–5 gennaio 1969. Convegno di studi su Corrado Giaquinto, Mezzina, 1971.

A. E. Austin, Jr., "A Small Tempera Panel by Fra Angelico," *Wadsworth Atheneum Bulletin*, Jan. 1929, 2–3.

A. E. Austin, Jr., "Hartford Reports the Year's Purchases," *Art News*, XXXVIII, 14 Oct. 1939, 8–9.

A. E. Austin, Jr., "Purchases of the Year at Hartford's Museum," *Art News*, XXXIX, 16 Nov. 1940, 7–8, 16.

M. Bacci, *Piero di Cosimo*, Milan, 1966.

P. Bacci, *Bernardino Fungai*, Siena, 1947.

G. Baglione, *Le Vite de' pittori, scultori, architetti, ed intagliatori*, Rome, 1642; ed. G. Passari, Naples, 1733.

U. Baldini, *L'Opera completa dell'Angelico*, Milan, 1970.

F. Baldinucci, *Notizie dei professori del disegno da Cimabue in quà*, Florence, 1847.

A. Ballarin, "Jacopo Bassano e lo studio di Raffaello e dei Salviati," *Arte veneta*, XXI, 1967, 77–101.

Baltimore, Baltimore Museum of Art, *Contrasts in Impressionism. An Exhibition of Paintings by Alessandro Magnasco, Claude Monet, John Marin*, 13 Nov.–27 Dec. 1942.

Baltimore, Baltimore Museum of Art (also St. Louis, St. Louis Museum of Art), *Three Baroque Masters: Strozzi, Crespi, Piazzetta*, 28 Apr.–4 June 1944.

W. Barcham, *The Imaginary View Scenes of Antonio Canaletto*, New York, 1977.

W. Barcham, *The Religious Paintings of Giambattista Tiepolo*, Oxford, 1989.

Barnard Castle, Durham, Bowes Museum, *Italian Art, 1600–1800*, 1964, exh. cat. by T. Ellis.

P. Barocchi and R. Ristori, eds., *Il Carteggio di Michelangelo*, 5 vols., Florence, 1967–73.

F. Barocelli, "Per la discussione sul Traversi: I. Problemi di committenza e il ciclo di Castell'Arquato," *Paragone*, nos. 383–85, 1982, 43–88.

M. A. Baroncelli, *Faustino Bocchi ed Enrico Albrici, pittori di bambocciate*, Brescia, 1965.

C. Baroni, *All the Paintings of Caravaggio*, trans. A. O'Sullivan, Complete Library of World Art Series, no. 7, New York, 1962.

C. Baroni and S. Samek Ludovici, *La Pittura lombarda del quattrocento*, Messina and Florence, 1952.

L. Barroero, "Il 'Compianto sul corpo di Ettore' di Domenico Corvi," *Paragone*, no. 417, 1984, 66–71.

Fra Bartolomeo dal Pozzo, *Le Vite de' pittori, degli scultori et architetti veronese*, Verona, 1718.

A. Bartsch, *Le Peintre graveur*, 21 vols., Leipzig, 1866–76.

G. Baruffaldi, *Vite de' pittori e scultori ferraresi*, ed. G. Boschini, 2 vols., Ferrara, 1844–46.

Bassano del Grappa, Palazzo Sturm, *Marco Ricci*, 1 Sept.–30 Nov. 1963, exh. cat. by G. Pilo.

C. Bassi, "Opere ignote di Cav. Giuseppe Petrini da Carona (Lugano)," *Zeitschrift für schweizerische Archäologie und Kunstgeschichte*, 1939, 138–46.

J. Baticle and C. Marinas, *La Galerie espagnole de Louis-Philippe au Louvre, 1838–48*, Paris, 1981.

F. Baumgart, *Caravaggio Kunst und Wirklichkeit*, Berlin, 1955.

J. Beck and A. Schultz, "The Origins of Piero di Cosimo," *Source*, IV, no. 4, 1985, 9–14.

I. Belli Barsali, "Pompeo Batoni," in *Dizionario biografico degli Italiani*, Rome, 1965, VII, 196–202.

P. Bellini, *L'Opera incisa di Giovanni Benedetto Castiglione*, Milan, 1982.

G. P. Bellori, *Le Vite de' pittori, scultori, et architetti moderni*, Rome, 1672; reprint ed. Genoa, 1931.

L. Bellosi, *Il Museo dello Spedale degli Innocenti*, Florence, 1977.

E. Benezit, *Dictionnaire des peintres, sculpteurs, dessinateurs et graveurs*, 10 vols., 3rd ed., Paris, 1976.

E. von der Bercken, "Jacopo Tintoretto," in Thieme and Becker, 1939, XXXIII, 189–96.

E. von der Bercken, *Die Gemälde des Jacopo Tintoretto*, Munich, 1942.

B. Berenson, *Italian Pictures of the Renaissance*, Oxford, 1932.

B. Berenson, *Del Caravaggio, delle sue incongruenze e della sua fama*, Florence, 1951.

B. Berenson, *Caravaggio, His Incongruity and His Fame*, English edition of 1951 publication, London, 1953.

B. Berenson, *Italian Pictures of the Renaissance: Venetian School*, 2 vols., London, 1957.

B. Berenson, *Italian Pictures of the Renaissance: Florentine School*, 2 vols., London, 1963.

B. Berenson, *Italian Pictures of the Renaissance: Central Italian and North Italian Schools*, 3 vols., London, 1968.

B. Berenson, *Homeless Paintings of the Renaissance*, ed. H. Kiel, Bloomington and London, 1970.

Bergamo, Galleria Lorenzelli, *Natura in posa, aspetti dell'antica natura morta Italiana*, 1968, exh. cat. by F. Bologna.

Bergamo, Caravaggio, Brescia, Milan, Mantua, Bologna, *Immagine del Caravaggio. Mostra didattica itinerante*, 1973, exh. cat. by M. Cinotti, F. Rossi et al.

R. Bergerhof, *Caravaggio*, Berlin, 1970.

I. Bergström, review of Rosci, 1971, in *Art Bulletin*, LVII, 1975, 287–88.

A. Berne Joffroy, *Le Dossier Caravage*, [Paris, 1959].

G. Bertini, *La galleria del duca di Parma*, Florence, 1987.

J. Bialostocki, *Caravaggio*, Warsaw, 1955.

L. Bianchi, *I Gandolfi*, Rome, 1936.

G. Biavati Frabetti, "Niccolò Viviani. Una Traccia per la sua identificazione," *Paragone*, no. 353, 1979, 77–90.

Bibliotheca sanctorum, 12 vols., Rome, 1961–69.

D. Bindman and L. Puppi, *The Complete Paintings of Canaletto*, London, 1970.

Binghamton, State University of New York at Binghamton, University Art Gallery, *Bernardo Strozzi: Paintings and Drawings*, 8 Oct.–5 Nov. 1967, exh. cat. by M. Milkovitch.

Birmingham, Ala., Birmingham Museum of Art (also Montgomery, Ala., Museum of Fine Arts), *Veronese and His Studio: In North American Collections*, 1 Oct. 1972–1 Jan. 1973.

Birmingham, Ala., Birmingham Museum of Art (also Springfield, Mass., Museum of Fine Arts), *The Tiepolos: Painters to Princes and Prelates*, 8 Jan.–19 Feb. 1978.

R. Bissell, "The Baroque Painter Orazio Gentileschi: His Career in Italy," Ph.D. diss., 2 vols., University of Michigan, 1966.

R. Bissell, "Orazio Gentileschi's 'Young Woman with a Violin,'" *Bulletin of the Detroit Institute of Arts*, XLVI, no. 4, 1967, 71–77.

R. Bissell, "Orazio Gentileschi and the Theme of 'Lot and His Daughters,'" *Bulletin of the National Gallery of Canada*, no. 14, 1969, 16–33.

R. Bissell, review of Ottani Cavina, 1968, in *Art Bulletin*, LIII, 1971, 248–50.

R. Bissell, *Orazio Gentileschi and the Poetic Tradition in Caravaggesque Painting*, University Park and London, 1981.

V. Bloch, "Een Verrassend Museum," *Maanblad voor Beeldende Kunsten*, Mar. 1948, 61–67.

A. Blunt, *The Drawings of G. B. Castiglione and Stefano della Bella in the Collection of Her Majesty the Queen at Windsor Castle*, London, 1954.

A. Blunt, *The Paintings of Nicolas Poussin, a Critical Catalogue*, London, 1966.

A. Blunt, "A Newly Discovered Late Work by Nicolas Poussin: 'The Flight into Egypt,'" *Burlington Magazine*, CXXIV, 1982, 208–13.

O. Boetzkes, *Salvator Rosa*, New York, 1960.

F. Bologna, *Francesco Solimena*, Naples, 1958.

F. Bologna, *Gaspare Traversi nell'illuminismo europeo*, Naples, 1980.

F. Bologna, "Alla ricerca del vero 'San Francisco in estasi, di Michel Agnolo da Caravaggio' per il cardinale Francesco Maria del Monte," *Artibus et historiae*, VII, no. 16, 1987, 159–77.

Bologna, Palazzo Comunale, *Mostra del settecento bolognese*, 1935.

Bologna, Palazzo dell'Archiginnasio, *Mostra dei Carracci*, 1 Sept.–31 Oct. 1956; 3rd ed., 1958.

Bologna, Palazzo dell'Archiginnasio, *Maestri della pittura del seicento emiliano*, 26 Apr.–5 July 1959.

Bologna, Palazzo dell'Archiginnasio, *Guercino: I Dipinti*, 1 Sept.–18 Nov. 1968, exh. cat. by D. Mahon.

Bologna, Palazzo del Podestà, *La Raccolta Molinari Pradelli, dipinti del sei e settecento*, 1984.

Bologna, Pinacoteca Nazionale, *Catalogo generale delle opere esposte*, Bologna, 1987.

Bologna, Pinacoteca Nazionale (also Vienna, Albertina), *Bologna e l'umanesimo, 1490–1510*, 6 Mar.–24 Apr. 1988, exh. cat. by M. Faietti and K. Oberhuber.

Bologna, Soprintendenza ai beni artistici e storici (also Stuttgart, Staatsgalerie, and Moscow, Pushkin Museum), *Giuseppe Maria Crespi*, 1990, exh. cat. ed. by A. Emiliani

G. Bonsanti, *Caravaggio*, [Florence], 1984.

Bordeaux, Galerie des Beaux-Arts, *La Nature morte de Breughel à Soutine*, 1978, exh. cat. ed. by G. Martin-Méry.

E. Borea, "Aspetti del Domenichino, paesista," *Paragone*, no. 123, 1960, 8–16.

E. Borea, *Domenichino*, Milan, 1965.

E. Borea, "Considerazioni sulla mostra 'Caravaggio e i suoi sequaci' a Cleveland," *Bollettino d'arte*, LVII, nos. 3–4, 1972, 154–64.

T. Borenius, *A Catalogue of the Pictures . . . Collected by Viscount and Viscountess Lee of Fareham*, 2 vols., Oxford, 1923–26.

T. Borenius, "An Early Caravaggio Re-Discovered," *Apollo*, II, 1925, 23–26.

T. Borenius, "The Kaleidoscope of Taste," *Studio*, CII, 1931, 214–31.

T. Borenius, "An Allegorical Portrait by Valdés Leal," *Burlington Magazine*, LXXIII, 1938, 146–47, 151.

R. Borghini, *Il Riposo*, Venice, 1584.

W. Born, "An Unknown Work of Ribera in St. Louis, Missouri: 'Christ Crowned with Thorns,'" *Gazette des Beaux-Arts*, XXVII, 1945, 213–26.

F. Borroni Salvadori, "Le Esposizioni d'arte a Firenze, 1674–1767," *Mitteilungen des kunsthistorischen Instituts in Florenz*, XVIII, 1974, 1–166.

A. Boschetto, "Per la conoscenza di Francesco Albani, pittore," *Proporzioni*, II, 1948, 109–46.

M. Boschini, *La Carta del navegar pitoresco*, Venice, 1660; ed. A. Pallucchini, Venice and Rome, 1966.

M. Boskovits, "Su Niccolò di Buonaccorso, Benedetto di Bindo, e la pittura senese del primo quattrocento," *Paragone*, nos. 359–61, 1980, 3–22.

Boston, Museum of Fine Arts (also Madrid, Museo del Prado, and New York, Metropolitan Museum of Art), *Goya and the Spirit of Enlightenment*, 18 Jan.–26 Mar. 1989, exh. cat. by A. E. Pérez Sánchez and E. Sayre.

G. Bottari and S. Ticozzi, *Raccolta di lettere sulla pittura*, 8 vols., Rome, 1822–25.

S. Bottari, "Fede Galizia," *Arte antica e moderna*, no. 24, 1963, 309–18.

S. Bottari, *Fede Galizia, pittrice (1578–1630)*, Trento, 1965.

S. Bottari, "Still Life," in *Encyclopedia of World Art*, 1967, XIII, 407–30.

A. Bovi, *Caravaggio*, Florence, 1975.

J. and J. Boydell, *A Set of Prints Engraved after the Most Capital Paintings in the Collection of Her Imperial Majesty, the Empress of Russia, Lately in the Possession of the Earl of Orford at Houghton in Norfolk*, 2 vols., London, 1788.

C. Brandi, *Quattrocentisti senesi*, Milan, 1949.

A. Brejon de Lavergnée, *Dijon, Musée Magnin. Catalogue des tableaux et dessins italiens, XVe–XIXe siècles*, Paris, 1980.

Bridgeport, Conn., Museum of Art, Science, and Industry, *Twenty Top Treasures from Connecticut Museums*, 3–27 May 1962.

G. Briganti, "Pieter van Laer e Michelangelo Cerquozzi," *Proporzioni*, III, 1950, Essays in Honor of Pietro Toesca, 184–98.

G. Briganti, *L'Europa dei vedutisti*, Milan, 1968; English trans. P. Waley, *The View Painters of Europe*, New York, 1970.

G. Briganti, *Pietro da Cortona o della pittura barocca*, eds. L. Trezzani and L. Laureati, 2nd ed., rev. and enl., Florence, 1982.

G. Briganti, L. Trezzani, and L. Laureati, "Viviano Codazzi," in *I Pittori bergamaschi. Il Seicento I*, Bergamo, 1983, 643–741.

H. Brigstocke, *Italian and Spanish Paintings in the National Gallery of Scotland*, Edinburgh, 1978.

British Institution for Promoting the Fine Arts in the United Kingdom, *An Account of All the Pictures Exhibited in the Rooms of the British Institution from 1813 to 1823, Belonging to the Nobility and Gentry of England*, London, 1824.

J. Brown, "Hieroglyphs of Death and Salvation: The Decoration of the Church of the Hermandad de la Caridad," *Art Bulletin*, LII, 1970, 265–77.

J. Brown, *Francisco de Zurbarán*, New York, 1974.

J. Brown, *Images and Ideas in Seventeenth-Century Spanish Painting*, Princeton, 1978.

E. Brunetti, "Situazione di Viviano Codazzi," *Paragone*, no. 79, 1956, 48–68.

E. Brunetti, "Some Unpublished Works by Codazzi, Salucci, Lemaire, and Patel," *Burlington Magazine*, C, 1958, 311–16.

E. Brunetti, "Il Panini e la monografia di F. Arisi," *Arte antica e moderna*, no. 26, 1964, 167–99.

W. Buchanan, *Memoirs of Painting, with a Chronological History of the Importation of Pictures by the Great Masters into England since the French Revolution*, 2 vols., London, 1824.

F. Buonanni, *Catalogo degli ordini equestri e militari*, 4th ed., Rome, 1741.

A. Busiri Vici, "Ritratti di Sebastiano Ceccarini, pittore fanese a Roma," *Palatino*, XII, 1968, 263–73.

J. Byam Shaw, *The Drawings of Domenico Tiepolo*, London, 1962.

J. Byam Shaw, *Drawings by Old Masters at Christ Church Oxford*, 2 vols., Oxford, 1976.

J. Cadogan, *Popes, Princes, Personalities: Baroque Portraiture in Italy*, gallery pamphlet accompanying Sarasota (1984–85), 1985.

C. Cairns, "Domenico Bollani, a Distinguished Correspondent of Pietro Aretino," *Renaissance News*, XIX, 1966, 193–205.

C. Calamai, "Formazione e arte di Alessandro Magnasco," *Antichità viva*, II, no. 5, 1963, 15–32.

E. Callman, "Apollonio de Giovanni and Painting for the Renaissance Room," *Antichità viva*, 1986.

M. Calvesi, "Simone Peterzano, maestro del Caravaggio," *Bollettino d'arte*, XXXIX, no. 2, 1954, 114–33.

M. Calvesi, "Caravaggio o la ricerca della salvazione," *Storia dell'arte*, no. 9–10, 1971, 93–141.

M. Calvesi, "Le Realtà del Caravaggio," *Storia dell'arte*, pt. 1 (Vicende), no. 53, 1985, 51–85; pt. 2 (I Dipinti), no. 55, 1985, 227–87; pt. 2 cont. (I Dipinti), no. 63, 1988, 117–92.

E. Camesasca, *L'Opera completa del Bellotto*, Milan, 1974.

G. Campori, *Raccolta di cataloghi ed inventarii inediti*, Modena, 1870.

V. da Canal, *Vita di Gregorio Lazzarini*, ed. G. Moschini, Venice, 1809.

P. Cannata, "St. Sebastian," in *Bibliotheca sanctorum*, Rome, 1968, XI, 790–802.

V. Caprara, "Giacomo Ceruti," in *Dizionario biografico degli Italiani*, Rome, 1980, XXIV, 60–63.

Caracas, Museo de Bellas Artes, *Grandes Maestros, siglos XV, XVI, XVII, y XVIII*, exhibition on the occasion of the 400th anniversary of the founding of Caracas, 1967.

A. Caravita, *I Codici e le arti a Monte Cassino*, 3 vols., Monte Cassino, 1869–70.

Il Cardinale Alessandro Albani e la sua villa: Documenti, eds., M. Di Marco et al., Quaderni sul neoclassico, Rome, 1980.

G. Carlevaro, "Materiale per lo studio di Bernardo Zenale," *Arte lombarda*, LXIII, 1982, 19–126.

G. V. Castelnovi, "Settecento minore; contributi per Giuseppe Petrini, Pietro Francesco Guala, Michele Rocca," *Studies in the History of Art Dedicated to William E. Suida on His Eightieth Birthday*, London, 1959, 325–37.

M. Caturla, "Ternura y primor de Zurbarán," *Goya*, XXX, 1959, 342–45.

R. Causa, "Francesco Nomé, detto Monsù Desiderio," *Paragone*, no. 75, 1956, 30–46.

R. Causa, *Caravaggio*, I Maestri del colore series, nos. 154–55, Milan, 1966.

R. Causa, "La Natura morta a Napoli nel sei e nel settecento," in *Storia di Napoli*, Naples, 1972, V, pt. 2, 997–1055.

J. A. Ceán Bermúdez, *Diccionario histórico de los mas ilustres profesores de las bellas artes en España*, 6 vols., Madrid, 1800; 5 vols., Madrid, 1965.

G. A. Cesareo, *Poesie e lettere edite e inedite di Salvator Rosa*, Naples, 1892.

C. Chambert, T. Heinemann, A. L. Lindberg, "Konstmseer, pedagogik, arkitektur. En kritisk granskning," *Paletten*, no. 3, 1978, 9–17.

M. Chappell, "A Figure Study by Bacchiacca," *Source*, VI 1986, 24–28.

I. Cheney, "Notes on Jacopino del Conte," *Art Bulletin*, LII, 1970, 32–40.

I. Cheney, "A 'Turkish' Portrait by Jacopino del Conte," *Source*, I, no. 3, 1982, 17–20.

M. Chiarini, "Ricci o Magnasco?," in *Atti del congresso internazionale di studi su Sebastiano Ricci e il suo tempo*, Venice, 1971, 146–50.

M. Chiarini, "Antonio Francesco Peruzzi," *Paragone*, no. 307, 1975, 65–69.

M. Chiarini, "Nuove proposte per Marco Ricci," *Arte veneta*, XXXII, 1978, 371–75.

M. Chiarini, "Tre quadri dei Gandolfi nelle collezioni fiorentine," *Paragone*, no. 343, 1978, 61–62.

Chicago, Art Institute of Chicago, *Paintings, Drawings, and Prints by the Two Tiepolos*, 4 Feb.–6 Mar. 1938.

Chicago, Art Institute of Chicago (also Minneapolis, Minneapolis Institute of Arts, and Toledo, Toledo Museum of Art), *Painting in Italy in the Eighteenth Century: Rococo to Romanticism*, 19 Sept.–1 Nov. 1970, exh. cat. ed. by J. Maxon and J. Rishel.

J. F. Chorpenning, "Another Look at Caravaggio and Religion," *Artibus et historiae*, VIII, no. 16, 1987, 149–58.

K. Christiansen, "Early Renaissance Narrative Painting in Italy," *Metropolitan Museum of Art Bulletin*, XLI, no. 2, 1983, 3–48.

K. Christiansen, "Caravaggio and 'L'esempio davanti del naturale,'" *Art Bulletin*, LXVIII, 1986, 421–45.

C. Cieri Via, "Per una revisione del tema del primitivismo nell'opera di Piero di Cosimo," *Storia dell'arte*, no. 29, 1977, 5–14.

Cincinnati, Cincinnati Art Museum, *The Robert Lehman Collection*, May–July 1959.

M. Cinotti and G. A. Dell'Acqua, *Michelangelo Merisi, detto il Caravaggio, tutte le opere*, critical essay by G. Dell'Acqua, Bergamo, 1983.

Claremont, Calif., Pomona College Gallery (subsequently part of the Galleries of the Claremont Colleges), *The Baroque*, exh. checklist, 1966.

A. M. Clark, "'Painting in Italy in the Eighteenth Century: Rococo to Romanticism' at Chicago, Minneapolis, and Toledo," *Art Quarterly*, XXXIII, 1970, 415–20.

A. M. Clark, *Pompeo Batoni*, ed. E. P. Bowron, New York, 1985.

C. Clement, *A Handbook of Legendary and Mythological Art*, Boston, 1883.

Cleveland, Cleveland Museum of Art, *Catalogue of the Twentieth-Anniversary Exhibition*, 1936.

Cleveland, Cleveland Museum of Art, *Style, Truth, and the Portrait*, 1963, exh. cat. by R. G. Saisselin.

Cleveland, Cleveland Museum of Art, *Caravaggio and His Followers*, 27 Oct. 1971–2 Jan. 1972, exh. cat. by R. Spear; rev. ed., 1975.

Cleveland, Cleveland Museum of Art (also Fort Worth, Kimball Art Museum, and Naples, Museo Pignatelli Cortes), *Bernardo Cavallino of Naples, 1616–1656*, 14 Nov.–30 Dec. 1984, exh. cat. by A. T. Lurie and A. Percy.

R. Cocke, *Pier Francesco Mola*, Oxford, 1972.

R. Cocke, "Observations on Some Drawings by Paolo Veronese," *Master Drawings*, XI, 1973, 138–50.

R. Cocke, *Veronese*, London, 1980.

R. Cocke, *Veronese's Drawings*, London, 1984.

W. Cohn, "Il Beato Angelico e Battista di Biagio Sanguigni," *Rivista d'arte*, XXX, 1955, 207–16.

W. Cohn, "Nuovi documenti per il Beato Angelico," *Memorie domenicane*, LXXIII, 1956, 218–20.

L. Coletti, *Il Tintoretto*, Bergamo, 1940.

Cologne, *Katalog des Museums Wallraf-Richartz in Köln*, Cologne, 1869.

F. Colonna di Stigliano, "Inventario dei quadri di casa Colonna," *Napoli nobilissima*, IV, no. 1, 1895, 29–32.

A. M. Comanducci, *Dizionario illustrato dei pittori, disegnatori, e incisori italiani moderni e contemporanei*, 4 vols., 4th ed., Milan, 1973.

W. G. Constable, "Vedute Painters in the Wadsworth Atheneum," *Wadsworth Atheneum Bulletin*, Summer 1963, 1–20.

W. G. Constable, *Canaletto*, 2 vols., 2nd ed., revised by J. G. Links, Oxford, 1976; reprinted with a supplement, Oxford, 1989.

G. Coor, "Cozzarelli, and Fetti's 'Martyrdom' at Hartford," *Burlington Magazine*, CIII, 1961, 396.

G. Coor-Achenbach, "A Fresco Fragment of a Nativity and Some Related Representations," *Bulletin of the Museum of Fine Arts, Boston*, LI, 1953, 11–15.

A. Corboz, "Sur la prétendue objectivité de Canaletto," *Arte veneta*, XXVIII, 1974, 205–16.

A. Corboz, *Canaletto, una Venizia Immaginaria*, 2 vols., Milan, 1985.

S. Cormio, "Il Cardinale Silvio Valenti Gonzaga, promotore e protettore delle scienze e delle arti," *Bollettino d'arte*, LXXI, nos. 35–36, 1986, 49–66.

H. Cornell, *Iconography of the Nativity of Christ*, Upsala, 1924.

S. Craven, "Three Dates for Piero di Cosimo," *Burlington Magazine*, CXVII, 1975, 572–76.

L. Crespi, *Vite de' pittori bolognesi non descritte nella 'Felsina pittrice,'* Rome, 1769; reprint ed., Bologna, 1970.

E. Croft Murray, "A Sketchbook of Giovanni Pannini in the British Museum," *Old Master Drawings*, XI, 1937, 61–65.

T. Crombie, "A Reappraisal of Rosa," *Apollo*, XCVIII, 1973, 502–3.

F. L. Cross, ed., *Oxford Dictionary of the Christian Church*, Oxford, 1957.

J. A. Crowe and G. B. Cavalcaselle, *A History of Painting in North Italy*, London, 1871; ed. T. Borenius, 3 vols., London, 1912.

N. de la Cruz y Bahamonde, *Viage de España, Francia e Italia*, 12 vols., Cadiz, 1812.

F. Cummings, *Notes on Caravaggio's 'The Conversion of the Magdalene' (The Alzaga Caravaggio)*, Detroit, 1974.

C. C. C[unningham], "A View of Pisa—Giovanni Paolo Pannini," *Wadsworth Atheneum Bulletin*, 1947, [1].

C. C. C[unningham], "Gaspari Traversi: The Quarrel," *Wadsworth Atheneum Bulletin*, Jan. 1949, 2.

C. C. Cunningham, "'The Quarrel' by Gaspari Traversi," *Art Quarterly*, XII, 1949, 182–85.

C. C. C[unningham], "Domenico Zampieri (called Domenichino): Landscape with St. John Baptising," *Wadsworth Atheneum Bulletin*, Apr. 1950, 2.

C. C. C[unningham], "Bequest of Mrs. Charles C. Beach," *Wadsworth Atheneum Bulletin*, Nov. 1951, 2.

C. C. C[unningham], "Collected in Three Years, a Museum within a Museum," *Wadsworth Atheneum Bulletin*, Spring 1957, 1–14.

C. C. C[unningham], "A *Modello* for Pietro da Cortona's Cupola of the Chiesa Nuova in Rome," *Wadsworth Atheneum Bulletin*, Winter 1961, 18–21.

C. C. Cunningham, "Vincenzo Damini–Gaius Mucius Scaevola before Lars Porsena," *Wadsworth Atheneum Bulletin*, Summer 1964, 19–21.

C. Curtis, *Velázquez and Murillo*, London and New York, 1883.

L. Cust, *A Description of the Sketchbook by Sir Anthony van Dyck, Used by Him in Italy, 1621–1627, and Preserved in the Collection of the Duke of Devonshire*, London, 1902.

J.-P. Cuzin, "French Seventeenth-Century Paintings from American Collections," review of Paris, 1982, in *Burlington Magazine*, CXXIV, 1982, 526–30.

J.-P. Cuzin and P. Rosenberg, "Saraceni et la France," *Revue du Louvre et des Musées de France*, XXVIII, no. 3, 1978, 186–96.

A. Czobor, *Caravaggio*, Budapest, 1960.

Dallas, Meadows Museum, Southern Methodist University, *Goya and the Art of His Time*, 7 Dec. 1982–6 Feb. 1983, exh. cat. by E. Sullivan.

D. Dania, *La Pittura a Fermo e nel suo circondario*, Fermo, 1967.

J. Daniels, *Sebastiano Ricci*, Hove, 1976.

J. Daniels, *L'Opera completa di Sebastiano Ricci*, Milan, 1976.

D. F. Darby, *Francisco Ribalta and His School*, Cambridge, Mass., 1938.

D. F. Darby, "The Ecstasy of St. Francis: A Newly Acquired Painting by Francisco Ribalta," *Wadsworth Atheneum Bulletin*, Fall 1957, 1–2.

M. Davenport, *The Book of Costume*, 2 vols., New York, 1948.

M. Davies, *National Gallery Catalogues: The Earlier Italian Schools*, London, 1951; 2nd ed., London, 1961.

M. Davies et al., *European Paintings in the Collection of the Worcester Art Museum*, 2 vols., Worcester, Mass., 1974.

E. Davis, *The Life of Bartolomé E. Murillo*, London, 1819.

R. Davis, "Loan Exhibition of Great Portraits Sponsored by Friends of the Institute," *Bulletin of the Minneapolis Institute of Arts*, XLI, Nov. 1952, 150–55.

Dayton, Dayton Art Institute, *The City by the River and the Sea: Five Centuries of Skylines*, 18 Apr.–3 June 1951, exh. cat. by E. Seaver.

Dayton, Dayton Art Institute, *Flight: Fantasy, Faith, Fact*, 17 Dec. 1953–21 Feb. 1954.

Dayton, Dayton Art Institute (also Sarasota, John and Mable Ringling Museum of Art, and Hartford, Wadsworth Atheneum), *Genoese Masters: Cambiaso to Magnasco, 1550–1750*, 19 Oct.–2 Dec. 1962, exh. cat. by R. and B. Suida Manning.

B. De' Dominici, *Vite dei pittori, scultori, ed architetti napoletani*, 4 vols., Naples, 1840–46.

D. DeGrazia, *Le Stampe dei Carracci*, rev. and enl. Italian edition by A. Boschetto, Bologna, 1984.

G. Dell'Acqua and M. Cinotti, *Il Caravaggio e le sue grande opere da San Luigi dei Francesi*, Milan, 1971.

G. De Logu, *G. B. Castiglione, detto il Grechetto*, Bologna, 1928.

G. De Logu, "Riberismo," *Arte*, XXXI, 1928, 147–54.

G. De Logu, *Pittori veneti minori del settecento*, Venice, 1930.

G. De Logu, *Pittori minori liguri, lombardi, piemontesi del seicento e del settecento*, Venice, 1931.

G. De Logu, *Pittura veneziana dal XIV al XVIII secolo*, Bergamo, 1958.

G. De Logu, *Natura morta italiana*, Bergamo, 1962.

G. De Logu, *Caravaggio*, trans. J. Shapley, New York, 1964.

C. Dempsey, "Castiglione at Philadelphia," *Burlington Magazine*, CXIV, 1972, 117–20.

Denver, Denver Art Museum, *Baroque Art: Era of Elegance*, 3 Oct.–15 Nov. 1971.

A. De Rinaldis, *Lettere inedite di Salvator Rosa a G. B. Ricciardi*, Rome, 1939.

Descrizione istorica del monastero di Monte Cassino, Naples, 1751.

C. De Seta, "Topografia urbana e vedutismo nel seicento: A proposito di alcuni disegni di Alessandro Baratta," *Prospettiva*, no. 22, 1980, 46–59.

C. De Seta, *Napoli*, Rome and Bari, 1981.

Detroit, Detroit Institute of Arts, *Venice and the Eighteenth Century*, 30 Sept.–2 Nov. 1952.

Detroit, Detroit Institute of Arts, *Art in Italy, 1600–1700*, 6 Apr.–9 May 1965, exh. organized by F. Cummings.

Detroit, Detroit Institute of Arts (also Florence, Palazzo Pitti), *The Twilight of the Medici: Late Baroque Art in Florence, 1670–1743*, 27 Mar.–2 June 1974.

Detroit, Detroit Institute of Arts (also Chicago, Art Institute of Chicago), *The Golden Age of Naples: Art and Civilization under the Bourbons, 1734–1805*, 11 Aug.–1 Nov. 1981.

P. De Vecchi, *L'Opera completa di Raffaello*, Milan, 1966.

P. De Vecchi, *L'Opera completa di Tintoretto*, Milan, 1970.

G. De Vito, *Ricerche sul seicento napoletano*, Milan, 1982.

G. De Vito, "The Author of the 'Duns Scotus' at Hampton Court," *Burlington Magazine*, CXXXV, 1983, 685.

Diagram Group, *Musical Instruments of the World*, London, 1976.

Dizionario biografico degli Italiani, 36 vols., Rome, 1960–88 (incomplete).

L. Dolce, *L'Aretino ovvero dialogo della pittura*, Venice, 1557; ed. M. Roskill, New York, 1968.

C. Donzelli, *I Pittori veneti del settecento*, Florence, 1957.

R. L. Douglas, *Piero di Cosimo*, Chicago, 1946.

H. Doursther, *Dictionnaire universel des poids et mesures*, Brussels, 1840; reprint ed., Amsterdam, 1976.

P. Dreyer, *Kupferstichkabinett Berlin, italienische Zeichnungen*, Stuttgart and Zurich, 1979.

Dublin, National Gallery of Ireland, *Illustrated Summary Catalogue of Paintings*, introduction by H. Potterton, Dublin, 1981.

L. Dussler, *Sebastiano del Piombo*, 1942.

L. Dussler, *Raphael*, trans. S. Cruft, London, 1971.

H. Ebert, *Kriegsverluste der Dresdener Gemäldegalerie, vernichtete und vermiste Werke*, Dresden, 1963.

E. Edwards, *Anecdotes of Painters*, London, 1808.

Encyclopedia of World Art, 17 vols., New York, Toronto, London, 1959–68; McGraw-Hill English-language edition of the *Enciclopedia universale dell'arte*, Venice and Rome, 1958–67.

R. Enggass, review of Cleveland, 1971–72, in *Art Bulletin*, LV, 1973, 460–62.

E. Fahy and F. Watson, *The Wrightsman Collection: Paintings, Drawings, Sculpture*, The Wrightsman Collection, V, New York, 1973.

S. Lane Faison, Jr., "Baroque and Nineteenth-Century Painting," *Apollo*, LXXXVIII, 1968, 466–77.

I. Faldi, "I Dipinti Chigiana di Michele e Giovan Battista Pace," *Arte antica e moderna*, nos. 34–36, 1966, 144–50.

I. Faldi, *Pittori viterbesi di cinque secoli*, Rome, 1970.

I. Faldi, "Dipinti di figura del rinascimento a neoclassicismo," in *L'Accademia Nazionale di San Luca*, Rome, 1974, 81–170.

C. Felton, "The Earliest Paintings of Ribera," *Wadsworth Atheneum Bulletin*, Winter 1969, 2–29.

C. Felton, "Jusepe de Ribera, a Catalogue Raisonné," Ph.D. diss., University of Pittsburgh, 1971.

C. Felton, "More Early Paintings by Jusepe de Ribera," *Storia dell'arte*, no. 26, 1976, 31–43.

C. Felton, "Ribera's Early Years in Italy: the 'Martyrdom of St. Lawrence' and the 'Five Senses,'" *Burlington Magazine*, CXXXIII, 1991, 71–81.

O. Ferrari, "'The Entombment': A Youthful Work by Luca Giordano," *Bulletin of the Detroit Institute of Arts*, LIV, no. 1, 1975, 25–32.

O. Ferrari and G. Scavizzi, *Luca Giordano*, 3 vols., Naples, 1966.

L. Festa, "Aspetti della vita e dell'arte di Salvator Rosa da documenti inediti," *Archivio storico per le province napoletane*, 3rd ser., XXI, 1982, 101–23.

C. J. Ffoulkes, "Le Esposizioni di arte italiana a Londra," *Archivio storico dell'arte*, VII, 1894, 168.

L. Ficacci, *Guy François, 1578?–1650*, Rome, 1980.

A. Filangieri di Candida, "La Galleria Nazionale di Napoli," in *Le Gallerie nazionali italiane*, V, 1902.

G. Fiocco, *Bernardo Strozzi*, Biblioteca d'arte illustrata, ser. 1, fasc. 9, Rome, 1921.

G. Fiocco, *Giambattista Crosato*, Venice, 1944.

G. Fiocco, "Il Cavaliere Petrini," *Arte antica e moderna*, nos. 13–16, 1961, Essays in Honor of Roberto Longhi's Seventieth Birthday, 453–61.

X. D. Fitz-Gerald, *L'Oeuvre peint de Goya*, Paris, 1928–30.

J. Fleming, "Art Dealing in the Risorgimento III," *Burlington Magazine*, CXXI, 1979, 568–80.

Florence, Palazzo Pitti, *Mostra della pittura italiana del sei e settecento*, 1922.

Florence, Gabinetto Disegni e Stampe degli Uffizi, *Cento disegni napoletani*, 1967, exh. cat. by W. Vitzthum and A. M. Petrioli.

Florence, Palazzo Pitti, *Artisti alla corte granducale*, May–July 1969, exh. cat. by M. Chiarini.

Florence, Palazzo Vecchio, *Committenza e collezionismo medicei, 1537–1610*, 1980.

Florence, Suore S. Filippo Neri, *S. Filippo Neri nell'arte*, 27 May–9 June 1989.

Florence, Palazzo Pitti, *Caravaggio e Caravaggeschi nelle gallerie di Firenze*, 1970, exh. cat. by E. Borea.

Florence, Palazzo Vecchio, *L'Opera ritrovata, omaggio a Rodolfo Siviero*, 1984.

R. Ford, *A Handbook for Travellers in Spain*, I, 3rd ed., London, 1855.

Fort Worth, Kimbell Art Museum, *Jusepe de Ribera, lo Spagnoletto, 1591–1652*, 4 Dec. 1982–6 Feb. 1983, exh. cat. by C. Felton and W. B. Jordan.

Fort Worth, Kimbell Art Museum, *Giuseppe Maria Crespi and the Emergence of Genre Painting in Italy*, 20 Sept.–7 Dec. 1986, exh. cat. by J. T. Spike.

G. Frabetti, *Manieristi a Ferrara*, Milan, 1972.

F. Franchini Guelfi, "Su alcuni 'paesaggi' di Alessandro Magnasco," *Pantheon*, XXVII, 1969, 470–79.

F. Franchini Guelfi, *Alessandro Magnasco*, Genoa, 1977.

F. Franchini Guelfi, "Alessandro Magnasco," in *La Pittura a Genova e in Liguria*, 2nd ed. rev., Genoa, 1987, vol. 2, *Dal Seicento al primo Novecento*, 325–45.

A. Frankfurter, "Midas on Parnassus," *Art News Annual*, XXVIII, 1959, 35–204.

B. B. Fredericksen and D. Davisson, *Benvenuto di Giovanni, Girolamo di Benvenuto: Their Altarpieces in the J. Paul Getty Museum and a Summary Catalogue of Their Paintings in America*, Malibu, 1966.

B. B. Fredericksen and F. Zeri, *Census of Pre-Nineteenth-Century Italian Paintings in North American Public Collections*, Cambridge, Mass., 1972.

S. J. Freedberg, *Painting of the High Renaissance in Rome and Florence*, 2 vols., Cambridge, Mass., 1961.

S. J. Freedberg, *Andrea del Sarto*, 2 vols., Cambridge, Mass., 1963.

S. J. Freedberg, *Painting in Italy, 1500–1600*, Baltimore, 1971.

S. J. Freedberg, "Gentileschi's 'Madonna with the Sleeping Christ Child,'" *Burlington Magazine*, CXVIII, 1976, 732–34; reprinted in *A Dealer's Record: Agnew's, 1967–81*, London, 1981, 45–49.

B. Frey and K. Grossman, "Die Denkmale des Stiftes Heiligenkreuz," *Österreichische Kunsttopographie*, XIX, Vienna, 1926, 193–94.

W. Friedlaender, review of Hinks, 1953, in *Art Bulletin*, XXXVI, 1954, 149–52.

W. Friedlaender, *Caravaggio Studies*, Princeton, 1955.

H. Friedmann, *The Symbolic Goldfinch: Its History and Significance in European Devotional Art*, Washington, 1946.

L. Fröhlich-Bum, "An Exhibition of Italian Baroque Painting," *Burlington Magazine*, CXXI, 1937, 93–95.

C. Frommel, "Caravaggio und seine Modelle," *Castrum peregrini*, no. 96, 1971, 21–56.

C. Frommel, "Caravaggios Frühwerk und der Kardinal Francesco Maria del Monte," *Storia dell'arte*, nos. 9–10, 1971, 5–52.

N. Gabburri, "Vite di pittori," MS in Biblioteca Nazionale, Florence, Codice Palatino, E.B.9.5., 1719–41.

N. Gabrielli, *Galleria Sabauda: Maestri italiani*, Turin, 1971.

J. Gallego, *Vision et symboles dans la peinture espagnole du siècle d'or*, Paris, 1968.

C. Gamba, "Piero di Cosimo e i suoi quadri mitologici," *Bollettino d'arte*, XXX, 1936–37, 52–56.

A. and A. García Carraffa, *Enciclopedia heráldico y genealógico hispano-americana*, 88 vols., Madrid, 1952–69.

J. García Hidalgo, *Principios para estudiar el nobilísimo y real arte de la pintura*, Madrid, 1965.

E. Gardner, *The Painters of the School of Ferrara*, London, 1911.

G. Gardner, "The Paintings of Domenico Puligo," Ph.D. diss., Ohio State University, 1986.

J. Gash, *Caravaggio*, London, 1980.

J. Gash, "American Baroque," review, *inter alia*, of Bissell, 1981, in *Art History*, VIII, 1985, 249–60.

P. Gassier and J. Wilson, *The Life and Complete Work of Goya*, New York, 1971.

W. Gaunt, *Painters of Fantasy: From Hieronymus Bosch to Salvador Dali*, London, 1974.

J. A. Gaya Nuño, *La Pintura española fuera de España*, Madrid, 1958.

A. M. Gealt, *Looking at Art: A Visitor's Guide to Museum Collections*, New York and London, 1983.

B. Geiger, *Alessandro Magnasco*, Berlin, 1914.

B. Geiger, *Saggio d'un catalogo delle pitture di Alessandro Magnasco, 1667–1749. Registi e bibliografia*, Venice, 1945.

B. Geiger, *Magnasco*, Bergamo, 1949.

B. Geiger, *I Dipinti ghiribizzosi di Giuseppe Arcimboldi*, Florence, 1954.

Genoa, Palazzo Rosso, *Problematiche sulla pittura di paesaggio tra seicento e settecento, dipinti restaurati del Museo Luxoro*, 1976–77, exh. cat. by G. Biavati.

J. Genty, *Pier Francesco Mola, pittore*, Bellinzona, 1979.

F. Gibbons, *Dosso and Battista Dossi, Court Painters at Ferrara*, Princeton, 1968.

C. Gilbert, "Sisto Badalocchio," in *Dizionario biografico degli Italiani*, Rome, 1963, V, 64–66.

C. Gilbert, "Caravaggio Revealed," *Art News*, LXXXII, Dec. 1983, 35.

C. Goldstein, "Seventeenth-Century French Paintings," *Art Journal*, XLII, 1982, 328–31.

V. Golzio, *Documenti artistici sul seicento nell'archivio Chigi*, Rome, 1939.

M. Gómez-Imaz, "Inventario de las pinturas del palacio y salones del Alcázar de Sevilla pertenecientes a S. M. C. el Señor D. José Napoleno (q. D. g.)," in *Inventario de los cuadros sustraidos por el govierno intruso en Sevilla (ano 1810)*, 2nd ed., Seville, 1917.

C. Gómez-Moreno, "A Reconstructed Panel by Fra Angelico and Some New Evidence for the Chronology of His Work," *Art Bulletin*, XXXIX, 1957, 183–93.

Gorizia, Castello, *Guardi, metamorfosi dell'immagine*, June–Sept. 1987.

Gorizia, Catello, *Marieschi tra Canaletto e Guardi*, 30 June–15 Oct. 1989, exh. cat. by D. Succi.

Gosudarstvennyi Ermitazh, *Catalogue de la Galerie des Tableaux: première partie, les écoles d'Italie et d'Espagne*, St. Petersburg, 1909.

Gosudarstvennyi Ermitazh, *Peinture de l'Europe occidentale*, Leningrad, I, 1976.

Göteborgs Konstmuseum: Malerisamlingen, Göteborg, c. 1979.

C. Gould, *National Gallery Catalogues: The Sixteenth-Century Italian Schools*, London, 1975.

C. Gould, *The Paintings of Correggio*, London, 1976.

M. Gozzoli, *Pittori bergamaschi dal XIII al XIX secolo. Il Settecento*, I, Bergamo, 1982.

L. Grassi, *Piero di Cosimo e il problema della conversione al Cinquecento nella pittura fiorentina ed emiliana*, Rome, 1963.

L. Grassi, M. Carreri, M. R. Donati, "Il Caravaggio," Rome, 1953, reproduction of a typescript manual in the Bibliotheca Hertziana, Rome, for a course given at the Università di Roma.

A. Graves, *A Century of Loan Exhibitions, 1813–1912*, 5 vols., London, 1913–15.

M. Gregori, "Una Notizia del Peruzzini fornita del Magalotti," *Paragone*, no. 169, 1964, 24–28.

M. Gregori, "Caravaggio O.K.," *Bolaffiarte*, II, no. 14, 1971, 9–10.

M. Gregori, "Note su Orazio Riminaldi e i suoi rapporti con l'ambiente romana," *Paragone*, no. 269, 1972, 35–66.

M. Gregori, "Notizie su Agostino Verrocchi e un'ipotesi per Giovanni Battista Crescenzi," *Paragone*, no. 275, 1973, 36–56.

M. Gregori, "Significato delle mostre caravaggesche del 1951 a oggi," *Novità sul Caravaggio*, Milan, 1975, 27–70.

M. Gregori, "Altre aggiunte a risarcimento di Antonio Francesco Peruzzini," *Paragone*, no. 307, 1975, 69–80.

M. Gregori, "Caravaggio," in *Enciclopedia europea*, Milan, 1976, II, 868–71.

M. Gregori, *Giacomo Ceruti*, Bergamo, 1982.

M. Gregori, *La fruttivendola di Vincenzo Campi*, Bergamo, 1989.

N. B. Grimaldi, *Il Guercino*, Bologna, 1968.

A. Griseri, "Luca Giordano alla maniera di . . . ," *Arte antica e moderna*, nos. 13–16, 1961, Essays in Honor of Roberto Longhi's Seventieth Birthday, 417–36.

A. Griseri, "Il 'Rococo' a Torino e G. B. Crosato," *Paragone*, no. 135, 1961, 42–65.

A. Griseri, "Arcadia: Crisi e trasformazione fra sei e settecento," *Storia dell'arte italiana*, II, pt. 2:1, 1981, 525–95.

G. Gronau, "Francia," in Thieme and Becker, 1916, XII, 319–23.

V. Grunfeld, *Games of the World*, New York, 1975.

J. Gudiol, *Goya, 1746–1828: Biografía, estudio analítico, y catálogo de sus pinturas*, Barcelona, 1969.

F. Guidi, "Per una nuova cronologia di Giovanni di Marco," *Paragone*, no. 223, 1968, 27–46.

F. Guidi, "Ancora su Giovanni di Marco," *Paragone*, no. 239, 1970, 11–23.

G. Guidi, "Notizie di Orazio Riminaldi nei documenti pisani," *Paragone*, no. 269, 1972, 79–87.

P. Guinard, "Los Conjuntos dispersos o desaparecidos de Zurbarán. Anotaciones á Cean Bermúdez," *Archivo Español de Arte*, XX, 1947, 161–201.

P. Guinard, *Zurbarán et les peintres espagnols de la vie monastique*, Paris, 1960.

P. Guinard, *Les Peintres espagnols*, Paris, 1967.

H. Haberfeld, *Piero di Cosimo*, Breslau, 1900.

D. von Hadeln, "Early Works by Tintoretto—I," *Burlington Magazine*, XLI, 1922, 206–17.

The Hague, Mauritshuis (also Cambridge, Mass., Fogg Art Museum), *Jacob van Ruisdael*, 1 Oct. 1981–3 Jan. 1982, exh. cat. by S. Slive.

W. Hammond and H. Scullard, eds., *Oxford Classical Dictionary*, 2nd ed., Oxford, 1970.

Hanover, N.H., Dartmouth College, Hopkins Center, Art Galleries, *European Paintings of the Sixteenth and Seventeenth Centuries. The World of William Shakespeare*, 1964.

Harda y Muxica, *El Nuevo machabeo del evangelio, y cavallero de Christo S. Serapio martyr*, Madrid, 1727.

A. J. C. Hare, *Walks in Rome*, London, 1905.

A. S. Harris, review of Cocke, 1972, in *Art Bulletin*, LVI, 1974, 289–92.

A. S. Harris, *Andrea Sacchi*, Princeton, 1977.

A. S. Harris, "Exhibition Reviews: New York, Italian Still Life," *Burlington Magazine*, CXXV, 1983, 514.

E. Harris, "Spanish Painting from Morales to Goya in the National Gallery of Scotland," *Burlington Magazine*, XCIII, 1951, 310–17.

E. Harris, "Velázquez's Portrait of Prince Baltasar Carlos in the Riding School," *Burlington Magazine*, CXVIII, 1976, 266–75.

E. Harris, "Velázquez as Connoisseur," *Burlington Magazine*, CXXIV, 1982, 436, 438–40.

N. Harrison, *The Paintings of Giovanni Battista Crosato*, Ph.D. diss., University of Georgia, 1983.

Hartford, Trinity College, *The Medieval Mind: The Technique of Wood Panel Painting*, 27 Nov.–5 Dec. 1967.

Hartford, Wadsworth Atheneum, *A List of Pictures in the Wadsworth Atheneum Galleries*, 1901.

Hartford, Wadsworth Atheneum, *Distinguished Works of Art*, 18 Jan.–1 Feb. 1928.

Hartford, Wadsworth Atheneum, *Exhibition of Italian Painting of the Sei- and Settecento*, 22 Jan.–5 Feb. 1930.

Hartford, Wadsworth Atheneum, *Retrospective Exhibition of Landscape Painting*, 20 Jan.–9 Feb. 1931, exh. cat. by H.-R. Hitchcock.

Hartford, Wadsworth Atheneum, *Collections in the Avery Memorial*, 1934.

Hartford, Wadsworth Atheneum, *The Painters of Still Life*, 25 Jan.–15 Feb. 1938.

Hartford, Wadsworth Atheneum, *Night Scenes*, 15 Feb.–7 Mar. 1940.

Hartford, Wadsworth Atheneum, *In Memoriam*, 24 Feb.–22 Mar. 1942.

Hartford, Wadsworth Atheneum, *Men in Arms*, 2 Feb.–4 Mar. 1943.

Hartford, Wadsworth Atheneum, *Caravaggio and the Seventeeth Century*, 26 June 1943–16 Jan. 1944, no cat.

Hartford, Wadsworth Atheneum, *The Nude in Art*, 1 Jan.–3 Feb. 1946, cat. introduction by J. G. Constable.

Hartford, Wadsworth Atheneum, *Still-Life Painting: The Real World and the Dream World*, 6–28 Sept. 1947.

Hartford, Wadsworth Atheneum, *A Loan Exhibition of Fifty Painters of Architecture*, 30 Oct.–7 Dec. 1947.

Hartford, Wadsworth Atheneum, *Life of Christ*, 12 Mar.–25 Apr. 1948.

Hartford, Wadsworth Atheneum, *In Retrospect: Twenty-one Years of Museum Collecting*, 2 Apr.–29 May 1949; exh. cat. is *Wadsworth Atheneum Bulletin*, Apr. 1949.

Hartford, Wadsworth Atheneum (also Andover, Mass., Addison Gallery of American Art, and Boston, Symphony Hall), *Pictures within Pictures*, 9 Nov.–31 Dec. 1949.

Hartford, Wadsworth Atheneum, *Acquired in Three Years*, 9 Jan.–7 Feb. 1954, no cat.

Hartford, Wadsworth Atheneum, *Off for the Holidays*, 14 Apr.–5 June 1955.

Hartford, Wadsworth Atheneum, *Homage to Mozart*, 22 Mar.–29 Apr. 1956.

Hartford, Wadsworth Atheneum, *Collected in Three Years: A Museum within a Museum*, 1957, no cat.

Hartford, Wadsworth Atheneum, *A Second Look: Late Nineteenth-Century Taste in Paintings*, 8 July–6 Aug. 1958, mimeographed cat.

Hartford, Wadsworth Atheneum, *Salute to Italy: One Hundred Years of Italian Art*, 20 Apr.–28 May 1961.

Hartford, Wadsworth Atheneum, *Harvest of Plenty. De Gustibus. An Exhibition of Banquets and Eating Scenes*, 24 Oct.–1 Dec. 1963.

Hartford, Wadsworth Atheneum, *Let There Be Light*, 11 Mar.–26 Apr. 1964.

Hartford, Wadsworth Atheneum, *Visions of the Sea, 1550–1971*, 1979, exh. cat. by J. Cadogan and R. Saunders.

Hartford, Wadsworth Atheneum, *Framing Art: Frames in the Collection of the Wadsworth Atheneum*, 22 May–25 July 1982, exh. brochure by J. Cadogan, L. Horvitz, S. LaFrance.

See also Wadsworth Atheneum.

"Hartford Thrives on Baroque," *Art News*, XLVIII, May 1949, 28–29.

F. Haskell, *Patrons and Painters*, London, 1963.

M. Heimbürger Ravalli, "Data on the Life and Works of Gaspare Giovanni Traversi (1722?–1770)," *Paragone*, nos. 383–85, 1982, 14–42.

F. Heinemann, *Giovanni Bellini e i Belliniani*, 2 vols., Vicenza, 1962.

G. Heinz, *Katalog der Graf Harrach'schen Gemäldegalerie*, Vienna, 1960.

J. Held, "Caravaggio and His Followers," *Art in America*, LX, May/June 1972, 40–47.

T. F. Henderson, "Henry, Cardinal York," in *Dictionary of National Biography*, Oxford, 1963–64, IX, 561–62.

R. Henniker-Heaton, "Two Thirteenth-Century Frescoes," *Bulletin of the Worcester Art Museum*, XV, 1924, 60–71.

A. Hentzen, *Hamburger Kunsthalle, Meisterwerke der Gemäldegalerie*, Cologne, 1969.

H. Herbst, "Desiderius Barra aus Metz in Lothringen," *Weltkunst*, XXXIII, 1 Feb. 1963, 9.

J. Hernández Díaz, *Museo Provincial de Bellas Artes en Sevilla*, Madrid, 1967.

J. Hess, "Modelle e modelli del Caravaggio," *Commentari*, V, no. 4, 1954, 271–89.

J. Hess, "Caravaggio's Paintings in Malta: Some Notes," *Connoisseur*, CXLII, 1958, 142–47.

H. Hibbard, *Caravaggio*, New York, 1983.

H. Hibbard and M. Levine, "Seicento at Detroit," *Burlington Magazine*, CVII, 1965, 370–72.

R. Hinks, *Michelangelo Merisi da Caravaggio: His Life, His Legend, His Works*, London, 1953.

M. Hirst, *Sebastiano del Piombo*, Oxford, 1981.

H.-R. Hitchcock, "Italian Baroque Art at Hartford," *International Studio*, Apr. 1930, 21–24.

H.-R. Hitchcock, "Salvator Rosa," *Wadsworth Atheneum Bulletin*, VIII, no. 2, Apr. 1930, 22–23.

H.-R. Hitchcock, "The Saint Catherine by Bernardo Strozzi," *Wadsworth Atheneum Bulletin*, Apr. 1931, 15–16.

J. Hoffman, "Lelio Orsi da Novellara (1511–1587): A Stylistic Chronology," Ph.D. diss., University of Wisconsin, Madison, 1975.

C. von Holst, "Florentiner Gemälde und Zeichnungen aus der Zeit von 1480 bis 1580," *Mitteilungen des Kunsthistorischen Instituts in Florenz*, XV, 1971, 1–64.

D. Honisch, *Anton Raphael Mengs und die Bildform des Frühklassizismus*, Recklinghausen, 1965.

H. Honour, "Giuseppe Nogari," *Connoisseur*, CXL, 1957, 154–59.

G. J. Hoogewerff, "Pieter van Laer en zijn vrienden," *Oud-Holland*, I, 1933, 250–62.

H. Horne, "The Last Communion of St. Jerome by Sandro Botticelli," *Bulletin of the Metropolitan Museum of Art*, X, 1915, 52–56, 72–75, 101–5.

Houston, University of St. Thomas, Art Department, *The Age of a Thousand Flowers*, 9 Mar.–30 Apr. 1962.

T. Howe, Jr., "San Francisco Explores an Era Rediscovered by Modern Taste," *Art News*, XL, June 1941, 28–29.

R. Hubbard, *The National Gallery of Canada: Catalogue of Painting and Sculpture*, I, Ottawa and Toronto, 1957.

F. Huemer, *Corpus Rubenianum Ludwig Burchard*, pt. 19, vol. 1, *Portraits*, London, 1977.

L. Iacobilli, *Vite de' santi e beati dell'Umbria*, 1647; reprint ed., Bologna, 1971.

N. Ivanoff, *I Disegni italiani del seicento*, Venice, 1959.

Jacobus de Voragine, *The Golden Legend*, trans. G. Ryan and H. Ripperger, New York, 1969.

M. Jaffé, *Rubens and Italy*, New York, 1977.

Mrs. [A. B.] Jameson, *Companion to the Most Celebrated Private Collections of Art in London*, London, 1844; 2nd ed., 1852.

John G. Johnson Collection: Catalogue of Italian Paintings, Philadelphia, 1966.

L. M. Jones, "The Paintings of Giovanni Battista Piazzetta," Ph.D. diss., Columbia University, 1981.

E. de Jongh, "Grape Symbolism in Paintings of the Sixteenth and Seventeenth Centuries," *Simiolus*, VII, 1974, 166–91.

V. Joppi, "Contributo quarto ed ultimo alla storia dell'arte nel Friuli ed alla vita dei pittori . . . friulani del XIV al XVIII secolo," in *Monumenti storici publicati della R. Deputazione veneta di Storia Patria*, 4th ser., Miscellanea, app. to vol. XII, Venice, 1894, 41.

JRS [A. E. Austin, Jr., and H.-R. Hitchcock, Jr.], "Two Large Canvasses by Luca Giordano," *Wadsworth Atheneum Bulletin*, VIII, no. 1, Jan. 1930, 2–3.

R. Jullian, *Caravage*, Lyons and Paris, 1961.

Kansas City, Nelson-Atkins Museum of Art, *Venetian Paintings and Drawings of the Seventeenth and Eighteenth Centuries*, 28 Nov.–31 Dec. 1937, no cat.

T. Kaufmann, "Arcimboldo's Imperial Allegories," *Zeitschrift für Kunstgeschichte*, XXIX, 1976, 275–96.

Kent, Conn., Kent School, *Baroque Painting and Sculpture from the Wadsworth Atheneum*, 1966, no cat.

J. Kerslake, *National Portrait Gallery: Early Georgian Portraits*, London, 1977.

D. Kinkead, *Juan de Valdés Leal (1622–1690). His Life and Work*, 2 vols., London and New York, 1978.

W. Kirwin, "Addendum to Cardinal Francesco Maria del Monte's Inventory: The Date of the Sale of Various Notable Paintings," *Storia dell'arte*, nos. 9–10, 1971, 53–56.

M. Kitson, *The Complete Paintings of Caravaggio*, London, 1969; English edition with revisions of Ottino della Chiesa, 1967.

F. Knapp, *Piero di Cosimo, ein Übergangsmeister von Florentiner Quattrocento zum Cinquecento*, Halle, 1899.

G. Knox, "Giambattista-Domenico Tiepolo: The Supplementary Drawings of the Quaderno Gatteri," *Bollettino dei Musei Civici Veneziani*, III, 1966.

G. Knox, "Some Notes on Large Paintings Depicting Scenes from Antique History by Ricci, Piazzetta, Bambini, and Tiepolo," in *Atti del congresso internazionale di studi su Sebastiano Ricci e il suo tempo*, Udine, 1975, 96–104.

G. Knox, "Giambattista Tiepolo: Queen Zenobia and Ca' Zenobio: 'una delle prime sue fatture,'" *Burlington Magazine*, CXXI, 1979, 409–18.

G. Knox, "Venice: Piazzetta at Ca' Vendramin-Calergi," *Burlington Magazine*, CXXV, 1983, 510–11.

D. Kowal, "The Life and Art of Francisco Ribalta (1565–1628)," 2 vols., Ph.D. diss., University of Michigan, 1981.

S. Kozakiewicz, *Bernardo Bellotto*, trans. M. Whittall, 2 vols., London, 1972.

G. Kubler and M. Soria, *Art and Architecture in Spain and Portugal and Their American Dominions, 1500–1600*, Baltimore, 1959.

K. Kuh, "The Wadsworth Atheneum: Accent on Specialties," *Saturday Review*, July 1962, 33–34.

I. Kunze, "A Re-discovered Picture by Andrea Cordeliaghi," *Burlington Magazine*, LXXI, 1937, 261–67.

I. Kuznetsov, *Zapadnoevropeĭskiĭ Natiurmort/West-European Still-Life Painting*, Leningrad and Moscow, 1966.

M. Landcastle, "A Painting of Saint Francis by Caravaggio," *Vassar Journal of Undergraduate Studies*, XVIII, 1961, 55–63.

H. Langdon, "Salvator Rosa in Florence," *Apollo*, C, 1974, 190–97.

H. Langdon, "Salvator Rosa: His Ideas and His Development as an Artist," Ph.D. diss., Courtauld Institute, University of London, 1975.

Lansdowne, H. C. K. P.-F., 5th marquis of, *Catalogue of the Collection of Pictures Belonging to the Marquess of Lansdowne, K. G., at Lansdowne House, London, and Bowood, Wilts.*, London, 1897.

L. Lanzi, *Storia pittorica della Italia*, 6 vols., 4th ed., Pisa, 1815–17.

M. Laskin, Jr., and M. Pantazzi, eds. *Catalogue of the National Gallery of Canada, Ottawa, European and American Paintings, Sculpture and Decorative Arts*, 2 vols., Ottawa, 1987.

F. Layna Serrano, "El Cuadro de Ribera en Cogolludo," *Boletín de la Sociedad Española de Excursiones*, LIII, 1949, 291.

Leeds, Leeds City Art Gallery and Temple Newsham House, *Catalogue of Paintings*, pt. I, Works by Artists Born before 1800, Leeds, 1954.

F. Legrand and F. Sluys, "Some Little-known 'Arcimboldeschi,'" *Burlington Magazine*, XCVI, 1954, 210–14.

R. Lehman, *The Philip Lehman Collection*, Paris, 1928.

J. Lehmann, "Domenico Fetti: Leben und Werk des Römischen Malers," Ph.D. diss., Johann Wolfgang Goethe Universität, Frankfurt am Main, 1967.

Leningrad, Hermitage; see Gosudarstvennyi Ermitazh.

A. L. Lepschy, *Tintoretto Observed*, Ravenna, 1983.

M. Levey, "Canaletto's Regatta Paintings," *Burlington Magazine*, XCVI, 1953, 365–66.

M. Levey, "Notes on the Royal Collection, II: Artemisia Gentileschi's 'Self-Portrait' at Hampton Court," *Burlington Magazine*, CIV, 1962, 79–80.

M. Levey, *The Later Italian Pictures in the Collection of Her Majesty the Queen*, London, 1964.

M. Levey, *National Gallery Catalogues: The Seventeenth- and Eighteenth-Century Italian Schools*, London, 1971.

M. Levi d'Ancona, *The Garden of the Renaissance: Botanical Symbolism in Italian Painting*, Florence, 1977.

F. Licht, *Goya, the Origins of the Modern Temper in Art*, New York, 1979.

W. Liedtke, "Zurbarán's Jerez Altarpiece Reconstructed," *Apollo*, CXXXVII, 1988, 153–62.

U. Limentani, *Poesie e lettere inedite di Salvator Rosa*, Florence, 1950.

U. Limentani, "Salvator Rosa: Nuovi studi e ricerche," *Italian Studies*, VIII, 1953, 28–58; IX, 1954, 46–55.

U. Limentani, "Salvator Rosa: Nuovi contributi all'epistolario," *Studi secenteschi*, XIII, 1973, 255–73.

G. Lipparini, *Francesco Francia*, Bergamo, 1913.

I. Lipschutz, *Spanish Painting and the French Romantics*, Cambridge, Mass., 1972.

M. Liversidge, "A Drawing by Cortona for the Chiesa Nuova, Rome," *Burlington Magazine*, CXXII, 1980, 341–42.

C. Lloyd, *A Catalogue of the Earlier Italian Paintings in the Ashmolean Museum*, Oxford, 1977.

London, Burlington Fine Arts Club, *Exhibition of Pictures, Drawings and Photographs of Works of the School of Ferrara-Bologna*, 1894.

London, Burlington Fine Arts Club, *Catalogue of an Exhibition of Italian Art of the Seventeenth Century*, 1925, exh. cat. by O. Sitwell.

London, Burlington Fine Arts Club, *Winter Exhibition*, 1932–33.

London, Royal Academy of Art, *Catalogue of the Exhibition of Seventeenth-Century Art in Europe*, 1938.

London, Spanish Art Gallery, *From Greco to Goya*, 1938.

London, Royal Academy of Art, *Catalogue of the Exhibition of Works by Holbein and Other Masters of the Sixteenth and Seventeenth Centuries*, 1950–51.

London, Heim Gallery, *Italian Paintings and Sculptures*, 1966.

London, Agnew's, *Old Masters: Recent Acquisitions*, 1969.

London, Hayward Gallery, *Salvator Rosa*, 17 Oct.–23 Dec. 1973.

London, Victoria and Albert Museum (also Edinburgh, Royal Scottish Museum, and Vienna, Kunsthistorisches Museum), *Giambologna, 1529–1608. Sculptor to the Medici*, 5 Oct.–16 Nov. 1978, exh. cat. by C. Avery and A. Radcliffe.

London, Queen's Gallery, Buckingham Palace, *Canaletto*, 1980–81.

London, Royal Academy of Art, *Painting in Naples, 1606–1705: From Caravaggio to Giordano*, 30 Sept.–15 Dec. 1982, exh. cat. ed. by C. Whitfield and J. Martineau. Altered versions of the exhibition were subsequently shown at the National Gallery, Washington (using the London catalogue), at the Grand Palais, Paris (1983), and at the Fondazione Agnelli, Turin (1983). An expanded Italian version of the catalogue was published in Naples, 1982.

London, Iveagh Bequest, Kenwood, *Pompeo Batoni (1708–1787) and His British Patrons*, 1982, exh. cat. by E. Bowron.

London, Royal Academy of Art, *Bartolomé Esteban Murillo (1617–1682)*, 15 Jan.–27 Mar. 1983.

London, Royal Academy of Art, *The Genius of Venice, 1500–1600*, 26 Nov. 1983–18 Mar. 1984, exh. cat. ed. by J. Martineau and C. Hope.

A. Longhi, *Compendio delle vite dei pittori veneziani istorici più rinomati del presente secolo*, Venice, 1762.

R. Longhi, "Lelio Orsi," *Vita artistica*, I, 1926, 68.

R. Longhi, "Di Gaspare Traversi," *Vita artistica, studi di storia dell'arte*, II, 1927, 145–97.

R. Longhi, "Quesiti caravaggeschi I: Registro dei tempi," *Pinacoteca*, I, 1928, 17–33.

R. Longhi, "Ultimissime sul Caravaggio," *Proporzioni*, I, 1943, 99–102.

R. Longhi, "Ultimi studi sul Caravaggio e la sua cerchia," *Proporzioni*, I, 1943, 5–63.

R. Longhi, *Il Caravaggio*, Milan, 1952; 2nd ed., Rome, 1968; 3rd and posthumous edition ed. by G. Previtali, Rome, 1982.

R. Longhi, "Viviano Codazzi e l'invenzione della veduta realistica," *Paragone*, no. 71, 1955, 40–47.

R. Longhi, *Opere complete*, vol. 5, *Officina ferrarese*, Florence, 1956.

R. Longhi, "Una Tema ambrosiano del Magnasco," *Paragone*, no. 101, 1958, 70–71.

R. Longhi, "Codazzi e l'antologia," *Paragone*, no. 123, 1960, 41–44.

R. Longhi, "I Cinque sensi del Ribera," *Paragone*, no. 193, 1966, 74–78.

J. López Rey, "Disentangling Goya from Lucas," *Art News*, LV, no. 1, 1956, 40–41, 68–69.

G. Lorenzetti and L. Planiscig, *La Collezione dei Conti Donà dalle Rose a Venezia*, Venice, 1934.

Los Angeles, Los Angeles County Museum of Art, *The Golden Century of Venetian Painting*, 30 Oct. 1979–27 Jan. 1980, exh. cat. by T. Pignatti and K. Donahue.

Louisville, J. B. Speed Art Museum (also Ann Arbor, University of Michigan, Museum of Art), *Alessandro Magnasco*, 1967.

A. Luchs, *Cestello: A Cistercian Church of the Florentine Renaissance*, New York, 1977.

G. Ludwig, "Cordeliaghi und Previtali," *Jahrbuch der königlich preuszischen Kunstsammlungen*, XXIV, Beiheft, 1903, 58–59.

F. Lugt, *Répertoire des catalogues de ventes*, 3 vols., The Hague, 1938–64.

F. Lugt, "Man and Angel," *Gazette des Beaux-Arts*, LXXXVI, 1944, 321–46.

A. McComb, *The Baroque Painters of Italy*, Cambridge, Mass., 1934.

C. McCorquodale, "A Fresh Look at Carlo Dolci," *Apollo*, XCVII, 1973, 477–88.

C. McCorquodale, *The Baroque Painters of Italy*, Oxford, 1979.

J. L. McKenzie, S. J., *Dictionary of the Bible*, Milwaukee, 1965.

N. MacLaren, *National Gallery Catalogues: The Spanish School*, London, 1952.

Madrid, *Zurbarán. Estudio y catálogo de la exposición celebrade en Granada en Junio de 1953*, 1953.

Madrid, Casón del Buen Retiro, *Exposición Zurbarán en el III centenario de su muerte*, Nov. 1964–Feb. 1965.

Madrid, Casón del Buen Retiro, *Pintura italiana del siglo XVII*, exhibition celebrating the 150th anniversary of the founding of the Prado Museum, 1970.

Madrid, Salas de Exposición (also Valencia, Museo de Bellas Artes), *Joan de Joanes (d. 1579)*, Dec. 1979–Jan. 1980, exh. cat. by J. Albi-Fita.

L. Magagnato and B. Passamani, *Il Museo Civico di Bassano del Grappa*, Venice, 1978.

H. B. J. Maginnis, "The Literature of Sienese Trecento Painting, 1945–1975," *Zeitschrift für Kunstgeschichte*, XL, 1977, 276–309.

H. B. J. Maginnis, "A Reidentified Panel by Niccolò di Buonaccorso," *Source*, I, no. 2, 1982, 18–20.

S. Magnani, "Arnold, Hermann, and Salomon Corrodi," in *Dizionario biografico degli Italiani*, Rome, 1983, XXIX, 532–36.

D. Mahon, *Studies in Seicento Art and Theory*, London, 1947.

D. Mahon, "Egregius in urbe pictor: Caravaggio Revised," *Burlington Magazine*, XCIII, 1951, 223–34.

D. Mahon, "The Seicento at Burlington House: Some Addenda and Corrigenda, II," *Burlington Magazine*, XCIII, 1951, 78–84.

D. Mahon, "Addenda to Caravaggio," *Burlington Magazine*, XCIV, 1952, 3–23.

D. Mahon, "An Addition to Caravaggio's Early Period," *Paragone*, no. 25, 1952, 20–31.

D. Mahon, "Contrasts in Art-Historical Method: Two Recent Approaches to Caravaggio," *Burlington Magazine*, XCV, 1953, 212–20.

D. Mahon, "An Attribution Re-studied: Sisto Badalocchio's 'Holy Family,'" *Wadsworth Atheneum Bulletin*, Spring 1958, 1–4.

D. Mahon and N. Turner, *The Drawings of Guercino in the Collection of Her Majesty the Queen at Windsor Castle*, Cambridge, 1989.

M. Mahoney, *The Drawings of Salvator Rosa*, 2 vols., New York, 1977.

E. Malagutti, "Alla riscoperta di Paolo Borron," *Arte illustrata*, I, 1968, 34–41.

F. Malaguzzi Valeri, "La Chiesa 'della Santa' a Bologna," *Archivio storico dell'arte*, 2nd ser., II, 1896, 84.

F. Malaguzzi Valeri, *Pittori lombardi del quattrocento*, Milan, 1902.

E. Mâle, *L'Art religieux de la fin du moyen âge en France*, Paris, 1925.

E. Mâle, *L'Art religieux après le Concile de Trente*, Paris, 1932.

C. C. Malvasia, *Felsina Pittrice: Vite de' pittori bolognesi*, Bologna, 1841; reprint ed., 2 vols., Bologna, 1967.

G. Mancini, *Considerazioni sulla pittura*, 2 vols., Rome, 1956–57.

B. S. Manning, "The Transformation of Circe. The Significance of the Sorceress as Subject in Seventeenth-Century Genoese Painting," in *Scritti di storia dell'arte in onore di Federico Zeri*, Milan, 1984, II, 689–708.

M. Marangoni, "An Unpublished Caravaggio in Trieste," *International Studio*, Oct. 1929, 34–35, 106.

E. Marani and C. Perina, *Mantova, la storia, le lettre, le arti*, vol. 3, *Mantova, le arti*, Mantua, 1965.

V. Mariani, *Caravaggio*, Rome, 1973.

M. Marini, *Io Michelangelo da Caravaggio*, Rome, 1974.

M. Marini, "*Michael angelus caravaggio romanus*," rassegna degli studi e proposte, Studi barocchi series, no. 1, Rome, 1978 on frontispiece and 1979 on cover.

M. Marini, *Caravaggio. Werkverzeichnis*, Die grossen Meister der Malerei series, Frankfurt, Berlin, Vienna, 1980.

M. Marini, "Gli Esordi del Caravaggio e il concetto di 'natura' nei primi decenni del seicento a Roma; equivoci del caravaggismo," *Artibus et historiae*, II, no. 4, 1981, 39–83.

M. Marini, "Del Signor Giovanni Battista Crescentij, pittore," *J. Paul Getty Museum Journal*, IX, 1981, 127–31.

M. Marini, "Caravaggio e il naturalismo internazionale," in *Storia dell'arte italiana*, Turin, 1981, pt. 2, vol. 2:1, 347–445.

M. Marini, "Equivoci del caravaggismo 2, A) Appunti sulla tecnica del 'naturalismo' secentesco, tra Caravaggio e 'Manfrediana Methodus'; B) Caravaggio e i suoi 'doppi'. Il problema delle possibili collaborazioni," *Artibus et historiae*, IV, no. 8, 1983, 119–54.

M. Marini, "*Ut natura pictura*," natura come pittura, antologia di nature morte del XVI al XVIII secolo, Rome, 1986.

M. Marini, *Caravaggio, Michelangelo Merisi da Caravaggio, "pictor praestantissimus,"* Rome, 1987.

M. Marini, "Sembra di Orazio Gentileschi il 'San Francisco' venduto a Londra," *Tempo*, 12 Sept. 1987, 1.

A. Mariuz, *G. D. Tiepolo*, Venice, 1971.

R. van Marle, *The Development of the Italian Schools of Painting*, 19 vols., The Hague, 1923–38.

R. van Marle, *Iconographie de l'art profane au Moyen Age et à la Renaissance*, The Hague, 1932.

D. R. Marshall, "Viviano Codazzi as 'Quadratura' Painter at the Certosa di San Martino, Naples, and Santa Maria in via Lata, Rome," *Storia dell'arte*, no. 56, 1986, 49–80.

A. Martini, *Manuale di metrologia*, Turin, 1883; reprint ed., Rome, 1976.

E. Martini, *La Pittura veneziana del settecento*, Venice, 1964; 2nd ed., Udine, 1982.

S. and S. Martinotti, *P. F. Guala*, Turin, 1976.

A. M. Matteucci, *Bernardo Strozzi*, I Maestri del colore series, no. 134, Milan, 1966.

P. Matthiesen and S. Pepper, "Guido Reni: An Early Masterpiece Discovered in Liguria," *Apollo*, XCI, 1970, 452–62.

D. J. Matute y Gaviria, "Adiciones y correcciones de D. Justino Matute al tomo IX del 'Viaje de España' por D. Antonio Ponz, anotadas nuevamente por D. Gestoso y Pérez," *Archivo Hispalense*, III, 1887.

F. Mauroner, "Michele Marieschi," *Print Collector's Quarterly*, XXVII, 1940, 179–215.

J. Maxon, "Tintoretto's Use of the Antique," *Connoisseur*, CLI, 1962, 59–64.

A. L. Mayer, *Jusepe de Ribera*, Leipzig, 1908; 2nd ed., Leipzig, 1923.

A. L. Mayer, *Murillo*, Stuttgart and Berlin, 1913.

A. L. Mayer, "Notes on Spanish Pictures in American Collections," *Art in America*, III, 1915, 309–20.

A. L. Mayer, *Goya*, London, 1924.

F. Mazzini, *Affreschi lombardi del quattrocento*, Milan, 1965.

M. Meiss, "The Madonna of Humility," *Art Bulletin*, XVIII, 1936, 435–65.

Memphis, Tenn., Brooks Memorial Art Gallery, *Luca Giordano in America*, Apr. 1964, exh. cat. by M. Milkovitch.

U. Meroni, "Un Disegno sconosciuto di Salvator Rosa ed un raro autografo di Giovanni Battista Ricciardi," *Prospettiva*, no. 15, Oct. 1978, 68–70.

U. Meroni, *Lettere e altri documenti intorno alla storia della pittura: Giovanni Benedetto Castiglione, detto il Grechetto, Salvator Rosa, Gian Lorenzo Bernini*, Monzambano (Mantova), 1978.

U. Meroni, "Salvator Rosa, autoritratti e ritratti di amici," *Prospettiva*, no. 25, 1981, 65–70.

M. P. Merriman, *Giuseppe Maria Crespi*, Milan, 1980.

J. Meyer zur Capellen, "Andrea Previtali," Ph.D. diss., Würzburg, 1972.

A. Mezzetti, *Il Dosso e Battista Ferraresi*, Milan, 1965.

G. Michel, "Notes biographiques sur Giovanni Paolo Spadino," *Colloqui del sodalizio tra studiosi dell'arte*, 2nd ser., 1976–78/1978–80, 19–34.

O. Michel, "Giovanni Paolo Castelli, detto Spadino," in *Dizionario biografico degli Italiani*, Rome, 1978, XXI, 726–28.

P. Michelini, "Domenico Fetti a Venezia," *Arte veneta*, IX, 1955, 123–37.

Middletown, Wesleyan University, Olin Library Art Rooms, *Seventeenth- and Eighteenth-Century Art*, 1930, no cat.

Middletown, Wesleyan University, Davidson Art Center, *The Baroque Experience*, 28 Nov.–18 Dec. 1966, no cat.

Milan, Palazzo Reale, *Mostra del Caravaggio e dei Caravaggisti*, Apr.–June 1951, introduction by R. Longhi, entries by C. Baroni, G. Dell'Acqua, and M. Gregori.

Milan, Palazzo Reale, *Arte lombarda dai Visconti agli Sforza*, Apr.–June 1958.

Milan, Finarte, *Mostra dei dipinti del XIV al XVIII secolo*, 1972, exh. cat. by E. Volpe.

Milan, Palazzo Reale, *Settecento lombardo*, 1 Feb.–28 Apr. 1991, exh. cat. ed. by R. Bossaglia and V. Terraroli.

G. Milanesi, *Documenti per la storia dell'arte senese*, 3 vols., Siena, 1854–56.

G. Millet, *Recherches sur l'iconographie de l'Évangile*, Paris, 1916.

Minneapolis, Minneapolis Institute of Arts, *Great Portraits by Famous Painters*, 1952.

P. Mitchell, *Great Flower Paintings: Four Centuries of Floral Art*, Woodstock, N.Y., 1973.

A. Moir, *The Italian Followers of Caravaggio*, 2 vols., Cambridge, Mass., 1967.

A. Moir, "Did Caravaggio Draw?," *Art Quarterly*, XXXII, 1969, 354–72.

A. Moir, "Some Caracciolo Drawings in Stockholm," *Art Bulletin*, LII, 1970, 184–87.

A. Moir, *Caravaggio and His Copyists*, New York, 1976.

A. Moir, *Caravaggio*, New York, 1982.

Montclair, N.J., Montclair Art Museum, *Festival of Flowers*, 1961.

Montreal, Museum of Fine Arts and Art Association of Montreal, *Loan Exhibition of Masterpieces of Painting*, 5 Feb.–8 Mar. 1942.

A. Morassi, "G. B. e D. Tiepolo alla Villa Valmarana," *Arti*, III, 1941, 251–62.

A. Morassi, "Settecento inedito," *Arte veneta*, III, 1949, 70–84.

A. Morassi, *G. B. Tiepolo: His Life and Work*, London, 1955.

A. Morassi, "Considerazioni sugli inizi del Canaletto," in *Venezia e l'Europa; XVIII Congresso internazionale di storia dell'arte*, Venice, 1956, 357–60.

A. Morassi, *A Complete Catalogue of the Paintings of G. B. Tiepolo*, London, 1962.

A. Morassi, "Settecento inedito," *Arte veneta*, XVII, 1963, 143–55.

A. Morassi, "La Giovinezza del Canaletto," *Arte veneta*, XX, 1966, 207–17.

A. Morassi, *Antonio e Francesco Guardi*, 2 vols., Venice, 1973.

G. Morelli [I. Lermolieff], *Kunstkritische Studien über italienische Malerei: Die Galerien zu München und Dresden*, Leipzig, 1891.

L. Moretti, "Risarcimento di Antonio Marini," in *Scritti di storia dell'arte in onore di Federico Zeri*, Milan, 1984, II, 787–800.

L. Moretti, "Nuovi documenti sul Ponzone e sul Forabosco," *Arte veneta*, XL, 1986, 224.

L. Mortari, "Su Bernardo Strozzi," *Bollettino d'arte*, XL, 1955, 311–33.

L. Mortari, *Bernardo Strozzi*, Rome, 1966.

L. Mortari, "Considerazioni e precisazioni sulla Cappella Aldobrandini in S. Maria in Via," *Quaderni di Emblema*, II, 1973, 76–82.

G. Moschini, *Della letteratura veneziana dal secolo XVIII fino nostri giorni*, 3 vols., Venice, 1806.

G. Mueller, "Evaristo Baschenis—der Initiator von Musikstilleben—und sein Kreis," *Kunst in Hessen und am Mittelrhein*, 1977, 7–26.

P. Muller, *Goya's Black Paintings: Truth and Reason in Light and Liberty*, New York, 1984.

Munich, Bayerische Staatsgemäldesammlungen Alte Pinakothek, *Natura morta italiana: italienische Stillebenmalerei aus drei Jahrhunderten, Sammlung Silvano Lodi/Italian Still-Life Painting from Three Centuries, Silvano Lodi Collection/Tre secoli di natura morta italiana, la raccolta Silvano Lodi*, 27 Nov. 1984–22 Feb. 1985, exh. cat. by L. Salerno.

M. Muraro, *Paolo da Venezia*, University Park, 1970.

Musik in Geschichte und Gegenwart: allgemeine Enzyklopädie der Musik, 17 vols., Kassel, 1949–86.

Sir L. Namier and J. Brooke, *The History of Parliament: The House of Commons 1754–1790*, 3 vols., New York, 1964.

Naples, *Mostra della pittura napoletana del secoli XVII, XVIII, e XIX*, exh. cat. ed. by S. Ortolani, 1938.

Naples, Palazzo Reale (also Zurich, Rotterdam), *La Natura morta italiana*, Oct.–Nov. 1964, exh. cat. by R. Causa.

Naples, Museo e Gallerie Nazionale di Capodimonte, *Civiltà del Settecento a Napoli, 1734–1799* (also Detroit, Detroit Institute of Arts, and Chicago, Art Institute of Chicago, *The Golden Age of Naples*), 2 vols., Dec. 1979–Oct. 1980.

E. Nappi, "Pittori del seicento a Napoli," *Ricerche sul seicento napoletano*, Milan, 1983, 73–87.

S. Nash, *Albright-Knox Art Gallery: Painting and Sculpture from Antiquity to 1942*, New York, 1979.

M. Newcome, review of Franchini Guelfi, 1977, in *Kunstchronik*, Apr. 1979, 156–61.

New Haven, Yale University, Gallery of Fine Arts, *Eighteenth-Century Italian Landscape Painting and Its Influence in England*, 18 Jan.–25 Feb. 1940, cat. in *Bulletin of the Associates in Fine Arts at Yale University*, IX, 1940.

New Haven, Yale University, Art Gallery (also Sarasota, John and Mable Ringling Museum of Art, and Kansas City, Nelson-Atkins Museum of Art), *A Taste for Angels: Neapolitan Painting in North America, 1650–1750*, 9 Sept.–29 Nov. 1987.

New London, Lyman Allyn Museum, *Gardens in Paintings, Drawings, Prints, and Other Arts*, foreword by H.-R. Hitchcock, 1935.

New London, Lyman Allyn Museum, *Spanish Paintings of the Sixteenth to Twentieth Centuries*, 7 Mar.–11 Apr. 1948.

New London, Lyman Allyn Museum, *The Art of the Baroque*, 7–31 Mar. 1954, no cat.

New Orleans, Isaac Delgado Museum of Art (also New Orleans, New Orleans Museum of Art), *Fêtes de la Palette*, Nov. 1962–Jan. 1963.

Newport, R.I., Cushing Memorial Gallery, Art Association of Newport, *The Coast and the Sea, a Loan Exhibition Assembled from the Collections of the Wadsworth Atheneum*, 1964.

New York, Durlacher Bros., *An Exhibition of Italian Paintings and Drawings of the Seventeenth Century*, New York, 1932.

New York, Durlacher Bros., *An Exhibition of Venetian Painting, 1600–1800*, 1934.

New York, Metropolitan Museum of Art, *Tiepolo and His Contemporaries*, 14 Mar.–24 Apr. 1938.

New York, New York World's Fair, *Masterpieces of Art*, 27 May–31 Oct. 1939.

New York, New York World's Fair, *European and American Paintings, 1500–1900*, May–Oct. 1940.

New York, Durlacher Bros., *A Loan Exhibition of Paintings by Alessandro Magnasco*, 1940.

New York, Schaeffer Galleries, *Gems of Baroque Painting*, 27 Jan.–28 Feb. 1942.

New York, Coordinating Council of French Relief Societies, exhibition for the benefit of the societies, 3–31 May 1944.

New York, Durlacher Bros., *Caravaggio and the Caravaggisti*, 4–30 Mar. 1946.

New York, Durlacher Bros., *Paintings by Salvator Rosa*, 1948.

New York, Durlacher Bros., *Paintings and Drawings by Eugenio Lucas*, 28 Feb.–24 Mar. 1956.

New York, M. Knoedler & Co., *Masterpieces from Wadsworth Atheneum, Hartford*, an exhibition of paintings, sculpture, and porcelains for the benefit of the Wadsworth Atheneum Building Fund, 1958. The then just issued *Wadsworth Atheneum Handbook* [1958] and its page numbers served as a catalogue of the exhibition.

New York, Metropolitan Museum of Art and Pierpont Morgan Library, *Drawings from New York Collections II – The Seventeenth Century in Italy*, 23 Feb.–22 Apr. 1967, exh. cat. by F. Stampfle and J. Bean.

New York, Wildenstein & Co., *Gods and Heroes: Baroque Images of Antiquity*, exhibition organized by the Fogg Art Museum for the benefit of the archeological exploration of Sardis, 30 Oct. 1968–4 Jan. 1969, exh. cat. by E. Williams.

New York, Colnaghi, *Pompeo Batoni (1708–1787), a Loan Exhibition of Paintings*, 17 Nov.–18 Dec. 1982, exh. cat. by E. P. Bowron.

New York, National Academy of Design (also Tulsa, Philbrook Art Center, and Dayton, Dayton Art Institute), *Italian Still-Life Paintings from Three Centuries*, 2 Feb.–13 Mar. 1983, exh. cat. by J. T. Spike.

New York, Colnaghi, *Italian, Dutch, and Flemish Baroque Paintings*, 1984, exh. cat. by C. Whitfield and E. Banks.

New York, Metropolitan Museum of Art (also Naples, Museo Nazionale di Capodimonte), *The Age of Caravaggio*, Feb.–Apr. 1985.

New York, Metropolitan Museum of Art (also Paris, Grand Palais), *Zurbarán*, 22 Sept.–13 Dec. 1987.

New York, Metropolitan Museum of Art, *Painting in Renaissance Siena*, 20 Dec. 1988–19 Mar. 1989, exh. cat. by K. Christiansen, L. Kantor, and C. B. Strehlke.

New York, Metropolitan Museum of Art, *Canaletto*, 30 Oct. 1989–21 Jan. 1990, exh. cat. by K. Baetjer and J. G. Links.

B. Nicolson, "The Sanford Collection," *Burlington Magazine*, XCVII, 1955, 207–14.

B. Nicolson, "The Art of Carlo Saraceni," *Burlington Magazine*, CXII, 1970, 312–15.

B. Nicolson, "Caravaggesques at Cleveland," *Burlington Magazine*, CXIV, 1972, 113–17.

B. Nicolson, "Caravaggio and the Caravaggesques: Some Recent Research," *Burlington Magazine*, CXVI, 1974, 603–16.

B. Nicolson, *The International Caravaggesque Movement: Lists of Pictures by Caravaggio and His Followers throughout Europe*, Oxford, 1979.

L. Nikolenko, *Francesco Ubertini, called il Bacchiacca*, Locust Valley, 1966.

F. Nordstrom, "The Crown of Life and the Crown of Vanity. Two Companion Pieces by Valdés Leal," *Figura*, n.s., I, 1959, 127–37.

F. Nordstrom, "Goya, Saturn, and Melancholy," *Figura*, n.s., III, 1962, 153–71.

Northampton, Mass., Smith College Museum of Art, *Venetian Paintings from the Hartford Museum*, 18–30 Jan. 1932.

Northampton, Mass., Smith College Museum of Art, *Venetian Eighteenth-Century Painting*, 1936.

Northampton, Mass., Smith College Museum of Art, *Italian Baroque Painting, Seventeenth and Eighteenth Century*, 6–25 Feb. 1947.

North Salem, N.Y., Hammond Museum, *What on Earth?—an Exhibition Devoted to the Theme of Ecology*, 1971, no cat.

M. A. Novelli, *Lo Scarsellino*, Bologna, 1955; 2nd ed., Milan, 1964.

Novità sul Caravaggio. Saggi e contributi, ed. M. Cinotti, Milan, 1975.

M. Nugent, *Alla mostra della pittura italiana del seicento e settecento*, San Casciano, 1925.

Oberlin, Ohio, Oberlin College, Allen Memorial Art Museum, *Exhibition of Italian Paintings of the Seventeenth Century*, exh. cat. by W. Stechow contained in the *Allen Memorial Art Museum Bulletin*, IX, no. 2, Winter 1952, 36–63.

R. Oertel, "Neapolitanische Malerei des 17–19 Jahrhunderts. Ausstellung in Castel Nuovo in Neapel," *Pantheon*, XXI–XXII, 1938, 225–32.

U. Ojetti, L. Dami, and N. Tarchiani, *La Pittura italiana del seicento e del settecento alla mostra di Palazzo Pitti*, 2nd ed., Milan and Rome, 1924.

H. Olsen, "Et Malet galleri af Pannini: Kardinal Silvio Valenti Gonzagas samling," *Kunstmusseets Aarsskrift*, XXXVIII, 1951 [1952], 90–103.

E. Orioli, "Sentenza arbitrale pronunciata da Francesco Francia," *Archivio storico dell'arte*, V, 1892, 133–34.

P. Orlandi, *Abecedario pittorico*, ed. P. Guarienti, Venice, 1753.

S. Orlandi, "Il Beato Angelico," *Rivista d'arte*, XXIX, 1954, 167–68.

S. Orlandi, *Beato Angelico*, Florence, 1964.

L. F. Orr, "Classical Elements in the Paintings of Caravaggio," Ph.D. diss., University of California, Santa Barbara, 1982.

M. d'Orsi, *Corrado Giaquinto*, Rome, 1958.

H. W. van Os, *Sienese Altarpieces, 1215–1460*, II, Groningen, 1990.

H. W. van Os and M. Prakken, eds., *The Florentine Paintings in Holland, 1300–1500*, Maarssen, 1974.

S. Ostrow, *Baroque Painting: Italy and Her Influence*, an exhibition organized and circulated by the American Federation of Arts, New Haven, 1968.

A. Ottani, "Su Angelo Caroselli, pittore romano," *Arte antica e moderna*, VIII, 1965, 289–97.

A. Ottani Cavina, *Carlo Saraceni*, Milan, 1968.

Ottawa, National Gallery of Canada, National Museum of Canada, *The Young van Dyck*, 1980, exh. cat. by A. McNairn.

A. Ottino della Chiesa, *L'Opera completa del Caravaggio*, with an essay by R. Guttuso, Milan, 1967.

L. Ozzola, *Gian Paolo Pannini*, Turin, 1921.

W. and E. Paatz, *Die Kirchen von Florenz*, 6 vols., Frankfurt, 1940–54.

L. Padoan Urban, "'Impresari-macchinisti' teatrali nella Venezia del settecento (e un documento su Michele Marieschi)," *Arte veneta*, XXXIV, 1980, 225–27.

L. Palladino, "Aretino: Orator and Art Theorist," Ph.D. diss., Yale University, 1981.

A. Pallucchini and G. Piovene, *L'Opera completa di Giambattista Tiepolo*, Milan, 1968.

R. Pallucchini, "Domenico Fedeli, detto il Maggiotto," *Rivista di Venezia*, XI, 1932, 485–95.

R. Pallucchini, *L'Arte di Giovanni Battista Piazzetta*, Bologna, 1934.

R. Pallucchini, *Sebastian Viniziano*, Milan, 1944.

R. Pallucchini, *I Dipinti della Galleria Estense di Modena*, Rome, 1945.

R. Pallucchini, *La Giovinezza del Tintoretto*, Milan, 1950.

R. Pallucchini, *Piazzetta*, Milan, 1956.

R. Pallucchini, *La Pittura veneziana del settecento*, Venice, 1960.

R. Pallucchini, *La Pittura veneziana del trecento*, Venice, 1964.

R. Pallucchini, "A proposito della mostra bergamasca del Marieschi," *Arte veneta*, 1966, 314–25.

R. Pallucchini, *Sebastiano del Piombo*, I Maestri del colore series, no. 158, Milan, 1966.

R. Pallucchini, *Tiziano*, 2 vols., Florence, 1969.

R. Pallucchini, "Per gli esordi del Canaletto," *Arte veneta*, XXVII, 1973, 155–88.

R. Pallucchini, *La Pittura veneziana del seicento*, 2 vols., Milan, 1981.

R. Pallucchini, *Bassano*, Bologna, 1982.

R. Pallucchini, "Una nuova opera giovanile di Jacopo Tintoretto," *Arte veneta*, XXXVI, 1982, 124–26.

R. Pallucchini and A. Mariuz, *L'Opera completa del Piazzetta*, Milan, 1982.

R. Pallucchini and R. Rossi, *Tintoretto: Le Opere sacre e profane*, 2 vols., Milan, 1982.

A. Palomino de Castro y Velasco, *Museo pictorico y escala optica*, vol. 3, *El Parnase espanol pintoresco laurendo*, Madrid, 1724.

A. Palomino de Castro y Velasco, *Lives of the Eminent Spanish Painters and Sculptors*, trans. N. Mallory, Cambridge, 1987.

E. Panofsky, "The Early History of Man in a Cycle of Paintings by Piero di Cosimo," in *Studies in Iconology: Humanistic Themes in the Art of the Renaissance*, New York, 1939, 33–67.

J. Paoletti, "The Italian School: Problems and Suggestions," *Apollo*, LXXXVIII, 1968, 420–29.

Paris, Orangerie des Tuileries, *La Nature morte de l'antiquité à nos jours*, Apr.–June 1952, exh. cat. by C. Sterling.

Paris, Musée du Louvre, *Renaissance du Musée de Brest, Acquisitions récentes*, Oct. 1974–Jan. 1975, exh. cat by P. Rosenberg.

Paris, Grand Palais, *La Peinture française du XVII siècle dans les collections américaines* (also New York, Metropolitan Museum of Art, and Chicago, Art Institute of Chicago, *France in the Golden Age: Seventeenth-Century French Paintings in American Collections*), 29 Jan.–26 Apr. 1982, exh. cat. by P. Rosenberg.

Paris, Musée du Petit Palais, *De Greco à Picasso*, 10 Oct. 1987–3 Jan. 1988, exh. cat. by José Manuel Pita Andrade.

K. T. Parker, *The Drawings of Antonio Canaletto in the Collection of His Majesty the King at Windsor Castle*, London, 1948.

K. T. Parker, *Catalogue of Drawings in the Ashmolean Museum*, II Oxford, 1956.

V. Parrino, *Vito d'Anna e i suoi affreschi nelle chiese di Palermo*, Palermo, 1932.

L. Pascoli, *Vite de' pittori*, 2 vols., Rome, 1730–36.

J. Passavant, *Kunstreise durch England und Belgien*, Frankfurt, 1833.

G. B. Passeri, *Die Kunstlerbiographien von Giovanni Battista Passeri*, ed. J. Hess, Leipzig and Vienna, 1934.

L. von Pastor, *Storia dei papi*, eds. P. Cenci and A. Mercati, 16 vols., Rome, 1943–63.

L. von Pastor, *The History of the Popes*, trans. E. F. Peeler, 40 vols., London and St. Louis, 1961.

S. Pearce, "The Study of Costume in Painting," *Studies in Conservation*, IV, 1959, 127–39.

C. Peman, "Nuevas pinturas de Zurbarán en Inglaterra," *Archivo Español de Arte*, XXII, 1949, 207–13.

D. S. Pepper, "Guido Reni's Roman Account Book–II: The Commissions," *Burlington Magazine*, CXIII, 1971, 372–86.

D. S. Pepper, "Caravaggio riveduto e corretto: La Mostra di Cleveland," *Arte illustrata*, V, 1972, 170–78.

D. S. Pepper, "Baroque Painting at Colnaghi's," *Burlington Magazine*, CXXVI, 1984, 315–16.

A. Percy, "Magic and Melancholy: Castiglione's 'Sorceress' in Hartford," *Wadsworth Atheneum Bulletin*, Winter 1970, 2–27 [actually issued in 1972 after the 1971 Castiglione exhibition].

M.-F. Pérez, "Bilan de l'exposition Guy François," *Revue du Louvre et des Musées de France*, XXIV, no. 6, 1974, 468–72.

M.-F. Pérez, "Deux nouvelles attributions à Guy François (1578?–1650)," *Information d'Histoire de l'Art*, XX, no. 5, 1975, 220–24.

M.-F. Pérez, review of Ficacci, 1980, in *Prospettiva*, no. 25, Apr. 1981, 77–81.

A. E. Pérez Sánchez, *Pintura italiana del siglo XVII en España*, Madrid, 1965.

A. E. Pérez Sánchez and N. Spinosa, *L'Opera completa di Ribera*, Milan, 1981.

P. della Pergola, *La Galleria borghese, i dipinti*, 2 vols., Rome, 1955–59.

F. M. Perkins, "Su alcune pitture di Martino di Bartolommeo," *Rassegna d'arte senese*, XVII, 1924, 8–9.

A. Perotti, *I Pittori Campi da Cremona*, Milan, 1932.

Perugia, Galleria Nazionale dell'Umbria, *Cinque mostre di opere restaurate*, Apr. 1964.

M. Pettex Sabarot, "Guy François: Attributions et propositions à propos d'un ensemble de toiles franciscaines," *Revue du Louvre et des Musées de France*, XXIX, nos. 5–6, 1979, 414–25.

Philadelphia, Philadelphia Museum of Art, *A World of Flowers*, 1963.

Philadelphia, Philadelphia Museum of Art, *Giovanni Benedetto Castiglione: Master Draughtsman of the Italian Baroque*, 17 Sept.–28 Nov. 1971, exh. cat. by A. Percy and foreword by A. Blunt. See Percy, 1970.

C. Pietrangeli, "L'Accademia del nudo in Campidoglio," *Strenna dei Romanisti*, XX, 1959, 123–28.

C. Pietrangeli, "Villa Paolina," *Studi Romani*, VII, no. 3, 1959, 287–98.

C. Pietrangeli, *Villa Paolina*, Quaderni di storia dell'arte, XI, Istituto di Studi Romani, Rome, 1961.

A. Pigler, "Aus der Werkstatt Solimenas," *Archaeologiai Értesitö*, XL, 1923–26, i–xii, 210–26.

A. Pigler, *Barockthemen*, 2 vols., Budapest, 1956.

A. Pigler, *Katalog der Galerie alter Meister*, Museum der bildenden Künste, Budapest, Tübingen, 1968.

T. Pignatti, *Il Quaderno di disegni del Canaletto alle gallerie di Venezia*, Milan, 1958.

T. Pignatti, *Pietro Longhi*, trans. P. Waley, London, 1969.

T. Pignatti, *Giorgione*, trans. C. Whitfield, New York, 1971.

T. Pignatti, *L'Opera completa di Pietro Longhi*, Milan, 1974.

T. Pignatti, *Veronese*, 2 vols., Venice, 1976.

T. Pignatti, *Canaletto*, Bologna, 1979.

E. Pillsbury, "Jacopo Zucchi in S. Spirito in Sassia," *Burlington Magazine*, CXVI, 1974, 434–44.

E. Pillsbury, "The Sala Grande Drawings by Vasari and His Workshop: Some Documents and New Attributions," *Master Drawings*, XIV, 1976, 127–46.

G. M. Pilo, "Fortuna critica di Gregorio Lazzarini," *Critica d'arte*, XXVII, 1958, 233–44.

G. M. Pilo, "La Mostra dei vedutisti veneziani del settecento," *Arte veneta*, XXI, 1967, 269–77.

G. M. Pilo, *Sebastiano Ricci e la pittura veneziana del settecento*, Pordenone, 1976.

N. Pio, *Vite di pittori, scultori ed architetti*, Rome, 1724; eds. R. and C. Enggass, Vatican City, 1977.

G. Piovene and R. Marini, *L'Opera completa del Veronese*, Milan, 1968.

La Pittura a Genova e in Liguria dal Seicento al primo Novecento, various contributors, Genoa, 1971.

D. A. Ponz, *Viaje de España*, 18 vols., Madrid, 1772–94, ed. C. Maria del Rivero, Madrid, 1947.

J. Pope-Hennessy, *Fra Angelico*, London, 1952; 2nd ed., Ithaca, N.Y., 1974.

J. Pope-Hennessy, *Italian Paintings in the Robert Lehman Collection*, New York, 1987.

D. Posner, *Annibale Carracci*, 2 vols., New York, 1971.

D. Posner, "Caravaggio's Homoerotic Early Works," *Art Quarterly*, XXXIV, 1971, 301–24.

M. Pospisil, *Magnasco*, Florence, 1944.

Poughkeepsie, Vassar College, Art Museum, *Seventeenth- and Eighteenth-Century Italian Painting*, 1956, no cat.

Poughkeepsie, Vassar College, Taylor Hall, "The Age of the Baroque," symposium, 6–8 Mar. 1959, no cat.

M. Precerutti-Garberi, "Asterischi sull'attività di Domenico Tiepolo a Würzburg," *Commentari*, XI, 1960, 267–83.

M. Precerutti-Garberi, *Settecento Veneto. Paesaggi e vedute*, Galleria Levi, Milan, 1967.

G. Previtali, ed., *L'Arte di scrivere sull'arte; Roberto Longhi nella cultura del nostro tempo*, Rome, 1982.

G. Previtali, "Caravaggio e il suo tempo," *Prospettiva*, no. 41, Apr. 1985, 68–80, a review of the 1985 New York/Naples exhibition.

I. M. Price, "Belshazzar," in *A Dictionary of the Bible*, ed. J. Hastings, New York, 1899, I, 269–70.

Princeton, Princeton University, Art Museum, *Italian Baroque Paintings from New York Private Collections*, 27 Apr.–7 Sept. 1980, exh. cat. by J. Spike.

Princeton, Princeton University, Art Museum (also Detroit, Institute of Arts), *Painting in Spain, 1650–1700, from North American Collections*, 18 Apr.–20 June 1982, exh. cat. by E. Sullivan and N. Malory.

W. Prohaska, "Beiträge zu Giovanni Battista Caracciolo," *Jahrbuch der kunsthistorischen Sammlung in Wien*, LXXIV, 1978, 153–269.

U. Prota-Giurleo, *Pittori napoletani del seicento*, Naples, 1953.

Le Puy, Musée Crozatier (also Saint-Étienne, Musée d'Art et d'Industrie), *Guy François, Le Puy, 1578?–1650*, 22 June–1 Sept. 1974, exh. cat. by M.-F. Pérez.

Racalmuto, Chiesa Madre and Chiesa del Monte, *Pietro d'Asaro, il "Monocolo di Racalmuto," 1579–1647*, 1984–85, exh. cat. by M. P. Demma.

C. L. Ragghianti, "Pertinenze francesi nel Cinquecento," *Critica d'arte*, XXVII, 1972, 77–82.

N. Rash Fabbri, "Salvator Rosa's Engraving for Carlo de' Rossi and His Satire 'Invidia,'" *Journal of the Warburg and Courtauld Institutes*, XXXIII, 1970, 328–30.

C. Ratti, *Instruzione di quanto può vedersi di più bello in Genova*, Genoa, 1780.

C. Ratti, *Delle vite de' pittori, scultori, ed architetti genovesi*, Genoa, 1797.

A. Rava, *Marco Pitteri incisore Veneziano*, Florence, 1922.

I. Reale, "In margine alle origini del vedutismo veneto: Luca Carlevarijs el la macchietta," *Arte in Friuli Arte a Trieste*, V–VI, 1982, 117–31.

W. R. Rearick, "Jacopo Bassano's Later Genre Paintings," *Burlington Magazine*, CX, 1968, 241–49.

W. R. Rearick, "Observations on the Venetian Cinquecento in the Light of the Royal Academy Exhibition," *Artibus et Historia*, IX, 1984, 59–75.

L. Reau, *Iconographie de l'art chrétien*, 6 vols., Paris, 1957–59.

D. Redig de Campos, "Una 'Giudetta' opera sconosciuta del Gentileschi nella Pinacoteca Vaticana," *Rivista d'arte*, 2nd ser., XXI, 1939, 311–23.

C. Refice, "Ancora del pittore Bernardo Cavallino," *Emporium*, CXIII, no. 678, 1951, 259–70.

Reggio Emilia, *Mostra di Lelio Orsi*, July–Sept. 1950, exh. cat. by R. Salvini and A. M. Chiodi.

Reggio Emilia, Teatro Valli, *Lelio Orsi*, 5 Dec. 1987–30 Jan. 1988.

B. Riccio, "Ancora sul Mola," *Arte illustrata*, no. 51, 1972, 403–11.

Richmond, Virginia Museum of Fine Arts, *A Brief Chronicle of the Twenty-fifth Birthday Celebration and Catalogue of the Anniversary Loan Exhibition: Treasures in America*, 13 Jan.–5 Mar. 1961.

G. M. Richter, "A Portrait of Ferruccio by Sebastiano Veneziano," *Burlington Magazine*, LXIX, 1936, 88–91.

C. Ridolfi, *Le Maraviglie dell'arte, ovvero le vite degli illustri pittori veneti*, Venice, 1648; 2nd ed., Padua, 1837; ed. D. Von Hadeln, 2 vols., Berlin, 1914–24.

C. Ripa, *Iconologia*, Rome, 1603; reprint ed., New York, 1970.

M. Rizzatti, *Caravaggio*, I Geni dell'arte series, Milan, 1975.

A. Rizzi, *Luca Carlevarijs*, Venice, 1967.

A. Rizzi, *La Galleria d'arte antica dei musei civici di Udine*, Udine, 1969.

A. F. Robbins, "Humphrey Morice," in *The Dictionary of National Biography*, 1963–64 ed., XIII, 941–43.

R. Roli, *Alessandro Magnasco*, I Maestri del colore series, no. 59, Milan, 1964.

R. Roli, *Alejandro Magnasco*, trans. J. L. Pacheco, Buenos Aires, c. 1964.

R. Roli, *Pittura bolognese, 1650–1800, dal Cignani ai Gandolfi*, Fonte e studi per la storia di Bologna e delle province emiliane e romagnole, no. 6, Bologna, 1977.

M. Romani, *Lelio Orsi*, Modena, 1984.

Rome, Palazzo Massimo alle Colonne, *I Bamboccianti, pittori della vita popolare nel seicento*, May 1950, exh. cat. by G. Briganti.

Rome, Galleria dell'Obelisco, *Monsù Desiderio*, 1950, exh. cat. by G. Urbani.

Rome, Palazzo Venezia, *Seconda mostra delle opere d'arte recuperate in Germania*, 1950, exh. cat. by R. Siviero.

Rome, Galleria Nazionale di Palazzo Barberini, *Pittori napoletani del seicento e del settecento*, Apr.–May 1958, exh. cat. by N. di Carpegna.

Rome, *Il Settecento a Roma*, 19 Mar.–31 May 1959.

Rome, Palazzo Venezia, *Cavalier d'Arpino*, 1973, exh. cat. by H. Röttgen.

Rome, Accademia di Francia a Roma, *I Caravaggeschi francesi* (also Paris, Grand Palais, *Valentin et les Caravaggesques français*), 1973–74, exh. cat. by A. Brejon de Lavergnée and J.-P. Cuzin, introduction by J. Thuillier.

Rome, Palazzo Venezia, *Quadri romani tra Cinquecento e Seicento. Opere restaurate e da restaurare*, 1979, exh. cat. by C. Strinati.

Rome, Accademia di Francia a Roma (also Nancy, Musée des Beaux-Arts), *Claude Lorraine e i pittori lorenesi in Italia nel XVII secolo*, 1982, exh. cat. by J. Thuillier.

Rome, Calcografia Nazionale, *L'Immagine di San Francesco nella Controriforma*, 1982–83.

Rome, Régine's Gallery, *In proscenio*, 1984, exh. cat. by M. Marini.

Rome, Galleria Romana dell'Ottocento, *Il Gran Tour nelle vedute italiane di Salomon Corrodi, pittore svizzero (1810–1892)*, 1985.

M. Rooses, *L'Oeuvre de P. P. Rubens*, Antwerp, 1886–92; reprint ed., Soest, The Netherlands, 1977.

M. Rosci, *Baschenis, Bettera e Co.: Produzione e mercato della natura morta del seicento in Italia*, Milan, 1971.

M. Rosci, "Italia," in *Natura in posa: La Grande Stagione della natura morta europea*, Milan, 1977, 83–112.

M. Rosci, "Il Nodo caravaggesco: cinquant' anni fra Roma, Napoli, e Lucca e trent' anni di filologia italiana," in *Storia dell'arte italiana*, Turin, 1982, pt. 3, vol. 4, 90–97.

P. Rosenberg, review of Ottani Cavina, 1968, in *Revue de l'art*, no. 11, 1971, 106–7.

P. Rosenberg, "France in the Golden Age: A Postscript," *Metropolitan Museum of Art Journal*, XVII, 1982, 23–46.

M. Röthlisberger, *Claude Lorraine, the Paintings*, 2 vols., New Haven, 1961.

M. Röthlisberger, "A la recherche d'Adriaen Honig," *Bulletin of the National Gallery of Canada*, no. 4, 1964, 16–21.

H. Röttgen, *Il Caravaggio, ricerche e interpretazione*, Rome, 1974.

B. Rowland, "A Fresco Cycle from Spoleto," *Art in America*, XIX, 1931, 225–30.

W. Roworth, "Hartford, Connecticut: Baroque Portraiture," exh. review in *Burlington Magazine*, CXXVII, 1985, 406.

W. Roworth, "The Consolations of Friendship: Salvator Rosa's Self-Portrait for Giovanni Battista Ricciardi," *Metropolitan Museum of Art Journal*, XXIII, 1988, 103–24.

S. Rudolph, "Contributo per Pier Francesco Mola," *Arte illustrata*, nos. 15–16, 1969, 10–25.

S. Rudolph, "Pier Francesco Mola: La Monografia de R. Cocke e nuovi contributi," *Arte illustrata*, no. 50, Sept. 1972, 346–50.

S. Rudolph, "Primato di Domenico Corinella Roma del secondo settecento," *Labyrinthos*, I, 1982, 145.

E. Russo de Caro, "Quando dagli abiti si riconosce la committenza," *Tempo*, 12 Sept. 1987, 1.

E. Sack, *G. B. und D. Tiepolo*, Hamburg, 1910.

E. Safarik, "Riflessioni su *La Pittura veneziana del seicento* di Rodolfo Pallucchini," *Arte veneta*, XXXVII, 1983, 254–64.

E. Safarik, *Fetti*, Milan, 1990.

L. Salerno, "Per Sisto Badalocchio e la cronologia di Lanfranco," *Commentari*, IX, 1958, 44–64.

L. Salerno, *Salvator Rosa*, Milan, 1963.

L. Salerno, "Il Dissenso nella pittura," *Storia dell'arte*, no. 5, 1970, 35–65.

L. Salerno, "Salvator Rosa: Postille alla mostra di Londra," *Arte illustrata*, VI, 55–56, 1973, 408–14.

L. Salerno, "Salvator Rosa at the Hayward Gallery," *Burlington Magazine*, CXV, 1973, 827–31.

L. Salerno, *L'Opera completa di Salvator Rosa*, Classici d'arte series, no. 82, Milan, 1975.

L. Salerno, *Pittori di paesaggio del seicento a Roma/Landscape Painters of the Seventeenth Century in Rome*, trans. by C. Whitfield and C. Enggass, 2 vols., Rome, c. 1977–80.

L. Salerno, "Four Witchcraft Scenes by Salvator Rosa," *Bulletin of the Cleveland Museum of Art*, LXV, 1978, 224–31.

L. Salerno, "Caravaggio: A Reassessment," *Apollo*, CXIX, 1984, 438–41.

L. Salerno, *La Natura morta italiana, 1560–1805/Still-Life Painting in Italy, 1560–1805*, Rome, 1984.

L. Salerno, *I Dipinti del Guercino*, Rome, 1988.

M. Salmi, "Bernardino Butinone, I–II," *Dedalo*, X, 1928–29, 336–60, 395–426.

M. Salmi, *Il Palazzo dei Cavalieri e la Scuola Normale Superiore di Pisa*, Bologna, 1932.

M. Salmi, "Chiosa signorelliana," *Commentari*, IV, 1953.

V. de Sambricio, *Francisco Bayeu*, Madrid, 1955.

F. J. Sánchez Cantón, *Dibujos españoles*, II, Madrid, 1930.

F. J. Sánchez Cantón, *Escultura y pintura del siglo XVIII: Francisco Goya*, Madrid, 1965.

E. Sandberg-Vavalà, "Maestro Paolo Veneziano," *Burlington Magazine*, LVII, 1930, 160–83.

San Francisco, California Palace of Fine Arts, *Golden Gate International Exposition*, 1940.

San Francisco, California Palace of the Legion of Honor, *Exhibition of Italian Baroque Painting, Seventeenth and Eighteenth Centuries*, 1941.

San Francisco, California Palace of the Legion of Honor, *Illusionism and Trompe l'Oeil*, 1949.

Sarasota, John and Mable Ringling Museum of Art, *The Fantastic Visions of Monsù Desiderio*, Feb. 1950, exh. cat. by A. Scharf.

Sarasota, John and Mable Ringling Museum of Art, *The Art of Eating*, 29 Jan.–7 Mar. 1956.

Sarasota, John and Mable Ringling Museum of Art (also Hartford, Wadsworth Atheneum), *A. Everett Austin, Jr.: A Director's Taste and Achievement*, 23 Feb.–30 Mar. 1958.

Sarasota, John and Mable Ringling Museum of Art (also Hartford, Wadsworth Atheneum), *Baroque Portraiture in Italy: Works from North American Collections*, 7 Dec. 1984–3 Feb. 1985, exh. cat. by J. T. Spike.

S. Savini-Branca, *Il Collezionismo nel seicento*, Padua, 1965.

F. Saxl, *Antike Götter in der Spätrenaissance*, Leipzig and Berlin, 1927.

F. Saxl, "The Battle Scene without a Hero: Aniello Falcone and His Patrons," *Journal of the Warburg and Courtauld Institutes*, III, 1939–40, 70–87.

F. Scanelli, *Il Microcosmo della pittura*, Cesena, 1657.

C. Scano, *Michel Angelo io pittore da Caravaggio: La sua vita, i suoi tempi, il Seicento*, Milan, 1977.

G. Scavizzi, "Michelangelo Cerquozzi," in *Dizionario biografico degli Italiani*, Rome, 1979, XXIII, 801–5.

G. Scavizzi, "Viviano Codazzi," in *Dizionario biografico degli Italiani*, Rome, 1982, XXVI, 578–80.

G. Scavizzi, "Domenico Corvi," in *Dizionario biografico degli Italiani*, Rome, 1983, XXIX, 824–27.

A. Scharf, "Francesco Desiderio," *Burlington Magazine*, XCII, 1950, 18–21.

E. Scheyer, "Alessandro Magnasco," *Apollo*, XXVIII, 1938, 66–71.

A. Schiaparelli, *La Casa fiorentina e i suoi arredi nei secoli XIV e XV*, Florence, 1908.

E. Schleier, "Lanfranco's 'Notte' for the Marchese Sannesi and Some Early Drawings," *Burlington Magazine*, CIV, 1962, 246–57.

P. Schubring, *Cassoni*, 2nd ed., Leipzig, 1923.

L. Schudt, *Caravaggio*, Vienna, 1942.

J. Schulz, *Venetian Painted Ceilings of the Renaissance*, Berkeley and Los Angeles, 1968.

G. Schurhammer, *Franz Xaver, sein Leben und seine Zeit*, Freiburg, 1955–73.

G. Schurhammer, "Das wahre Bild des hl. Franz Xaver," in *Gesammelte Studien: Varia. Bibliotheca Instituti Historici S. I.*, Rome, 1965, XXIII, 213–15.

S. Schwartz, "Not Happy to Be Here," *New Yorker*, Sept. 1985, 75–81.

Seattle, Seattle Art Museum, *Caravaggio and the Tenebrosi*, 8 Apr.–13 June 1954, no cat.

Seattle, Seattle World's Fair, Century 21 Exposition, *Masterpieces of Art*, 1962.

R. Sedgwick, *The History of Parliament: The House of Commons, 1715–1754*, 2 vols., New York, 1970.

Il Seicento nell'arte e nella cultura con referimenti a Mantova, papers of the Convegno internazionale di studi held in Mantua in 1983, Milan 1985.

L. Servolini, *Sebastiano ceccarini*, Milan, 1959.

G. Sestieri, "Michele Rocca," *Quaderni di emblema*, II, 1973, 83–95.

C. Seymour, Jr., *Early Italian Paintings in the Yale University Art Gallery*, New Haven, 1970.

F. R. Shapely, *Italian Paintings from the Samuel H. Kress Collection, Italian Schools XIII-XV Century*, London, 1966; *Italian Schools XV-XVI Century*, London, 1968; *Italian Schools XVI-XVIII Century*, London, 1973.

F. R. Shapely, *Catalogue of the Italian Paintings*, National Gallery of Art, 2 vols., Washington, 1979.

J. Shearman, "A Manuscript Illustrated by Bacchiacca," in *Studies in Late Medieval and Renaissance Paintings in Honor of Millard Meiss*, ed. I. Lavin and J. Plummer, New York, 1977, I, 399–402.

J. Shearman, *The Early Italian Pictures in the Collection of Her Majesty the Queen*, Cambridge, 1983.

C. Shell, "Giovanni dal Ponte and the Problem of Other Lesser Contemporaries of Masaccio," Ph.D. diss., Harvard University, 1958.

A. Shield, *Henry Stuart, Cardinal Duke of York, and His Times*, London, 1908.

R. Shoolman and C. Slatkin, *The Enjoyment of Art in America*, Philadelphia and New York, 1942.

G. Silk and A. Greene, *Museums Discovered: The Wadsworth Atheneum*, Fort Lauderdale, 1982.

E. Siple, "Recent Acquisitions in America," *Burlington Magazine*, LXXI, 1932, 110.

B. Skinner, *Scots in Italy in the Eighteenth Century*, Edinburgh, 1966.

S. Slive, "Dutch Pictures in the Collection of Cardinal Silvio Valenti Gonzaga (1690–1756)," *Simiolus*, XVII, no. 2/3, 1987, 169–90.

F. Sluys, *Didier Barra et François de Nomé, dits Monsù Desiderio*, Paris, 1961.

P. Sohm, "Pietro Longhi and Carlo Goldoni: Relations between Painting and Theater," *Zeitschrift für Kunstgeschichte*, XLV, 1982, 256–73.

C. Someda de Marco, *Il Museo civico e le gallerie d'arte antica e moderna di Udine*, Udine, 1956.

M. Soria, "A Catalogue of Spanish Paintings, Done between 1550–1850, in the United States and Canada," Ph.D. diss., Harvard University, 1947.

M. Soria, "Firmas de Luis Egidio Meléndez," *Archivo Español de Arte*, LXXXIII, 1948, 215.

M. Soria, *The Paintings of Zurbarán*, London, 1953; 2nd ed., London, 1955.

M. Soria, "Velasquez and Vedute Painting in Italy and Spain, 1620–1750," *Arte antica e moderna*, Essays in Honor of Roberto Longhi's Seventieth Birthday, 1961.

R. Soria, *Dictionary of Nineteenth-Century American Artists in Italy, 1760–1914*, Rutherford and London, c. 1982.

R. E. Spear, "Unknown Pictures by the Caravaggisti with Notes on 'Caravaggio and His Followers,'" *Storia dell'arte*, no. 14, 1972, 150–60.

R. E. Spear, *Domenichino*, 2 vols., New Haven, 1982.

R. E. Spear, "Stocktaking in Caravaggio Studies," *Burlington Magazine*, CXXVI, 1984, 162–65.

R. E. Spear, "Domenichino Addenda," *Burlington Magazine*, CXXXI, 1989, 5–16.

L. Spezzaferro, "La Cultura del cardinale del Monte e il primo tempo di Caravaggio," *Storia dell'arte*, nos. 9–10, 1971, 57–92.

L. Spezzaferro, "Detroit's 'Conversion of the Magdalen' (The Alzaga Caravaggio), 4. The Documentary Findings: Ottavio Costa as a Patron of Caravaggio," *Burlington Magazine*, CXVI, 1974, 579–87.

L. Spezzaferro, "Ottavio Costa e Caravaggio: Certezze e problemi," in *Novità sul Caravaggio*, Milan, 1975, 103–18.

J. T. Spike, "A 'Voyage of Rebecca,' Signed and Dated by Francesco Castiglione," *Burlington Magazine*, CXXII, 1980, 348–49.

J. T. Spike, review of Bissell, 1981, in *Art Bulletin*, LXI, 1984, 696–98.

J. T. Spike, "The Age of Caravaggio," *Apollo*, CXXI, 1985, 415–17, a review of the 1985 New York/Naples exhibition.

G. Spinelli, *L'Abbazia di Montecassino, storia, religione, arte*, introduction by B. d'Onorio, Rome, 1982.

N. Spinosa, *L'Opera completa del Ribera*, Milan, 1978.

N. Spinosa, *La Pittura napoletana del seicento*, Milan, 1984.

Springfield, Mass., Museum of Fine Arts, *Opening Exhibition*, 7 Oct.–2 Nov. 1933.

Springfield, Mass., Museum of Fine Arts, *Alessandro Magnasco, c. 1677–1749*, 12 Jan.–6 Feb. 1938.

T. J. Standring, "Genium Io: Benedicti Castilionis Ianuen. The Paintings of Giovanni Benedetto Castiglione (1609–1663/65)," Ph.D. diss., University of Chicago, 1982.

T. J. Standring, "A Signed 'Penitence of St. Peter' by G. B. Castiglione," *Burlington Magazine*, CXXVII, 1985, 160–61.

T. J. Standring, "Giovanni Benedetto Castiglione, il Grechetto," in *La Pittura a Genova e in Liguria*, Genoa, 1987, 2nd ed. rev., vol. 2, *Dal Seicento al primo Novecento*, 151–81.

T. J. Standring, review of Bellini, 1982, in *Print Quarterly*, IV, 1987, 65–73.

Statens Museum for Kunst, *Royal Museum of Fine Arts, Catalogue of Old Foreign Paintings*, Copenhagen, 1951.

C. Sterling, *La Nature morte de l'antiquité à nos jours*, Paris, 1952; rev. ed., Paris, 1959; 2nd rev. ed., New York, 1981.

Stiftung Sammlung Emil G. Bührle, Zurich and Munich, 1973; entries on Italian and Spanish sixteenth- to eighteenth-century masters by R. Kultzen.

A. Stix and E. Strohmer, *Die Fürstlich Liechtensteinische Gemäldegalerie in Wien*, Vienna, 1938.

Storrs, Conn., William Benton Museum of Art, *The Academy of Europe: Rome in the Eighteenth Century*, 13 Oct.–21 Nov. 1973, exh. cat. by F. den Broeder.

M. Stoughton, "The Paintings of Giovanni Battista Caracciolo," Ph.D. diss., University of Michigan, 1973.

M. Stoughton, "Giovan Battista Caracciolo: New Biographical Documents," *Burlington Magazine*, CXX, 1978, 204–5.

W. Suida, "Die Werke des Cav. Giuseppe Petrini von Carona," *Anzeiger für schweizerische Altertumskunde*, XXXII, 1930, 269–80.

S. Susinno, "I Ritratti degli accademici," in *L'Accademia Nazionale di San Luca*, Rome, 1974, 201–70.

G. Syamken, "Die Bildinhalte des Alessandro Magnasco, 1667–1749," diss., University of Hamburg, 1965.

S. Symeonides, *Taddeo di Bartolo*, Siena, 1965.

F. M. Tassi, *Vite de' pittori, scultori, e architetti bergamaschi*, 2 vols., Bergamo, 1793.

F. H. T[aylor], "Rainaldictus Fresco Painter of Spoleto," *Worcester Art Museum Bulletin*, XXII, no. 4, 1932, 76–99.

C. Tellini Perina, "Schede per il settecento lombardo: Petrini, Pado Borroni, Londonio," *Arte lombarda*, XVI, 1971, 321–22.

P. J. J. van Thiel et al., *All the Paintings of the Rijksmuseum in Amsterdam*, Amsterdam, 1976.

U. Thieme and F. Becker, *Allgemeines Lexikon der bildenden Künstler von der Antike bis zur Gegenwart*, 37 vols., Leipzig, 1908–50.

H. Tietze, *Masterpieces of European Painting in America*, New York, 1939.

H. Tietze, *Tintoretto*, New York, 1948.

H. Tietze, "Bozzetti di Jacopo Tintoretto," *Arte veneta*, V, 1951, 55–64.

L. Tognoli, *G. F. Cipper, il "Todeschini," e la pittura di genere*, Bergamo, 1976.

Toledo, Spain, *El Toledo de El Greco*, 1982.

Toledo, Toledo Museum of Art, *Four Centuries of Venetian Painting*, Mar. 1940, exh. cat. by H. Tietze.

Toledo, Toledo Museum of Art, *Spanish Painting*, 1941.

Toledo, Toledo Museum of Art (also Madrid, Museo del Prado), *El Greco of Toledo*, 1982, exh. cat. by J. Brown and W. Jordan.

P. Tomory, *The John and Mable Ringling Museum of Art. Catalogue of the Italian Paintings before 1800*, Sarasota, 1976.

Toronto, Art Gallery of Ontario, *Loan Exhibition of Paintings Celebrating the Opening of the Margaret Eaton Gallery and the East Gallery*, Nov. 1935.

Toronto, Art Gallery of Ontario, *Fifty Paintings by Old Masters*, 1950.

Toronto, Art Gallery of Ontario (also Ottawa, National Gallery of Canada and Montreal, Museum of Fine Arts), *Canaletto*, 17 Oct.–15 Nov. 1964, exh. cat. by W. G. Constable.

Toronto, Art Gallery of Ontario, *Drawings in the Collections of the Art Gallery of Ontario*, 1970, exh. cat. by W. Vitzthum.

R. Torres Martín, *Zurbarán, el pintor gótico del siglo XVII*, Seville, 1963.

P. Torriti, *La Pinacoteca nazionale di Siena: I Dipinti dal XV al XVIII secolo*, Genoa, 1978.

P. Torriti, "Apporti toscani e lombardi," in *La Pittura a Genova e in Liguria*, Genoa, 1987, 2nd ed. rev., vol. 2, *Dal Seicento al primo Novecento*, 13–58.

B. Toscano, *Spoleto in Pietre*, Spoleto, 1963.

E. Du Gué Trapier, *Eugenio Lucas y Padilla*, New York, 1940.

E. Du Gué Trapier, *Ribera*, New York, 1952.

E. Du Gué Trapier, *Valdés Leal. Baroque Concept of Death and Suffering in His Paintings*, New York, 1956.

E. Du Gué Trapier, *El Greco: Early Years at Toledo, 1576–1586*, New York, 1958.

E. Du Gué Trapier, *Valdés Leal*, New York, 1960.

E. Du Gué Trapier, "Figures in a Landscape by Martínez del Mazo or His School," *Wadsworth Atheneum Bulletin*, Winter 1963, 7–10.

E. Du Gué Trapier, "Martínez del Mazo as a Landscapist," *Gazette des Beaux-Arts*, 1963, 293–310.

B. Treffers, "Il Francesco Hartford del Caravaggio e la spiritualità francescana alla fine del XVI secolo," *Mitteilungen des kunsthistorischen Instituts in Florenz*, XXXII, nos. 1–2, 1988, 145–72.

M. Trens, *María: Iconografía de la Virgen en el arte español*, Madrid, 1947.

E. Tufts, "Luis Meléndez. Documents on His Life and Work," *Art Bulletin*, LIV, 1972, 63–68.

E. Tufts, *Luis Meléndez: Eighteenth-Century Master of the Spanish Still Life, with a Catalogue Raisonné*, Columbia, Mo., 1985.

E. H. T[urner], "A Painting by Domenico Fetti," *Wadsworth Atheneum Bulletin*, Nov. 1955, 1.

N. Turner, *Florentine Drawings of the Sixteenth Century*, London, 1986.

C. van Tuyll, "Badalocchio's 'Entombment of Christ' from Reggio: A New Document and Some Related Paintings," *Burlington Magazine*, CXXII, 1980, 180–86.

C. van Tuyll, "Badalocchio in America: Three New Works," *Burlington Magazine*, CXXV, 1983, 469–76.

C. van Tuyll, "The Montalto 'Alexander' Cycle Again. The Contribution of Badalocchio," *Paragone*, no. 393, 1983, 62–67.

Gli Uffizi: Catalogo generale, Florence, 1979.

H. Ulmann, "Piero di Cosimo," *Jahrbuch der königlich preuszischen Kunstsammlungen*, XVII, 1896, 53, 120–22.

J. Urrea Fernández, *La Pintura italiana del siglo XVIII en España*, Valladolid, 1977.

Valencia, La Lonja (also Madrid, Museo del Prado), *Los Ribalta y la Pintura Valenciana de su Tiempo*, Oct.–Nov. 1987, exh. cat. by F. Benito Domenech.

G. Vasari, *Le Vite de' più eccellenti pittori, scultori, ed architettori scritte da Giorgio Vasari, pittore aretino*, Florence, 1550; 2nd ed., Florence, 1568; ed. G. Milanesi, 9 vols., Florence, 1906.

H. M. Vaughn, *The Last of the Royal Stuarts, Henry Stuart, Cardinal Duke of York*, London, 1906.

Venice, *Mostra del Tiepolo*, 16 June–7 Oct. 1951, exh. cat. by G. Lorenzetti.

Venice, Palazzo Ducale, *I Vedutisti veneziani del settecento*, 10 June–15 Oct. 1967.

Venice, Palazzo Ducale, *Tiepolo, tecnica e immaginazione*, July–Sept. 1979, exh. cat. by G. Knox.

Venice, Foundation Giorgio Cini, *Canaletto: Disegni, dipinti, incisioni*, 1982, exh. cat. by A. Bettagno.

Venice, Ca' Loredan Vendramin Calergi, *Giambattista Piazzetta*, 1983.

Venice, Fondazione Giorgio Cini, *G. B. Piazzetta*, 23 July–6 Oct. 1983, exh. cat. by A. Bettagno et al.

Venice, Fondazione Giorgio Cini, *Bernardo Bellotto. Le vedute di Dresda*, 4 Sept.–9 Nov. 1986, exh. cat. by A. Walther et al.

Venice, Ca' Pesaro, *Canaletto e Visentini*, 18 Oct. 1986–6 Jan. 1987, exh. cat. by D. Sueci.

A. Venturi, *La Reale Galleria Estense in Modena*, Modena, 1882.

A. Venturi, *Storia dell'arte italiana*, 11 vols., Milan, 1901–40.

A. Venturi, *Studi dal vero attraverso le raccolte artistiche d'Europa*, Milan, 1927.

A. Venturi, "Un Quadro ignorato di Michelangelo da Caravaggio," *Arte*, XXXI, 1928, 58–59.

L. Venturi, *Pitture italiane in America*, Milan, 1931.

L. Venturi, *Italian Paintings in America*, trans. Countess vanden Heuvel and C. Marriott, 3 vols., New York and Milan, 1933.

L. Venturi, *Il Caravaggio*, 2nd ed. rev., Novara, 1963.

G. Verci, *Notizie intorno alla vita e alle opere de' pittori, scultori, e intagliatori della città di Bassano*, Bassano, 1775.

G. Vergani, "Nuove considerazione sul ciclo di affreschi attribuito a Bernardo Butinone nella chiesa di S. Maria Maddalena a Camuzzago," *Arte lombarda*, LXXIII–LXXV, 1985, 31–44.

Verona, Museo del Castelvecchio, *Bernardo Bellotto, Verona e la città europee*, 15 June–16 Sept. 1990.

L. Vertova, "Il Maestro della pala Bagatti Valsecchi," *Antichità viva*, VIII, no. 1, 1969, 3–14.

G. Vertue, *Notebooks*, Volume of the Walpole Society, XXII, Oxford, 1933–34.

L. Viardot, *Les Musées d'Allemagne et de la Russie*, Paris, 1844.

Vienna, Palais Pallavicini, *Ausstellung italienische Barockmalerei*, exhibition arranged by the Galerie Sanct Lucas, 14 May–15 June 1937.

M. Villani, "Ricostruzione di un ciclo di affreschi di Lelio Orsi," *Arte antica e moderna*, I, 1958, 170–76.

G. Vio, "Per la datazione del 'telero' del Forabosco a Malamocco," *Arte veneta*, XXXVIII, 1984, 202–3.

W. Vitzthum, "Dessins de Pietro da Cortona pour la Chiesa Nuova à Rome," *Oeil*, no. 83, 1961, 62–67, 92.

W. Vitzthum, "Luca Giordano," *Burlington Magazine*, CXII, 1970, 239–44.

W. Vitzthum, *Il Barocco a Napoli e nell'Italia meridionale*, Milan, 1971.

M. Vloberg, "Iconography of the Immaculate Conception," in *The Dogma of the Immaculate Conception: History and Significance*, ed. E. D. O'Connor, Notre Dame, 1958.

H. Vollmer, "Jacopo Zucchi," in Thieme and Becker, 1947, XXXVI, 578.

C. Volpe, "Il Politico di Paolo Veneziano," in *Il Tempio di S. Giacomo Maggiore in Bologna*, Bologna, 1967, 87–91.

C. Volpe, "Annotazioni sulla mostra di Cleveland," *Paragone*, no. 263, 1972, 50–76.

C. Volpe, "Una Proposta per Giovanni Battista Crescenzi," *Paragone*, no. 275, 1973, 25–36.

C. Volpe and M. Lucco, *L'Opera completa di Sebastiano del Piombo*, Milan, 1980.

H. Voss, *Die Malerei des Barock in Rom*, Berlin, 1925.

H. Voss, "Studien zur venezianischen Vedutenmalerei des 18. Jahrhunderts," *Repertorium für Kunstwissenschaft*, XLVII, 1926, 1–45.

H. Voss, "Salvator Rosa," in Thieme and Becker, 1935, XXIX, 1–3.

H. Voss, "A Re-Discovered Picture by Alessandro Magnasco," *Burlington Magazine*, LXXI, 1937, 171–77.

H. Voss, "Die Caravaggio Ausstellung in Mailand," *Kunstchronik*, July 1951, 165–69.

S. Vsevolozhskaya and I. Linnik, *Caravaggio and His Followers*, trans. V. Vorontsov and Y. Nemetsky, Leningrad, 1975.

G. F. Waagen, *Treasures of Art in Great Britain*, trans. Lady Eastlake, 3 vols., London, c. 1854.

G. F. Waagen, *Galleries and Cabinets of Art in Great Britain*, a fourth and supplemental volume to Waagen, c. 1854, London, 1857.

M. R. Waddingham, "An Important Saraceni Discovery," *Paragone*, nos. 419–23, 1985, 219–24.

Wadsworth Atheneum Bulletin, a generic title used here for the museum publication that appeared as the *Bulletin of the Wadsworth Atheneum*, 1922–33; superseded by the *Wadsworth Atheneum Bulletin*, 1934; superseded by *The Wadsworth Atheneum News Bulletin*, 1935–44; superseded by the *Bulletin Wadsworth Atheneum*, 1944–48; continued by the *Wadsworth Atheneum Bulletin*, 1948–66; superseded by the *Bulletin of the Wadsworth Atheneum*, 1967–72.

Wadsworth Atheneum Handbook, Hartford, 1958.

H. Wagner, Michelangelo da Caravaggio, Bern, 1958.

R. Wallace, *The Etchings of Salvator Rosa*, Princeton, 1979.

H. Walpole, *Aedes Walpolianae, or a Description of the Collection of Pictures at Houghton Hall in Norfolk*, 2nd ed., London, 1752.

H. Walpole, *Anecdotes of Painting in England*, London, 1765–71; ed. R. Wornum, London, 1849.

Washington, D.C., National Gallery of Art (also Parma, Galleria Nazionale), *Correggio and His Legacy: Sixteenth-Century Emilian Drawings*, 11 Mar.–13 May 1984, exh. cat. by D. DeGrazia.

Washington, D.C., National Gallery of Art (also New York, Metropolitan Museum of Art, and Bologna, Pinacoteca Nazionale), *The Age of Correggio and the Carracci*, 19 Dec. 1986–16 Feb. 1987.

Washington, D.C., National Gallery of Art, *The Art of Paolo Veronese, 1528–1588*, 13 Nov. 1988–20 Feb. 1989, exh. cat. by W. R. Rearick.

E. Waterhouse, *Italian Baroque Painting*, 2nd ed., New York, 1969.

S. Weber, "Der Tessiner Maler Cav. Giuseppe Petrini," *Anzeiger für schweizerische Altertumskunde*, X, no. 3, 1908, 237–50.

E. Weddigen, "Jacopo Tintoretto und die Musik," *Artibus et Historiae*, X, 1984, 67–119.

Wellesley, Mass., Wellesley College, Museum of Art, *Salvator Rosa in America*, 20 Apr.–5 June 1979, exh. cat. by R. Wallace.

A. Werner, review of Cleveland, 1971–72, in *Pantheon*, XXX, 1972, 69–70.

P. Wescher, "The 'Reversed World' in Pictures of an Eighteenth-Century Venetian Painter," *Art International*, X, no. 1, 20 Jan. 1966, 50–52.

Westport, Conn., Westport Community Art Association, Kipnis Gallery, *Italian Masters*, 14–22 Feb. 1955.

Westport, Conn., Westport Community Art Association, Kipnis Gallery, *Spanish Masters through the Centuries*, 6–18 Nov. 1955.

Westport, Conn., Westport Community Art Association, Westport Public Library, *Still-Life Paintings Loan Exhibition*, 1958.

H. Wethey, *El Greco and His School*, 2 vols., Princeton, 1962.

H. Wethey, *The Paintings of Titian*, 3 vols., London, 1969–75.

F. Whiting, "The Royal Academy Tondo by Michelangelo," *Connoisseur*, CLXI, 1964, 44–45.

H. and S. Wichman, *Schach: Ursprung und Wandlung der Spielfigur in zwölf Jahrhunderten*, Munich, 1960.

G. C. Williamson, *Francesco Raibolini, called Francia*, London, 1901.

Williamstown, Mass., Clark Art Institute, *Italian Paintings, 1850–1910, from Collections in the Northeastern United States*, 1982, exh. cat. by D. Cass and J. Wetenhall, essay by R. Panczenko.

B. Wind, "Vincenzo Campi and Hans Fugger: A Peep at Late Cinquecento Bawdy Humor," *Arte lombarda*, XLVII–XLVIII, 1977, 108–14.

M. Winner, "Die Quellen der Pictura-Allegorien in gemalten Bildergalerien des 17. Jahrhunderts zu Antwerpen," Ph.D. diss., University of Cologne, 1957.

E. Winternitz, "The Curse of Pallas Athena," in *Studies in the History of Art Dedicated to William E. Suida on His Eightieth Birthday*, London, 1959, 186–95.

F. Wittgens, *Vincenzo Foppa*, Milan, 1950.

R. Wittkower, *Art and Architecture in Italy, 1600 to 1750*, Baltimore, 1958; 2nd ed., Harmondsworth, 1965; 3rd ed. rev., 1973.

Worcester, Mass., Worcester Art Museum, *Fiftieth Anniversary Exhibition of the Art of Europe during the XVIth–XVIIth Centuries*, 11 Apr.–16 May 1948.

Worcester, Mass., Worcester Art Museum, *Woman as Heroine*, 15 Sept.–22 Oct. 1972, exh. cat. by D. Minault.

C. Wright, *The French Painters of the Seventeenth Century*, Boston, 1985.

R. Wunder, "Giovanni Paolo Pannini," Ph.D. diss., 2 vols., Harvard University, 1955.

R. Wunder, "Addenda to Elaine Loeffler's 'A Famous Critique,'" *Art Bulletin*, XXXIX, 1957, 291–92.

E. Young, "Vincenzo Damini in England," *Arte veneta*, XXXIII, 1979, 70–78.

M. Sharp Young, "The Ruin of Painting," *Apollo*, XCV, 1972, 60–62.

S. Zamboni, "Vincenzo Campi," *Arte antica e moderna*, XXX, 1965, 133–40.

P. Zampetti, *A Dictionary of Venetian Painters*, 5 vols., Leigh-on-Sea, 1971–74.

A. M. Zanetti, *Della Pittura veneziana e delle opere pubbliche de' veneziani maestri*, Venice, 1771; reprint ed., Venice, 1972.

G. Zanotti, *Storia dell'Accademia Clementina di Bologna*, Bologna, 1739.

F. Zeri, *La Galleria Spada in Roma*, Florence, 1954.

F. Zeri, "Two Contributions to Lombard Quattrocento Painting," *Burlington Magazine*, XCVII, 1955, 74–77.

F. Zeri, *La Galleria Pallavicini in Roma*, Florence, 1959.

F. Zeri, "Rivedendo Piero di Cosimo," *Paragone*, no. 125, 1959, 36–50.

F. Zeri, *Metropolitan Museum of Art. Italian Paintings: Florentine School*, New York, 1971.

F. Zeri, *Diari di lavoro 2*, Turin, 1976.

F. Zeri, *Italian Paintings in the Walters Art Gallery*, 2 vols., Baltimore, 1976.

F. Zeri, "Rivedendo Jacopino del Conte," *Antologia di belle arti*, II, no. 6, 1978, 114–21.

F. Zeri, "Girolamo di Benvenuto: Il Completamento della 'Madonna delle Nevi,'" *Antologia di belle arti*, III, nos. 9–12, 1979, 48–54.

F. Zeri, *The Metropolitan Museum of Art. Italian Paintings: Sienese and Central Italian Schools*, New York, 1980.

Zurich, Kunsthaus, *Unbekante Schönheit*, 9 June–31 July 1956.

Zurich, Kunsthaus (also Rotterdam, Museum Boymans van Beuningen), *Das italienische Stilleben von der Anfängen bis zur Gegenwart*, Dec. 1964–Feb. 1965, exh. cat. by E. Hüttinger.

Subject Index

Berenson, Bernard, 20
Beresford, Samuel, 11
Berman, Eugene, 15, 17, 18
Bernini, Gian Lorenzo, 99, 117
Berrettini, Pietro. *See* Cortona, Pietro da
Bettera, Bartolomeo, 56, 57
Bettera, Bonaventura, 56
Biagio di Antonio, 125 n. 18
Bianchini, Bartolommeo (Bergamask painter), 152
Bianchini, Bartolommeo, portrait of (Francia), 145
Bibiena, Ferdinando, 184
Bibiena, Francesco, 276
Bicci, Neri di, 264
Bicci di Lorenzo, 264
Bigari, Vittorio Maria, 276; *Convito di Baldassare*, 276 n. 8;
 Disputa tra Filippo di Macedonia e Alessandro, 276 n. 8;
 Sacrificio a Venere, 276 n. 8
Biliverti, Giovanni, 271
Birth of John the Baptist, The? (Giordano follower?), 159, illus.
 on 159
Birth of the Virgin (Caracciolo), 82
Bison, Giuseppe Bernardino, 179
Bles, Henri met de, 141 n. 10
Bloemaert, Abraham, 258
Bocchi, Faustino, 277
Bologna, Giovanni: *Astronomy*, 259; *Hercules and Antaeus*, 276
Bologna, Vitale da, 251
Bolognese classicism, 14, 18, 81, 104, 126, 135, 157
Bombelli, Sebastiano, 152
Bonechi, Matteo, 219
Boniface, IX, pope, 260
Bonifacio de' Pitati, 58, 244
Bononi, Carlo, 223, 224
Bonzi, Pier Paolo, 93, 95
Bordone, Paris, 244
Borgherini, Salvi, 46
Borghese, Cardinal Pietro Maria, portrait of (Pietro da
 Cortona), 273
Borghese, Cardinal Scipione, 94
Borras, Fray Nicolás, 295 n. 10
Borroni, Paolo, 106; personification of Summer, 106
Bosch follower: *Temptation of St. Anthony*, 18
Boscovich, R. G., 190 n. 24
Bosio, Giacomo, portrait of (El Greco), 290
Bottani, Giuseppe, 278
Botticelli, Sandro, 264
Boucher, François, 210
Boy Bitten by a Lizard (Caravaggio), 95, 320
Boy Eating a Fruit (Caravaggio), 91 n. 27
Boy Holding a Lemon (Piazzetta), 194
Boy in a Polish Uniform (Piazzetta), 196 n. 11
Boy Peeling Fruit (Caravaggio), 87
Boy with a Basket of Fruit (Caravaggio), 94, 95
Boy with a Flute (Maggiotto), 196 n. 8
Boy with a Pear in His Hand (Piazzetta), 94–96, illus. on 195
Boy with a Pug Dog (Ceruti), 106, 109, illus. on 108
Braque, Georges, 17
Bramante, Donato, 205
Bramantino: *Nativity with Saints*, 73
Brandi, Domenico, 211
Brandi, Giacinto, 208, 286
Brass, Italico, 15, 230, 232
Breton, André, 15
Brill, Paul, 180
Brughel, Abraham, 207, 228 n. 2
Brughel, Jan Velvet, the Elder, 18, 92, 96 nn. 3 and 35, 207
Bruhl, Count Heinrich, 66, 68
Brustolon, Andrea, 163
Bueckalaer, Joachim, 266
Building of the Trojan Horse, The (G. D. Tiepolo; Hartford), 20,
 240–41, illus. on 240

Building of the Trojan Horse (G. D. Tiepolo; London), 240, fig. 45
Bullfight: The Divided Bull Ring (Lucas the Elder), 296
Buonaccorso, Niccolò di, 68–70; *The Annunciation* (workshop),
 68, 70, illus. on 69; *Coronation of the Virgin*, 68; *Lamentation
 over the Dead Christ* (workshop), 68, fig. 10; *Madonna and Child*,
 68; *Marriage of the Virgin*, 68; *Presentation of the Virgin*, 68; *S.
 Lorenzo*, 68
Buonaccorso di Pace, 68
Burckhardt, Jacob, 15
Burial of Count Orgaz (El Greco), 290
Burial of St. Petronilla (Guercino), 165
Burrini, Giovan Antonio, 126
Butinone, Bernardino, 11, 70–73; *The Crucifixion and Other
 Scenes* (circle of Butinone), 70, 73, illus. on 71 and 72;
 Madonna and Child with St. Vincent and St. Bernardino, 70;
 Treviglio polyptych, 70, 73
Butterflies (Ernst), 18
Byk, Paul, 16, 19

Cabanyes, Maestro de, 293
Cagnacci, Guido, 144
Cain and Abel (G. B. Castiglione), 100, 101
Caliari, Benedetto, 255; *Meeting of Joachim and Anna*, 255 n. 6
Caliari, Carletto, 255; *Marriage of the Virgin* (attributed to
 Caliari), 255, 256 n. 9, fig. 51
Caliari, Gabriele, 255
Caliari, Paolo. *See* Veronese, Paolo
Callot, Jacques, 111, 180
Calvaert, Denys, 135
Cambi, Lorenzo, 314
Cambiaso, Carlo, 150
Cambiaso, Michelangelo, doge of Venice, 150
Camera ottica, 78
Camille Desmoulins (Robert), 18
Campana, Pietro, 118
Campi, Vincenzo, 266–67; *Fish Vendor* (Kirchheim), 266; *Fish
 Vendor* (Milan), 266; *Fruit Seller*, 267, fig. 59; *Fruit Vendor*
 (Kirchheim), 266; *Fruit Vendor* (Milan), 266; *Kitchen Scene*, 266;
 Poulterer (Kirchheim), 266; *Poulterer* (Milan), 266
Campidoglio, Michelangelo di (Michele Pace), 72–73, 229; *Still
 Life with a Peacock and a Turkey*, 74; *Still Life with Fruit and
 Flowers*, 74, illus. on 74
Campo Vicino (Swanevelt), 110
Canal, Bernardo, 74
Canal, Fiorenza, 66
Canaletto (Giovanni Antonio Canal), 66, 74–78, 97, 111, 163,
 177, 178, 193; *Arch of Constantine* (attributed to Canaletto), 76;
 Capriccio: A Colonnade Opening onto the Courtyard of a Palace, 75;
 Capriccio with Ruins (attributed to Canaletto), 76; *Landscape
 with Ruins*, 75–76, 78, illus. on 77; *Piazza and Piazzetta S.
 Marco*, 78, fig. 11; *Tombeaux des princes* paintings, 75; *Tomb of
 Lord Somers* (with Piazzetta and Cimaroli), 193; *View of the
 Piazza S. Marco, Venice, and the Piazzetta Looking towards S.
 Giorgio Maggiore*, 78, fig. 12; *View of Venice: Piazza and Piazzetta
 S. Marco*, 78, 79, 81, illus. on 79
Candida, Alfredo, 206
Canigiani Madonna (Raphael), 293 n. 1
Cano, Alonso, 328
Canova, Antonio, 120
Canuti, Domenico Maria, 126
Capella, Francesco, 193
Cappuccino, Il. *See* Strozzi, Bernardo
Capriccio: A Colonnade Opening onto the Courtyard of a Palace
 (Canaletto), 75
Capriccio with Ruins (attributed to Canaletto), 76
Caprichos (Goya), 288
Capture of Christ (Badalocchio), 49
Capuchin monastery, Seville, cycles (Murillo), 302
Caracciolo, Giovanni Battista (called Battistello), 81–83, 104; *The
 Annunciation*, 81–82, illus. on 82 and 83; *Birth of the Virgin*, 82;
 Christ Washing the Feet of the Apostles, 81; *The Immaculate Concep-
 tion with Saints Dominic and Francis of Paul*, 81 n. 1; *Januarius
 and Companions Pulling Timothy's Chariot*, 82 n. 11; *Madonna and
 Child*, 82; *Madonna of the Purification of the Soul with Saints*

Maçip, Vicente (son of Juan de Juanes), 293, 295 n. 10

Macomber, Frank Gair, 156

McSwiney, Owen, 75

Madonna Adored by St. James Major and a Donor (Francesco Zucchi), 270 n. 10

Madonna and Child (Taddeo di Bartolo; Cambridge, Mass.), 54

Madonna and Child (Taddeo di Bartolo; Hartford), 54, 56, illus. on 54 and 55

Madonna and Child (Niccolò di Buonaccorso), 68

Madonna and Child (Caracciolo), 82

Madonna and Child Adored by Doge Francesco Dandolo and His Wife Elisabetta Contarini lunette (Paolo da Venezia), 251

Madonna and Child Enthroned with Eight Angels (Paolo da Venezia), 251

Madonna and Child in Glory with St. Anthony of Padua and the Sup. Luigi Morosini (Tinelli), 244

Madonna and Child with a Donor (Previtali; Hartford), 202–4, illus. on 203

Madonna and Child with a Donor (Previtali; London), 202–3; fig. 38

Madonna and Child with a Donor (Previtali; Padua), 203

Madonna and Child with Elizabeth and St. John (Andrea del Sarto), 204

Madonna and Child with Five Angels (Fra Angelico workshop), 44

Madonna and Child with Four Saints (Fra Angelico workshop), 44

Madonna and Child with St. Anne (Saraceni), 220

Madonna and Child with St. Catherine and an Angel (Fra Angelico workshop), 44

Madonna and Child with St. Francis (Francia workshop), 145, illus. on 145

Madonna and Child with St. John (Domenico Puligo; Florence), 205 n. 4

Madonna and Child with St. John (Domenico Puligo; Munich), 205 n. 4

Madonna and Child with St. John and Two Angels (Domenico Puligo; Genoa), 204

Madonna and Child with St. John and Two Angels (Domenico Puligo follower; Hartford), 204–5, illus. on 205

Madonna and Child with St. John the Baptist and an Angel (Domenico Puligo), 204, fig. 39

Madonna and Child with St. Joseph (Francia), 145

Madonna and Child with St. Joseph and Mary Magdalene (J. Bassano), 58

Madonna and Child with St. Peter and St. Paul (Perino del Vaga), 115

Madonna and Child with Saints (L. Bassano), 60

Madonna and Child with Saints (Girolamo workshop), 160

Madonna and Child with Saints Dominic and Peter (Fra Angelico workshop), 44

Madonna and Child with Saints John the Baptist and Catherine (Giovanni dal Ponte), 200, 202, illus. on 28 (color) and 201

Madonna and Child with Saints Joseph, Augustine, Louis, and Francis and a Young Donor (Guercino), 165

Madonna and Child with Saints Roch, Lawrence, John the Baptist, Jerome, and Sebastian (Dosso Dossi), 137

Madonna and Child with Saints Thomas Aquinas, Barnabas, Dominic, and Peter Martyr (Fra Angelico), 42

Madonna and Child with Saints Zeno and John the Baptist (J. Bassano), 58

Madonna and Child with St. Vincent and St. Bernardino (Butinone), 70

Madonna and Child with Magdalene (Jacopino del Conte), 116

Madonna and Child with Two Angels (Fra Angelico workshop), 44

Madonna and Child with Two Saints fragment (Guy François), 220

Madonna and Saints (Paolo da Venezia), 251

Madonna and Sleeping Christ Child with St. Anne (El Greco), 292, fig. 68

Madonna del Carmelo (G. B. Tiepolo), 236

Madonna del collo lungo (Parmigianino), 116

Madonna della Ghiara (Orsi), 181, 182

Madonna della Misericordia (Unknown Umbrian, c. 1300 [Maestro delle Palazze]), 260

Madonna della Sedia (Raphael), 206, 1897.9 n. 1

Madonna della Sedia (after Raphael; 1897.9), 206, illus. on 206

Madonna della Sedia (after Raphael; 1905.1180), 11, 206, illus. on 206

Madonna Enthroned (Paolo da Venezia), 251

Madonna Enthroned with Angels and Saints (Piero di Cosimo), 122

Madonna Enthroned with Ten Angels (Paolo da Venezia), 251

Madonna of the Harpies (Andrea del Sarto), 174 n. 12, 204

Madonna of the Purification of the Soul with Saints Francis and Clare (Caracciolo), 82

Madonna of the Rosary (Giordano), 153

Madonna of the Snow (Girolamo di Benvenuto), 159

Madonna with Lily (Fra Angelico), 42, fig. 4

Maella, Mariano Salvador, 234

Maestro de Cabanyes, 293

Maestro delle Palazze. *See* Unknown Umbrian, c. 1300

Maestro Marco. *See* Master of the Washington *Coronation of the Virgin*

Maggiotto, Domenico, 106, 193, 194; *Boy with a Flute*, 196 n. 8; *Poultry Seller*, 196 n. 8; *Young Pilgrim* (attributed to Maggiotto), 196 n. 8

Magnasco, Alessandro, 14, 162, 171–77, 280; *The Cloister School* (after Magnasco), 171, 176–77, illus. on 176; *Kleine Klosterschule* (after Magnasco), 177 n. 15; *Landscape with Monks* paintings (with Peruzzini), 174 n. 10; *A Medici Hunting Party* (with a collaborator [Marco Ricci?]), 171–74, illus. on 173; *La Piccola scuola del convento* (after Magnasco), 177 n. 15; portrait of Magnasco, 171, 173 n. 2; *The Presentation in the Temple* (Magnasco? and a collaborator), 171, 174–76, illus. on 175; *St. Ambrose Refusing Theodosius Admittance to the Church*, 175, fig. 30

Magnificentiores selectioresque etchings of Marieschi, 177

Maladie du Général (Chirico), 18

Malaspina, Ippolito, 90 n. 22

Malta, Order of, 53, 278

Malvasia, Count Cesare, 126

Mañara, Don Miguel, 326

Mancini, Francesco, 118

Manfredi, Bartolomeo, 208

Mann, Horace (British consular official), 64, 118

Mantegna, Andrea, 70

Maratti (Maratta), Carlo, 64, 210, 224, 286, 287; *Death of St. Joseph* paintings, 287

Marco (brother of Paolo da Venezia). *See* Master of the Washington *Coronation of the Virgin*

Maréchal, Jacques Philippe, 187

Maria Luisa de Parma, queen of Spain, 288; Mengs portrait of, 285 n. 6

Maria Theresa of Austria, 66

Marieschi, Antonio, 177

Marieschi, Jacopo, 177

Marieschi, Michele, 14, 75, 79, 163, 177–79; *Magnificentiores selectioresque* collection of etchings, 177; *Venice: Regatta on the Grand Canal* (after Marieschi), 177–79, illus. on 178; *View of a Regatta at Ca' Foscari*, 178–79, fig. 31

Marinetti, Antonio, 193

Marini, Antonio, 174 n. 30

Marionettes in a Storm (Klee), 18

Marriage of the Virgin (Niccolò di Buonaccorso), 68

Marriage of the Virgin (attributed to Carletto Caliari), 255, 256 n. 9, fig. 51

Marriage of the Virgin (Sagrestani), 219

Marriage of the Virgin, The (Veronese workshop; Hartford), 255–56, illus. on 257

Marriage of the Virgin (after Veronese; Paris), 255, fig. 50

Mars, Venus with Her Lovers, and Vulcan (Piero di Cosimo), 124 n. 5

Martinelli, Giovanni, 170, 214

Martínez, Sebastian, 288, 289

Martini, Simone, 42, 54, 56

Martyrdom of St. Afra (Veronese), 224 n. 5

Martyrdom of St. Agatha (G. B. Tiepolo), 233

Martyrdom of St. Agnes (Fetti), 142

Martyrdom of St. Andrew (G. M. Crespi), 126

Martyrdom of St. Andrew (Ribera), 310

Martyrdom of St. Andrew (Sagrestani), 219

Martyrdom of St. Bartholomew (Ribera), 310, 312

Martyrdom of St. Catherine (Orsi), 181, 182

Petrini, Marco: portraits of Count and Countess Riva, 192

Pevsner, Antoine, 17

Phaeton Asking to Drive His Father's Chariot (attributed to Niccolò Giolfino), 266

Phaeton Driving the Chariot of the Sun (attributed to Niccolò Giolfino), 266

Philip II, king of Spain, 290, 305

Philip IV, king of Spain, 309, 328

Philip V, king of Spain, 50, 286, 299–300

Philosopher (Giordano), 322 n. 2

Philosophers (Ribera), 314, 318–19

Philosophers Disputing (Giordano), 157

Pianca, Giuseppe Antonio, 280

Piazza, Paolo: *St. Francis's Vision of the Musical Angel*, 307

Piazza and Piazzetta S. Marco (Canaletto), 78, fig. 11

Piazzetta, Giacomo, 196 n. 14

Piazzetta, Giovanni Battista, 14, 106, 131, 132, 179, 192, 193–96, 233, 234, 236; *Adoration of the Shepherds*, 193; *Alfiere*, 193; *Assumption*, 193; *Assumption of the Virgin*, 193; *Beheading of St. John the Baptist*, 193; *Boy Holding a Lemon*, 194; *Boy in a Polish Uniform*, 196 n. 18; *Boy with a Pear in His Hand*, 194, 196, illus. on 195; *Death of Darius*, 194 n. 15; *Ecstasy of St. Francis*, 193; *Girl with a Ring Biscuit*, 194, fig. 37; *Guardian Angel with Saints Antonio of Padua and Luigi Gonzaga*, 193; *Indovina*, 193; *Mucius Scaevola*, 132, 194 n. 15; *St. Dominic in Glory*, 193; *St. James Taken to Be Martyred*, 193; *Saints Vincent Ferrer, Hyacinth, and Lorenzo Bertrando*, 193; self-portraits, 193; *Standard-Bearer*, 194; *Tomb of Lord Somers* (with Canaletto and Cimaroli), 193; *Virgin Appearing to S. Filippo Neri*, 193; *Woman Searching for Fleas* (with Bencovich), 193; *Young Boy with an Apple*, 194

Piazzetta, Venice, The (F. Guardi), 163, fig. 27

Picasso retrospective, Wadsworth Atheneum, Hartford (1933), 17

Piccinelli, Raffaelo, 204

Piccola scuola del convento, La (after Magnasco), 177 n. 15

Pictorial catalogue (painting type), 185

Picture Gallery of Cardinal Silvio Valenti Gonzaga, The (Panini; Hartford), 20, 184–91, illus. on 40 (color), 184, and 185, key 188 and fig. 36

Picture Gallery of Cardinal Silvio Valenti Gonzaga, The (attributed to Panini; Escorial), 187, fig. 35

Picture Gallery of Cardinal Silvio Valenti Gonzaga, The (attributed to Panini; Marseilles), 187, fig. 34

Pictures within Pictures exhibition, Wadsworth Atheneum, Hartford (1949), 188

Piedad (Ribalta), 306

Piero di Cosimo. *See* Cosimo, Piero di

Pierotti, Francesco, 196

Pierotti, Giuseppe, 196; *Interior of the Royal Museum, Naples: The Rotunda*, 196, illus. on 196

Pierotti, Pietro, 196

Pietà (Annibale Carracci), 50

Pietà (Domenichino), 135

Pietà (Foppa), 73

Pietà (Sebastiano del Piombo; Seville), 197

Pietà (Sebastiano del Piombo; Viterbo), 197

Pietà with Saints (Orsi), 181

Pietro da Cortona. *See* Cortona, Pietro da

Pillori, Antonio Nicola, 219

Pinturicchio, Bernardino, 146

Piombo, Sebastiano del, 20, 197–200; *Christ Carrying the Cross*, 197; *Flagellation*, 197; *Flagellation of Christ*, 197; *Judgment of Solomon*, 197; *Pietà* (Seville), 197; *Pietà* (Viterbo), 197; *Portrait of a Man in Armor*, 20, 197–98, 200, illus. on 31 (color) and 199; *Portrait of a Woman*, 197; *Portrait of Cardinal Ferry Carondolet*, 197; portraits of Clement VII, 197; *Self-Portrait as David*, 198; *Transfiguration*, 197; *Visitation*, 197

Piranesi, Giovanni Battista, 184

Pitteri, Marco, 194

Pittoni, G. B., 14, 219

Pius IV, pope, 280, *View of Pisa* n. 2

Pius VI, pope, 163

Pius XI, pope, 151 n. 15

Plato (Ribera), 314, 318–19, fig. 76

Platter of Fish (Giuseppe Recco), 207

Plymouth, earl of, 62

Podestà Lorenzo Cappello Kneeling before the Virgin (L. Bassano), 60

Podestà Matteo Soranzo Presented to the Virgin and Child (J. Bassano), 58

Polyptych (Paolo da Venezia), 252, fig. 49

Ponchino, G. B., 254

Poniatowski, Stanislaus, king of Poland, 66

Ponte, Francesco da (father of J. Bassano), 58

Ponte, Francesco da (son of J. Bassano). *See* Bassano, Francesco

Ponte, Giovanni dal, 200–202; *Annunciation with Saints* (Rosano), 200; *Annunciation with Saints* (Vatican), 200; *Coronation of the Virgin*, 200; *Madonna and Child with Saints John the Baptist and Catherine*, 200, 202, illus. on 28 (color) and 201; Scali Chapel frescoes (with Smeraldo di Giovanni), 200

Ponte, Jacopo da. *See* Bassano, Jacopo

Ponte, Leandro da. *See* Bassano, Leandro

Pontormo, Jacopo, 46, 114

Pope Clement Adoring the Trinity (G. B. Tiepolo), 233

Pordenone, Giovanni Antonio, 58

Porpora, Paolo, 300

Porta Coeli retable (Ribalta), 308

Portrait of a Boy (Guala), 162, illus. on 162

Portrait of a Fugger (circle of Giorgione), 200 n. 13

Portrait of a Man (Pietro da Cortona), 273

Portrait of a Man (Domenico Puligo), 204

Portrait of a Man in Armor (Sebastiano del Piombo), 20, 197–98, 200, illus. on 31 (color) and 199

Portrait of an Ecclesiastic (Ceruti), 106

Portrait of an Ecclesiastic (Unknown Italian, 17th Century), 271, 273, illus. on 272

Portrait of a Painter (Nogari self-portrait), 180, illus. on 180

Portrait of a Painter's Family (Mazo), 298

Portrait of a Violinist (Longhi follower), 170, illus. on 170

Portrait of a Woman (Sebastiano del Piombo), 197

Portrait of a Young Man (Domenichino), 135

Portrait of a Youth (imitator of Ghislandi), 152, illus. on 152

Portrait of Cardinal Ferry Carondolet (Sebastiano del Piombo), 197

Portrait of Cardinal Lambertini (G. M. Crespi), 126

Portrait of Count Lodovico Vidmano (Tinelli), 244

Portrait of Doctor Bernardi (Ghislandi), 152

Portrait of Don Pedro Arascot (Bayeu), 284–85, illus. on 284

Portrait of Francesco Biava (Ghislandi), 152

Portrait of Gattamelata (attributed to Giorgione), 198

Portrait of Marco Antonio Viaro (Tinelli), 244, illus. on 243

Portrait of Matteo Barberini (Caravaggio), 91 n. 27

Portrait of Paul III (Tintoretto; Naples), 249

Portrait of Pope Paul III (after Titian; Hartford), 248–49, illus. on 248

Portrait of Sir Humphry Morice (Batoni), 16, 64, 66, illus. on 65

Portrait of the Artist in His Studio (G. M. Crespi; Hartford), 18, 126, 128–29, illus. on 127

Portrait of the Artist in His Studio (G. M. Crespi; sale London), 128, fig. 22

Portrait of the Procuratore Alessandro Zeno (Nogari), 179

Portrait of Virginia Sacchetti Caprara (G. M. Crespi), 126

Portraits, Forty-three, exhibition, Wadsworth Atheneum, Hartford (1937), 17, 18

Port with a Walled City (Carlevarijs), 97

Posi, Paolo, 187

Poulterer (Campi; Kirchheim), 266

Poulterer (Campi; Milan), 266

Poultry Seller (Maggiotto), 196 n. 8

Poussin, Nicolas, 14, 16, 18, 64, 99, 103, 212, 217; *Adoration of the Shepherds*, 103; *Landscape with the Sleeping Silenus and a Nymph*, 212

Preaching of St. Paul (J. and F. Bassano), 58

Preaching of the Baptist (Jacopino del Conte), 114

Preparations for the Crucifixion (Ribalta), 305

Presentation in the Temple (L. Bassano), 62

Presentation in the Temple, The (Magnasco? and a collaborator), 171, 174–76, illus. on 175

Index of Previous Owners

Abercorn, duke of, 244
Agnew, Sir John, 298
Agnew & Sons, Thos., 50, 99, 137, 213, 244
Alcázar, 328, 332?
Allport, Comdr. R. L., 290
Amory, Sir John Heathcoat, 50
Appleby Bros., 290
Arcade Gallery, 111
Aretino, Pietro, 244
Arnold Seligmann-Helft Galleries, 282
Arnold Seligmann, Rey & Co., 62, 64, 84, 106, 114, 126, 165,
 176, 177, 208, 224, 277, 282, 296, 302
Artier, Francisco, 302
Ashburnham, earl of, 50
Ashburnham, Lady Catherine, 50

Bass, J., 204
Bates, 197
Bayet, Baron Ernesto, 260
Bayo Collection, 296
Bazzani, Bernardo, 260
Beach, Mrs. Charles, 229
Beaumont, Sir George, 184
Beaumont, Sir George Howland, 184
Beer, M. de, 278
Benson, Robert and Evelyn, 122
Bermejillo del Rey, marquesa de, 288
Bliss, Arthur, Collection, 54
Bloch, Vitale, 136
Blum, Mr., 111
Böhler, Julius, 67, 202, 241, 271
Böhler and Steinmeier, 234
Bondy, Oskar, 137
Bottenwieser, P., 54
Brass, Italico, 229
Brownlow, earl of, 137
Brydges, James, first duke of Chandos, 197
Buchanan, W., 255
Butler, Charles, 136
Butler, Patrick, 136

Caledon, earl of, 165
Cambiaso, Carlo?, 148
Campbell, Mr., 302
Canterbury, archbishop of, 309
Caridad, Hospital de la?, 325
Carlos of Bourbon, 50
Carlton, Sir Dudley, 244
Central Picture Galleries, 298
Cevat, Daan H., 284
Chester, Stephen?, 211
Chiesa, Achillito, 182
Cholmeley, Sir Hugh, 148
Cholmeley, Sir Hugh Arthur Henry, 328
Cholmeley, Sir Hugh John Francis Sibthorp, 328
Cholmeley, Sir Montague Aubrey Rowley, 328
Cholmeley, Sir Montague John, 328
Clark, Kenneth, 104
Clifford, B. T.?, 137
Colnaghi, Martin, 78
Colnaghi & Co., 103, 122, 131, 136

Colson, Percy, 262
Colt, Elizabeth Hart Jarvis, 116, 191, 206, 233
Cooley, Paul W., 132, 196
Corsini Collection?, 255
Costa, Ottavio?, 84
Costa Torro, Louis, 78
Courtauld, Stephen, 244
Curti Lepri, Marchese Alessandro, 165

D'Atri, 98
Davenport, Sir William Bromley, 244
De Boer, N. V. Kunsthandel Pieter, 58
Dehaspe, M. A., 220
Delacotte Collection?, 62
Demidoff, Prince, 274
Demotte, 62, 240?
Donà delle Rose, Count, 75
Doria Collection?, 177, 229
Douglas, R. Langton, 200
Durand-Ruel, 264
Durlacher Bros., 46, 81, 104, 153, 163, 182, 212, 218, 237, 247,
 249, 262, 265, 266, 278, 288, 290, 325, 332
Dutton, Mrs. Catherine Goodrich, 287
Duveen, Joseph, 122
Duveen Bros., 122, 320

Ehrich Galleries, 182, 262
Eminete, Juan Francisco?, 302
Erlanger, Mr. and Mrs. Arthur L., 162, 211, 234, 280
Erle-Drax. See Sawbridge Erle-Drax

Farnese Collection, Parma, 50
Farnese Collection, Rome, 50
Feilchenfeldt Collection, 131
Festetis, Graf Samuel von, 204
Ford, Richard, 328
Foresti, Carlo, 126
Frank, R., 62
Friedman, Irwin E., 118
Friedman, Judge Samuel E., 118
Fröhlich-Bum, Lili, 249

Gans Collection, 57
Gavet, Emil, 264
Geiger, B., 176
Ghisi, Stefano, Collection?, 141
Gimpel, René, 42, 260
Giovanelli, Prince Alberto, 168
Gonse, 98
Gonzaga, Cardinal Luigi Valenti, 184
Gonzaga, Cardinal Silvio Valenti, 184
Gonzaga Collection?, 255
Goodhart, Albert E. and Sophie Lehman, 160
Gordon, 244
Gozzadini Collection, 252
Graham, William, 122, 137
Grandi, Fratelli, 176
Grant, Lt. Col., 302
Grant, Mrs., 302
Grassi Collection?, 141
Greenberg, Mr. and Mrs. Leonard, 103
Grioni, Guido, 84
Grisar, A., 266
Grosvenor, William, 3rd duke of Westminster, 60
Guggenheim, 191

Photographic Credits

All photographs are by Joseph Szaszfai and Irving Blomstrann, except for the following:

Fratelli Alinari, Florence (Fig. 34)
Ampliaciones y Reproducciones MAS, Barcelona (Fig. 79)
Archivio Fotografico, Gallerie e Musei Vaticani (Fig. 25)
Archivio Fotografico, Museo Civico, Turin (Fig. 23)
Archivio Fotografico, Soprintendenza per i Beni Artistici e Storici di Modena (Fig. 33)
Archivio Fotografico del Museo Correr, Venice (Figs. 29, 44)
Art Institute of Chicago (Fig. 30)
Bibliothèque Nationale, Paris (Fig. 50)
Brescia, Pinacoteca (Figs. 60–63)
Bührle Collection, Zurich (Fig. 42)
Cleveland Museum of Art (Fig. 12)
Collection Thyssen-Bornemisza (Fig. 24)
Piero Corsini, Inc. (Fig. 84)
Documentation Photographique de la Réunion des Musées Nationaux (Figs. 43, 52)
Fogg Art Museum, Harvard University (Fig. 55)
Fondazione Giorgio Cini (Fig. 31)
Fotoabteilung, Staatliche Kunstsammlungen, Dresden (Figs. 5, 9, 77)
Gabinetto Fotografico, Soprintendenza Beni Artistici e Storici, Bologna (Fig. 49)
Gabinetto Fotografico, Soprintendenza ai Beni Artistici e Storici di Firenze (Figs. 21, 51, 57, 58)
Greenberg-May, Inc. (Fig. 66)
Hermitage, Leningrad (Fig. 19)
Indianapolis Museum of Art (Fig. 81)
Istituto Centrale per il Catalogo e la Documentazione, Rome (Fig. 26)

Bruce C. Jones (Fig. 47)
Laboratorio Fotográfico, Museo del Prado (Figs. 18, 67, 69, 72, 80)
Laboratorio Fotoradiografico, Soprintendenza ai Beni Artistici e Storici, Milan (Figs. 65, 73)
Lowe Art Museum (Fig. 48)
Metropolitan Museum of Art, Robert Lehman Collection (Fig. 10)
Museo Civico e Gallerie d'Arte Antica e Moderna, Udine (Fig. 14)
Museo de Santa Cruz, Toledo (Fig. 68)
Museum of Fine Arts, Boston (Fig. 54)
Národní Galerie, Prague (Fig. 8)
National Galleries of Scotland (Fig. 17)
National Gallery, London (Figs. 38, 45, 46)
National Gallery of Art, Washington (Fig. 70)
National Gallery of Canada, Ottawa (Fig. 20)
Nelson-Atkins Museum of Art, Kansas City (Fig. 41)
North Carolina Museum of Art, Raleigh (Fig. 71)
Philadelphia Museum of Art (Fig. 32)
Photographic Survey, Courtauld Institute of Art, London (Fig. 7)
Rijksmuseum-Stichting, Amsterdam (Fig. 4)
Sir John Soane's Museum (Fig. 11)
Sotheby's (Figs. 22, 37)
Stanford University Museum of Art (Fig. 39)
Worcester Art Museum (Fig. 53)
York City Art Gallery (Fig. 86)

Wadsworth Atheneum Paintings II
was designed by Nathan Garland
in New Haven, Connecticut.

The text was set in Baskerville by the
Southern New England Typographic Service
in Hamden, Connecticut.

It was printed by The Stinehour Press
in Lunenburg, Vermont.

Color illustrations were printed in
four-color process. Monochrome illustrations
were printed in two impressions of black.

Five hundred copies of this edition
of two thousand were casebound.